PRODIGAL FATHER

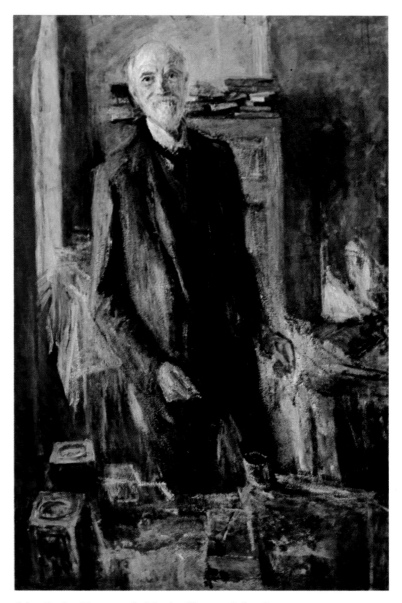

John Butler Yeats, unfinished self-portrait in oil, 1911–1922.
Collection: Michael B. Yeats.

PRODIGAL FATHER

The Life of John Butler Yeats
(1839–1922)

WILLIAM M. MURPHY

Cornell University Press Ithaca and London

First published 1978 by Cornell University Press.
Published in the United Kingdom by
Cornell University Press Ltd.,
2–4 Brook Street, London W1Y 1AA.

International Standard Book Number 0–8014–1047–9
Library of Congress Catalog Card Number 77–3122
Printed in the United States of America
Librarians: Library of Congress cataloging information appears on the last page of the book.

To TIMOTHY F. MURPHY

who, poor in the world's goods,
was prodigal in understanding
and support of his grateful son

Contents

Preface 9
Prologue 17
CHAPTER ONE | 1839–1862 19
CHAPTER TWO | 1863–1867 40
CHAPTER THREE | 1868–1870 56
CHAPTER FOUR | 1871–1873 74
CHAPTER FIVE | 1874–1881 97
CHAPTER SIX | 1882–1886 125
CHAPTER SEVEN | 1887–1891 152
CHAPTER EIGHT | 1892–1896 171
CHAPTER NINE | 1897–1900 194
CHAPTER TEN | 1901–1902 224
CHAPTER ELEVEN | 1903–1905 248
CHAPTER TWELVE | 1906–1907 295
CHAPTER THIRTEEN | 1908–1910 328
CHAPTER FOURTEEN | 1911–1913 381
CHAPTER FIFTEEN | 1914–1916 414
CHAPTER SIXTEEN | 1917–1919 461
CHAPTER SEVENTEEN | 1920–1922 505
Epilogue 541
Abbreviations and References 543
Notes 548
Index 651

Preface

SINCE THE death of John Butler Yeats in 1922, and especially since the publication of a selection of his letters by Joseph Hone in 1946, many students and lovers of things Irish have requested the complete story of the remarkable man whose fathering of a famous family was by no means his principal achievement. What needs to be explained is how the fortune of producing it fell to me, since many people have been eager to take up the challenge. The explanation is long and complicated, and I can say only that the chief reason is one that would have appealed to John Butler Yeats— what he would have called luck, chance, the stars, fate. Circumstances put me in the way of Mrs. Jeanne Robert Foster, a long-time friend and admirer of John Butler Yeats and close companion of JBY's friend and supporter John Quinn. Over a period of many years before her death in 1970 she turned over to me hundreds of JBY's letters, many of his sketches and paintings, and a wide assortment of miscellaneous material relating to the Anglo-Irish Renaissance. At her death, after a number of specific bequests to others, she left to me the rest of her vast collection, an almost essential source for a complete biography of the elder Yeats.

That good fortune led to an even more significant association with the living descendants of John Butler Yeats. In 1966, Michael B. Yeats and Anne B. Yeats, the son and daughter of William Butler Yeats, placed at my disposal thousands of pages of relevant manuscripts. Upon the death of their mother in 1968, vast additional treasures were uncovered in the house on Palmerston Road in Dublin where she had lived since her husband's death, and these were likewise turned over to me. Of the extensive sources from which this biography has been constructed, perhaps eighty percent has come to me through the generosity of the Yeats family. To my everlasting gratitude, virtually every other person or institution to whom I turned for help was quick to give it, so that I have had access to almost every scrap of information bearing on the life and works of John Butler Yeats, though I am aware that other sources now unknown to me will almost certainly spring into view as soon as this book is published.

A few words need to be said at the outset about what the book is and what it is not, what it does and does not pretend to be. It is not a biography of William Butler Yeats or his brothers and sisters. It is not a history of the Abbey Theatre, or of the Dun Emer and Cuala Industries. It is not a critique of art, JBY's or anyone else's. It is not psychoanalysis or psychobiography. It is, quite simply, the story of a man's life, an account of what happened to him from day to day and year to year. As JBY touched many people and places and movements, much must be said about them. But it is the story of the man himself that I have tried to tell, the very human story of a lovable, brilliant, and distressingly improvident man. Perhaps this volume may provide material for others interested in digging more deeply into some of the subjects mentioned above, but no final treatment of them is attempted here.

In a work of such scope the writer places himself under such heavy obligation to so many people that he finds it difficult to express his gratitude adequately and runs the danger of overlooking the names of some of his most valuable and valued contributors. Anyone working the Yeats cornfield must begin with acknowledgment of the pioneering researches of Joseph Hone, Allan Wade, Richard Ellmann, and A. Norman Jeffares. Hone's edition of a small portion of JBY's letters and the further selections edited by Donald Torchiana and Glenn O'Malley are of great use to all students of John Butler Yeats; recent critical studies by Jeffares, Douglas Archibald, and Denis Donoghue are filled with wise and illuminating commentary that I have happily absorbed. Perhaps the most important single book for its information about John Butler Yeats is B. L. Reid's biography of John Quinn, *The Man from New York*, absolutely essential and invaluable to any student of the Yeats family. The sources I have used are usually different from his. He has viewed affairs from Quinn's point of view rather than JBY's, but I do not think my own studies of John Butler Yeats would have been as rewarding without a reading of Reid's excellent book. George M. Harper's work on W. B. Yeats's occultism guided my steps over many a rough spot in the road. James Flannery's monograph on Annie Horniman and the Abbey Theatre and the brilliant condensation of Joseph Holloway's journals by Robert Hogan and Michael J. O'Neill are of the greatest value to all scholars of the Irish National Theatre Society; and the biography of J. M. Synge by David Greene and J. H. Stephens is a mine of information and intelligent commentary. The scholarly and sensitive work of Ann Saddlemyer on Synge is something I would not willingly forgo. The two-volume collection of WBY's hitherto uncollected prose by John Frayne and Colton Johnson has become a necessary source for every Yeats scholar, as has Denis Donoghue's edition of WBY's hitherto unpublished *Memoirs* (which, however, I first saw and studied in the transcript prepared by the late Curtis Bradford). The diaries of John Sloan edited by Bruce St. John and the published recollections of Van Wyck Brooks were indispensable for the New York period. To all these and to uncounted Yeats scholars through-

out the world I give my thanks, and in the notes to the book I hope I have adequately expressed the extent of my indebtedness to them; any oversights have been inadvertent.

Of my feelings during the long gestation of this book I can only repeat what John Butler Yeats said of his unfinished self-portrait: "It fills my life. I have never an idle moment or idle thought. It is a long revel, just as satisfying to me as Gibbon's *Decline and Fall of the Roman Empire*, and I think I have been at it almost as many years." Friends have remarked that it has taken me almost as long to write John Butler Yeats's life as it took him to live it. One reason is that, with the exceptions already noted, the material on which the book is based, chiefly JBY's letters and other writings, is handwritten in almost illegible script. Neither the painter nor his son the poet took care to write clearly, and as a result it took me several years merely to convert the original writing to manageable typescript of well over two million words. Glenn O'Malley and Donald Torchiana generously provided me with typescripts of JBY's letters to his American friends totaling about a quarter of a million words, and without their contribution my own work would have been slowed even more. A first long draft of the biography, completed several years ago, was more than three times the length of the present volume. The process of distilling it to its present length has been long and arduous and could not have been accomplished without the ruthless but intelligent wielding of the blue pencil by my old and good friends Van Vechten Trumbull and Bettina Trumbull, and John Van Schaick and Sally Van Schaick, who all worked heroically to throw out the bathwater while saving the baby. Phillip L. Marcus and Elizabeth Mansfield read and criticized the manuscript, and I am grateful for their constructive comments; Harry Marten kindly read the final version. Jane Reverand was a sympathetic but demanding copy reader to whose brilliant editing much of the book's merit (whatever it may be) is owing. To her and Marcia Poucher, who painstakingly shepherded the text from typescript to bound copy, I offer thanks.

To them and all others who helped in the making of the book I give my thanks, and once again I must acknowledge the exceptional contributions of the members of the Yeats family, who provided not only the materials on which most of the book is based but also many hours of hard work. Michael Yeats and his sister Anne were unsparing of their time and labor; as the only children of William Butler Yeats and the only grandchildren of John Butler Yeats they were generous in their offers of everything except censorship. I am aware that passages in a biography may be painful to the descendants of the subject; what is written here represents my own interpretation of the material available, and neither of the poet's children, whatever their private feelings, attempted to dictate either the contents or the conclusions. The biography may be "authorized" but is by no means "official." Gráinne (Mrs. Michael) Yeats (herself the distinguished daughter of a distinguished Irish patriot, P. S.

O'Hegarty) has been of great assistance in the translation of passages in the Irish language, her native tongue. The children of Michael and Gráinne Yeats, Caitríona, Siobhán, Síle, and Pádraig, shared the drudgery of copying thousands of pages of documents; and the friendship and support of the family as a whole sustained me and my family through many difficult years. My wife, Harriet Doane Murphy, spent endless hours assisting with copying and filing, and contributed immeasurably otherwise to the lightening of my labors. My children, David, Susan, and Christopher, gave generously of their help. In many ways the work is the product of two families. I must add, too, that without the kindly and skillful ministrations of two good friends and physicians, Dr. Miriam Friedenthal and Dr. James W. Nelson, I might never have made it through some dark hours.

I also received invaluable assistance from scores of people and institutions. Among the latter I mention first the American Philosophical Society, which showed its confidence in the project by early and absolutely essential support: to George W. Corner, Executive Director, and Julia Noonan, Executive Secretary, I express deep thanks. Other institutions that contributed importantly, either through financial grants or the use of library, museum, or other facilities, I give below in alphabetical order: Abbey Theatre Company, Admiralty Register (London), Albright-Knox Gallery (Buffalo), American Council of Learned Societies, Australian News and Information Bureau, Birmingham (England) City Museum and Art Gallery, British Museum Library, Brown University, University of California at Los Angeles, Colby College, Dartmouth University, University of Delaware, Delaware Art Museum, Dublin Records Office, Harvard University, Henry E. Huntington Library, King's Inns (Dublin), University of Leeds (England), Library of Congress, Lloyd's of London, Metropolitan School of Art (Dublin), Middle Temple (London), National Archives and Record Service (Franklin D. Roosevelt Library), National Gallery of Ireland, National Library of Ireland, National Maritime Museum (London), State University of New York at Albany, State University of New York at Binghamton, State University of New York at Buffalo, New York Public Library (Berg Collection), Northwestern University, University of Pennsylvania, Pollexfen, Inc., Shipbrokers (Liverpool), Princeton University, Queen's University (Belfast), University of Reading (England), Sligo County Museum, Smithsonian Instutition (Archives of American Art; Hirshhorn Museum and Sculpture Garden), University of Texas (Humanities Research Center), University of Toronto, Union College, Wagner College, Wesleyan University, Yale University, and Yeats Society (Sligo).

The librarians, curators, and others connected with the listed institutions were most helpful. They include, again in alphabetical order: Freda Adams, Gertrude Anteman, W. J. Bell, Arthur J. Breton, Dorothy W. Bridgwater, Frank Byrne, Caroline Danchak, Edna C. Davis, William Dieneman, Ellen S. Dunlap, J. A. Edwards, Edward Elliot, Rowland Elzea, Ruth Anne Evans,

David Farmer, Marion Fleisher, K. C. Gay, David Gerhan, Lorraine Ghigliotti, Thora Girke, Holley D. Greene, Janet Gregor, Margaret C. Griffith, Leonard Halperin, Ian Hamilton, Patrick Henchy, Doris Herbrandson, William Hopkins, J. L. Howard, Russell Johnson, Maria Kenny, Karen Lewis, David M. Liddy, Maired Looby, Charlotte Lutyens, John McGinlay, the late Thomas MacGreevy, Kenneth McGuffie, Bridget MacMenamin, Daniel McNett, Annette Masling, K. R. Mason, Donald R. Masson, Ronald Milkins, Delia Moore, Peter Morrin, John Murdoch, Nora Niland, Alf O'Lochlainn, James E. O'Neill, William O'Sullivan, C. H. Oswald, Cecilia Pawlicek, Daphne Pipe, James Provost, Hilary Pyle, Martin Ryan, Joseph Slade, Wayne Somers, M. K. Stammers, Nancy Sterling, Lola Szladits, the late Edwin K. Tolan, Loretta Walker, James F. Ward, Anne Whelpley, James White, Betty Jane Wilcox, the late Charles Wilde, Ronan Wilmot, N. C. B. Wright, and Elspeth Yeo.

Other scholars, friends, colleagues, and former students who have been of help are Cheryl Abbott, Julia E. Abbott, Neal W. Allen, Paul Andrews, F. G. Atkinson, Eleanor R. (Mrs. August) Belmont, Eloise Bender, Paul Benjamin, Whitney Blake, Harold E. Blodgett, Harold W. Blodgett, George Bornstein, Zack Bowen, the late Curtis Bradford, Mrs. Van Wyck Brooks, Heywood Hale Broun, Edward Fawcett Brown, Robert Brown, Timothy Brownlow, Martha Caldwell, the Reverend A. W. R. Camier, Thomas Clohesy, Josephine Coffin, Kathleen Cohalan, George Cole, Dr. Thomas F. Conroy, Major E. A. S. Cosby, Mr. and Mrs. J. F. Crowder, the late Joseph Culhane, Alan Denson, Mrs. Lorenzo Dole, Joseph Doty, Oliver Edwards, Philip Edwards, Mrs. Karl Ege, Maurice Elliott, Richard Ellmann, Milton Enzer, Davis Finch, Mary FitzGerald Finneran, Richard Finneran, Caroline H. Fish, Ian Fletcher, James Ford-Smith, Laura Frank (Mrs. Robert Chudd), Frances-Jane French, Larry Friedman, Daphne Fullwood, Ira and Nancy Glackens, Mark Glazebrook, Helen Crosby Glendening, Robert Gordon, Aideen Gore-Booth, Warwick Gould, Robert Graves, T. Affleck Greeves, Maurice Harmon, George M. Harper, Jocelyn Harvey, the late James A. Healy, the late Thomas Rice Henn, Richard Hirsch, Teresa Hoban, Michael Holroyd, John Horwath, Michael Horwath, Doreen Jameson, the Reverend W. Jack Jenner, Admiral Sir Caspar John, Colton Johnson, Josephine Johnson, Ralph Johnson, John Kelly, the late Martin Keogh, Jr., John M. Keohane, Joseph Killorin, the late Sheelah Kirby, Carole Kohan, Janet Lambe, Joan Todhunter Lambe, the late Maria Leach, E. A. S. Lewis, Judith Lockman, Theodore Lockwood, Seán MacBride, Sister M. Ursula McDermott, Norman MacKenzie, James McKillop, George P. Mayhew, Stella Mew, Liam Miller, Kathleen Moran, Rosemary Phelps Murphy, Paul Myers, Alan Nelson, Carl Niemeyer, the late Sean O'Casey, William H. O'Donnell, Robert O'Driscoll, Brendan O'Neill, Susan O'Regan, Harold Orel, Annette K. O'Sheel, Lt. Col. Frank Oswald, David Park, Roger Parris, Yvonne Pène du Bois, Bennard A. Perlman, Emily Phelps, Percy Phelps, Peter Prosper, the late Olive Purser, Benjamin L. Reid, Francis Markoe Rivinus,

Alan Roberts, William L. Roberts, Mrs. Lennox Robinson, Marilyn Gaddis Rose, Richard Rovere, the late Aline Saarinen, Mikel Schwarzkopf, Sir Robert and Lady Rosalind Scott, Constance Sherman, Harvey Simmonds, Robin Skelton, Helen Farr (Mrs. John) Sloan, Robert Spivy, Samuel S. Stratton, W. A. Taylor, Charles Thomas, William H. Thompson, Marjorie Todhunter, Rebecca Trumbull, Victor Waddington, Brigid Westenra, Terence de Vere White, Anne Wickens, Wallace Winchell, the Rev. Canon T. P. S. Wood, Jane Woodroffe, Grace Yeats, Harry Yeats, Pamela Butler Yeats, and Judith Zilczer. The late Evelyn Richardson, of Bon Portage Island and Barrington, Nova Scotia, followed the course of my work with the greatest sympathy and interest, and I am distressed that she has been deprived by death of the opportunity to observe the results. She was a friend of thirty years whose own writings delighted and inspired me.

I have been particularly fortunate in having had the opportunity to meet and talk with many people who knew John Butler Yeats: the late Conrad Aiken, the late Van Wyck Brooks, the late Padraic Colum, the late Constantine P. Curran, the late Ida Varley Dewar-Durie, Leonard Elton, the late Jeanne R. Foster, the late Beatrice Lady Glenavy, Laurence Gomme, the late Delia Lady Hanson, the late Bishop T. Arnold Harvey, Ruth Hart (Mrs. Andrew) Jameson, the late Luba Kaftanikoff, Senator Nora Connolly O'Brien, Edwin Avery Park, the late Ezra Pound, and John Hall Wheelock.

The photography of sketches and of old and often faded photographs was prepared for this book chiefly by Peter Klose of Rhinebeck, New York, and Rex Roberts of Sandycove, County Dublin, Ireland. Secretarial help was provided by Hilda Clohesy, Linda Dean, Elizabeth De Feo, Joanna Fotheringham, Lillian Heinen, Patricia Konczeski, Georgia MacFarlane, Dora Pugh, Barbara Seeger, Betty Shaver, Patricia Stoddart, Susan Thomas, Audrey Werner, Margaret Windstone, and the late Elizabeth Wilsey.

The greatest debt I owe is expressed in the dedication.

Others, who will not read these words, had nothing to do directly, but much indirectly, with this book: David Worcester (1907–1947), my first and best teacher of English; Albert Damon (1918–1973), gentleman and genius; and Patrick Kilburn (1924–1974), stimulating companion and healing colleague. All were friends I worshiped this side idolatry; it is a pleasure to me merely to write their names and record my gratitude to them.

I must make the customary acknowledgment that although many of the virtues in this work can be traced to the labor and kindness of others, the responsibility for errors of fact and mistakes of judgment, which I hope are few but suspect are many, is mine alone.

<div align="right">WILLIAM M. MURPHY</div>

Bear Point, Shag Harbour, Nova Scotia

PRODIGAL FATHER

Prologue

JOHN BUTLER YEATS died in New York City on February 3, 1922. Eight weeks later, at the boardinghouse where he had lived for the twelve years before his death, friends and acquaintances held a dinner to honor his memory. The guest list reads like an intellectual and artistic *Who's Who in America*.[1] Representing the world of literature were Van Wyck Brooks, Witter Bynner, Percy MacKaye, Grove Wilson, and the Irishmen Padraic Colum and Ernest Boyd; the world of journalism, Heywood Broun and Oliver Herford; the world of politics, Allen Benson, one-time socialist presidential candidate. From John Butler Yeats's world of art came George Bellows, William Glackens, Robert Henri, John Sloan, and the collector John Quinn. Many a seeker after fame would have paid pounds and crowns and guineas for an honor that came to this man unsought and unbought. At his death he had little money or goods. He left only the memory of a fascinating personality, of a magnificent conversationalist, of a philosopher and idealist who had sacrificed conventional comforts for the sake of art and the well-lived life. The men and women who came to the memorial dinner for one whom Boyd called "the youngest of old men"[2] did so out of simple affection.

Although John Butler Yeats had two sons of great reputation, one a poet, the other a painter, the guests came to honor not the father but the man. They knew he had journeyed to New York from Ireland fourteen years earlier, at the age of sixty-eight, with a reputation as a distinguished portrait painter, and they had watched as he drew pencil sketches busily in his sketchbook; but they regarded him less as artist and relic than as man and contemporary. Despite his years, he seemed either ahead of the fashions or independent of them. He spoke with sound good sense and delightful humor about art and poetry and people, and the influence that radiated out from him touched a whole generation. "I assure you that my own father's death was not so great a loss to me," John Sloan wrote JBY's daughter Lily. "A few score men such as your father in the world at any one time would cure its sickness."[3] Van Wyck Brooks said of JBY, "He was a much greater man than his son William Butler Yeats."[4]

Yet the person honored at the shabby boardinghouse on West Twenty-ninth

Street seemed the very image of failure, a standing object lesson in missed opportunities, which formed a repeating pattern that had been established by outer fate and inner compulsion long before he entered the rich autumn years of his life in New York. He had painted scores of portraits for which he had been paid poorly or not at all. He had inherited a landed estate in Ireland and lost it. In New York, to which he had come with hopes, he could not succeed in making a living from his work and during his years there had existed only by virtue of his elder son's filial but difficult generosity and the emotional support of John Quinn.

His impecuniosity, however, did nothing to diminish the affection which others felt for him. He never lost his capacity for friendship and encouragement. He had a way of making people feel better about themselves and of arousing them to a sense of their own highest possibilities in a world in which art and thought had meaning. It was a great gift to give, and they knew it and were acknowledging it. Not many men have had such a marked effect on so many lives or touched them at so many points as John Butler Yeats.

1839–1862

JOHN BUTLER YEATS, although born an "Ulsterman," was the antithesis of all that is implied by the word. Indeed, his ancestors had bequeathed him non-Ulsterian qualities almost in excess—sociability, curiosity, irrepressible optimism, and an affection for people. At his birth, on March 16, 1839, his father, the Reverend William Butler Yeats, was Rector of the Church of Ireland in the parish of Tullylish, near Lawrencetown, County Down.[1] Two older children, both daughters, had died in infancy, and younger ones would not arrive until some years later. In his earliest and most impressionable years he was the sole delight and interest of his parents, to whom he became strongly attached.

His father, easygoing and nondogmatic, thought his duty "a very simple one: to follow closely in the footsteps of Jesus, to be like him sympathetic and like him affectionate, and like him courteous."[2] He caught his manners from his own father, "Parson John" Yeats of Drumcliff parish in County Sligo, who also had been a gentle shepherd. When Parson John was about to enter a room where he knew two servants of opposite sexes might be together, he rattled his keys so that he would run no danger of finding them in embarrassing circumstances.[3] He loved the good things of life, constructing in the Drumcliff Rectory a secret drawer where he hid the liquor so that his wife couldn't find it. When he died in 1846 he left a liquor bill of four hundred pounds, which his son promptly paid.[4]

There was no trouble meeting the bills, for Parson John's income during his term there from 1811 to 1846 was about four thousand pounds a year. His preferment for such a lucrative post was probably connected with the power and influence of the family of his wife, Jane Taylor. Her father, William Taylor, was an official in Dublin Castle, the center of English dominance in Ireland, where John's brother George Yeats also served, perhaps through the influence of the Taylors. Parson John's son William Butler Yeats was born in 1806 in a room in the Castle,[5] where his grandfather Taylor lived. One of the Taylors was employed by the government "to know the history of every person of prominence in Dublin," and at his death the government claimed and took

five thousand pounds in "secret service money" found in his desk.[6] Because of the family connection, all the news coming to Sligo from Dublin arrived at the Drumcliff Rectory first.

If the Taylors held the political power, it was through Parson John's mother, Mary Butler Yeats, that the family could claim a connection with the ancient Irish Ormondes, the Butler family of great wealth and power that had settled in Ireland in the twelfth century.[7] The Yeats branch of the family was the more humble. The Benjamin Yeats who married Mary Butler and fathered Parson John had been a wholesale dealer in linens in Dublin, as had his father Jervis Yeats before him.[8] How a man of such origins as Benjamin's came to marry Mary Butler is not known. By the standards of her time she appears to have married beneath her,[9] but since she was only one of many children of Edmond Butler her prospects for marriage may have looked poor. Through an uncle, John Humphry, her brothers became entitled to property he owned at Thomastown in County Kildare and to a house in Dorset Street, Dublin. Humphry willed the property to male members of his family in the usual line, and to female members only if the male line should fail. Luckily for Parson John, all his uncles died without issue, and he (in the words of the legal claim) "became entitled as *next in remainder.*"[10]

The marks of the humbler parts of their origin never disappeared from the Yeatses. Parson John was revered by the Catholics in his parish—the priests once "got up a bonfire" on his return from Dublin[11] —and brought up his son in the same tradition of tolerance and affection. Both were scholarly, simple, and courteous; a half-century after Parson John's death his family was still remembered as "the best blooded in the county and no impudence about them."[12]

William Butler Yeats grew up to be a slender six-foot-two-inch redhead with brown eyes. He was admitted to Trinity College, Dublin, in 1828 without having endured the rigors of public-school life.[13] While at Trinity he lived in Great Cumberland Street with his grandmother, who allowed him two hundred pounds a year; he always had a fine horse and was able to continue the free and easy life of his Sligo boyhood. He became the best high-jumper at Trinity, where his friends included Isaac Butt, then an unconverted Tory Unionist, and Archer Butler the Platonist. He was also extraordinarily sensitive. Once, returning from Dublin to Drumcliff, he stood aside at the gate of the Rectory to let a string of carts carrying turf pass in. He recognized one of the horses as a favorite of his childhood, one he had hunted with as a boy; now it was lame and reduced to the work of hauling. "Grown gentleman that he was," said Honour Burke, whose father had been butler at the rectory, "he sat down on the green bank by the road and cried."[14]

He held a curacy at Moira in County Down for a year or two before his marriage in November, 1835, to Jane Grace Corbet at St. Mary's Church, Donnybrook.[15] She was a woman of wit and spirit who delighted her bride-

groom after the wedding by bribing the postillion of their coach to race another bridal couple going down the same road.[16] Through her the Yeatses joined with another distinguished Anglo-Irish family. Her mother, Grace Armstrong, was the daughter of Captain Robert Armstrong of Hackwood, County Cavan, and the grandniece of John Armstrong, one of Marlborough's generals.[17]

To these amiable, secure, and comfortable parents John Butler Yeats was born in the third year of Queen Victoria's reign,[18] and the memories of his first ten years with them helped sustain through a long life his belief in the fundamental goodness and kindness of people. All about him he saw signs of family affection. His earliest memory was of his nursery days, when his father's sister Eleanor, married to a clergyman named Elwood, paid a farewell visit with her husband and a flock of children before striking out for a new life in Canada.[19] To the young boy the world radiated out from his family: when Aunt Mickey (his father's sister Mary) visited from Sligo, she was such a joy to the children that everyone would be miserable if she left the house for even half a day.[20] Uncle Robert Corbet came often to Tullylish from the large house called "Sandymount Castle," on the outskirts of Dublin, where he lived with his mother and aunt. Once, after Uncle Robert had left to catch the night coach to Dublin, young Johnnie, "out of pure affection and loneliness," crept over and "drank out of his tea-cup."[21] Occasionally he would be taken into Dublin, where he was happy chiefly because his parents were with him. "In those days," he wrote his son later, "it was considered bad manners for parents to speak crossly to their children, and so we grew up in what I may call the discipline of good manners as contrasted with the discipline of good morals."[22] "The charm of the poor old Yeats family was that they never scolded."[23]

The Ulster in which the Reverend William Butler Yeats served his church was the direct ancestor of twentieth-century Northern Ireland, heavily populated by descendants of the Plantation settlers of two centuries earlier, now thoroughly transplanted Irishmen who embraced Knox Presbyterianism and its gloomy puritan doctrines, especially the belief in "getting on." The church of the Yeatses, on the other hand, was that of the oldest Anglo-Irish settlers, who looked askance at Ulster Presbyterians and Englishmen alike and regarded their own church—the church of Jonathan Swift and Oliver Goldsmith and Laurence Sterne—as the ecclesiastical analogue of Anglo-Irish nobility and gentry. William Butler Yeats in Tullyish, like his father in Drumcliff, always found something good to say of the Roman Catholics, the theoretical enemy, and lived on good terms with the neighboring Catholic priest while remaining unacquainted with the Presbyterian minister.[24] During the cholera pestilence of 1845 he risked his life moving among the people and raised funds for their relief.[25]

In normal times the Reverend Mr. Yeats was the reflective philosopher and gentleman. He needed intellectual companionship, provided in that lonely

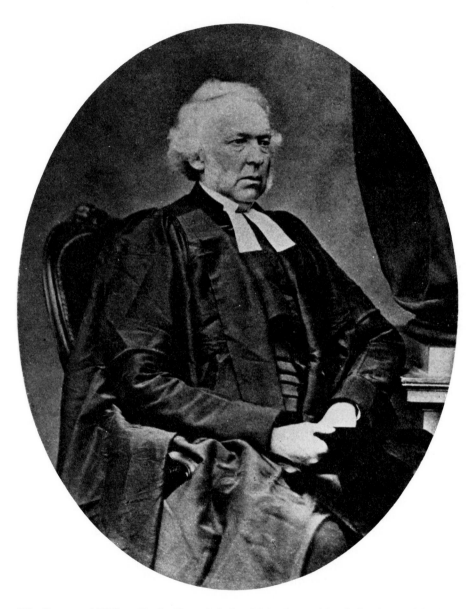

The Reverend William Butler Yeats (1806–1862), about 1860. Collection: Michael B. Yeats.

place by his growing son, who has left us a charming account of their relation-
ship:

Every night when the whole house was quiet and the servants gone to bed he would sit
for a while beside the kitchen fire, and I would be with him. He never smoked during
the day and not for worlds would he have smoked in any part of the house except the
kitchen. And he always used a new clay pipe, and as he waved the smoke aside with his
hand he would talk, and I would listen, of his college days and of the men he had known
there as his fellow-students.[26]

After a village schoolmaster taught young Johnnie to read, the boy tested his
skill on a novel by a man whose works he would later illustrate. After dinner,
while his father sat beside his candle reading and his mother by her candle
sewing, the child would "nestle beside her reading *Robinson Crusoe*," which he
believed a true story. "I can remember," he wrote, "that at certain critical
passages in this history I would tremble with anxiety, and that I was most
careful lest my elders should discover my excitement and laugh at me." The
only disappointment he brought to his father was his utter unteachability at
arithmetic, for which his father once boxed his ears, then immediately
apologized.[27]

The father was charming and lovable, with the power to make people
believe in themselves.[28] Part of his selflessness came from the conviction that
the Anglo-Irish were "socially the equals and the superiors of most," and that
"there were no gentlemen in England."[29] The son was to learn how different
life could be in the two kinds of homes. In the Yeats household, "everything
was settled by 'nice' feeling as it was understood among 'gentlemen.'" In
English families, "'nice' feeling did not count, only discipline and the law and
Anglo-Saxon force, above all 'force.'"[30] The Anglo-Irish believed "in sym-
pathy, affection, and social refinements, and that if you were not a gentleman
in this sense of the word, you could not be a saint."[31] His father was "always on
the lookout for the beautiful and the pleasing," his son wrote. "It was this made
him the most agreeable of companions and the finest of gentlemen. With a
wave of his hand he made all difficulties disappear as if by magic. He made
castles even in Ireland, as others did in Spain."[32] In him his son found the very
model of the Irish gentleman, "a man who takes as much care of the dignity of
the person with whom he has relations as he would take of his own."[33] It was a
model he would never forget and would duplicate in his own later life.

If his father was "a centre of character," caring nothing for authority or
power, his mother was a center of "order," disciplining her children with
kindliness but firmness, never speaking a harsh word.[34] His father was in-
terested in things of the intellect and in long, graceful theoretic explanations;
his mother had no theoretical faculty, substituting for it a way of saying "Yes,
darling," or "No, darling," that "was sufficient for all purposes."[35] She wrote

poems which she kept private. When her husband one day committed the indiscretion of showing them to others, she destroyed them and never wrote more.[36]

She was also more practical in economy than her husband. John Butler Yeats as a small boy found he had a liking for drawing and a certain facility at it. Paper was expensive in those days because of the heavy tax placed upon it by the English government to discourage the distribution of subversive literature. His mother, not sympathetic to his artistic strivings and wanting to reduce household expenses, tried to keep paper from him. His father saw to it that the paper was provided.[37] It was a rich and happy boyhood, and it fixed his personality forever.

In 1849, when Johnnie was ten, the good days came to an end. The time for school had come, and his father chose a place in Seaforth, outside Liverpool, run by three maiden sisters named Davenport. The boy, not suspecting what was coming, was delighted at the prospect of meeting strange people in a new environment. When Uncle Robert Corbet, who accompanied him, offered to stay a day longer, young Johnnie waved him away, eager to plunge into the new life.[38]

He soon regretted his decision. At home in Tullylish, religion had been pleasant and good, "heaven" a future reality, "hell" a meaningless word for a nonexistent place. Now he learned how other Christians saw the world. Seventy years later he remembered their teachings vividly:

My first school was managed by a fear of God, and of Miss Emma. The Bible to me was then the word of God, who I thought had always spoken in archaic English. . . . One day Miss Emma said all men and all children were sinners, which I understood to mean convicted and brought before the bar. That was a shock for which I was unprepared. Another day she said that we were so wicked that even if we got to heaven we should not enjoy ourselves.[39]

Each child slept with a Bible under his pillow, but the religion taught was of fear and punishment, not of love and redemption. For the first time young Johnnie Yeats met the morals of the puritanical mind. One day he and another boy were caught climbing a tree and were soundly punished by Miss Betsey Davenport, who rapped them on the knuckles with a cane. Once a drawing master compelled him to stop reading *The Children of the New Forest* because all novels were lies and lies were sinful. The sinner remembered seventy years later that he had reached page 224 in the second volume when the blow fell. Yet the same master touched up the boys' drawings "for the edification of our parents and for their deception."[40] Life as it was didn't seem to correspond with the Davenports' description of what it was supposed to be. Seeds of doubt were planted: the boy used to pray fervently for letters from home and then wonder "whether there was any use in praying when I knew the time for posting letters to me had passed."[41] The mind that was later to be a ripe field

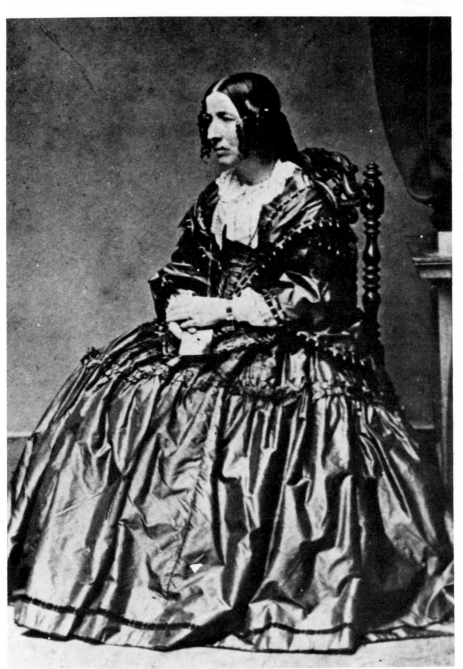

Jane Grace Corbet (Mrs. William Butler) Yeats (1811–1876), mother of John Butler Yeats, about 1857. Collection: Michael B. Yeats.

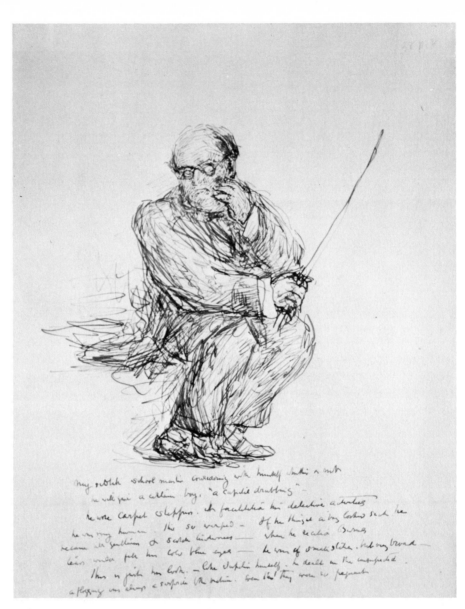

Walter Forrester, M.A., in letter from JBY to John Quinn, April 5, 1916. "My Scotch school master considering with himself whether or not he will give a certain boy 'a capital drubbing.' He wore carpet slippers. It facilitated his detective activities. He was very human, tho so warped. If he thought a boy looked sick he became all gentleman and Scotch tenderness. When he recited Burns tears would fill his cold blue eyes. He was of small stature, but very broad. This is just his look—like Jupiter himself, he dealt in the unexpected, a flogging was always a surprise to the victim, even tho' they were so frequent." Collection: Foster-Murphy.

for the harvest of Comtism and Darwinism was plowed and seeded by the age of twelve.

After two years at Seaforth, Johnnie Yeats and his younger brothers William Butler, Jr., and Robert Corbet were packed off to the Atholl Academy on the Isle of Man, a private school run by Walter Forrester, M. A., a Scotsman who believed in flogging as the sovereign remedy for the evil in small boys. On their first day there they saw three boys "flogged very effectively with a gutta percha whip" in what the master called "three capital drubbings." The school taught certain lessons "that will be valuable to the millennium," wrote JBY years later. "We knew how to sleep well though tomorrow would bring, certain as fate, a sound caning, and to laugh and be cheerful five minutes after a caning."[42]

Yet for Mr. Forrester he came in time to have "entire respect." "He was an able and honest man of great natural force and he loved his boys, not of course as they were but as he intended to make them. He believed that in every boy were intelligence and the seeds of virtue—only they needed the rod . . . and he measured the dose according to what he conceived to be the necessities of the case. He was decidedly a hopeful schoolmaster."[43] But he was also a Scotch Calvinist opposed to any activity that looked enjoyable. He spied on the boys, padding stealthily through the halls in carpet slippers.[44] At Seaforth retribution for sins lay in the future in another world; at Atholl it came in this one and without delay. Still, Mr. Forrester insisted, with "a kind of savage and iconoclastic intensity," on "hard work and honest thinking." He hated shams and slipshod work, reinforcing in young Johnnie an attitude—first encouraged by his father—that led to JBY's later rejection of the religious beliefs with which he had been indoctrinated.[45]

For several years, despite his weakness in arithmetic, Johnnie Yeats was by his own account the top boy in the school.[46] Most of the honors were carried off by the Irish boys, who comprised about half the student body; the English were usually near the bottom, even though the Irish were enrolled in the difficult classics program and the English in the less demanding commercial one. Once the Irish boys challenged the combined English, Scotch, and Manx to a tug-of-war and beat them.[47] One of the principal services of the Irish boys to the English was to instruct them when to drop their aitches and when to keep them.[48]

Perpetually at the foot of the class, however, to the embarrassment of their countrymen, were two brothers from Sligo, Charles and George Pollexfen, in 1851 thirteen and twelve years old. In County Sligo the Yeatses and the Pollexfens were not acquainted. The Yeatses and their relatives were military, civil, and ecclesiastical powers in Ireland. The Sligo Pollexfens, though well-connected in their ancestral Cornwall and Devon, were small-town Anglo-Irish entrepreneurs. William Pollexfen, father of Charles and George, worked with his brother-in-law William Middleton in the milling and transportation of grain. His lack of interest in education was matched only by his desire to

accumulate worldly goods and to raise his family in station. The brothers were an odd pair, Charles sour and sullen, George slow and stolid. They were opposite in personality to the cheerful and ebullient Yeatses. Having come to the school "badly educated" (as John Butler Yeats expressed it), they had difficulty succeeding academically. Both were unpopular, refusing to take part in games, although they could play well enough. George particularly was lithe and athletic despite an apparent lethargy. But he could be surly, and when the fit was on him his brother Charles would allow no one near him except those who were "his inferiors and flatterers." Even "the masters let them alone," for in the solid and brooding Pollexfen brothers was something forbidding. "They were not the sort to be interfered with."[49]

(In the late 1860's and early 70's John Butler Yeats began a number of short stories and novels that he never finished—and completed one short story—in which the characters and events are obviously drawn from his own life.[50] In one story in which "Harry Bentley" is JBY, he describes a school friend of Harry's who resembles Charles Pollexfen: "He was amusing and sarcastic and made a parade of despising people. He had a large stock of acquaintances in college by whom he was perpetually attended. They were rather an inferior sort of men. He did not care much for the companionship of those who were likely to vie with him in wit or who would subject his character to any penetrating scrutiny. He loved the consciousness of personal superiority.")

Both brothers, particularly George, fascinated John Butler Yeats. George was his most "intimate" and indeed "only" friend—or so Johnnie Yeats regarded him at the time. He came to believe in the retrospection of old age that it was George's "melancholy" that first attracted him. Among people he did not know or felt uncomfortable with, George was not merely uncommunicative; he was chilly. "Socially," his schoolmate wrote, "he was a bore, he was an iceberg. In his presence conversation grew languid and then stopped."[51] Yet in the dormitory where he slept with nine or ten other boys, he wore a face the headmaster never saw.

Night after night he would keep these boys wide awake and perfectly still while he told them stories, made impromptu as he went along. . . . He was as rich in natural fertility as a virgin forest. . . . What he knew he presented without philosophy, without theories, without ideas, in a language that recalled the vision of Chaucer and the early poets. . . . He talked poetry though he did not know it.[52]

He was, his friend said, "a poet who in Wordsworth's phrase had not 'the sweet accomplishment of verse.'"[53] In him Johnnie found what he called "magnetism" and was later to call "primitivism," a closeness to nature, an almost animal connection with earth, air, and water, the stuff of which poets and poetry are made. He found the same magnetism in Charles, who however was "openly hostile" to his brother's friend.[54]

Young Johnnie Yeats laid their faults to their upbringing. They had been "cradled in commerce and brought up on Puritanism," conditioned to repress

expressions of pleasure. George had come to Atholl with little faith in human nature and had developed a mask to cover his "indwelling spirit."[55] At times "he would throw off some of his melancholy, and then his gaiety had the charm of the unexpected, like rare sunshine on a gloomy mountain."[56] Often as they walked the fields around Atholl, George would talk, dwelling on things he knew in Sligo, like horses and the servant boys who looked after them. Yet there was always a wall separating him from others. "He was an incurable solitary. . . . Opinions he did not want. They are about truth, but not the truth itself."[57]

The impact of George Pollexfen's personality on John Butler Yeats made almost everything else of importance at Atholl pale in significance. In JBY's recollections, written sixty-five years later, we hear little of his younger brothers and the schoolmasters but much of George, to whom he became tied by bonds he could not properly analyze or describe. George represented something alien to his own experience, yet of value, an unmined hill beneath which lay precious ore. The friendship, profound, disappointing, one-sided ("I don't think George took any interest in me then or at any other time," he wrote sadly years later)[58] was the central fact of JBY's early education—and would lead to the central partnership of his life.

In school Johnnie Yeats was popular and attractive. His skill at sketching likenesses was much in demand. At the wedding of the headmaster's daughter he was chosen to represent all the schoolboys.[59] Yet he felt that the school was not helpful in the education either of artists, who needed to have their senses fed, or of independent thinkers, who didn't like to be taught the "right" answers to other people's questions. As a result, in unconscious rebellion against an unthinking orthodoxy, he found himself perversely saying "No" when he fully intended to say "Yes," thus developing a habit that was to plague him all his life.[60] It was also a way of objecting to Mr. Forrester, who, he wrote sadly, "brushed the sun out of my sky."[61] Atholl Academy had shown him a world utterly different from the kind he had known as a child. If both worlds could exist, why not strive for that of the Reverend William Butler Yeats rather than that of Walter Forrester?

Before entering Trinity College, Dublin, in December, 1857, John Butler Yeats spent one of the happiest half years of his life at Sandymount Castle, the home of his uncle Robert Corbet, within comfortable walking distance of Dublin and yet in the quiet suburbs. Free of the constraints of Atholl, he found in his new environment a "pleasant Capua." His father had retired about four years earlier from his rectorate in Tullylish because of ill health[62] and moved to a small house in Sandymount next to the larger "Castle," from which it was separated by a high wall and a wicket gate.[63] The "Castle" was a large castellated house set on spacious grounds on which was a pond with an island, and on the island a couple of old chained eagles.[64] In the house Uncle Robert lived

with his mother and aunt, both approaching their nineties, and an assortment of other relatives, including his brother Arthur, so badly afflicted with a stutter that he was effectively cut off from society and reduced to working as a clerk in the back room of a bank. Uncle Robert was, by his nephew's admission, the man "most dominant" in his life "for the next four or five years."[65] Uncle Robert had made an accidental fortune through a lucky political appointment and thereafter regarded himself as somehow better than others, though he was disliked by the Gaelic Dubliners.[66] He was a charming anachronism whom his nephew never fully understood until after reading the letters of Horace Walpole.[67] Uncle Robert was an eighteenth-century gentleman living out of his time. Those outside his own circle, which included "born Tories and born Protestants," he regarded with suspicion. In him his sharp-eyed nephew saw the colonial Englishman disguised as Anglo-Irish gentleman. "In those happy times," wrote JBY years later, "the Protestants owned everything (of course it was only right) and despised the Catholics for being so poor (which also was quite right)."[68]

Uncle Robert "kept a pleasant table, not that he might hear his own voice, but that he might hear other people talking together as they ate the food he provided and drank his wine.[69] The other people were "his own sort, his comrades, the men of the club and his society." Their lives were routine: "They went to church every Sunday morning, when ill were attended by a Doctor who was a near relation and a gentleman. They died in the odours of a well-approved and well-tested worldliness."[70] The two elderly sisters, JBY's grandmother Grace Armstrong Corbet, and his great-aunt Jane Armstrong Clendenin (known as "Sis"), were delightful conversationalists. He regretted in later years not having asked them about the troubles of 1798, which they had lived through as young women.[71] These cheerful and amusing ladies, with "a genius for common sense," "knew and remembered facts and hated every kind of excitement and extreme, [and were] *saturated through and through with the spirit of the eighteenth century*." Devout believers in a better hereafter administered by the celestial counterparts of the Church of Ireland, they were "too intrepid and controlled to have become Bible Christians or take up any religion which preached Hell fire."[72]

There were Yeatses in the distant neighborhood too. In nearby County Kildare both Uncle Matt and Uncle John Yeats were land agents, and their nephew often went out of his way to see them. John hated his work "because of the harshness and cruelty of the life"; he admired the Irish peasant and helplessly watched the calculated chicanery of the landlords in forcing him to make judgments in their favor. The landlords "were rich, and therefore remote not only from him but from the impoverished country which supplied all their needs, and which they contrived to make poorer."[73] The lesson of his experience was not lost on the future landlord. His youngest uncle, Matt, later to become land agent for his nephew, was yet another affectionate Yeats.

Having married late, he was beginning to raise a family just as his nephew was about to enter college.

Because of his family John Butler Yeats moved easily in the best society in Dublin. He and his parents often dined at the home of Sir William Wilde, and JBY remembered one dinner at which Sir William discoursed authoritatively about salmon fishing while the Reverend Mr. Yeats muttered under his breath, "He knows nothing about it." [74] Isaac Butt, the clergyman's college classmate, visited Sandymount often despite a long-standing quarrel with Robert Corbet. JBY learned a few years later from his mother that there was a closer relationship between the Butts and the Wildes than anyone suspected. Butt, a brilliant orator with a precise mind, was endowed with enormous physical and mental energy. He loved wine and women, and only the magnificence of his other talents kept the two weaknesses from destroying him. Once his wife caught him *in flagrante delicto* with Miss Jane Francesca Elgee before she married Sir William Wilde, and confided the details to JBY's mother. [75] Despite Butt's peccadilloes, the Yeatses worshiped him. JBY early learned "to judge people by their manner," which he thought "a surer indication as to character than deeds, though it be heresy to say so." [76] "Such is the charm of personality," he observed years later, "that the man who has it is forgiven, though his sins be scarlet—for instance lovable Isaac Butt"; and he quoted what Archer Butler said of him, "We leave such people to the God who made them." [77]

At Sandymount—where he joined his elders in downing a tumbler of whisky before dinner and was a full partner in their conversations—JBY was free to indulge in the reading denied him at Atholl Academy. He had often discussed theology with his father. Now he asked him the grounds of his faith. His father replied that Bishop Joseph Butler's *The Analogy of Religion* had provided him conclusive proof of the truth of Christianity. Fascinated by the power one book could exercise, especially over so intelligent and fair a man as his father, JBY read it himself and came away convinced that it proved Christianity "myth and fable." [78] He took to reading John Stuart Mill, from whom he gained a habit of thought which he kept all his life. Another profound influence on his thinking at the time was Auguste Comte. [79] Men, Comte maintained, passed through three stages: the Theological, in which they believe objects to be determined by some outside power, like the Judaeo-Christian God; the Metaphysical, in which an abstract but still outside force is substituted; and the Positivist, in which men merely record what happens and try to reduce phenomena under general laws. Before the end of 1857 John Butler Yeats had become a skeptical positivist. As he put it decades later, "I came in time to recognize natural law, and then lost all interest in a personal God, which seemed mainly a myth of the frightened imagination." [80] Uncle Henry Yeats of Dublin Castle was shocked by his views. "Johnny, you are an atheist," he cried, and rushed from the room. He returned later to

apologize for the awful charge, "and I cared nothing," JBY recalled, "for suddenly I had realized that his accusation was true."[81]

His father didn't seem to mind what he probably regarded as a touch of late adolescent freethinking, but Uncle Robert was pained beyond endurance, for he had wanted his nephew to follow his father into the church. Often Robert would refuse to speak to his nephew following an argument about the orthodoxies, waiting for an apology.[82] To JBY these were times of "contented negation." When he attended church at Kingstown (as he did every Sunday to keep his family happy) he would remain near the entrance: "I would stand all two hours at the door, half within and half without, so that while listening to the clergyman I could at the same time comfort my eyes and my spirit by looking out towards the sea and sky. . . . Though my mind was negative towards 'the great truths,' it was by no means negative towards matters which to my present judgment are fraught with a finer illumination."[83]

Young Yeats was unable to keep his ideas to himself. He found that he possessed a "certain power of statement," and the presence of Uncle Robert always brought it out in confrontation of ideas separated by two centuries, for John Butler Yeats had drifted innocently out of the world of Victorian orthodoxy and into the twentieth century, while Robert Corbet had never really entered the nineteenth. He "looked upon ideas as a species of contraband," and, since his nephew dealt in such matters, thought he should not be encouraged.[84]

JBY enrolled at Trinity College, Dublin—"TCD"—on November 6, 1857, having passed the entrance examinations with no difficulty except in arithmetic: although he could explain the basic principles clearly, he always got the answers wrong.[85] As his father and grandfather and a couple of uncles, all named Yeats, had attended TCD before him, there was no serious question about his being admitted as a "pensioner," an ordinary student who paid fees and was granted no financial help. His father accompanied him to the gates of Trinity where the young and eager intellectual entered to meet his tutor, the famous Dr. John Kells Ingram, Professor of Oratory and History, author of "Who fears to speak of Ninety-Eight," a poem regarded by many as recklessly radical, supporting as it did the principle that Irishmen should be entitled to their own Parliament. Ingram had long since been forgiven for his indiscretion,[86] and was on his way to becoming a member of the Establishment.

John Butler Yeats did not take to the Establishment, nor did he take to Trinity College, its academic instrument. In the world of Anglo-Irish gentlemen, if the Church of Ireland was the equivalent of the Church of England, Trinity College was its Oxford and Cambridge. But where the latter two were part of their own country, Trinity College was not really a part of Ireland. Its members regarded it as a colonial establishment in what was essentially a foreign country. Trinity, declared John Butler Yeats, had always "turned away from Irish aspirations to think of England and the Vice-Regal lodge." Its

"most brilliant student would not stand a chance socially against a vice-regal aide-de-camp or any other castle stripling." "From the very first," he charged in later years, TCD "set itself against every Irish national hope and insulted the Irish soul." He saw that it produced little of value in controversial matters, as a spirit of inquiry would be dangerous for England, and excelled only in "mathematics and things purely scientific."[87] Real freedom of thought was as impossible in this alien academy for the children of the country's conquerors as it was in any of the Catholic schools they despised so thoroughly.

Yet Irish nationalism among Protestants had its center there too. The latent conflict occasionally surfaced. Only a few months after his matriculation, JBY saw an encounter between Trinity students and the city police on the occasion of the official entry into the city of the new Lord Lieutenant, Lord Eglinton, who had publicly declared that he would follow an "Orange" policy. JBY was standing on the roof of the TCD building facing College Green and watched students behind the fence throw firecrackers at the policemen's horses as the carriage carrying Lord Eglinton rounded the corner at Nassau and Grafton Streets. The policemen charged the students and cracked a few heads. For months afterward, charges and countercharges were exchanged before peace was restored. It was clear that the confrontation would not have taken place but for the tension arising out of the English occupation.[88]

At the college he saw cheating, even by an old clergyman trying at an advanced age to take his degree, and JBY himself joined other students in copying answers on an astronomy examination from the one student capable of answering the questions. The proctor was old and feeble and did not notice what was going on. The cheating could have been inferred from an analysis of the examination books; all but one in the class failed the other two tests given. As a student had to pass only one test out of three to win credit for the course, there were no failures.[89]

It was not the kind of academic atmosphere to appeal to the young inquirer. "A university should attract the vagrant intellect by making it competitive within its walls," JBY wrote later. "It is the business of the University to house and comfort with libraries and lectures and conversation and companionship the vagrant intellect which is now so strongly stirring" within the student. He found "the Trinity College intellects noisy and monotonous, without ideas or any curiosity about ideas, and without any sense of mystery, everything sacrificed to mental efficiency. . . . Trinity College is intellectually a sort of little Prussia."[90]

Part of his feeling of estrangement from the college arose from his not taking rooms there but living at Sandymount. The saving of money, which was considerable, was made necessary by the state of the Reverend William Butler Yeats's finances. In 1846 he had inherited the house in Dorset Street, Dublin, and the Thomastown properties in County Kildare—346 acres, two roods, and twenty-five perches, Irish measure (equal to about 560 acres English or

American measure), which were divided into seventeen farm tenancies.[91] These were already heavily mortgaged, and when the Reverend Mr. Yeats ceased to have an earned income, the net proceeds from his properties were not sufficient to care for his family, which by 1857 included (in addition to JBY) Robert Corbet, William Butler, and Isaac Butt Yeats, and five daughters, Mary, Grace Jane, Jane Grace, Ellen, and Fanny. While his schoolmates retreated to their dormitory rooms, John Butler Yeats roamed the college library, read widely, studied at home, and walked across the Dublin mountains.

(*In one of his fictional pieces, Harry Revell is described in such a way as to make his autobiographical origin unmistakable: "He was known among his college friends to despise all notebooks and fixed rules as to reading so many hours and resting so many hours. Fortunately there was in his nature an immense fund of what we may call studiousness. . . . In the Great College library hard reading men would sometimes pause . . . to watch Revell as with dreamy brow he wandered from book shelf to book shelf, apparently the idlest and yet, as was plain to those who knew something of his multifarious reading, the busiest in all that company."*)[92]

The records of TCD reveal no distinction for John Butler Yeats. He was graduated in the spring term of 1862 "unclassified," that is, without honors. But there is an explanation for which the college makes no provision in its records. On the day of the final examinations he was stricken with rheumatic fever and unable to appear. Of the five who took the examination, three won very high honors and one the highest. JBY alone won nothing. Yet it was he whom his teacher sought out with the suggestion that he should continue his studies, declaring that he would "certainly gain medals in the courses of literature and history, and in metaphysics and logic."[93]

About this time he fell in love. The details are obscure: we know neither the young lady's name nor her precise reception of his suit. The involvement affected him so deeply that seven years after his marriage he spoke of it in a rare burst of confidence to one of his most intimate friends. It was "blameless," "delightful," and "beautiful," but it was also fruitless. It apparently left him stunned and bitterly disappointed and perhaps set the stage for what would soon happen to him with another young lady.[94]

Instead of continuing with metaphysics and logic, JBY determined to become a barrister and enrolled at the King's Inns to begin his studies in the fall. His father was delighted; Uncle Robert, realizing that his nephew's unorthodox views disqualified him for the clergy, sniffed grumpily and accepted the lesser but still respectable alternative. Between graduation and the start of his legal studies JBY decided to contest for the prize at TCD in Political Economy. On the morning of the competition he walked into the vast Examination Hall to find Mr. Hinston, the examining professor, all alone. No other contestants appeared. Hinston put a number of questions to the confident

young student, then "was good enough to say that he was glad to give me the first prize because he found that I had thoroughly understood the subject, as I think I did."[95] The prize was ten pounds, the first money John Butler Yeats ever earned—and the last he was to earn for almost a decade. Characteristically, instead of putting it in a bank and watching it grow, he decided to make immediate use of it by visiting Sligo to see his old friend George Pollexfen.[96]

From the town of Sligo, where JBY arrived one evening in early September, 1862, after a day-long journey from Dublin, he proceeded at once to Rosses Point, a few miles to the north, where the Pollexfens were staying for a vacation. Almost at once he and George went for a walk along the shore, and JBY was caught up by the beauty of the place: the sea, the mountains— Knocknarea to the south, Ben Bulben to the north—the sloping fields, all of which he saw with the eye of the artist. His old friend was unusually talkative and happy. The combination was irresistible:

The place was strange to me and very beautiful in the deepening twilight. A little way from us, and far down from where we talked, the Atlantic kept up its ceaseless tumult, foaming around the rocks called Dead Man's Point. Dublin and my uneasy life there and Trinity College, though but a short day's journey, were obliterated, and I was again with my school friend, the man self-centered and tranquil and on that evening so companionable.[97]

Among the Pollexfens JBY found another charm, Susan Mary, eldest of the Pollexfen daughters, two years younger than JBY and George. Slight of build, she was extraordinarily pretty, despite the striking contrast in her eyes, one of which was blue, the other brown, each of a "decided" color.[98] John Butler Yeats promptly, but to his own surprise, succumbed to her attractions. One day on a family excursion to Bundoran the young couple escaped from the others to explore the caves eroded into the stone cliffs. In one of these were uttered the words that were to lead to one of the most frustrating and fruitful marriages in the history of Ireland. In the cave he kissed her often and was "sometimes timorously kissed in return."[99] Within a few days he had given her sufficient evidence of the kind of man she would involve herself with: strong-minded, determined, articulate. For his part he saw the very qualities in Susan that were to mark her for the rest of her life: petulance, absence of a sense of humor, a tendency to pout. In the flush of young love he accepted her as she was. "If you were to lose those faults," he assured her, "you would lose your individuality."[100] If he was somewhat too ready to voice his opinions about people and ideas he disapproved of, she could be morose and sulky in the hope, seldom realized, of converting him to her notions.

Her notions were those of her family. Back in Sligo at their small home on Union Place, John Butler Yeats saw the genus Pollexfen in its natural habitat.

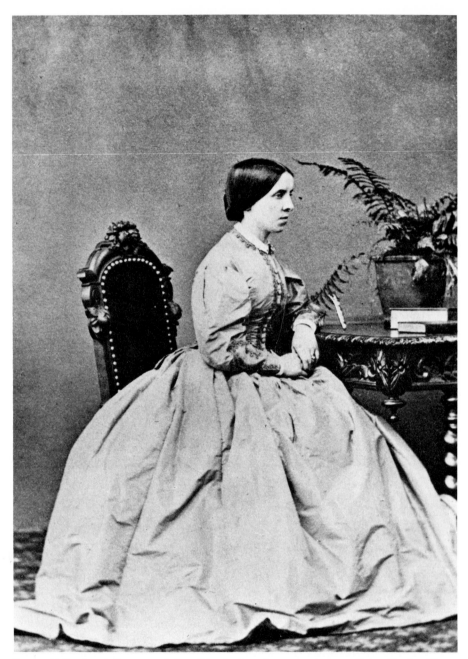

Susan Pollexfen (1841–1900) in 1863, before her marriage to John Butler Yeats. Collection: Michael B. Yeats.

It was an unusual family, grim and solemn, with a silence suggesting unprobed depths. He described a Sunday morning at their home: "the family gathered in force and sat together mostly in one room, and all disliking each other, at any rate alien mutually, in gloomy silence broken only by the sound of [Mrs. Pollexfen's] turning over the leaf of a book, or by the creaking of someone's brace, or by a sigh from George Pollexfen."[101] William Pollexfen, the father, was at fifty-one the most imposing and silent of them all, of iron determination, the absolute sole lord of his little principality. He had run away from his home in Devon when he was twelve and had settled in Sligo at twenty-six after marrying a distant cousin whose Pollexfen mother had married a Middleton from Sligo. The Pollexfens were a family of ancient Cornish lineage who occupied Kitley Manor in Devon, near the Cornwall border. William Pollexfen believed his line was really entitled to Kitley; all his life a picture of the Manor hung in his bedroom. In twenty-five years he had grown from weatherbeaten sailor to local merchant of power and means. In partnership with his brother-in-law William Middleton he had added a shipping firm, the Sligo Steam Navigation Company, to the milling company of Middleton and Pollexfen that was the foundation of the family fortune.[102]

In the families was a confusing welter of Williams and Elizabeths. William Pollexfen's wife was Elizabeth Middleton Pollexfen, whose mother was Elizabeth Pollexfen Middleton and whose brother and late father were both named William. She was to have a daughter named Elizabeth, two sons named William, and a grandson and granddaughter named William and Elizabeth.[103]

In the summer of 1862 the family had long since been completed. Besides Charles, George, and Susan were Elizabeth Anne, born 1843; John Anthony, 1845; William Middleton, 1847 (an earlier William had lived only two years, 1844–1846); Isabella, 1849; Fredrick Henry, 1852; Alfred Edward, 1854; Agnes Middleton, 1855; and Alice Jane, 1857. They were a strange, intense people, silent and brooding when together: "the crossest people I ever met," JBY's sister Ellen was to say of them.[104] The family was on its way up in the world. All "despised literature and poetry as being part of that idleness which they regarded as so calamitous to morals," yet they had "a wonderful facility in picking up and remembering anything in the papers written in rhyme."[105] John Butler Yeats never accepted their philosophy but allowed himself to be encircled by it. His alignment with the Pollexfens was a symbol of what his life was to become, a perpetual diversion of interest and division of talents that was to lead to something just short of excellence in almost everything he attempted.

Before he returned to Dublin two weeks later, John Butler Yeats became engaged to Susan Pollexfen. Trying to explain his choice, he maintained years later that her family's genius "for being dismal" was just what he needed. "Indeed it was because of this I took to them and married my wife. I thought I would place myself under prison rule and learn all the virtues."[106]

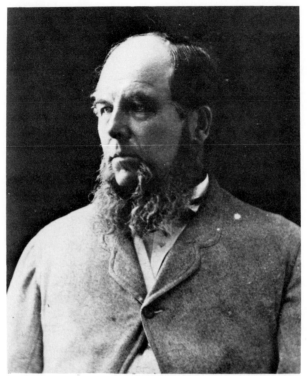

William Pollexfen
(1811–1892), about 1862.
Collection: Michael B.
Yeats.

Back in Dublin he entered the King's Inns on Henrietta Street to begin the study of law; but he continued to draw in his sketchbook and to spend evenings with friends he had made in college, particularly the Dowden brothers, John and Edward, and John Todhunter, whose company and conversation he found more stimulating than his law books. Then, with terrible suddenness, a new responsibility was thrust upon him. On the afternoon of November 26, 1862, the Reverend William Butler Yeats died unexpectedly after lunching upstairs alone in Sandymount Castle. The young law student had to deal not only with his studies and his coming marriage, but with his mother's grief and his own. ("My father was not a great man," wrote his son at the age of eighty, "but he had personality, always himself and his personality like a springing fountain in a summer garden.")[107] He was now landlord of the Thomastown properties and the Dorset Street house and the heir in charge of settling the estate. It took three years before the tax-gatherers were made happy; their final record showed that the Kildare lands were worth approximately £9,420 and the house in Dorset Street £600.[108] Mortgages against the properties totaled £2,200. The rents of the Thomastown properties were £471.11.11 per year and of the house £30. After necessary deductions (ground rents, widow's jointure, commitments to relatives, and

interest on mortgages), the net income was £379.0.6.[109] The new landlord promptly asked his uncle Robert Corbet to act as his agent for the collection of rents and for dealing with the tenants in all matters arising out of the rental agreements. He showed little disposition then or later to look after the estate himself.

Jane Grace Yeats was shattered by her husband's death and worried that the family might be broken up. She even suggested that John and Susan should live with her—and presumably with her other children as well—but nothing came of her plan.[110] Perhaps Susan Pollexfen put the damper on it. During the Christmas holiday of 1862, JBY visited his fiancée in Sligo to discuss the future. He was optimistic about their coming life together: "If I was ever so despondent *you could cheer me.* . . . If I were doing wrong you could make me do right. I always think you far better and stronger than I am."[111] His vision of marriage was charming if unoriginal: "I long to be married to you because then when vexed about anything, instead of brooding about it I will go to you with it, and we will share it together. You have no idea what a comfort you will be to me, and what a source of comfort and tranquillity to me."[112] All that can fairly be said is that John Butler Yeats was not the first bridegroom to make a poor prophet.

1863–1867

I N THE winter and spring of 1863 John Butler Yeats got a foretaste of what a crowded life could be. At the King's Inns he discovered that his engaging personality had political value. Asked to stand for Auditor of the Law Students' Debating Society, he was assured of the necessary support to win the election, two rival groups providing enough votes between them. But he declined, and at the election the two groups fell to angry shouting, their faces "white with rage."[1] The group with which he was more or less allied nominated a student who had been a gold medalist at TCD, but he lost by two votes. The winner's supporters made it clear that they voted for him only because JBY withdrew.

While winning friends at law school he was spending most of his time with those interested in art, philosophy, and religion. The Dowden brothers, sons of a linen draper of Cork, were two of the brightest jewels in Trinity's crown. John, whom JBY later called "my oldest and most intimate friend," was born in 1840, entered TCD in 1858, and took his B.A. in 1861 with First Class Honours in Logic and Ethics, winning prizes and offices along the way.[2] Before he came to know JBY well he had chosen the Episcopal ministry as his life's work and was too deeply committed to have his mind changed by the daring and radical Yeats, who always regretted not having known him earlier.[3]

John's younger brother Edward was to become the most distinguished literary scholar of Trinity College, and indeed all Ireland, in the late nineteenth and early twentieth centuries, and its most internationally re-nowned teacher and critic. Born in 1843, he entered TCD only a year after his brother, and in 1863 won a Senior Moderatorship in Logic and Ethics.[4] From his earliest college days he wrote poetry for the university magazine. In conversation he was brilliant and charming, if less volatile than his more tendentious friend.

Through the Dowdens JBY also met John Todhunter, who, although born in the same year as JBY, did not enter TCD until four years after him, having tried his hand first at business in Dublin. The child of Quakers, he worked for a family firm of sugar and tea importers, but he was more interested in music

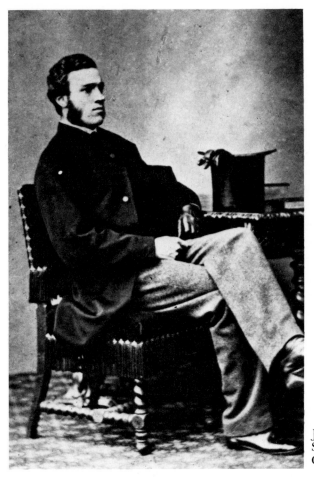

John Butler Yeats, Sligo,
September, 1863.
Collection: Foster-Murphy.

and poetry than commerce. While attending a service at Dublin's Christ
Church Cathedral, he was so moved by Handel's *Messiah* that he abandoned
Quaker meetings in favor of the opera.[5] At TCD he won the Vice-Chancellor's
prize for verse three times.[6] Even though he took up medical studies after
college in order to have a source of "sovereigns," he longed to be a writer or
artist.[7] During their years in Dublin together, he, Yeats, and the Dowdens
constituted almost a private club for conversation and discussion. (*In his fiction
JBY described Harry Bentley's friends as "dreamers, who loved the impalpable and the
intangible and turned away from the actual and the practical as from a world which
bewildered them."*)[8] It was a group that would prove more influential on John
Butler Yeats than his companions in the King's Inns, with whom he apparently
discussed only the law.

He wanted to visit Susan in the spring of 1863, but business always inter-

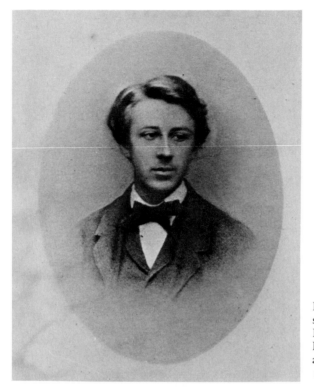

Edward Dowden as a student at Trinity College, Dublin. From *Poems* by Edward Dowden (London and New York: J. M. Dent, 1914).

vened. In March he had to have his photograph taken and complained about the long delays and the difficulty of getting a good result.[9] In June he had to go to London with fellow students to become enrolled at the Middle Temple.[10] In July he had to rearrange the mortgage of £2,200 on the Thomastown lands.[11] With his fiancée he had to satisfy himself with correspondence, which was full of warning signals he did not want to recognize. She fretted because he might receive valentines from other girls, and he had to assure her he had received none.[12] She grew agitated when he told her he was to go to a ball on June 31 where he might meet other young ladies; he apologized hastily and teased her for not realizing there was no such day as June 31.[13]

After the summer term at the King's Inns JBY traveled to Sligo, where he took a room at the Imperial Hotel. On September 9, 1863, the day before his wedding, JBY and the Pollexfens signed a marriage settlement. Among other things John Butler Yeats allowed his wife-to-be a widow's jointure of £150 a year with the Thomastown lands secured as the source of payment.[14] The following day, in St. John's Church, came the culmination of what JBY described in later years as "a sudden engagement," "a surprise no less to the girl than to me, a sort of stumble in the dark—or rather an overruling Provi-

dence."[15] They then went to Galway for their honeymoon. Three days later the bridegroom came down with diphtheria and was saved only by the timely care of the local physician.[16]

Back in Dublin the couple set up housekeeping at 5 Sandymount Avenue, a small house known as "Georgeville," across the way from the castle of Robert Corbet, who contemptuously called their place "the quarry hole."[17] A small building, it was all the young couple could afford. They bought most of their furnishings at auctions, purchasing new only the drawing-room carpet, the bedsteads, and the bedding.[18]

The Pollexfens may not have fully understood the voluble and iconoclastic young man who had joined the family, but they could abide a few idiosyncrasies in one whose formal credentials were so good. They must have watched with pride and satisfaction as their eldest daughter was married to an authentic Irish landlord, a descendant of the Ormonde Butlers, of respected Irish clergymen, and of men of power in the Castle, who was moreover a rising star in the King's Inns and well connected throughout Dublin. It was an auspicious marriage for a family on the rise, yet it was virtually the last time they would be pleased with John Butler Yeats.

The newlyweds were a striking couple, she slight, pretty, and quiet, he tall, slender, and talkative. She was fair-skinned, he so dark that he was often taken for Italian.[19] In 1863 he was clean-shaven, with a strong, handsome face. He, however, finding a deficiency in himself that others couldn't see, thought he had a weak chin.[20] The bride became a dutiful housewife while the young law student plunged into his studies, reading "quantities of very big books" and filling "reams of foolscap with notes."[21] He tried to devote himself fully to the law, and he carried out his extracurricular obligations conscientiously by taking an active part in the Law Students' Debating Society. Yet all the time the same mind was working that had questioned the hypocritical practices at Seaforth, the dogmas of Christianity, and the pre-eminence of Trinity College. The natural perversity that had clouded JBY's school days still enveloped him. (*In his fictional hero Harry Bentley he observed the contradictions in his own nature: "It was characteristic of Harry that men of the most opposite types who could never meet without quarreling did yet like him and like to be in his company. . . . I do not think it an adequate explanation simply to say that Harry was good-natured, ready always with his powerful help and needing nothing in return, not even thanks. . . . We know that in the case of little children we do not very strictly enforce the theory of moral accountability. . . . Now Harry never dreamed, except on some rare and peculiar occasion, of applying very strictly even to grown-up people the theory of moral accountability. He treated all as we treat children; hence, he liked, appreciated, and enjoyed everybody."[22] But he knew the dangers to himself: "Ordinary people set down Harry as a half-cracked enthusiast who would never do any good in the world."[23] In another place he was even more detailed about his character and personality and the view others held of them: "It is impossible for*

anyone to understand Harry who does not keep in mind that he always lived in the world of ideas and not at all in the world of fact. He was subjective, not objective, in his modes of feeling. . . . In the world of ideas he was very skeptical in receiving and weighing evidence, and very daring and resolute in affirmation and denial. In the world of fact he was very credulous, sinful, and ignorant. Intellectual men delighted in him. He was among them a disturbing individuality, stimulating and delighting them.") [24]

In his memoirs, written half a century later, John Butler Yeats scarcely mentions his fellow law students, but his recollections are rich with accounts of the Dowdens and Todhunter. The four were a consortium of free minds expatiating on matters which they considered fundamental. Even with John Dowden, whose religious convictions were unshakable, no subject was beyond discussion. JBY was disturbed that the Dowdens read and talked about George Eliot and James Anthony Froude but seemed to know nothing of Mill, Darwin, or Comte, to whose work he introduced them. All four had been touched to some degree by the currents of doubt sweeping the world's shores, but only JBY had jettisoned all his ecclesiastical ballast. As a Quaker unburdened by Christian dogma, Todhunter found it less troubling than the Dowdens to question old superstitions. Indeed, he welcomed the skepticism of Darwin and Huxley as "healthy," writing of it to Edward Dowden in the fall of 1864: "if the Bible be demonstrably false no sentimental appeals to 'faith' will suffice to protect it. . . . If Christianity is good for anything it will be all the more firmly established by this spirit of inquiry." [25] John Dowden was attached to the Holy—if not quite Roman—Catholic Church and could not give up his belief in the metaphysical. JBY believed he was in "a false position," [26] but their friendship was the stronger for their mutual respect of the other's convictions. He and John Butler Yeats were natural intellectual partners, one the doubter, the other the believer. They listened to each other always "with an understanding sympathy." [27]

Of the four it was Edward Dowden who placed himself in the most ambiguous and questionable position. He shared much of the theological skepticism of JBY and Todhunter, yet hesitated to speak out. To JBY he opposed Comte's logical positivism in nontheological terms but wrote to his brother that Comte had overlooked "the real religious instincts." "I am in God's image," he asserted, [28] as if refuting the Comtists. It was the unanswerable rationalization of the trapped Victorian who did not want to agitate the serenity of those around him. What Edward Dowden surrendered in intellectual integrity, however, he was to gain in social acceptance. Handsome, charming, quiet, talented, industrious, he shunned enmities. "Everyone rocked his cradle," JBY was to write of him decades later. "By nature a deeply sympathetic and affectionate man . . . he found with unerring certainty what was good in human nature." [29]

Within the group John Butler Yeats was the intellectual leader. In spite of a tendency to overpersuade, his charm of manner and utter sincerity won the

complete affection of others. John Dowden always spoke to his children in later years "in glowing terms" of JBY's brilliance.[30] Todhunter told Edward Dowden that JBY was the only man he "ever really worshiped," and Edward Dowden for his part thought him "a genius."[31]

They were not a good influence on a law student whose family and wife's family expected him to fit into a prepared niche in the Dublin world. For one thing, he and they all disliked Dublin and talked constantly of leaving it. Todhunter found life there "ugly" because it was "conventional, monotonous, unimpassioned, and deficient in colour."[32] Edward Dowden declared that "Dublin has the evils of city life without its compensations," and—in a passage that would have appeared bitterly ironic if included in his obituaries—"I don't think I shall ever settle down for good here."[33] John Dowden, as a clergyman, might end up anywhere; his first curacy, in early 1865, was, fortuitously, at St. John's Church in Sligo. In 1864 the only one of the four who seemed destined for a life in Dublin was John Butler Yeats; in the end it was only Edward Dowden who failed to escape.

JBY studied hard and fulfilled his obligations at the King's Inns. In 1865 he was again asked to stand for the Auditorship of the Debating Society, which held weekly debates on legal and political subjects. This time he agreed and won the election. The Auditor's chief duty was to deliver an address to the Society in the fall, and as soon as he won the post the young Yeats began working on the speech.[34]

Between the election and the address occurred an event at Georgeville that was to render all other events that year of little consequence. On Tuesday, June 13, 1865, at 10:40 P.M., Susan Pollexfen Yeats gave birth to a son.[35] Mrs. William Pollexfen came from Sligo to be with her daughter and her first grandchild. Dr. Thomas Beatty, a relation who was attending physician,[36] looked at the baby, declared he had a fine *os frontal*, and pronounced him so strong that "you could leave him out all night on the window sill and it would do him no harm." In honor of his late grandfather, the child was named William Butler Yeats. The father, who had never cared for children, suddenly found himself "fond of" of his first child, and from the beginning "hated to see any stranger, even the nurse, touching Willie."[37] It was a protective attitude he was to keep all his life.

With the new baby, he and Susan spent some weeks during the summer in Sligo, where he found relief from the dour and gloomy Pollexfens in visits to the Reverend John Dowden and to Yeats relatives in the area. His main labor through the summer was the preparation of his address for the Debating Society. The customary Auditor's address was like such addresses everywhere, like commencement speeches and declamations at political rallies. Accepted truths were appropriately massaged and proper deference paid to the mighty. But JBY was not a commonplace Auditor. On the night of November 21, 1865, the lecture hall at the King's Inns was more crowded than usual, perhaps

William Butler Yeats as a baby, 1865. Pen. JBY. Collection: Michael B. Yeats.

because of the spreading reputation of the student already known as a spellbinding speaker. The Lord Chancellor and the Lord Chief Baron were present, Queen's Counsels and Judges (among them Sergeant Richard Armstrong, whose small daughter Laura was destined to be the first love of the Auditor's young son lying asleep at Sandymount), Sir William Wilde, Dublin's most distinguished oculist, and Isaac Butt, her most distinguished barrister.

The Lord Chancellor took the chair at eight o'clock and, after the reading of the minutes, introduced the Auditor. What the guests listened to for the next ninety minutes must have astonished them. In a highly polished, gracefully written essay, diplomatically kept impersonal, John Butler Yeats delivered himself of a root-and-branch attack on the basic principles of the Society and

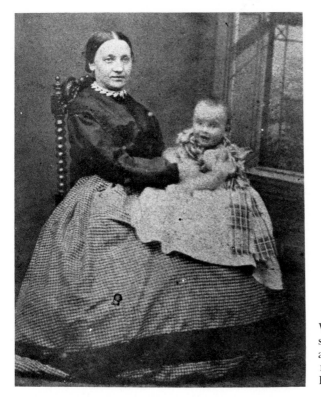

William Butler Yeats, aged
seven months, with nurse,
at Sligo, late December,
1865. Collection: Michael
B. Yeats.

by implication of the whole business of the law. He spoke without once glancing at the manuscript, yet never missed a word.[38] After a few phrases about the increased membership of the society—and the "exceedingly happy circumstance" that "almost all subscriptions are paid up"—he moved to the theme of his lecture, entitled "The True Purpose of a Debating Society." That purpose, he declared, should not be merely the cultivation of oratory, a self-defeating end. The only proper purpose should be "the attainment of truth" by "oral discussion." It should be the goal of the Society to sow "in men's hearts and consciences noble purposes, without which life would be barren indeed of all fruit of noble action."[39]

On this simple proposition the young John Butler Yeats elaborated his strongly held convictions. For students particularly, he insisted, "no question has any interest except for truth's sake." They should make use of "mind coming into collision with mind" to discover "no longer dead dogmas or corrupt prejudices, but living energies, moulding the whole character into conformity with themselves." Once learned, these new habits of thought would be carried "into those noiseless inward debates which are going on incessantly in the minds of each of us." Now, while they were young, students

Sketches made in the Four Courts, Dublin, at the trial in the Fitzgerald will case, February, 1866. Pen, JBY. Identifications, captions, and signature in the hand of JBY. Collection: Michael B. Yeats.

should seek the truths difficult to come by later; if they did so "that deep slumber which is too apt to settle upon long accepted beliefs . . . will be broken as with the sound of a trumpet."[40]

The address, enthusiastically received, was, as customary, printed at the expense of the Society. It was a sweet triumph for a young man at the outset of his career. He was popular with his classmates, had proved himself as a brilliant public speaker, and had made a strong and favorable impression on the most important men of law in Ireland. Before him stretched the promise of a successful and profitable career, at the culmination of which would almost

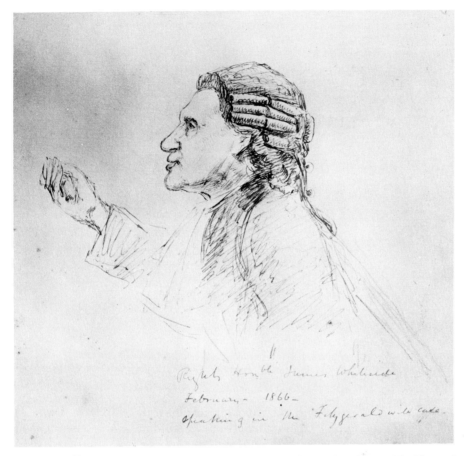

"Right Hon^ble James Whiteside, February, 1866, speaking in the Fitzgerald will case."
Pen. JBY. Caption in the hand of JBY. Courtesy of the National Gallery of Ireland

certainly come elevation to Her Majesty's Bench, with perhaps a knighthood
thrown in as well.

Yet the speech marked the high point of JBY's career in the law. He really
believed what he had said, and he believed it so deeply that the practitioners of
the law, more devoted to winning cases than to attaining the truth, could
hardly have been won to his cause. Two months later, in January, 1866, he was
admitted to the bar.[41] In the Four Courts he did not like what he saw. In the
Law Library stood young barristers "round the fire with their backs pressed up
against the mantlepieces," waiting for a call to service. He saw older ones who
reportedly had not had a case in twenty years.[42] It was a depressing sight. In his
very first month as a barrister he saw an instructive example of the law at work
in a case involving a disputed will. The courtroom was crowded, and John

Shore scene, Enniscrone, County Sligo. August, 1866. Pen. JBY. Collection: Michael B. Yeats.

Butler Yeats attended with sketchbook and pencil in hand. The issue was whether the late Lord Fitzgerald had been of sound mind when he made his will, and in pursuit of a conclusion the most sordid and salacious details of his private life were paraded in open court. The plaintiff had several attorneys, chief of whom was Isaac Butt, and the defendant retained six, among them James Whiteside, Q.C. JBY was struck by the triviality of the case and the astonishing waste of time by men of intelligence on matters quite beneath them. The most lasting result of the trial was JBY's pencil sketch of Whiteside,[43] who later became Lord Chief Justice. In the same month as the Fitzgerald case JBY also saw William Pollexfen rewarded handsomely for the loss of his ship *The Repeater*, rammed and sunk off Newfoundland while bound for Quebec with a cargo of coal.[44] It is not surprising that John Butler Yeats found his evenings with Todhunter and Edward Dowden more rewarding and exciting.

By February of 1866 Susan Yeats was pregnant again. The enforced quiet of her life and the care of the young Willie left her little opportunity to become the intellectual helpmeet her fiancé had once described so hopefully in his letters, and her husband's dabblings with the artistic set of TCD troubled her.

"I don't think she approved of a single one of my ideas or theories or opinions, to her only foolishness," he wrote in old age.[45] In the summer they traveled to Sligo, and there, on August 25, at nearby Enniscrone, Susan was delivered of a seven-month daughter of delicate health.[46] The baby was named Susan Mary for her mother but promptly nicknamed "Lily," the name by which she was thereafter known. Susan Pollexfen Yeats was seldom "in good spirits," and the care of two infants led to "nervous exhaustion."[47]

JBY spent his days whenever possible with John Dowden, now transferred from St. John's to Calry, the second parish in Sligo. Dowden disliked his new congregation, which he called a "nasty, cantankerous self-righteous tabby-dom," and the congregation on its side urged the bishop not to sanction his nomination to the curacy. But at least he was settled in with his wife and new baby.[48] In October, Edward Dowden was married too, to Mary Clerke, ten years his senior, and Edward in December told his brother he was being considered, despite his youth, for the new position of Professor of Literature at TCD.[49] Todhunter, having taken his B.A. earlier in the year, had virtually decided to become a physician. At the end of 1866 each of the intellectual quartet seemed to have moved at least a rung higher in his chosen career, yet John Butler Yeats still preferred sketchbooks to law books, art and philosophy to the contentions of court, and he himself knew that the difficulties of his nature might be dangerous to himself and his family.

(*Harry Bentley, bemoaning his failures, explained to his wife: "I have been denied also the practical businesslike energy by which many men, inferior to me as I know and believe, have been enabled to procure for themselves a state of happiness and goodness which again in intensity and purity is inferior to what I might and will obtain. Or had I been covetous of money or greedy for coarse pleasure, I could have found full exercise for my feelings. It may be charged against me as a fault that I have not cultivated a habit of practical energy. . . . I want these coarse instincts which set the practical energies of other men in operation.*")[50]

He was soon to make manifest his difference from others of his group. Shortly after JBY's admission to the bar, Robert Corbet's servant Michael had extracted a promise from Isaac Butt to help young Johnnie. Butt kept his promise, though the form of his help is not known. It is widely believed that JBY "deviled" (that is, gained practical legal experience) with Butt, but JBY says nothing of such work. We know he never won a case; whether he pleaded one is difficult to determine.[51] "I meant to succeed," he insisted. "My will was in it, that is my conscious will." But deep inside was "another will,"[52] and it was the second will that won out.

He had been drawing amusing, often satirical sketches of such quality that Dowden and Todhunter urged him to submit samples to someone in London who might be able to evaluate them properly, so he sent some off in late 1866 or early 1867 to Tom Hood, editor of *Fun*. In court in his notebook he constantly drew the faces of those about him, showing considerable skill at

caricature. While he was waiting to hear from Hood he committed an almost deliberately suicidal act. His friends had warned him against sketching in court: no solicitor would assign a case to "a man so fatuously inclined." All warnings were in vain. His talent was irrepressible. "A man sitting next to me would see a sketch, then borrow the note-book and, without a license, pass it to another, and finally it would reach the victim."

One day during an important trial someone passed JBY's notebook to a barrister named Richard Dowse, while Dowse's colleague MacDonagh was pleading a case before "four judges grave as owls." Dowse had a short nose, "witty" lips, and a round figure, and JBY thought he had done more than justice to his qualities. On perusing the sketch "the genial man turned round and sent back over the benches a pleasant nod." Then Dowse turned over the leaves of the book and found a sketch of MacDonagh. The latter, though a "most wily and subtle pleader at the Bar," was at the same time "pompous and vain." JBY's sketch caught his shortcomings perfectly, being (as the artist admitted) not only "effective" but "indeed malignant." Dowse, amused, passed the notebook to MacDonagh, who was at the moment addressing the court "in his most long-drawn Chesterfieldian manner." MacDonagh, thinking his colleague was offering advice on the case, paused in his address, "searched for his glasses and put them on in his careful way," and looked at the notebook, "the judges gravely waiting." MacDonagh, seeing the sketch, made a "gesture of disgust" while Dowse tried to suppress his laughter. Everyone in the courtroom enjoyed the joke but the object of it. That night JBY walked home "making new resolutions."

"Afterwards various things happened," he noted cryptically in his memoirs. "I need not detail them," he added, thereby depriving us of a glimpse into the heart of the Irish Bar. At this difficult moment word came providentially from Tom Hood. Pleased with JBY's sketches, he invited him to come to London and offered to introduce him to people in the magazine business. John Butler Yeats liked to say as an old man that if he had stayed with the law he would have become a Q.C. and a judge. Yet if the MacDonagh incident had not occurred, almost certainly some other clash with his conventional colleagues would have caused a break. Hood's encouragement provided the escape he unconsciously sought. In the first of many such moves, John Butler Yeats impulsively decided to change course and pursue truth through rational thinking and through art. "I ought to have stayed in Dublin and worked hard for success," he reflected in later life, "for that was the voice of prudence." But Truth did not hold her mansion in the Four Courts. Something stronger than prudence impelled him—"intuition, the inner voice—the something which . . . impels and directs the countless birds when they migrate."[53]

He made the decision quickly and carried it out. In the face of the open hostility of his wife and her family and the horrified apprehension of his own, he gave up the house at Sandymount, took his family to Sligo, where they

would stay until he could send for them, and prepared for his move to London. A few nights before he left Georgeville for the last time, he dined with Hugh Holmes and three other young barristers, all of whom became judges and one a Chancellor.[54] There was never any question about how much he was giving up.

At Sligo he found the Pollexfens as unpleasant as ever. They had moved from the small house on Union Place to the commodious Merville, a big eighteenth-century house on spacious grounds on the outskirts of town. "No one ever got excited there," he wrote, "but the atmosphere was awful."[55] He didn't like the atmosphere, as it affected the twenty-one-month-old Willie, who was extraordinarily sensitive "to being laughed at," and would cry "oh! so sorrowfully, not with anger, but in sorrow that was pitiful to see." His aunts observed that the child was "more serious than other infants,"[56] but thought he resembled his father, who now fecklessly was abandoning the sanity of conventional life. Nevertheless William Pollexfen was half persuaded that his son-in-law could make a living as an artist after a reasonable period of apprenticeship and lent a grudging approval.

JBY left for London in late February or early March of 1867, took temporary lodgings at 10 Gloucester Street, near Regent's Park, and began searching for a permanent home. Tom Hood accepted some of his drawings for the magazine *Fun*,[57] and JBY enrolled in Heatherley's Art School to learn his trade. In the proper Bohemian way he allowed his beard to grow to hide the unliked chin, and thereafter was never clean-shaven. He showed some of his sketches to John Henry Foley, the sculptor, a Dubliner who had been elected to the English Royal Academy, and Foley declared: "I have no doubt whatever but that you will rise to a position of eminence."[58] Richard ("Dicky") Doyle, another artist, also gave encouragement and advice.[59] The new career seemed well launched. He found an attached three-story house at 23 Fitzroy Road, also near Regent's Park, on which he took a six-year lease beginning July 1, 1867. By the end of that month Susan, pregnant again, and the two children joined him there, along with Susan's eighteen-year-old sister Isabella as guest and helper.[60]

Now the same impracticality that blighted his success as a lawyer intervened with his art. He liked studying at Heatherley's far more than running around to magazine offices selling sketches. In the school he found "the quietest people in London," few of them good conversationalists, but the atmosphere was "tranquillizing, like a peaceful day in the country."[61] At first the faces were a blur, but in time he came to sort them out. Two of the students were named Butler, the first the kindly but unstable Thomas William Gale Butler, who had a poor command of his "aitches,"[62] the other Samuel Butler, returned to England after a stay as a sheep rancher in New Zealand. A public-school boy, Samuel was aware of his privileged position. The other students addressed him as "Mr. Butler." JBY recalled him as "the politest, the most ceremonious of

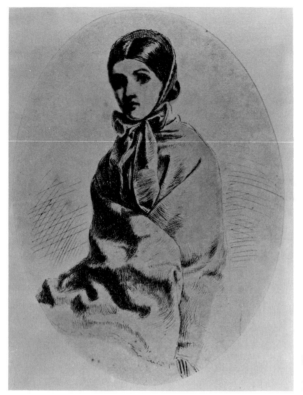

Susan Pollexfen Yeats,
1867. Pen. JBY. Collection:
Michael B. Yeats.

men, but the sneer was there and all the more palpable because so palpably veiled."[63] Butler helped arouse JBY's dormant Irish nationalism, hitherto more Anglo-Irish than Gaelic. In the fall of 1867 the English hanged three members of the Fenian Brotherhood in Manchester for murders they had not committed. Samuel Butler's only comment was: "We have to think of our own might." JBY thought the executions would burn "in the national memory."[64] It was the first of many experiences that would sour him on the English in their relations with the Irish. Echoing terms he heard regularly during his years in London, he commented in later life on "how insolently the English and all the smug tribe of the Pharisees have trampled on the poor Irish, the miserable Irish, the dirty papist, the scum of the earth."[65]

Because of what he saw at Heatherley's, JBY grew ashamed of his work for the magazines. He destroyed wood-block drawings that had been approved by Hood, passing up the money they might bring. Unsure whether art was his real strength, he began writing autobiographical fiction, which he told Edward Dowden might grow into "a large volume," for which he would also do the illustrations. But he approached the writing negatively. "If the story is bad, the illustrations may be better," he wrote Dowden.[66] The effect of his divided

application was that he neither completed the novel nor won a commission for a painting. Meanwhile, Dowden composed poems in his spare time and spent most of his hours writing polished critical essays meritorious enough to be published in English journals like *Fraser's*, the *Fortnightly*, and the *Contemporary Review*.[67]

JBY's refusal to cultivate the marketplace meant that he had little earned income in 1867 to supplement the Thomastown rents. Before the end of the year he was forced to take an additional mortgage of £850 on the estate. The mortgagor would agree to a loan only if Susan Yeats would waive prior rights to her widow's jointure. The indenture, drawn up in London, was witnessed by Todhunter, back from a summer in Switzerland.[68] Total indebtedness on the estate rose to £3,050, interest on which had to be paid twice a year. Susan, unable to shop in the best stores or travel in a coach and four, had to find such satisfaction as she could in two pencil sketches of her which her husband drew that year.[69] She so strongly disapproved of his new life that she refused to discuss his work or help him with its mechanical details.

During this period JBY's friendship with Edward Dowden was at its height. Reading the correspondence between them, one would scarcely imagine that John Butler Yeats was a painter. They had separated in Dublin with an unfinished argument, JBY trying to compel Dowden to apply the principles of Mill and Comte to his thinking, which JBY thought loose and undisciplined, Dowden arguing the superiority of intuition.[70] It was a paradox, often to be repeated: Dowden, the organized, successful scholar, the very image of reason, was attacked for vagueness by John Butler Yeats, who could finish neither painting nor story and whose sole earned income, save for what he received from *Fun*, was still the ten-pound prize in a one-man contest.

Yet the friendship flourished. Dowden was desolate at his friend's absence. He made a pilgrimage to Sandymount Castle out of sheer affection and wrote a poem about the garden there.[71] He was less inclined to argue by letter than his friend of the "bold and original opinions." He wished he could be in London to talk with him instead.[72] In letters to Dowden JBY established the pillars of his esthetic and philosophical creed: that human emotions mattered most, but that man should try to base his emotions on the "facts" of experience and on "reason," not on unthinking acceptance of assumptions like "conscience." "The intuitional school tells you to assert boldly whatever you feel firmly persuaded of," he wrote disapprovingly,[73] words that resembled what he was to say of his son's mysticism a quarter of a century later.

Dowden wanted with all his heart to be a poet, but he wanted financial security too, both to bring comfort to his family and to make his own poetic path smoother. JBY wanted financial security, but he desired even more to be an artist and, except when under desperate pressures, would seek nothing else—not even money—if he thought the seeking might stand in the way of his goal.

CHAPTER THREE

1868–1870

SUSAN POLLEXFEN YEATS was morose and dispirited away from Sligo and Ireland. She had trouble managing two children and was hardly prepared to accept a third, which arrived on March 11, 1868. It was a daughter, christened Elizabeth Corbet and promptly nicknamed "Lollie." When Susan registered the birth a month later she listed her husband's profession as "barrister."[1] Twenty days after Lollie's birth JBY hung yet another mortgage on the Thomastown money tree, this one for three hundred pounds; again Susan had to agree to waive her widow's jointure.[2] Home life was not pleasant for her. Her husband took no interest in the care of infants or small children.[3] When they were old enough he would read to them and instruct them, but until then they were birds in the nest, to be cared for by their mother. Unfortunately his wife had few domestic instincts or talents. "Susan could not have boiled an egg," JBY complained; and he never left home without "wondering what would happen" in his absence.[4]

Except for his fellow students at Heatherley's the young artist knew nobody in London well. He met neighbors like the Ford Madox Browns and their friends but made no attempt to become close to them, being too busy with his other work to become involved socially. Only Isabella Pollexfen seemed to profit; she and the precocious teen-ager Oliver Madox Brown took a liking to each other, despite the disparity of six years in their ages. Shortly after settling in at Fitzroy Road, JBY wrote Edward Dowden that he was "terribly lonely" and eight months later described himself as still "exile and friendless." He often longed to go home to Dublin, yet, he told Dowden, "I would not for a great deal live out of London." Whenever he saw a vacant house he would say to himself, "I wish Dowden was located there."[5]

But facts were closing in on Dowden. The income from the two chairs at TCD was too substantial to be ignored—one hundred pounds from the Literature, fifty from the Oratory Professorship—and he earned a stipend also for teaching at Alexandra College, a girl's school in Dublin. He began also to manage from a distance his father's drapery business in Cork, which brought in a comfortable supplementary income. His position improved

annually, and the more it did the more he became attached to it. "If I were to give up my professorship I should be obliged to work for my bread," he explained to JBY in late 1869.[6]

The friendship had to be nourished with correspondence. JBY kept up an unceasing attack on what he considered Dowden's inaccuracy of phrasing and on his belief in such vague concepts as "intuition" and the "existence of mind or spirit."[7] Dowden showed JBY's letters to Todhunter, who joined in the correspondence. Todhunter wanted to be a man of letters too, and to live in London, and only the need for "sovereigns" kept him at his medical studies.[8] "I wish I had known you ten years ago," he wrote JBY. "You would have been of immense value to me."[9]

When JBY argued warmly for knowledge based on "fact," Dowden, the defender of "intuition," chided him for "fanaticism,"[10] and JBY responded with a revealing explanation:

> I think you are right about the *fanaticism*. . . . It is indeed partly because I have such a disposition to intense ill-regulated beliefs that I cling to the sceptical philosophy. I try to fortify my reason (the judicial faculty by which we examine the evidence) lest my feelings should take my beliefs wholly into their own power. Sometimes these latter do gain the victory and then I do things that make me very miserable.[11]

He was worried about his self-recognized weaknesses: "I am a Celt and therefore enamored of beauty, but too eager, too restless, wanting in concentration, and therefore ineffective."[12]

When not philosophizing, JBY labored diligently to better himself as a painter. In June he visited the studio of Frederick Sandys, who praised his pictures "very warmly" and encouraged him to return whenever he wanted.[13] At Heatherley's he found two other students who slowly displaced Samuel Butler at the focal point of his interests. One was John Trivett Nettleship, whom JBY at first thought "most crude and juvenile."[14] Nettleship fancied himself a literary critic as well as a painter, and by the end of the year had produced *Essays on Robert Browning's Poetry*,[15] a feat which brought him instant status at Heatherley's. But Edward Dowden diplomatically declined to review it for John Morley's *Fortnightly*, and his implied doubt of the book's merits has been matched by the world's neglect of it.[16] The other student was Edwin J. Ellis, nineteen years old, who observed the much older JBY from afar.[17] Before long JBY had begun to have a different opinion of Nettleship and had developed a deepening friendship with Ellis, with whom he began long discussions on artistic theory. From Sligo in late August he wrote Ellis that verisimilitude was "a thing to be despised by the true artist," and that the axiom that "nothing can surpass nature" was irrelevant. But he added significantly: "it must not be forgotten that there are such things as the bloom of a peach, the texture of a rich embroidery, the appalling coldness . . . of a dungeon or convent wall."[18]

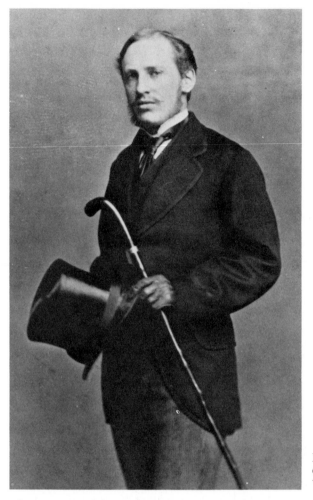

Edwin J. Ellis, about 1870.
Collection: Michael B.
Yeats.

In Sligo the chill of the Pollexfens again drove the scorned, unsuccessful son-in-law to the more friendly environments provided by John Dowden and the neighboring Yeatses. With John he took up where he had left off the year before, undertaking to instruct the young clergyman in theology, as he had instructed Edward in literature. After a while John felt he had to admonish his friend. Only a trained theologian, he maintained, could venture safely into an arena where JBY had boldly entered armed only with intelligence. Many of the "assumptions" about the moral world that JBY scoffed at were in fact proofs of the very religion he was trying to refute. "Thus 'the sense of sin' belongs to the natural history of man, and no account of human nature that omits to notice it could fairly pretend to be complete, any more than an

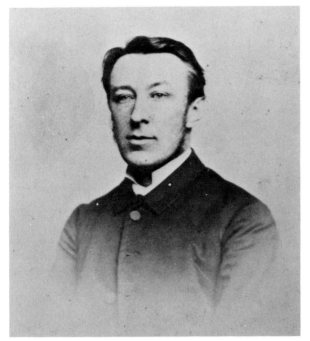

The Reverend John
Dowden, Calry Parish,
Sligo, 1866. Collection:
Michael B. Yeats.

account which omitted to notice the sense of sight. . . . A man should be no more *proud* of not possessing a *spiritual capacity* than he should boast of having no ear for music or one eye out."[19] It was a telling argument, for JBY was utterly tone-deaf and, even though he was an artist, had congenitally bad eyes.[20]

But their exchanges were discussions, not arguments. "We were not in the least like lawyers," boasted the former barrister, "setting our wits against each other, he the cleric and I the artist. We had souls, our test of truth intellectual desire and not logic." Dowden preferred "order," JBY "liberty"; "how could we fail to be in continual sympathy?" Dowden taunted his hostile congregation by reading from the pulpit a sermon by Cardinal Newman which he knew they wouldn't recognize,[21] and he invited JBY to write a sermon for him, promising to deliver it as his own; JBY never took up the offer.[22]

A certain melancholy hung over John Dowden and aroused a special sympathy in John Butler Yeats. Dowden's wife had begun having emotional problems after the birth of her first child, and her condition grew steadily worse. When the Calry congregation was seeking to bring him down, his wife took the side of his opponents. Dowden alluded to her condition only once, and JBY, probably realizing how much less serious were his own problems with Susan, carefully avoided the subject.[23]

Edward Dowden also had problems as a husband, though his were different from those of his brother and friend. To paraphrase the poet whose works he was preparing to criticize, two loves he had of comfort and despair. Unhappily, the second of these was his wife. Mrs. Dowden was not only ten years older than her husband but also, in JBY's recollection, "ugly, loquacious, and very tiresome."[24] In 1867, in one of his classes at Alexandra College, Dowden met Elizabeth Dickinson West, only a few years younger than he. She developed an intense admiration for her professor and began a "literary" correspondence with him, punctuated by frequent visits to his home. Mary Dowden developed headaches and neuralgia and became insanely jealous of Miss West. For the next twenty-five years the triangular relationship continued, with Dowden at the apex. The ultimate winner was Miss West, who outlived her rival. She was the intermediate winner as well, for Dowden not only responded to her friendship but encouraged it.[25]

Back in London in September of 1868, John Butler Yeats ruefully wrote Todhunter that he would from need have to give up training at Heatherley's and make wood blocks for the magazines instead. He would probably regret all his life his "want of technical power," he complained.[26] Yet there is no evidence that he made or sold woodcuts at that time. Instead he caught new fire from both Ellis and Nettleship. His attachment to Ellis strengthened despite the youth's obvious gaucheries. Ellis, who lived with his parents, brother, and sister on Argyll Road in Kensington, began to spend most of his evenings at Fitzroy Road, where he and Yeats continued their discussions of art and poetry. By the end of the year he was a fixture—one not wanted by Susan Yeats[27] —in the Yeats home.

Equally important to JBY was his discovery of the "genius" of J. T. Nettleship. He had avoided Nettleship's studio, for he was sure he would not like his work,[28] but one day he paid a visit and became a convert on the spot. Nettleship could be haughty and overbearing, but JBY won his friendship by "a lucky hit." Nettleship "delighted in phrases," JBY wrote. When the artist showed his design of the temptation of Jesus by the Devil, JBY noticed that Satan's hand was on Christ's shoulder. "That, I suppose," he remarked, "is an assumption of familiarity." Nettleship was overjoyed at the choice of language, and JBY at once "stepped into the charmed circle of those who understood Nettleship."[29]

"Nettleship is a real genius," he declared to Edward Dowden; "he conceives his subjects and draws them after a fashion which is most *original* and most *impressive*." One of the designs, that of God creating Evil, was to JBY (as to Rossetti and many others) the grandest and most profound concept he had ever seen. He spoke of it to Dowden at the time and continued speaking of it for the next fifty years.[30]

Even one of his wife's brothers was impressed. Young John Anthony Pollexfen, twenty-three years old, was passing through London while serving with

the Royal Navy. The most sociable of the Pollexfens, John shared his family's distaste for the Bohemian life. When JBY told him he preferred London, where he knew almost nobody, to Dublin, where he had troops of friends, John "marvelled and was almost indignant." But JBY took him to Nettleship's studio, and John was no longer astonished.[31]

Of JBY's early years in London, 1869 was the most exciting and promising. From the Heatherley students developed an informal association called "the Brotherhood."[32] At first it consisted of Yeats, Nettleship, Ellis, and Sydney Hall. By the end of the year Hall had found steady work as an illustrator and left the group.[33] His place was taken by George Wilson, a Scot, who appeared on the scene in the summer, drank coffee with Ellis at Argyll Road, and was moved by Ellis's poetry.[34] Samuel Butler was not a member, preferring to remain outside and above to deliver critical pronouncements on his inferiors. (But he left his mark. "Butler has had a considerable effect on both of us," Ellis admitted to JBY, but it was "neither a warming nor an exhilarating effect." JBY asserted that Butler had flung over both himself and Ellis "a chilling shade.")[35] The Brotherhood was noncreedal and nonpropagandistic, and JBY and Ellis were both sorry for its misleading name. Dowden mistakenly thought the group must have some fixed principles, and Ellis had to correct him. "The brotherhood really is only a handful of men here in London who hold opposite opinions, take each his solitary path in art, delight in the power and anxiously try to help on the progress of one another, and are in a perpetual state of artistic civil war." Personal friendship, not dogma, bound them together.[36]

George Wilson, the latecomer, was the least assertive. The Big Three were Nettleship, Yeats, and Ellis, and of these Nettleship was, at least in JBY's view, the unquestioned leader. He had a forceful personality and supreme self-confidence and, though JBY thought he had little power as a writer and might be "juvenile in everything," was "full to the brim of excitement" and had "enthusiasm for great ideas."[37] JBY found in him a charisma, a natural leadership, to which he himself became wholly subordinated in the few years that lay immediately ahead.

Nettleship was two years younger than JBY but seemed older. With two brothers distinguished scholars at Oxford and a third a successful oculist in London, Nettleship seemed more "versed in the ways of the world" than the others. He was something of a lady's man and shocked the less liberated at Heatherley's by discussing his exploits openly.[38] His commanding presence made his talents, however considerable, seem perhaps greater than they were. Nettleship had the gift, common to religious revivalists and cult leaders, of seeming not to reveal his mind fully, possibly because he himself wasn't sure what was in it, possibly because there was nothing more to reveal. Still, his design of God creating Evil was a powerful work. Todhunter described the

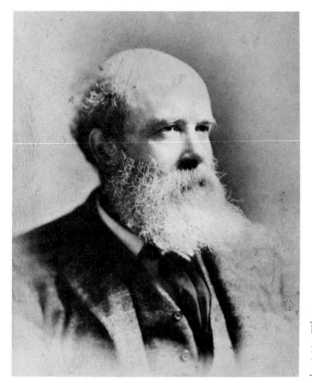

John Trivett Nettleship in later life. Collection: Admiral Sir Caspar John. By permission of Admiral John

face of Nettleship's God to Dowden: "a truly awful face, like a rock, its wrinkles deep-cut fissures, the eyes glaring with darkness and without pupils, the lips sucked in and pressed together with supreme volition, the chin massive and stern."[39] Edwin Ellis would often say to Yeats, "My dear fellow, there is nothing in Nettleship except mystical religion and genius." He was a "challenge" to his friends, a puzzle with no clear solution. In later years JBY, perhaps partly from wishful thinking, insisted that Nettleship's art sprang from the same double root that nourished his own son's poetry: "with all his visions and strange mystical calm, always did he stand firmly on the many-coloured world of fact and the laws of fact and common sense, the substance of his art and life."[40]

Ellis was quite different. Perhaps because of his youth he all too often displayed selfishness and boorish behavior—"His manners are to me disgusting," Todhunter told Dowden[41] —but he had a "vitality" within that "bubbled free as a fountain." When he was at his best he was irrepressible, with always "something to say that would set you laughing." To remember him in later years, said JBY, was "to be full of pleasure and annoyance."[42] His chief weakness was an imperfect acceptance of his role as an artist. His father, Alexander J. Ellis, philologist and phonologist and associate of Isaac Pitman,

had changed his name from "Sharpe" to qualify for a large inheritance. Perhaps that small sacrifice to Mammon gave a bent to the Ellis twig. JBY was to find that Ellis viewed poems and paintings as devices for "getting on."[43] To satisfy his "personal vanity" Ellis sought the financial rewards and social contacts they might bring.[44] JBY tried to remind him of the role of the authentic artist: "You must become a *solitary, a recluse, a very hermit*—not necessarily in your actual surroundings but in your character and your feelings. . . . The test of the reality and genuineness of a belief is your not caring to talk about it. It is held for yourself, not for others."[45] Neither Ellis nor his older brother Tristram ("Tristie") was willing simply to do good work and let success follow if it cared to. Both strove more for fame than for form; in the end neither achieved what he sought.[46] Edwin Ellis would today be virtually unknown were it not for his association with the eldest son of his friend from Fitzroy Road.

Ellis became JBY's constant companion, almost a member of the household, often staying overnight. Lily remembered his walking up the steep stairs with books under his arms carrying a burning candle.[47] In early January of 1869 the young bachelor declared to JBY that their common bond was "Art." "It is our wife," he wrote ominously to the married man with three children. "Were we to lose it, nothing could make up for the loss."[48] The metaphor was not one Susan Yeats would have appreciated; during Ellis's frequent visits she sat silently and moodily while the young man ignored her and talked enthusiastically with her husband.[49]

The heavy burdens of JBY's landlordship persisted. Uncle Robert Corbet, fallen on hard times, had been compelled to give up Sandymount Castle, dismiss his faithful servant Michael,[50] and take lodgings on Upper Mount Street. He had also developed "creeping paralysis" and was unable to continue as agent for his nephew's properties. For a short time Uncle Thomas Yeats took his place, then was succeeded by his youngest brother Matthew in the summer of 1868. Uncle Matt's account book,[51] faithfully kept for the next two decades, reveals how difficult and uncertain was the life of an absentee landlord. The 345 acres were let to seventeen different tenants, each holding his own acreage on a separate lease. Some tenants paid promptly, others were chronic delinquents. Matthew had to mediate among the bickering tenants, and before he could send the profits semiannually to his nephew he had to pay interest on the mortgages as well as the jointure to Jane Grace Corbet Yeats and a grant, guaranteed under an earlier agreement, to a Yeats aunt. Late in 1869, in a dispute among the tenants over the rights to a farm, an assassin shot and seriously wounded a relative of John Doran, the longtime Yeats bailiff.[52] The life of an absentee landlord was not always as easy as Irish patriots believed.

JBY failed to get down to the business of doing paintings for pay but spent much energy on his campaign to get his Irish friends to London. Late in May

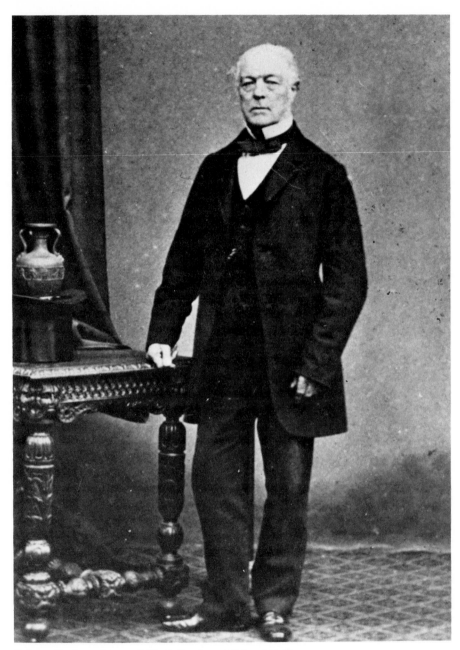

Robert Corbet, about 1866. Collection: Michael B. Yeats.

1869, John Dowden unexpectedly appeared at Fitzroy Road, en route to an ecclesiastical conference in Brussels, and stayed five days.[53] At a dinner in Dowden's honor the guests were Ellis, Sydney Hall and his brother, and a painter named Jones. The talk was more of philosophy than art, to judge from a letter from Dowden several months later; and apparently the brash young Ellis did most of the talking. "If Ellis is every day the same sort as I saw him I fear very little good work will be done in his company. Stimulant we need, to be sure, but we need concentration as well."[54] Ellis fretted because he didn't think Hall's brother or Jones worthy of the august company and asked Yeats whether George Wilson might not be substituted another time. He was easily annoyed, then and at other times.[55] When JBY took Dowden to Nettleship's studio to see the design of God creating Evil, Ellis was irritated by JBY's using the edge of another sketch as a pointer.[56]

JBY impulsively joined Dowden on his trip to Belgium, doing no good to his ledger balance. Between May 27 and June 3 the two toured the country, spending most of the time in Antwerp. They visited the galleries, and JBY told Dowden he looked everywhere for "the portrait of some subtle cardinal which would resemble Dowden."[57] It was an exciting trip filled with engaging talk. JBY felt himself "the more Christian and religious of the two," finding that John Dowden, like Edward, was too much interested in the critical and intellectual and not enough in the emotional. "The blind instinctive movements of ignorance have for him nothing beyond a scientific interest," he told Ellis. "Emotions, which to me are everything, are to him little more than blind forces tending to anarchy. Intellect, which is nothing to me, is to him everything. . . . I value but one thing—there is but one thing beautiful to me—human feeling. Of this I find none in Intellect, which is colorless as light."[58] It is no wonder that Todhunter called to his attention the "strange phenomenon" of his being simultaneously a disciple of John Stuart Mill and William Blake, the poet in whom the Brotherhood was beginning to take a passionate interest.[59]

Returned to London, JBY entertained once more for Dowden, with Ellis and Sydney Hall (but not Hall's brother) present. Nettleship was away at Oxford. The party was a smashing success, and JBY felt that Dowden had come close to being "one of us." The only flaw in the evening was again Ellis's behavior. The host suggested singing, and everyone but Ellis joined in. Then Ellis left without saying his "good-byes" properly.[60] Ellis later apologized in a rambling letter in which he pleaded fatigue, confessed that his egotistical brilliance was a flaw, and revealed irrelevantly that he had been involved in a hopeless love affair for the preceding two years. In a burst of illogic he tried to explain his petulance by charging that Dowden was a "fettered" spirit.[61]

On his return to London from Sligo via Dublin in the summer of 1869, JBY fired Todhunter with visions of life in London. Todhunter, who accepted Ellis chiefly because his friend defended him, was so fond of JBY that he included

him even in his private plans. When he became engaged to the sister of Robert Ball (later the Astronomer Royal) he asked JBY to shop in London for a suitable ring.[62] JBY's reaction was unexpected and violent. Give up the idea, urged the young father, and go to London instead "to study for a painter."[63] Marriage, he warned, would be "a fatal mistake," and Todhunter would "repent it hereafter in sackcloth and ashes."[64] At the time these words were written JBY's eldest son Willie was just over four years old, Lily three, and Lollie one. It was a chilling index of the course his own marriage was taking. (*The fictional Harry Bentley, after making the rounds of the editorial offices in London without selling his stories, lashes out at his wife: "You have done nothing but make stupid irrelevant remarks all evening. . . . I sometimes think you are as regards me a kind of irrelevancy, a sort of disturbing element in my whole scheme of life." Later, in remorse, he adds: "There are some people in the world who ought never to marry. I am one of them. I wish I was a bachelor. I'd be happier and you'd be happier."*)[65]

It is not difficult to identify the pressures. Susan hated London and the absence in it of her own kind of society. She disliked having no money in the house. For JBY too the absence of money was galling, but he found himself unable to do anything to earn it. Late in 1869, Todhunter had invited him to return to London from Sligo again by way of Dublin, but that was too expensive even for an Irish landlord, and JBY could hardly waste the money under the very eye of his father-in-law, from whom he had repeatedly borrowed small sums. So he and Susan returned aboard one of the Pollexfen ships bound for Liverpool—their customary way of free travel between England and Ireland—the children remaining behind until December.[66] Many decades later, in what should have been the peaceful haven of his old age, the deep anxiety of those early days rose from his unconscious and disturbed his slumbers. "I dreamed last night," he wrote his eldest son in 1914, "that I had a visit from your grandfather, who asked me how long I expected him to support me. I thought I was staying at Merville. I awoke miserable and remained so for a long time."[67]

Soon after they arrived at Fitzroy Road, Todhunter paid a visit. On his way to the Allgemeines Krankenhaus in Vienna, he was determined to see what he had been missing in London. Nettleship, impressed by JBY's praise of Todhunter's artistic promise, came to Fitzroy Road bearing a number of designs. The irreverent Todhunter promptly proclaimed some of them "subsublime," to Nettleship's annoyance. Next day Todhunter went to the studio and, after admiring the design of God creating Evil, found fault with a sketch of a lion which Rossetti had already bought. Nettleship said in an aside, "To think that I should stand this!" When Todhunter told him that now, after seeing his studio, he was "beginning to believe in him," Nettleship replied, "Why? Didn't you believe in me last night then?" But he admitted that Todhunter's criticism showed more appreciation than most.

Todhunter grew enthusiastic about Ellis, finding his talk "a perpetual bran-

dishing of the intellect," and described him to Edward Dowden as "all animal and intellectual spirits, which effervesce like champagne—the most brilliant man I ever met." About the life he saw during his visit he was rhapsodic. "O Edward, I have dwelt in that great human hive called London and realized its immensity more than ever. I enjoyed my visit to Yeats. . . . The man lives in a whirlwind of ideas. It is like breathing pure Oxygen after the CO_2 of Dublin." As for JBY's opinion of Dowden's life in Dublin: "He thinks you are slowly but surely sinking into the sleep of death and that nothing but instant emigration from Ireland can save you." [68] He noticed something else too. Edwin Ellis's brilliance was not matched by a bounty of human understanding. "I don't wonder at all at poor little Mrs. Yeats's hatred of him. He has not only estranged her husband from her, but he quietly ignores her existence." [69] The marriage was clearly sailing near the ledges.

Despite Todhunter's enticements, Dowden heeded the call of prudence. He could not possibly visit "at present," he wrote JBY. "London would be a whirl of ideas, and the best flows out of me, not in the obsession of many ideas, but in the calm brooding possession of a few." [70]

Dowden had read Ellis's poetry and found it good; JBY had thought it good too but did not trust his own judgment until Dowden confirmed it. [71] He told Dowden to stick to poetry and give up criticism. Only residence in London could keep him from becoming a Dryasdust. "It is his one chance left of being a poet," he told Todhunter. "It would chastise the prose out of him." [72] Edward did not budge.

JBY decided in the fall to take a studio with Ellis at 74 Newman Street, near Nettleship's. He had long wanted one and now, despite the expense, he acted decisively. He and Ellis moved in on October 5 with "5 chairs, 2 tables, 2 platforms, 3 blocks (boxes formerly), an easel, 2 lay figures, etc." [73] Their stay was to be a short one, but JBY felt a start had been made. The evidence suggests that there was more talk of William Blake, the evangel of the Brotherhood, than practice of painting. Yet it was not John Butler Yeats who was to be associated with Ellis in the eyes of the world as a leading expositor of Blake's philosophy, but rather his son William Butler Yeats, the "curious little elf," [74] who, when first introduced to Ellis in the living room at Fitzroy Road earlier in the year, had asked: "Are you related to Cinder Ellis?" [75]

In 1869, John Butler Yeats's dream of living the life of pure art with compatible companions had reached its high-water mark; by contrast 1870 seemed anticlimax and disappointment. The studio with Ellis proved an expensive luxury; JBY failed to use it to generate business, and by late June he had to give it up. [76] But he learned much while there about painting. He often worked alone from models and developed habits that stayed with him all his life. He encouraged them to talk: "otherwise it was so dull for them and so dull for me. . . . A man would tell me of his wife and children, or a girl of her

mother or sweetheart. And if there was the accent of sincerity, instantly I was all attention. How could it be otherwise? And what is more to the purpose, my paint brush moved freely over the canvas."[77]

In March, after three years of profitless apprenticeship, he got his first big commission: to do a drawing of "Pippa," the character in Browning's play, for ten pounds. The gloss of his good fortune was somewhat slubbered, however, for the assignment and the money came from the generous Todhunter.[78] He accepted with reckless optimism, and hopefully assumed he would never again have to worry about sketching for comic journals or doing woodcuts.[79] "My besetting sin," he wrote years later, was in "hoping that fame and success would suddenly descend like an angel from heaven."[80]

The history of *Pippa* set a pattern for most of his later work; it differed chiefly in being finished more quickly. Todhunter sent a deposit of five pounds in late February. On March 2, JBY told him he had a "fresh" design for the work, which he would begin to paint at once. A month later he promised he would be at the picture "immediately." On April 24 he told Todhunter he planned to add pines to the picture and dress Pippa in nothing but white, and also asked him not to send more money for the picture. Two weeks later he announced a new design and told Todhunter he was ready to accept the remaining five pounds of the fee.[81] Then he sent Todhunter an entirely different picture entitled *Good Things of Day Begin to Droop and Drowse*,[82] featuring young ladies and a prominently displayed raven. He intended it as a gift for Todhunter and his bride but didn't make his intention clear, so Todhunter, feeling free to criticize, called it slovenly in execution.[83] (When Dowden declared it "great in execution" Todhunter relented, and his wife, who also liked it, had it placed on the chimney mantlepiece.)[84]

Meanwhile JBY continued working "very industriously" on *Pippa*,[85] but it was still unfinished when Todhunter wrote—on Willie's fifth birthday—with the astonishing news that a total stranger to JBY, one W. T. Grahame, had sent Todhunter twenty-five pounds to commission either a single picture by Yeats or one by Nettleship for five pounds and one by Yeats for twenty. Todhunter chose the second option. JBY was to take his time—a dangerous concession, as Todhunter and Grahame would discover. The only limitation on the artist was that Grahame wanted a "moonlight picture." Todhunter gave JBY the kind of advice he didn't need: "Live as if you were immortal. Keep up your spirits, believe in yourself, don't sell yourself more to the devil than is necessary."[86]

Yet JBY remained unsure of his own talents. After three months of work on *Pippa* he apologized abjectly for its condition. "The picture is a failure. You will have little for your money except the feeling that you by this commission have helped me *enormously*." By early August he was again "bubbling and brimming with elation" about it, yet he warned Todhunter that it was by no means finished but "still merely in its commencement."[87] A short time later he told Dowden the picture had already cost him more than ten pounds and Dowden,

not realizing the remark was meant to be confidential, told Todhunter. JBY had to insist to Todhunter that his only fear was that picture would not be worth the money.[88]

He left *Pippa* in London when he visited Sligo in the summer and on his return discovered that it had deteriorated. "I found the face of Pippa *black*, greenish black, nearly all over. I have painted it in and out since ever so many times, but it has not come right." He hoped to finish it in a "couple of days,"[89] a phrase that was to become a cliché. On December 30 the painting finally found its way into the Dudley Gallery,[90] but after the showing JBY retrieved it and worked at it for another year. Todhunter did not receive it until April, 1872, two years after the commissioning. Ellis, watching the progress of the work and observing Yeats's tendency to converse rather than paint, charged him with being lazy. Yeats admitted that except when actually putting brush on canvas he was "lazy, supine, careless," and, as he confessed years later, "so destitute of executive talent that it is a wonder to me how I learned to tie my shoestrings."[91]

To all the artists of the Brotherhood but particularly to JBY neither space nor time was important. Art was all that mattered. It was a mistake, JBY wrote, to think the Brotherhood "ever attempted to paint or talk alike." Rather, "we cherished a sort of mutual aloofness, only we considered that we and we alone knew of the close connection between art and life." Three of the four came out of constricting backgrounds—"prisons," JBY called them—Wilson from Scotch Presbyterianism, Ellis from conventional society, and himself "from the teaching of J. S. Mill."[92] Only Nettleship seemed secure and confident, regarding himself so highly that the painter Edward Burne-Jones referred to him as "His Nettleship."[93] Sydney Hall found him annoying. Of his brother Lewis Nettleship, the Oxford don, Hall asked testily, "Is he as near a relation to God Almighty as Jack Nettleship?" Yet JBY found in Nettleship a "mystic" who "cultivated an inner life," even if he was hard to get along with, one moment "affectionate and confiding," the next "suspicious and vindictive."[94] One morning on the way to art school Ellis and Wilson proposed to Yeats that the three attend the opera that evening. JBY was short of funds. Suddenly he remembered that Nettleship owed him five pounds and, with Ellis and Wilson, walked out of the way to call on him. Nettleship was pleased at the unexpected visit but turned cold when he learned its purpose. His pleasure was spoiled— and so was JBY's.[95] Compensating for Nettleship's idiosyncrasies was his conversation, which had as much influence on JBY as George Pollexfen's earlier. "He talked without seeming to talk," JBY wrote admiringly, "and without making any effort was always the centre of our circle." Nettleship watched his companions closely and was "ready on the instant to become silent if he thought anyone was bored."[96]

George Wilson, the fourth member, was the quietest and the least assuming. He was also, in the opinion of Nettleship and Yeats, the "born painter," "richly

endowed with all the artistic instincts, with an intellect and a judgment that was like sunlight." Even Nettleship admitted that as an artist he could be only envied, not imitated. He spoke seldom but perceptively, interjecting a remark or chuckle that "stimulated and at the same time checked the conversation."[97]

JBY's campaign to have Edward Dowden meet his marvelous colleagues and taste the glories of London with them at length succeeded. In July, 1870, Dowden brought his wife and children to London with him, taking a place at Pimlico. He visited at Fitzroy Road, went boating on the pond with JBY and Susan,[98] and met Ellis, Nettleship, and the others. Dowden, earnestly wishing to be a poet, agreed with Yeats that one needed freedom to pursue the craft. As a professor of literature he could of course have found the time, but teaching led to criticism, and criticism required qualities that inhibited the poetic impulse. If Dowden was to make a move it would have to be made soon. His friends encouraged him but could do no more. Dowden was a difficult man to argue with, as he was consistently calm, even-tempered, and gracious. His effect on people is nowhere better evidenced than in an affectionate parody by Todhunter, who had received five pounds from the more affluent Dowden for medical services Todhunter thought worth only a pound:

> Dowden, Dowden burning bright,
> Full of sweetness, full of light,
> Full of light and full of sweetness,
> Full of roundness and completeness,
>
> Full of sunshine and sweet air,
> Full of music everywhere,
> Full of ripe humanity—
> Did he who made the snob make thee?[99]

The visit to London was not productive. The painter was disappointed. "Ed Dowden I really do not know more of than heretofore," JBY complained to Todhunter. "I know his 'amiable' qualities. I know little or nothing of his nature." He saw what divided them. "I think he never will declare himself until he does something creative. I fancy he has a very great love for order and method in matters of idea; hence he can scarcely like the fragmentary and chaotic state of many of my ideas. Moreover his work lies more among ideas, philosophical abstract ideas, than mine. My work lies among ideas but it is as they are the means of exciting feelings."[100]

As Dowden became more secure at TCD his politics tended to take on the color of his surroundings. When Todhunter expressed sympathy for a revival of the Young Ireland movement[101] —the movement to instill in the Irish a sense of national identity independent of England—Dowden appears not to have responded. Now, in 1870, the Prussians under Bismarck were marching against France, and Gladstone warned that England might feel compelled to intervene. Dowden was enthusiastic at the prospect of England's going to war,

believing it would ennoble the nation, which was at the moment in the grip of a "money-getting peace." JBY chided him sharply, calling the war fever a "mania."[102] Even as their friendship continued its level course, their views grew further and further apart.

While in London, Dowden generously ordered for five pounds a chalk study of the head of Pippa.[103] He engaged in a dispute with JBY and Ellis over Wordsworth, whom he admired and they abhorred. It was not until years later that JBY realized that he disliked "the ethical part" of Wordsworth, that the poet in him "was offended."[104] Dowden had to respond by asking the Brotherhood, "breathing an air so foreign to the air" the poet breathed, to leave Wordsworth alone.[105] "You don't understand each other a bit," commented Todhunter from the sidelines.[106] Dowden, despite his disagreements with JBY, was impressed by his powers and suggested he become a critical writer. "I believe you could at once gain the attention and respect of cultured men."[107]

But Dowden disliked Edwin Ellis, who "behaved very badly with him," being "almost impertinent in manners" and "drivelling in conversation," as JBY regretfully expressed it to Todhunter. Perhaps Ellis's normal boorishness was intensified by jealousy of Dowden. Yet JBY defended Ellis as one who would "requite" his defects "with all good deeds."[108]

His defense of Ellis illustrates the powerful hold of the younger man on JBY despite his outrageous behavior to Susan Yeats. "No human being who is out of sympathy with him could stand his perpetual brilliancy," Todhunter had explained to Dowden before his visit. "He talks forever, with a fifty-gratiano power—blazes, coruscates, detonates, reverberates, rhapsodizes, laughs, sneers by the hour together." "Unfortunately," he added, "when such an intellect is combined with such animal spirits the result is naturally appalling to the Philistine mind." There is no doubt whom he identified with the "Philistine."[109] At Fitzroy Road, Ellis deliberately spoke in an artist's jargon so that Susan would be kept in the dark. In February the older man wrote a friendly but chiding letter—"a really monumental letter," Ellis called it.[110] Susan had objected to Ellis's slang, calling it "insincere," and her husband praised her, asserting that the very presence of her kind of person should be a joy to all true artists. Ellis's reply contained no apology but rather a defense of his own conduct and an attack on Susan. His "slang" appeared insincere to her, he charged, only because it had no meaning for her, as a term out of Christian theology would be meaningless to "a born pagan." He insensitively concluded: "The Mrs. Yeatses make war upon what they suppose to be art, or a part of art, and in its name cry out upon many things which they don't like."[111]

Susan had to endure more than her husband's Bohemian friends. At her Sligo home she had been brought up in the ways of the Church of Ireland, and now, although the children were too young to attend church, she wanted them to learn their prayers. Their father flatly refused and from the beginning

counteracted his wife's influence. In the Protestant Church, he believed, religious frenzy led to madness. If people wanted to go in for that sort of thing they should join the Roman Catholic Church, where they would be "kept in order by their priests."[112] Susan's desires were thwarted at every turn.

Eventually she became clear of Ellis, who went to Italy, married, and temporarily lost interest in his London friends until his wife died a year later.[113] His long absence gave everyone a chance to cool off.

On March 27, 1870, Susan gave birth to another son, named Robert Corbet after JBY's brother (who had died at fifteen) and his aging uncle. The baby's arrival brought virtually the only joy in family affairs that year. At Thomastown one of the tenants was killed when he fell from a horse while drunk.[114] His death released a bagful of troubles. His widow and brothers entered conflicting claims for the lease, and two outsiders appeared, maintaining that Uncle Thomas Yeats had made promises to them during his brief tenure as agent. John Doran, the bailiff, felt he was entitled to more money, and his brother Richard wanted JBY to give him ten pounds to purchase timber and slates.[115] The estate was troublesome, as it had always been and would continue to be. When brother William Butler Yeats, who had settled in Brazil with a firm of spice merchants, suggested that JBY sell the estate—which JBY told him was worth twelve thousand pounds—and invest all or some of the proceeds in Brazilian businesses, the idea must have been tempting.[116] Nothing came of the scheme, perhaps because of the complexity of selling mortgaged lands, or perhaps because of JBY's inertia in business affairs.

Altogether it was not a good year. Willie developed scarlatina in April, and JBY caught a bad cold and began coughing and spitting blood. He had become depressed about his prospects. He felt he should keep acquiring skill in his craft, but money was desperately needed. He confided to Todhunter that his wife's and his fears "of being some day left penniless" in London were "destroying health and spirits and happiness and retarding greatly artistic progress."[117] He even thought of giving up the Fitzroy Road house, but the lease ran until June 30, 1873,[118] and JBY saw no prospect of breaking it or subletting the house. Yet by the time he recovered from the cold a couple of months later he was full of optimism again.

Susan Pollexfen Yeats and Lily, February 13, 1870, six weeks before the birth of Robert Corbet Yeats. Pencil. JBY. Collection: Michael B. Yeats.

CHAPTER FOUR

1871–1873

THE INCONCLUSIVENESS of 1870 was matched by the relentless unproductivity of the years following, and it was clear that some kind of change would have to be made sooner or later. If JBY had been a bachelor, as the Harry Bentley in him desired, he might have continued indefinitely at the schools, under no compulsion to produce anything for sale. "But everyone was crying out and clamouring for some practical success," he complained, "and so against *my own instincts* [I] devoted myself to portraits and pictures which were never finished." What he should have gained was *"good technique."*[1] During the early years of the 1870's he satisfied neither his critics nor himself.

Pippa hung in the Dudley for the first weeks of 1871 and was a conspicuous success, even the great Dante Gabriel Rossetti being impressed.[2] But it had already been sold at less than cost, and there were no profitable pictures to offset it. At the height of the Dudley show JBY was forced to ask for another loan from his father-in-law, who responded with twenty pounds, along with a letter expressing hope that the *Pippa* would lead to some profitable commissions.[3] The hint was clear enough. The implicit understanding between JBY and the Pollexfens was that he would be given a period of time in which to sharpen the tools of his trade and would then make the trade pay. Up to now there had been little to show. *Pippa* was the first commission, but an unprofitable one; the moonlight picture for Grahame was hardly begun.[4] More frightening was JBY's own inability or reluctance to seek commissions actively. It was his friends who found such slender assignments as he was to receive.

The life at Fitzroy Road was not in itself prohibitively expensive. The house was a simple one, a narrow, three-story building attached on both sides. Save for a low-waged servant or two, there were no frills. There is little evidence that John Butler Yeats spent much on himself, save for the necessary instruction at art school, but he could never keep accounts, and one wonders how much might have been frittered away in penny squandering. He thought Tristram Ellis had lowered himself in the eyes of others by cutting corners on train fares,[5] so it can be presumed he never practiced such economies himself.

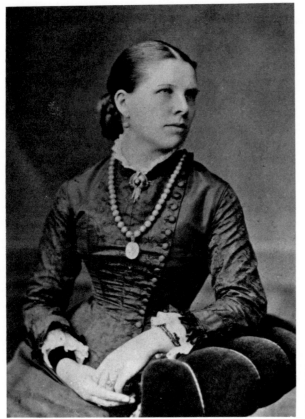

Isabella Pollexfen (later
Mrs. John Varley), about
1870. Collection: Michael
B. Yeats.

(Harry Bentley, on the brink of starvation one day, treated himself to an unnecessary hansom cab the following day when he received £15.15 for a story—and did so with the feeling that he had behaved appropriately.) The annual receipts from his property failed to match his expenditures. In the average year the estate could generate gross proceeds of £600 (compared to John Dowden's £79 for the Sligo curacy and Edward Dowden's £300 from his Chair of Literature).[6] Out of the gross had to be paid mortgage interest, widow's jointure, support for the aunt, income tax, ground rent, bailiff's pay, and agent's fee.[7] What was left for the landlord was considerably less than £220. Occasionally legal fees were payable when new mortgages were negotiated or evictions or other processes were necessary. An occasional default in payment of rent had to be deducted from the landlord's portion, though the Yeats tenants on the whole maintained a good record of faithfulness in payment. For the year ending March 31, 1873, JBY received from Uncle Matthew a net payment of £206. Whether such a sum was adequate for the kind of life he chose to lead may be debatable. It was a large sum for those days, and a man of ordinary prudence with even a

Susan Mary ("Lily") Yeats,
about 1870–1871.
Collection: Michael B.
Yeats.

primitive sense of budgeting could have managed. Clearly, JBY was not such a man.

Nor had his self-confidence been strengthened by events. When Rossetti sent his brother William Michael as a personal emissary to Fitzroy Road to invite JBY to visit, the offer, though repeated, was never taken up. Without declining it, JBY simply never accepted it. In later years he regretted his indecision. "Better to have talked to a man like Rossetti than to travel a thousand leagues to see a thousand cities. Meeting a man like Rossetti must have been like sitting down to a great banquet in a King's hall." In fact he was never able to explain his refusal. "I think I feared him," he wrote. "I was becoming interested in a kind of technique different from that of Rossetti's, and feared he would divert my mind." Yet in the same passage he added, "I admired Rossetti very much and wished to postpone my visit to some time when I should think better of my own work." In old age JBY declared that "everyone's life is a long series of miraculous escapes." Perhaps his failure to see Rossetti was an example. Years later, when another famous artist, Robert

Browning, called to offer compliments on his paintings, JBY was out and did not return the call.[8]

As month followed unsuccessful month in the crowded quarters at Fitzroy Road, which served as both home and studio, the tensions grew worse. Susan was again pregnant, and the prospect of yet another baby in a family where the first child was not yet six years old depressed her. She wanted to leave Fitzroy Road. The thought of living there another two years was unbearable. Her husband saw that she "suffered materially" from the conditions of her life and that it was "cruelty" to keep her there.[9] She lost part of her desired Sligo summer in 1871 by remaining in London till after the birth of her third son and fifth child on August 29. The baby, christened "John Butler Yeats, Junior," was born at Fitzroy Road. For some time during his infancy he was called "Johnnie,"[10] but that soon gave way to "Jack," the name by which he was known to everyone and which he himself chose in later life.

After a brief stay in Sligo the family returned to London for the long winter and spring of 1871 and 1872, which constituted perhaps the most dismal period of their long first residence in London. It was a time of "wearing anxiety," JBY told Susan, "injuring our characters as well as our physical strength."[11] Fortunately Ellis was still in Italy, but the continued unproductivity of her husband drove Susan into ever-deepening gloom and frustration, for which her only remedy was to sulk and endure. With JBY's friends all had not gone well either. Todhunter's vivacious and likable wife of less than a year, who had admired both JBY and his paintings and lent him a kind of secondary support, died in March, 1871, and Todhunter was left widowed with a baby son in his house at 116 Lower Baggot Street.[12] Edward Dowden's loss was, in JBY's mind, almost as great; his friend had become so successful a critic that he was slowly losing the creative impulse. JBY kept after him: "I wish you were *creating*. . . . As long as you are not creative you must occupy a wrong position."[13] Dowden was privately writing verse which he was afraid to show JBY because, as he told Miss West, now a faithful correspondent and constant caller, "he would not care for my more recent way of feeling."[14] Yet JBY recognized that despite his passion to advise others he could do little for himself, as he admitted to Dowden. "The impulse of tomorrow contradicts the impulse of today. I cannot rely on myself for twenty-four hours. . . . I, as it were, live or rather hide in the desert, never entering the settlements either to mass or market."[15]

His depression was compounded by the deaths of two favorite relatives. On April 7, 1872, Thomas Yeats, his father's brother, died at sixty-one after a lifetime devoted to caring for his widowed sister and her children.[16] JBY not only mourned his death but regretted that his own children were not old enough to have known him well. "You would be proud to have their blood," he wrote warmly to Lily years later of the Yeats relatives. "They were so clever and so innocent. I never knew and never will know any people so attractive."[17]

The other loss was far more depressing because of the circumstances. Robert Corbet had spent not wisely but too well; now old, broken with palsy, and insolvent, he committed suicide. Taking the ship for England, he went above, laid his rings, watch, and chain on the deck, and stepped overboard into the Irish Sea. Behind him he left an estate sufficient to pay his creditors only fifteen shillings in the pound. The kindly, if snobbish and bigoted, Anglo-Irish gentleman, as his nephew saw it, had outlived "two centuries and ways of thought." He deserved a better end—"a peaceful old age closing in a painless death."[18]

Both Uncle Robert and JBY had a talent for insolvency, able to receive money when it came unsought but ignorant of the ways of earning or conserving it. JBY had lost money on *Pippa* yet was worried only that Todhunter might be displeased with it. When he released a landscape commissioned by Dowden his satisfaction was "qualified by the thought that the execution is so very unsatisfactory."[19] In the spring of 1872 the Grahame picture was still unfinished. An artist with a clear head for business would have estimated quickly how large a landscape could be painted for twenty pounds, promptly executed it, and moved on. JBY could only dawdle while he thought about it. Dowden got his friend two commissions for portraits from fellow Dubliners. Almost any other artist would have made an appointment for sittings, proceeded to Dublin at once, done the two paintings in a single stay, and submitted his work along with a bill. The purchasers knew they were not buying oil and canvas but a man's talent and time. By giving the latter for almost nothing JBY ignored the fact that a man who holds himself at little value will be but little valued by others. Once he agreed to do a painting, for whatever sum, he behaved as though under an obligation to produce something worthy of a place in the Uffizi. His description of the landscape he painted for Dowden is illuminating:

I began the picture in the snow, when the whole place was hung and festooned and draped with a luxuriance of dead leaves. This indeed was the great attraction. Interruptions occurred, and I finished the picture when the spring winds were on every side of me with great dispatch, dislodging and carrying off the dead leaves, except a few that still stood out and *flecked* the brown gloom as I have painted them.[20]

A better businessman would have let the winter scene stand, painted a spring and then a summer scene, and sold all three. Why not collect for several less-than-final pictures rather than one? JBY often collected for none.

He had moved from Heatherley's to Slade's Art School and been accepted as a student by Edward Poynter, associate of the Royal Academy and one of the chief painters of England.[21] Still he made no money. Life in London had lost much of its early bloom. An occasional happy event, like a visit from Edward Dowden—who was taking his wife to Paris in an attempt to ease her "neuralgia"[22]—was not enough to offset the disadvantages. The residence in London

had clearly been disastrous. So it was agreed that when the family departed for Sligo in the summer no attempt would be made to return Susan and the children to Fitzroy Road. When on July 23, 1872, all the Yeatses left London for Liverpool and the long steamship voyage to Sligo, it was the last time the children were to see the Fitzroy Road home. None was old enough for it to have made much of an impression;[23] now it was to be replaced by another residence far more fascinating and memorable.

Neither parents nor children had any idea that what had begun as an ordinary summer vacation would last as long as it did. Father made no decision about a permanent residence but simply waited for things to happen. He didn't enjoy Sligo as much as he used to, for John Dowden was preparing to leave Calry to become assistant curate to Archbishop Lee of St. Stephen's Church, Dublin.[24] Except for the few Sligo relatives like Aunt Mickey and Uncle Matthew, the only people JBY saw regularly were Pollexfens, and between him and them yawned gulfs of misunderstanding. "Intellect was the sun of my solar system, and dulness was the centre of theirs."[25] (Years later, when he read Galsworthy's *The Man of Property* he saw in the Forsytes—"such quantities of dull rich English people, splendidly described and *shown up*"— the Pollexfens of Sligo.)[26] He admired "the Pollexfen nature" while "loathing some of their notions," he explained to his son. "I find the soil rich in fertility and even with something volcanic in it, but I do not like the crops that grow upon it."[27] He welcomed the chance to run over to Dublin periodically to work on the portraits Dowden had secured for him.[28] To justify himself to family and friends he had to buckle down and prove that he could paint pictures that would sell. So when the summer was over he was forced to return to London, leaving wife and children behind him.

As a result of their father's inability to manage his own home properly, the Yeats children were to spend a long residence at Merville. When it began Willie was seven years and one month old, when it ended nine years and five months—the years between among the most impressionable of his life. Lily was only a year younger, Lollie three. The other two boys were still too young to be affected deeply by their environment. Just when his older children were most malleable their father, through his own deficiencies, had to put them under the care of the one family he would most have wished them to avoid. As John Butler Yeats came to know the Pollexfens better he saw in them three unfortunate qualities that outweighed the magnetism and suppressed poetry that had attracted him to them. The three were a striving for property, a worship of class, and an unhappy tendency to depressive melancholia. All characteristics were well represented by the uncles and aunts who surrounded the Yeats children in those critical years. Charles, the oldest brother, JBY's sour, unpleasant Atholl schoolmate, had been sent to manage the affairs of the Sligo Steam Navigation Company in Liverpool and was seldom in Sligo. George, who appeared occasionally, resided in nearby Ballina, where he

managed the company's affairs. John, the merchant seaman who had been so astonished at the Bohemian life in London, was now serving on the family steamer *Glasgow*.[29]

The three sons remaining were fascinating and disturbing as only Pollexfens could be. William Middleton Pollexfen, age twenty-five, was a high-strung, imaginative young man with a passion for engineering. He had designed new quays for the Sligo harbor and was working on an unsinkable ship with a hull of solid wood.[30] But he was in the process of going mad, and within a few years would enter a mental hospital in England for a lifelong stay. Fredrick, younger by four years, was erratic, unstable, and selfish. With a gift for irritating others, he was always in the wrong place at the wrong time, "like a bluebottle fly buzzing at a window," as his brother-in-law put it, "and without the sense to see that a little lower down the window is wide open."[31] He was the favorite of his father, who liked men of spirit and who spoiled him. JBY liked him too and often helped him with his lessons, believing he had one of the "most imaginative minds" he had ever met, though absolutely "incapable of *rational* thought."[32] Alfred, eighteen, was the quietest and most humorous of the Pollexfens but filled with a sense of his own worth that JBY called "self-exaggeration," "the great Pollexfen malady," though in him it was cheerful and pleasant. Alfred thought he had a most distinctive face and his brother-in-law a quite commonplace one. Once, when Alfred was sitting to JBY, the Reverend John Dowden entered and quietly congratulated JBY on not having to paint such a "blooming face" every day. Alfred was somewhat deaf, and Dowden thought his remark would not be heard. But Alfred heard it and turned red, then excused himself and fled to the office.[33] He loved music and as a young boy would follow traveling bands about Sligo. He played the concertina, and when he heard a tune once he would remember it perfectly. Yet he would "burlesque" the tune rather than take it seriously. He had no faculty whatever for business but followed the family's wishes and stayed with first one and then the other of its firms until his death. The Pollexfens did not recognize his incapacity. "It was as if a Spartan suspected one of the family of being a coward," JBY wrote his son years later.[34]

The daughters (except for Susan) were all unmarried when their nieces and nephews came for the long sojourn. Elizabeth, twenty-nine, somewhat vague, light-headed, and easygoing, was what JBY called a "primitive." She was unable to learn her multiplication tables until a clever young teacher set them to music, when she learned them instantly.[35] Her sister Isabella, twenty-three, admired of the young Oliver Madox Brown (now sixteen), had "intelligence," her brother-in-law thought: "She is somebody and you cannot easily set her aside."[36] The youngest daughter, Alice, fifteen, was the most selfish and the least interesting. Agnes, seventeen, would prove most troublesome to the young William Butler Yeats, as she took it upon herself to supervise his upbringing and education in ways of which his father did not approve. Yet

William Butler Yeats, about 1872. Pencil. JBY. Identification in the hand of
Lily Yeats. Collection: Michael B. Yeats.

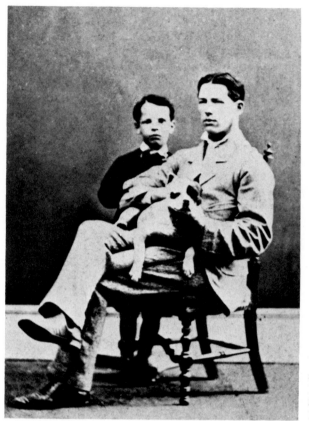

William Butler Yeats, aged seven, Uncle Fred Pollexfen, and dog Spot. Sligo, 1872. Collection: Michael B. Yeats.

JBY found her the most intense and interesting of the sisters, with great "nervous and cerebral energy." He also noticed in her "a dangerous silence."[37] Like her brother William, she was to suffer later from emotional instability and spend many years in asylums.

Among this group the Yeats children were like so many specimens in a laboratory. For Willie, the eldest son of Susan, eldest grandson of William and Elizabeth Pollexfen, and heir to the Butler properties in Thomastown, it was an upsetting experience. For one thing, although seven years old he didn't know the letters of the alphabet. His father wasn't at all worried, having read in Herbert Spencer that educating a child too early might stunt his intellectual growth. The aunts, who hadn't read Spencer, chose to make an issue of their nephew's backwardness. His father knew he had "many things to occupy his mind, imaginative and busy," but all the aunts could see was that Willie was inattentive to the "important trivialities of the outer world" and were "irritated and wearied out of patience" by him.[38] It was a paradoxical opposition: the family that cared nothing for poetry wanted desperately to have the nephew

learn to read, while the nephew's father, who cared for little else, was not worried about the deficiency at all.

Whether John Butler Yeats liked it or not, his own weaknesses compelled him to leave the tutelage of his children to his wife's family. He returned to London according to plan in the fall of 1872, apparently with the understanding that he would try to sublet the Fitzroy Road house and then return to Sligo to consider the future. But such business enterprise was beyond him. He found it easier to persuade George Wilson to live with him at Fitzroy Road, sharing the expenses of rent and a maid.[39] Instead of looking for subjects for portraits he attended Slade's for Poynter's instruction. When the widowed Ellis returned from Italy,[40] and Nettleship resumed his studio, the Brotherhood once again had a chance to function.

Living with Wilson was easy, as the Scot wished merely to be alone and quiet. He often played the piano, "nothing but the great masters" and exercises,[41] and he worked industriously at his art. Altogether he was a delightful companion. Through him JBY came to appreciate Corot, whose work at first he did not understand.[42] At Slade's JBY got along well with Poynter but showed his unchanged lack of faith in his own technical powers. When Poynter directed both him and Nettleship to begin working with oils, Yeats resisted, saying he preferred to remain with chalks.[43] Nettleship also urged him to give up his formal training and begin painting portraits, but when Nettleship sought Poynter's support Poynter agreed that JBY had made the right decision and was "making great progress."[44]

Naturally Susan had to be reassured, and so did her mother. "She thinks I have no common sense," JBY told his wife, but he thought she would be pleased by Poynter's comment. He also had to explain another of his preoccupations to his mother-in-law. "I fancy she can't understand my reading so much or occupying myself with ideas." He felt he couldn't be an artist without being also a man of ideas.

I know that years back I have night and day thought of nothing else except how and when I can get a competency. Time can only tell whether I am on the right track. . . . I have hopes, expectations, but no certain knowledge. I am going on trying to get skill. . . . Possess skill and you possess money—and great skill means a great deal of money. . . . I must grind on as everyone else has done and be patient. Of course it is very unpleasant, and very galling and very humiliating, but to me quite as certainly as to you, unless it is that *I know* that the event will be a success. Show me a better course and I will take it.[45]

He thought Wilson was doing him "a great deal of good," and he resolved to remain in London until the following June, when the lease expired. He enjoyed the "at homes" held every two weeks at the home of Forbes Robertson, the future actor, a student at the Royal Academy. The members of the Brotherhood, and others, would exhibit "designs" ("ideas for pictures we proposed to paint," JBY called them)[46] on assigned subjects. Nettleship won

most of the time, but occasionally Yeats took the honors and was always quick to let Susan know.[47]

Susan wasn't satisfied. She complained of his absence and reported gloomily on Lily's trouble with breathing and Lollie's prolonged fits of gloom,[48] and particularly on the ill treatment accorded Willie by his aunts. Papa wasn't worried about what they might do to Bobbie, who was "robust and hardy" and could take "rebuffs," or to Jack, who was too young to be affected. But Willie was different, "intensely affectionate," his father called him, one who would "only develop by kindness and affection and gentleness." He was "sensitive, intellectual, and emotional, very easily rebuffed" and hence in need of "sensitive" care. "Above all," Papa warned his wife, "keep him from that tarmigant Agnes who is by no means so indulgent to other people's whims and oddities as she has been to her own."[49]

At Christmas of 1872 when he returned to Sligo he made arrangements to finish one of the Dublin portraits and hoped he might find another commission there.[50] He had also found a sitter in Richmond, a Mrs. Hoare, whom he agreed to paint in oils for ten pounds, or fifteen if she wanted the hands included. Some unknown benefactor had also found him his first big commission, to do a number of portraits at Muckross Abbey in Killarney of members of the Herbert family. He planned to finish the bigger job in early March before returning to London for Mrs. Hoare.

At Susan's insistence he stopped in Sligo on his way to Killarney. He arrived at Muckross in late February, 1873, and scarcely had time to set up his easel when the news arrived from Sligo that little Bobbie, the "red-haired and dark-eyed" child, "so dear and loveable,"[51] had died on Monday, March 3. A cold which developed just as his father was leaving Sligo developed into croup, and death came suddenly. The family went into shock, and JBY postponed indefinitely his commission at Muckross. On March 7, 1873, William Middleton Pollexfen reported the death to the local authorities and identified Robert's father as a "barrister."[52] Even in the midst of grief the Pollexfens made clear where their preferences lay.

When JBY left Sligo for London to work on the Richmond commission, he stopped in Dublin to visit Dowden at his home and found his father-in-law there. The elder Pollexfens were on their way to England to find rest for the patriarch, who had not been feeling well. As the Pollexfens and Dowdens had nothing in common save a respect for money, their presence together was unnerving. Simultaneously William Butler Yeats, home from Brazil for a brief visit, appeared in Dublin too and attended church with the Pollexfens.[53] It looked very much like a planned effort on all sides to help the feckless painter. No details of the many dialogues survive, but it was at about this time that Dowden provided JBY with three hundred pounds, which both understood as a loan but which Dowden privately viewed as a disguised gift (he accepted eventual repayment unwillingly).[54] Perhaps William Pollexfen had suggested

to Dowden that a loan or gift from him might make more of an impression on the improvident painter than a further advance from himself.

By the end of March, JBY was back in London, where he worked on the portrait of Mrs. Hoare, who sat to him for about an hour a day. He also continued to work with Poynter. Oliver Madox Brown, who at the age of eighteen had just had a novel, *Gabriel Denver*, accepted by the publisher Smith Elder,[55] called at Fitzroy Road to suggest that he return with JBY to Sligo to meet the Pollexfens. Brown was still in love with Isabella, but JBY discouraged the visit, feeling that Brown would not understand the Pollexfens nor they him.[56] As young Brown died suddenly not long afterward the issue was never joined.

In late April, JBY and Wilson stayed in Dublin, where JBY still had the unfinished portraits waiting. Wilson was a guest of Edward Dowden, JBY of John.[57] Then a new and brilliant idea came to JBY. The house in Dorset Street, which brought in an annual rent of a little more than thirty pounds, was easily separable from the farms in Thomastown and could be sold without trouble—or so he thought. He asked Uncle Matt to look into the possibilities. "We will want money to come over here," he wrote Susan from London, "and we shall want money to give up the house, and I shall want money to get clothes." His spirits, never hard to raise, soared heavenward. Once they were clear of the Fitzroy Road house and settled in Ireland where he could be "in full swing at the portrait paintings" "things would begin to look better."[58] It was a characteristic Yeatsian solution. Calculated at twenty times the annual rental the Dorset Street house might bring six hundred pounds, a magnificent sum. But once spent, it and the income the house generated would be gone forever, a principle JBY never seemed to grasp. Fortunately nothing came of the scheme for another four years, but during all that time the dream floated before his eyes.

In July, 1873, the lease on the Fitzroy Road house expired, and JBY, with the help of Susan, come over from Sligo for the purpose, cleared out the house. There is no record of the discussions between them about what they would do next, nor is it known whether the furniture was stored in London or sold. What is known is that JBY had no fixed residence outside Merville until the family's return to England more than a year later. In Dublin he painted Dowden, "killing the time before he leaves for Killarney," as Dowden put it to Miss West. JBY, who had found him a poor sitter a few years earlier, now praised him as almost as good as a model. Dowden described his method to Miss West:

—he gets so thoroughly into the "fluid and attaching" state, every glance at one's face seems to give him a shock, and through a series of such shocks he progresses. He finishes nothing, but gets his whole picture just into an embryo existence, out of which it gradually emerges by a series of incalculable developments; and all the while he is indulging in endless gossip of the peculiar *Yeatsian* kind, i.e., telling trivial facts and

reducing them under laws of character founded on ethical classifications on down to Aristotle or any other student of character—classifications which are perpetually growing and dissolving![59]

Sitting to him and listening to him were a joy. He had "a pleasant rather high-pitched but musical voice. . . . a soft elusive voice," and "one noticed the keen look in his eyes and the movement of his hands and fingers, for he had wonderful hands, not beautiful, but the long hand and finger of the sculptor and artist."[60]

When JBY returned to Sligo in midsummer to attend the wedding of Elizabeth Pollexfen to Alexander Barrington Orr, his children had already been living there for a year and would remain fifteen months longer. Willie was eight years old, Lily seven, Lollie five, and Jack two, and now the struggle over them between their intellectual and artistic father and the dour puritani-cal relations of their mother was fully joined. Susan Yeats did not have the impact on her children that mothers ordinarily do. The strain and uncertainty of her life accentuated a natural frailty. "She was not at all good at house-keeping or child-minding," observed Lily, and like all the Pollexfens she worried constantly: "As a girl in Sligo," her daughter wrote, "her life had been very easy, enough money, no cares."[61] It is not surprising that the descent to Bohemia should be too much to bear. Her eldest son was later to describe her actions as "unreasoning and habitual like the seasons."[62] Although she was moody, however, her husband said of her that she was "either the most difficult or the most easy to manage according to *the spirit in which you approach her*."[63]

"Very silent and undemonstrative," she yet had a few stories the children never tired of hearing. The favorite was of "the wry-mouth family," an account of a family "with mouths all awry in different ways." The children acted the story with a candle on a chair. "We knelt round it and with twisted mouths blew in turns, only getting the candle out when we all blew together, which was what the famous family had done."[64] Susan also reminded the children constantly of the financial difficulties in the family. They were told they could not have things they wanted badly till Mrs. Flanagan, a delinquent Thomastown tenant, paid the rent. So they named a rag doll "Mrs. Flanagan" and, when the rent did not come on time, ill-treated the doll.[65]

In Merville the unassertive Susan Yeats was the least impressive of figures, but her place was more than filled up by the others. Chief among them was her father William Pollexfen, of the terrifying presence. When his eldest grandson read *King Lear* in later years the image of his grandfather filled his mind's eye.[66] Of middle height, "broad built but not stout," as Lily described him, he had a "complexion fresh, eyes very blue, his hair and beard gray," though dark when he was young. "He held himself upright, walked stiffly, creaked a little as he went." There was no doubt about his calling. "He always looked the sea-captain."

He lived in a constant state of irritation. He spoke little but grumbled and complained all day long. He had no time to worry about the past and future— "he was so irritated by the present he could think of nothing else." He was a man the small children "liked, admired, and avoided." Children learned to sit on the same side of the table with him so that he could not observe them. "He had an alarming way of stopping grumbling and eating and looking at us as we carried the sugar spoon from the bowl to our plates."[67] He often said big noises did not irritate him, only small ones, so one evening a young guest took him at his word and dropped a set of fire irons from a height into the fender. Grandpapa, defeated by his own logic, "went slowly out of the room and to bed."

One of the small noises that irritated William Pollexfen was the tapping sound people made whey they took the top off an egg. "His way was to hold the egg cup firmly on its plate with his left hand, then with a sharp knife in his right hand to behead the egg with one blow. Where the top of the egg went to was not his business. It might hit a grandchild or the ceiling. He never looked." He was also impatient at corked bottles of carbonated beverages.

His way of opening a bottle of lemonade was alarming. In those days the bottles were corked and wired. You took off the wire and gently moved the cork from side to side and out it came. Grandfather took off the wire, gave the cork a few violent side-to-side shakes, then shook the bottle till the lemonade bubbled and foamed up, then he held the bottle at arm's length and out flew the cork and most of the lemonade.[68]

Having spent his impressionable years at sea, he never developed the social graces. He once struck one of his men on the Sligo quays, his big red carbuncle ring inflicting a deep wound. Mrs. Pollexfen had to apologize and offer a sum of money to the man, who prudently declined to blame "the master." When a ship had a damaged rudder and none of his men had the courage to dive into the water to inspect it, William did so himself. In church he carried a pistol in his pocket in case the Fenians caused trouble. It was little wonder that such a commanding, explosive, and uncommunicative figure should have a powerful effect on his grandchildren. Part of Willie's misery at Merville was caused by "fear" of his grandfather, even though "he was never unkind." The boy used to confuse his grandfather with God, "for I remember in one of my attacks of melancholy praying that he might punish me for my sins."[69]

Grandmother Elizabeth Pollexfen was the only one who could soothe and calm the old man. When he was not at the office or on the quays "he sat with grandmama, sitting very near to her, and was quiet. She had a tranquillizing effect on all but most on him."[70] In Sligo she fulfilled the role of village matriarch beautifully. If her husband carried a pistol against potential trouble, she carried a sweet smile and bundles of good works. She had been educated at local schools and contributed flowers and subscriptions to the nuns. She never had servant trouble and kept in touch regularly with the

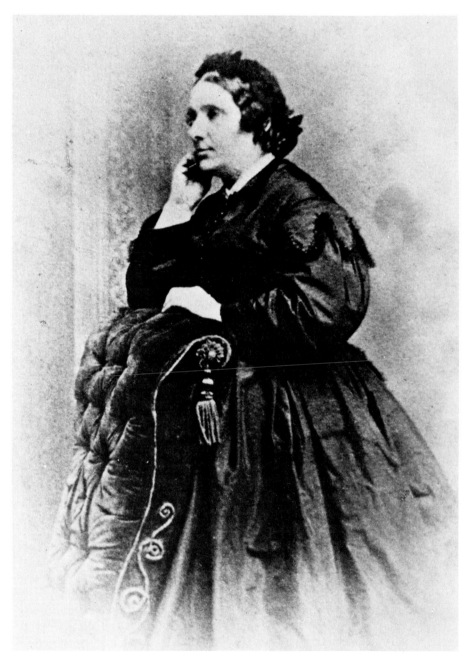

Elizabeth Middleton (Mrs. William) Pollexfen (1819–1892), about 1873. Collection: Michael B. Yeats.

young girls who emigrated to America. Every day, clothed simply but correctly—"black silk dress, real lace cap, collar and cuffs, quilted black satin petticoat, thin cream-coloured stockings, and thin black shoes"—she drove about in the outside car or the phaeton and "looked about her all the time for people to whom she could give a gift."[71] She was the perfect lady, calm, ordered, generous, sensible.

The atmosphere at Merville was heavy with propriety and seriousness, with none of the joyousness the children were accustomed to find in their father's family. When Lily was ill in late 1872 her mother sent her to stay for a short time with Grandmother Yeats in her house on Upper Leeson Street in Dublin. Lily recalled the experience:

> I was never so happy before. She was demonstrative, called me by pet names, caressed me. I followed her about. She gave me feathers to stuff a child's mattress, got them then and there from the Cook who was plucking a chicken. I was put to bed by several Aunts. They ran about, laughed, and played. Grandmama Yeats had nicknames and pet names for things as well as grandchildren. Her scissors had a name. The house was full of old things, everything had a story.

The contrast with the Pollexfen household was striking. At Merville "all was serious and silent, no merry talk at meals, no running to and fro." At Grandmama Yeats's house all "were at their ease with one another. Tempers were good and manners courteous."[72]

"I was always afraid of my uncles and aunts," wrote William Butler Yeats in his *Autobiographies*. All except Alfred seemed bent on making him miserable, though the impulse was unquestionably not malice so much as mere Pollexfen thoughtlessness. Living among them left its marks on the boy who was to become his nation's most celebrated poet: an aggressive insecurity, a need to hide his real person behind a mask, an all too frequent insensitivity to others. Sligo may have been beautiful, but some of its inhabitants were not. "Indeed," WBY wrote in middle age, "I remember little of childhood but its pain."[73]

Still, there were compensations. Away from Merville and the Pollexfens, Sligo was a different habitation. A small and beautiful town situated almost at the western edge of Europe, it was bounded by green fields, mountains, and the sea, and its narrow streets were lined with small shops. At the quays there were boats loading and unloading, and sailors with stories that made the world seem "full of monsters and marvels."[74] Over the town to the west loomed the mountain Knocknarea, on its flat top an enormous mound supposed to contain the remains of Queen Maeve; to the north beyond Drumcliff stood Ben Bulben, the long stone outcrop ending in a massive, razor-sharp edge. With its mists and changing colors, its ancient mysterious mounds and dolmens, Sligo was a place where one could easily believe in a world of magic. William Butler Yeats saw his first fairy, or "fay," as he called it, when he was a child in Merville. It was night, and he saw through the open window a fay

The sons of William and Elizabeth Pollexfen, about 1863. Charles seated; clockwise from upper left: Alfred, Fredrick, George, William Middleton, John. Collection: Michael B. Yeats.

moving down a moonbeam toward him. He made the mistake of trying to speak to it, and it retreated.[75] That was the first of his many experiences with the spirit world, of whose existence he was certain. Everything in Sligo had meaning for him.

At Rosses Point or Ballisodare, depending on the season, the Yeats children could see their Middleton cousins, quite a different breed from the Pollexfens, "practical, always doing something with their hands, making boats, feeding chickens, and without ambition." They didn't take care of their property, were easygoing and likable, in many ways like Willie's father, though paradoxically it was Great-uncle William Middleton who provided the business acumen that brought prosperity to the firm of Middleton and Pollexfen. The Middletons "were liked," William Butler Yeats said, "but had not the pride and reserve, the sense of decorum and order, the instinctive playing before themselves that belongs to those who strike the popular imagination."[76] They were fine people but not poets.

Through the Middletons, however, Willie first developed his interest in country stories. One of his cousins, Lucy Middleton, had "the second sight"[77] and in later years invoked "visions" with him. Great-uncle William's house at Rosses Point, called "Elsinore," was said to have underground passages leading to the caves on Bowmore Strand. Lily described it as "a house of strange noises, tappings on the window, footsteps. Door handles turn and no one comes in. Black, the old smuggler, who built the house ages ago, walks in the Verandah."[78] Among the people of Sligo the Yeats children heard the "grotesque or tragic or romantic legends" that grew around all the well-known families. One such story was of their great-grandfather William Middleton the smuggler, who had died in the cholera epidemic of 1832, his little daughter Mary dying at the same time. The local people insisted that he and Mary were seen walking hand in hand after death, and that "even their pet dog saw them and ran out to greet them."[79]

Throughout the surrounding countryside were Yeats relatives. None of these liked the Pollexfens, partly, as William Butler Yeats suggested, because the Pollexfens were on their way up in the world and the Yeatses down. Great aunt Mickey had a silver cup bearing the Yeats crest believed in the family to have been already old in 1534, when the name of a bridal couple had been engraved on it. It proved their connection with the old and honored Ormonde Butlers, who meant more in Ireland than the Cornish Pollexfens. But now the sources of the Butler Yeats money had dwindled to the estate at Thomastown and the house in Dorset Street, and these were in the control of one not likely to enhance their value. Otherwise the members of the family depended on earned income from work doled out by the Ascendancy. The new money in Ireland was springing from commercial enterprise, and the Pollexfens were gathering it in.

Great-aunt Mickey was the favorite of the Yeats children; though strict, she

was kind, and had "the same gay spirit" as her nephew John Butler Yeats. She lived on a farm off the main road, her house looking out on Knocknarea and the distant town of Sligo on one side and Ben Bulben on the other. She was tall and "very thin," and "her arms were so long or her body so thin that she could cross her arms behind her back and meet her hands in front." She was the neighborhood eccentric, sometimes wandering out in the dead of night in a white nightgown to chase the sheep that "her bones" told her were there.[80]

Uncle Matthew lived not far away in a house called "Fort Louis," on the site of an old fairy rath with thorn trees about it. It was an "entrancing" place for play, a long, white, one-storied building with a ruined mill beside it, and before the house was a grass lawn with trees here and there and a gravel path leading down to "the wide shallow mill stream." Willie and Lily and Lollie often walked out there—Jack was too young for the long walk—to play with Uncle Matt's children. Lily relates that one afternoon the six Yeats cousins quietly but ruthlessly made war on three blond children named Wynne who were calling in their "go-a-visiting clothes."[81]

Sligo also provided its share of Gaelic, non-Ascendancy Irish, represented chiefly by the servants at Merville, who were "friendly and wise." The Yeats children had a long room with four windows, two looking into the garden and the rising fields beyond, two into the stable yard. They seldom looked at the distant view but "hung for hours over the stable yard where something was always happening." In the dark of night it was pleasant to awaken to the rattle of the manger chains of the horses in the stable below. A favorite was old Scanlan the coachman, who let the children watch him shave, who always allowed a child to sit beside him as he drove the coach and kept track of whose turn it was, and who had a "stout, untidy" wife who lived with him in the gatehouse and took snuff, "keeping the box hidden deep in her bosom among the folds of many little shawls." There was a stableboy, Johnny Healy, whose accent Willie and Lily unconsciously imitated, to the later delight and edification of Alexander Ellis.[82]

The Hazelwood Racecourse was nearby, and every year the Pollexfen family gathered for the races. Lily never forgot "the crowds, the smell of bruised grass, the thud of the horses over the jumps." Uncle George came over from Ballina with a postillion and four horses in primrose and violet, his colors. Frederick's colors were primrose and blue, and his horses were there also. Uncle George raced at Ballina himself under the name of Paul Hamilton, but he stayed out of the saddle at Hazelwood, as such an activity might appear unseemly for a Pollexfen. One year Lollie got in the way of the horses at the water jumps and had to be pulled back "roaring with rage and fear" by her father.[83]

The effect of such a place on a sensitive boy like William Butler Yeats and on his brother and sisters was profound and lasting. In County Sligo was a community of interest, a core of shared stories and superstitions, that London,

with its shifting population and constant growth and change, could not provide. Sligo was a *locale fixe* to which all the Yeats children could attach themselves. There they had the feeling of belonging to two families that counted for something. "I am delighted with all that joins my life to those who had power in Ireland," WBY was to write years later. At Merville one was aware of that power. "I thought that nobody could be so important as my grandfather," he remarked in awe. Years later, when he looked at his brother Jack's picture, *Memory Harbour*, a foreshortened, impressionistic view of the main road at Rosses Point, with Sligo harbor off to the left, the Metal Man buoy in the channel, and the summer home of George Pollexfen at the top of the road just before it curves to the right, it filled him with "disquiet and excitement." The Sligo of his childhood became to him in later life an ideal land, a dream world to which, though once its inhabitant, he could never return. "I have walked on Sindbad's yellow shore and never shall another's hit my fancy." [84]

Young Willie was not the only person who thought his grandfather powerful and important, "so looked up to and admired." When he returned from Bath with his wife for his daughter Elizabeth's wedding in the summer of 1873, his men lighted bonfires along the railway "for miles." [85] Although it was late at night and the children were supposed to be in bed, Scanlan the coachman had set up boxes for Willie and Lily inside the gate so they could watch the procession, marked by burning pots of tar and people lining the roads.[86] Their homecoming coincided with JBY's own return from London. He would now have to live for a while with them, having nowhere else to go. Two extended commissions, the deferred one at Muckross and another at Stradbally Hall, awaited him after Elizabeth's wedding in August. Elizabeth, now thirty, "humorous, gentle, always good-tempered," [87] had been courted and won by the Reverend Alexander Barrington Orr. John Butler Yeats watched the premarital sparring with amusement. Orr, "a good kind man, extraordinarily kind and generous," [88] was nevertheless as imprisoned by the British notion of "class" as the Pollexfens were. He believed himself of higher social standing than his fiancée and felt that her dowry should be large, as she "belonged to a family who were not gentlefolk." His own family, having made a fortune manufacturing soda water, believed itself perched on the summit of gentility.[89] JBY, the non-churchgoing Comtist Bohemian, the eldest descendant of a branch of a family far more entitled to such petty egotisms than either Orrs or Pollexfens, observed the pathetic struggles of those about him as they sought to be identified with the right people. Though amused, he despised the climbers, calling "class feeling" "a curse, a sort of imprisonment corrupting the people who benefit by it, and enraging and brutalising the others." [90] As he told Lily years later, "Like a *heavy air clogging all their energies*, class feeling destroys life. Because of it everyone is vulgar in England and Ireland, ashamed to be their real selves, always pretending to like people and things they don't really like, and to dislike people and things they naturally

would like."[91] In JBY's view the Pollexfens had something far more valuable than class, if they had only realized it; they had "personal dignity," an integrity that made them not gentlemen but "aristocrats." In reaching for the symbol the Pollexfens had lost the truth. They were aristocrats as they were poets but lacked the vision to recognize that they were either. They should have left well enough alone.

The wrangle over the marriage settlement finally resolved, the wedding took place, the Yeats children all attending. Lily and Lollie were dressed in white muslin with blue sashes, Willie in a blue knickerbocker sailing suit, and Jack, not quite two, in a white dress with a red sash. On the steps of Merville Grandfather William stood glowering over the carriages, ordering them to move off even if they were not properly filled. When beggars stayed on after the bridegroom had thrown silver to the crowd, he took up his whip and began to drive them out of the yard. One poor woman, in a burst of Irish logic, cried out, "My husband is a daycent man," but Grandpapa cracked his whip and she scurried off.[92]

Into this strange group in the summer of 1873 came John Butler Yeats to battle for the souls of his children. Jack was still too young to worry about—although even as a small child he was so cheerful and comic that everyone liked him, his grandfather most of all—and Lily and Lollie seemed to bear up fairly well under the stress of the household. Willie was the troubled one. Unhappily for him, he was born without the social graces that came so easily to his father, his namesake Uncle Willy Yeats, and his brother Jack. He was not immediately likable. Awkward and somewhat withdrawn, he had a talent for getting in the way and for never doing things properly, that is, doing them as the Pollexfens would have liked. His father thought the root of the difficulty lay in his being too much a Pollexfen and not enough a Yeats, and would plead for his son that he was "like his mother." But they saw it otherwise, believing that "he was just like his unsuccessful father, unsuccessful and therefore wicked."[93] They could endure the other children, but Willie "they hated, positively hated."[94] The Pollexfens were afraid the eldest grandson would grow up to be like his father; the father was afraid he would grow to be like them.

Young Willie was caught in the middle. He resisted his aunts' efforts to teach him because he found it "hard to attend to anything less interesting" than his "thoughts." They simply concluded that he didn't have all his "faculties," as he later learned from his father.[95] Yet who would wish to read the black and white of a printed book when the colors of the real world lay all about him on the pages of mountain, field, and sea?

JBY's arrival was a traumatic experience for the eight-year-old boy. It was his "first clear image" of his father. As Fitzroy Road had faded from his memory, so had the early pictures of the artist father, who had been more concerned with the infancy of his skill than of his children. Now the son was aware of a tall man with a "very black beard and hair," with "one cheek bulged out with a fig

that was there to draw the pain out of a bad tooth."[96] The towering new presence was soon to exercise a fresh and unwanted authority. The long struggle that would last a lifetime had begun.

When Willie saw that his father stayed away from church he decided to remain home himself. His father countered by trying to teach him how to read. But he proved, according to the pupil, "an angry and impatient teacher and flung the reading-book" at his son's head. Next Sunday, Willie "decided to go to church."[97] After the disastrous first lesson JBY desisted for a while, then changed the lessons to weekdays till, as Willie expressed it, "he had conquered my wandering mind"; but most of the Pollexfens thought he would never be able to read, as his mind was filled with "hobgoblin fancies."[98]

Like his Uncle Alfred and Aunt Elizabeth young Willie had a natural sense of rhythm. His father had observed that all the members of the family "had a wonderful facility in picking up and remembering anything in the papers written in rhyme." "They had not the poetical mind," but "they had the poet's ear," even if they didn't know how to use it.[99] Willie had all the qualities of the poet that his father had noticed long ago in his brother-in-law George Pollexfen at Atholl Academy. The Pollexfens might think their strange little nephew a carbon copy of his father, but the father knew better.

Father read to him and Lily and Lollie—at the place between Sligo and Rosses Point "where dead horses are buried"—*The Lays of Ancient Rome*, and later *Ivanhoe* and *The Lay of the Last Minstrel*, the last of which gave the young boy "a wish to turn magician that competed for years with the dream of being killed upon the sea-shore."[100] The readings, dwelling heavily on works which showed the heroic individual spirit in action, proved in the long run to have far more influence on the poet than the formal lessons. As the children grew older, Shakespeare, Chaucer, the Brontës, Dickens, Shelley, Keats, were added to the list—a rich and miscellaneous one.

Willie, like his father, had a tin ear. When he was sent for a time to a "dame school" in Sligo and sang for his father a song he had learned there, JBY wrote immediately to the teacher that his son was never to be taught singing again.[101] But he approved completely when Esther Merrick, daughter of the sexton at St. John's, gave him spelling lessons and, on her own initiative, read poetry to him. In later years JBY would say that it was Esther Merrick who had "made a poet" of Willie,[102] though he charitably refrained from giving her the credit for his spelling, which was abominable all his life.

The summer visit of 1873 was agonizingly brief from JBY's point of view, if too long from Willie's. The painter could not remain at Merville permanently. By late October he was staying at Muckross Abbey to complete his interrupted assignment.[103] When Lily wrote him a letter in her own handwriting, the first of the children to do so, he described Muckross to her and told her of the lake and the fishing. There were other scenes and events that he discreetly withheld from her. He told Edward Dowden some of the details later, branding the

inhabitants of the great house "Barbarians." The Herberts themselves not only quarreled "like children," but they and their guests behaved "like animals." Theirs was an old Ascendancy house with a manner of living that the commercial Pollexfens had not risen to, in which the leisured Anglo-Irish, having nothing else to do, beguiled the time by moving from bedroom to bedroom and bed to bed *ad libitum*. One of the ladies, quite properly married, tried to seduce the dashing young painter, who resisted successfully, or said he did.[104]

The stay at Muckross was not entirely successful, partly because of Mrs. Herbert, an attractive young woman, sweetly innocent in appearance. JBY painted her portrait, full-length, in a richly colored and patterned gown. A few days after he submitted it to her husband for approval, Mrs. Herbert departed Muckross Abbey with one of her bedroom companions, never to return. The husband, nettled by this consequence of his own house rules, refused to take the portrait, which still remains with the Yeats family.[105]

On December 11, JBY arrived at Stradbally Hall for another long stay to paint one group of four children, another of three, and, if all went well, Mr. and Mrs. Cosby too.[106] The Cosbys were of an ancient Ascendancy family that had occupied Stradbally Hall in County Queens (now Laois) since late in the sixteenth century. It was one of the most beautiful residences in Ireland, filled with magnificent paintings by Reynolds, Gainsborough, and other old masters. JBY was fascinated by the life there, much more ceremonious and far more proper than at Muckross. He wrote a long letter to Ellis describing the morning prayers, the chapel services, the hunting party, a one-armed colonel who was good at billiards, and "a white-headed old foxhunter."[107]

His stay at Stradbally extended well into the spring of 1874. His productions there were supposed to mark his emergence from the cocoon of apprenticeship. Henceforth he would present himself as an accomplished portrait painter who would accept any commission, no matter how difficult, and would paint landscape and narrative pictures as well. Almost thirty-five, he should have been toughened by long years of study. The time had come, or should have come, to translate his undeniable talents into pounds and crowns and shillings.

1874–1881

Todhunter wrote enthusiastically to Robert Catterson Smith about his friend's "success" at Stradbally; Smith replied that he and all the Slade and Heatherley crowd hoped that Yeats had "now passed through the surf" and was "getting into smoother water."[1] JBY could only compare his own aimless meanderings with Edward Dowden's effortless triumphs. He had just read of the success of lectures Dowden was giving on Shakespeare and wrote from Stradbally to congratulate him. Dowden, flattered, gave him a preview of his next lecture, on *Richard II*:

in K. Richard II Shakspere represents the man with an artistic feeling for life, who isn't an artist of life. The artist of life is efficient and shapes the world and his destiny with strong creative hands. Richard likes graceful combinations, a clever speech instead of an efficient one, a melodious passion instead of one which achieves the deed. . . . If things can be arranged so as to appeal gracefully or touchingly to his esthetic sensibility, he doesn't concern himself much more about them. And so all of life becomes unreal to him through this dilettantism with life.

Richard, he declared, owns the "melodious passion," Henry that "which achieves the deed."[2]

Dowden thus expresses what virtually all readers of the play feel: that Richard is a dreamer who throws away his heritage. At the end of the play it is his cousin, the scheming, practical Bolingbroke, who emerges as Henry the Fourth, with Richard, the rightful king, banished to Pomfret Castle.

Seldom has a random comment provoked such an outraged reply, and such a revealing one. John Butler Yeats leaped to the defense of Richard, denouncing Dowden's judgment of the characters as "a sort of splenetic morality that would be fitter in the mouth of the old gardener." Richard and his wife were "absolutely *perfect*," he maintained, with "the *sweet irreverence of children*." The trouble with the contemporary world and the critical judgments to which it gave rise was "a most damnable heresy–worship of success." Those who won, like Henry the Fourth, were not necessarily stronger than others in qualities that mattered, only "stronger in prudence." The displaced king was stronger

Jack Yeats, 1874. Pencil. JBY. Identification in the hand of Lily Yeats. Collection: Michael B. Yeats.

Lollie Yeats, about 1874. Pencil. JBY. Collection: Michael B. Yeats.

than his usurper in important ways. "He had a more mounting spirit, his disdain was nobler, his mirth more joyous, his happiness had a more untiring wing." Of the code of the practical scheming man with a desire to "get on," Richard knew nothing and Bolingbroke everything. "In the rules of goodness, of bravery and chivalry and comradeship and true love, Richard is an admirable proficient."[3]

JBY treated Dowden's criticism almost as a personal slap in the face. Dowden, who hadn't written the play but merely made a perceptive comment on it, stuck to his guns and allowed the remarks to appear in his volume, *Shakspere: His Mind and Art*, published later in the year. He wrote to Miss West with an air of relief that by rejecting Yeats's objections he had put himself on "absolutely equal terms" with him: "He used to have a power of attracting undercurrents of my being in strange ways."[4]

The division between the two old friends was thus sharply articulated. Dowden liked King Richard, as most readers do, but the fact is that

William Butler Yeats, about 1874. Pencil. JBY. Identification in the hand of Lily Yeats. Collection: Michael B. Yeats.

Bolingbroke, by recognizing the realities of life and acting upon them, prevailed. If Dowden had been an aristocrat in England in 1398 there is little doubt whose side he would have chosen. Yeats admitted that Richard didn't understand the ways of the world and was unequipped to cope with them (*even as his own hero, Harry Bentley, had been*); yet Richard had daring and poetry and a grand carelessness, a "mounting spirit" and a noble "disdain." If a fourteenth-century Yeats had to choose his master from the two there could be little doubt about the preference either. If we consider Richard and Bolingbroke in their basic temperaments, were they not like John Butler Yeats and Edward Dowden, one gloriously and quixotically unsuccessful, the other assured, deliberate, and triumphant?[5] Neither changed the other's views. JBY passed his judgments on to his son, who assimilated them so completely that when he expressed them publicly a couple of decades later he forgot where he had received them.[6]

John Dowden, after only a short stay in Dublin, left for Scotland, spurred by

Lollie and Lily Yeats, about 1875. Collection: Michael B. Yeats.

Gladstone's disestablishment of the Church of Ireland. In Edinburgh he became Pantonian Professor of Theology and would spend the rest of his life there, dying thirty years later as Bishop of Edinburgh.[7] Todhunter also prepared to leave Dublin after the death of his motherless child in 1874. "I am afraid there is no such thing as Bohemianism proper in this little city," Edward Dowden observed sadly to Miss West,[8] though he made no attempt to find it elsewhere.

For JBY the months at Stradbally were profitable. He sold several paintings to the Cosbys,[9] and during his stay there he made an unusual one-time profit at Thomastown by the transfer of a lease netting close to £1,000.[10] Otherwise the estate was behaving predictably. For the six months ending September, 1874, total income was £273.16.6; after obligations were met the landlord received only £72. George Pollexfen, by contrast, had managed his own affairs so well that in the same year he was able to buy a half-ownership in the steamship *Emerald* with his brother Charles as co-owner.[11]

JBY returned to Sligo and spent the summer of 1874 with his family, resuming the education of his children. WBY recalls his father's reading of Chaucer's "Prioress's Tale" and, particularly, of "The Tale of Sir Thopas," which he preferred.[12] JBY told them stories as they walked; from him they heard his versions of the Merchant of Venice and *La Peau de Chagrin.* Any little thing would start him off on a fantastic story. Lily wrote of his method: "Once when we were making little paper boats and sending them floating off on the river by the lake, he told us the history of one of these little boats, how it floated down the clear brown river through the town over the weir past the Rosses Point into the Atlantic, being spotted by the steamer from Liverpool, and finally came ashore at New York."[13] He was a moulder of plastic minds. Uncle Matt's son Frank came under his tutelage that summer, and JBY told Matt it was "the pleasantest time" he had ever spent in Sligo.[14]

JBY was, not surprisingly, dissatisfied with his progress at Muckross and Stradbally. "He will, I think, decline orders he has got in Dublin," Dowden wrote Miss West, "and perhaps go to London to spend yet more time in his apprenticeship."[15] He was right. Despite Susan's feelings, by late October of 1874 the entire Yeats family was settled again in London, at 14 Edith Villas, North End (now West Kensington).[16] Dowden had secured commissions for JBY in London, but these he postponed.[17] The move aroused hostility among the Pollexfens, who didn't realize one purpose of the move was to escape their influence. An aunt (almost certainly Agnes) said to Willie: "You are going to London. Here you are somebody. There you will be nobody at all." She couldn't understand why Willie's father wasn't selling pictures, and, knowing nothing of London or its ways, thought Heatherley's was a club, "a place of wantonness," where he wasted his time.[18]

In London the painter resumed his old courses. He invited Robert Catterson Smith to see his paintings but so overwhelmed him with the brilliance of

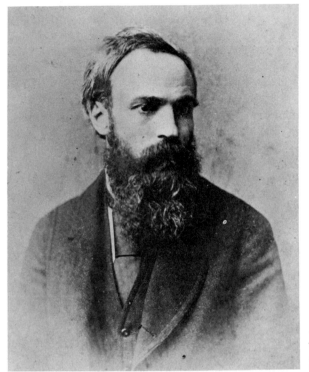

John Butler Yeats, about 1875. Collection: Michael B. Yeats.

his talk that Smith never noticed the canvases. "The conversation of a man of his education always makes me helplessly ignorant in some ways," he wrote Todhunter.[19] It may not have been yet clear whether John Butler Yeats was fundamentally a painter or a studio philosopher, but his presence was unmistakably overpowering.

Along with the talk, JBY continued to paint slowly and carefully, revising constantly, but making no serious effort to arouse the interest of potential customers. Nettleship thought him "pigheaded": "he will never be any good," he told Todhunter, "as long as he has the lust of perfection so strongly in him. He ought to leave things imperfect, acknowledge that they are so and pass on to something new."[20] Until 1874 he could perhaps be charitably considered a late apprentice. Now the world would expect him, in his mid-thirties, to produce, not merely to paint but to exhibit and sell. By these standards, however, John Butler Yeats was to prove a failure, even if it would be another fifteen years before he could face the fact squarely. In early 1875 he told Ellis he might stand "a little reputation" but couldn't stand "much reputation." He had to work in his "own way," he insisted.[21] He was thirty-six years old when he wrote the words.

But he was to be denied even the "little reputation." When he offered the

William Butler Yeats, about 1875. Pencil. JBY. Collection: Michael B. Yeats.

Royal Academy a portrait of his sister Gracie (who had come to Edith Villas with the family), it was rejected. Todhunter valiantly tried to raise his spirits: "The only consolation for your present vexation must be that if ever there was a man whose friends thoroughly believe in him, you are the man. . . . You deserve to be classed with Blake, and Michael Angelo, and the Lippis, and Sandro Botticelli."[22] JBY tried to keep up his own spirits by insisting to Ellis that everything would "be all right in the end" if he simply followed his own course.[23]

Dowden asked JBY to paint a picture for him, based on "The Lute Girls," a design he had liked. The negotiations are amusing and pathetic. Yeats declared he would probably not ask more than fifty pounds and certainly not more than a hundred, as it probably wouldn't be much good anyhow.[24] Dowden promptly agreed to pay one hundred pounds, then gently but wisely spread seeds of counsel on stony ground: "I must object to the ignorance both you and I display of the true relations of buyer and seller. Let me tell you that the seller always looks for a high price, and the highest he can get; and the buyer, then, tries to cut him down to the lowest possible. You and I seem likely to take just the opposite view." Yeats had expressed surprise that Dowden should choose "a *subject* picture" rather than a portrait; Dowden tried to raise his spirits and at the same time subtly direct him to a broader highway: "You must paint this picture and it must be the one that marks Yeats's advent—*the* picture of Yeats's first period; and it must always be mentioned in the Handbooks as in the possession of Edward Dowden, *Esquire.*"[25]

For the children the return to London was like an introduction to a new world, for they could scarcely remember their earlier days at Fitzroy Road. For a long time they enjoyed it. One day Alexander Ellis, Edwin's father, invited Lily and Willie to lunch alone with him in Argyll Road and asked them many questions. Not at all shy, they replied fully. Not until later did they discover he was interested in their accent, influenced as it was by Johnny Healy the stable boy.[26] The brother and sister became inseparable companions, taking walks to the National Gallery, sailing model boats in Kensington Pond, and eating "long rolls."[27] But the boats reminded them of Sligo; after the freshness of the new life wore off they grew desperately homesick for the place where they had spent the twenty-eight wonderful months. One day at the drinking fountain in Holland Park they spoke together "of our longing for Sligo and our hatred of London." They were both "close to tears," and Willie "longed for a sod of earth from some field I knew, something of Sligo to hold in my hand."[28] Even the life below stairs was different. In Sligo the servants "knew so intimately angels, saints, Banshees and fairies." In London they talked of nothing but suicides and murders.[29]

Life was changing for the children, but it was all too consistent for JBY and Susan. Not long after the move she became pregnant again, and the prospect of yet another child depressed her further. The baby, a girl, was born on

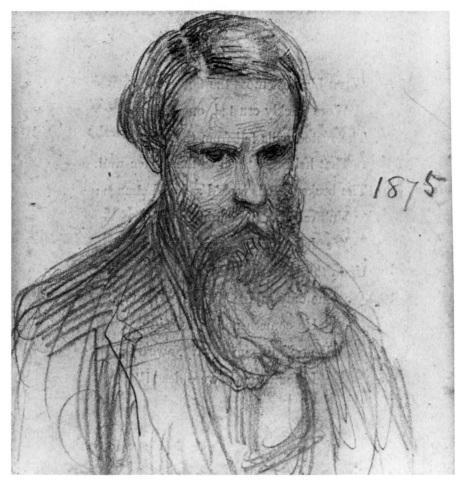

John Butler Yeats, pencil self-sketch, about 1875. On blank page in a volume of Tennyson. Collection: Michael B. Yeats.

August 29, 1875, Jack's fourth birthday, and christened Jane Grace Yeats. Six weeks later the father registered the birth at the Fulham Office and identified himself as "Artist."[30] At home there was hardly room for everyone, and Lollie became the special victim. Two years younger than Lily, three years older than Jack, she was alone in the middle. Willie and Lily were brought together by age, only fourteen months separating them. Jack, always treated as the baby, was blessed with a cheerful nature, which made everyone like him instantly. Lollie was more troublesome than anyone in the family except Willie, whom she strongly resembled temperamentally. As intelligent and gifted as he (in

her father's opinion), she was also as willful and insistent. From the beginning she did not get along with her older brother. Lily and Willie grew closer together, while Lollie became increasingly isolated.

At Thomastown the tenants were again causing trouble, this time because of rivalry among themselves. The Widow Flanagan refused to give up what she considered her rights to her husband's lease, and John Doran, the bailiff, announced that he wanted nothing further to do "with these savages."[31] In August 1875, Anne Clark called in her mortgage of three hundred pounds, and JBY had not only to find another mortgage to replace it but to bear the expense as well.[32] His friends and family knew his position was precarious and tried to help with advice and suggestion. In June, 1875, his mother let him know that her son Willy in Rio de Janeiro had offered to pay her two hundred pounds a year as soon as he was made a partner in the spice firm of Phibbs and Co. "I have no doubt of his doing so," she wrote, "in which case I will gladly resign the £50 you so generously allow me in addition to my jointure." She also wondered why her son could not do work that would sell: "Do you ever think of painting small pictures such as would sell quickly? Many people would give 5 guineas for a picture who could not afford 30 guineas."[33] The letter was skillfully worded, yet there is no hint in the facts of JBY's life that he was moved by her subtle rebuke or acted in response to it.

During the first four months of 1876, Todhunter was in London, where Yeats worked on a portrait of him begun during the Christmas holiday. Complaining that the likeness, "detestably good," made him look like "a drugged maniac,"[34] Todhunter assured Dowden that now JBY could "get lots of portrait painting at any time" and could accept commissions "with perfect confidence." But Yeats insisted he needed "a year's more work" after which he would set up a studio in Dublin and prosper.[35]

In one of his periodic accesses of diligence to prove he knew his responsibilities, JBY resolved in early 1876 to go after commissions himself. His first move was to approach his father's old schoolmate and friend, Isaac Butt, whom he had not seen since his days in the Four Courts when he had done a pen-and-ink sketch of him.[36] Butt was now leader of the Irish Party in the House of Commons. A conservative and Unionist by birth and breeding, he had been converted to the Irish nationalist cause during his defense of the Fenians from 1865 to 1870. He is credited with having made the term "Home Rule" a household word. In the spring of 1876, with more than forty supporters in Parliament, Butt was at the height of his power and influence. To do a portrait of him would certainly prove a coup for a painter ready to announce his artistic maturity to the world.

Butt was generous to the son of his old friend, inviting him to attend the House of Commons to listen to the debates and at dinner later arranging for his portrait to be done at Nettleship's studio. The first sitting came on May 25, but on July 30 JBY was begging Butt for another. "A very few will suffice, as the

Jack Yeats, about 1876.
Pencil. JBY. Collection:
Anne B. Yeats.

portrait is well started," he wrote. Out of these sittings, delayed and multiplied, came the portrait now in the National Gallery of Ireland.[37]

The history of another painting suggests his unbusinesslike if idealistic ways. It was *The Red Girl*, in which the subject was shown listening to a bell. JBY didn't like the first version and, after showing it to Todhunter, threw it in the fire and began another; Todhunter reported to Dowden that months later the second version had "arrived at nearly the same point as the one he burnt already."[38] JBY carried his perfectionism to an extreme. He refused to keep a work, he later told Uncle Matt, if he "thought it bad and therefore fraudulent."[39] Dowden begged JBY to tamper no more with *The Lute Girls*, more than

a year in the making but still undelivered, and urged him to begin paintings for the following year's exhibition that "would be likely to arouse admiration."[40]

While JBY was painting Butt's portrait, his baby daughter Jane Grace fell ill, and Lily and Lollie were sent away to Aunt Elizabeth ("Lolla") Orr. On June 6, 1876, with her father at her bedside, the baby died.[41] After the funeral Susan joined her daughters, taking Jack with her. JBY remained in London alone until word came from Dublin that his mother, suffering from cancer, was *in extremis* at a nursing home at 15 Upper Leeson Street, a short distance from her own home at 47. JBY went to Dublin to be with her when she died. On her last day, Lily wrote, "she kept counting over her children and then just before she went tried to rise, saying she heard the car drive up with Grandfather Yeats back from some Parish work."[42]

While JBY was being consumed by the "lust of perfection," Dowden and Todhunter were producing measurable works of art. Dowden's *Poems*, which appeared in late 1876, included everything he thought worth preserving from his youth and early manhood. Although it sold well, it evoked no critical enthusiasm, and Dowden published no more poetry during his lifetime. Almost simultaneously Todhunter produced *Laurella and Other Poems*. JBY thought Dowden's the better. Todhunter, he told Dowden, "haunts the outer courts of belief but never penetrates to the innermost shrine."[43] Yet both had something to show for their efforts. In public notice, sales, critical acclaim, JBY had very little.

Yet he pretended confidence: "*I am getting on,*" he wrote Dowden, "*and prosperity will soon come.*"[44] But he was not getting on. Dowden carefully insured his own survival with a paid job as secretary of the College Council, "a good deal of drudgery to me being less vexatious," he explained to Todhunter, "than uneasiness as to where one's rent is to come from." He expressed fears about their perfectionist friend. "Will he ever succeed in making art *pay*? He appears as far from it as ever."[45]

After the Butt portrait no commission appeared to match it. The Thomastown properties were also behaving disastrously. Uncle Matt couldn't collect £57.10.0 owed by the Widow Doherty. By the time Matt had paid the bills in March, 1876, he was owed £98.10.7 ½ in agent's fees; JBY received nothing for that period.[46] The widow's default seemed to have a silver lining, for Matt found a tenant willing to pay four hundred pounds for her lease. At the same time the railroad had secured an easement on part of the lands, for which JBY was to receive five or six hundred pounds. Then, at the last moment, the widow paid up and JBY lost the four hundred pounds; at the end of the year the railroad had not paid up. As a result JBY could not repay a loan of ten pounds to Dowden.[47] His plight was so serious that when in mid-1877 the long-desired sale of the Dorset Street house was consummated, the approximately six hundred pounds he received for it vanished without a trace.[48]

Suddenly John Butler Yeats made another of his inexplicable, radical shifts. Instead of pursuing further commissions, he abruptly decided to refine his technique in landscape.After the late summer vacation in Sligo in 1876 he returned to England, leaving the family behind. Instead of living at Edith Villas regularly, however, he stayed with a Mr. and Mrs. Earle of Beech Villa at Farnham Royal, near Slough, lodging with them sometimes for a night only, sometimes for as long as a week.[49] There, close to the beautiful scenery at Burnham Beeches, he proceeded to the study of landscape. Once settled in, he insisted that Willie join him, not wishing to leave him to the "dictatorial aunts." He purchased a primer on physical geography in a series edited by Huxley and instructed his son from it, then moved on to a primer on chemistry. "Willie takes great interest in them," he told Dowden, "and I have no compunction in forcing him to get them up with great accuracy."[50] In the spirit of Comte, Mill, Spencer, Darwin, and Huxley, John Butler Yeats educated his son not that he might follow a particular trade but that he might understand the world about him. He did not consciously train him to be a poet.

It was a time of mixed emotions for Willie. The hapless father who couldn't manage his own life showed no hesitation in advising others about theirs.[51] His own troubles JBY viewed as minor and inconsequential. Unpaid bills were an annoyance, like buzzing flies; they shouldn't exist, and there ought to be some kind of social fly swatter to dispose of them. The life of the mind and emotions was the only thing that mattered, and he would be sure his son was prepared to live it.

Willie, with a native shyness and melancholy, was touchy and unapproachable like his mother, hardly the malleable material his father preferred. At Farnham Royal the two, following the routines of artist and student, lived together in symbiotic disharmony. The other children in the neighborhood attended the local school, but Willie was taught by his father. They breakfasted together at eight, then Willie took a walk and returned to begin his lessons, "working till one-thirty or two in the afternoon." He was then free until dinner time. If he knew his lessons, Papa read aloud to him in the evening until nine o'clock, when Willie went to bed.[52] On the whole the son enjoyed the countryside and the freedom to explore; he found salamanders and shot sparrows and caught fish. But he lived in dread of the daily lesson, which "was a continual misery, for I could very rarely, with so much to remember, set my thoughts upon it and then only in fear."[53] He wrote his first two known letters from Beech Villa, one of them in a simple substitution cipher given him by Uncle Alfred.[54] Each is factual and unpretentious. In the first, among other things he wrote simply, without comment: "Mrs. Earle gave a live bird to her cat today." In the second he tells of lizards which had escaped. "Mrs. Earle came in one morning to settle the books on the top of the cupboard on which were the lizards but when she found them gone she was afraid to touch the

Susan Pollexfen Yeats and William Butler Yeats, about 1875. Pencil. JBY. In JBY's hand: "reading Jules Verne." In Lily's hand: "W. B. Yeats." Collection: Michael B. Yeats.

Susan Pollexfen Yeats and Jack Yeats, about 1875. Pencil. JBY. In JBY's hand: "im-pressment." In Lily's hand: "Jack B. Yeats." Collection: Michael B. Yeats.

books lest she should put a hand on them. We looked everywhere for them but have not found them yet."[55]

The eleven-year-old boy could not help observing that his father, no longer a young man, seemed unable to complete a picture. He saw himself what happened to a landscape of a pond between Slough and Farnham Royal: "He began it in spring and painted all through the year, the picture changing with the seasons, and gave it up unfinished when he had painted the snow upon the heath-covered banks. He is never satisfied and can never make himself say that any picture is finished." He recalled the stranger in London who, learning who Willie's father was, laughed and said, "O, that is the painter who scrapes out every day what he painted the day before."[56]

In early 1877, Susan and the other children returned to Edith Villas, where Papa and Willie joined them. A twenty-two-year-old Yorkshire girl named Martha Jowitt came to live in as governess. She was to remain for three years, during which she "laughed more" "than in all the rest of her life." The children liked her. "I don't think she was clever," wrote Lily, "but she had an

orderly mind and never nagged us. Our life was ordered and peaceful. She was a demon of tidiness. If we left things about she would get us up out of bed to put everything into its place. She did this with good temper and firmness." Lily, amiable and easygoing, had no trouble with Miss Jowitt, but Lollie, sensitive and self-centered, behaved predictably. If Lollie got into trouble, Lily wrote, "she would start what we others call her 'whilaboloughing.' Tears of great size fell. There seemed to be no end of the supply. As they fell on the table she drew with her fingers pictures, using the tears as her medium, howling all the time." The children play-acted. The others "just romped about," but Willie "was serious about it." Jack, "a good mimic," made everyone laugh. "He always wanted a part in which he could wear Mama's wedding boots," for he liked to prance about in them.[57]

At the age of eleven and a half, in early 1877, Willie was sent off to the Godolphin School on Iffley Road in Hammersmith for his first disciplined schooling. Lily was saddened by the change; for Willie it was not unwelcome. Although his father hadn't realized it, he often "humiliated" his son and "terrified" him, so school became an asylum from parental scoldings. At Godolphin, Willie learned that people were interested in what his father did and how much money he had. He got into fights because he was Irish, but far from feeling inferior to his English schoolmates, he looked down on them. His father's feelings about the superiority of the Irish gentleman to his English counterpart were burned deep in his psyche. Yet he discovered that the English boys were able to become excited at stories "of Cressy and Agincourt and the Union Jack," whereas he, "without those memories of Limerick and the Yellow Ford that would have strengthened an Irish Catholic," had nothing to fall back on except the dream and symbol of Sligo, "of mountain and lake, of my grandfather and of ships."[58] Among strangers of his own age for the first time, he found himself a solitary, as he was always to be.[59] In London he was an Irishman among Englishmen, in Sligo a Protestant among Catholics, at Merville a Yeats among Pollexfens. The dualisms which were to become so much a part of his life shaped themselves early: he was destined never to become a member of the majority no matter where he went.

JBY's puttering around at Burnham Beeches continued through 1877. The technical defects which Todhunter thought less important than the "spiritual qualities" were those JBY sought to cure by studying landscape. As a portrait painter his most conspicuous weakness was in the drawing of hands, yet his early drawings from Heatherley's prove his strength. The real source of his "technical defects" as a portrait painter was that he refused to paint what didn't interest him. With the passing of years he simply abandoned hands altogether.

Susan Yeats was no happier at Edith Villas than she had been at Fitzroy Road. Now it was Willie rather than Edwin Ellis who annoyed her, just as he annoyed Miss Jowitt, who didn't like his "apathetic disregard about things."[60] As soon as Papa arrived at Mrs. Earle's for his weekly stay, letters from Susan

William Butler Yeats's Godolphin School record, Lent term, 1877. Collection: Michael B. Yeats.

would come, almost one a day. He soon learned to leave them unopened as he knew "what a mournful history they would contain of disasters and mistakes." When he returned on Saturdays he was no sooner in the house than he had to listen to "dreadful complaints of everybody and everything," but especially of Willie: "It was always Willie. Sometimes I would beg her to wait till after supper. I always hoped she was not as unhappy as she seemed."[61]

At school Willie had a disappointing record; of thirty-one boys in the form he placed twenty-first. His best performance was in classics, where he ranked sixth; in modern languages and English he stood eighteenth and nineteenth, in mathematics twenty-seventh.[62] JBY perhaps provided the best part of Willie's education by his dinner-table conversation. "For God's sake," he would say to his children, "don't form opinions. Let me have a quiet house." By "opinions" he meant final, fixed conclusions. One should always be ready to change one's views. "I love the give and take of quiet conversation—but I hate wrangling and the uproar and noise of newspaper polemics," he told an aggressive socialist years later.[63]

His conversation was more successful than his career. Wilson and Nettleship had paintings accepted by the Royal Academy for the summer exhibition of 1877, but JBY didn't have "anything anywhere." Yeats, Nettleship, Wilson, and Catterson Smith had formed a "designing club" modeled on the informal association at Forbes Robertson's. Each member paid two shillings and six-pence per meeting, the proceeds used for the purchase of the design which was chosen best by the others. At the first meeting, on June 28, JBY argued so eloquently for his subject that it was chosen for the competition. Catterson Smith described it to Todhunter: "There was a little city and few men within it, and there came a great king against it and built great bulwarks against it. Now there was found in it a poor wise man, and he by his wisdom delivered the city; yet no man remembered that same poor man." It sounded like an allegory of what John Butler Yeats might have regarded as his own life and purpose. Fulfilling the allegory, JBY failed to win the prize, which went to Wilson.[64]

JBY became involved more than he wished with two people who did him little good. One was William Litton Woodroffe, a Trinity College friend, an absentee landlord with an unreasoning hatred of the Irish Catholics whose hard labor provided his income. He insisted on attaching himself to JBY, who could never say no to a friend but who disliked everything Woodroffe stood for.[65] Woodroffe embarrassed JBY by reminding him that he too was an Irish landlord, a position JBY hated and needed. "The Irish landlord did not trust his tenants nor did his tenants trust him," he recalled years later. "Yet as I know, the Irish landlord, particularly if resident in England, could be pro-fusely eloquent on the subject of his own virtues and loving care and other myths of that kind. I know, for I was one of them, even if my eyes were open, opened too by J. S. Mill and others."[66] When Uncle Matt had to get rid of an unreliable tenant, JBY urged him to do so "as gently as possible." "Re-

member," he wrote, "I am very anxious to do what is right whether I can afford it or not."[67] The other "Hair-Shirt" friend[68] was Tristie Ellis, Edwin's brother, an engineer turned artist, with whom JBY shared a studio for a while. "Wood-roffe and Ellis were my friends *corporeally* but *spiritually* my enemies."[69] Ellis was full of "negative criticism," and too much devoted to "getting on." He knew what the Royal Academy wanted and exhibited there from 1868 till 1904, twenty-three times in thirty-six years. Even the artist George Watts admired work he did in the studio with Yeats, but Tristie abandoned serious painting "to spend his life selling water-color drawings, agreeable in colour and photographic in their rendering of local truth, and so was a tradesman and not an artist."[70]

JBY, on the other hand, went nowhere. Late in life he wrote, "I can make no plans, have never had a firm enough footing on which to build for the future. Always have the stars done what they liked."[71] The stars were particularly malevolent in the years that remained of JBY's long first stay in London. For a time he divided his efforts between the studio with Tristie Ellis on Holland Park Road and the landscape painting with the Earles at Farnham Royal. Todhunter, finally abandoning medicine, came to London and joined a nude class "in Yeats's studio,"[72] enjoying himself more than JBY, who felt depressed and admitted to Dowden that he was unable to work on portraits and canvases already begun. Yet Todhunter told Dowden that JBY had done some good portraits, one in five hours that "looks more finished than the works he has hacked away at for months." In a phrase that became almost a cliché and a joke with Todhunter and his friends, he declared that JBY had "turned the corner."[73] Yet JBY continued "hacking away," insisting on the artist's absolute responsibility to accept nothing less than perfection. "Every artist," he wrote, "knows how difficult it is to make up one's mind that a picture is finished, for a picture is never finished, since it is never perfect, and perfection is the artist's goal."[74] One of Todhunter's acquaintances told Robert Browning about *Pippa* and another painting, *In a Gondola*, both in Todhunter's possession, and urged him to see them. Browning did so and was so impressed that he promptly paid a call on Yeats to offer his congratulations. Almost as if the malevolent stars were circling overhead, JBY was not at home. Browning left a message with an invitation for the painter to visit him, but JBY neglected to do so, possibly for the same perverse and only dimly understood reasons that lay behind his failure to call on Rossetti.[75]

The son was doing little better than the father. For the summer term of 1878, WBY placed sixteenth out of twenty-one in form IIb. The form master, W. G. Harris, acknowledged that his "home lessons" had been prepared "more satisfactorily," and that he seemed to like Latin. His handwriting had improved but his spelling was still "bad." In mathematics he was "exceedingly weak," in modern languages "very indifferent." His conduct, like his Latin, was "good."[76] Of the Master's report Papa commented: "In polite official

language he described the boy as amiable but hopeless." JBY had "long ago discovered that Headmasters interest themselves in the head boys and re- member the others only when they break the rules." He thought Willie's education at home was more valuable, for there he "learned to believe in art and poetry and the sovereignty of intellect and of the spirit."[77]

In 1878 there was no summer visit to Sligo. The cause is unknown, but two possibilities suggest themselves. The most obvious is that JBY was so strapped by lack of money that he could not afford the expense, even with free transportation from Liverpool to Sligo. The second may be the unhappiness at Merville caused by the reluctant decision of the Pollexfens to have their son William committed to a mental institution. His condition had been deteriorat- ing for years, and now confinement could be avoided no longer. His parents sent him off to the mental hospital in Northampton, England, where he languished until his death more than thirty years later. Reports came regularly from the attending physicians to William Pollexfen, who would turn them over to his wife. She took them away and read them alone. "I have had one great sorrow," she often said to Lily, and Lily knew exactly what she meant.[78] Also in 1878, Agnes Pollexfen married Robert Gorman in Sligo. There was no big family ceremonial as at Elizabeth's wedding. The Pollexfens looked down on the Gormans, another Sligo commercial family, and disapproved of the marriage. The tensions resulting from Agnes's ambiguous position were partly to blame for her breakdown later. Altogether it was not a good year for either the Pollexfens or the Yeatses.

The home at Edith Villas, now inevitably associated with the death of Jane Grace, was small and uncomfortable. One day Papa announced that he had found an ideal new settlement to which the family would move shortly. It was Bedford Park, a development just off the Turnham Green Station of the suburban railway. Scores of new houses were built on a plot of land formerly the estate of John Lindley (1799-1864), the horticulturist, in the center of which had stood Bedford House. Jonathan Carr had designed a settlement there about 1876 and had hired Norman Shaw to design the church and many of the houses. Bedford Park also contained a shopping center, an athletic club, and a tavern. House plots were laid out to skirt the large old trees, and the houses were built without cellars. Bedford Park was deliberately intended for painters, writers, composers, and people interested in the arts. In the first three years 350 houses had been erected. Shaw persuaded his friend William Morris to design wallpaper which the occupants were encouraged to choose for their halls and rooms.[79]

When the Yeatses moved into 8 Woodstock Road in the spring of 1879, the children were delighted. Willie was disappointed at finding that Bedford Park was not a walled city, and Papa had to apologize for his exaggerations: "He had merely described what ought to be." With or without walls, Bedford Park was remarkable. If not quite Paradise, this first of the "garden cities" seemed so to

many of its inhabitants. Willie remembered "the newness of everything, the empty houses where we played at hide-and-seek, and the strangeness of it all."[80] The children planted their own flower gardens. Willie had "a forest of sunflowers with an undergrowth of love-lies-bleeding" and Jack a "comic and exciting plot" where he mixed all his seeds and sowed them together. They took dancing lessons in "a low, red-brick and tiled house" and had one room set aside as their "kingdom," where they "constantly made things and played."[81]

The designers tried to incorporate every modern improvement in the houses, including indoor plumbing. Victorian designers had not learned all the pitfalls, however, and some bathtubs lacked overflow drains. Occasionally minor calamities resulted, and one of these, recalled by JBY, casts a revealing light on his elder son's place in the family:

Willie used to get blamed for everything, and he could not deny he was generally the cause of whatever went wrong. I can however recall an occasion when he was wholly innocent. Hearing a commotion I went out into the hall and found Willie dancing about in great glee repeating over and over, "I didn't do it." Somebody had left the water flowing in the bathroom and forgotten about it till it made its appearance coming down the stairs, and my son it seems had a perfect alibi.[82]

One incident there that embarrassed JBY and must have brought home to him the seriousness of his financial plight involved Susan, who seldom intruded herself into the management of affairs. Her husband had invited Edward Dowden for a long visit to feel the "peculiar experience" of London. He warned Dowden that the Woodstock Road house might not be "as comfortable" as expected, but he boasted of the "very healthy" neighborhood and of Kew Gardens, within "a half-hour's walk."[83]

Dowden was eager to come, but either in a separate letter or in a postscript to one of her husband's, Susan slyly suggested to the Dowdens that if they came they might like to contribute the purely "nominal" sum of fifteen shillings toward household expenses. Dowden replied in some perplexity, and his embarrassed friend wrote: "As I did not know my wife had said anything about £15/s, I was utterly puzzled by that part of your letter. 15/s would not appear to me a nominal sum, but my wife would not really like you to pay anything and most certainly I should not."[84] He insisted that Dowden come, for in London "intellect and emotion shake hands in eternal friendship." Dowden, always the diplomat, refused to become involved in a family squabble and simply postponed his visit.

Todhunter's presence in London might have compensated for Dowden's absence but for one unfortunate development. He had decided to remarry and move to Bedford Park, first to a house at 27 Bath Road, later to one built for him on a street called "The Orchard"; he christened it "Orchardcroft." The new wife was Dora Louisa Digby, described by JBY as "well-educated and rather pretty," and recognized by everyone as a person quite able to match

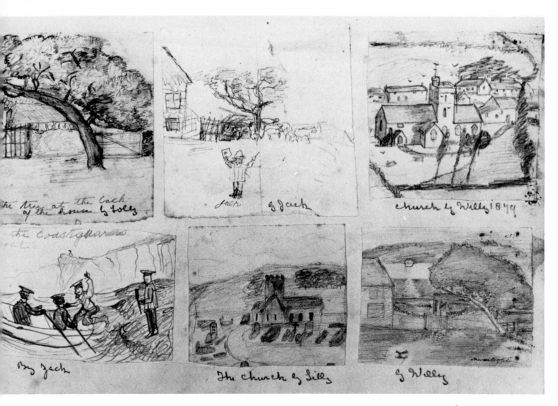

the tree at the back of the house by Lolly

the coastguards

Jack

by Jack

church by Willy 1879

The church by Lolly

by Willy

Pasted in family album: sketches by Willie, Lily, Lollie, and Jack Yeats. Branscombe, Devon, 1879. Collection: Michael B. Yeats.

Todhunter in intelligence. But she was an aggressive woman of positive opinions who made a strong and not always pleasant impression on everyone she met. She was "hospitable," JBY admitted, only "because she was burning to meet people whom she might contradict in incessant *wrangle*."[85] She was so argumentative that people avoided her, and as a result Todhunter became, according to JBY, "a melancholy figure." He told Lily that Todhunter had been regarded as a young physician of great promise and that if his first wife had lived he might have become "a successful doctor." "But that wife died," he lamented, "and he turned to literature and Dora Digby."[86]

The remorseless pressures of economics persisted. For the half-year ending in March, 1879, JBY received only fifty pounds in rents and of that sum owed thirty. With the remainder he bought "a little furniture" for the drawing room, apologizing to Uncle Matt for the extravagance. He went on to say, dreaming of greener pastures: "I want to come to Dublin to paint portraits, to put my sickle into the harvest. I think I shall succeed. I have practiced very hard at painting faces and draperies all the winter. . . . I hear an immense income is to be made in Dublin by portrait painting. Friends are constantly urging me to come over."[87]

When school was out he packed the family off to Branscombe in Devon, where Susan enjoyed the "green countries and sky and the sea,"[88] and where the children bathed in the pools, looked for smugglers' caves, and watched the "beautiful blue and silver" mackerel being pulled ashore in nets.[89] JBY came on the weekends, once bringing another painter friend, Frank Potter, with him. Potter joined the children in a campaign to get their father to obtain black paint, which he refused them because "there was no black in Nature." At night Papa read aloud from *Old Mortality, The Antiquary,* and *David Copperfield.* The children also sketched and drew. They enjoyed the vacation immensely and never forgot it.[90]

JBY made another attempt to get into the Royal Academy Exhibition, making a special trip to Dublin to fetch his portrait of Edward Dowden's daughter Hester ("Essie"), which the Academy rejected.[91] In Dublin he did a chalk portrait of one of the Fitzgeralds. It was pronounced a great success: another man, seeing it, promptly ordered a sketch of himself.[92] So, Dublin seeming more hospitable than London, JBY quixotically and suddenly decided to make a change. When Dowden offered him the use of his rooms at TCD he quickly accepted. Toward the end of 1879 he reluctantly discharged Miss Jowitt and sent Lily off to the Notting Hill School, while Willie continued at Godolphin (where in the spring sports he won the cup for the half-mile race because the handicapper underestimated his ability).[93] Lollie was pressed into housekeeping at home, and Jack was sent for an extended visit to Sligo which, interrupted by a brief return to London in the summer of 1880, was to last eight years.[94]

Yeats enjoyed his stay with Dowden and began a portrait of his host which, predictably, was not to be finished for two years. Many of the sittings were given over more to conversation than painting. One night Dowden told of a meeting in 1878 with the great Tennyson in Dublin. As Ireland's most distinguished literary scholar Dowden was invited to dine with the poet at the Archbishop's home. All was amiable, dinner was done with, and they settled down for an evening of good talk, as Tennyson was becoming "conversational and agreeable." Then the most incredible thing happened. Dowden suddenly remembered that in his pocket were tickets for the opera that night, tickets which he had paid for in hard cash. Abandoning the opportunity to spend an evening in private conversation with one of England's greatest poets, Dowden excused himself so that he could rush home, pick up his wife, and get to the opera on time. As he listened to Dowden's innocent recital of events, JBY was appalled. It was the Anglo-Irish mentality at its worst:

Those tickets had cost money, and so he must get the whole worth of the money. The real Dowden cared nothing for money. . . . He was just being the careful methodical Englishman, and I, painting him there, lost a richly accentuated narrative of what would have been an unforgettable evening with the old poet. Yet an Englishman would

not have done it. It was just the pose of an Irishman trying to be an Englishman and overdoing the part.[95]

The "real" Dowden corresponded with Yeats and Todhunter, read Whitman's "To a Prostitute" in class and faced the wrath of the Hebdomadal Board, which governed TCD, and gave lectures on Goethe that upset "the archbishop and his clerical posse."[96] The real Dowden was the poet, not the essayist; and even if his essays were better than his poems, he allowed the spirit of the essayist to gain ascendancy. To JBY, Dowden seemed a kind of literary Pollexfen, a man gifted with the tongue of an angel which he sold to a Philistine devil. He used his talents for advancement, not for art; and even if the advancement he sought was not sordid, still it was measured by creature comforts, by the big town house, by the rooms at Trinity College, by association with the socially acceptable. He kept his Bohemianism carefully concealed beneath his academic robes, his poetic impulse comfortably tucked away in an obscure corner of his spirit, while the orthodox Anglo-Irishman managed and directed all. He did not dare boldly. And he prospered.

JBY's idyllic life in the College Park came to an abrupt end when in the spring of 1880, after he had been living there only a short time, the Hebdomadal Board sent him a notice to vacate the rooms. Dowden protested vehemently, arguing that if his guest had been John Todhunter or Edmund Gosse the Board would not have objected. At Oxford, Sydney Hall told JBY, he would have been "made an honorary member of the commons mess."[97] But JBY was a critic of the Anglo-Irish establishment, which included Trinity College, and a religious heretic who might corrupt the young. The outraged Dowden's protests moved the Board to agree that Yeats might remain in the rooms but that "it was not to be a precedent." Such a grudging concession was not satisfactory to either Yeats or Dowden, and the arrangement was abandoned, in JBY's words, "by his wishes and with my consent."[98]

Not long afterward he returned to London and by summer had fallen into one of his periodic fits of despondency. In the last week of August, 1880, he arrived at the midpoint of his life, with a little less than forty-one and a half years elapsed and as many more to go, and had still met no consistent success in either art or finance. He told Susan just before they left for Sligo for a late summer vacation that there was no business to be had in either Dublin or London, only paying models and painting pictures to keep in practice,[99] to find, as he expressed it to Dowden, "the jewel of style." He said he had "nearly finished" a painting of Eurydice and another of Oenone and was progressing again.[100] But the painting of Eurydice was not finished. More than a year later it was still on the easel. Both Dowden and Todhunter had promised to take it. In December of 1881, Dowden relinquished his claim, writing to Todhunter: "The Eurydice belongs of right to him who can bring her up from the hell of Yeats's studio. . . . I think she ought to be yours."[101]

The portrait of Dowden also dragged on. It "looks at present like what I might be in some higher and better world, not in this," Dowden told Todhunter in March, 1881, a year after it was begun. "But [Yeats] says it's sure to be a success, and probably he's right." Two months later he wrote again. "His portrait of me, like the original, is growing old. It is now in its second year."[102] Todhunter sympathetically sent JBY, then back in Dublin, four pounds, without comment. Yeats announced he would send the money to Susan in London. "I ought not to take it," he wrote in anguish, "but the need is too great." He offered to repay with a portrait or painting.[103] Living under such embarrassments Susan was as sullen and inhospitable as ever. When JBY's artist friend Sarah Purser and her brother John visited London in July, 1880, JBY's attempts to have friends in at night to meet them failed because of "difficulties," and the entertainment never took place.[104] The difficulties could hardly have arisen from anyone except Susan.

During his last year at Godolphin, Willie's status at the school unexpectedly rose. The interests of headmasters everywhere had suddenly switched to science, and Willie surpassed even those who were about to enter Cambridge. No longer were the reports of an "amiable but hopeless boy," JBY noted with satisfaction: "After that and as long as he remained, the school reports were written in rose water. 'Of exceptional ability' was a blessed phrase that once occurred, and I said to myself, 'He will be a man of science; it is great to be a man of science.'"[105]

After the vacation in Sligo, Jack stayed behind with his grandparents, while JBY laid plans to leave Woodstock Road when the lease expired in mid-1881. Willie spent the fall term of 1880 and the Lent term of 1881 at Godolphin, his return preceded by a letter to the headmaster from his father, who summarized it for him: "I told him you were not naturally at all idle but had a dislike to dull taskwork. In fact you will want a little being hardened. . . . I fear you will find it very hard settling to work. The lakes, mountains, fishing rods, guns, boats, etc. will come like so many imps and demons of mischief and get between you and your book." Things would get worse when his son grew up, he continued, and added: "With you it is thinking of what is pleasant that torments, with me it is thinking of what is most unpleasant."[106]

He had plenty to worry about. In the summer of 1880, the butcher at Bedford Park demanded payment of a long overdue bill of £26.14. JBY begged Matt for half the amount, or even for ten pounds, or, failing those, a letter from his solicitor that he might show the butcher. "We are afraid of his suddenly refusing to let us have any more meat."[107] Things got worse, not better. In April, 1881, JBY regretted that a check Matt sent him in Dublin had not gone directly to Susan in London, where an irate creditor had just demanded payment of a debt of four pounds.[108] A big change would have to be made if total financial disaster were to be prevented. While waiting for the lease on 8 Woodstock Road to end, JBY himself moved to Dublin, lodging at 90

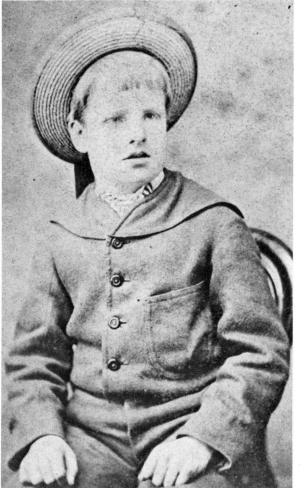

Jack Yeats, about 1880.
Collection: Michael B.
Yeats.

Gardiner Street and renting a studio in a house at 44 York Street, just west of
Stephen's Green.[109] The York Street house was still an elegant and graceful
building, but the neighborhood was beginning to decay, and the house could
no longer command a good rent as a private residence.

Toward the end of 1881, JBY moved his wife and Willie, Lily, and Lollie to
Balscadden Cottage in Howth, just north of Dublin across the bay. Six months
later they moved to a house nearby called "Island View," where they remained
until the fall of 1883. The two years at Howth were to be unusually happy for
the family. Susan Yeats was with her husband and children in the kind of place
she loved, one with a magnificent view of the sea and in the neighborhood of

fishermen and their wives. When WBY was in middle age his memories of his mother were centered on the days at Howth, where she enjoyed the people so much. "She read no books, but she and the fisherman's wife would tell each other stories that Homer might have told, pleased with any moment of sudden intensity and laughing together over any point of satire."[110]

So the first long exile came to an end. John Butler Yeats, a failure in the world's eye in London, was back in the city he had deserted in such high hopes fifteen years before. It was a fateful move for the whole family. For Willie, moving into the enthusiasm of young manhood, it was to mean the difference between a career as a displaced alien in unpoetic England and one as a mystic, a poet, and an Irishman of Ireland.

1882 – 1886

T HE IRELAND of late 1881 was different politically from the one JBY had left in 1867. Then Irish nationalist aspiration represented by Fenianism had been fractured by vigorous legal and extralegal action by the English.[1] The nucleus remained, dominated as it had been for more than a century and a half by Anglo-Irish Protestants, beginning with Jonathan Swift and continuing through Wolfe Tone, Robert Emmet, and Thomas Davis. After the Fenian setbacks of the 1860's it was the Reverend William Butler Yeats's old schoolmate Isaac Butt who had taken control of the movement. He founded the Home Rule Confederation of Great Britain, and was elected its president by a largely Fenian membership. Butt, however, a good Anglo-Irishman, believed that if the English were treated as gentlemen and men of reason they would see the justice of Ireland's cause, and he never changed his conclusion even as the continuously accumulating evidence refuted it. He was to prove no match for a shrewder, more hard-headed Irish leader, also an Anglo-Irish Protestant, Charles Stewart Parnell, who challenged Butt's leadership successfully in 1877, displacing him just a year after John Butler Yeats had done Butt's portrait.

Parnell carefully refrained from the use of arms—if not from suggestive hints that it might become necessary—and concentrated instead on the tactics of obstruction, which proved far more successful than Butt's "courtly bumbling."[2] In Parliament he engaged in lengthy debate—what is called the "filibuster" in the United States Senate—and among the peasants of Ireland he advised late payment of rents, withholding of services, and studied neglect of political enemies, as in the celebrated case of Captain C. C. Boycott. He became an authentic folk hero to the Irish tenant farmer and the nationalist. The English assisted his cause in peculiarly English ways, one being the series of Irish Coercion Bills which greatly impaired the politcal freedoms of the residents of Ireland. With tenants withholding rents *en masse* and boycotts becoming commonplace, the government sought to pull the linchpin from the movememt by arresting Parnell and lodging him in Kilmainham Jail on October 17, 1881, just about the time the Yeatses were moving to Howth.

Understandably, John Butler Yeats did not like Parnell. His reasons were not entirely emotional. He was displeased that a young upstart (Parnell was thirty-five) should take the leadership away from his father's old friend. But also, like Butt, JBY believed in rational discussion and abhorred physical violence. "In Ireland statesmanship died with Isaac Butt," he told his son later. "Since [his time] we have had only politicians with Parnell as the archpolitician."[3] Despite his experiences with Samuel Butler, he too believed that the Englishman was amenable to sweet reason, and that time was the certain solvent for his obduracy.

Among the radical Irish was a group called "the Invincibles" dedicated to any kind of action, peaceful or violent, that would help the cause. In May, 1882, just after Parnell had been released from prison, England's new Lord Lieutenant for Ireland, Lord Frederick Cavendish, was walking toward the Viceregal Lodge in Phoenix Park with the Permanent Undersecretary, Thomas Burke. A small band of men suddenly attacked Burke and stabbed him to death. Cavendish, coming to Burke's aid, was stabbed mortally also. The weapons were surgical amputating knives. The Invincibles promptly let it be known that they were responsible. Parnell repudiated them and their acts, and when a handbill purporting to come from the Executive Committee of the Irish Republican Brotherhood attempted to justify the act, the leaders of one wing of the nationalist movement, the "Old Fenians," including John O'Leary, disowned it too.[4]

On the day of the murders Susan Yeats had escorted Lily and Lollie to the Kingsbridge Station where they took the train to visit Uncle Matthew, who now lived in Celbridge. Lily saw that Dublin was "crowded and the streets lined by soldiers all waiting for the state entry of the new Lord Lieutenant." Next morning in the Celbridge church the rector announced from the pulpit that "a very terrible thing had happened in Dublin the evening before." As he gave no details, the men "tiptoed out and vanished" to learn what they could.[5]

The assassinations showed the feelings of certain patriotic Irish but not their practical wisdom. England imposed a new Crimes Bill on Ireland and successfully stifled all attempts at political action for three years. To those opposed to the murders there were still at least two possible points of view. Edward Dowden was later to refer to "this struggle between the loyal and the rebel parties,"[6] assuming that the "loyal" Irish "party" was the one which supported England. John Butler Yeats was put to a test that demanded more than commentary. In the basement of the York Street house the caretaker, "a drunken young carpenter," lived in "dirty and smelly" surroundings with his wife and baby. At the time of the murders Lily noticed that the wife looked "very ill." One day, when the search for the criminal Invincibles was at its height, the wife asked JBY if he could help her. She must have known her man and his answer, for when he agreed she took a revolver from under her apron and asked if he would hide it for her. She offered no explanation and he

sought none, quietly hiding the gun.[7] At the trial of the accused men in early 1883, JBY attended court and made sketches of the prisoners.[8] Neither then nor later did he reveal to anyone outside the family his secreting of the suggestive revolver. Nevertheless, John Butler Yeats was not a politician. His letters seldom mention practical politics, even indirectly. Like John Todhunter, he was for "whatever was good for Ireland,"[9] but positive political action was beyond him. The lessons he taught his children stuck with them too. As a result none of them except Jack—who paradoxically, was brought up among the Unionist Pollexfens—took part in the politics of violence or approved of it.

The York Street studio quickly became a center of art and philosophy in staid Dublin. Sarah Purser—also a portrait painter but a shrewd businesswoman as well—often dropped by for lunch, and she and JBY would share a herring cooked on a poker and "feel Bohemian."[10] Nine years his junior, Miss Purser, a member of a large and prominent Dublin family, was already on her way to becoming the *grande dame* of intellectual Dublin. JBY enjoyed her wit and appreciated her talents as a painter. Not many could survive her "withering touch," as JBY called it. One woman standing in line at a party said to her, "Miss Purser, I've met you a dozen times, yet you never remember me when I see you." Miss Purser brushed by and replied, "If you insist on having such an ordinary face, what can you expect?"[11] Yet she was fundamentally kind, and she made a marvelous companion for JBY. "I have only one fault to find with you," he told her. "I wish you wore a beard."[12] He described as "her unique quality" that "you felt for her an every-growing gratitude, and yet you did not fall in love."[13]

For William Butler Yeats the five-and-a-half-year residence in Dublin was decisive in determining his future. In addition to young love he discovered the three interests that were to dominate his life: poetry, mysticism, and Ireland. Willie and his father took the train in from Howth to Dublin every day, and at the studio Edward Dowden frequently stopped by for breakfast, to the delight of the youth who had heard his father speak so often about his old friend. One morning at the studio his father told Willie to walk down Harcourt Street and enter himself in the Erasmus Smith High School, a five-minute walk away. The new boy made an immediate and lasting impression on his schoolmates, among whom were William Kirkpatrick Magee (who later wrote under the pseudonym "John Eglinton"), Frederick James Gregg, and Charles Johnston. He was older than most of the boys in his class, and his unusual education and upbringing made him stand out among the homogenized Dubliners. His bad eyes also made him seem distant and standoffish. Thirty years later two old schoolfellows met. "Tell me," said one, "isn't Yeats the poet the Yeats who was in class with us at school, and whom we always regarded as being such a 'queer' chap?" "He is," replied the other.[14]

He was sixteen-and-a-half, tall for his age, dark and good-looking.[15]

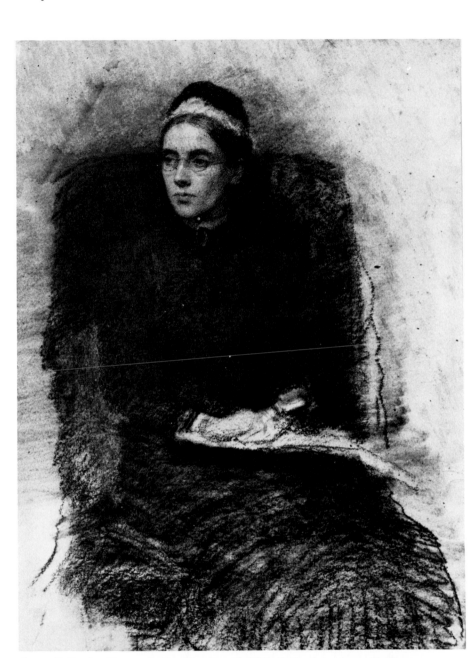

Susan Pollexfen Yeats, about 1881. Pencil. JBY. Collection: Anne B. Yeats.

Though he seemed unusual or even queer to his schoolmates, a young lady friend, Katharine Tynan, later recalled him in another way, as "a white blackbird, a genius among the commonplace."[16] His father's training had given him a rich and deep, if uneven, background of general culture. As his father took a cavalier attitude toward formal education, he had read books others knew little about and was familiar with the dangerous ideas of Darwin, Huxley, and Haeckel. The headmaster, William Wilkins, "a hated man and a bully," disliked Willie for his refusal to observe the conventions. Wilkins wanted his students to take the intermediate examinations and the university scholarship tests, but Willie refused.[17]

His record as a student was spotted. He floundered through "routine tasks" and was as bad as ever at mathematics, but he held his own in classics, and in history "displayed not a little superiority to the rest." Still fascinated by science, he was known as an "insect-collector" who carried in his pocket cardboard boxes and pillboxes "filled with his victims." One day he was admonished by a master for bounding out of his seat and lunging at a beetle which was crossing the floor.[18]

The student who remembered him thirty years later as "queer" also carried away another impression of WBY: he observed that "there was something quietly repellent in his manner which affected even his relations with his masters."[19] It was to affect his relations with others for the rest of his life and was partly to determine his response to the world. Unlike his father, who was immediately likable and was actively admired even by those who knew his shortcomings, William Butler Yeats was not the kind of person who aroused instant affection. People who did not know him well saw only what they thought "repellent." Years later a sympathetic and understanding JBY was to write to Lily: "People say Willie is not human, but these people have not had a tete-à-tete with him."[20] Yet even JBY in the next quarter century was to endure his son's unnecessary offensiveness and to be driven to irritation by it. The core of his being may, as his father wished, have been Yeats, but there was a solid chunk of pure Pollexfen in him, as unmistakable and visible as the wart on the nose of Chaucer's Miller.

With the unpleasantness went a certain lack of sympathy for people who disagreed with him or whose ways he didn't understand. In the York Street studio he was baffled by Dowden's manner. In London he had grown accustomed to the free and open speech of Ellis and Nettleship who, like his father, wasted little time in formalities and cared little about the consequences of expressing their opinions. Dowden was cast in a different mold. In the studio with father and son he was, as he had always been, courteous and even-tempered. But he was ambiguous about issues on which the Yeatses were firm. He had "none of the instincts of Irish nationality," as he himself admitted,[21] yet he lived in Ireland and considered it his country. John Butler Yeats understood Dowden and, while disagreeing, could not be angry with him. Willie saw

Dowden's politeness as hypocrisy, and their relationship gradually deteriorated.

The portrait factory which the elder Yeats had hoped to establish was slow abuilding. Todhunter commissioned him to do a work in which the principal figure was a nihilist, but he found his friend's habits had not changed. Like the portrait of Dowden begun early in 1880, *A Nihilist* was to remain on the easel in a constantly changing state.[22] Yet Dowden believed Yeats was "rapidly 'turning the corner'" and thought his skill was improving.[23] Miss Purser, whose interest in his work never slackened, suggested that he raise his prices. Instead of heeding her advice he had some to offer her. "As to your work, I have here also only one fault to find—*you are too anxious to arrive.*" It was a dangerous thing to say, and he knew it. Miss Purser had no spouse or children to feed, no staggering burdens of debt. He ruefully tried to anticipate her reply. "I have always wanted to tell you this but feared a very obvious retort—or rather a whole fusillade of very obvious retorts."[24]

He was also free with his criticism of Dowden's work. When he read Dowden's poem "Crake" he made a comment that struck home. "Yeats says I wrote it *furtively*," Dowden told Todhunter, "and that all my poems have a furtive look, as if I were ashamed to confess myself a Poet. That seems to me a good criticism."[25] Indeed, Dowden had moved far off the path of poetry, yet he gained little in local prestige from his prose. Those in power at TCD regarded him with suspicion. Aggressive academic politicians like John Pentland Mahaffy, eyes fixed firmly on the provost's chair, regarded Dowden with something close to contempt. Dowden may have been known around the world as a great scholar. At Trinity he was still viewed as somehow radical and was never to become a member of the Hebdomadal Board or exercise influence in the councils of the mighty.

In December, Dowden expanded upon his metaphor of JBY's development. After Todhunter wrote him that "even in the estimation of his friends" Yeats was at last beginning to move, Dowden answered, "Yeats has his head and shoulders round the corner," then added, "his legs are following as fast as possible."[26] The portrait of Essie Dowden was finally exhibited at the Royal Hibernian Academy and "much praised,"[27] but the honor carried little money with it. Occasionally a serious commission might come to him, like that from the barrister Acheson T. Henderson, who sat for a magnificent oil,[28] and old friends like the Fitzgeralds gave him orders for sketches. But the people with power and money in Dublin were not inclined to sit for endless sessions and listen to the iconoclastic utterances of the painter. Even those who were sympathetic found difficulty understanding what he said, as he changed his views—or at least his way of expressing them—so often along the way. The result was that he often bewildered his sitters, especially those of different political, theological, and ecclesiastical views, just as he bewildered his son with shafts of eloquent light that pointed at a central core of meaning but never

quite reached the target. "Looking backwards," wrote WBY years later, "it seems to me that I saw his mind in fragments, which had always hidden connections I only now begin to discover."[29] Yet more contributory to JBY's inability to succeed was his own fear. "The weakness in my character is a distrust of any kind of personal success. It is a very serious fault, and though I constantly deplore it I cannot overcome it."[30]

He desperately needed to sell portraits. The estate brought in little money, not because of the Land Wars (as Willie was to believe years later when he wrote his memoirs)[31] but rather because of the generally declining economy. The conditions of the estate were so confusing that the landlord was once reduced to asking Uncle Matt what the total amount of the mortgages was. JBY was in debt not only to mortgages but to friends. Todhunter he could put off, Dowden would accept paintings in lieu of money, but when Uncle Matt cheered his nephew with the news that he was to receive £160 on the transfer of one of his leases his joy was dampened by the further news that two bills totaling £130 had to be met at once. Then he discovered that after payment of solicitors' fees and other expenses the £160 had dwindled to £128, two pounds shy of the debt. Later an award of £90 was partly offset by "an old claim of succession duty" of £17, and a solicitor made off with an additional £6. He had nothing left for a £50 loan secured through William Pollexfen, and worst of all was a swollen debt of £116 to the irritating W. L. Woodroffe, who demanded immediate payment.[32]

Willie performed at the Dublin high school about as well as he had done at Godolphin. He was by no means as carefree as his schoolmates thought. His father interfered constantly in his lessons, modifying the teachers' instructions at will, and causing Willie to be penalized with after-school "impositions."[33] To compound his academic difficulties Willie discovered chess and soon became totally immersed in it. At first, finding no opponent, he played his right hand against his left. Finally he persuaded his father to play. JBY, who protested he knew nothing of the game but the moves, beat him every time. Papa watched for "slips and mistakes,"[34] which Willie invariably fell into, and pounced on them at once. The son could see the sweep and flow of the wooden armies as they advanced in beautiful ranks against each other, but he tended to overlook bishops that were about to be captured by knights. The grand disregard of specific fact so evident when he was in his teens was to mark his methods, if it didn't much trouble him, all his life. Soon he found a regular competitor in his school friend Charles Johnston and was able to dispense with his father as an adversary, at least in chess.

One evening Papa was frightened when he arrived home in Howth to discover that Willie and Charlie were missing somewhere on the water in a rowboat. It was almost dark, and the boys had been gone for hours. An "alarmed" JBY insisted on rowing out with a fisherman, who was "too polite" to tell him that the boys were hopelessly lost; by the details he gave of the tides

and current he left no doubt that he thought the boys had been swept out to sea. When they reached Ireland's Eye, a small rocky island about a mile from shore, they shouted but got no response. Just as JBY had almost, but not quite, lost hope,—"I think I had an abiding belief that both these generous boys had lucky stars"—they heard from the distance "a faint halloo," and, rowing in the direction of the sound, found the boys on a point of land, "without topcoats and without food and consequently very hungry and very cold." Neither seemed at all worried. They had rowed to the island deliberately, pulled the boat up on shore, and gone off to explore the cliffs. When they returned they found the outgoing tide had left their boat high and dry and "immoveable." So they sat down, Willie pulled a set of chessmen and a board from his pocket, and they began playing. When it became cold they abandoned the game and walked to keep warm, losing themselves in "never-failing conversation." Both boys were unruffled, Charlie wondering only whether he would catch his train back to the city. Father was impressed by their seriousness, which he thought one of the characteristics of genius.[35]

Willie's passion for science—for insects, for geologic formations at Howth[36]—gave way to another quite suddenly during the summer and fall of 1882. On the beach near Bowmore Strand he had accidentally experienced the awakening of his sexual powers.[37] That fall he met a distant cousin, Laura Armstrong, whom he had first seen at Howth driving in a pony-carriage, "her lovely red hair blowing in the wind."[38] She was the youngest and prettiest of the daughters of Sergeant Richard Armstrong, a distinguished Dublin barrister who had gone mad years before.[39] She was older than Willie by about three years but, although already engaged to be married, enjoyed his attentions. She had a "wild dash of half-insane genius," just the quality to appeal to the adolescent youth; JBY called her "a most fascinating little vixen" and painted her portrait (since lost).[40] She and Willie carried on a literary flirtation, writing letters in which she took the name "Vivien" and he "Clarin."[41] Because of her he took to composing verse and wrote his first play.[42] But he was young, too young for Laura, and she was romantic and eager. In September, 1884, she married her young man, a solicitor named Henry Morgan Byrne, only a month after she had written WBY a flirtatious letter.[43] Willie regarded her as "a pleasant memory," although in his novel *John Sherman* she appears as a "wicked heroine" in the character of Margaret Leland.[44]

For Laura, Willie had written "Time and the Witch Vivien" and "The Island of Statues," with the part of the enchantress in both works based on her.[45] From the beginning he wrote verse meant to be spoken and heard, not written and read. His lines didn't always scan, for he couldn't understand prosody as explained in text-books.[46] The rhythm and verbal passion in his poetry came from the sound of his father's voice; he thought of poetry as something to be read dramatically by a sensitive speaker. Words on a printed page were in themselves worthless. They must sound as if spoken by a real person speaking

real language. WBY disliked Tennyson's poetry because it lacked "the impulse of passionate life," and he found that "In Memoriam" did not contain the speech of a man "when moved."[47]

When JBY saw the results of Laura's inspiration he was impressed, if not entirely surprised, by the movement away from science, for he suspected that Willie had simply been "amusing" himself and "playing with it."[48] Knowing how undemonstrative and silent were the Pollexfens, he had not expected his son to turn toward poetry. Yet somehow the Yeats ease and gracefulness and love of conversation and of beauty had sent shafts through the granite wall of Pollexfen Puritanism behind which something elemental surged and struggled. His son's verses "delighted because of a wild and strange music."[49] The die had been cast; after that, no matter what other enterprises Willie undertook, he never gave up the writing of poetry. He had taken the first step that was to lead to embarkation at Innisfree for the long voyage to Byzantium.

The new poet's devotion was soon put to the test. On November 20, 1883, Oscar Wilde was scheduled to appear in Dublin to speak on poetry, and Willie, even though he wasn't feeling well, wanted to hear him. That morning his father had received peremptory letters from Mr. Thomas Caught, butcher, of Broadway, Hammersmith, London, and Mr. Wooster, chemist, of the same address, demanding immediate payment of overdue bills of five pounds and thirty-two pounds. JBY was so upset that he dispatched Willie to Celbridge to deliver the bills by hand to Uncle Matt. In an accompanying note he begged that Willie be allowed to stay the night as the return trip might not be good for him. Willie delivered the letters, chatted briefly, then, despite his illness, caught the return train to Dublin and attended the lecture.[50]

Willie as a boy never gave evidence of being impressed by his role as heir. Once, late in 1882 or early in 1883, the Thomastown bailiff, John Doran, came up to Dublin to see JBY about a dispute among the tenants. Doran was "a fine old man in a big frieze coat," one who after long years of service knew precisely what his position was. Lily and Lollie were in the York Street studio when he came, and he asked the older sister what her name was. "Lily," she answered. "That wasn't the name the nurse put on you when I saw you as a baby," he replied sternly. Lily hastily corrected herself, admitting she was really Susan Mary. He questioned the girls, Lily remembered, "as if we were his grandchildren." Then Willie "wandered in" from school. Instantly Doran was a changed man. He rose and stood stiffly and was "elaborately polite," for "here was the heir." Willie was merely embarrassed.[51]

As Willie's interest in poetry grew, his standing in class declined, though a too ambitious program was partly responsible. "This boy's taking up French and German simultaneously with Latin and Greek is ruinous to him," wrote Headmaster Wilkins to JBY. The future Nobel Prize winner finished twelfth in the class. His highest grade, 76, was in, of all subjects, mathematics. In

English he received 69, in classics 28.[52] Neither he nor his father cared much. WBY might be weak in the formalities, but he had read, or heard his father read, Dickens, Keats, Shelley, Chaucer, Blake, Shakespeare. He had personally known practicing artists like Nettleship, Wilson, and Potter, had listened to the talk of Ellis and Todhunter. He had heard from his father's lips, again and again, that art was more important than mechanics, that the function of the complete man was to be an artist, a role which required the acceptance of the primacy of "intensity" and "sincerity." An artist need not be a painter or a poet, but he could not become an artist of any kind if he allowed his interests and passions to become entrapped in the mundane and sordid. One might have trouble collecting the rents and paying the bills, but such annoyances were the unpoetic stuff that lay on the other side of art, as the slums lay on the other side of the elegant city. One knew they were there and occasionally had to deal with their inhabitants; one didn't live there.

Although delighted by his son's unexpected emergence as a poet JBY was also disturbed, thinking of the cost of bread and butter; "I did want you to be a scientist, and not a poet or artist," he told him years later.[53] It is not surprising that Willie's very first poetic efforts should have been dramatic. His father always read from a play or poem "at its most passionate moment." When WBY saw *Coriolanus* on the stage in later life, it was his father's voice he heard "and not Irving's or Benson's." JBY didn't care "for a fine lyric passage" unless there was "some actual man" behind it, "and he was always looking for the lineaments of some desirable, familiar life." Perhaps observing how his son tended to get lost in mists of trackless reflection and, as in chess, to see the pattern rather than the pieces, JBY praised the precise and sensuous Keats above the cloudy Shelley and tried to explain why one was a better poet than the other. Yet JBY cared little for Keats either, his son thought, wanting only that poetry which was "an idealization of speech, and at some moment of passionate action or somnambulistic reverie."[54]

Perhaps doubtful of his son's talents, JBY kept Willie's secret to himself for some time. Then, in early 1884, he sent the manuscript of a play to Edward Dowden. To his astonishment and delight Dowden praised it, and the proud father replied:

I am glad you are so pleased with Willie. It is curious that long ago I was struck by finding in his mother's people all the marks of imagination—the continual absorption in an idea—and that idea never one of the intellectual or reasoning faculty, but of the affections and desires and the senses. . . . To give them a voice is like giving a voice to the sea-cliffs, when what wild babblings must break forth.[55]

Dowden asked whether JBY had thought of publishing the play, and Father (as Willie came to call JBY, even as the girls called him "Papa") replied: "Of course I never dreamed of publishing the effort of a youth of eighteen." It contained only one passage which he thought worthy: "There was evidence in

it of some power (however rudimentary) of thinking, as if some day he might have something to tell." For one peculiarity of the verse he offered an explanation: "His bad metres arise very much from his composing in a loud voice manipulating of course the quantities to his taste." Such minor weaknesses were unimportant: "That he is a poet I have long believed, where he may reach is another matter."[56]

Despite Dowden's friendly comments, which WBY later said he appreciated,[57] the idealistic youth, shy in person but positive in ideas, continued to be annoyed by what he considered Dowden's vacillating and basically inartistic nature. When Dowden casually mentioned that he had grown tired writing his biography of Shelley, on which he had worked so many years, Willie regarded his attitude as the ultimate Philistinism.[58] JBY had himself discouraged hero worship, telling Willie how Dowden's pragmatic career had disappointed the expectations of his friends. Father "would talk of what he considered Dowden's failure in life. . . . 'He will not trust his nature,'"—the most deadly accusation with which a poet could be charged.[59]

Toward the end of 1883, JBY had moved from York Street into a new studio at 7 Stephen's Green, owned by Mr. Smyth the grocer, whose shop was next door. The rent was forty pounds a year, and almost from the beginning JBY had trouble making the quarterly payments. "I don't suppose you have it," he pleaded with Matt in January, 1884, "but my quarter's rent, £10, has been due some little time."[60] Another sign that all was not well was the move from beautiful Howth, which everyone in the family loved, to the much less fashionable neighborhood of flat Terenure, south of the Liffey, far away from hills and sea. At Howth there were open spaces and spectacular views; the Irish poet Samuel Ferguson lived nearby, and even though he was ill indoors, the Yeatses knew he was there, and Lily used to leave at his house "as an offering" fish she had caught in the nearby waters.[61] At Terenure, where they lived at 10 Ashfield Terrace,[62] they were far less satisfied with their quarters.

The reasons for the move are obvious. JBY's letters to Uncle Matt during the period are a litany of disaster which provide their own commentary:

As you know, my rent was due the first of last month. It is £13-15s. . . . Could you send me a few shillings for Saturday?

If you could manage it I would be glad if you *could* send me by *Saturday early* a pound or 30/s. I am just now hard up waiting for money to come in.

I have received the cheque for £15 all right. You are a gentleman, the best of uncles, and the prince of good fellows.

At the beginning of this month our butcher stopped supplies, and Susan went and saw him and induced him to resume by promising positively to pay him £20 before this month was out. Would it be possible to get that amount on a bill, say for two months, by which time I would be able to meet him?

It is terrible the way the money goes. I owe Louis Purser £102, and I shall want close to £100 to pay various small debts. . . . It is awful. I have hardly slept for weeks worrying about it.[63]

Unaware of the irony that he was behaving as if the fifteen preceding years had never existed, he wrote to Uncle Matt in the same language he had poured over Susan when her mother complained about his long apprenticeship.

It must seem extraordinary to you and all my friends that I should make so little money, but for a painter there are only two courses. One is to know his business thoroughly, which means a long period of struggle and difficulty, and then peace and ease and dignity. The other course is perhaps to have, as I might have had, some short period of success, and then for the rest of his life scheming and imposture, doing bad work palmed off as good.

Even in late 1885, despite a continued lack of success, he was convinced his course was right. "I used to destroy my work because I thought it bad and therefore fraudulent. I now think my work good and well worth the money paid for it." He added in a burst of optimism, "You will see this year a wonderful change."[64]

But there was no wonderful change. At his prices anyone could afford him, and in Dublin the people who mattered didn't want to be considered just "anyone." Nor were his idiosyncrasies designed to attract customers. He would not paint people who didn't interest him. With his sitters he carried on conversations, largely monologic, "advancing on his canvas with great strides, . . . putting on touches with the ardour of one who would storm a fortress, retreating as eagerly . . . talking enchantingly all the time, his whole nature in movement."[65] But that was not necessarily the way to bring in money. People who understood how to "get on" were quick to give advice. Mrs. Alexander Sullivan of Chicago visited him in Katharine Tynan's company and heard him talk "of art and its mission." Mrs. Sullivan retorted, "Sir, your patrons would tell you that you had not to consider your mission, but your commission." Miss Tynan has left a vivid description of life at 7 Stephen's Green:

Everybody who was anybody in Dublin, or visiting Dublin, seemed to find his . . . way there. . . . It was a delightful place, its atmosphere permeated by the personality of Mr. J. B. Yeats, the quaintest and most charming of men.

Canvases were stacked everywhere round the walls. They were used to conceal many things—the little kitchen and tea-table arrangement at one end, Mr. Yeats's slippers and the dressing-room of the family.[66]

Today John Butler Yeats's paintings are acknowledged as among the finest of their time. Henry Lamb considered him "by far the greatest painter that Ireland [had] produced," and the late Dr. Thomas MacGreevy, Director of the National Gallery of Ireland, thought him second only to Renoir as a portraitist of the late nineteenth and early twentieth centuries.[67] Yet he never was in demand among those who wanted to spend large sums on portraits. More and

more he disregarded hands and garments, concentrating on the face; but as the face changed continually the work never ended. At the R.H.A. Exhibition of 1885 none of his paintings won recognition. He admitted that one of Miss Purser's pictures, which won a prize, and one of Millais's might have been better than his, but he thought he might be the victim of the animosity of other members of the Academy.[68] In technique he may have been advancing; in ability to make his art pay he moved, if at all, backward.

At Terenure the family had to practice economies. Every night all sat around a single lamp, "for the sake of a necessary thrift," as Papa delicately put it. Willie would work quietly over his lessons. Then he would begin composing verses, murmuring to himself. He soon forgot the people around him, and his voice grew louder and louder until it filled the room. "Then his sisters would call out to him, 'Now, Willie, stop composing!' And he would meekly lower his voice." The process would be repeated, the girls would again object, and finally Willie would be compelled to find another lamp and retire to the kitchen, "where he would murmur verses in any voice he liked to his heart's content."[69]

Even as he was composing his dramatic lines, however, William Butler Yeats was moving simultaneously into another study which was to rank only slightly behind it, that of the spirit world, the mystic, the occult: of, in the term he used, "Magic." About midway through his long residence in Dublin, his aunt Isabella Pollexfen sent him a book by A. P. Sinnett entitled *Esoteric Buddhism*.[70] Isabella, like her nephew, was powerfully affected by stories of Little People who lived in fairy raths, of banshees and fairies. Willie read the book, gave it to Charlie Johnston, who was immediately captivated by it, and with him founded a "Hermetic Society"[71] to ferret out the secrets of the universe.

For John Butler Yeats it was a paradoxical and ironic punishment. He had not only discouraged his son from attending church but had persistently attacked the theology of the Christian religions. He thought the Roman Catholic Church "good for the heart" but "bad for the brain," and like many Irishmen of his time believed that "had the Irish been Protestants they would have thrown off long ago the English tyranny." He thought "the Catholic religion" to be "a fraud—but it is a beautiful fraud, prepared and written out by the most intellectual and noblest men of their time." On the other hand "the Protestant religion" was "broad but stupid," yet had the advantage of encouraging "freedom of thought and honest thinking."[72] He left his son little choice. Willie had from his early days in Sligo a "religious" nature; he profoundly believed that outside or above or beyond the mundane were forces, probably supernatural, that could be studied and known. "I was often devout," he wrote of his childhood days, "my eyes filling with tears at the thought of God and of my own sins, but I hated church." JBY apparently thought that by sparing his son the follies of Christian belief he could move him in a single step to his own broad acres of cheerful agnosticism. It was to prove the most serious mistake of his life. "My father's unbelief had set me thinking about the

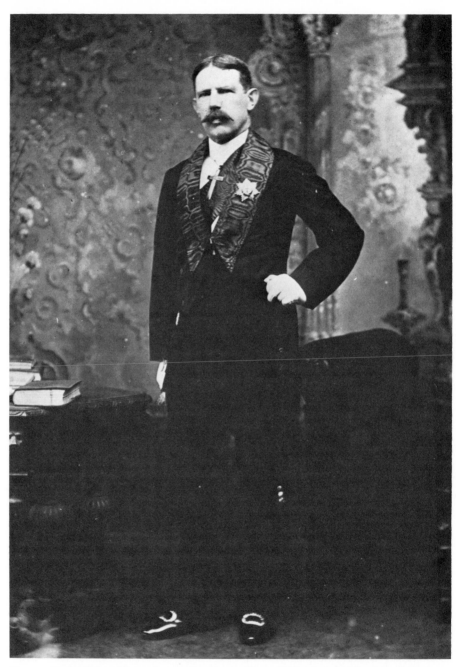

George Pollexfen in Masonic regalia, about 1892. Collection: Michael B. Yeats.

evidences of religion," his son wrote, "and I weighed the matter perpetually with great anxiety, for I did not think I could live without religion."[73] With the golden gates clanged shut against him, it is not surprising that Willie should turn to the wisdom of the Indies. The "Hermetic Society" he founded with Johnston was not "theosophical" in the sense applied to the organization founded by H. S. Olcott and Mme Helena Blavatsky,[74] but it was replete with incantations, with the absorbing of "the Odic Force," and with other mystical trappings, including the inevitable philosopher of the Mysterious East in the person of a Persian professor at TCD.[75] William Butler Yeats had found a religion that was to give him infinite satisfaction until the end of his days and occupy him almost as much as poetry. When his father disapproved, the son retreated into silence. John Butler Yeats cast at Willie's mystical beliefs arrows dipped in the acid of skepticism and ridicule; Willie responded by going underground, keeping his father as unaware of his secrets as possible.[76]

As the time came for Willie to leave high school the question of his further education became disturbing. Father insisted he should attend Trinity College as his Yeats ancestors had done for generations, but with his unconventional education he might have had trouble with the entrance examinations.[77] Furthermore, JBY had also to see to the education of his daughters. Beginning in May, 1883, Lily and Lollie attended the Metropolitan School of Art on Kildare Street,[78] and JBY planned to enroll them in the more conventional Alexandra College. Indeed he had made all the arrangements and had the necessary funds in hand in October, 1883, when a letter from Matt arrived with a bill that required immediate payment. The Alexandra money went to pay the debt, and, save for Lily's brief schooling at Notting Hill, that was as close as the girls were ever to come to a normal education.[79] Willie decided, "on his own responsibility,"[80] as his father put it, to pass over TCD. Instead he joined his sisters at the Metropolitan School of Art. It was still not obvious to the world or to himself that he would be a poet. All the children had drawn, sketched, and painted since they were old enough to carry a brush, and it seemed natural that an artist's son should follow in his father's footsteps.

Art school was only a holding device, though one that lasted long, from May, 1884, to April, 1886.[81] WBY's account of his stay there[82] is of interest chiefly for demonstrating that his father's influence was so strong that in all likelihood he would never have become an original or remarkable painter himself. Outside the school he wrote poetry. Sarah Purser worried about the apparent aimlessness of his career. "You can make the boy a doctor for fifteen shillings a week," she told JBY bluntly at dinner in her home. JBY defended his son's course, and his own approval of it, by making claims not for Willie's painting but for his poetry. He asked the diners if they would be willing to hear a poem his son had written. "I will listen," replied Miss Purser, "but without any sympathy." So he read aloud a poem called "The Priest and the Fairy." That was all that was needed. "From that moment she and her family became my

son's friends. His passports were made out and he was free to enter the kingdom of poetry, all because of a little poem . . . in which these infallible critics had found the true note, the fresh note of the Discoverer."[83] Before long the tall, strange-looking youth who intoned verses while walking the streets was known throughout Dublin as a poet; nobody regarded him as a painter.

The son's rebellion would manifest itself in another way also. Willie had realized for years that JBY, despite constant hard work, was making no money and gaining no reputation. When his own chances came he would be less willing to cultivate anonymity and an unnecessary poverty.

By late 1884 the young Yeats had discovered love, poetry, and the occult. Now came, in the following year, the last element in the compound. One of Dowden's colleagues at TCD, Charles Hubert Oldham, invited friends to his room every Saturday night to discuss literary and political topics over tea and tobacco. Oldham was a Home Ruler, and most of those who came to his rooms shared his views. The conservative powers in the college sought to prevent him from turning his quarters into a hothouse for quasi-treasonable and conspiratorial goings-on, and before long Oldham was forced to move the meetings to rooms above Ponsonby's Book Shop at 116 Grafton Street. In 1885 the group organized as the Contemporary Club. "Members need have nothing in common," one of them said, "except that they were all alive at the same moment." Members were limited at first to fifty, later to seventy-five, and guests were always welcome if there was room. The chief topic of discussion, politics, appealed to only half the Dublin crowd, and that half did not include Unionists of the extreme right like Professor John Pentland Mahaffy or the moderate left like Dowden. By its by-laws the club could take no public action. Its object was simply to afford opportunities for "the interchange of opinion upon the social, political, and literary questions of the day."[84] John Butler Yeats was invited to join, and for almost two years he and Willie attended meetings faithfully.

To JBY the club was a godsend. He had neither the space nor the means to entertain guests in Terenure; in all his correspondence the only guest identified with the Ashfield Terrace home was Frederick J. Gregg, a schoolmate of Willie's and "a great friend" of the daughters.[85] Those who came to call at the studio were old friends and friends of friends. At the Contemporary Club, only a five-minute walk from Stephen's Green and about a half hour from Terenure, half of intellectual Dublin suddenly became available to JBY and his son.

The Contemporary Club can be partly judged by its membership, which included at one time or another Douglas Hyde, Michael Davitt, Thomas W. H. Rolleston, Dr. George Sigerson, T. W. E. Russell, the Reverend James Walker (a Presbyterian Parnellite), W. F. Stockley, and John F. Taylor. Looming above all in 1885 was the impressive John O'Leary, the old Fenian leader, returned to

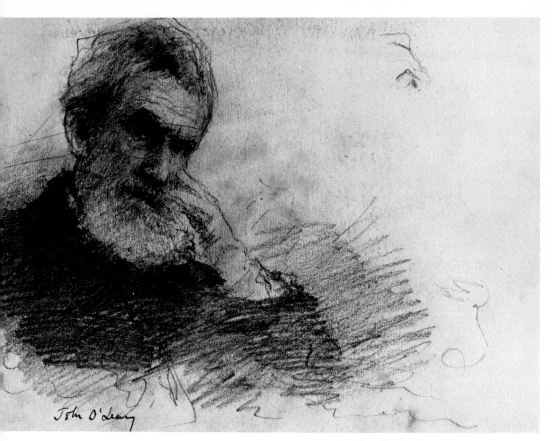

John O'Leary, about 1894. Pencil. JBY. Identification in the hand of Lily Yeats. Collection: Michael B. Yeats.

Dublin after an absence of twenty years. O'Leary had been imprisoned in 1865 for the crime of printing in Ireland an Irish newspaper that expressed the Irish point of view. After serving five years, O'Leary was freed on condition that he would not return to Ireland until the original term of twenty years had expired. He agreed and kept his word. In 1885, when he was morally free to do so, he returned to Dublin and appeared regularly at Oldham's club, and there he met the young William Butler Yeats.

As one who exercised an enormous influence on W. B. Yeats, O'Leary is worth understanding. The modern world knows of his views chiefly through the clouded glass of WBY's description. WBY's view of O'Leary was not entirely—and in some respects not at all—O'Leary's view of himself. John Butler Yeats's position on Irish politics had been taken from Isaac Butt and never moved beyond it, and his son inherited it. Like Butt, JBY wanted an Ireland that ruled itself—an Irish parliament elected by the people, Irish local councils, Irish education controlled by the Irish—but he did not think it important that Ireland be independent of England. Above all he abhorred

violence and, like Butt, hoped and assumed that the English could be educated to treat Ireland decently. His son's political position always hovered about that rather fuzzy center and never moved very far from it before the events of the second decade of the twentieth century.

John O'Leary seemed in 1885 to be almost completely a member of the Yeats party, at least when viewed from a certain angle. He thought Irishmen should be aware of their own heritage, should understand a culture that was separate from England's, not only different but probably superior. Unlike Butt and his followers, O'Leary saw no hope of a real nationalism without independence from England, and, like most Fenians, he never gave up independence as the goal. What he seemed to have given up, when Willie Yeats met him, was a belief in inconsequential violence. He deplored the actions of the wing of Fenians called "the Dynamitards" because of their preference for weapons, for destruction that achieved no good ends, and he believed all such behavior was futile. He did not believe, as WBY's autobiographical writings have misled many readers into believing, that the violent and forcible overthrow of English domination was evil or undesirable, merely that the time for it was not ripe. He thought it immoral to shed blood in a losing cause. He had seen too many failures and now felt that a long time must pass before a chance of certain victory would arise. He was thus content to let Parnellism run its course.[86] During the two years of his greatest influence on the young Yeats he was in the pacific phase of his involvement with independence, a phase that historical circumstances would keep unchanged until his death twenty-two years later.

O'Leary was an arresting figure, the most noble and magnificent of the unsuccessful Irish leaders. His large head, "worthy of a Roman coin," full beard, and burning eyes are depicted in JBY's superlative portrait in oil.[87] Young Willie was impressed by his "moral genius" and liked to quote one of his utterances: "There are things that a man must not do to save a nation."[88] The remark was often misunderstood. The senseless bombing of theatres and railroads, for example, must be avoided because it made enemies of those who might be friends and achieved no other purpose; fruitful, successful violence was not disallowed. O'Leary had an ideal of heroism that also appealed to the young Yeats: if a man suffers in a good cause he should not cry in public. O'Leary refused to pity himself for his five years in an English prison and would not complain of his treatment there. "I was in the hands of my enemies," he would say simply. "Why should I complain?"[89] O'Leary himself had been accepted into the Fenians without taking an oath and had stipulated that he never be asked to administer an oath to anyone else. He so impressed the young poet that WBY always regarded himself, except for the oath, "as one of the party," though it was a secret membership that he admitted only six years before his death.[90]

O'Leary quickly recognized Yeats as the only one in the group of young

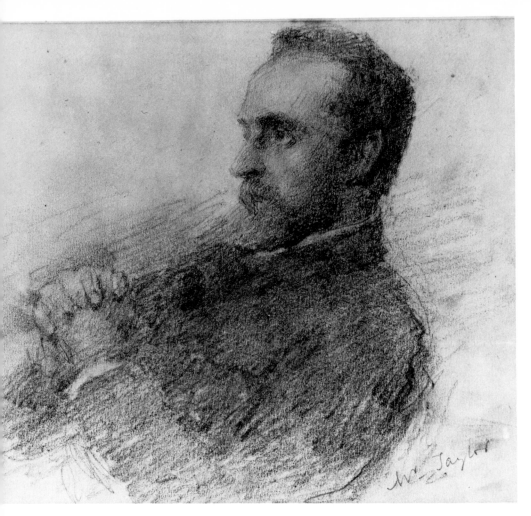

John F. Taylor, Q. C. Contemporary Club, 1885. Pencil. JBY. Identification in the hand of JBY. Courtesy of the National Gallery of Ireland.

people in the Contemporary "who will ever be reckoned a genius" and encouraged him from the beginning. The club engaged in debates, sometimes sharp, and Willie often found himself in contentious argument with others, principally John F. Taylor, Q.C., a magnificent public speaker who, like WBY, was plagued by private insecurities and wanted the assurance of O'Leary's support.[91] Taylor, like Dowden, became a kind of convenient enemy to WBY, who proved early in his days at the Contemporary that he was still "repellent," though no longer "quietly" so. "Willie likes fighting," JBY admitted to his brother Isaac in later years, and added sadly: "He does not get it from me."[92] At the club JBY himself was noted as "an excellent talker on art, literature,

philosophy," but usually "he kept silence, busily sketching in his sketch-book."[93] Willie did not keep silent. Stephen Gwynn, the literary historian and journalist, wrote of WBY's early days in Dublin in a revealing passage: "Some of us were recognized as counting for something and likely to count for more. But everyone of us was convinced that Yeats was going to be a better poet than we had yet seen in Ireland; and the significant fact is that this was not out of personal liking."[94]

In O'Leary, Willie found the counterpoint to Dowden. Father could abhor the views and love the man; his son could not. When O'Leary became the hero, Dowden found himself, to his surprise, cast as the villain. Soon O'Leary was feeding his young charge the materials that would shape his prose and poetry. "From these debates, from O'Leary's conversation, and from the Irish books he lent or gave me has come all I have set my hand to since," WBY wrote later.[95]

Oldham and his friends founded a new journal in 1885, the *Dublin University Review*, and when the young poet submitted two poems the editors accepted them eagerly. In the March issue were "Song of the Faeries" and "Voices."[96] These were followed by further contributions, always of poems or poetic dramas, in the issues of April, May, July, September, and October. His work instantly drew favorable comment. Even the cautious Dowden wrote in tempered admiration to Todhunter: "Willie Yeats is an interesting bow of hope in the clouds—an interesting boy whether he turn out much of a poet or not. The sap in him is all so green and young that I cannot guess what his fibre may afterwards be. So I shall only prophesy that he is to be a great poet after the event."[97] Todhunter was more perceptive, paying the teen-aged youth a compliment by declaring that the drama in the April and July issues, "The Island of Statues," was not "on the highest level," thereby presuming WBY's work to be worthy of judgment by only the severest standards. A month later Dowden was equally equivocal. "He hangs in the balance between genius and (to speak rudely) fool," he wrote Todhunter. "I shall rejoice if it be the first. But it remains doubtful."[98]

C. H. Oldham, like O'Leary, was impressed by the youth's knowledge, his ability to express ideas, and his earnestness. One day he took him to see Andrew Tynan at his home, Whitehill, at the foot of the Dublin mountains. Tynan's daughter Katharine, some years older than Willie, was herself a poet, and Oldham said to her, "I've got a queer youth named Yeats," announcing his find "much as one might announce the capture of a rare moth." She was a gentle, sensitive young lady, utterly devoted to her father, who had brought her up "under a kind star" and given her a life which she later expressed in simple but felicitous verse.[99] Into her world now came Oldham's "tall, lanky, angular youth; a gentle dreamer, 'beautiful to look at, with his dark face, its touch of vivid colouring, the night-black hair, the eager dark eyes.'" Oldham treated him with that mixture of "the deference due to genius and the

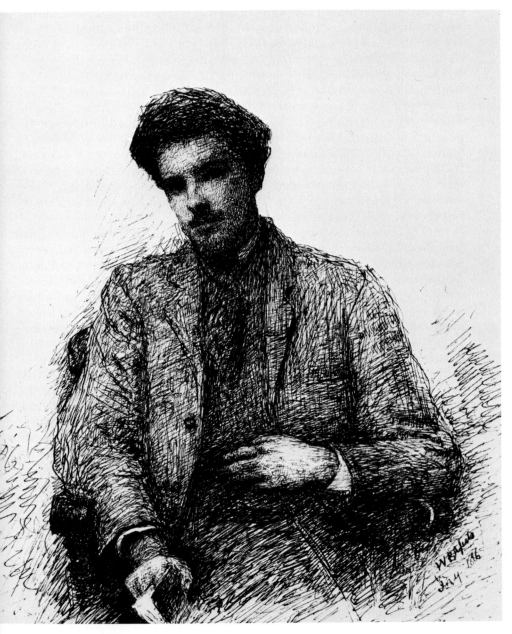

William Butler Yeats, January, 1886. Pen. JBY. Collection: Michael B. Yeats.

amusement which is the lot of the oddity."[100] Years later Miss Tynan was to describe what she herself saw, more than what was visible to Oldham, "all the dreams and gentleness and generosity, without a trace of bitterness."[101]

From that visit grew a lifelong friendship. For the several years following they met constantly and, when separated, corresponded. For a long time she was his only female companion outside the family, and he had feelings, which made him uncomfortable, that she might be falling in love with him.[102] They shared their poetry; she was one of the few Irish writers of his time whom he did not severely criticize. Her subject matter was grounded in religion, the language and form of her verse simple and conventional. In her work William Butler Yeats found the note of the true poet. It was gentle, but it was sure. "God gave a gift of singing to my mouth" she wrote of it; "A little song and quiet that was heard/Through the full choir of many a golden bird."[103] The gift was a flawless gem, if a small one; WBY cherished it early and always respected its possessor.

John O'Leary now opened other doors for WBY. One led to the *Gael*, the penny weekly of the Gaelic Athletic Association, which accepted the young writer's work.[104] Others led to the American *Boston Pilot* and *Providence Sunday Journal*, which on O'Leary's recommendation agreed to publish WBY's essays on Irish subjects.[105] The assurance that his writings would reach print lent wings to his pen. In the June, 1886, issue of the *Dublin University Review* appeared *Mosada*, a dramatic poem. In October it was reprinted as a twelve-page pamphlet by Sealy, Bryers, and Walker of Middle Abbey Street, Dublin. It was the first separate work by William Butler Yeats published as a complete booklet; he was a few months past his twenty-first birthday. John Butler Yeats insisted on including as its frontispiece a pencil portrait by himself of the author, preferring this to "a picture of some incident in the play," as had been planned at first. In the sketch Willie wears a fuzzy beard, which his father had urged him to grow.[106]

The volume had little sale. Papa and Willie gave copies away liberally. One reached the hands of an English Roman Catholic priest who had recently come to Dublin, Gerard Manley Hopkins. At Katharine Tynan's suggestion[107] he called on JBY at the Stephen's Green studio to discuss the painter's theories of art. JBY promptly gave him another copy of *Mosada*. Hopkins charitably refrained from commenting on the play, which he could pretend he had not read, but he gave his view of it a few days later to Coventry Patmore: "This *Mosada* I cannot think highly of. It was a strained and unwork-able allegory about a young man and a sphinx on a rock in the sea (how did they get there? what did they eat? and so on). People think such criticisms very prosaic; but common sense is never out of place anywhere." It was an observa-tion that was to apply to many of Yeats's dramatic works. Hopkins also told Patmore that JBY was "a fine draughtsman," but he was chiefly amused by the presence of the frontispiece in *Mosada*. "For a young man's pamphlet this was

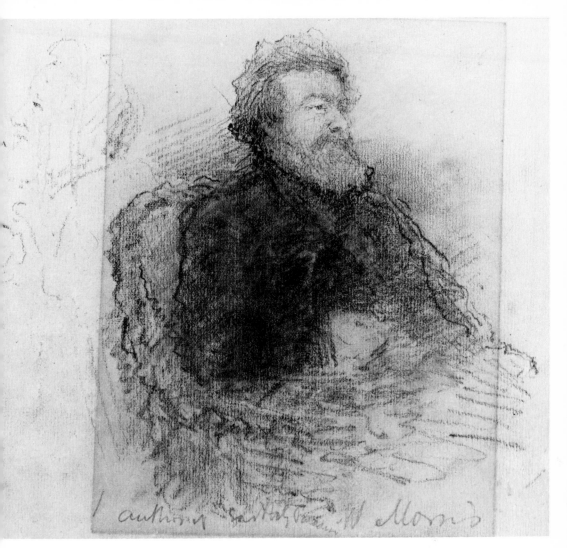

William Morris at the Contemporary Club, about 1885. Pencil. JBY. Courtesy of the National Gallery of Ireland.

something too much," he commented, then added in Christian understanding: "But you will understand a father's feeling."[108] Hopkins later found an opportunity to talk with Willie about Robert Bridges's *Prometheus the Firegiver*, which had been lent to the young poet by Dowden.[109] No record of the discussion survives, but it must have been an interesting confrontation, on one side the student of technique who had moved beyond the conventional into a new poetic cosmos, on the other the poet who professed to know nothing of technique except what his ear taught him.

At the Contemporary Club WBY was listened to with respect. William

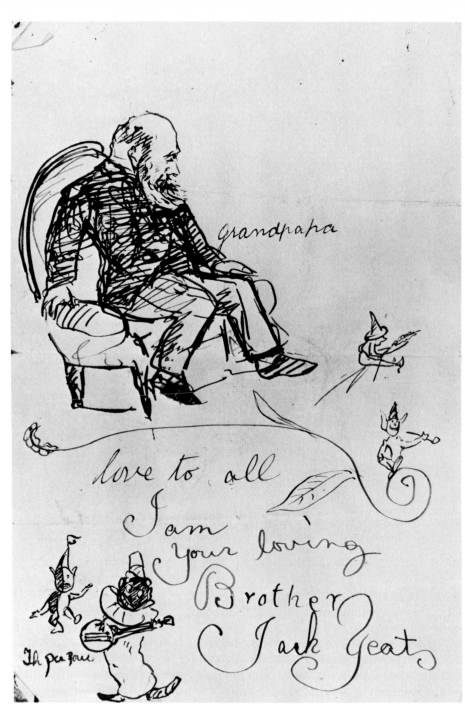

grandpapa

love to all
I am
your loving
Brother
Jack Yeat

William Pollexfen, about 1881. Ink. Jack Yeats (aged about ten); last page of letter to Lily, undated. Collection: Michael B. Yeats.

Morris, the socialist and reformer poet, visited the club and, while JBY sketched him, spoke to Willie. Morris told him that he would "gladly lecture in Dublin on Irish literature, but that the people knew too little about it."[110] Discussion raged in Dublin in late 1886 on the question of Irishness or Gaelicness or Celtichood, aroused by the death on August 9 of the poet Samuel Ferguson. Anglo-Irish, Gaelic, Nationalist, and Unionist forces tried to claim Ferguson as their own. The redoubtable John Pentland Mahaffy, clawing his way up the ladder to the provostship of Trinity College, rushed into print to assure the world that Ferguson's primary loyalty was to England.[111] Young Willie Yeats would have none of it. To him Ferguson was a nationalist *malgré lui*, a true Irishman and Celt, not a Saxon, no matter what he might have been compelled to say publicly in his last years. Willie wrote a long essay on Ferguson, a shortened version of which was published in the *Irish Fireside* on October 9. In it he laid down the basic lines of what would constitute his subject matter for many years. It was a paean to heroic poetry of the ancient Irish times, a poetry whose purpose was to change men's attitudes, to make them aware of their Irishness, of their place in the long history of the Irish people. Of Ferguson's "Lament of Deirdre" he wrote, "Great poetry does not teach us anything—it changes us," and, later, of heroic poetry generally, "It ignores morals, for its business is not in any way to make us rules for life, but to make character."[112] One can hear the echo of John Butler Yeats's voice as the son asserts the superiority of art to the heresy of "getting on."

The most important passage in the essay was not revealed until the complete version was published in the *Dublin University Review* in November. In the first article, WBY had scorned those critics who had paid no attention to Ferguson's work because it had "entered their world with no homage of imitation towards things Anglican." Now he named names:

> It is a question whether the most distinguished of our critics, Professor Dowden, would not only have more consulted the interests of his country, but more also, in the long run, his own dignity and reputation, which are dear to all Irishmen, if he had devoted some of those elaborate pages which he has spent on the much bewritten George Eliot, to a man like the subject of this article. A few pages from him would have made it impossible for a journal like the *Academy* to write in 1880, that Sir Samuel Ferguson should have published his poetry only for his intimate friends. . . . If Sir Samuel Ferguson had written to the glory of that, from a moral point of view, more than dubious achievement, British Civilization, the critics, probably including Professor Dowden, would have taken care of his reputation.[113]

So the die was cast. The twenty-one-year-old son of Dowden's old friend took his irritation with the gently ironic and detached professor out of the closet and displayed it to the world. It was the kind of thing his father would not have done. JBY could not bring himself to excoriate a man with whom he simply disagreed. His crusty son had no such inhibitions.

During the years in Terenure, Susan Pollexfen Yeats suffered in silence,

enjoying only the periodic visits to Sligo. There Jack had lived with his grandparents since 1879. Save for one visit to London in 1880 and a few to Dublin later, Jack spent all his time in Sligo, attending the local school but getting his greatest education from gazing over the bridges into the Garavogue River, which ran through the town.[114] He drew constantly, filling his letters with sketches—one a remarkable portrait of Grandfather William Pollexfen seated—and writing amusing accounts of his adventures. These years were the most important of his life. He had been born "to observe and paint," his father said, and Sligo gave him all he needed—"the dramatic skies, all cloud and storm and sunshine and all the life of that little town and its people, with so many 'characters,' and humourists half tragic, half comic."[115]

In January, 1882, William Middleton died at the age of sixty-one. None of the Middleton children showed any interest in either the milling or the shipping company and gradually liquidated their portion of the assets.[116] The Sligo Steam Navigation Company retained its name, but Middleton and Pollexfen was reorganized as the W. and G. T. Pollexfen Company, and George returned from Ballina to take up Uncle William's place. Fredrick Pollexfen, freshly married to Henrietta Johnson of Bawnboy, County Cavan, took his position on the lowest rung of the corporate ladder, though he was not to remain on the ladder long. Charles and Alfred stayed in Liverpool, the latter as a "quiet drudge" who pored over ledgers in a small office and found his excitement serving as secretary to the Dickens Society of Liverpool. "I am considered to be quite an authority, John," he once told his brother-in-law.[117] It was none of the sons, however, but a shrewd young businessman from Belfast, Arthur Jackson, who moved himself into a strategic position to take effective control of the company later. He secured his flanks by falling in love with Alice, the youngest Pollexfen child, and marrying her.

In contrast, affairs were not improving with John Butler Yeats. He painted constantly—from this period came portraits of, among others, Sir Andrew Hart, Lord Justice Fitzgibbon, D. H. Madden, and Katharine Tynan[118]—but his sense of business was as poor as ever, and he made little money. By the end of 1885 the situation at Thomastown had worsened. Conscientious Uncle Matthew suffered under the increasing tensions and in the summer of 1885, at the age of sixty-nine, fell ill. Instead of devoting his energies to recuperating, he made the mistake, as his nephew saw it, of resorting to prayer.[119] In August he died, and suddenly the complicated business of the Thomastown rentals fell into the hands of a landlord who could not add a column of figures. JBY found another agent, this one a private accountant, I. W. Mullins, a stranger, not an uncle who could make loans and have a casual, easy relationship with his client. In October, 1886, Mullins presented his first accounting: rents due for the year ending May amounted to £499.11.11, and a backlog of late rents brought the total to £839.6.11½. Only £557.10.11½ had been received, leav-

ing rents in arrears amounting to £199.3.2. Mullins listed charges against the estate of £463. Yet he allowed his client £120, putting JBY in debt to him.[120]

It was no longer possible to hope for much help from the estate, and JBY concluded that it was hopeless to make a living as a painter in Dublin. Again the grass in the other pasture beckoned. In London were opportunities with publishers of newspapers and of pamphlets as well as chances for portraits. Impulsively, he decided to return there. Katharine Tynan made a joke of it, saying he was leaving Dublin to avoid painting a woman whose face he didn't like.[121] The real reasons were more complicated and more dreadful, and his decision was made easier by two other developments. William and Elizabeth Pollexfen, having sold Merville and moved to Charlemont, a house overlooking Sligo harbor, felt that Jack should attend art school. Almost at the same time, in 1885, the Ashbourne Act was passed by the English Parliament, providing funds to allow Irish tenant farmers to purchase their holdings from their landlords if the landlords were willing. By providing the full amount of the purchase price, the government made it possible for such sales to be consummated with full satisfaction to mortgagee, landlord, and tenant. The Irish Land Commission would handle all details. By the end of 1886 the machinery had been set in motion, and John Butler Yeats and his tenants were among the first to agree to sale and purchase. "I was glad to terminate the impossible relation," JBY wrote of his decision.[122] All that remained was the determination of a fair price. Characteristically, JBY was not aware of the methods used for fixing values or of the procedures by which the money would be paid. He left Dublin in late 1886, hoping for the best.

Not everyone in the family approved. Susan hated the thought of leaving Ireland. Willie was just beginning to carve out a place for himself in Dublin; the future in London was uncertain. Yet JBY's friends had all advanced great distances toward their own goals. Edward Dowden had brought out his biography of Shelley, John Dowden had just been elected Bishop of Edinburgh,[123] Todhunter was settled in Bedford Park producing poems and plays. Of the original Dublin four, John Butler Yeats was the only one who had made no progress measurable by the common standards of his society. Perhaps he was indeed a great artist. Who knew? What he knew, and what others knew, was that he was a poor provider for his family, a failure in men's eyes. So he embarked on his second emigration. The impulse was the same as underlay the first, but the specific purpose was not, for now he would try to make a living doing hackwork. Art would be secondary, something to be tried if the opportunity presented itself. First had to come the business of taking care of his family.

CHAPTER SEVEN

1887–1891

IT WAS A dispirited John Butler Yeats who returned to London late in 1886. He took a room in an out-of-the-way part of the city while he sought suitable lodgings for his family. The morning after he arrived he saw Samuel Butler walking by outside his window and opened it to call to him, then immediately closed it again. "God forbid," he wrote years later, "that I should intrude myself uninvited on an Englishman."[1] At the time he may have had other reasons. How could JBY tell Butler he was back in London with hardly a penny in his pockets, with a broken career as a serious artist behind him and an uncertain one as a commercial sketcher before him? Shortly afterward he heard that his friend Frank Potter was dead and for an hour or two walked the streets gloomily.[2] It was not a cheerful beginning to a new life.

He found a small house at 58 Eardley Crescent in South Kensington. The family came to London in stages, taking lodgings in different places. Susan and a servant tried to put the house in order, receiving little help from her husband, who was off painting in Oxford where he had unexpected commissions to do portraits of two children.[3] To stave off the commercial sketching he hopefully placed a large watercolor done in Dublin, *The Girl with the Basket*, in the Academy Exhibition[4] but as usual received no recognition.

The Eardley Crescent place was "old and dirty and dark and noisy."[5] Lily called it "a horrible house." What the landlord called a garden was only "a bit of cat-haunted sooty gravel."[6] When the Yeatses moved in, Buffalo Bill and his Indians were performing at the adjacent Earl's Court, and gunfire went off at regular intervals. The promoter sought to calm the neighbors by giving each family a season pass. Jack, sixteen years old, went often, Lily recalled, and, when home, "could tell by the noise just what was happening at any moment of the day."[7]

Bad luck hit them almost at once. Lily fell ill and was sent to Aunt Isabella's for rest. Then the grim, frustrated Susan Pollexfen Yeats, trapped in a shabby house that she hated, facing the prospect of a long stay in London, suffered a stroke. Until the end of 1887 she was too ill to be moved. There was hardly enough money in the house to buy food. The sale of the Thomastown

William Butler Yeats, about 1888. Pencil. JBY Identification in the hand of Lily
Yeats. Collection: Michael B. Yeats.

properties moved with glacial slowness, and JBY had difficulty selling wood-cuts, which he peddled to *Atalanta*, Cassell's, Harper's, and the Tract Society. ("In wood drawing he has no range for his special gifts," Dowden told a friend.)[8] When T. W. Rolleston sent a check for £2.6 to be forwarded to O'Leary, the beleaguered JBY cashed it and used the money, sending its equivalent to O'Leary with apologies later.[9] In late winter Susan was sent with Lily, still ill herself, to stay with Elizabeth Pollexfen Orr at Denby, near Huddersfield. There Susan suffered another stroke and fell down a back staircase. It was unthinkable to bring her back to Eardley Crescent. Household expenses were paid principally by Willie out of the money he received for his contributions to periodicals.[10]

In Bedford Park, at 3 Blenheim Road, JBY found "an admirable house, large and airy, with plenty of room," and the rent was only forty-five pounds a year, which Willie called "very cheap," and which pleased him as he would have a study all to himself. There was also a "good large room fit for a studio" for Papa.[11] The neighborhood itself had grown, as its founders had hoped, into "a resort of painters, players, poets, journalists, schoolmasters, exiles, Bohemians mostly innocent, 'nephews of Rameau,' stray city men and bourgeois." Some called it the "pauper's paradise," Oliver Elton remembered, but added: "It was rich in talk and in the gifts of the spirit."[12] John Butler Yeats would find friends there in the artists Henry Marriott Paget and Joseph Nash,[13] the publisher C. Elkin Mathews, and the Oxford professor Frederick York Powell, and would renew his friendship with John Todhunter, now a full-time poet; for conversation there was a club, the Calumet,[14] which JBY joined at once.

Papa, Willie, Jack, and Lollie moved to the new house on Saturday, March 24, 1888, and put it in order, and on April 13 Mama and Lily returned from Denby. For Mama it was to be the last move, as she remained in and about the Blenheim Road house, seldom stirring from it, until her death twelve years later.[15]

The rent may have been cheap, but JBY couldn't afford both it and food. Jack, sixteen, was sent to art school[16] and was not expected to contribute financially, although he soon did. Willie thought he should get a steady job to bring in money regularly, but his father deplored the prospect that the poet might lose "mental liberty." In any event, neither knew how to go about finding a job.[17] When York Powell suggested a position on a newspaper Willie declined it, much to the relief of his father,[18] who urged him to write a romance instead. So he began *Dhoya*, an extravagant and quite unrealistic tale set in Sligo which involved a heroic giant of the old times. JBY was disappointed, saying he had expected a book dealing with real people. Willie thereupon began the complexly disguised autobiographical novel, *John Sherman*, which was to be published, along with *Dhoya*, in 1891.[19] But no job developed. Even with O'Leary's advice and Todhunter's offer to help find him

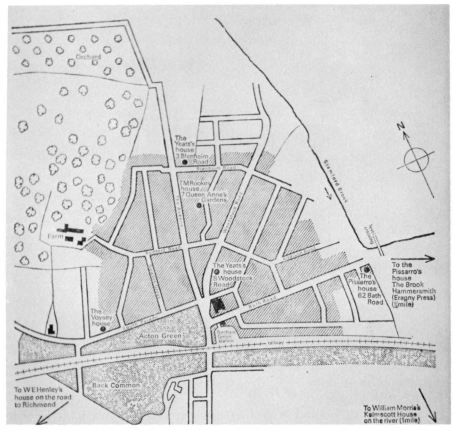

Plan of Bedford Park, with the Yeatses' homes at 8 Woodstock Road and 3 Blenheim Road marked. From Mark Glazebrook, ed., *Artists and Architecture of Bedford Park, 1875–1900* (London: published by Mark Glazebrook, 5 Priory Gardens, Bedford Park, on behalf of the Bedford Park Festival, 1967). Map by Gemma Best. By permission of Mark Glazebrook.

an assistant librarianship despite his "bad writing and worse spelling,"[20] at the end of the year Willie was still only a free-lance journalist.

Willie collected thirty or so of his poems, published and unpublished, and, under O'Leary's guidance, sought subscribers for a printed edition, which appeared in January, 1889, under the title *The Wanderings of Oisin.*[21] Todhunter read Willie's manuscript and wrote in high praise to Dowden. "He has genuine imagination, richness of diction, and above all a power of writing easy musical verse quite remarkable in these days of Tennyson, Rossetti, and Swinburne and their followers."[22] His reputation as a poet brought WBY into touch with many of the literary luminaries of London, particularly the group that gathered around William Morris, whom he had already met in Dublin. Morris

William Butler Yeats, about 1888. Pencil. JBY. Identification in the hand of Lily Yeats. Collection: Michael B. Yeats.

was full of good stories and liked to have people with him who would listen to them. JBY thought Morris had "no philosophy," that he "solved all questions of conduct by the immediate intuition of an optimistic disposition, or of explosive temper,"[23] and he spent little time at Morris's home, Kelmscott House. Morris saw far more of WBY, who studied French there, at first by himself and later, at his father's insistence and to Willie's annoyance, with his sisters.[24] At Morris's WBY met George Bernard Shaw, Walter Crane, Emery Walker, Henry Hyndman the socialist, and Prince Kropotkin the anarchist. Of them all he most admired Morris, who reminded him of his grandfather William Pollexfen. If he had been given his choice of living another man's life, he was to write, Morris's would be the one.[25]

The Morris family was not a happy one. Morris had a quick temper; his wife and their daughter May were restless and dissatisfied. Another daughter, Jenny, "had a bad case of epilepsy" but was the only one in the family for whom Morris showed affection.[26] May Morris, good-looking in a mannish sort of way, operated an embroidery shop at her father's home. She had become engaged to Herbert Halliday Sparling, partly to spite her parents, who disliked him. Sparling, editor of *Commonweal*, Lily described as "a freak to look at,

very tall, no chin, and very large spectacles," contrasting with Morris's "fine head and shoulders" set on a body that was "much too short."[27] Sparling had an unpleasant way about him too. Willie was made "melancholy or irritable" by his "atheisms and negations."[28] But he was a convenient stick for May to beat her parents with.

Some time during this period, perhaps in 1888, Willie proposed marriage to Katharine Tynan and was refused. He had long felt an obligation to her: friends had told him she was the kind of girl who could "make herself very unhappy about a man." But she was "very plain" and his dutiful impulses, strong when they were separated, weakened when she was present. It must have been a relief when she declined.[29]

Lollie, with her nervous excitability, was busier and more active than anyone else in the family. With some friends she helped produce an issue of an artistic journal, designed and produced by hand, called *The Pleiades*, which first appeared at Christmas in 1887.[30] More important, she began a diary, making her first entry on Thursday, September 6, 1888, her last on May 24, 1889.[31] The account is so detailed that life at 3 Blenheim Road and in Bedford Park generally during these months can be reconstructed vividly, the whole filtered through the eyes and mind of a twenty-year-old girl who was a combination of intellectual rationalist and Victorian romantic.

"This day that I commence writing a diary on seems to be particularly dull and uneventful," she wrote, in a surprisingly flat start for what was to be on the whole a sprightly work, "but as one must make a beginning, I suppose one day is as good as another." On that day, Lollie and Lily went shopping, cleared the bill with the butcher and grocer, and paid for one month's arrears of milk. After dinner they walked to Acton, the village west of Bedford Park, to visit their Uncle John Varley's sister, trying without success as they walked to fashion a plot for a story Lollie wanted to write. At length JBY joined them, and he and his daughters walked back to Bedford Park together. That night Willie read aloud "all the evening" to his father. There was no interesting mail, though Willie received five pounds for some copying he had done. Lollie went to bed at ten o'clock.

On most days Lollie stayed in Bedford Park. Occasionally she went to the theatre or shopped in the city. The diary is filled with domestic and social activity, and through it runs one thick, uniting thread, the acute shortage of money. For one two-week stretch the entries are reminiscent of Papa's letters to Uncle Matt:

September 17: Went to Hammersmith, bought a leg of mutton on tick. "Another crisis" on now, only 2 pence in the house.

September 22: . . . got sirloin of beef on tick. . . . "Crisis" as bad as ever. Papa and L took the only shilling the house possessed to get to town with.

September 25: No butter for tea but luckily we have some marmalade.

September 26: Seems to be no prospect of funds turning up. No butter for breakfast, no potatoes for dinner, but we have meat.

September 30: Not enough marmalade to go round at tea and no butter.

October 4: The Crisis is over for the present but paid all the money off in bills.

All the children had long since learned to live with the "crises." When the Todhunters came for tea on September 27, Willie casually asked Todhunter if he could borrow three shillings. While the others sat in the drawing room and talked, Willie slipped around the corner and bought tea, sugar, butter, and marmalade to feed, at their own expense, to the unsuspecting guests. Less than a week later, when a summons for the tax arrived, Lollie took money just paid to Willie and gave it to the tax gatherer. Their friends made a habit of sending small sums from time to time. Bedford Park neighbors, the Gambles, gave the girls clothing, for which they were grateful. "All the same," Lollie confided to her diary, "I wish people didn't give us things. Makes you feel queer. One certainly has to pocket one's pride. All the same don't know what we should do without such gifts."[32]

When income arrived to pay off old bills, a new set of debts would accumulate. In late November, JBY asked his neighbors the Farrers for money to tide him over. Two days later he "borrowed" a half-dozen eggs from Mrs. Nash and made his children eat one each; it was the first egg any of them had had in a year. During the Christmas season the relatives were careful to make gifts of money, many specifically assigned to the children.[33] Old William Pollexfen made a grand gift to his daughter of twenty-five pounds, which JBY promptly appropriated to buy himself some badly needed clothes and an umbrella and to pay Rose the servant six pounds and Mrs. Watson the dressmaker seven pounds.

Lollie kept track of her own attempts at writing stories, playing "badmington," and helping around the house. Susan Pollexfen is described as reading constantly, but otherwise we hear little about her. Lollie's views on people are amusingly conventional. Despite her father's broad horizons, she held orthodox opinions about love and romance reminiscent of those in her mother's letters to JBY before their marriage. Lollie wished that in *Anna Karenina* "they wouldn't all fall in love with other men's wives and other women's husbands." She pronounced a play she attended in London "awful rubbish," even though "the girl's dress was pretty." Of a neighbor and frequent companion she wrote: "Charlotte is a most monotonous person, egotistical to a degree and under the mistaken idea that she is most original and far superior to her family, above dances, men, and such frivolities, whereas in reality her conversation runs much on these very subjects." When she played badminton at the club one night she saw a Miss Austin flirting with a youth on the stairs in the darkness. "A shame on them both," she commented severely. Next week the two vanished in the garden but did not escape Lollie's notice. Of *The Lady's Mile*, by a Miss Brandon, she wrote: "I wish people in books would have a little

better morals and not always wait until after marriage for flirtations and love affairs."[34]

In the diary JBY appears in more than fifty of the entries. He stands revealed as out of touch with reality. One day he decided he would write stories and then illustrate them (an idea first broached to the Dowdens in the late 1860's). Every day for almost two months he dictated a ghost story to Lollie. Never having disciplined himself as a writer he was unable to produce commercially acceptable work. The ghost story failed to sell, and the sketches remained in the family, also unsold.[35] He attempted drawings to illustrate articles in magazines but had poor success in marketing them. On January 21, 1889, Lollie walked to Hammersmith with her father, who left a drawing at *Cassell's*. The editor said he would like to keep it and "look at" it. Lollie notes, with a touch of bitterness, "That I suppose only means a freezingly polite letter in the course of a few days to say that 'The editor regrets he is unable to see his way to using it.'" Papa left the ghost story at *Harper's* on November 7 and learned three weeks later that it had been rejected. During the course of the diary there is no mention of JBY's making any money whatever.[36]

On October 11 he began a portrait of Lily, which Lollie pronounced the "best," very like in "look, colour, everything," and in late December began Lollie's, another unprofitable if pleasing task.[37] In late November he began a portrait of Mrs. Farrer, perhaps commissioned as a kindness or done for no fee, as he began it only three days after borrowing the money from her. He told Lollie that Mrs. Farrer "did not sit long and sat badly."[38] Thereafter the diary is silent on the subject.

Lollie also records a shattering event for Papa. On the day when he finished the ghost story she noticed that he was unusually depressed. At length he revealed what he had tried to keep from the family, that the Irish Land Commission had allowed him only £7,032 for his Thomastown properties, about five hundred pounds less than what he had hoped for.[39] After provision for debts, the balance was £1,004.4.8, , but that would not be paid for some time. When it came (according to a note by Lily in her sister's diary) it was eaten up by other debts.[40] JBY had hoped for five hundred pounds free and clear after the sale was complete. It was a characteristic hope and a characteristic miscalculation. "Isn't it dismal?" wrote Lollie. "It seems so sad to sell a property like his that has been in the family for time out of mind. He I think feels it greatly. No wonder he is worried."[41]

Other entries about Papa were more cheerful, of visits made and received, theatre parties, Calumet talkfests. He appears throughout as an active participant, popular with everyone. Through the diary we are made privy to the devices of the chronically impecunious. On October 13, when JBY attended the Irish Exhibition (a trade fair) with Lollie and Jack on a pass which entitled him to bring a guest, he entered at one gate with Lollie, then walked out and entered by another with Jack. Lollie records the deception matter-of-factly,

without moral judgment; as with the innumerable "loans" they were accustomed to receiving, life had to be dealt with on its own terms, and a certain shrewd conniving was unavoidable.

Two events recorded by Lollie were to prove of the greatest consequence to the family. The first was May Morris's inviting Lily to work in her embroidery shop. The family thought May meant merely to do Lily a kindness by teaching her how to embroider. But on December 8, to everyone's surprise, Lily came home with ten shillings, payment for a week's work. The event created a sensation. The sum seemed large to a family that had so little. There was great joshing at Blenheim Road. All told Lily how respectful they would be from now on. Lily told Lollie to buy a pair of evening gloves with the money. Papa sagaciously advised Lily to spend it herself, as otherwise the family might get it. Jack sidled up to her "in his best costermonger style" and said, "I allus was a friend of your'n Lily warn't I?"[42] The newly found job, which would last six years, was to prove more profitable than happy.

The second event was the visit of Maud Gonne to Blenheim Road. On Wednesday, January 30, 1889, she arrived at the door, ostensibly to call on Papa.[43] Her reputation had preceded her. Lollie described her as "the Dublin beauty (who is marching on to glory over the hearts of the Dublin youths)" and observed that she was really calling on Willie, not Papa. Lollie couldn't see her well as her face was turned away but was obviously impressed by her grandeur. Lily noticed that the stately beauty was wearing slippers,[44] and noted her "gracious manner" while also being "annoyed" by it. Miss Gonne was tall and striking, with a Junoesque figure and a bearing to match. "I hated to be smiled on, a sort of a royal smile," said Lily of her.[45] Willie was smitten at once and the following evening dined with Miss Gonne in London.[46] To him she seemed a goddess: "Her complexion was luminous, like that of apple-blossom through which the light falls."[47] Despite the poetic or other cultural benefits that may have derived from the meeting, it was to be regretted by the other members of the family, who came to wish it had never taken place.

Lollie's two entries about Miss Gonne are doubly important, first because they chronicle the initial meeting of the famous pair, and second because they constitute a sizable portion of the references to Miss Gonne made by the members of Willie's family. Her name seldom appears in letters between JBY and his daughters or between him and Willie. From family papers, one would scarcely know of her existence were it not for Lollie's entries and for Willie's own autobiographical works. To the family their relationship appears to have been too painful a subject to discuss.[48]

The world well knows that Willie fell hopelessly in love with the Irish goddess who combined intelligence and strength of will with overpowering beauty and a reckless revolutionary fervor. The world knows too that his love was not reciprocated, though it persisted for almost thirty years. Maud Gonne, despite her deep admiration for Willie's poetry and her acceptance of his

friendship and all the help that sprang from it, simply never caught fire from him emotionally. At the time she met Willie, she was involved with a more mature and sophisticated man, Lucien Millevoye, a journalist and politician who was trying to reform France as she was Ireland. Within a few years she was to bear the first of two children by him, and already her attachment was so strong that it drove out all other possible commitments.[49] As one of her biographers, Elizabeth Coxhead, puts it: "Yeats is a figure of such towering importance, and Maud Gonne was for so long the centre of his life, that none of his numerous biographers seem to have realized how far away he was from the centre of hers."[50]

Only a couple of weeks before Miss Gonne's visit Willie's first complete book of poetry had appeared, *The Wanderings of Oisin*, important enough to warrant what Lollie called "an abusive review" in the *Freeman's Journal*.[51] Morris and the poet William Ernest Henley liked the book, and Oscar Wilde and Todhunter too. Its publication certified WBY's fame and helped to loosen the ties to his father. The act was made easier, if more painful, by JBY's conspicuous failure at his own career. While children, the Yeatses might see their father as an artist of great promise whose standards rose above those of the crowd. Grown, they saw something else, and what they saw he saw too. Unable to support his family, his inherited estate gone, his career in Dublin ended, he had lost much of the authority and respect he had so long enjoyed. While Willie was rising to prominence—the period from 1887 to 1891 was so significant in WBY's life that he wrote a separate volume of his autobiography about it, *Four Years*[52] —John Butler Yeats came as close to emotional breakdown as it was possible to do without going over the edge. Even thirty years later the memory of that time of "incessant humiliation" burned.[53] His distress showed itself sometimes in unpleasant ways. One night he argued at the top of his voice with Willie, and a week and a half later they "had a hot argument on Metaphysics."[54] Lollie doesn't report another incident which Willie remembered vividly and his father conveniently forgot. One night they were discussing John Ruskin and, according to Willie, JBY broke the glass of a picture over the back of Willie's head.[55] Another time he followed Willie to the room shared with Jack, and, in Willie's words, "He squared up at me, and wanted to box, and when I said I could not fight my own father replied, 'I don't see why you should not.'"[56] The cause of the dispute, Willie told Lollie, "was entirely abstract and impersonal," simply a "quite legitimate difference between the ideas of his generation and mine."[57] As ominous as Father's belligerence was the reaction of Jack, who flew into "a violent passion" because he had been awakened. After Papa had "fled without speaking," Jack said to Willie, "Mind, not a word till he apologizes." It was several days before the two spoke again.[58]

To Willie his father's character and behavior, which had been merely embarrassing when he was a schoolboy, were now irritating beyond endurance. Almost alone among the important people he knew, his father seemed lacking

in the one quality without which all the others meant nothing—decisiveness, will power, the inner drive to work out an idea or project to its conclusion. Willie called his father's weakness "infirmity of will." Although unable or unwilling to tell his father precisely how he felt, thirty years later WBY could remember his feelings vividly:

> It is this infirmity of will which has prevented him from finishing his pictures and ruined his career. He even hates the sign of will in others. . . . The qualities which I thought necessary to success in art or in life seemed to him "egotism" or "selfishness" or "brutality." I had to escape this family drifting, innocent and helpless, and the need for that drew me to dominating men like Henley and Morris, and estranged me from his friends.[59]

Papa was particularly disturbed that Willie also included his sisters and brother as objects of his derision, "They paid the penalty of having a father who did not earn enough and who was besides an Irish landlord." He thought his older son regarded the others in the family as bearing "the brand of inferiority."[60] With Jack, Willie was less than brotherly, regarding him as a perpetual youngster and seldom showing enthusiasm for his paintings, just as later he would look down on his writings. Yet there was apparently no specific origin for his behavior beyond his "lack of ordinary good nature."[61] Papa liked to think there was affection between the brothers but was never quite sure. Writing to Lily years later about his sons, he said pessimistically, "I don't suppose things there will ever alter."[62]

The only satisfactions for JBY were trivial ones. He painted a portrait of Willie in competition with H. M. Paget, and Willie thought his father's better.[63] But JBY's work brought in almost nothing, and under all the pressures his health began to give way. At this crisis in his troubled career he found a savior in a forty-year old Oxford professor, Frederick York Powell, recently widowed and left with a small daughter. Powell spent as much time at his Bedford Park home at 6 Priory Gardens as he could spare from his work at Oxford. His distinction as a scholar sprang from his influence on others rather than from his own original work. He was a good listener, able to draw out the best in others. JBY once told Willie that he got his philosophy from York Powell "by looking at him." He had to give that explanation, Willie maintained, because "Powell was without ideas."[64] Stubbornly anti-Semitic and pro-Empire, he was otherwise broad-minded, amiable, and humanitarian. When JBY was in the depth of depression Powell would often stop by at 3 Blenheim Road, sometimes at midnight, and let his friend talk himself out. Then JBY "would go to bed and sleep soundly, and awaken in the morning refreshed and confident."[65]

Powell disliked fuzziness and nonsense generally but fell into no school. Democracy he disliked but accepted as a necessary evil, hoping that within it an aristocracy of the intellect might find soil to flourish in. He was glad his friend's son was a poet but looked with disfavor on what he called the "Celtic mist"; the

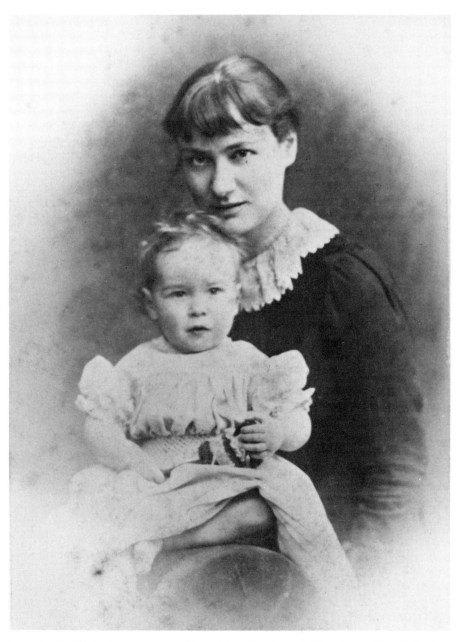

Dora Louisa Digby Todhunter and her eldest daughter, Edith, about 1883. Collection: Joan Lambe, née Todhunter. Permission of Mrs. Lambe and Mrs. Marjorie Todhunter.

excesses of Irish nationalists he thought "Gaelic rubbish."[66] He told JBY that since the coming of Darwin and Huxley the quality of clergymen had so deteriorated "it was difficult to get a man of any intellectual distinction to make a bishop of him."[67]

Not surprisingly, Powell found Jack a more attractive companion than his older brother.[68] Jack had "ordinary good nature" in abundance. His progress from an exciting boyhood in Sligo to mature artistry can be viewed at this Period through Lily's scrapbooks and Lollie's diary. He was still the favorite child, the comic one. When art school was not in session, he sped to Liverpool to board the family steamer to Sligo. When Lollie began her diary he was with his grandparents. "We expect the *Baby* home this week," she wrote on September 25, and next day the neighboring Miss Cole asked after "the Baby," her name for him "because he has such nice sleepy blue eyes."[69] When he arrived at Blenheim Road he brought a pocketful of shrimps and a valise packed with damson plums and pickled herring.

Both Edith Todhunter and Susie Orr, small girls, were staying with the Yeatses, the latter (Elizabeth Pollexfen Orr's daughter) as a guest, the former as a temporary tenant while her parents' home was being renovated. (By employing the Yeatses as baby-sitters Todhunter was able to help his indigent friend, paying JBY four pounds for five weeks, so generous a sum that Papa intended "giving back £1";[70] Lollie doesn't record whether the pound was in fact offered or accepted.) Both the young girls wanted to marry Jack Yeats when they grew up. He attended church faithfully every Sunday—a result of his Sligo training—and showed a talent for business enterprise, drawing menus (offered for sale to Lady Gore-Booth at Lissadell, the Sligo Ascendancy house) and doing sketches which despite his youth he tried to sell to magazines.[71] Like his brother, Jack sought to escape from his father's "drifting." He began making money early: in the thirteen months ending December 1890, he earned at least £19.2.8.[72]

When cousin Ida Varley (Isabella Pollexfen Varley's daughter), nine years old, saw the brothers for the first time shortly after the publication of *The Wanderings of Oisin* she was instantly attracted to Jack. Willie struck her as affected. When she was presented to him he said in a loud and "unnatural" voice, "Oh, ah, and so this is Ida," pronouncing her name as if it were "I-dah," with both syllables accented.[73] Jack, she said, was "very sweet and gentle, not noisy like the Yeatses but quiet like the other side of the family"—by which she meant, of course, her side of the family, the Pollexfens.

Lily's work with May Morris, begun with such high hopes, was to sour quickly. May proved a "she-cat,"[74] with a temper to match her father's. Lily stayed with her five and a half years, her wages rising from ten shillings a week to thirty. Though welcomed by the Yeatses, the pay was low; and May allowed her employees no holidays. She never paid them when absent for illness, and if a girl arrived five minutes late in the morning she had to make up the time

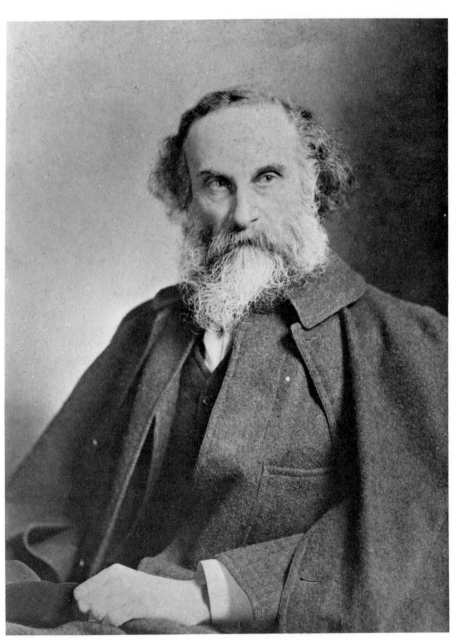

Dr. John Todhunter (1839–1916), about 1893. Collection: Joan Lambe, née Todhunter. Permission of Mrs. Lambe and Mrs. Marjorie Todhunter.

during lunch hour. Each employee got two weeks' vacation a year. Lily, hungry for Sligo, always took an extra week at her own expense, left for Euston Station by the night mail train immediately after work, and, on the return trip, rode the train through the night in order to report on time the Monday after vacation ended.[75]

May looked for trouble where none existed and even set others in the Morris household to spy for her. Lily had been troubled since childhood by respiratory difficulties, perhaps the result of her premature birth, and was frequently tired. Once, when Emery Walker was at the house, he found that the door to Lily's workroom wouldn't open. Lily heard him go into the next room and say indignantly to William Morris, "She's locked herself in." Morris sprang up to chastise Lily who, he was sure, was taking a nap or otherwise neglecting her work. When he threw his weight against the door it opened easily; it had been sticking to the floor because of the damp weather. Lily was sitting placidly at her table, embroidering. She did not feel obliged to say anything and simply smiled at the two men standing in the doorway in their fractured indignity.[76]

The work was not what outsiders thought. May seldom did any work herself but supervised the girls, who never completed a curtain or bedspread but simply began the needlework for wealthy women who purchased the designs from May. Lily enjoyed the work more when the shop was in Kelmscott House than after it had been moved, on May's marriage to Sparling, to Hammersmith High Street. At Kelmscott she often stayed for dinner and met interesting people; no one called at the other shop, which William Morris denounced as "a hole." Because of the Morris reputation, other promising young ladies signed on to learn embroidery, but Lily was the only one who stayed; the others came and went. The actress Florence Farr (Mrs. Edward Emery), H. M. Paget's sister-in-law, was one. Another was Lily Mason, daughter of the artist who painted *Harvest Moon*; her mother made her leave, maintaining she could not "attend to her social duties," or, as Lily puts it, "meaning she would never get a husband sitting on a chair doing embroidery."[77] Mrs. Mason's instincts were right; her daughter eventually married and moved to China. Lily Yeats stayed with May Morris and remained a spinster.

Lollie wanted to work regularly outside too but was prevented by Mama's illness until a second servant, Maria Brien, was brought to join Roseanna ("Rose") Hodgins, who had been with them since the mid-1880's. Maria, hired to be "temporary," stayed with the Yeatses permanently.[78] Then Lollie began teaching at a kindergartern school in Bedford Park as an apprentice and set herself to learning the Froebel system, named for the German educator who had formed the first kindergarten. She won her certificate with honors,[79] then developed a "brushwork method" of painting which she taught to neighborhood children, among them Mariella ("Cuckoo") Powell, York Powell's daughter. But her schooling was punctuated by a recurrence of nervous upset, which caused her to flee to Dublin for a while. "She has not been very well,"

Willie wrote Katharine Tynan in April, 1889; "combined housekeeping and kindergarten anxieties have been too much for her perhaps."[80] When she returned a month later Willie reported that she was "working very well," but the family knew that the next outbreak would come in time. "Jack says she is on her good behavior but that she will get 'a fling in her tail' soon."[81]

Mama was the anchor that held them to Blenheim Road. The paralysis caused by the strokes had disabled her for housework, although she remained able to read and write. She was not an easy patient even though, just as she had told her children to "grin and bear it" when ill, she herself "endured and made no moan."[82] With each passing year she grew worse. In early 1889, Willie described her as "feeble,"[83] completely unable to manage the household chores. Yet she stubbornly refused to be regarded as unusual. Once, when a barking dog troubled the neighborhood, Joseph Nash the artist suggested that a complaint to the owner from JBY might be effective since he had "an invalid in the house." Susan overheard the remark and was as disobliging as ever. Insisting that she was not an invalid, she refused to let her husband write the letter.[84]

Willie still kept his father in the dark about his mystical pursuits. Shortly after the move to London he met MacGregor Mathers and, at a studio in Charlotte Street, Fitzroy Square, was initiated into the Hermetic Order of the Golden Dawn;[85] among its other members by 1890 were Florence Farr Emery and a wealthy Manchester spinster, Annie Elizabeth Frederika Horniman, both of whom were to affect WBY's career profoundly. In 1889 also he met Mme Helena Petrovna Blavatsky the theosophist. JBY knew tantalizingly little about what his son did among such people. In 1890, Willie and Charles Johnston spent a vacation at Ballykilbeg House near Downpatrick[86] and Father could only guess what occult matters were under discussion. Most humiliating of all must have been the meeting at 3 Blenheim Road in the last week of 1891, shortly after Parnell's death, a meeting called and directed by WBY to establish an Irish Literary Society in London. Todhunter attended, along with J. G. O'Keefe and W. P. Ryan. Out of their deliberations the new society was to arise, but JBY, in the full vigor of middle age, seems not to have been included, nor did he make any attempt to join the organization.[87]

The artist sought solace in the Calumet, the conversation club that met on alternate Sundays in members' homes. It was a small group, "not more than a dozen," according to JBY's memory.[88] During the 1890's it included, besides J. B. Yeats and Todhunter, York Powell, Joseph Nash, Elkin Mathews, Sergius Stepniac the anarchist, and Paget. Meetings began at nine in the evening and sometimes lasted till two or three in the morning. JBY persuaded the members to adopt two principles: that just enough wine be served to loosen the tongue, and that the lights be turned up so that speakers could see one another's faces.[89] At the meetings JBY was the genial and pleasant public man, concealing his personal problems, which most of his neighbors knew about anyway.

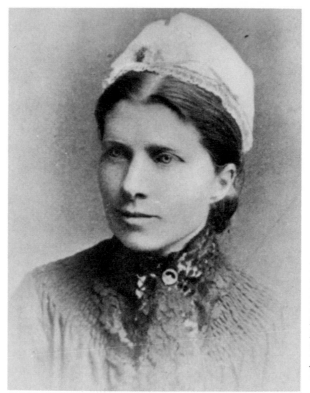

Elizabeth Dickinson West, who became the second Mrs. Edward Dowden on December 12, 1895. From *Fragments from Old Letters: E. D. to E. D. W., 1869–1892.* Second Series. (London: J. M. Dent; New York: E. P. Dutton, 1914), facing p. 151.

Being interested only in artistic principles, he was in no danger when he made extravagant pronouncements or argued inconsistently. He was good at making friends if not money. To many his lack of interest in "getting on" was one of his principal charms. Oliver Elton, who had brought his bride to Bedford Park in 1889, found him a man "spectacularly not on the make," and hence a good companion to whom he could talk freely.[90]

Yet success in conversation could not substitute for the prosperity and achievement of his friends and children. Todhunter's play, *A Sicilian Idyll*, was produced at the Bedford Park Social club on May 5, 1890, and played to packed houses for twice the number of performances originally planned.[91] Edward Dowden, in a letter praising the painter's son warmly for his *Oisin* (Willie was so pleased he walked to Todhunter's with the letter and then sent it on to Miss Tynan),[92] urged him to try his hand at a poetic drama, in which Ellen Terry might play the leading part. Willie repeated Dowden's suggestion to O'Leary, adding that he had for some time been thinking of writing a poetic drama based on the tale of Countess Kathleen O'Shea; perhaps because of Dowden's encouragement he was deep into its composition by early March.[93] Willie had been impressed by the acting of Florence Farr (the maiden name

and stage name of Mrs. Emery) in Todhunter's play and because of her began to develop his ideas about chanted drama, in which the end sought would be the impersonal presentation of verbal and vocal beauty.[94] In the same month in which Dowden praised Willie's book the *Fortnightly Review* published an article by Dowden attacking the Celtic revival. Without mentioning Willie by name, he called the revival foolish, describing what he saw in unflattering terms. "If the Irish literary movement were to consist in flapping a green banner in the eyes of the beholders and upthrusting a pasteboard 'sunburst' high in air, I, for one, should prefer to stand quietly apart from such a movement."[95] Todhunter was disturbed. "I wish we had a Nationalist Dowden to direct the literary movement now on foot," he wrote him pointedly.[96] When his brother John wrote him in protest, Dowden replied in less diplomatic language than appeared in the article, attacking "the absurdities of Irish antiquaries and others," and praising Anglo-Irishmen of the Ascendancy instead, men like McCullagh and Hamilton and Salmon.[97] To Dowden nothing could be properly Irish if it were not also somehow English.

JBY's old friend Edwin Ellis, still in the neighborhood, was no longer as exciting as he had once been. Cowed by his wife, he was dubbed by Lollie "the forlorn sheep." Willie took Ellis over, and before long the young poet and his father's old friend were deeply engrossed in a study of Blake's mystical poetry. Ellis served a purpose Willie's father could not: Lollie reports that on November 27, 1888, Willie went to Ellis's "to talk his head off."[98]

Wives had taken a heavy toll of the friendships begun years before. Ellis's wife, his second, was a termagant, jealous and possessive. Mrs. Edward Dowden, after enduring her third decade of the persistent propinquity of Miss West, died in October, 1892, and a released Dowden, after a seemly wait of three years, married Elizabeth Dickinson West in December, 1895.[99] In Edinburgh, John Dowden cared for an incurably psychotic wife. In Bedford Park, JBY found it hard to visit at Orchardcroft, where his old friend Todhunter was cut off from friendly association with his fellow men by the sharp and mobile tongue of his second wife. On Christmas Day in 1888 JBY dropped by for a few hours of glorious talk with Todhunter until "that she-dragon of contention, his wife," entered the room and "soured the cream."[100] (A neighbor at Bedford Park, a paralytic, who enjoyed Todhunter's visits, "always wished Mrs. Todhunter could not come"; but "she always came.")[101]

Still, Todhunter was producing plays, the Dowdens were flourishing in their chosen professions, and even the no-longer-young Ellis was hitching his wagon to the star of the younger Yeats. That star exploded brightly in late 1890 with the publication of the poem which more than any other was to establish WBY's fame throughout the world, "The Lake Isle of Innisfree," another product of his nostalgia for Sligo and dislike of London.[102] He had now overtaken his father, described by Dowden two years earlier as "a man of genius with some flaw in his working powers as a painter."[103]

As young Willie moved upward toward success, his father descended. Most of the editors to whose publications he submitted drawings humiliated him. In April, 1889, he received a letter from the editor of the Tract Society saying he would have no use for the drawings JBY had just submitted.[104] At the same time the Society sent Willie two drawings by another artist and asked if he could write verses to accompany them. JBY was sure the only reason his sketches were considered at all was that Lily had been the model for the faces in all of them. He was so ashamed of the few pictures that were accepted that he could never bring himself to look at them after they were printed.[105] The descent from Olympus is seldom easy, and he, who had never achieved the peak, was not enjoying the fall.

1892–1896

IF WILLIAM BUTLER YEATS's Four Years saw a shift in the compara-
tive positions of father and son on the ladder of reputation and
success, the next four widened the distance between them by several rungs. By
Willie's thirtieth birthday he had published or made ready for publication
seven books (and American editions of four of them), had seen 173 essays,
letters, or poems published by twenty-nine different periodicals, and had
edited or contributed to fourteen other volumes. One achievement, almost an
unspoken rebuke to his father, was *The Works of William Blake*, published in
February, 1893, with Edwin Ellis as co-editor, the man with whom his father
had begun the study of Blake a quarter of a century earlier. Another, *The Celtic
Twilight* (1893), a collection of poems and essays, was to give its name to the
movement that led to the Irish Literary Revival.[1] During the same period John
Butler Yeats had all but abandoned portrait painting and, despite being
admitted as an associate member of the Royal Hibernian Academy,[2] was
marching relentlessly toward the country of the hack artists.

Yet the acknowledged poet of the new day still lived in the small room in his
father's house on Blenheim Road, with an invalid mother, two spinster sisters,
and a younger brother. He spent as much time away from it as he could,
among his fellow occultists or among publishers and fellow poets at the Che-
shire Cheese, where he and Ernest Rhys founded the Rhymers Club with
Lionel Johnson, Ernest Dowson, Arthur Symons, and John Davidson.[3] In
Dublin he stayed with John O'Leary, in Sligo with George Pollexfen, and
whenever he could he tried to be in the neighborhood of Maud Gonne, to
whom his passionate devotion was total. Yet, when he was not away from
London, Bedford Park was home, the place where he hung his hat and kept
his books and wrote his poetry. Every night his father was there, like the
Ancient Mariner, at the other side of the dinner table, discoursing on
philosophy, art, and literature, and Willie could not choose but hear. It has
been said that John Butler Yeats was one of the few fathers who lived long
enough to be influenced by his son, and the epigram is so good that one wants
to believe it. Yet it is clear that, except for his forays into the occult, the ideas on

literature, art, and politics that William Butler Yeats made known throughout the world all grew from the seeds planted by John Butler Yeats, the sower who could not reap. Try as he might, the demon of Blenheim Road was one Willie could never exorcise.

Around the Irish countryside WBY was already a well-known figure,[4] but he was still awkward and unsure of himself. One night Lily came across Willie in the street "in the agony of another lyric." The two walked together toward home, the passers-by looking at Lily "with sympathetic eyes," saying to themselves, "Such a nice girl, out with that poor mentally afflicted gentleman." Once in the kitchen Lily hung flypaper. which the flies studiously ignored, "being intensely interested in everything else in the room." Willie, clad in a magnificent new coat chosen partly to improve his image as a poet, got stuck on it, and the coat was separated from the sticky glue with difficulty. His sense of diplomacy, especially where his own interests were not involved, had not improved. When Cousin Susie Orr telegraphed Lily that she had won her school certificate, Lily wrote and congratulated her, then forged a second letter and put Willie's signature to it. Six months later Susie got the brilliant idea of asking Willie to write the verses for a song for her new school but couldn't summon the courage to ask him—though she had no hesitation about asking Jack to do illustrations for the school magazine, a request he complied with at once.[5]

During these long slow years John Butler Yeats was an alienated witness, viewing his son's achievements with a mixture of admiration and anguish, happy that Willie was famous and successful but disturbed because he wasn't developing quite as his father had hoped. Willie's devotion to mystical pursuits was particularly upsetting, for JBY felt that its continuance would damage both his poetry and his health. Knowing how much his son respected John O'Leary, he dropped a hint to the old man to use his influence to get Willie back on course. O'Leary responded with a strongly worded postcard to Willie. With customary bluntness Willie rebuked the old Fenian.

Now as to Magic. It is surely absurd to hold me "weak" or otherwise because I chose to persist in a study which I decided deliberately four or five years ago to make, next to my poetry, the most important pursuit of my life. Whether it be, or be not, bad for my health can only be decided by one who knows what magic is and not at all by any amateur. The probable explanation however of your somewhat testy postcard is that you were out at Bedford Park and heard my father discoursing about my magical pursuits out of the immense depths of his ignorance as to everything that I am doing and thinking. If I had not made magic my constant study I could not have written a single word of my Blake book, nor would *The Countess Kathleen* have ever come to exist. The mystical life is the centre of all that I do and all that I think and all that I write.[6]

The truculent rejoinder was not mere bravado, for Willie meant every word he wrote. Father changed his methods and thereafter engaged in sniping attacks, tossing firecrackers into the mystical tents, abandoning frontal

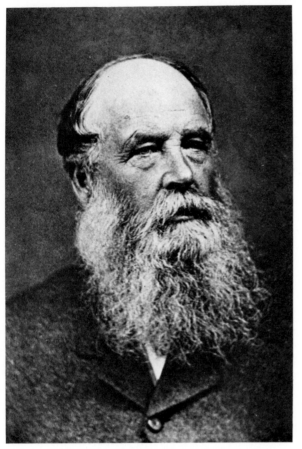

William Pollexfen, about 1890. Collection: Michael B. Yeats.

assaults. Father's own position was not so simple as it had once been: his objections to the occult were blunted somewhat by his discovery that Lily, like her cousin Lucy Middleton, had an unusual kind of foresight, seeing visions that proved remarkably prophetic. She usually experienced them when wide awake, sometimes when in the half-waking state just before or after sleeping. Her visions, unlike her brother's, came unsought and unforced. She stared into no crystal balls, joined no mystic societies. She reported the visions but made no special claims about them. Years later she compared them to radio waves which would be explained by "the Marconis of the future."[7]

Papa's career as a portrait painter seemed finished, even though some friends of O'Leary's had joined together to commission a portrait of him.[8] As the "crises" in Bedford Park were unending, he had to undergo the embarrassment of asking O'Leary to get his friends to pay up.[9] Despite this and portraits of Jack, Sergius Stepniac, and William Morris, he did so little in oils

that he almost forgot that he had done anything at all.[10] Just as the family fortunes seemed to touch bottom in late 1892, a double event in Sligo, sorrowful as it was, came to the family's aid. On October 2, Elizabeth Pollexfen died at the age of seventy-three. At Blenheim Road, JBY opened the telegram intended for Susan and read the sad news. Unable to make the journey himself, he wired Willie, then in Dublin, and Willie hastened to Sligo to represent the Yeatses at the funeral. As he was about to leave after the ceremony, Grandfather William, who had not been well, took a turn for the worse, and Uncle George asked Willie to stay. Just six weeks after his wife died Grandpa joined her. He died with only a nurse and his daughter Elizabeth Orr present. "He said, 'George, fetch your mother' (thinking that George was there) . . . and then after a pause held out his hands saying, 'Ah, there she is,' and with that he died. They thought at first he was asleep."[11] He was buried beside his wife in the "grey stone tomb" he had designed in the churchyard of St. John's, not wishing to be buried near the Middletons inside the church.[12]

To the Yeats children the deaths of their grandparents marked the ending of an age, a final farewell to childhood. "With them went Sligo for us," wrote Lily, "and all its charm and beauty, and our childhood seemed pushed back into space."[13] Years later, when William Butler Yeats wrote his *Reveries over Childhood and Youth*, he ended it with the deaths of his grandparents.

Three of William's eleven surviving children did not attend the funerals. Susan could not move from Blenheim Road. William Middleton Pollexfen was well into his second decade in the Northampton mental hospital. Agnes Pollexfen Gorman, the "tarmigant" of Willie's boyhood, had fallen victim to the same illness that afflicted William and was herself confined under restraint, as she was to be many times during her long life, in an institution for the emotionally disturbed.

One who did attend the funeral showed distressing symptoms of the kind found in Agnes and William. Elizabeth Pollexfen Orr, the happy-go-lucky, somewhat light-headed daughter who was present at her father's deathbed, visited Bedford Park after the funerals and took to discussing her parents' deaths with anyone who came by, even with delivery boys who were strangers to the family. At first her behavior was dismissed as the immediate effect of shock. But she showed no signs of improvement, her symptoms rather growing worse, and "she had to be 'put away' for some weeks and not allowed to see anyone or get any letters even from her husband."[14]

The size of William's estate was surprisingly small for one so important in the affairs of the town and justifies Lily's later contention that after her great-uncle William Middleton's death in 1882 the business faltered badly.[15] The executor's account showed a gross sum of only £1,975.1.4, not including £2,500 already set aside for the care of William at Northampton. The will provided that all surviving children, with two exceptions, share equally.[16] William was of course excluded. So was Fredrick, who, "tiresome and ag-

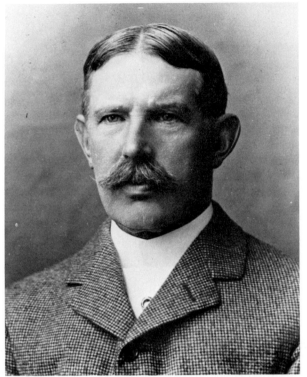

George Pollexfen, about 1892. Collection: Michael B. Yeats.

gravating," had long since fallen out of his father's favor. Not long after the firm was reorganized at William Middleton's death in 1882 Fred was eased out; and when his marriage to Henrietta Johnson began to crumble, the Pollexfens took her side, not his.[17]

Susan's share of the legacy, £116.11.11, was paid in installments of fifty pounds each December until 1898, the annual five-per-cent interest accumulating until the final payment. In the reorganization of the firm, which continued to be called the W. and G. T. Pollexfen Company, Alice's husband Arthur Jackson, who had been managing director for almost a decade, was allowed to assume control. George declined to exercise responsibility. About the time his father died George confided to Jackson that he had lost all his money except for £10,000 tied up in the firm and was worried lest that go too.[18] Thereafter Arthur saw to it that George's money was protected, and one of the firm's bookkeepers named Doyle, whom George had saved from drink,[19] managed his accounts.

George had always liked Lily and had grown close to Willie through their shared interest in the occult. During late 1894 and early 1895, Willie stayed six months with George at Thornhill, his home in Sligo. Early in the visit George became ill from a bad smallpox vaccine, and Willie cast symbols and invoked

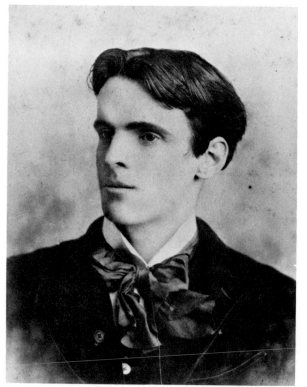

William Butler Yeats, 1894.
Collection: Michael B.
Yeats.

"divine names connected in the kabalistic system with the moon."[20] George attributed his quick cure to his nephew's magic, and the event cemented their friendship. JBY always felt George would have been happier if his talented nephew had been named Pollexfen and not Yeats.[21] According to a Sligo relative, George thereafter privately allowed Willie a pound a week, which was continued for some years until Willie's nationalist sympathies angered him and he stopped the grant.[22] Despite his friendship George remained the difficult egoist JBY had known in the Isle of Man forty years earlier. "He never treated me quite as a grown man," WBY complained, "and had the selfishness of an old bachelor—I remember still with a little resentment that if there was but one kidney with the bacon at breakfast he always took it without apology."[23]

To his old schoolmate and brother-in-law George remained aloof and, beneath his emotionless exterior, disdainful. George had long since given up answering his letters and refused to help him financially. JBY wrote sorrowfully to Lily years later: "George would give you everything down to his last farthing *from principle,* but *not a farthing from good feeling.*"[24]

If Willie was still emotionally tied to Blenheim Road, Jack was under no such

restraint. One day in 1892 he informed his father that he had found at art school the girl he wanted to marry and was going to make money as quickly as possible to be able to take the step. She was Mary Cottenham White ("Cottie"), from nearby Gunnersbury. She was quiet and shy, "frightened of her own shadow," as JBY saw her, though he found the quality "engaging." Everyone in the family liked her.[25] When Jack found a job on a newspaper in Manchester he moved there immediately and stayed two years—"the least satisfactory working days of his life," he was to call them.[26] By 1894 he felt he had earned enough to justify marriage, although his own affluence was not an issue; Cottie was the beneficiary of a trust established by her father which brought in a substantial income for the rest of their lives. Knowing what her new in-laws were like, and worried that she might not have the strength of will to keep her inheritance from disappearing down the Yeatses' "swalley hole," she had her lawyer draw up papers to insure that the allowance she made to her mother was removed from her control.[27]

The marriage took place on August 24, 1894, at the Emmanuel Church in Gunnersbury, with all the Yeatses except Lollie and her mother present.[28] The newlyweds settled in Chertsey, Surrey,[29] in the open country yet only thirty-five minutes from Waterloo Station. Thereafter Jack and Cottie were members of the family at a distance, though visits were frequent. By 1896 they had found even Chertsey too hectic and ordered a cottage and studio to be built for them at Strete, near Dartmouth, in Devon. Called "Snaile's Castle,"[30] it became their permanent residence until their move to Ireland more than a decade later.

The energetic Lollie earned money by her teaching of brushwork painting, one year bringing in three hundred pounds.[31] Between her classes she managed to write and publish in 1895 a little book on the subject. It was an instant success and made her seem "happy, and quite easy about the future." An unsatisfactory review of it in the *Chronicle* angered Lollie and her father, but the book sold well and even created a demand for brushwork paper.[32] By late January of 1896, Lollie was able to bank five pounds, give another five to Papa and ten shillings to Rose, and to pay off a few small bills as well. Harry Lawrence (of the publishing firm of Lawrence and Bullen) told Willie he thought the book very good and added, "Indeed, you are an able family."[33]

But Lollie's old troubles remained. She found it hard to be happy, and she continued to allow Willie to annoy her, as she annoyed him, once having a tiff with him over "*an ink bottle.*"[34] When Willie got up early one morning, an uncommon practice with him, Jack asked, "Why on earth are you getting up at such an *unearthly* hour?" Willie replied, "I want to be down in time to pour Lollie's tea." Her father had warned her of the "plot against her peace," yet when Willie with elaborate courtesy tried to pour her tea and treat her as a *grande dame* she refused and made her own. "You can always get a rise out of Lollie," Papa told Lily.[35]

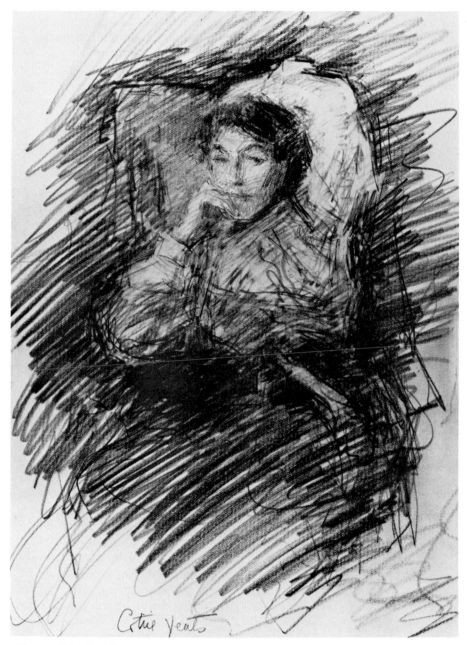

"Cottie" (Mrs. Jack B.) Yeats, about 1900. Pencil. JBY. Identification in the hand of Lily Yeats. Collection: Michael B. Yeats.

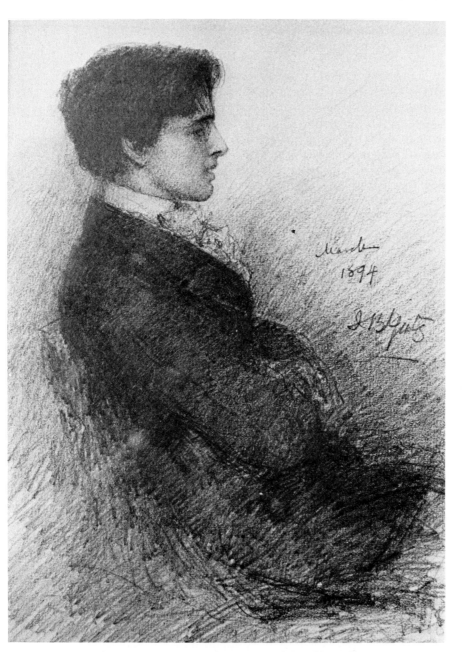

William Butler Yeats, March, 1894. Pencil. Signed and dated by JBY. James Augustine Healy Collection of Irish Literature, Colby College, Waterville, Maine. Permission J. Fraser Cocks III, Special Collections Librarian.

At the root of her problem was Louis Purser, brother of Sarah, a man of position at Trinity College, Dublin. Lollie, now in her mid-twenties, was ripe and marriageable. Louis had often visited her but never made a move.[36] He was in his early forties, unambitious and unaggressive, buried at TCD in the study of Latin texts. When a brilliant essay on Marcus Caelius Rufus appeared in one of his books, Robert Y. Tyrrell, his co-editor, received all the public acclaim for it, though Louis was the author. Louis never pressed his claim to public recognition, content that Tyrrell enjoy the credit.[37] When he visited Bedford Park in 1896 he was helping Arthur Palmer edit Ovid's *Heroides* and was only two years away from succeeding Palmer as professor of Latin. To Lollie he must have seemed, except for his years, an ideal catch. His family was almost as interesting as her own and, in the eyes of the world, far more successful. The writer of Louis Purser's obituary called him a "capable man of affairs, shrewd, cautious, successful in finance."[38] The words might well have been "miserly," "fearful," and "selfishly conservative," but these are not appropriate for lapidary inscription. Having achieved a comfortable life in commodious quarters within walking distance of the college, unburdened by a wife, Louis Purser could hardly have been expected to surrender his independence lightly. Yet he was powerfully attracted to Lollie, and his periodic visits kept her hopes alive. Lollie would have enjoyed the role as wife of a prominent TCD scholar, and the vision beckoned tantalizingly for decades.

While Lollie worked restlessly at her projects, Lily, still troubled by her undiagnosable ailment but as amiable and observant as ever, continued at May Morris's embroidery shop until her health gave way. May's bad temper had not improved; Lily always privately called her "the Gorgon." One girl developed nettle rash whenever May looked at her.[39] May's marriage to Halliday Sparling was disintegrating, to the disimprovement of her relationships with others. Lily stayed on only because the family needed the assured income. Papa was racked with guilt at his daughter's sacrifice and hoped it would end with an improvement in his own fortunes, which he was as always sure could not be far off. In the late summer of 1892 he had written Willie with unjustified optimism: "I am going to make a desperate effort to let Lily bank her money, or most of it. She is the only one in the house whose work is quite without intellectual interest, sewing away amid such depressing associations and in near neighborhood to the bitter and half-crazed Mrs. Sparling."[40] In April, 1894, when Lily's throat began to bother her, Papa suggested that perhaps it was time to leave the job. May and her husband were away at the time, and Lily, trying to be fair to her employer, sent a letter explaining that she would have to leave after May's return. May's reply was characteristic. She should have dismissed Lily long ago, she said, as Lily had always been so "delicate." Lily was furious, calling May's letter "very mean." Papa was so angry he couldn't sleep all night. Next morning Lily sat at the table and wrote to May at his dictation: "Dear May, I have received your malicious and impudent letter and will leave

Lily Yeats, about 1894. Pencil. JBY. Collection: Michael B. Yeats.

at once. Lily Yeats." She carried out her threat and never saw May Morris again.

For Lily the release was like freedom to a long-term prisoner. It was more than a year before she could go out in the daylight without thinking it must be Saturday afternoon.[41] She enjoyed the new liberty immensely. Her father had received a commission from J. M. Dent, publisher of the Temple Library, to illustrate the complete fiction of Defoe. Lily served as model for all the characters except the man Friday.[42] As a reward she was allowed to take the drawings to London, going on top of the bus all the way. The results were not always as pleasant as the journey. "Old Dent used to shed tears at the beauty of the drawings, and then used to pay me the miserable cheque for them."[43]

To the world at large the greatest benefit of Lily's new freedom was a diary begun a little more than a year after she left May Morris. As with Lollie's, it was the only one she kept and was regrettably brief.[44] Much of it was written while she was away in France as a governess and concerns people of little interest to those in Bedford Park. In compensation, her absence in France resulted in scores of letters to and from her father and sister at 3 Blenheim Road. From the twin sources we can piece together a detailed account of the Yeatses and their neighbors from August, 1895, until December, 1896, and get the first clear evidence of the "humour and observation" (Willie's words) which fill all Lily's written works.[45] But she had no ambition for authorship; she was devoted to father and fireside, got along well with everyone in the family, and served as confidante to all. Her sharp eye observed all that went on about her, and she described it in a direct, vigorous prose in diary and letters. When her letters from France arrived at Bedford Park the neighbors gathered round to hear Papa read them aloud.

Those in the immediate family appear and reappear in the pages of the diary, as do Florence Farr Emery, Elkin Mathews and his sisters, the Nashes, Pagets, and Todhunters, York Powell, John O'Leary, "Cattie" Hinkson (Katharine Tynan, now married to Henry Hinkson), Imogen Guiney, Nora Hopper, Lionel Johnson, Dora Sigerson, and Clement Shorter. Lily records the little adventures that made up life in the homogeneous community, and gives engaging portraits of her older brother. One day Willie went to Henley's home "in all the glory of a new coat, black, a joy and at the same time a disappointment," for he had wanted "to be a symphony in grey." "He had only got as far as the gloves," she reported, "and they are already buttonless." That was before he got stuck on the flypaper. She reports how Willie received an advance copy of his *Poems*: "He can't part from it but sits not reading it but looking at the outside and turning it over and over." That night a policeman rang their bell to tell them that the Pagets' door was open. As the Pagets were away Willie "had to go round" to see if anything was missing. "Nothing missing that they could discover, though how would they know unless the burglar had taken the grand piano or the dining table? Could not get the door to lock, so

between them fastened up the porch in such a way that Mr. Paget himself couldn't get in if he wanted to." On another day a friend of Lily's named Dora Isbister called. Willie confused her with someone else he didn't like and sardonically gave her "one of his grandest bows." Lily had no idea who he thought she was and suspected he didn't know either. In another entry Lily noted the appearance of a "Mrs. Shakespear," who was described as "Willy's latest admiration, very pretty, young, and nice."[46]

The diary is rich in such glimpses of people and activities. Two Pollexfens appeared at Bedford Park within a month, both under unusual circumstances. On August 13 when Lily answered the doorbell she found Uncle John Pollexfen the mariner standing uncertainly outside. He refused to come in until given positive assurances that nobody in the house was afraid of mumps, as he had just left his own house outside Liverpool where it was suspected the disease might have struck. Lily was delighted at the visit. "All the same hope he won't give the Yeatses the mumps. What spectacles we would be. Think of a poet with mumps."[47]

A month later, before breakfast, there was another unexpected ring of the bell. Standing on the front steps was a distraught Agnes Pollexfen Gorman seeking haven from the mental home from which she had escaped. It showed her own estimate of the comparative merits of the Yeatses and the Pollexfens that she fled to the home of her scorned brother-in-law. Papa had long since revised his earlier opinion that she was a "tarmigant"; now he thought her "the most gifted and generous" of the family.[48] She had been the only member of the Pollexfen clan to remember JBY on birthdays and anniversaries,[49] and he thought "she had a deeper insight in matters of feeling than any of the others but would never let you see what she thought."[50] Unhappily, "she was mad from the cradle."[51] Lily does not describe Aunt Agnes's symptoms, but her behavior may be inferred from the response to it. The Yeatses spent five shillings on telegrams. A nurse arrived that evening and was kept in hiding, and Robert Gorman came the next morning and procured a second nurse. It was not until six o'clock that evening that the patient and her company departed. "What a time," wrote Lily, "no sleep and unceasing talking. Poor people. How will it end?"[52] Papa was if anything more upset than Lily. "I could not remain in the same room with her more than three minutes and yet could not remain out of it," he wrote. "Her husband sat there with the tears rolling down his cheeks saying nothing, she quite dry-eyed. Of course she was mad, but every faculty of her really splendid and original intellect [was] fully alert and actively prompting."[53]

JBY himself sustained and withstood heavy assaults on the fortress of his sanity. In August, 1895, Lily began to notice that her father was not feeling well. He grew worse; Jack at length carried him off to a doctor, and he gradually grew better. Papa's troubles were probably psychosomatic, though there were clear physical symptoms. Troubled all his life by poor digestion,

now he was racked by abdominal pains of an intensity he had never experienced before.[54] He was fifty-six years old. His contemporaries were successful barristers, judges, or professors. JBY alone seemed to be standing still, a career of unfulfilled promise behind him. In the end it was only an unconquerable resilience and optimism that kept him going, the perpetual hope that he would soon be "turning the corner." But even as late as October 9, Lily recorded that Papa was "not very well" and added later, "Wish the Good man was all right."[55]

The most nostalgic, and most revealing, section of Lily's diary is of the two and a half weeks she spent in Sligo from late September through early October. All the beauties of the place in which she had spent her happiest childhood years appeared in sharp focus. She noted the "crowd at the station, all the cars, apple women," and, at Bowmore, everything "beautiful, lovely, hazy, sunny," with "the smell of the sea" "like strong drink." So delightful was everything that for more than a week she never sat down long enough to write in her diary.

She was not at all pleased with some of the news that came from London. She learned that Willie had moved out of Blenheim Road and rented a room at the Temple near Arthur Symons; he had told Lollie he thought he could live on ten shillings a week. "Let him try," wrote Lily. She added, and tried unsuccessfully to delete, another passage charging that if Willie could afford the Temple he could afford the board and room at Blenheim Road.[56] It is one of Lily's few mildly bitter passages. What she did not know was that Willie was leaving home not merely to assert independence but to be free to enter upon an affair with "the very pretty, young, and nice" Mrs. Olivia Shakespear. In June, 1895, he had reached his thirtieth birthday.

While Lily was still in Sligo, Mrs. Benson, wife of one of the Calumets, wrote to ask whether she would care to go to the south of France for six months as a governess. Papa and Lollie insisted she would be "an idiot" not to accept. Rose Hodgins, the servant, joined the plea, even though Lily's absence would mean more responsibilities for herself. When more letters came, Lily saw a web of fate entrapping her. That night, after Uncle George finished working at his astrological charts, he and Lily went out for an evening walk. Next day she realized fully how much she would miss Sligo: "I felt the affection of old friendship for the very mud tonight." It was "a lovely calm hazy day, the mountains so rich in colour, looks as if they were cut out against the sky." Then a telegram from Papa arrived: "Come on at once." She wrote in the diary, "Fate seems to have me by the hair of my head." She discovered that Uncle George was depressed and thought his condition might be the result of her decision to leave. But it wasn't, he assured her; it was only the weather, which had turned wet.[57]

She returned to Bedford Park, where Willie, home for a visit, was busy on a new poem, "very good, I think," she judged it. He told her fortune—"devil a word of truth in it," she wrote later after his forecast had been put to the test.[58]

T. W. Rolleston, about 1895. Pencil. JBY. Collection: Michael B. Yeats.

Jack and Cottie came to visit and say good-bye. Papa was still sick, unable to finish his drawings for Dent's Defoe. She saw Mr. Dent to explain the situation, and on Sunday, October 13, when York Powell and Paget dropped by, Paget "like a good angel" offered to help Papa with the drawings, which had to be done whether the artist was "ill or not." [59]

Less than a week later Lily arrived in Hyères, in the south of France, to begin work as unpaid governess to two little Anglo-Indian girls. Their aunt, a Miss MacKinnon, was an invalid who was cared for by a companion, Martha Wardle, who became a close friend of Lily's. [60] Within three months Lily came down with typhoid fever, and the other symptoms that had plagued her since childhood became magnified. Her employers took over her care while she continued to make entries in her diary and write letters home, bedridden

virtually the entire time. Fourteen months after she left London she returned, in December, 1896, still weak and uncured.

Papa was left at Blenheim Road with his sick wife, who more and more kept to her room, where Maria slept beside her at night, and with the nervous and excitable Lollie. Aside from what he got from Dent and an occasional fee from the Tract Society, he made little from his trade. He continued sketching, of course, but except for the O'Leary portrait there is no evidence that he was paid for his oils. An expected commission for a portrait of the treasurer of the King's Inns never developed, but it is hard to believe that the one of William Morris was not paid for.[61] There is no doubt that he was no longer regarded primarily as a portrait painter. The most telling evidence appears in a letter from T. W. Rolleston to Elkin Mathews in the spring of 1894. Mathews and his partner John Lane had just reached the pinnacle of their success with the *Yellow Book*.

I want to make a suggestion to you about the *Yellow Book*. It is that you should get some of the work of Mr. J. B. Yeats reproduced for it. (He is the father of Mr. W. B. Yeats). He is very unequal as a painter, but has at times done astonishing things and has a manner full of interest and individuality. I am thinking particularly of a thing called "A Nihilist," a picture now in possession of Dr. Todhunter, who I am sure would lend it if required for reproduction. . . . I think a picture of such power from a comparatively unknown man would attract much interest, and the topic is "up to date." [62]

"A comparatively unknown man"! "He is the father of Mr. W. B. Yeats"! It was good JBY never saw the letter. Rolleston seemed unaware that Mathews lived beside the Yeatses at 1 Blenheim Road and would know that JBY was a painter.

JBY suffered indignities from editors as well, who found excuses for rejecting his drawings. Mr. Stevens of *Leisure Hour* suggested that he learn the trick of doing more easily reproducible drawings, and Papa assumed that if he did so Stevens would automatically buy whatever he could produce.[63] On one occasion Stevens did pay him eight pounds for an illustration of "Innisfree" and apologized for not being able to give ten guineas for it.[64]

He sketched heads, conversed, and visited friends in Bedford Park. One of these was Mathews, known as "Charlie" or "Elkin," who lived next door with a gaggle of unmarried sisters whose idiosyncrasies at times converted his natural timidity to a poorly suppressed irritation. Lily described him as a "cross little man," and JBY told Willie he was "afraid of his own shadow." [65] His household was a menagerie of Victorian frustrations. In 1894, Mathews fell in love with Edith Calvert and until their marriage two years later engaged in a complex series of maneuvers to lodge the sisters as far from Blenheim Road as possible.[66] To those who knew the sisters it was no wonder that Charlie, though forty, fled to the dubious freedoms of marriage.

One night York Powell invited several friends to a supper before the

Elkin Mathews, December, 1893. Pencil. Signed and dated by JBY. Identification by Lily Yeats. Collection: Michael B. Yeats.

Calumet meeting at H. R. Fox Bourne's,[67] but a visiting lady ruined the evening. Papa wrote Lily:

I can tell you, if hatred killed, Tottie Bullen would be dead. There were we, Paget, Elton, York Powell, Williamson, and myself, all fond of each other and trying for a talkee-talk. But Tottie made it impossible, for she allowed no one to talk but herself and never took herself off to bed till 11:45 o'clock—and such talk, so inane, empty and perpetual, and in her *awful* voice—and with that perpetual grin on her awful hawk-like visage.

Elton had been the soul of courtesy throughout, but "when he and I came away together there was a burst of fury that astonished me and would have astonished her." It had happened before, Elton said: "Three or four right sort of talking friends assembled and no talk with each other because of this intolerable woman."[68]

Another meeting, delightful at the time but tragic in retrospect, was held in December, 1895, at Sergius Stepniac's home. The host was a forty-three-year-old Russian anarchist whose brilliance and good sense delighted his friends. He had just been made editor of a newspaper at a good salary and was in high spirits. JBY brought a portrait of Mrs. Stepniac which he had been working on for some time. She, knowing that JBY had been ill, remained in the living room until he arrived, sitting in the most comfortable chair to save it for him. The Calumet was a great success, and Stepniac shook JBY's hand when the party broke up, telling him how much he liked the portrait of his wife. "Never did I hear Stepniac talk so well," wrote JBY, "brilliant and yet as solid and sensible as the multiplication table." Early next morning Stepniac, walking along a little used railroad track that bounded Bedford Park on the east, was struck and killed by a train. Because of his position as a Russian revolutionary idealist in exile, there were rumors of suicide, and there was "a little passing anxiety about the inquest." But Dr. Hogg saw to it that such a verdict was not rendered. "Besides," said JBY, "it would have been too absurd."[69]

In addition to the Calumet there was Bedford Park itself with its commingling of talented and interesting people.[70] The Yeatses were responsible for much of the intellectual ferment there. Callers at Blenheim Road, in addition to those already mentioned, included Katharine Tynan Hinkson, John O'Leary, the American poet Imogen Guiney, Nora Hopper, Dora Sigerson, Clement Shorter, and Thomas Lyster and his sister Alice. Lily's diary and family letters are threaded with comings and goings. When George Pollexfen was a guest at a Calumet meeting he left early, done in by his hypochondria, and missed seeing York Powell, who arrived late.[71] One evening when Sarah Purser appeared at Blenheim Road, JBY promptly took her to visit the Pagets. York Powell was already there, as well as Florence Farr Emery, and there was a good deal of laughing. "You know Powell's powers," said Papa to Lily.[72] A month later Paget accompanied his sister-in-law to court, where she was

Mrs. Henry Marriott Paget (sister of Florence Farr Emery), Bedford Park, about 1895. Pencil. JBY. Collection: Michael B. Yeats.

granted a divorce from her husband, from whom she had been separated for years. There had been misgivings about the court's verdict as the grounds were desertion and, as Papa explained to Lily, "Emery had not deserted exactly, he was *sent* away." It was also his impression that Mrs. Paget "paid him money to depart."[73] Another marriage that collapsed was that of May Morris and Halliday Sparling. Only a couple of months after Lily quit her job May had to give up the shop. "She tried to make the girls love her and does not know why she did not succeed," Papa wrote Lily. She did no better with Sparling. By June of 1894 it had been agreed that Sparling would stay permanently in Paris and the marriage be allowed to lapse. "Lucky dog, Sparling," was JBY's comment. They were legally divorced in 1898.[74]

Long before he left Blenheim Road for his own quarters Willie tried his hand at the kind of poetic drama which had appealed to him ever since he saw Florence Farr's performance in Todhunter's *A Sicilian Idyll.* WBY had her in mind as elocutionist when he wrote *The Land of Heart's Desire.* Miss Farr had persuaded Annie Horniman to subsidize a season of plays, and the result was WBY's play and Todhunter's *A Comedy of Sighs,* produced together. Todhunter's play was not well received and was replaced after two weeks by George Bernard Shaw's *Arms and the Man.* Yeats's however, was held over for three weeks. Willie looked upon the treatment of the Todhunter play as a test of the critics. "The whole venture will be history anyway for it is the first contest between the old commercial school of theatrical folk and the new artistic school."[75] In the remark one can see the germination of the seed that was later to flower into the Abbey Theatre.

After he left Blenheim Road, Willie visited there regularly, especially when he was short of funds. In mid-December of his first winter away he dropped in and sat till after eleven o'clock, "visibly and unmistakably enjoyed himself and [was] pleased to find himself with his family." He explained that he had no money but that the new method of living had an advantage: "it tends to economy."[76] Two weeks later, when Willie stopped by on his way to Florence Farr's, his father induced him "with difficulty" to stay for tea: "it came out that he had had no dinner and did not expect to have any, since Symons had borrowed all his money, and he had only enough for his train." Symons to be sure would have no dinner either.[77] On another occasion Papa had the unusual pleasure of lending Willie two and six and sending him away happy. The poet had been "wandering about like one of the disinherited."[78]

Always where Willie went was that "lack of ordinary good nature." Papa wrote Lily in the spring of 1896, "Willie has been staying here the last few days. He has the greatest wish to be friendly and peacable, but he can't manage it, and though I was very sorry to see him go, for he is in good humour, both most attractive and affectionate, still wherever he is there is a constant strain and uneasiness."[79] The outward manifestations simply reflected the inner turmoils. During the early days of the Irish Literary Society, Rolleston had backed

Gavan Duffy rather than Willie for the leadership. Willie never forgave him, bearing his resentment even after Rolleston's death.[80] Although his father knew little about the intense and troubled life his son led—the unrequited love for Maud Gonne, the requited but not fully satisfying affair with Olivia Shakespear, the complicated and always frustrating dabblings in the occult—he could see that Willie aroused enmities as naturally as spiders spin webs. When JBY presented Mrs. Farrer, a neighbor who knew his son all too well, with a copy of Willie's *The Countess Cathleen* she put the book aside and changed the subject.[81] When an unfriendly, unsigned review of the book appeared in the *Daily Chronicle*, his father suspected John Davidson had written it out of spite, for Willie had offended Davidson. JBY took his son to task. "Was it Davidson—as a 'tit' for your 'tat'?" he asked.[82] Willie continued his warfare with Dowden in the periodicals on the merits of Saxon and Celt. When Katharine Tynan's husband Henry Hinkson edited for Elkin Mathews a selection of poetry by Trinity College graduates, *Dublin Verses: By Members of Trinity College*, Willie seized it as a club to beat Dowden with. In an article in the *Bookman* listing "the best Irish books," he slipped in the sentence: "Year after year the graduates and undergraduates of Trinity College compose vacant verses, and how vacant their best are can be seen from a recent anthology."[83] Naturally Hinkson was irritated and complained; Alice Mathews sat for a sketch next day and told JBY all about it.[84] Miss Tynan had a weekly column in the *Freeman's Journal*, and two weeks after the Hinkson complaint Papa reported to Lily that she had not yet mentioned Willie's new volume of poems.[85]

In the Rhymers Club, WBY was closest to Arthur Symons, more critic than poet, a student of the symbolist movement. At Symons's urging, Willie made a ten-day visit to Paris in February, 1894, after the exhausting work of finishing *The Land of Heart's Desire*. He was glad to go, for Maud Gonne was in Paris at the time. Symons gave him a letter of introduction to Paul Verlaine; and he carried a second letter, perhaps from York Powell, to Mallarmé. In Paris he was the guest of MacGregor Mathers and his wife, Henri Bergson's sister. He saw with Miss Gonne[86] a production of Villier de L'Isle Adam's *Äxel*, of which he wrote an enthusiastic notice for the *Bookman*.[87] He met Bergson at Mathers's house, and Symons arrived from London and took him to see Verlaine. Though the visit to Paris was brief,[88] it was to be one of the most important and influential in Yeats's poetic life.

One day early in 1896 JBY, in town with some drawings, stopped by the Temple to call on his son and knocked at Symons's door by mistake. Willie was out, he learned, working at the British Museum. Symons told him he liked Willie very much. "It is so pleasant to have someone to talk to when he comes in at night," Papa wrote Lily.[89] However, Willie soon abandoned the Temple to settle into an urban snuggery at Woburn Buildings, where he could entertain Mrs. Shakespear more discreetly.[90]

Although Willie was doing well with his magazine pieces—he got six pounds

for one story in the *Weekly Sun* and ten for another[91] —his first big commission came in the spring of 1896. Lawrence and Bullen, publishers of *The Celtic Twilight*, agreed to finance him in writing a long novel. They would pay two pounds a week for six months, plus expenses from England to Ireland and back. The novel was to be *The Speckled Bird*, an account of WBY's experiences with mysticism, of his relationships with Mathers and others in the Golden Dawn, and of Maud Gonne.[92]

Since Willie's departure from Bedford Park, Father had been troubled by his son's social rootlessness. During Willie's boyhood his father had served as a symbol of authority and support, as had Grandfather Pollexfen to some extent. After Willie's supposed rejection of his father, John O'Leary had served to fill the vacuum, but although Willie never lost respect for the old Fenian, he was a pale figure intellectually next to his father, and as Willie grew older O'Leary's influence receded. Edwin Ellis served for a while during their study of Blake. WBY learned much from Ellis, including "mastery of verse,"[93] but by 1896 his influence had waned, and there seemed no one to take his place. Just before his son embarked on his Irish venture, JBY made a remarkable comment:

I have no doubt when the six months he is allowing himself in his arrangement with L[awrence] & B[ullen] are expired and the novel only half begun he will find himself at [his uncle] George's, and moreover that the novel will go on all the faster. In those other places he will waste his energy in dreaming and projecting mighty plans. However, he might have the luck to find some friend who will listen to the MS, and help with his sympathy. Willie could never work alone.[94]

Prophetic words. What was clearly needed was another father to replace those he had inherited or adopted, had squeezed dry and discarded. Yet JBY never dreamed when he wrote the prescient lines that the new father would be a woman.

Traveling about Ireland, WBY and Symons at length found themselves in County Galway at the home of Edward Martyn, cousin of George Moore the novelist. Martyn was passionately interested in the stage, his zeal for it exceeded only by his devotion to Catholicism. Nearby lived another amateur scholar, Lady Augusta Gregory, a forty-five-year-old widow whose interest in Irish folk tales had been inflamed by a reading of *The Celtic Twilight*. She saw Symons and Yeats at Martyn's home, then invited the two younger men to dine at her home at Coole Park.[95] When Lady Gregory and WBY had met in 1895 at "some literary function" in London,[96] the meeting had meant nothing. Now sparks were struck. The new father Willie needed had appeared, if in an unlikely form.[97] More important, a new mother had appeared too to take the place of the pale and ineffectual Susan Pollexfen, who had never been able to exert her own influence on her son against that of her more powerful husband. Neither Willie nor his new friend was to be the same again, and neither were Ireland and Irish literature.

After the first visit to Coole, WBY took Symons to Sligo. Lollie was already there, and Jack and Cottie arrived shortly afterward. Papa filled Lily in on the details, as he had them from Lollie, who said that "the two poets were much liked. All the natives, men and women, fell in love with Arthur Symons—he is so quiet and unassuming." But when Jack arrived the two writers had to give way to Sligo's favorite Yeats. Jack would disappear in the morning, leaving Cottie and Lollie to the others. "Where were you all those hours?" his wife would ask him in the evening. "In a hayloft," he would answer. "Then details would come out, the fishermen and pilots he was with and the stories he told and they told." Cottie and Symons stood out as "the two Saxons" in the crowd. They "saw everything to the best advantage" and had "a *very pleasant* time." When Symons and Willie left, Lucy Middleton, the visionary cousin, said to Lollie, "The house is melancholy without the two poets."[98]

Then Symons left for England, and Willie returned for another visit to Coole, where he stayed several days. At Lady Gregory's flat in London that winter he saw her more often, and soon he was telling her about his play, *The Countess Cathleen*.[99] She was eager to fall in with his plans and to modify them with her own. Arthur Symons and others were later to deplore their parts in starting what they considered an unfortunate association. For Willie, who in the view of his friends was essentially a lyric poet, had persuaded himself that his strong point was drama. Now a champion with a strong will had come along who shared his opinion. Years later when Symons told Agnes Tobin that he hated Lady Gregory—clearly not herself but what she had done—she replied, "Well, Arthur, it was your fault." And he answered, "Yes, I know. It was I who brought him to Coole, and as soon as her terrible eye fell upon him I knew she would keep him, and he is now lost to lyrical poetry."[100] Symons never referred to Lady Gregory without calling her "Strega," Italian for "witch," though he used the term without malice.[101] There was no denying her force and resolution and the chilling severity of her presence. Recounting Symons's story in 1912, JBY said: "I don't regret her witchcraft, though it is not easy personally to like her."[102] Likable or not, the Dame of Coole's "powerful character" was to change the course not only of WBY's life but of his father's too.

CHAPTER NINE

1897–1900

JOHN BUTLER YEATS did not meet Lady Gregory until late 1897. In the months before, he had ample evidence of her effect on his son. By the time WBY left Coole Park after his second visit, he was convinced something could be done to make real his dream of a new poetic drama based on Irish themes and meant for Irish audiences. Now he had powerful outside support. Lady Gregory could provide the prestige of an old Ascendancy name and country home as well as her talents as writer and organizer. Her neighbor, Edward Martyn, could lend the moral support of a devout Irish Catholic and the financial help of a country gentleman.

In Paris in 1896 WBY had met a young Irishman named John Millington Synge, a TCD graduate who was studying French and German and producing imitative poems and essays. Long ago he had learned Irish but forgotten it. WBY advised him to abandon Paris and French literature, which could only be unprofitable for him. "Go to the Arran Islands," he said. "Live there as if you were one of the people themselves; express a life that has never found expression."[1] The chance meeting was to prove the source of the Irish Theatre's greatest plays, and to help divert WBY from lyrical and dramatic verse, where his genius lay, into work for which his father and others thought him much less suited.

With Miss Gonne, WBY established a branch of the Irish League in Paris and persuaded Synge to join it. His membership was brief. Even WBY was fundamentally unsympathetic to Maud's "most violent" ways and joined her political activities chiefly from a desire to please. He wanted to unite the Irish in a sense of their common history and to encourage them in self-education about the almost forgotten details of their Celtic heritage. Miss Gonne, a militant revolutionary, envisioned different purposes for the society. When Synge resigned after a few months he wrote her: "I wish to work in my own way for the cause of Ireland, and I shall never be able to do so if I get mixed up with a revolutionary and semi-military movement."[2]

WBY later wrote of 1897 as a year in which "a new scene was set, new actors appeared."[3] He began spending more time in Dublin, resuming his friend-

ship with O'Leary and with younger men like George Russell, the poet and mystic (usually called "AE" by himself and others) who had not been old enough to join Willie and Charles Johnston when they began their study of the occult ten years earlier. In London, WBY, Lady Gregory, Edward Martyn, and Martyn's cousin George Moore laid practical plans for establishing an Irish theatre. Martyn, who fancied himself a good playwright, had already written two plays that had been turned down in London and was thinking of offering one of them in Germany.[4] Each of the three men was to write his own account of their association in which, as one critic observed, "the other two were pictured as eccentrics."[5] Early in the year Willie laid aside his work on *The Speckled Bird* to complete a new play, *The Shadowy Waters*, intended as his contribution to the first series of Irish plays in Dublin. The play managed to include all the elements that appealed to Willie's interests at the time: Irish legendary figures with Celtic names like Forgael and Dectora, magic, visionary mysterious worlds, and the love of an insistent hero and a queenly woman. His father pronounced the play "absolutely unintelligible." But, he commented dryly to Miss Purser, "Mrs. Emery says she understands it, and as she is to act in it one of the principal parts this is important, though I suppose not absolutely necessary."[6]

JBY's judgment of the play in its 1897 form may be partly explained by Willie's own purposes, as he explained them in a letter to the Scottish poet William Sharp: "My own theory of poetical or legendary drama is that it should have no realistic, or elaborate, but only a symbolic and decorative setting. A forest, for instance, should be represented by a forest pattern and not by a forest painting. . . . The acting should have an equivalent distance to that of the play from common realities."[7] What was lacking in his definition of drama, then and later, was the dramatic. Fired by the magical voice of Florence Farr, driven by his notions of a "real" spiritual world more authentic than the "unreal" physical world in which we are forced to live our mortal lives, eager to bring pride and strength to the Irish tradition, WBY perceived the ideal theatre as an arena in which his own dreams and aspirations might be acted out to audiences eager to hear them. It was an interesting theory, if one not shared by Sophocles, Shakespeare, Sheridan, and Synge.

It may have been Father's unfriendly reaction to *The Shadowy Waters* that sealed Willie's lips again that year when he took off for Ireland. In July, JBY told Sarah Purser: "I don't know where Willie is or what he is doing. The last I heard was that he and Russell had gone west (Sligo or thereabouts) to find a new God."[8] In October, Willie made another visit to Maud Gonne, this time at the instigation of Lady Gregory, to find out once and for all whether she loved him. He had been pressing his claims for almost a decade and had never been flatly rejected. The forthright Lady Gregory wanted him to get the matter settled so they could proceed with their business. Willie traveled with Maud through England on her campaign to stir up its Irish inhabitants, but he never

received a clear answer to his question. Perhaps he didn't want to receive one. "She is very kind and friendly," he wrote Lady Gregory from Manchester, "but whether more than that I cannot tell."[9] Lady Gregory, with characteristic directness, sought out Miss Gonne and asked her intentions toward Willie. "I have more important things to think of than marriage," replied Maud Gonne, "and so has he."[10]

That settled the matter for the Dame of Coole, but not for Willie. Late in the year, when he was in need of money, Lady Gregory gave him an essay which, after slight revision, he sold for fifteen pounds to the *Nineteenth Century,* where it was published under the title "The Prisoners of the Gods" in January, 1898.[11] When the check arrived some time later he heard that Maud Gonne was in Belfast and instantly spent the funds on a visit. To Lady Gregory the act was a squandering of money, and the thought of it smoldered within her for years.[12]

Lady Gregory was a formidable woman to deal with, and when she set her mind to reconstituting Willie Yeats there was no one to gainsay her. From her perch atop the Anglo-Irish Ascendancy she could exercise her passion for Irish cultural causes without suspicion of self-interest; and she had a personality to match her determination. "She has a smile a little too scornful," JBY wrote, "only you know that danger or weakness is among the things she scorns."[13] She didn't like women, choosing to exercise her "powerful character" on men.[14] It is not surprising that she did not get along with Maud Gonne. She never took to Willie's sisters either, and when later in the year she took a fancy to Jack she showed a "too obvious dislike" of Cottie.[15]

When she took on Willie she took on his family too. In the fall she attended an exhibition of Jack's work at the Clifford Gallery, his first public show, and enjoyed it.[16] Soon she met the whole family at Bedford Park, where Edward Martyn was being sketched by JBY, who in turn was being soothed by the singing of a young woman from Dublin, Susan Mitchell, who had come to live with the Yeatses at Blenheim Road.[17] Lady Gregory commissioned a sketch of Willie, and later invited the whole family to attend his lecture at the Metropole. When JBY was somewhat late with the sketch, he offered the excuse of poor light: "I should like a chance of doing him by daylight." The next day, perhaps trying to impress his new admirer with his dedication to business, he declined an invitation to lunch, saying he needed time to finish the sketch.[18] By the end of 1897, Lady Gregory had lined up all the Yeatses she thought important— the three men—for further management.

Jack would prove not so easy to manage. He remained as always socially delightful, but was still a private man with an impenetrable reserve. Still not sure whether he was a painter or a writer, he wrote stories for periodicals.[19] He and Cottie moved in early 1897 into their new cottage at Fuge, near Strete, just outside Dartmouth. In the studio across the road he would hole himself up in the morning and allow no one, not even his wife, to watch him paint. No one

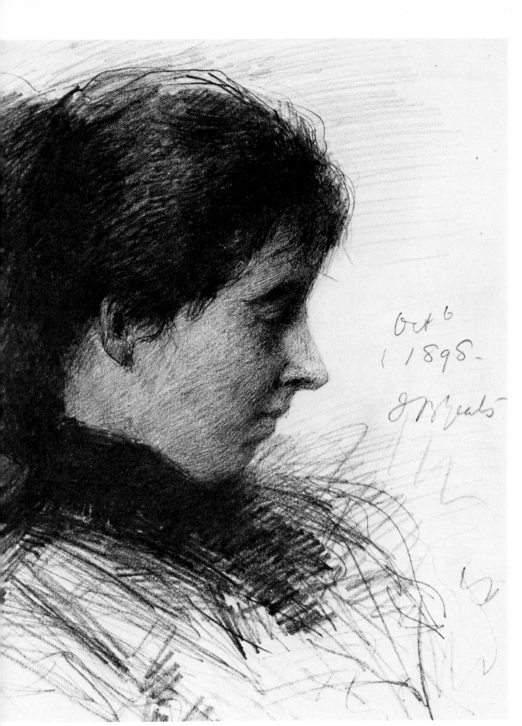

Oct 6
1898-

J B Yeats

lie Yeats, October 6, 1898. Pencil. JBY. Signed and dated by JBY. Collection: Michael B. Yeats.

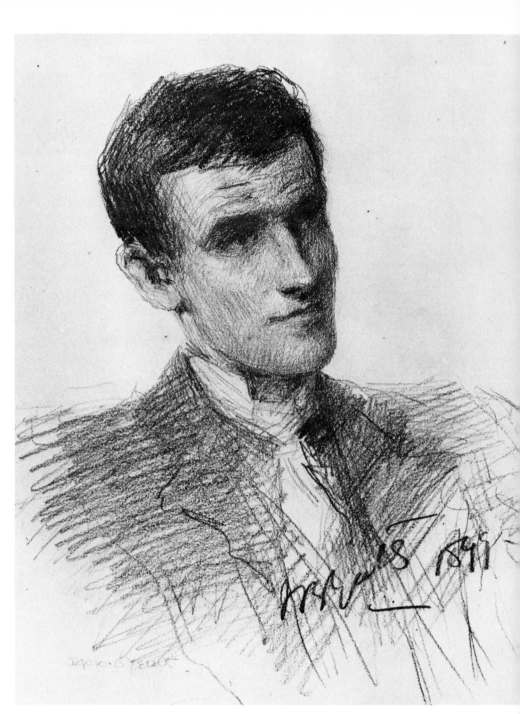

Jack B. Yeats, 1899. Pencil JBY. Signed and dated by JBY. Autographed lower left by Jack B. Y
Collection: Michael B. Yeats.

ever saw a painting of his till it was completed. If he was interrupted for any reason he threw a covering over the easel, left and locked the studio, and did no more work that day, even if the interruption came in the morning. Cottie occasionally forgot, so they developed a system: he wrapped a pipe cleaner around the doorknob with an end sticking out; when Cottie touched it she remembered not to knock.[20]

At Blenheim Road, JBY was alone in a household of women. Lily had returned from France in December, 1896, but was so weak from the effects of typhoid that she could hardly get out of her chair. As late as April, 1897, she reports (the next-to-last entry in her diary): "Still an invalid but better, go out in bathchair for twenty minutes in the morning, spend the rest of the time in my room on sofa."[21] Susan Yeats was still a granite block weighing the household down. Some time in the middle of the decade, perhaps in 1894 or 1895, she suffered another stroke, the effects of which became evident only with time.[22] In her eldest son's words about her last years, "her mind had gone in a stroke of paralysis and she had found, liberated at last from financial worry, perfect happiness feeding the birds at a London window."[23] She was conscious and able to read books and letters but most of the time did not really know where she was or what was happening around her. Her husband assigned her the daily task of writing to him, "and always she described the sky as seen from the parlour in Blenheim Road—*described it well*. It was the only thing she ever wrote about, for everything else was only a worry."[24] Once, when both daughters were away, Papa wrote to Lollie: "Your mother thinks you and Lily are still here."[25]

The Blenheim Road rooms needed renovation, but the landlord balked at bearing the cost for a tenant thirteen pounds in arrears. JBY was forced to redo Lily's room at his own expense, with help from his brother Isaac, who came through with a gift of thirteen pounds just when it was needed.[26] JBY's only income, save for the commissions from Lady Gregory, came from the sale at low prices of illustrations for magazines. In 1897 a set of eighteen such drawings appeared in the *Leisure Hour* to illustrate a story by Frederick Langbridge, published later in the year under the title *The Dreams of Dania*, with four of the drawings included.[27] When his friend Paget, forced to develop habits of punctuality by a heavy press of business, boasted one day that he had "no overdue work on his conscience," JBY wrote wryly to Sarah Purser, "I wish I had some overdue work on my conscience." He hoped to break into the Royal Academy Exhibition the following year, visiting the Academy regularly to see whether by studying closely the works of other portraitists he might see what was deficient in his own. He told Miss Purser he had been working on and off for a year and a half on a portrait of Lily.[28]

His happiest moments were those when he could enjoy the company and conversation of friends. In July he watched in delight as York Powell, the Anglophile, listened to John O'Leary and learned about Ireland from a Gaelic

Cashlauna Shelmiddy, Strete, near Dartmouth, South Devon

Overhead view of Jack Yeats's house and studio at Strete, Devon. India ink. Jack Yeats. In his letter to John Quinn, December 13, 1904. Collection: Foster-Murphy.

point of view.[29] He was overjoyed by a visit from John Dowden, resplendent in his garb as Bishop of Edinburgh. It was the first time they had met in twenty years and the last time they were to see each other. To JBY's disappointment Dowden declined to meet with York Powell because of his "evil reputation with churchmen,"[30] and as all his other neighbors were away they saw no one else.

When Willie fell ill at Coole, in the summer of 1898, his father feared he might be coming down with rheumatic fever and wrote Lady Gregory a letter full of worry and advice, "seeing that you are to him as a mother, better than a mother." She placed Willie on a regimen of strawberries and cream, and he recovered. Later in the year, when Willie had trouble with his eyes, it was to Lady Gregory that he wrote, not his father.[31]

The question inevitably arises why Lady Gregory took such an interest in William Butler Yeats. Maud Gonne did not hesitate to suggest—after Lady Gregory's death—that she was in love with him, and there were many to accept the suggestion and what it implied. Not that it matters; if an unmarried young man—or a married one for that matter—and a widow thirteen years his senior wished to become lovers, they would not have been the first such couple in history, nor would the world's supply of moral currency have been depleted. But nothing in the mountainous record of the relationship suggests anything of the kind. She shared his interests, and she was strongly attracted to him as a young man in need of mothering, though in fact she seemed at times more like an aunt. Elizabeth Coxhead wisely noted that in their correspondence she regularly addresses him as "My dear Willie," while to him she is invariably "My dear Lady Gregory."[32]

In 1898 the new partnership of Yeats, Martyn, Lady Gregory, and Moore was ready for its coming invasion of Dublin with "Irish" plays. To engender publicity for the project, WBY entered into a controversy with his former schoolmate W. K. Magee, who had written (under his pseudonym "John Eglinton") an article entitled "What Should Be the Subjects of National Drama?" Yeats persuaded George Russell and William Larminie to join him in an argument with Magee. The result was a volume, *Literary Ideals in Ireland*, published in May, 1899, intended, as WBY wrote Lady Gregory, to "keep people awake" until the great day arrived.[33] George Moore in the meantime was fashioning a novel, *Evelyn Innes*, in which Willie was cast as Ulick Deane, a musician.[34] As usual, Willie had more than one iron on the anvil. Shortly after the year opened he held an occult evening at Woburn Buildings at which Florence Farr and Arthur Symons were present, among others, along with the indispensable Hindoo mystic, this one named Sarojini Chattopâdhay. Willie announced the meeting in a letter to another mystic, Dorothy Hunter, in language that would have curled his father's beard:

I have had a number of visions on the way home, greatly extending the symbolism we got tonight. The souls of ordinary people remain after death in the waters and these waters become an organized world if you gather up the flames that come from the waters of the well when the berries fall upon it, and make them into a flaming heart, and explore the waters with this as a lamp. They are the waters of emotion and passion, in which all but purified souls are entangled, and have the same relation to our plane of fixed material form as the Divine World of fluid fire has to the héroic world of fixed intellectual form.[35]

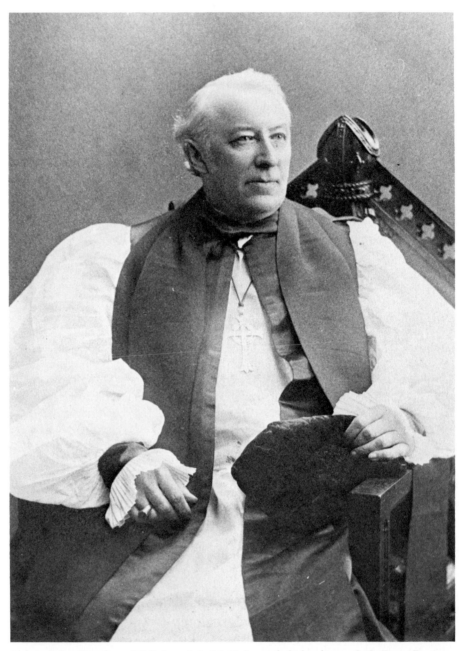

Bishop John Dowden of Edinburgh in his Episcopal chair, about 1898. From Rectory, St. John's Church, Sligo. Courtesy Canon T. P. S. Wood, Calry Rectory, Sligo, and the Very Reverend C. C. W. Browne, Dean of Elphin and Ardagh.

Everyone he knew and worked with was caught up in the occult, even Maud Gonne. Willie wrote Russell: "I am deep in 'Celtic Mysticism,' the whole thing is forming an elaborate vision. Maud Gonne and myself are going for a week or two perhaps to some country place in Ireland to get as you do the forms of gods and spirits and to get sacred earth for our evocation." Miss Gonne even proposed to build "a little temple of the heroes" to make the centre "of our mystical and literary movement," but only after the celebrations of 1898 were ended. She herself had seen a vision of the temple she hoped to build.[36]

Having brought William Butler Yeats under her control and encircled his father, Lady Gregory again set her sights on Jack, who still proved elusive. Both Papa and Willie urged him to accept her invitation to visit Coole Park. Jack assured Lily he would,[37] but failed to do so, greatly upsetting his father, who apologized to Lady Gregory on his son's behalf. "I think it was a great opportunity missed," he wrote her. "Jack does not know his Ireland outside Sligo. A hurried rush through the country is bad for work, and especially in the case of Jack who is contemplative and sensitive and finds all his ideas in that direction."[38] Jack may well have been responding to Lady Gregory's supercilious behavior toward Cottie.

Lady Gregory did better with JBY, who was happy to be wanted. She had been impressed by his sketch of Willie and, later, his portrait of Jack.[39] She gave him commissions for pencil sketches of George Russell, Horace Plunkett, and Douglas Hyde, work which required his presence in Ireland. For several months in the summer of 1898 he left Lily and Lollie at home with their mother and took up lodgings in Dublin at 18 Hume Street and worked out of a studio at Stephen's Green. There he sketched and painted and taught, in a school run by a Miss M. R. Manning, a class of young people, among them Clare Marsh, a painter who became almost like a daughter to him. Clare persuaded her aunt to sit for a portrait by JBY; but his habits had not changed, and after the second sitting she dismissed him in what he thought was a "summary and imperious" manner.[40]

He sketched Russell and Hyde[41] and, on Willie's thirty-third birthday, sketched him at Russell's home in Rathmines. He thought it the best sketch of Willie he had ever done, though he was cautious in describing it to Lady Gregory: "I feel very apprehensive as to how you will regard Willie's. With him I have never succeeded. Some *uncertainty of intention* always hangs over my pencil. . . . I shall no doubt some day get a good portrait of Willie. The medium (Chinese white and charcoal gray) as used is always a treacherous one, since when dry it looks so different from what it did when put on fresh."[42] Lady Gregory, with a sharper eye for his welfare than the older man himself, intended hanging all the sketches in her London flat so that viewers might "want a portrait of themselves."[43]

The sketches were to mark a new stage in JBY's career. Lady Gregory, like JBY's mother, realized that portraiture did not have to be in oil, watercolor, or

even chalk. JBY's skill lay in the pencil sketch, done usually in a single sitting and not easy to revise, and it proved the best advertisement for the oil portraits which he thought his specialty. By asking him to do simple pencil sketches, Lady Gregory at a stroke provided JBY with self-respect and an income, setting the pattern imitated later by Hugh Lane and John Quinn. By his work for those three patrons alone he was to create a portrait gallery that included virtually everyone of importance in the Irish Renaissance and in Anglo-Irish Dublin between 1898 and 1907.[44] Gradually he abandoned the illustrations for the mean little magazines. With someone to take an interest in his work he couldn't help philosophizing about the sketch as a form of art: "A sketch is far better—*reveals more* of a man portrayed than the best photograph—since it gives not merely the facts but a comment. One feels instinctively from the way the pencil or brush is handled what manner of man is the sitter. The artist does this quite *unconsciously*—otherwise it would not be done rightly."[45] If a sketch didn't come right one could put it aside and try another. Whenever John Pollexfen visited Bedford Park his brother-in-law tried to capture his interesting face, full of curiosity and benignity; there are more surviving sketches of John than of anyone else except Lily.[46] In 1898 he also sketched Clement Shorter, having to make a quick trip from Dublin to London to do so, then hurried back to continue his work on Horace Plunkett.[47] His old habits still enslaved him; in December he told Willie he had wasted the autumn doing two large portraits "for which I got nothing."[48]

Despite Lady Gregory's generosity, the money supply was still low. When WBY asked Russell in March, 1898, to mail him some copies of the *Internationalist*, he promised, "I will send the money afterwards. I do not know where to get it here."[49] Lollie, though working "fewer hours" than her father, had made seventy-five pounds during the last third of the year,[50] more than he. At Christmas only an unexpectedly large check from Sligo rescued the household from its annual flirtation with disaster. The check, signed by George Pollexfen and Arthur Jackson, was the final payment of William Pollexfen's legacy. Every December since 1893 Susan had received fifty pounds, with the five-per-cent annual interest on the balance accumulating. Now the remaining principal of £28.8.4 was combined with the accumulated interest to make a final payment of £75.16.0, half again as much as JBY had expected.[51] He had been ignorant of the state of his wife's account.

Yet the living room at Blenheim Road continued to be one of the brightest and most cheerful places in London. Two testimonials to the quality of life there came from Susan Mitchell and G. K. Chesterton. Miss Mitchell spent two years at Blenheim Road—from late 1897 to late 1899 as a companion to Lily and a paying guest. When she arrived, JBY said of her later, "she was merely a pretty woman who sang rather well"; when her sojourn ended "she was an intellectual woman" who had developed the weapons of wit with which she later tormented George Moore.[52] To her the experience was a liberal educa-

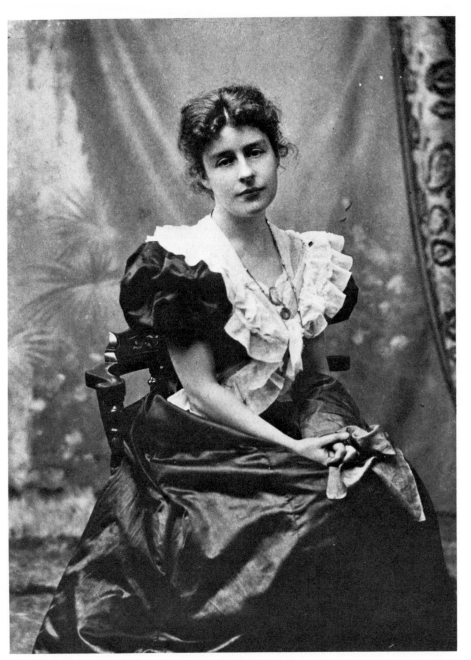

Susan Mitchell, about 1899. Collection: Michael B. Yeats.

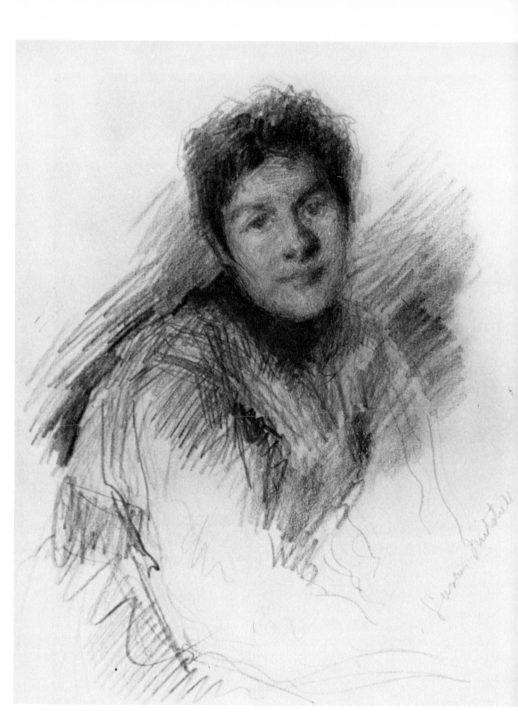

Susan Mitchell, about 1899. Pencil. JBY. Identification in the hand of Lily Yeats. Collection: Michae
Yeats.

tion. A few months younger than Lily, she had been adopted by two aunts on the death of her father in 1873. She grew up a beautiful girl with curly red hair who enjoyed the advantage of living next door to the Pursers on Wellington Road in Dublin. That had not prepared her for Blenheim Road:

> In the house of Mr. Yeats I found myself in what seemed to me a wonderful society, a society where ideas were valued above all other possessions and where normal conversation ran on subjects, some of which I had indeed thought of, but which thinking I regretted in myself. . . .
> . . . Here I might pour out voice and heart without obstruction, here pride of country, intellectual speculation, creative aspirations were fostered and not frowned on. . . . Now I was a fighter with one hand tied behind his back suddenly liberated; my powers were doubled. . . . In the Irish men and women I met under Mr. Yeats's roof I was having my first contact with a movement that was bringing about a revolution in thinking and feeling in my own country. . . .
> I wish I was skillful enough in words to paint for you that delightful household in Bedford Park, where first I learned what conversation meant, where Mr. Yeats, that brave head thrown back, his eyes smiling, said things that seemed to me daring, witty, full of old wisdom and young folly, but said them always with a distinction and grace that made the mere saying significant.[53]

Chesterton was courting Frances Blogg, a resident of the Park, and came to know many of its inhabitants, among them the Yeatses. His report on the Blenheim Road ménage supplements and confirms Miss Mitchell's:

> William Butler Yeats might seem as solitary as an eagle; but he had a nest. Wherever there is Ireland there is the family; and it counts for a great deal. . . . The intensity and individualism of genius itself could never wash out of the world's memories the general impression of Willie and Lily and Lollie and Jack: names cast backwards and forwards in a unique sort of comedy of Irish wit, gossip, satire, family quarrels, and family pride.

Then Chesterton, the master conversationalist, went on to pay tribute to the rivals of his genius, in an order that may help explain Willie's later denial of close acquaintanceship with him: "W. B. is perhaps the best talker I ever met, except his old father." Chesterton elaborated on JBY's gift:

> Among twenty other qualities, he had that very rare but very real thing, entirely spontaneous style. . . . A long and elaborately balanced sentence, with dependent clauses alternative or antithetical, would flow out of such talkers with every word falling into its place, quite as immediately and innocently as most people would say it was a fine day or a funny business in the papers. I can still remember old Yeats, that graceful graybeard, saying in an offhand way about the South African War, "Mr. Joseph Chamberlain has the character, as he has the face, of the shrewish woman who ruins her husband by her extravagance; and Lord Salisbury has the character, as he has the face, of the man who is so ruined." That style, or swift construction of a complicated sentence, was the sign of a lucidity now largely lost.[54]

In the ocean of later correspondence and miscellaneous writings one can see the qualities of JBY's mind and personality that had been in full flower long

before the years at Bedford Park. In addition to the musical voice and the instant command of elaborate syntax, he made no demand on his companions for anything but the best of themselves, and he seldom sought the "original." He once called Fred Pollexfen "a great dull original" but was not being complimentary. John Butler Yeats was the eclectic, the absorber, the artist who sought to take the ideas and expressions of others, whether original or not, and make of them something individual and special; in their rearrangement lay whatever originality appealed to him. The lessons JBY had learned from Mill and Comte as a youth he carried into age: that the raw material of the world is susceptible of examination by man's reason, but that reason is impor- tant only as it contributes to the highest development of the individual human being. As an artist and critic he never became a member of a "school" and indeed all his life deliberately avoided entrapment behind the barbed wire of other men's philosophies. He shunned permanent conclusions, his mind a vast computer receiving the raw materials of experience and imagination and rearranging them in infinite combination; but it was a computer that lacked a button to give the total. There could be no final answer while there was a possibility of further information to be fed into it. Hence he insisted on his own boundless receptivity and on that of others as well. JBY was the perfectly civilized citizen of an imperfectly civilized world, often assertive but never dogmatic, constantly playing with ideas as a child plays with toys. He excited others to think thoughts they had not thought before, and they left his presence with a higher opinion of their own worth. The most amusingly melancholy paradox of his career is that he who could so arouse the en- thusiasms and emotions of others should be so continually battered and harried himself by the exigencies of ordinary life.[55]

To his continuing problems with money were still joined those with Willie. He disliked the idea of Willie's working with Moore and declined to look at *Evelyn Innes*. "I do not feel very eager to read it," he told Lady Gregory. "I am certain to dislike intensely his *version* of Willie. To me it will be a sort of complicated insult though of course such things never really matter."[56] He shared Lady Gregory's opinion of Maud Gonne and hoped with her that Willie's infatuation would soon end. One night he and Lily attended a meeting of the '98 Centennial Association in London, with Willie in the chair and Maud Gonne the principal speaker. When he wrote Lady Gregory about it he went out of his way to compliment a young lady, otherwise unknown to history, by making an indirect comment on their common foe: "Miss Long looked beauti- ful—really a spirit from Paradise. I know other ladies, one especially, of unsurpassed brilliancy, who seem to have come straight from Purgatorial fires. But then Purgatory is the way to Heaven."[57]

As the influence of Lady Gregory mounted, John Butler Yeats marveled at the relationship of his son and the stern widow in her black Victorian weeds.

At the time he kept his counsel, but fifteen years later, from the safety of New York, he wrote Lily: "There could not be in the wide world two people more different from each other than Willie and Lady Gregory. Such a friendship or comradeship must be obstructive to the free play of natural feelings."[58] Nevertheless it thrived. Lady Gregory was still trying to draw Jack into the net, and still finding there was no mesh fine enough to contain him. When Jack visited Coole in the spring of 1899 he spent most of his time fishing with her son Robert, making friends with Robert's tutor, T. Arnold Harvey (called "Long" Harvey because of his height), a tall, handsome TCD athlete and scholar later to become Dean of St. Patrick's Cathedral and later still Bishop of Cashel, Tipperary, Waterford, and Cork. Jack took naturally to the "younger" group, itself a significant choice, for there was a strain between Robert and his mother: "she was more than anxious to please him, as if she felt that her power was slipping away or would do so some time."[59] She bought some paintings of Jack's for sixty pounds, and JBY thanked her. He told her he thought Jack would become a great painter, for at an exhibition of his paintings he had seen students with their faces close to the pictures trying to determine how Jack had mixed his colors. "I thought to myself, 'This is the sign that Jack is an initiator.' Jack is getting his happiness early." To "Long" Harvey he confided: "Some day I shall be remembered as the father of a great poet—and the poet is Jack."[60] Yet Jack still failed to behave conventionally, neglecting again to send a thank-you note for his stay at Coole.[61] He was cordial to Lady Gregory but kept his distance, preserving his privacy behind a solid wall papered over with charm.

The most important Irish literary event of the year took place on May 8, 1899, when WBY's *The Countess Cathleen* (rather than *The Shadowy Waters*) was produced at the Antient Concert Rooms in Dublin, with Florence Farr in the role of Aleel. Martyn's *The Heather Field* followed it on the same program. Lady Gregory, Martyn, and WBY had announced their intention to establish an Irish Literary Theatre to produce Celtic or Irish plays in Dublin every spring. "We will show that Ireland is not the home of buffoonery and easy sentiment, as it has been represented, but the home of an ancient idealism." They sought subscriptions, which flowed in from the whole range of Irish society, from Douglas Hyde, the Irish-speaking Protestant proponent of Celtic culture, to John Pentland Mahaffy, archetype of the Anglo-Irishman; from John O'Leary to Lord and Lady Ardilaun; from Maud Gonne to the Viscount of St. Albans.[62]

From the beginning WBY's role aroused antagonism. His play was read aloud at the National Library before its production, and immediately a holier-than-the-Pope Catholic, Frank Hugh O'Donnell,[63] circulated a pamphlet calling it heretical, since the heroine sold her soul to the devil to save the lives of her countrymen.[64] Cardinal Logue of Armagh, who hadn't read the play, publicly accepted O'Donnell's estimate. Martyn, devout Catholic that he was,

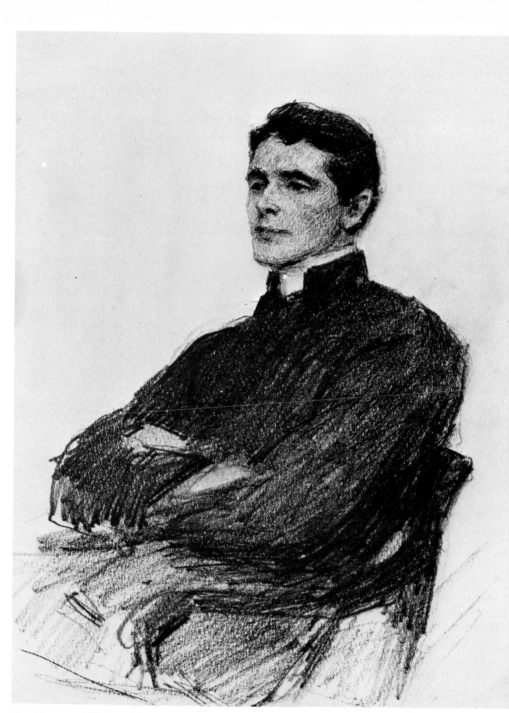

The Reverend T. Arnold Harvey, about 1904. Pencil. JBY. Collection: Michael B. Yeats.

became upset. Yeats had to get a third opinion—"the last thing I desire is to give legitimate offense to any of my countrymen"[65] —and chose an English Catholic priest, Dr. William Barry, who, not being Irish, found nothing heretical or offensive in the play. It was the first of many attacks on WBY from the right wing of Catholicism; the assaults of Gaelic romantics and extreme nationalists were yet to come.

One moderate Dubliner annoyed by O'Donnell's attack was Joseph Holloway, an architect who was also a fanatical lover of the theatre. He would attend any play anywhere. A bachelor who lived within a fifteen-minute walk of central Dublin, he wrote a detailed account of every play he saw, every rehearsal he attended, every talk he held with people connected in any way with the theatre. At his death he left 221 manuscript volumes containing 100,000 pages and 25,000,000 words. He was present at all stages of the development of the group that was to become the Abbey Theatre Company, and his journal provides an invaluable commentary.[66] By his own admission, Holloway was moderate and broad-minded. A Roman Catholic and devout, he loved Ireland and was enthusiastic about the idea of an "Irish" theatre. He did not pretend to be "a professional critic" but merely "an ordinary play-goer." He was interested in plays "from the audience's point of view." In the theatre he wanted to be transported, to see life acted on the stage and acted well.[67] Save for his ingrained prejudices, Holloway was about as undogmatic and free of fads as he claimed to be, an ordinary man with an ordinary critical intelligence and an ordinary prose style.

It is interesting, therefore, to note that Holloway's views on what he saw in the theatre in the following decade were remarkably close to those of John Butler Yeats. Except when Catholicism or romantic Irishism ruled Holloway or agnosticism swayed JBY, they thought alike. When *The Countess Cathleen* was produced, Holloway denounced the "brainless" group of students who came to make trouble,[68] for he accepted Dr. Barry's opinion of "the correctness and inoffensiveness of its ideas from the Roman Catholic point of view." His chief worry was that it would not be "actable," and he was pleased to find it "weirdly, fantastically, pathetically, or picturesquely effective by turns."[69]

Holloway was disturbed by the method of acting, "not acting in the ordinary sense," he protested. "That the artists wholly succeeded . . . I cannot truthfully say." Miss Farr "declaimed all her lines in majestic, beautiful, rhythmic manner grand to listen to—most impressive if occasionally indistinct."[70] Eleven days later JBY wrote to Lady Gregory: "I hope Willie will go on writing dramas . . . which are to be *acted* as well as chaunted," and added, "I cannot agree with Willie in all his ideas as to the rendering of it."[71] The *Irish Times* was harsher, declaring it "not a play" at all, having "no action which could seize and carry on to a climax the interest of an audience."[72]

But WBY had carried the day and smoothed the path for the following year. Back in London he held fascinating "at homes" at Woburn Buildings on

Monday nights[73] and turned up at Blenheim Road whenever the spirit moved him. ("We know nothing about Willie," JBY wrote Lady Gregory early in the year, "but have some idea that he may come in upon us any moment.")[74] He returned to working on *The Speckled Bird*, which he wouldn't let his father see. Remembering how "absolutely unintelligible" was *The Shadowy Waters*,[75] he tried to get at his son indirectly through Lady Gregory. "I am full of curiosity as to his novel—I may say *anxiety*. Mysticism may become a rank vegetation destroying the vital principle. A novel with elaborate notes and a commentary would be a portentous kind of art." Then, perhaps remembering Lily's visions, he added, "I am no enemy to mysticism."[76] He was not shown the novel, which remained unfinished.

Father was also kept in ignorance of his son's pursuit of Maud Gonne. Blind to what any man not in love would have recognized as a rejection, WBY went to Paris again early in 1899, this time with Uncle George's approval and partly at his expense.[77] The result was as uncertain as it had been the year before: "I don't know whether things are well or ill with me, in some ways ill, for she has been almost cold with me, though she has made it easy for me to see her."[78] JBY learned whatever he knew of such activities from Lady Gregory.[79] Occasionally he had to demean himself by seeking his son's help. He suggested that Willie might switch publishers from Fisher Unwin to William Robertson Nicoll, who had been recommended by Clement Shorter. Shorter was starting a new journal, the *Sphere*, and JBY urged Willie to help with contributions if he could. "If we help him he will help me—not us but *me*. I don't ask you to do anything in your own interest. He is helping me now. I do not think he is conscious of any calculated plan or intrigue, but these practical men always *instinctively* act on the principle that one good turn deserves another. As Bismarck puts it, *do ut des*. Things are with me desperate *unless*?&cc."[80]

Things were desperate because money was not coming in. On March 16, 1899, John Butler Yeats reached his sixtieth birthday. With ordinary development he should have been in the full glory of autumn, the rich harvest of his growing season gathered and stored. Yet he had no public achievement behind him. Jack had already held an exhibition. Willie had published enough poems and essays to last a lifetime. Father, full of ideas, articulate and vocal, had published nothing since the talk before the debating society at the King's Inns thirty years before. He had preserved no record of the considerable body of portraits he had painted, nor did he know what had happened to most of them. And he had no money. When he heard that he might lose the chance to paint Dora Sigerson Shorter, Clement's wife, he lay awake till four in the morning. "One cannot take things at sixty as we do at twenty or even as we do at thirty," he wrote Willie.[81] He could not know then that he stood at the doorway of a new career. The twenty-three years left to him were to prove the most exciting and productive of his life. He would not make money; the unbusinesslike habits of a lifetime could not be undone. Yet his best

paintings and his best years lay ahead, though on JBY's sixtieth birthday the most optimistic gambler wouldn't have wagered a farthing on his chances.

With Lady Gregory's encouragement of his pencil sketches, his painting of portraits became again a regular occupation. He began oils of Clement and Dora Shorter, Nannie Farrer Smith, Henry Hinkson, Kate Lee, Richard Ashe King, King's wife, and Susan Mitchell. He sketched York Powell, Andrew Tynan, Ernest Rhys, Hinkson, and Elton's two small sons.[82] His profits were, as usual, small. Elton had to press four guineas on JBY. Nannie Smith insisted on giving him a bicycle, not new but second-hand. Father told Willie only that the bicycle was a great success, but he confided to Lily that it was really too small and that he would try to exchange it for another at the local shop.[83] He kept hoping rich relatives of his sitters would appear to give splendid commissions. "We always know that one good portrait, one good picture, will retrieve everything. Moreover a good portrait is, everyone knows, not an accident. Done once it can be done again and again."[84] The rich relatives never materialized. When Richard Ashe King praised JBY's portrait of him, the artist hoped he might get further commissions from King's brother and sister-in-law,[85] but nothing developed. The record is peppered with such disappointed expectations. He began to see dimly that there might be more to the business of painting than technical skill. "I fancy," he admitted to Lady Gregory, "the great thing for a portrait painter is not to paint well but to know how to pounce upon a sitter, and then never let go till you have inoculated a whole clan with an enthusiasm to have themselves painted."[86] What some grasped instinctively at twenty he was struggling to grasp at sixty.

Blenheim Road was still a fetter on his leg. He enjoyed the house only while guests were present or when Lily and Susan Mitchell were with him. When the two left for Ireland in mid-1899 (Lily's first visit there since her sudden departure from Sligo in 1895),[87] JBY wrote to Lady Gregory that the house was "a desert." He added: "Every house needs a woman, a *professed* woman. Lolly's work lies outside and very enchanting she often finds it. In this house just now there is no unoccupied person into whose sympathetic ear one may drop a confidential remark."[88]

Times were changing. The English were involved in the Boer War, and York Powell, with his "dog-in-the-manger kind of Toryism," as JBY put it to John O'Leary,[89] supported the English cause completely. Powell had been converted to the principle of Home Rule for the Irish—Home Rule within the sovereign British Empire—but his liberalism did not extend to Bombay or Cape Town. JBY would argue "hotly" with him, and Powell would answer that "without war a nation cannot educate its people."[90] JBY's daughters grew so sick of the jingoist sermons in the Church of St. Michael and All Angels that, unbeknown to their father, they took to attending the Catholic Church instead.[91] The Calumets were meeting with "diminished numbers."[92] To cap the bad news for the year, JBY learned from his sister-in-law in Brazil of the death

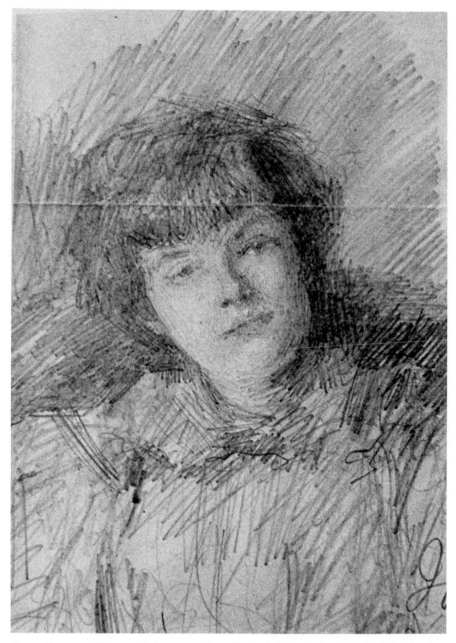

Dora Sigerson Shorter, July, 1900. Pencil. JBY. Drawn in flyleaf of book. James Augustine Healy Collection of Irish Literature, Colby College, Waterville, Maine. Permission J. Fraser Cocks III, Special Collections Librarian.

at fifty-six of his brilliant younger brother Willy, the brightest and most likable boy at Atholl Academy, who had become "the life of the town" in Rio de Janeiro and amassed a sizable fortune there. He had never been sick a day until his final illness struck.[93] JBY pondered his fate gloomily, often implying that if only his brother had been allowed to live longer he might have thrown over his career as a stockbroker and become an artist or poet.

Brother Willy's death was the first of three within six months. The second was far more consequential. On January 3, 1900, after twelve years of declining health, Susan Pollexfen Yeats died, suddenly and unexpectedly. Lollie was in Germany on vacation; Lily was away to fetch Fred Pollexfen's daughter Ruth, who was to live with her cousins; and Willie was staying a few nights at Blenheim Road. On December 30, 1899, he and his father spent the evening at George Moore's, where Willie read the latest version of *The Shadowy Waters*. On January 2, JBY wrote Lady Gregory about it ("It is perfectly fresh and genuine—fruit in good season") but said nothing about his wife.[94] Some time early in the morning of Wednesday, January 3, Maria, the maid who had slept for years in the same bedroom with Susan, roused the household, as her mistress seemed to be having trouble breathing. Shortly afterward, in the presence of her husband, her eldest son, and Rose and Maria, Susan Yeats died. Willie's presence was purely fortuitous. There had been no warning, no crisis. Death came not from a sudden blow but from a long slow debilitation. Dr. Hogg gave the cause as "general paralysis." On January 6 she was buried in the nearby Acton Rural Cemetery.[95]

JBY left no contemporary record of his feelings about the deaths of his parents and children; at the time of his wife's death he wrote nothing about her. Years later Lily wrote with more frankness than the other members of the family dared. She supported her father's charge that Susan was "not at all good at housekeeping and child-minding," but went further: "She was prim and austere, suffered all in silence. She asked no sympathy and gave none. . . . She endured and made no moan."[96] WBY writes carefully and cautiously in words that conceal more than they reveal: "I can see now that she had great depth of feeling, that she was her father's daughter. My memory of what she was like in those days has grown very dim, but I think her sense of personality, her desire of any life of her own, had disappeared in her care for us and in much anxiety about money."[97]

JBY, the Anglo-Irish gentleman, was always careful in speaking to his children never to say a word against their mother. He was determinedly conservative about marriage, despite whatever shortcomings he may have found in Susan. "I often said to your mother," he wrote to Willie, "that her affection was a matter that one *inferred*. No one ever saw it or heard it speak."[98] Of course Susan was an inarticulate Pollexfen. If she found shortcomings in her husband she left no record of them. The axiom that those who do not publish perish is not merely academic. Padraic Colum recalls that JBY once

said of Susan that she was the kind of woman who, if he had returned unexpectedly after ten years in China, would say, "Oh, have you had dinner?" JBY accepted her as she was. "My wife was a poor acquaintance but a valuable friend," he told Elton, "and so inscrutable that I often told her that though I was always studying her I never knew her."[99] To Willie sixteen years later JBY made the most informative comment on his marriage:

People seem to me to have quite forgotten *what a wife is*. A man may admire one woman and be in love with another, and all sorts of wanton fancies in his restless heart may play continually about a third. There is one woman whom *he accepts* and she is his wife—all her limitations, her want of intellect, even her want of heart. All her infirmities and all her waywardness he accepts and would not have them altered. If there be such a woman she is his wife. The feeling grows slowly. It is not affection as it is not passion. It is just *husband's feeling*, and she has doubtless a corresponding *wife's feeling*.[100]

Susan's life had been traumatic for her and for all her family, especially its slow closing years. Considering her hopes and needs, one finds it hard to wish she had lived longer. Her life had been, by her standards, unhappy. She had married an Irish landlord and barrister who had betrayed her family's expectations and her own. She had thought she would live in Dublin as the wife of a successful man of law, enjoying a conventional life and having easy access to the wild coasts of Ireland, which she loved. It is true that her husband did not mislead or deceive her. He had no idea in 1863 that he would rebel against his own society and turn Bohemian; there was no malice in his actions. Yet every step he took was in conflict with her reasonable expectations. Under the successive blows she weakened and fell. Her husband knew very well the principal cause of her collapse. Twelve years after her death he wrote to Lily: "Had I had money your mother would never have been ill and would be alive now—that is the thought always with me—*and I would have done anything to get it for her*—but had not the art."[101]

She remained a Pollexfen to the end, frightened of affection yet deeply needing it, loving the simple fishermen of Howth and Sligo who made no pretense to being artists or intellectuals, and hating the sophisticated city people like Edwin Ellis. Her inability or unwillingness to adjust to a life she loathed rendered her a person of no consequence among her neighbors. The weekly parish newspaper of St. Michael and All Angels listed the date of her death but gave no obituary.[102] Oliver Elton, who knew her in her last years, could describe her only as "a silent flitting figure."[103] She was almost a non-person for the last decade of her life.

Jack did no sketches for six months after his mother died, though, as his biographer observes, "He never made a direct comment on a matter about which he felt deeply.[104] It was he who took charge of the purchase and placement in St. John's Church, Sligo, of a plaque honoring her.[105] She became only a memory her children tried to recall with sympathy. The chief result of her death was quite simply the liberation of the family. Now Lily and

Lollie could be more free to come and go, Rose and Maria could attend to the needs of others, John Butler Yeats could make wider plans. Her death was a release not only for her but for everyone else. Willie, writing to a friend eight years later, expressed the effect on her children quite simply: "My mother was so long ill, so long fading out of life, that the last fading out of all made no noticeable change in our lives."[106]

On the night Susan died, Elizabeth Orr, in Yorkshire, heard the banshee cry outside her window. A little more than three weeks later Lily heard the banshee at Blenheim Road and saw a white sea bird in her room. Later that day a message arrived that John Pollexfen the sea captain had died suddenly at his home in Blundellsands outside Liverpool. Only a few days after his sister's death he had returned from a voyage to South Africa (having transported troops there to fight the Boers), caught a cold which turned into pneumonia, and died at the age of fifty-five. Within a month two of William Pollexfen's children had disappeared suddenly from the scene. John was the uncle who had visited Bedford Park most often and was popular with his Yeats nieces and nephews. The most sociable and genial of the Pollexfen sons—his life as a sea captain having forced sociability upon him—he was a romantic figure whose life his poet nephew was to exaggerate later.[107]

Between the two deaths came another development. The Irish Land Commission, having gathered in payments from the tenants for the purchase of the Thomastown lands, was prepared to make a partial settlement, and JBY discovered a gross balance to his credit of £869.[108] It was a staggering sum. Lily recorded her father's astonishment when the solicitors wrote him. "Any other man would have known it was coming," she wrote. "He has paid all his debts," Willie wrote Lady Gregory in the spring, "and must feel very unlike his old self."[109] He spent what was left over on a two-week visit to Paris, a vacation which no one begrudged him. Edwin Ellis and his wife were there, and at first JBY enjoyed seeing them. But he discovered that Mrs. Ellis was an intolerable shrew. One day he and Edwin were late in returning from an exhibition, and she flew into a rage. Papa wrote Lily:

She will kill that man, and it is my opinion that she goes about blackguarding him to all her male and female acquaintances. He never now reads anything, he who used to read everything. Why he does not leave her, why he does not vanish some day, passes comprehension. He fetches and carries for her all day long, and if he misses the lunch hour by a few minutes she disgraces him before his own particular friend by vociferous personal abuse, calling him a bad wicked man, a suspicious man, and a man who gets drunk &c. Never did I see such a scene.[110]

He discovered that Mrs. Ellis was trying to persuade Edwin to return to London, and to his dismay the next year they took a house in Bedford Park which he could have rented himself if he hadn't procrastinated.[111]

Back in England he enjoyed Blenheim Road for a while, welcoming his wife's niece Ruth Pollexfen, then in her late teens, as a new member of the

household. Ruth's mother had left the unbearable Fred Pollexfen; in the ensuing divorce, the Pollexfens sympathized with the wife. The daughters were made wards of the court, and Ruth was assigned to Lily's care.[112] Ruth was a girl JBY found "extremely ingenious and artistic, with an eye in her head."[113] Her education under him began at once. She became devoted to him as a substitute father and later declared that he was the first person who had taught her to see the world through her eyes, to notice colors and shapes.[114] She was to remain a member of the family, mothered and fussed over by Lily, until her marriage more than a decade later.

JBY exuded a new spirit now that he could leave home without cost to his conscience. "I never knew him beforehand so anxious to see anything," Willie wrote Lady Gregory of his visit to Paris.[115] JBY called on Sarah Purser and Edward Martyn, who were visiting in London, and accompanied Miss Purser to an exhibition of Romney paintings. Then he and Lily and Ruth paid a lengthy visit to Jack and Cottie in Devon. Jack had finished a playlet called *James Flaunty, or The Terror of the Western Seas*, for which he prepared cardboard figures and a small stage so that it could be produced before small groups of children without the need of a theatre or professional players. It was published by Elkin Mathews the following year. Papa thought it "the prettiest and most poetical little play" he had ever read and tried to interest Willie in it. "The play is done with the most wonderful stagecraft. You and Moore and Pinero and Arthur Jones had better take lessons from Jack. I assure you the play haunts me. He must have a real gift for *construction*."[116] Perhaps Willie thought he detected a rebuke of his own talents in his father's enthusiasm for Jack (as Cottie suspected and told JBY). Father tried to rouse fraternal devotion in his difficult elder son. "I do want you to encourage Jack as much as possible to go on writing these little plays. . . . I think this play of Jack's in its miniature way one of the most *vigorous* and DELICATE pieces of dramatic characterization."[117] But Willie showed little interest in Jack's writing, then or ever, preserving his crustiness intact.

By June the travelers were back at Blenheim Road. JBY talked of having a new house built, to be ready for occupancy in six weeks. ("Can they build a really serviceable house in six weeks? using good glue and all?" Jack asked Lily.)[118] Nothing came of the project, but the mention of it shows that JBY was ready for fresh quarters and a different air. The Blenheim Road house must by this time have been as filled with memories of illness and poor fortune as Eardley Crescent had been.

The second season of the Irish Literary Theatre was not so successful as the first, despite the high quality of the productions. The three plays offered at Dublin's Gaiety Theatre on February 19, 1900, were Moore's *The Bending of the Bough*, Martyn's *Maeve*, and Alice Milligan's *The Last Feast of the Fianna*. Although moderately successful at the time, the plays did not survive as popular repertory pieces. Moore's was the best received, but its presence on

the program caused resentment as it was merely a reworking of Martyn's play *The Tale of a Town*, which had been rejected by Moore and Yeats as unsuitable for the stage. The upshot was that Martyn was offended and made noises about withdrawing from the theatre. Willie and Lady Gregory had to work hard to keep him from abandoning the ship.[119]

Willie, worried about the quality of the year's offering, tried to arouse interest in Irish controversy by peppering the newspapers with letters. A statue of Parnell had been proposed for Dublin, and Willie suggested that a sculptor be chosen by a competent committee, not by a single politician, and that the sculptor then be allowed to proceed on his own without being required to submit a design for approval. His words could have come straight from his father:

few men do their best when their getting work at all is dependent on their pleasing anybody but themselves. The good sculptor, poet, painter or musician pleases other men in the long run because he was first pleased himself, the only person whose taste he really understands. Work done to please others is conventional or flashy and, as time passes, becomes a weariness or a disgust.[120]

During 1900 tension between Irish and English over the Boer War increased. The Irish saw it as just another adventure in English imperialism. When the aged Queen Victoria was shipped to Ireland by her ministers to drum up Irish volunteers, WBY produced an incendiary letter for *Freeman's Journal* proposing a giant meeting of Irishmen in protest. Among those supporting the English cause was, not surprisingly, Edward Dowden, who was troubled by the government's leniency toward Irish "disloyalty." Rolleston tried to persuade WBY that the English weren't really so bad, but Willie, still resentful of Rolleston's preference for Duffy's leadership a decade earlier, would not be mollified.[121]

JBY shared his son's opinions of the war and was probably responsible for them. It was "a blackguard war" presided over by "a blackguard minister."[122] Since York Powell thought it right and proper, feelings ran high. JBY warned O'Leary it might be hard to get Powell to visit when he came to Bedford Park, "since as it appears to me he now consorts only with Jingos."[123] One night Willie came in and, echoing his father, spoke of his pleasure at seeing John Bull "limping with a sore foot." Powell left the house in a huff, and JBY had to pad down the street in his slippers after him. "A pact was made; JBY promised not to speak of the war again. Separation from Powell would have broken his heart."[124]

In the summer of 1900 both Jack and Willie were at Coole. It was the first of the big summers there, with many artists and writers gathered to work and talk. Time has woven fanciful legends about the Coole summers through an understandable telescoping of people and events. Over the years almost everyone of importance in the Irish Renaissance visited there, and it is easy for

York Powell, about 1899. Pencil. JBY. Identification in the hand of Lily Yeats. Collection: Michael B. Yeats.

the imagination to picture all together seated around an enormous table, exchanging brilliant ripostes and sharing trade secrets. The reality is less grand; there was seldom more than a small group at Coole at any one time. An old copper-beech tree on the grounds developed into a kind of guest book, and Lady Gregory's accolade was to ask those she deemed worthy to carve their initials in the bark. As her biographer Elizabeth Coxhead sardonically observed, the tree must have placed a strain on both hostess and visitors, and for the latter it could prove a shattering symbol of nonrecognition. "One can easily picture the mounting chagrin of the not quite sufficiently eminent guest," Miss Coxhead writes, "waiting, penknife at the ready, for the invitation which never came."[125]

Jack arrived at Coole on July 1 to find Willie already there. Jack still sought the company of "Long" Harvey and Robert Gregory. One day he and Willie fished for trout. Coole by no means meant for Willie only the writing of plays and poems. He also occasionally painted, apparently for relaxation; two watercolors survive of the house itself and the library.[126] He wandered about the spacious grounds, watched the swans on the pond, heard at twilight the bell-beat of their wings above his head, fished in the streams, or merely meditated. Back in the rooms and passages at the great house he walked among people interested in art, talked to them about poetry and the theatre, and lived the life of the mind and spirit among a nobility of the artistic and intellectual. After years of genteel poverty in London it is no wonder that he came to admire what aristocracy had to offer.[127] In later years he questioned what values could accrue to the people of a country from the destruction of its noble houses, from which came "gradual Time's last gift, a written speech / Wrought of high laughter, loveliness and ease."[128] His feelings about houses like Coole are expressed in the first stanza of "Meditations in Time of Civil War":

> Surely among a rich man's flowering lawns,
> Amid the rustle of his planted hills,
> Life overflows without ambitious pains;
> And rains down life until the basin spills,
> And mounts more dizzy high the more it rains
> As though to choose whatever shape it wills.[129]

Though JBY was informed about what went on at Coole, Willie did not tell him about a power struggle in the Order of the Golden Dawn. WBY and MacGregor Mathers engaged in a cloak-and-dagger activity that resembled the machinations of an international spy ring run by the Boy Scouts. When WBY started an investigation of Mathers's stewardship, Mathers, incensed, deputed one Aleister Crowley to take possession of the society's premises and papers. Crowley, whom WBY thought "a quite unspeakable person,"[130] was something of a charlatan, yet a man of powerful personal magnetism and ambition. Mathers filed a suit against Yeats which he later thought it prudent

to withdraw, paying five pounds in costs. Crowley thereupon made wax images of the members of Yeats's faction and stuck pins in them.[131] Years later JBY would discover the accuracy of his son's description of Crowley as "unspeakable."

After his return from Paris and Devon JBY continued the portrait painting which he had so energetically resumed. "I think I have greatly advanced," he boasted to O'Leary, "as indeed I have given almost the whole of the year to portrait painting. Hitherto I have done it on occasions when by some luck I had the chance, but this last year I have done nothing else."[132] Yet his problems as a painter remained, as well as his inability to recognize them. To the surprise of nobody he was still working on the portrait of Dora Sigerson Shorter,[133] which was to have been finished the year before; in July he had not yet completed the portrait of Kate Lee; Nannie Farrer Smith, who had paid JBY with the bicycle, was still waiting for hers. One customer who refused to allow JBY to indulge his whims was Richard Ashe King. When JBY came to "put in the hands" on his wife's portrait, King made sure the artist did not touch the face and spoil it. The portrait of King himself was hung at the Royal Hibernian Academy that year, and all the "Dublin academicians" said that it was far better than any of those by Walter Osborne, the reigning portraitist in Dublin.[134] JBY was still working on a portrait of Lily, his favorite subject, and he did a pencil sketch of Arthur Symons, "*much the best I have ever done*," which he sent to the editor of the *Dome* so that its "expert" could assess its suitability for reproduction.[135]

Little money flowed in from all his work, and for the usual reason. When Dora Shorter said he should persuade her father, Dr. George Sigerson, to sit, he didn't have the courage to ask. "If I could afford it," he told O'Leary, "I would ask only the pleasure of painting him. But I would not charge him much and I wish you could induce him to sit."[136] Before the end of the year the money from the Land Commission had vanished in the payment of old debts and in the vacations in Paris and Devon. Jack, who had regularly sent contributions to the family disguised as gifts to his mother, began to send "weekly money" to his sisters after she died. He also raised with Lily the question of taking on himself the management of Papa's affairs, at least in art:

What about an exhibition of Papa's sketches? I never felt flush enough myself to do it. But if the war was over at all, I am sure it would be a good thing done *if* the expenses were kept *very low*, frames *cheap* though chosen with care, and only *one* week at Walker's costing a fiver, and sending out a lot of invitations and stating on catalogue of course that Papa was open to do similar portraits of people *perhaps* mentioning the price of £5.5s a piece.

Nothing came of the plan, possibly because Papa couldn't bestir himself to go along with it.[137] When he sent portraits to Ireland for the R.H.A. it was at the insistent behest of the new president, Thomas Drew, who, attempting to put fresh life into the organization, wrote an urgent letter to every Irish artist he

knew. JBY planned to send several works, among them portraits of Lily and Lollie.[138] One of his offbeat works was a nude, *Echo*, one of the few paintings he had done in several years that wasn't a portrait, and he planned to send it for exhibition, though he anticipated it would be judged "very bad."

At the end of the year the family was still at Blenheim Road, though JBY was seeking quarters elsewhere. He had in mind another place in London, though events seemed to be drawing him toward Ireland. "I should very much like to come over to Dublin and will if I can," he told Clare Marsh in July.[139] Jack was drawing people and scenes in western Ireland, and the play Willie was working on with Moore was to be offered in Dublin during the coming year.

JBY urged Willie to come home for Christmas so that the family could "see something" of him and because he needed a rest. The collaboration with Moore on *Diarmuid and Grania* JBY described as work of an "irritating kind." He was blunter with Sarah Purser: "I saw Willie a few days ago. He looked rather badly, which is due I dare say to his toils over a play he is writing in conjunction with George Moore. Collaborating with Moore must be like fighting for your life. Their aims would be sure to be at variance."[140] The criticism contained a prophecy. It would not be long before Willie would separate his colleague from the Irish Literary Theatre and help ripen Moore's malice for the later series of autobiographical books that would feature Willie as more egotist than genius.

CHAPTER TEN

1901–1902

IN 1901 the Yeatses hung on at Bedford Park, marking time. The English were doing poorly in South Africa, so it was a good year for the Irish in London. John O'Leary even began "moderating his whiskey consumption" and told JBY that "not for twenty years" had he been so happy. JBY described his diplomacy while a guest at the Calumet: "He discoursed the whole time with great astuteness, avoiding dangerous subjects. He is not without the wisdom of the serpent. I tried several times to roll in the apple of discord, but they all looked as if they did not see it."[1] Despite the compact with Powell, when JBY lodged in Dublin in the fall he tried to involve him on the subject of English imperialism as it operated both in Ireland and in South Africa. Powell refused to take the bait, professing an ignorance of Irish problems, but adding: "You don't understand the English or English politics nor what Englishmen really feel, nor what they mean, and it is quite useless for me to try to convince you of what you won't believe." Then he made an acknowledgment quite remarkable for Oxford's Regius Professor of History to utter of one generally regarded as a hopeless failure: "I know you are a better man in heart and brain than I am, and I am always glad to try and follow the high example you set in life and thought, and I honestly believe that I am very much the better for having had the privilege of your friendship, a blessing that I think much of."[2]

On June 24 all the Yeatses except Willie and Jack attended the wedding of Frances Blogg and Gilbert Keith Chesterton in Bedford Park. The Yeatses admired Chesterton not only because of his natural charm but because of his determined and persistent opposition to the British posture in South Africa. As conversationalists he and JBY delighted each other. "Long before he was anybody I often met Gilbert Chesterton," JBY wrote of him; "he . . . had the gift not merely of good talking but of good listening, and while throwing off the most brilliant generalizations would stop in sudden silence and listen endlessly." The girls, particularly Lily, were to maintain their friendship with the Chestertons for a lifetime. The day after the wedding the bride's mother

asked JBY whether he thought Chesterton would "ever be able to make a penny," for his own mother had told Mrs. Blogg he could never earn money. The kindly JBY "predicted a brilliant future."[3]

Under Lady Gregory's spur JBY continued his painting and sketching, and now another well-wisher came along to encourage and needle him, his old friend Sarah Purser. When he painted Isaac Butt's daugher Rosa late in 1900 he told Miss Purser the portrait needed "another sitting badly,"[4] though he did not explain why. She was continually irritated by the inability of her amiable friend to move ahead and by the poor reputation he seemed to have fastened upon himself. He was as unbusinesslike as ever. He had changed the lease on the Blenheim Road house to a quarterly tenancy "to take another house any time if I find one with a suitable studio,"[5] yet when he found one he let Ellis steal it from under his nose.[6] He was no more financially mature than before. "Last year I paid off over £400 of old debts," he wrote Willie in February. "If only I could have kept that £400."[7] (He had received from the estate not £400 but £724.0.10 net, yet the remaining £324 had evaporated too.) In March he applied through solicitor Frederick Gifford for an additional £100 loan against the remaining interest of £329.4.7 held in his name by the Land Commission and got it at seven per cent.[8]

At the Royal Hibernian Academy Exhibition in 1900 his portraits of Richard Ashe King and Nannie Smith had been praised by his fellow painter Vincent Duffy,[9] but they had been accepted largely because Sir Thomas Drew, president of the Academy, was trying to win as much support as possible for a plea for a larger governmental grant for Irish art; the National Galleries of Scotland received £1,140 a year compared to only £50 for the Irish.[10] Miss Purser urged JBY to submit portraits again for 1901. He did so, but all were turned down on the first round of judging. "It is long since they rejected all my things *straight off*. I was generally reserved for the final judgment," he wrote Lollie. His only consolation, he told her, was his own knowledge that he was "a much better painter than nine-tenths of them."[11]

The rejection was a godsend to JBY, the first in a series of events that was to change the course of his life. Miss Purser was furious at the selection committee. She had long been disenchanted with Ireland's treatment of artists. She was incensed that stained glass in Irish churches had to be imported despite an abundance of local artisans, and she had noticed that another Irish artist, Nathaniel Hone, had been subject to the same kind of "persistent neglect" visited upon JBY. Hone had virtually ceased to paint and never exhibited. Spurred by the R.H.A. committee's action, Miss Purser resolved to put on at her own expense an exhibition of the works of Hone and Yeats in the heart of Dublin and proceeded to manage the enterprise herself. JBY heard the good news in August. Miss Purser secured the rooms of the Royal Society of Antiquaries at 6 Stephen's Green, next door to JBY's old studio, now occupied

Rosa Butt (daughter of Isaac Butt), about 1901. Pencil. JBY. Collection: Michael B. Yeats.

by Walter Osborne, for two weeks starting Monday, October 21, and set about collecting paintings and preparing a catalogue.[12] JBY stood by helplessly as Miss Purser moved with swift efficiency to carry out her aims.

Meanwhile Willie and Jack were manipulating their own destinies. Jack gathered his work done in Sligo and elsewhere in the west of Ireland and arranged an exhibition, "Sketches of Life in the West of Ireland," to be held at 9 Merrion Row, opening by coincidence the day after his father's show. By a further coincidence, on the evening of the opening of JBY's exhibition and the night before Jack's, William Butler Yeats's play *Diarmuid and Grania* (written in collaboration with Moore) was scheduled for the Gaiety Theatre. Without any concerted plan, the three Yeats men were to dominate Dublin's artistic season, lending further credence to publisher Lawrence's compliment that the Yeatses were a remarkable family.

The collaboration on *Diarmuid and Grania* had been unpleasant. WBY had lost none of the Pollexfen clumsiness in handling others, and Moore, still the smirking, subtly insolent superior, was not easy to manage. But in WBY, Moore met his match. Moore was ten years older and had been an established novelist when WBY was still unknown. Yet in their agreement to collaborate it was understood that Moore would have general responsibility only for the drama, with WBY taking charge of the writing. "I have recognized that you have a knowledge of the stage," WBY admitted to Moore, "a power of construction, a power of inventing a dramatic climax far beyond me." But when Moore tried to overstep the informal boundaries Willie was sharp in his response: "On the question of style . . . I will make no concessions. Here you need give way to me. Remember that our original compact was that the final words were to be mine. I would never have begun the play at all, but for this compact. . . . The final version must be in my words or in such words of yours as I may accept."[13] Despite the difficulties of the collaboration, as soon as the play was completed WBY unwisely agreed with Moore to do another, perhaps because the proposed plot was passed on to the two of them jointly by George Russell. It was to be based on the idea of a man who would try to live as a perfect Christian, "a religious Don Quixote." But not long afterward WBY abruptly withdrew from the partnership and proceeded to work on the play alone. Moore maintained that he had rights in the idea, and there was to be a deepening of the unpleasantness between them, with Moore ultimately using the threat of a lawsuit, which Willie disregarded.[14]

The Irish National Theatre aroused opposition in the customary places. Many objected to the English actors in supposedly Irish plays. WBY learned that the Dublin booksellers were hostile to him and that "clerical influence" opposed him because of his mysticism. He had also incurred the enmity of the poets of the "Pan-Celtic Society," admitting that he "had probably earned it by some needless criticism at a moment of exasperation."[15] But as the second play

on the program, Douglas Hyde's *Casadh an tSugain* (*The Twisting of the Rope*) was to be played in the Irish language by the Keating Branch of the Gaelic League, some of its Irish virtue rubbed off on Moore and Yeats.

The plays aroused mixed responses. For Hyde's everyone had high praise. The audience was given English texts and could easily follow the action. Holloway felt "a thrill of pleasure" and was filled with regret "that most Irishmen (including myself) have been brought up in utter ignorance of their own language." But although he enjoyed *Diarmuid and Grania* he found it "lacking here and there in dramatic action."[16] The *Leader* attacked the play with magnificent irrelevance, not only finding the actors unsatisfactory because English, but complaining that the plot constituted "a travesty of an Irish legend." Moore felt compelled to reply that every incident in the play was completely faithful to Irish legend, including the blood potion of comradeship and the infidelity of Grania; but publicly acknowledged impurity in an Irish lady was hardly to be countenanced in the Dublin of 1901. The truth about Irish heroes and heroines, ancient and modern, was to prove strong stuff for many defenders of the myth of Irish virtue. The baffled editors responded to Moore's letter with silence.[17]

The opposition of the *Leader* represented one of three millstones that would hang about the neck of the Irish theatre. The first had made its weight felt when O'Donnell attacked the theological irregularity of *The Countess Cathleen*. Now the *Leader* demanded another orthodoxy: that the Celtic heroes of drama must, as the ancestors of contemporary Irishmen, be morally pure as measured by the peculiar Irish standards of morality and purity. The heroines and heroes must be courageous and daring but at the same time sexless and passionless. The discrepancy between legendary Celtic history and Irish Catholic notions of what that history should have been was a troubling obstacle to shapers of nationalistic dreams like William Butler Yeats. At times he had doubts about the viability of the creature he was trying to bring to birth. "Here are we a lot of intelligent people," he wrote Lady Gregory, "who might have been doing some sort of work that leads to some fun. Yet here we are going through all sorts of trouble and annoyance for a mob that knows neither literature nor art."[18] The third millstone would grind with the others later, when Synge appeared: not only must mythological heroes be shown as paragons of virtue and morality; so must contemporary Irishmen. The "stage Irishman," an imaginative invention of the detested English, must be replaced by a "pulpit Irishman,"[19] no more real and a good deal less edifying than the fantasy he edged aside.

To WBY the future of the Irish National Theatre was not promising. English actors would not do, nor could George Moore be tolerated long as a collaborator. Before the annual season opened on October 21 WBY had publicly prepared to let the Theatre die. In May, 1899, had appeared the first number of an "occasional publication" called *Beltaine*, subtitled "The Organ of

the Irish Literary Theatre." To the three numbers of the journal Yeats contributed pieces about the theatre's purposes. In the month when the Yeats-Moore play was produced he issued a new magazine called *Samhain* in which he announced his intention to retire from the field: "now that the Irish Literary Theatre has completed the plan I had in my head ten years ago . . . I want to get back to primary ideas."[20] It was a strange farewell, for scarcely anything had yet been done to establish a theatre on a sound footing, and little immortal literature had been produced.

The "retirement" was in fact a maneuver by WBY to set Moore ashore and continue his voyage with new companions. Fortunately he found two mates looking for a captain. The Fay brothers, Frank and William, had been passionately interested in the stage for years. Frank was an accomplished speaker in verse drama (chiefly Shakespearean), Willie (as the other was called) a brilliant actor in plays of character and comedy.[21] Before 1899 they had organized amateurs into the Ormonde Dramatic Society and begun producing plays. They possessed exactly what WBY's vision required. They were gifted performers with clear, beautiful voices. They knew acting was difficult, so they constantly rehearsed and performed, taking pains to perfect the illusion of drama. If not men of letters, they were artists of the stage, and superb ones. They had watched the Irish Literary Theatre with interest, and when news arrived from America that *The Land of Heart's Desire* had been "a great success,"[22] Frank Fay wrote a friendly notice of it for the *United Irishman*, and WBY responded with an amicable personal letter.[23]

To produce AE's *Deirdre*, the Fays had formed a larger group, W. G. Fay's Irish National Dramatic Company.[24] Even before the production of *Diarmuid and Grania*, WBY and Lady Gregory, unknown to Moore, had determined to dissolve their own company and associate themselves with the Fays. During their summer at Coole they worked on the one-act play that was to take final shape as *Cathleen ni Houlihan*, and Willie offered it to the Fays if they should need it to fill out the program with *Deirdre*. Out of the maneuverings came the new company that was to grow into the Abbey Theatre; and when it was formed William Butler Yeats stood in the center of it, while George Moore stood outside pressing his nose to the glass.

In Stratford-on-Avon to evaluate the English actors for the Yeats-Moore play, WBY attended a number of Shakespearean plays, read them and others in his free time, and decided to take on the critics. "The more I read," he told Lady Gregory confidently, "the worse does the Shakespeare criticism become and Dowden is about the climax of it." A month later he had changed his tune. He submitted a long essay to the *Speaker* and wrote Lady Gregory: "I think I really tell for the first time the truth about the school of Shakespeare critics of whom Dowden is much the best."[25]

Amusingly—though WBY himself would hardly have been amused if he knew—WBY's remarks about Shakespeare are virtually identical, not only in

idea but even at times in language, to those so impetuously dashed off almost thirty years earlier by John Butler Yeats in his letter to Edward Dowden from Stradbally Hall.[26]

Shakespeare . . . made [Richard II] fail, a little because he lacked some qualities that were doubtless common among his scullions, but more because he had certain qualities that are uncommon in all ages. To suppose that Shakespeare preferred the men who deposed his king is to suppose that Shakespeare judged men with the eyes of a Municipal Councillor weighing the merits of a Town Clerk.[27]

When later Dowden replied, it was the son's remarks he quoted, not the father's.[28] The uses to which father and son put their common views are instructive. JBY confined his spirited defense of Richard to a private letter which never saw print. The son absorbed and appropriated his father's views and had them published in a place where the world—including Dowden— could see them. Dowden, also in character, took care to answer the son publicly as he had answered the father privately.

Willie wrote several long and unusually detailed letters to Blenheim Road in 1901. At Rosses Point, after having passed through Dublin on his return from Stratford, he wrote about a confrontation in Dublin involving Bullen the publisher, George Moore, and a representative of Eason the bookseller:

I saw Bullen to my surprise. I found him at the Contemporary and he came on to Moore's where he got more or less drunk. I dined with him on Sunday night when he got still more drunk. He asked Moore and myself to dine with him that evening to meet Eason's man, which Moore indignantly refused to do. Eason is going to refuse Moore's book and Moore objected on other grounds also. He said to me, "Why should I dine with Bullen and a tradesman who want to get solidly drunk?"

Moore's misadventures as a returned resident of Ireland were already well under way. He had been living at Ely Place only a few months yet was about to fire his seventh cook.[29] In London a few months earlier he had embarrassed Willie by insisting on accompanying him uninvited to dinner with the Short- ers, even though he knew Shorter did not like him. Willie was obliged to write Shorter beforehand to warn him what was about to happen: "But embarrassed as I am I shall be four times as embarrassed if I may not bring him."[30] Later Willie reported that Moore "was labouring a comparison between Mahaffy and 'a long pink pig,'" and pinning him down as "'the type of the Irish sycophant.'"[31] Susan Mitchell found Moore ridiculous as well as bothersome. "The deference paid to that man makes one very impatient," she told Lily, "and yet one can't help being amused at him, the obvious and dull things he says with an air as if each were an epigram."[32]

Willie made fifteen contributions to periodicals that year and worked on new poems "of the Irish heroic age," the first of their kind "since the wander- ings of Usheen." He explained to his father that he had shrunk "from bigger things" until his "blank verse seemed sufficiently varied."[33] He did not tell his

father about his privately printed pamphlet, *Is the Order of R.R. and A.C. to Remain A Magical Order?*, meant for the eyes of Adepti of the Order only. It is full of the mumbo-jumbo of the occultists:

It is indeed of special, perhaps of supreme moment, to give the Degree of Theoricus, the highest degree known to us . . . for [it] is our link with the invisible degrees. . . . If we despise it or forget it, we despise and forget the link which unites the Degree of Zelatores, and through that the Degree of the Portal and the four degrees of the G.D. in the Outer, to the Third Order, to the Supreme Life. . . . [34]

There are twenty-eight pages of the same, every word of which pleased George Pollexfen. John Butler Yeats was mercifully spared the reading of it.

Once Sarah Purser had resolved on the Hone-Yeats exhibition nothing could stop its birth, though she found the effort trying. She was forced to do most of the work, chiefly because she scared other people off. When she asked York Powell to contribute an essay of appreciation on JBY for the catalogue—George Moore providing the counterpart for Hone—he assented only after much quailing. She crushed Susan Mitchell, who hoped JBY's sketch of her would be included, by telling her it wouldn't be. "I'm so sorry," wrote a crestfallen Susan to Lily. "I feel like the worm that hasn't begun to turn." [35]

JBY was in a frenzy of indecisiveness. What was he supposed to do? Should he come to Dublin to help Miss Purser? Lily asked Miss Mitchell to sniff the breezes for him. "I don't know what she thinks about your Father coming over," Susan reported. "She asked was he coming, was he waiting to be asked. She was unsatisfactory about him, some way, and I couldn't gather her view." [36] Only a week before the opening of the exhibition JBY was still in London.

Miss Purser worked round the clock. She persuaded possessors of JBY's sketches, portraits, watercolors, pastels, chalks, and oils to lend them for the occasion—Katharine Hinkson, "Essie" Dowden's husband Travers Smith, Oliver Elton, Miss M. R. Manning (in whose painting classes JBY had taught Clare Marsh), Charles Fitzgerald, Maurice Fitzgerald, Rosa Butt, York Powell and his daughter "Cuckoo," Walter Osborne, Lily Gordon (JBY's cousin), Mrs. George Coffey, W. E. Purser, John O'Leary, Sir Thomas Drew, Todhunter, and Lily. The Contemporary Club lent two frames of sketches, and the Irish Literary Society of London sent a sketch of Barry O'Brien. [37] By the appointed day she had gathered and hung seventy-two items, forty-four of JBY's and twenty-eight of Hone's. Admission was set at one shilling, including catalogue; an open ticket good for the duration cost two and six.

If it had not been for the exhibition John Butler Yeats might well have remained at Blenheim Road puttering around, for he could hardly afford the fare to Dublin. When he left London for the show the action seemed inconsequential, but he was never to see Bedford Park again. His earlier moves had usually been made after brief and insufficient planning. This one was made with no planning at all. [38]

The exhibition was an immense success. As there were twenty-one separate sketches in the two frames lent by the Contemporary Club, sixty-three of JBY's works were on display. Of these some were dramatic or scenic sketches which included *The Village Blacksmith*, *Dressing Dolls*, *Winter*, *Haunted Room*, *Playing Cards*, *The Beechwood*, *Street Children Dancing*, *The Bird Market*, *Day Dreams*, *Girl Reading*, "*The Roses for me, the Thorns for you*," *In a Gondola*, *The Nihilist*, *Playing Truant*, *Pippa Passes*, and *Rufus*. There were portraits or sketches of Willie, Lily, and Jack, Katharine Tynan Hinkson and her father Andrew, "Essie" Dowden, Mrs. Oliver Elton and her two sons, Miss MacKinnon (Lily's employer in Hyères), George Fitzgerald, Isaac Butt, York Powell, "Cuckoo" Powell, John Mullins, Barry O'Brien, Douglas Hyde, Edward Martyn, Horace Plunkett, George Russell, Lily Gordon, George Coffey, and John O'Leary. In the first Contemporary Club frame were pencil sketches of Arnold White, Mohini Chatterji, Professor Sullivan of Cork College, William Morris, John O'Leary, Dr. MacDonnell, and J. F. Taylor; in the second Arthur Patten, T. W. Russell, W. E. Bailey, W. T. Stead (of the *Pall Mall Gazette*), Arthur Perceval Graves, George Coffey, Mr. McNiffe, Charles Hubert Oldham, Mr. Doherty (who built the O'Connell Bridge), and Mr. Brooks, as well as two further sketches of Mohini Chatterji. There were also his portrait of King Goll modeled on WBY and several sketches of unnamed people.[39]

The collection covered JBY's range of gifts fairly and showed that his interest lay chiefly in faces. York Powell's "Appreciation" provided a just if affectionately partial critique of his friend's achievement. "The inspiration of Mr. Yeats's art is sympathy," he began, and went on to admit what JBY never tried to deny:

A person, a thing, must appeal to his feeling, as well as to his intellect, before he can care enough about it to make it the subject of his brush. . . . He will do but the thing he likes best, and he will do only the thing he likes. Hence the fine and intimate delicacy of his art, the sensitive lines of his pencil work, the gentle composition of his illustrations, the humane quality of his portraits. . . . To him the sitter is a living being capable of joy and sorrow, and it is the life, the humanity, the mood, the temper of the sitter that he is always striving to render through, and by means of, colour and line. . . .

It is possible that the persistent effort to give as much as Mr. Yeats wishes to give in every portrait sometimes hampers him, and one occasionally feels that some of his best results have been attained when subject and accident have compelled him to be satisfied, or at least to stop, when his first intentions and intuitions have been recorded. . . .

He is always definitely himself. You cannot mistake his work for any other man's. . . .

. . . But in all he does, whatever the measure of his success, he is always a Seeker, a Mystic, and not seldom he makes us feel that he is a Seer, an Interpreter. . . . He does not try to teach or convince or elevate or inspire, he simply puts down as well as he can what is borne in upon him by the things he beholds or recalls.

The reviews were equally favorable. George Coffey, in a long critique in the *Daily Express*, spoke highly of both painters. He flattered JBY by comparing

him to an Old Master: "It has been said of Rembrandt that he takes a head and hangs it in the infinite, and that in the relation of the head to the background there is the whole mystery of existence. . . . It is because we find something of this quality in Mr. Yeats's best work that his portraits are so interesting to us." He wrote enthusiastically of the portrait of John O'Leary, "probably the finest portrait painted by an Irish artist in recent years," indeed "a great portrait." But he warned the viewer of what he would not find. "People who marvel at the imitation of lace, or the painting of buttons on a coat, will be disappointed in Mr. Yeats's portraits. To him the interest of the subject is in the head, all the rest is accessory, to be felt to be there, but never taking attention from the central interest of the picture."[40]

The critic for the *Irish Times* reconstructed Yeats's artistic development from the early works to the latest. He saw that JBY had begun as a pre-Raphaelite who found that the school was against "his natural direction." "The elaborate finish and accumulation of accessories, which seemed so vital to Holman Hunt and Madox Brown, are the very antithesis to Mr. Yeats's impatience of subsidiary truths and eagerness to get to essentials, to concentrate himself on character." With the portrait of John O'Leary the critic found fault because of the neglect of the nonessentials:

The artist has spent all his care and time—too much time even—on the head. He has made up his mind to show you the enthusiast brooding over his single dominant idea; everything—the heavily knitted brow, the commanding nose, the great beard sunk on the chest—contributes to the expression of an absorbing thought and a frustrated purpose. There Mr. Yeats's interest stops; the rest of the figure and the chair are alike mere background to relieve the head; whether or not there may be a framework of flesh and bones under Mr. O'Leary's clothes the painter neither knows nor cares

If Coffey found a parallel in Rembrandt, the *Times* critic thought JBY resembled George Watts in caring more "for the spirit of man than for the body."[41]

Attendance was excellent, not only in the number of visitors but in their quality.[42] Suddenly John Butler Yeats was an established figure. At the age of sixty-two he had been introduced to society, like a late-arriving debutante. Sarah Purser had done her work well. Formal debuts may be in themselves unproductive; but just as a novelist must publish his book before the world can know his talent, so a painter must sooner or later present a showing of his works, especially if he wants to be recognized and acknowledged by the newspapers and the critics and hence also by the patrons. JBY was at last in a commanding position to make his move as a money-making painter.

Yet JBY was down and out in Dublin when the show ended, and he remained so. He took cheap lodgings at 86 Lower Leeson Street, not being able to afford the return voyage to London, and he made a practice of dropping in on friends for dinner. The George Harts in Howth resumed the generosity of old friendship with pleasure, for "old Mr. Yeats," despite his

unorthodox views, was one of their favorite guests. He often took lunch with Edward Dowden, who issued him a standing invitation. He hoped that Mrs. Lenny would pay him five pounds for his portrait of her and that George Hart might give him three guineas for a black-and-white sketch of him. On one occasion he was able to send three pounds home to Blenheim Road but simultaneously increased his debt by the same amount at Leeson Street. Fortunately he had relatives who would not let him starve. "I don't know what would happen to me," he wrote Lily, "if I had not Isaac to dine with whenever I like."[43]

The ripples of the Hone-Yeats Exhibition spread outward. In New York City a young lawyer named John Quinn read about it and was impressed.[44] Quinn, born in a small town in Ohio, was a driving, intense, highly intellectual man who had come to New York after a brief stay in Washington as the bright young assistant to the Secretary of the Treasury, by whom he was carried off

JBY's first letter to John Quinn, November 19, 1901. Collection: Foster-Murphy.

from the University of Michigan. He took law degrees at Georgetown and Harvard, invaded New York, and in 1900 became junior partner in the firm of Alexander and Colby. By 1901, at the threshold of a prosperous career, he found he had the time and money to indulge his tastes, which included art, literature, and Ireland. When he read the reviews he promptly wrote to Jack Yeats to ask about the pictures. Quinn was not the first, as he would not be the last, to be confused by the two Irish painters named John Butler Yeats, one "Senior," one "Junior." [45] When Jack straightened him out, Quinn wrote to the father asking if he might buy the portraits of O'Leary, W. B. Yeats, and King Goll, as well as some other works in the exhibition. The startled painter, unused to such enthusiasm in a total stranger, responded gravely, informing Quinn that *King Goll* was sold and that O'Leary's portrait had been done for subscribers. He suggested doing a copy of the latter for thirty pounds, offered the portrait of Willie for twenty pounds, and, somewhat gratuitously, in-

Sarah Purser, about 1904.
Pencil. JBY. Collection:
Michael B. Yeats.

formed Quinn he had just done a replica of his black-chalk portrait of Isaac Butt for fifteen pounds. "The other pictures you name are already disposed of," he concluded with a businesslike air.[46]

It was the first in a long series of letters that was to continue until JBY's death twenty years later, just two years before Quinn's. It marked the beginning of an association that would profoundly alter both men's lives, as well as Willie's and, to a lesser extent, Jack's. Sarah Purser, by managing the affairs of a man who couldn't manage his own, had unwittingly succeeded in bringing him at last a measure of the fame he deserved, and in providing him with an impulse that would carry him through a half decade of remarkable productivity. The

wandering prodigal, as full of years and wisdom as he was empty of purse, had without knowing it ended his long self-exile in London and returned to the place where he belonged: Dublin, a city that was itself entering upon its most intensely interesting period, one in which he and the other members of the Yeats family would be among the most active participants, but one of which he would say later, as he could of his London years, that it was "a world of anxiety and care" which he "could not alleviate."[47]

John Butler Yeats remained in Dublin only because of an acute shortage of funds. He was sure he would make the return to Bedford Park soon, and when he wrote of leaving Blenheim Road it was always another house in London that he envisioned. When Lollie, .possibly designing new traps for Louis Purser, raised the question of settling in Ireland, he countered with rational objections. "What would become of you and your work and your *life work generally,* which seems to lie in London? In London I feel a sort of fortune awaits you. Besides there is Jack and Willie who are nearer to you over there than they would be here." He suggested instead a smaller house in London, "a very much smaller house or one with a studio," but he did nothing about his own proposal, preferring to let things happen. When Lollie turned down a job as Secretary of the Irish Literary Society in London under Barry O'Brien he was relieved only because he was sure she would clash with her employer.[48]

He remained in Dublin also because for the moment that was the place where he thought the jobs were to be found, though the few assignments he got came chiefly from old friends. Dining at the King's Inns one day early in 1902 he was surprised to discover that he was the second senior barrister present,[49] and as such was invited to dine with Judge Walter Boyd and an older barrister, both of whom he sketched after lunch. The judge was pleased, he thought—"(I think I had flattered him a little)"—but "the other complained that I had taken his bad side where he had a glass eye."[50] No commissions resulted. When he dined with the Harts he sketched as many people as he could, always hoping commissions might come his way. Sir George Hart's wife had been a Hone, and her sister Mrs. Bellingham, "an eminently practical person" like all the Hones, was so taken with his pencil drawing of Hilda Hart that she took it with her to show to Sir Walter Armstrong, hoping to snag him as a customer.[51] The Harts bought his sketches chiefly as a device for enabling him to repay innumerable small loans.[52] Mrs. Hart provided free meals for the ebullient guest who was so much in need of them, and when it was impossible to include him in the evening dinner she always made her meaning clear by insisting that he eat a heavy luncheon. One day she served him cold goose. "It had been a fine bird," he told Lily, "and was still a noble ruin. When I had done with it, it was like British Honour, no longer recognizable."[53] Without the Harts and other friends he might have become undernourished. Between January and June he dined with Tom Lyster, George Moore, Sir Thomas

Drew, the O'Briens, the Rollestons, the Gills at Dalkey (the publishers), another family of Gills at Roebuck, the Hinksons, the Butts, the Mullinses, the Sigersons, the Stewarts, and, most frequently of all, his brother Isaac.[54]

Yet he was happy at only a few places and in many felt he wasn't welcome: "as you get older people care less about you, and then my political views are in most people's eyes so very bad."[55] "I have received many compliments, but I have no sitters," he told Willie cheerfully. "We Yeatses have such bad characters the people who live in good society and have their feet on the rock of ages and order their portraits disapprove of us, so that I am likely to starve for my sins."[56] But Willie knew that the reason lay, as it always had, in poor management. When he heard about the astonishing letter from the New York lawyer, he made a suggestion to Lady Gregory that he knew would be ineffective with his father if it came from him. "I should think that he had better get some kind of agent—there must be such people—to arrange the matter in America, if he knows nothing of Quinn."[57] Father did nothing of the kind. Fortunately Quinn proved himself an honest and sincere patron. He bought a number of JBY's finished works, including his portrait of Willie, and commissioned others, for twenty pounds each, of O'Leary, Hyde, and AE, then produced the fees without cavil. "You are a grand paymaster and a prompt one," JBY wrote gratefully.[58]

Quinn came to Europe in the summer of 1902, his first sojourn abroad, and touched all the bases. In London he was shown about by Jack, from whom he bought about a dozen paintings. On his tour he met all the Yeatses, Russell, Rolleston, Hyde, Moore, Martyn, and Lady Gregory, and took part in the Killeeneen Feis (or Celebration) on August 31 in honor of the blind poet Raftery. At Coole Park he added his initials to the copper-beech tree. Under the stimulation of his largess JBY completed the portrait of Russell, asking Quinn's permission to keep it for another Dublin Exhibition, and asking if he might make a new portrait of O'Leary rather than copy the older one.[59]

With his crisp decisiveness and his sympathy for all things Irish, Quinn won friends easily. At Blenheim Road he and Lily found each other fascinating companions. Lollie, ever the romantic, thought they "were greatly attracted to one another." (She could hardly speak for Quinn, of course, but her comment about Lily years later is invaluable: "He was the only man except J. M. Synge that she took *that sort* of interest in.")[60] By the time Quinn returned to America he had laid a solid foundation for his visits in the coming years, which he enjoyed until the Irish got on his nerves and he ceased the annual pilgrimages.

Papa had unashamedly asked Lady Gregory in May whether she still wanted to commission a portrait of Standish O'Grady. "I should like very much to do it and have now plenty of opportunity of doing it." He suggested also doing a nude picture of Echo and wondered whether he might "submit the idea to Martyn." He was disappointed, he told her, "over some portraits that *were* and *are to be* but as yet *are not*."[61] She responded generously, not only with the

Isaac Butt Yeats (1848–1930), about 1904. Pencil. JBY. Identification in the hand of Lily Yeats. Collection: Michael B. Yeats.

O'Grady commission but with a check.[62] Others were less obliging. Andrew Jameson of the whiskey company and JBY's old friend Hugh Holmes—who kept a floating balance of a thousand pounds in his checking account so he would never be short of ready cash—were both "pleased" with his portrait of Mrs. George Hart, but nothing important came from either.[63] The old litany was resumed. "Could you let Lily have a few pounds," Father asked Willie in February, "as much as £10 or whatever you can?" Ruth Pollexfen was adding to the expenses at Blenheim Road, and the sisters couldn't send her away "since there is no place for her to go." Fred, "that poor mad man, her father," couldn't find work. In May the ritual was repeated. "I am awfully sorry to ask you," Father wrote, "but could you lend me two or even one pound—and could you send it by money order or postal order?" In early June he had only three shillings to his name and, as Isaac was unable to provide dinner at the time, found himself in straits. Willie responded with a note for two pounds, which Father repaid in August.[64] Dr. Sigerson, at his daughter's prodding, had agreed to sit but then changed his mind, unwilling to endure the endless process that accompanied the flow of talk. The old difficulty of low prices also remained: "I have been asking (in vain) £10 for a head and £20 when the hands are included. This may be considered my minimum. I *ought* to get £20 or £15 for a head and £30 when the hands are included." He begged Willie to find customers. "It would be a salvation for Lily and Lollie. All our debts are quite small except the butcher, so that it is possible to help us. I mean a portrait or two at small prices would make us safe."[65] He was reduced to doing a set of four panels, one representing each of the seasons, for a restaurant, but he dawdled over them, much to the annoyance of the restaurateur.[66]

While he was floundering, things were happening in London which would change the lives of all the Yeatses. Early in 1902, Miss Evelyn Gleeson, forty-six-year-old daughter of an Irish-born physician who had practiced for many years in England, came to 3 Blenheim Road with a proposition. She felt Ireland should provide an outlet for the talents of its young girls. Like Sarah Purser, she thought foreign manufactories were doing harm to Ireland both esthetically and economically. It was her wish "to find work for Irish hands in the making of beautiful things."[67] She proposed that the Yeats sisters join with her in establishing a shop in Ireland where young girls could create artistic objects for pay. Miss Gleeson would manage a branch for the production of chair and stool coverings, tufted carpets, and carriage rugs. She wanted Lily to organize a department for embroidery. William Morris's friend Emery Walker persuaded Lollie to take a month's course in printing at the Women's Printing Society in London[68] and establish a printing press as part of Miss Gleeson's organization. Lollie had no knowledge of printing, "disliked machinery and said she was afraid of even a sewing machine."[69] Nevertheless she took Walker's advice, and by midyear both girls were eager to try the new venture.

William Butler Yeats was to say sourly a couple of years later that "the whole

Dun Emer venture should have been thought out carefully at the start,"[70] but at the time he raised no objection to it and seems to have welcomed the experiment as a device for giving work to his sisters. The trouble was that Miss Gleeson did not offer complete financing. The sisters had to raise funds of their own, no easy thing to do. Augustine Henry, a friend of Miss Gleeson's, agreed to guarantee the salaries of the girls who would work under Lily and Lollie by offering an interest-bearing loan which they were to repay out of profits.[71] There was some kind of agreement to share general profits and an understanding about sharing responsibilities, but these were to prove unsatisfactory and unworkable and would soon cause trouble.[72]

Events developed quickly. On May 10, Jack asked Lily about "the Gleeson business."[73] On June 7 he wrote, "How about Lolly and the printing?" Within another month or so the decision had been made. The girls would follow Miss Gleeson to Dublin, move out of 3 Blenheim Road permanently, and set to work as soon as possible. When Lollie showed fear at the prospect her father encouraged her: "You have every bit as much intellect as Willie—only you have not his serene self-confidence. And [not] having this you have not his patience. Lily and Willie both have a talent for making phrases—but Lily has not your power of reasoning, power of intellect. You are here quite as strong as Willie only you don't exercise it."[74] Her natural apprehension about producing books was alleviated when Willie agreed to serve as literary adviser and help find books for her to print. In addition to his other reasons for helping, WBY was interested in beautiful books as things in themselves.[75] Lollie's press, the stepchild of the business, was to bring immortality to Miss Gleeson's enterprise, but it would also bring Willie and Lollie into continual conflict.

While the sisters prepared to leave Blenheim Road, Miss Gleeson went to Dublin, found a large house in Dundrum that bore the name "Runnymede," and took out a lease on it in her name. It was rechristened "Dun Emer" ("Emer's Fort") and the business given the name of "Dun Emer Industries."[76] Emer, wife of the Irish legendary hero Cuchulain, was noted for her interest in needlework and other domestic skills and arts, so the name was an appropriate one. As rent on the house had to be paid at once there could be no delay about getting to work. Papa tramped about to find suitable quarters for the two sisters, their young cousin Ruth, two servants, and himself, and at length discovered a house in Churchtown, near Dundrum, a thirty-five minute walk from Dun Emer.[77] Papa didn't know how they would raise the cost of moving. "I have a lot of commissions coming to me," he assured Willie, "but at present we are all at our wit's ends to manage the move. . . . How to get that £48 is the problem."[78]

But the money was raised somehow, and by October 1 the furniture had left Blenheim Road. JBY did not return to help. When Elkin Mathews's sister Minnie heard the news in Italy she was overcome with distress: "I can hardly believe it. Your leaving has been talked of for so long, I always hoped it would

come to nothing. I can't realize that when I get back you will not be there to hear my adventures. . . . Yours was the first house I always went to when I returned home. We shall all miss you more than I can possibly tell you."[79]

The new Yeats residence, called "Gurteen Dhas" by Lily and Lollie (Irish for "pretty little field"), was far enough away from Dun Emer to mean a "weary long walk four times a day" for the sisters, who came home for dinner at noon.[80] It was far enough from central Dublin to benefit from green fields here and there, and the Rathgar tram was within a half-hour walk. Although the name might suggest more lawn and elegance than the place afforded, still it was commodious, and it came to be as popular an oasis for Dubliners as Blenheim Road had been for the wandering Irish.

The sisters began working at once. Lollie bought a second-hand printing press and, at Emery Walker's suggestion, selected 14-point Caslon as her basic type face. It was used in the production of all the books of the Dun Emer Press and, later, the Cuala Press. By early December of 1902 Lollie had some page proofs of Dun Emer's first book ready for her brother's inspection.[81] It was a volume of his poems, *In the Seven Woods*, which would be published in the following year.

From the beginning there were problems. Dun Emer, theoretically a unified enterprise, was in fact rigidly divided; each branch had to meet its own expenses. As Miss Gleeson held the lease on the house, the Yeats sisters had to pay rent to her. The young girls employed as helpers had to be paid weekly. Over the years many interesting names turned up on the list of employees, including those of Eileen Colum (sister of Padraic), Maire nic Shiubhlaigh (Mary Walker, the Abbey actress), and the Yeatses' cousin Ruth Pollexfen. Lollie got along no better with Miss Gleeson than with Willie, and even the tolerant and pacific Lily found Miss Gleeson difficult. They had not been long in their strange partnership before Papa began to notice Miss Gleeson's "queerness over money and business, and her explosions of violent temper."[82] Furthermore, she sometimes took a drop too much of distilled beverages. John Butler Yeats once described perfect felicity as "the second glass of Jameson stabilized forever";[83] Miss Gleeson too often could not resist the third.

To Lollie the year meant great success and happiness, even if it was marred by financial worries. There seemed to be a late stirring in the long-banked fires of Louis Purser. Perhaps her move to Dublin had made his evasiveness no longer feasible. Shortly after settling in at Gurteen Dhas some kind of understanding—or, as events were to suggest, misunderstanding—was reached between the two. Lollie "gave her love" to Louis "in a real and serious sense" (the words are Lily's, whatever they mean),[84] and the possibility of marriage at last filled her with a happiness that made her work easier.

Jack too had a good year, developing cleanly and consistently as always. From August 18 to August 30, during Quinn's stay in Ireland, there was an

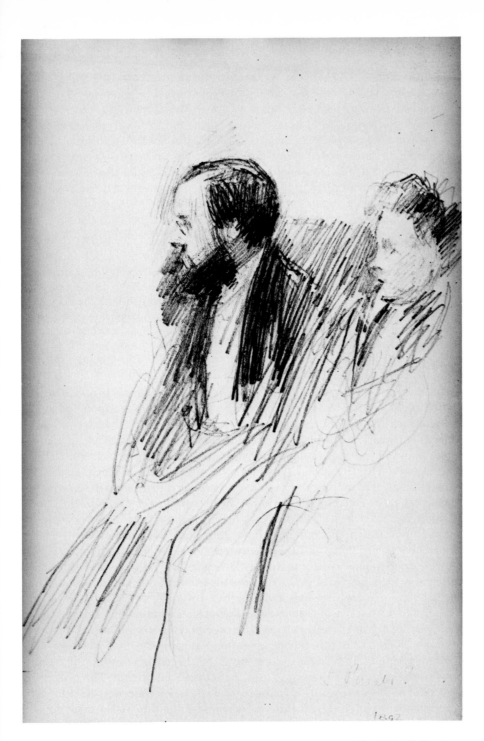

Louis Purser and an unindentified woman, about 1904. Pencil. JBY. Collection:
William M. Murphy; gift of Olive Purser.

exhibition of Jack's works at the Wells Central Hall which aroused the art critic of *An Claidheamh Soluis* ("The Sword of Light" or "The Flaming Sword," a nationalist Irish-language newspaper) to praise its originality. Jack was "a man of artistic ability and genius and also a peculiar man," who preferred to draw "pictures of poor people" "in a strange way." He did not follow rules laid down by others but rather broke "new ground."[85] Earlier in the year Jack produced his first printed issue of *A Broadsheet* with Pamela Colman ("Pixie") Smith as partner and illustrator; Elkin Mathews was the publisher. Early the next year Pixie left the partnership, telling Jack she "thought it best to withdraw."[86] Jack managed the disengagement skillfully, bruising no egos, in contrast to his brother's treatment of adversaries. Jack said nothing publicly, but a letter to Quinn explains what happened:

Pamela Smith did *not* start the Broad Sheet. I did. In fact I had a weird thing called the Broad Sheet two years ago, just stencils that I used to print myself. . . . I am not sure yet that I will go on with it or not. Between you and me and the wall, as they say, Miss Pamela Smith (though I think a fine imaginative illustrator with a fine eye for colour, and just the artist for illuminating verse) is a little bit erratic, and she being a woman I can't take a very high hand with things, so there is often a lot of bother about the numbers, and I don't like being responsible for anything that I have not got absolute control of.[87]

Father kept up his campaign to get Willie to appreciate his brother's work. Criticizing Willie for revising his work too much, he made a point of again praising Jack's *Flaunty* as *"poetic drama."* He told Willie that its construction was "perfect, or nearly so" and that he could never read it without a break in his voice. It was, in short, a good play, the dramatic qualities of which could affect the audience. Then he added: "All this might interest Jack, so perhaps you will send it to him." He slyly avoided explaining why he did not send the comments directly to Jack. He thought perhaps Willie was "too critical," having been "brought up in a critical atmosphere," while Jack's imagination had never been put in chains, for the Pollexfens among whom he grew up "never uttered an opinion about anything and thought intellect a poor sort of thing."[88]

Willie's testy determination would be needed in the days to come. The Dublin to which the Yeatses returned in 1902 was entering on its most exciting and abrasive decade, and only the doughty would survive. George Bernard Shaw called it "that city of tedious and silly derision where men can do nothing but sneer."[89] It was essentially a small town with a city's population. Everyone who was anybody knew everyone else who was anybody. Everyone who was anybody tended to be Anglo-Irish by birth and breeding, though the indigenous Irish Catholics were starting to swim to the social surface. The process of land reform under which JBY had already yielded his inherited acres to their occupants was widening, and the determination of the Irish people to win some form of self-government was so strong that few politically astute Englishmen believed it could be denied much longer. The parade that marches

across the pages of the Yeats family records is peopled with artists and writers and actors and politicians, with the famous and the obscure, with those who were to mould and direct the country's history.

WBY wanted the focus of the Irish Renaissance to be the theatre, and the coming half decade would see its finest flowering. After WBY's announcement that the original plans of the Irish Literary Theatre had been "completed" and that he himself wanted "to get back to primary ideas,"[90] the schemes of a bedazzled Englishwoman either changed his announced plans or promoted his secret ones. Miss Annie Horniman, the well-to-do Manchester spinster with a consuming passion for drama and the occult, had developed an intense romantic interest in William Butler Yeats, five years younger than she. To many women WBY was extraordinarily attractive, and Miss Horniman yielded to no one in her admiration for him. In her correspondence with him she makes clear that she fervently wished William Butler Yeats would choose her above all women, a preference for which he never showed the slightest inclination.[91] She was as blind to the realities of their relationship as he was to his with Maud Gonne. And just as Miss Gonne used him for her nationalist purposes, so he used Miss Horniman as the means to his desired theatre.

Despite Miss Horniman's contempt, indeed hatred, for Ireland and all things Irish, she offered to finance a theatre in Dublin if WBY could find an acting company that could handle his verse plays properly. In April, Willie wrote to Frank Fay of the offer of a "wealthy friend," concealing Miss Horniman's identity by referring to her as "he." If he deceived Fay he did so with Miss Horniman's concurrence, for the handwriting in the letter was hers and only the signature WBY's.[92] The "wealthy friend," Yeats let Fay know, preferred his own theories of poetic drama to those of others.

In early April of 1902, the new group formed to present Russell's *Deirdre* had added WBY's *Cathleen ni Houlihan* to the program, with Maud Gonne in the title role. The presentation was a notable success. Holloway liked both plays, particularly the second, pronouncing the evening "very creditable to Mr. W. G. Fay's Irish National Dramatic Company."[93] Some did not find Yeats's play so enjoyable, chiefly because of Miss Gonne's role in it. The *All Ireland Review* declared her not an authentic actress but merely "Maud Gonne the well-known Nationalist agitator, addressing not the actors, as is usual in drama, but the audience."[94]

For a time *Cathleen ni Houlihan*, a moving patriotic play, united the diverse factions, and the new company was "placed on a more definite basis." Though it was the Fays' company and not WBY's, the candidacy of George Russell for the presidency of the newly created Irish National Theatre Society folded before the overpowering claims of Miss Horniman's friend, who had not openly sought the post. At the election on August 9, William Butler Yeats was chosen president, Maud Gonne, Douglas Hyde, and Russell vice-presidents, William G. Fay stage manager, and Fred Ryan secretary. The table of organi-

zation suggests that the officers were considered at least partly to hold only honorific titles: Maud Gonne and Douglas Hyde had little connection with the drama but much with other Irish causes. Willie's preferment over AE was perhaps a result of Frank Fay's lobbying for the support of Willie's "wealthy friend." A program for October was planned (James Cousins's *The Sleep of the King* and *The Racing Lug*, Fred Ryan's *The Laying of the Foundations*, Yeats's *A Pot of Broth*, and an Irish play by Peadar MacFhionnlaich, *Eilis Agus an Bhean Deirce*), and what would become the Irish National Theatre was well launched.[95]

Ominous symptoms appeared almost at once. Notifying WBY of his election, Fred Ryan had made clear that it was "Mr. Fay's" society, a comment that may not have been accidental. The Fays' first move may have been meant as a deliberate test of strength. Lady Gregory had written a little play, *Twenty-Five*, the plot of which involved a young man deliberately losing his savings in a card game to save the husband of an old sweetheart. The Fays rejected it, at the same time approving a play entitled *Sold*, by James Cousins, a writer who had brought AE and the Fays together. They also thought Yeats's *A Pot of Broth* unsuitable when they first heard it read aloud, though they did not press their objections. Willie chose to take a stand at once and, with the power of his imposing presence and the promised support of the "wealthy friend" behind him, he had his way. He wrote Frank Fay "a very severe letter" about *Sold*, branding it "rubbish and vulgar rubbish," even though he had praised Cousins earlier. Cousins did not bear Willie's hostility with a befitting grace. WBY wrote Lady Gregory, "Cousins is evidently hopeless and the sooner I have him as an enemy the better." Cousins soon ceased to be a member of the company, and Willie claimed credit for getting rid of him. WBY also overrode the objections to Lady Gregory's play, which the Fays thought derogatory of the Irish: Frank Fay thought no Irishman should be presented on stage as playing a man for his money, and Willie Fay personally disapproved of card playing for gain. Furthermore, they said, America was spoken of in such "glowing terms" that people "in country districts" might be encouraged to emigrate.[96] It was strange reasoning. A Pole or Englishman or Italian might be shown behaving so, never an Irishman. But WBY held the strings to Miss Horniman's yet unopened purse, and the upshot was that *Twenty-Five* and *A Pot of Broth* were presented and *Sold* was not. Willie had won the first skirmish in what was to be a long war, prevailing over allies who would, in his own good time, become his enemies.

In the meantime he continued his running battle with George Moore over the rights to the play they had originally planned to write together. Russell, who had suggested the plot, tried to mediate, working on Willie through his father. JBY suggested to his son that "it would really be a calamity to quarrel with Moore," whom JBY called a "Hair-Shirt" friend.[97] WBY, despite Moore's threat of an injunction and a law suit, published his version of the play as a

supplement to the *United Irishman* in November.[98] The Pollexfen sourness and contentiousness were too powerful to be curbed.

By 1902, W. B. Yeats was already, at thirty-seven, Ireland's most famous poet and essayist. Just rising to view was a young man of twenty, known for his promise if not his production. James Joyce, the most powerful voice to rise from the middle-class Catholic population of the divided country, was not to remain for long in the native land whose defects and virtues he saw with terrifying keenness, yet even he for a time touched the edges of that other literary group which provided most of the great names of the Irish Renaissance. In August, 1902, Joyce called on Russell in the dead of night to introduce himself. Joyce wanted to meet Yeats, whose poetry he admired, and Russell prepared the way by describing Joyce to Willie as "an extremely clever boy who belongs to your clan more than to mine and still more to himself." He went on to praise Joyce's talents as a writer and declared that he had "all the intellectual equipment—culture and education, which all our other friends here lack. . . . I think you would find this youth . . . with his assurance and self-confidence rather interesting." When Yeats returned to Dublin from Coole in October the two met. The details of their dialogue, a fencing match between an assured but somewhat startled poet of established reputation and a brash and confident young genius on the attack, are described brilliantly by Richard Ellmann; Joyce's remark to Yeats, "We have met too late; you are too old for me to have any effect on you," or some such words, is well known.[99]

Lady Gregory, impressed by Joyce's drive and power, invited JBY and Willie to dine with her and Joyce at the Nassau Hotel on November 4, but if JBY was present he left no account of the meeting. JBY and Joyce met once "for a few minutes on Northumberland Road," where according to Joyce the old man was "very loquacious," but JBY apparently forgot the meeting or didn't realize clearly who Joyce was.[100] Oliver St. John Gogarty describes how he and Joyce met JBY and tried to borrow money from him. According to Gogarty, the old man refused on the ground that they would waste it on drink. Joyce broke in to describe JBY's answer as an example of the logical principle known as "the Razor of Occam": JBY's reason for refusing the loan was meaningless as he didn't have the money to lend.[101] Perhaps the incident took place at the meeting on Northumberland Road. Perhaps it never took place at all. If Gogarty were searching for a character to fit his story he could not have found one more apt than John Butler Yeats. In any event, the meeting was inconsequential: Joyce was one of the few great Irishmen of his day who escaped JBY's sketching pencil.

CHAPTER ELEVEN

1903 – 1905

FOR THE YEATS family the half decade from 1903 through 1907 was exciting and rewarding, and the year 1903 was the *annus mirabilis*. To be sure, Jack made no great leap forward, for his growth as an artist then and later was steady and well regulated. For WBY with his theatre and occult activities, the girls with Dun Emer, and JBY with his painting, the year would produce a bountiful harvest, even if the chaff of old plantings diluted the mixture.

"I think this year will see us all prosperous," JBY had written to Lady Gregory early in January,[1] but on August 6 came a formal notice from Frederick Gifford that a payment of twenty pounds was owing on the outstanding £400 Thomastown mortgage. JBY not having such a sum available, it had to be paid out of his account with the Landed Estates Court, even as £150 principal of the original £550 mortgage had been paid three years earlier.[2] Failure to complete assignments plagued JBY still. When Quinn commissioned a sketch of George Russell, JBY produced two, not being satisfied with the first, which Russell hadn't liked either. "I am fierce occasionally," Russell explained to Quinn, "but not so fierce as in the first sketch."[3] Later in the year JBY wrote apprehensively to Lollie about his inability to finish a portrait of Douglas Hyde on time. "This is my last day, so I need praying for," he wrote;[4] yet Hyde had given him many sittings.

The Hyde portrait was done at Coole, where JBY was invited by Lady Gregory to join the other guests, carve his initials in the copper beech, paint Hyde, advertise his wares, and generally enjoy himself. He took full advantage of the last offer, wandering about the neighborhood and disregarding his hostess's schedules.[5] Lady Gregory remembered years later how difficult he had been as a guest. "I think him the most trying visitor possible in a house," she told Quinn. "Space and time mean nothing to him, he goes his own way, spoiling portraits as hopefully as he begins them, and always on the verge of a great future!"[6] He was careless about his socks, which he dropped anywhere, and his laundry, and was neat only with his brushes, oils, and palette.[7] From his point of view Lady Gregory had weaknesses too: he wrote York Powell about

his visit and one can infer the contents from Powell's reply. "Lady Gregory must be a charming host, I am sure. I think I should be happy in her house, but houses where one is *ruled* rather than *enjoyed* fill me with a deep horror, as you know." [8]

Mrs. Algernon Persse, Lady Gregory's sister-in-law, liked Hyde's finished portrait so much that she agreed to ask JBY to do her portrait for twenty-five pounds.[9] Back in Dublin, JBY did a second oil of O'Leary and portraits and sketches of Norah Holland (a cousin from Canada),[10] Walter Starkie, Padraic Colum, Kuno Meyer, the Reverend P. S. Dineen, Susan Mitchell, Lady Gregory, George Pollexfen, and Willie Fay.[11]

Fay was a cheerful sitter. "I find him to be very pleasant company," JBY wrote Lady Gregory. "He has a very engaging philosophy of life, some of it derived from Russell but most of it personal to himself. He is . . . content to sit in absolute silence and in the same position and attitude for hours. He is such a genial sweet-tempered fellow that he finds nothing tedious." [12] Fay recorded his own recollections of the same event: "He was a peculiarly restless worker. He walked back and forward all the time, only halting now and again to use a tiny mirror from his pocket to see by reflection how the picture was getting on. Also he talked all the time, and it was the most entertaining talk I have ever listened to." [13]

JBY made no attempt to avoid controversial subjects with his sitters except theology. When he painted Father P. S. Dineen he "carried on the most tremendous flow of conversation" and provided an account of it in a letter to Quinn. "It is not every day that a Protestant has a chance of buttonholing a priest, and I seized my chance to say what I am always wanting to say to Catholics." His message was simple. "If the Catholic mother had the same desire to see her son renowned for some kind of intellectual prowess that the Protestant mother has, Ireland would be as famous as ancient Greece." He meant of course the Church-of-Ireland mother of the Southern Anglo-Irish gentility, not of the Ulster Presbyterian and those infected, like the Pollexfens, with the virus of "getting on." Nor did he mean the Protestant mother of England, "who from the first takes toward her son an attitude of uncritical admiration, reserving her criticism for other people's sons." The English mother could afford to spoil her sons, who "as a rule take up some easy path in life, because the people being rich and numerous there are plenty of such paths for them to take."

As it was fruitless to argue about theology JBY discussed sociology instead with the genial priest. He had always admired Catholicism, being able to accept almost everything about it except its insistence on the supernatural and its unhappy attraction for people like those who found *The Countess Cathleen* heretical, though he liked to think these were in the minority. "Given the Protestant efficiency," he wrote Quinn, "the Catholic Irishman would leap to far higher altitudes than the Protestant will ever attain—because of his imagi-

nation and traditions. If Catholic Ireland would awake and become articulate, we should all listen *spellbound*. Catholic Ireland has something to say or will have something to say, and this whether it fights with its priests or agrees with them."[14]

Lady Gregory's nephew Hugh Lane, already in his twenties an established and successful art dealer and critic, had been impressed by JBY's work at the Hone-Yeats Exhibition. From it he got the idea of establishing a gallery of portraits of important Irish people which he could present to the nation. By 1903 he had talked the hesitant painter into accepting a mass of commissions for portraits which were to be done in a certain way: they were to include more than simply faces and were to be finished within a limited time. Jack described the project to Quinn: "The governor" was to do a "series of heads of prominent men in Ireland" which were destined "for the modern room in the Irish National Gallery." Jack wasn't sure he approved of all those considered by Lane as prominent. Of the Lord Lieutenant, Lord Dudley, whom his father was painting in December when Jack wrote to Quinn, he commented, "It's rather feeble to have him in, I think, but I don't suppose the governor chooses who the portraits are to be of."[15]

One of the first sitters was Lady Grosvenor, the wife of George Wyndham (great-grandson of Lord Edward Fitzgerald). Wyndham was a strong Unionist who nevertheless regarded himself as liberal for having pushed through a land-reform act. When JBY, with delicate playfulness, began discussing Fenianism with his subject, Wyndham was so irritated he wouldn't let her return for a second sitting. Wyndham didn't realize that JBY would as readily talk Unionism to a Fenian merely out of a desire to get a discussion going.[16]

Hugh Lane took an immediate liking to Willie's father—though it took him some time to get used to Willie[17] —and was to provide strong support for JBY during his five years in Dublin. He was especially helpful in JBY's unsought conflict with two peculiar Dubliners, Sir Thomas Drew, the architect who was serving as president of the Royal Hibernian Academy, and Stephen Catterson Smith, secretary of the Academy,[18] who hoped to become president himself some day, though JBY maintained he never had "the slightest chance" for the appointment.[19] Drew was cranky and ill-tempered and besides "disgusting to look at, and as full of hatred and malice and envy as any man I ever met."[20] Drew had secured the support of Sarah Purser, Lane, and JBY in his campaign to get a higher governmental appropriation for the National Gallery, but his primary interest was his own advancement. As Drew disliked almost everybody, his feelings hardly constitute a judgment on JBY. Drew's general complaint against the world, JBY recalled, was that he could never get anybody to be "civil" to him, that he was never treated "with courtesy." JBY's father had spoken to his son about such people years earlier, advising him, "If a man is rude to you, it is always your own fault."[21]

Mrs. Catterson Smith, whom JBY regarded as "a grotesque little person,"[22]

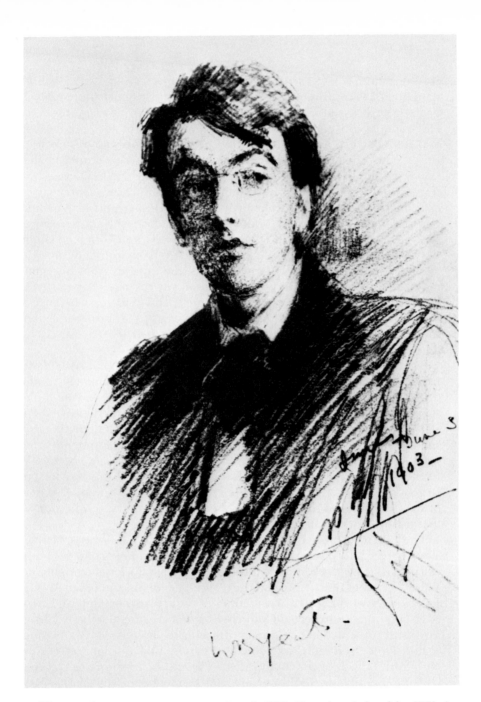

William Butler Yeats, June 3, 1903. Pencil. JBY. Signed and dated by JBY. Auto-
graphed by W. B. Yeats. Photographed from the original formerly in the possession
of Jeanne Robert Foster.

served in the front ranks in the attacks on the harmless old painter. She was the daughter of a Scottish shopkeeper, and JBY found in her all those signs of class groping he despised.[23] She showed her hand in the spring of 1903, when JBY's old studio at 7 St. Stephen's Green became vacant by the sudden death of Walter Osborne. Lane supported the bid of JBY, who soon resumed his old lease. "The other artists are green with envy," Lady Gregory told Willie. Mrs. Catterson Smith was furious. While JBY was inside the building discussing terms with the landlord, she stood outside with Lane, denouncing JBY, charging him with being in debt to everyone in Dublin, and even mentioning "the condition of his children's clothes!" Lane listened with amusement, and as soon as he was alone with JBY told him the details, and both men laughed.[24] On another occasion Catterson Smith saw JBY talking with Lady Aberdeen, a woman of influence, and became "jealous and envious" that his aged rival might be scoring diplomatic points. "Without any apology," Papa wrote Lollie, he "rushed in between us to introduce some friend of his, and so put a stop to the celestial harmony."[25] Fortunately for JBY, everyone else in Dublin knew of the machinations of the Catterson Smiths, but their mere existence was an annoyance to him.

A story JBY had written a year earlier was published in the Irish *Homestead*. It was his first published short story, and he was inordinately fond of it, describing it to Lady Gregory as his "bantling."[26] He also wrote a plea for stronger support for the R.H.A.,[27] a critical article on Sargent (as a letter to the editor of *Freeman's Journal*) and a subsequent defense of it in the *Leader*.[28] He spoke openly in Dublin to those of the Anglo-Irish Establishment. "I feel the keenest desire to start a movement against England *socially*," he told Willie. "Admiration for English character is the greatest possible mistake. Its source is largely hunkering after the *fleshpots* of their beastly civilisation. Also the sight of so much ordered routine is impressive, to people, that is, who don't know that prisons and lunatic asylums are equally orderly."[29]

The fight to advance Irish culture—whatever that was—was not easy, as the Yeatses were to discover. John Quinn, fired with enthusiasm by his Irish visit, organized a New York branch of the Irish Literary Society, arranging to have Willie elected as one of two honorary vice-presidents, the other Archbishop Farley of New York. JBY accepted an honorary membership and wrote an open letter that he expected Quinn to read aloud to the members.[30] After one successful presentation at Carnegie Lyceum of three of WBY's plays, Archbishop Farley suddenly and quietly resigned, and not long afterward the New York branch of the Society died. The causes, irritating to Quinn—and incomprehensible to JBY until his later residence in New York—could be grasped only by those who understood the Irish in America. Certainly the inclusion in the organization of such "agnostics" as the Yeatses and the occultist Charles Johnston (who was president) was not without its influence on His Grace. Quinn, who had come from a small town in Ohio, was more

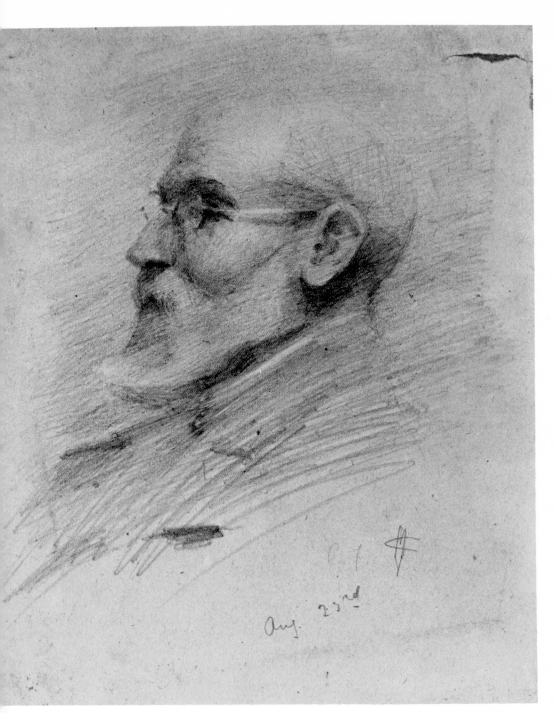

John Butler Yeats, about 1903. Pencil. Mary Cottenham ("Cottie") White (Mrs. Jack B.) Yeats. Collection: nne B. Yeats.

surprised at the collapse of the Society than W. B. Yeats, who had endured such follies before. He wrote Quinn: "I am often driven to speak about things that I would keep silent on were it not necessary in a country like Ireland to be continually asserting one's freedom if one is not to lose it altogether."[31] WBY once said that he had believed that literature came "from the inspiration of God" until he got to Ireland, where he discovered that "being inspired by God was a profession that was full."[32] He learned as early as the time of his fight over *The Countess Cathleen* that there are more Popes in Dublin than in Rome, all self-appointed.

Just as there were super-Popes in Ireland, so there were super-Gaels and superpatriots, and all three were to march their forces against the Yeatses in 1903. The new Irish Theatre of Yeats and the Fays produced its first plays on March 14, 1903. They were WBY's *The Hour-Glass* and Lady Gregory's *Twenty-Five*, the play of which the Fays had originally disapproved. During the intermission WBY gave a talk on his theory of theatrical production. JBY told Quinn his son's play was "an innovation" which "won its success in the teeth of much opposition," and he thought the talk excellent. Lady Gregory's play did not in his opinion come off quite so well.[33] WBY was also delighted with the evening, writing Quinn: "[*The Hour-Glass*] is the first play in the production of which my ideas were carried out completely. . . . Everything seemed remote, naive, spiritual, and the attention, liberated from irrelevant distractions, was occupied as it cannot be on the ordinary stage with what was said and done."[34]

Joseph Holloway thought the play well done—"a simple legend beautifully and poetically expressed"—but declared that the poet had made a vague and ridiculous speech, pretentious and affected, and had "meandered on making many statements that no sane playgoer could agree with, . . . trying to prove that acting should be something other than acting and that stage plays should be something quite different also—in fact, that nothing on the stage should be as it is."[35]

More important for the fame of the company was its appearance in London at the Queen's Gate Hall on Saturday May 2. Just before the March productions Miss Horniman had predicted to WBY, after analysis of the Tarot cards, that "very swiftly a current of mental energy [would] carry him along towards a voluntary change, great violence of a new energy bursting over the whole of his life." As for herself, matters would prove "slightly troublesome," but "work for love [would] bring Divine Wisdom."[36] Willie's response, if any, is not preserved. She also hinted to the Fays that she might be able to help their company if some shares she held in the Hudson's Bay Company should show a profit.[37] Later in the year John Quinn helped the project with a gift of fifty pounds.[38] The day before the London performance Miss Horniman reinspected the Tarot cards and predicted that WBY "would enjoy 'the materialisation of his ideas' and 'a gain of authority about his dramatic affairs.'"[39]

One gets two strong impressions: the first of her desire for William Butler Yeats, the other of her determination either to give or to withhold money to achieve her goal.

The London shows were highly successful. Many of the city's leading dramatic critics were present, and the audience included even so distinguished a visitor as Henry James.[40] Praise for the plays and the players was overwhelming, and there can be little doubt that their acceptance by the cosmopolitan audience and critics contributed strongly to the ultimate success of the Irish Literary Theatre even before the name "Abbey" was associated with it.

The stage was set, literally and metaphorically, for the theatre's most important work of the year, John Millington Synge's *In The Shadow of the Glen*. Synge had heeded Yeats's advice and returned to Ireland years earlier to study his own people. Willie reported to Quinn in March that the company had received two "wonderful prose peasant plays" from Synge who, he explained, "lives between Paris and the Isles of Aran."[41] The other play was the one-act *Riders to the Sea*. Fay thought the second "wanted more speed toward the end, after the body is brought in," and it was decided to delay its production and to put the other into rehearsal immediately. It was a fateful if fortuitous decision, for it meant that the first play of Synge's to reach a Dublin audience would fix him in the general mind as destructively anti-Irish and disrespectful of Gaelic virtue and nobility. It would also lead to worldwide notoriety for the Irish Theatre and catapult Synge to fame.

In The Shadow of The Glen is the story of an old Wicklow peasant and his much younger wife who live in a cottage near Glendalough. The wife has a young admirer for whose visits she longs. As the curtain rises the peasant husband is "dead" on the bed, his wife afraid to go near him as he lies prostrate. A tramp knocks and is admitted. In a dialogue with him the wife reveals the past history of the marriage. The tramp, superstitious like her, is afraid to touch the corpse. When the wife steps outside to see if her young admirer is coming, the "dead" man rises quickly, takes a swig from a whisky bottle to kill his thirst, and returns to his bed, threatening to kill the tramp if he reveals the deception. Later, with the husband still playing dead, the lover enters, the husband reveals himself, and the lover is given the choice of running off with the wife and suffering the social consequences or remaining as the husband's friend and sharing his hospitality. The lover, taking thought, chooses to remain conventional. When the husband banishes his wife, the tramp offers to share his life with her, and she accepts, preferring the free and open life of the tramp to the narrow confines of the small cottage with a crabbed husband.

The dramatic movement is beautifully paced, the characters brilliantly drawn, the language rich and poetic. Holloway watched it in rehearsal and saw that it was a good play: "The dialogue is capital and most amusing in parts." Yet he wasn't sure of its effect on the Irish. "How an audience will receive it I am curious to see, for . . . the tone of it is not quite Irish in sentiment

at all events."[42] Among the players the work aroused strong feelings. Dudley Digges, one of Fay's most competent actors, refused to accept a role in it and eventually resigned from the company. Maire Quinn, who later became his wife, joined him.[43] Even before the play was produced news of its content had spread, and those who shared Digges's way of thinking opened a barrage at once. The *Irish Independent*, controlled by William Martin Murphy,[44] appeared on the stands on the day of the performance with an attack on both Synge and Yeats and urged people to "make their voices heard against the perversion of the Society's avowed aims by men who, however great their gifts, will never consent to serve save on terms that never could or should be concealed,"[45] leaving to the reader the interpretation of the dark phrase about the "terms." Only the *Daily Express*, which was generally sympathetic to the Irish Literary Theatre, took the play as "most agreeable fooling" and refused to be upset by it.

The most spirited and challenging defense of the play appeared in Arthur Griffith's *United Irishman* before the actual opening; it was written by John Butler Yeats, who found in Synge's offering the first chapter in the Book of Irish Redemption. He seized the opportunity to deliver a lecture to the Irish people on what he considered the basic problems they had to solve, tying everything to his commentary on the play itself and its author. The long and sprightly piece was called "Ireland Out of the Dock," an appropriate metaphor from an inactive barrister. For centuries, the author declared, Ireland had been like a criminal facing his accusers, the English. "From time immemorial, in the logic of the well-to-do, misfortune is proof positive of guilt." But times had changed. "Ireland is no longer in the dock. She has slipped out of the toils of her oppressors. She is sufficient to herself."

If superpatriotic readers thought the writer was about to deliver a blast against the English, they were mistaken. JBY indeed let his opinion of Englishmen be known in the epigrammatic style he employed in conversation with his sitters:

When their ill-gotten possessions are not molested or their right to universal thieving questioned, the English are a good-natured people, who steer the middle course, avoiding extremes; in matters of conduct, choosing compromise, and in matters of art, adoring the pretty. They have the lax morals and the easy manners of the genial highwayman and the footpad.

But now he was discussing Synge's play, which constituted an early contribution to a pressing Irish need. As Ireland was now "sufficient to herself," so she was also under certain obligations. "Let her therefore put her house in order in accordance with her own judgment and conscience; let her begin the work of self-examination and self-accusation." In short, let Ireland now face the truth about herself so that she might move forward. Synge had contributed his part. "Putting aside the pretty and caring nothing for the idyllic," he wrote,

Synge "has attacked our Irish institution, the loveless marriage." Where Holloway had seen a play "not quite Irish in sentiment," old Mr. Yeats saw one that was all too Irish in fact, showing as it did "a young girl having every instinct of womanhood uprooted by marriage with a man crabbed by age and avarice." He approved of the wife's decision: "better be a young tramp's drudge, better be a target for everyone's scorn, better anything than the foulness of such a marriage."

Anyone familiar with John Butler Yeats's own life will understand why the wife's choice would strike him as correct. Symbolically, it was the choice he had made for himself—"life on the open highway and under the open sky." But to suggest that the play was about something that really existed in Ireland, contracts for loveless marriages, something that wasn't noble and fine and pure and indeed was something else altogether, was not playing according to Irish rules. In Dublin such a story would have been greeted with laughter if only the nationality of the people had been Italian or French or otherwise decadent. To attribute such behavior to the Irish was to sin against the Holy Ghost, to put it less than metaphorically.

JBY closed with a prophetic evaluation of the young writer whose first play had not yet been seen by the public:

> I do not know whether Mr. Synge is as great as Shakespeare, but he has begun well. And I cannot conceive any events more important in Irish history for some time to come, than a few more plays by him.
>
> I am among those Irish people who think we should take no criticism from our enemies, Briton or West Briton. But Mr. Synge has the true Irish heart—he lives in Aran, speaks Irish, and knows the people. He is, besides, a man of insight and sincerity, that is to say, a man of genius. Such men are the salt of Ireland.[46]

The first performance was held before a crowded house and was sandwiched between the maiden performance of Yeats's *The King's Threshold* and *Cathleen ni Houlihan*. Holloway reported enthusiastically on the first and third but noted that Synge's play found a mixed reception. He acknowledged "the cleverness of the dialogue and the conciseness of the construction," but was still troubled by "the nature of the plot." Such a "subject," Holloway asserted, "no matter how literary-clad, could never pass with an Irish audience as a 'bit of real Irish life.'"[47] As a lover of the drama and a human being he knew the play was good; as a Catholic Irishman he had the uncomfortable feeling that it couldn't be.

The newspapers generally supported Holloway. When their attacks mounted, JBY, delighted by the dissension, returned to the fray, writing in the *United Irishman* again.

> The outcry against Mr. Synge's play seems to be largely dishonest, the real objection not being that it misrepresents Irishwomen, but that it is a very effective attack on loveless marriages—the most miserable institution so dear to our thrifty elders among

The Embroidery Room at Dun Emer, 1903. Lily Yeats is in right foreground. Others, from left to right: Ellen McCabe, Sarah Mooney, Jane Gill, Maire nic Shiubhlaigh (Mary Walker), Eileen Colum. Collection: Michael B. Yeats.

the peasants and among their betters, by whom anything like impulse or passion is discredited, human nature coerced at every point and sincerity banished from the land. . . . My complaint of Mr. Synge's play is that it did not go far enough.[48]

Miss Horniman was not displeased with the turn events were taking. "What is the right thing for me to do . . . now?" she asked WBY on October 9. She had herself served as costume designer for *The King's Threshold* and been consumed with enthusiasm: "Do you realize that you have given me the right to call myself 'artist'? How I do thank you!" Fortunately the Tarot cards gave a favorable answer, if a troubling one. "I am so anxious to help effectively as best I may and it seems as if it were already ordained." Yet, she continued, "some gift will cause quarrels and anger. . . . Self-assertion is absolutely necessary."[49] Clearly, the Hudson's Bay shares had gone up, and so the prospects for the theatre were brighter, and the prospects for discord as well.

Dun Emer ran on a double track during its first full year, one heading toward moderate success, the second toward possible failure. Miss Gleeson,

The Dun Emer Press, 1903. Lollie is at the press at right. At left correcting proofs is Esther Ryan. Standing at the ink roller is Beatrice Cassidy. Collection: Michael B. Yeats.

who had picked up notions of class from her long residence in England,[50] proved an arrogant and unpleasant superior with the girls who worked under her. She didn't get on well either with her supposedly equal partners, the Yeats sisters. Although Lily and Lollie paid a high rent for their portion of the house, they found it "cramped."[51] Miss Gleeson was easily thrown into "panic" when money didn't roll in as copiously as she wanted it to, and during the first year it didn't. Yet the chief difficulty sprang from the relationship between Lollie, the manager and publisher of the press, and Willie, the editorial adviser. A suggestive sentence in a letter from York Powell to JBY—"They ought to have a free hand and a free purse"[52]—shows that the painter had already expressed his concern about Dun Emer. Two books were issued in 1903, WBY's *In the Seven Woods* (finished in July and published in August), and AE's *The Nuts of Knowledge*. Though Lollie was in charge, Willie looked on the press almost as a private fiefdom, taking a hand in the design of the first book and watching its progress carefully,[53] even annoying the usually placid Lily in the process. Despite the little time he was able to give Dun Emer, he managed to upset the sisters and make himself as offensive as possible. When, at his request, Russell submitted a group of poems called *The Divine Vision*, Willie found fault with some and insisted on his own absolute approval of everything that appeared over the imprint. According to Russell, WBY objected to one of the poems even though he never looked "beyond the second verse." Both men were "stiff-necked," and finally WBY suggested that Russell make a selection from all his verse rather than insist on the original group. "This I am doing," Russell wrote Quinn. "It enables him to get rid of the poem in *The Divine Vision* series which he disliked." He commented dryly on Willie's role as literary adviser: "If he will not let them print anything which is not on the level of a sacred book the output will be small."[54] Having won his way, Willie was expansive. When *The Nuts of Knowledge* appeared in December he described the volume as "perfectly charming," "better than *The Seven Woods*," and said it ought to "advance the fame of the press."[55] His treatment of Russell was an unpleasant foretaste of what was to happen repeatedly at Dun Emer.

Of all the events of the year, however, none was to be of more significance to the whole family than Willie's first invasion of the United States. In the summer, Quinn, realizing that the Yeatses were walking a financial tightrope, suggested that WBY come to America to give lectures which Quinn would arrange for. After some misgivings Willie agreed, and Quinn put together a crowded and varied schedule. WBY left for New York on November 11. By the time he arrived back in Dublin four months later he had covered the United States from coast to coast. He lectured in the east at the leading colleges and universities like Yale (where he gave his first lecture), Harvard, Williams, Amherst, Mount Holyoke, Smith, Vassar, and Bryn Mawr, in the west at Stanford and Berkeley, and at a number of other places between. In Washington he met Theodore Roosevelt. Everywhere he went, according to Quinn, he

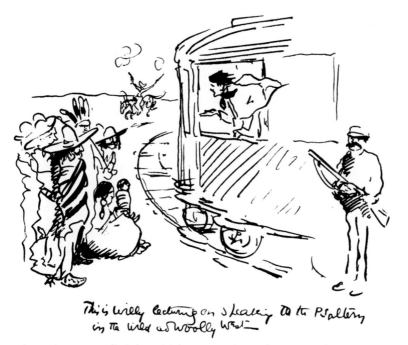

Cartoon by Jack Yeats. India ink. In his letter to John Quinn, December 15, 1903. "This is Willy lecturing on Speaking to the Psaltery in the wild and woolly West." Collection: Foster-Murphy.

made a remarkable impression, and he received ample fees, seventy-five dollars being standard for a lecture.[56]

It was an active and successful year, yet one takes note of the abiding realities. In a letter to Willie in the spring of 1903 his father began, "I would be very much obliged if you would lend me a sovereign for a short time (I should much prefer two sovereigns if at all possible)," and concluded, "I should be very glad if you could send me the money I am asking for by return."[57] The more things changed the more they were the same, as Willie would discover even before he returned, laden with American money, in early 1904.

Willie earned $3,230.40 (£646) in clear profit from the American tour,[58] and his ego was expanded by the enthusiastic response to his appearances. But there were irritating annoyances to dim the luster of his new fortunes and one heavy blow that shocked and dismayed him. Before 1903 had ended he learned that Maud Gonne had married Major John MacBride, a final and compelling message from his "good friend" that could not have been put more unambiguously. On the train from Montreal to New York he composed a poem, "Old Memory," in which he wrote in resignation, "For when we have

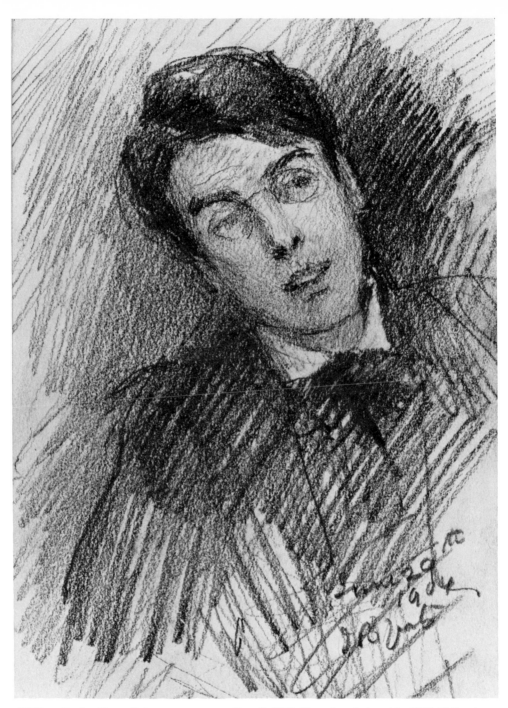

William Butler Yeats, February 20, 1904. Pencil. JBY. Signed and dated by JBY. Collection: Michael B. Yeats.

blamed the wind we can blame love."[59] Only five years or so earlier Maud had joined in a "mystical" marriage with him, offering that as her final answer, and he had pressed in vain for a bond less spiritual.[60]

His distemper was not eased when he suddenly received excited requests from home for contributions to family causes. Lily wrote in agitation that she and Lollie were again having trouble with Miss Gleeson, who was in a "panic," and asked if he could send money immediately to help keep Dun Emer afloat. He wrote testily to Lady Gregory that he felt "cold" about their plight. "I confess I do not like the thought that the first money I ever earned beyond the need of the moment will be expected to go to Dun Emer." For one thing, he believed it would do no good: to give too much would be to squander money, too little to incur blame.He was annoyed at being asked to haul into port a sinking ship which, he now believed, should never have been launched in the first place. He supposed he would have to see Uncle George and get his advice about the business. He clearly found the whole burden unwelcome: "family duties—just perhaps because they are rather thrust upon one—leave me colder than they should."[61]

He had hardly spoken his mind to Lady Gregory when a long and chatty letter from his father arrived, a mountain of anecdote and comment all meant to clothe the overwhelming question at the end. Even JBY was aware of its magnitude. "And now I have a sentence to write which I hardly have courage to write. Could you lend me £20?"

There was a quality of breathless daring in the request. In all the years since Father began putting the touch on Willie, the sums asked had seldom exceeded a guinea or two. Now, in a logarithmic leap, he sought twenty pounds. Father, like his daughters, apparently looked on Willie's American adventure much as James the First had looked on Ralegh's. We do not have Willie's response, but however annoyed he may have been, he must certainly have been fascinated by the rest of the letter. Father tried to explain away his indifferent success with the Lane commissions: "He genuinely loves pictures, but he likes a picture to be a success."[62] Willie had been warned by Lady Gregory two days earlier—"The portraits are *not* going very well"[63] —so his father's story was not unexpected.[64] More ominous was JBY's charge that the only reason Dublin's Establishment had agreed to sit to him was that its members hoped through him to capture Willie and his theatre, and to induce its members "to play before the King when he arrives here next April." As soon as he let it be known that such a capture of Willie was impossible, their interest in him "subsided." That was why he was short of funds. "Lane has been very liberal in advancing me money and I cannot ask him for more till I have more work to show for it. . . . I am afraid you will think me very shabby in writing this just the moment when you have got together a few pounds, but I am quite sure that before very long I shall be in a position to repay you." He

wrote hastily the following day to warn Willie not to let any of the Establishment know what he had said. "Of course it would make me appear worse than indiscreet if I . . . betrayed this confidence." [65]

While in New York, WBY had been initiated by Quinn into the unorganized fellowship of Nietzscheans. Quinn, a brilliant, self-made man, would of course regard with favor Nietzsche's doctrine of the natural superiority of a few men over all others, and it was not difficult to convince WBY that he was a member of the tribe too. Nietzscheanism provided an overcoat for the personality he had been cultivating since the mid-1890's. The gray gloves and the coat that got stuck on the flypaper at Blenheim Road were early manifestations of his attempt to shape an outward posture that would somehow work its way inward, his theory "that the form creates life," as Russell put it to George Moore, when in fact "life creates the form." AE thought Yeats's deliberate "posing" made him less interesting than he might otherwise have been. Yeats seemed to have thought, though Russell admitted he never said so, "that if you make a picturesque or majestic personality of yourself in appearance, you will become as wonderful inside as outside." [66] It was the celebrated theory of the mask. When WBY's mask as posing poet was reshaped by the arrogance of Nietzscheanism the result was not always pleasing to his associates. Two of those who came to know him well described his impression on others. "He came into a room," wrote Edmund Dulac, "with slow, deliberate steps, his hand raised in a gesture between a salute and a blessing. He did not say, 'Hullo! How are you?' Some resented it. The gesture of the hand, like the beautfiully untidy hair, the large enamel ring, the subtle color of shirt, tie, and dress, were part of the picture." [67] L. A. G. Strong wrote, "He could magisterially resent a liberty, and the uninvited stranger was soon shown the door. He had no time for bores, or the self-satisfied and empty. He required of a man that he should have something to say, or else keep his mouth shut." [68] WBY's view of his role in the city to which he returned was expressed in a letter to Stephen Gwynn: "What Dublin wants is some man who knows his own mind and has an intolerable tongue and a delight in enemies." [69]

So when Willie arrived in London from New York, angry and irritated on the one hand,[70] rich and satisfied on the other, he gave some the impression of regarding himself as a conquering hero. Wilfred Scawen Blunt recorded his feelings after a dinner with Lady Gregory and Robert, Gilbert Murray, and WBY: "Yeats is just back from America, where they have made a great fuss with him, and he takes himself very seriously as a consequence. Though doubtless a man of genius, he has a strong touch in him of the charlatan, and his verse is thin stuff, not so good as his prose." [71] In face-to-face confrontation he could be sincere and warm—"When he does not pontify he is all right," Charles Ricketts said of him[72] —but he was not always so, and his newly acquired Nietzscheanism did not improve him. He was so irritated with Lollie because of her troubles at Dun Emer that Father had to admonish him:

Jeanne Robert Foster presents an embroidered Cuala jacket to Caitríona Dill Yeats, great-granddaughter of John Butler Yeats, 1970. Lily Yeats had given the jacket to Mrs. Foster in gratitude for her care of JBY. Mrs. Foster died six months after this picture was taken. Collection: William M. Murphy.

I daresay there have been mistakes made. Only don't let irritation or unreasonableness of any kind bear sway. To make Dun Emer a pecuniary success is a matter of life and death to Lily and Lollie. . . . Dun Emer is, as it appears to them, their one chance of ever having any sort of support in life. That is why they are so keen about things.

I hope you won't mind my suggesting that you are *gentle* with Lollie. If things go wrong and she gets much exasperated she gets quite ill. Please don't say I have written.[73]

Willie replied that his contributions to Dun Emer—whether financial or otherwise he did not specify—had not been sufficiently appreciated. He privately admitted to Elkin Mathews that he was "merely literary adviser,"[74] yet he seemed to Lollie to be trying to run the show. When Father's first letter was met by his son's testy reply he responded more diplomatically: "It is the easiest thing in the world to arrive at a misunderstanding." All he meant to say on the subject was that the Yeatses, unlike the Pollexfens, had always helped one another out without fuss. For years he and others in the family had

supported Aunt Ellen Yeats and her large brood even though the Pollexfens knew nothing about it. It was the kind of thing one simply did.[75]

But Willie was in no mood to derail his own career to discharge duties "thrust upon" him. With a hopelessly improvident father and two maiden sisters not quite able to make ends meet, he could never be free. He might escape from Blenheim Road to Woburn Buildings and mingle with mystical and literary societies with which they had no connection, and they might even move to Dublin while he remained in London. But always the family and its demands were present and insistent. At what seemed the peak of his career, he was never away more than a week or so without receiving a letter from Father or Lily to remind him of the debt he never promised.[76] He must always be the dutiful son and brother, but he did not like the role, and he did not propose to sacrifice his own career to fill it.

Dun Emer's problems lay not in the quality of the products,[77] which were widely praised, but in the profits. There were unpleasant charges and countercharges about who was and who wasn't doing her proper share of the work. In the perhaps partial view of the Yeatses, Lily and Lollie had always done more than was required of them. "Everything devolves on them," Father told Willie. "They have to do the *thinking and the working in Dun Emer.* I often wonder at their devotion and tirelessness."[78] George Russell, who had already won a reputation as a peacemaker,[79] worked out a plan under which Miss Gleeson and the sisters were to be financially separate and independent—almost. Under the new arrangement the company was assigned a total of 159 shares. Of these 150 were shared by Miss Gleeson and her niece, Katharine MacCormack; one share apiece went to Lily, Lollie, and the seven workers. Miss Gleeson was named president and Lollie secretary, and it was agreed that the sisters would continue to pay rent for their rooms. Lily described the new Dun Emer as "two cooperating societies, Lolly's and mine one and Miss Gleeson's carpets the other." Nevertheless, Lily told Quinn early the following year, Dun Emer was "not a bed of roses."[80]

The new arrangement was to prove no more viable than the old, though at least the change brought quiet for a time. Because of the negotiations WBY's *Stories of Red Hanrahan,* which had been completely set in type and proofread by August 15, 1904, wasn't published until May 16, 1905. Russell was careful to warn the sisters not to sign any final agreement with Miss Gleeson until he had seen and approved it.[81] Father urged Willie to speak to George Pollexfen about helping out;[82] but there is no record of Willie's response. The Department of Agriculture and Technical Instruction offered a subvention to encourage the useful employment of Irish girls, and Miss Gleeson accepted its help, much to the disgust of JBY, who thought her part of the business "*a farce,*" and who later complained to Quinn that Miss Gleeson was "an integral part" of the Department's "fraudulent machinery."[83]

Lily, the family peacemaker, had held her tongue in 1903, but in July of 1904

she wrote Papa in exasperation. When Dun Emer was just getting under way, she told him, Willie had been insufferable in his arrogance, "full of 'Do this,' 'You must do that,' etc., 'A press man is absolutely necessary,' and so on to us. He even threatened us and bullied generally." Nevertheless, "Lolly and I are hardened and stood our ground."[84]

Her letter was written to complain not about Willie alone, but also about Papa, Lady Gregory, and Quinn for their treatment of Jack. Jack had gone to New York in early 1904, at Quinn's invitation, to exhibit his paintings, and he and Cottie spent several weeks enjoying the noise and bustle of the crowds and the deep valleys of the streets. He placed sixty-three pictures on exhibition at Clausen's Gallery from March 28 to April 16, but only twelve were bought, ten of them by Quinn; the total sum realized was only $430.[85]

Quinn was sure there must be something wrong with Jack, that he must be "too quick and crude, too lazy in much of his work."[86] Since Quinn's opinion fitted in nicely with JBY's belief that Jack should work from models, he was happy to add his advice to Quinn's. When Willie and Lady Gregory gave voice to their view too, Lily exploded to her father:

> I don't like your writing to Jack. You say too much. He is all right and knows what he is doing. He never drifts. Willy and Lady Gregory are both too ready to criticize and direct. They forget Jack is at the beginning and is *seven years* younger than Willy. What of Willy's technique seven years ago? They all forget this and from their pedestal direct and order others a great deal too much.

She added a prediction as astonishing and as correct as her father's about Synge the year before: "Don't worry Jack. He wants encouragement, and his work is beautiful and his own. When we are all dead and gone great prices will be given for them. I know they will."[87]

The year was not an easy one for Lily, since Lollie was unhappy. In midyear the two traveled to Frankfurt am Main for a vacation, but even boat trips down the Rhine couldn't cure Lollie's ills. Lily, noncommittal when writing from Germany, told Papa later the experience had been "dreadful," and he let Willie know. Remembering her mother, JBY feared for Lollie's condition. "I have often had my own dread that Lollie may lose her wits. The Pollexfen blood can't stand worry. At any rate Lollie can't. At times she becomes terribly depressed."[88] After their return Lily insisted that Lollie rest every day after dinner, and she seemed to grow better. "In the quiet of bed she reads tranquilly," Father told Willie, "whereas if she is down she fusses writing letters, designing fans, and talking and driving herself and others."[89] Lollie's melancholia in 1904 was the beginning of twenty years of misery for Lily, which she endured stoically, knowing her sister's troubles were too deep for cure.

(In 1923 or 1924, when Lily lay sick in the hospital she wrote a pathetic note to Willie which she first entitled "My will," then, realizing she had nothing to leave, crossed out "will" and substituted "wishes." What she wrote is central to an understanding of her life and JBY's—not to mention Lollie's—in the years after 1904.

I feel this is a break which had to come, and I feel I ought to take advantage of it and make a complete separation from Lolly, for life with her for the past twenty years has been torture. Dr. Goff knows she is incurable, and having suffered so much and gone through so much with her . . . I feel it is impossible ever to think of living with her again. . . .

I do not want Willy . . . to think from this that we led a cat and dog life. It never came to that, for many years ago I saw no escape and I faced it and decided I would never be the cause of a scene with Lolly. I felt nothing would ever be gained by as it were "having it out with her." I said to myself she is incapable of realising what she is either saying or doing, but I also said to myself, "She is getting less and less sane, and she is gradually killing me." But again I thought, "I can do nothing as I have to live with her.)[90]

Lily also had to look after Ruth Pollexfen, an obligation she bore willingly. Between Lily and her younger cousin there developed a relationship like that of mother and daughter. Funds were scarce, and Lily was allowed by the court barely enough to defray the costs of board and keep. Lily worked patiently on Uncle George, who at length agreed to contribute to the costs of Ruth's education.[91] None of the other Pollexfens gave a shilling.

While William Butler Yeats was in America early in the year, the Irish National Theatre Society continued the series begun with *In the Shadow of the Glen*. On January 14, 1904, the players presented WBY's *The Shadowy Waters* (his most recent version, part verse, part prose) and a folk play by Seamus MacManus, *The Townland of Tamney*, and on January 25 Synge's *Riders to the Sea. The Shadowy Waters* Holloway found not very convincing. It was the play which JBY had found uncompelling in its earlier form. As Father never fully elaborated on his objections to the play, it is worthwhile to consider Holloway's opinion of it. He thought it "weird, puzzling, melancholy, and depressingly gloomy," a piece which "fairly mystified the audience by the uncanny monotony of its strange incomprehensibleness. . . . Had this dramatic poem any real dramatic life in it, it must have discovered itself under the living treatment given it by the players. That it possessed any would be drawing the long, long bow of fact to assert." Yet he was glad to have seen it. "It was strangely tiresome but very beautiful and lovely all the same."[92]

If this was the opinion of the unsophisticated Holloway, it is no wonder that two such different people as Standish O'Grady and Edward Dowden[93] wondered why Willie didn't return to lyric poetry. J. M. Synge, whose inscrutability always baffled and defeated W. B. Yeats, privately remarked of *The King's Threshold*, as Holloway reported his words, that the comic relief in it was "a mistake, and arrests the interest."[94] To Stephen MacKenna, Synge wrote what he would never have uttered openly to Yeats: "We had the 'Shadowy Waters' on the stage last week, and it was the most *distressing* failure the mind can imagine—a half empty room, with growling men and tittering females. . . . No drama can grow out of anything other than the fundamental realities of life which are never fantastic, are neither modern, nor unmodern, and as I see

them rarely spring-dayish, or breezy, or Cuchulainoid!"[95] Yet the play went on and continued to go on. After seeing his third performance Holloway "felt quite sad that such a beautiful work of art" should be spoiled by "the dense obscurity of the text. . . . Oh, the pity of it, that such a precious thing should thus leave itself open to ridicule."[96]

The Fays had withheld their approval from Lady Gregory's new play *The Rising of the Moon*. It is clear from their objections and her supercilious attitude toward them that the partnership was frail. Writing to WBY in America, she made her disdain obvious:

> The company have at last passed *Rising of the Moon*, but sent it back to have some of the speeches made shorter, and "the speech in which the policeman changes his mind made shorter and more clear." You will remember there is no speech in which he changes his mind, and the speeches all through are short enough. However I wrote in a sentence here and there to please them.[97]

Synge's one-act play, *Riders to the Sea*, was the one success on whose merits everyone agreed. It was set in a fishing community on the Aran Islands, its plot concerned with the death of fishermen who go down to the sea in small boats and the grief of those left to mourn. Synge's magnificent poetic prose and perfect timing conferred greatness on a simple story. Even Holloway was moved, noting that "some of the audience could not stand the painful horror" of the closing scene and "had to leave the hall during its progress." At the end the audience was too much moved to applaud.[98]

In April, 1904, Miss Horniman sent a long letter to WBY, with copies to other officers of the Society, setting forth the terms on which she would subsidize the company. She would take over the old Mechanics Institute on Abbey Street, connect it to another building at a right angle to it on Marlborough Street, and convert the whole into a theatre complete with lobby and fire exits. She would put up five thousand pounds of her own money, part for renovation of the buildings, part for an annual subsidy. The members of the Society accepted,[99] and by the end of the year they were performing in a new theatre called The Abbey, the name by which the Irish National Theatre Society would be immortalized.

There were difficulties from the start. Miss Horniman decreed one stipulation that was not received with good grace. She refused to allow sixpenny seats, even when the theatre was rented out to other groups. The prices might be raised above a shilling, she conceded, but not lowered. Under the circumstances the company had to accede, but Maud Gonne MacBride reported to Willie in November that there was "great and ever growing indignation" over the absence of sixpenny seats and that the Irish clubs were saying that Willie himself was "lost to nationalism."[100] The source of the friction lay not so much in the edict itself as in its promulgator, for Miss Horniman made little

effort to conceal her venomous anti-Irishism. "The relations between her and the Theatrical Company are decidedly uneasy," JBY told Lady Gregory, "and one never knows what may result."[101]

William Butler Yeats was her quarry, not the cause of Irish culture, but if Miss Horniman thought she was buying the playwright with the theatre she was mistaken. She did not in fact even acquire a theatre but merely a building. To operate a theatre in Ireland required a patent from the authorities, and rival theatres were opposed to new companies that might compete for their business. The Yeats-Fay group countered their objections by insisting that its company would offer only plays on Irish subjects or "artistic" plays appealing to a special class. There was a long struggle before the authorities gave in. By a quirk of the law, the legal patentee had to be an Irish rather than English subject of His Royal Highness; so Lady Gregory was co-opted to serve as legal trustee of the patent, which empowered the Irish National Theatre Society "to exhibit plays in the Irish and English languages, written by Irish writers on Irish subjects, or such dramatic works of foreign authors as would tend to interest the public in the higher works of dramatic art."[102] Miss Horniman's surrogate trustee was vested with authority. If the National Theatre Society dissolved, the patent would lapse. The patent, which in London could be had for ten pounds, cost in Dublin £455.2.10.[103]

Altogether it was an expensive year for Annie Horniman, especially as Lady Gregory ended up with the power her rival had paid for. For the Fays it was also to prove expensive; they needed the theatre which Miss Horniman's money provided, yet had to accept Lady Gregory as their legitimate superior in order to get it. As a mere officer of the Theatre Society she might not have more power than they; as patentee she was like the owner of the only football among a group of boys eager to play. George Russell was irritated at the assumption by Yeats and Lady Gregory of proprietorship of the idea of an Irish Theatre, feeling that "the Fays never got the credit they were entitled to get." Holloway too felt that the Fays were "the guiding spirits of the new theatre."[104]

The relationship between Miss Horniman and the company worsened with time. Her attempts at costume designing the year before had annoyed the players, yet Frank Fay had allowed her to continue with what Lennox Robinson, later the manager of the Abbey, called her "incredibly graceless and ugly" creations[105] because Willie Yeats cannily advised him that that was the road to a theatre building.[106] The members of the company knew and disliked her views on Ireland. She did not get along with Lady Gregory, each regarding the other with disdain and suspicion. Joseph Hone, an Irishman, wrote of the relationship, "Lady Gregory was polite, even gracious, but it was obvious that she disliked being under obligation to a middle-class Englishwoman for the production of her plays."[107] Miss Horniman's animus against Lady Gregory was equaled only by Lady Gregory's against her. Poor Miss Horniman per-

ceived too that Lady Gregory, though a widow thirteen years WBY's senior, was somehow a rival for the attentions of her beloved poet.

If Willie didn't get the message Miss Horniman was sending by way of the theatre renovation and the patent, she made it about as clear to his father as it could be made. When JBY was in London in June, 1904, to combine a visit to the Guildhall Exhibition with attendance at a performance of Willie's *Where There Is Nothing*, he stayed in the building where Miss Horniman lived and saw her regularly. One day she told him that a "witch" had prophesied to her "that she would marry a man from overseas, tall, dark, and very thin, with some foreign decorations." The description fitted Willie in every way except for the "foreign decorations"; but fortune-telling operates under accepted principles of ambiguous obscurity, and those wishing to identify Willie with the witch's prophecy (or curse) could point to his honorary vice-presidency of the Irish Literary Society in New York. Miss Horniman had asked the witch "why she would marry him" and received the answer, "To make him a comfortable home."[108] Papa passed the story along to Lily, but whether either shared the forecast with Willie is not known. Nor is it certain whether the "witch" was a tea-leaf reader at a local restaurant or an incubus in Miss Horniman's dreams. Her hints came to nothing, however. Although she addressed Willie in her letters as either "Prince S." or "Dear Demon" (the first her private name for him under her "system," the latter the first word of his secret name in the Order of the Golden Dawn, "Demon Est Deus Inversus"),[109] he consistently wrote to her as "My dear Annie." There is no evidence of any kind that he ever encouraged her suit.

The appearance of JBY's paintings at the Guildhall Exhibition came about in a peculiar way. Hugh Lane had planned to send a collection of Irish paintings to the World's Fair in St. Louis[110] to publicize the renaissance in Irish art. Contemptuous of bureaucracy, he had neglected to comply with the formal requirements for receiving a grant for insurance, and his application was rejected. Shifting ground, he offered the paintings to the Guildhall. The Exhibition of a Selection of Works by Irish Painters opened in May, and six of JBY's paintings were among the 465 works on display.[111] As the show coincided in time with the London performance of *Where There Is Nothing*, a great number of Dubliners flocked there in mid-June for the double event. The artist Charles Shannon wrote Lady Gregory that he admired JBY's work, the painter having "great powers of characterization and also great technical gifts in the rendering of faces; a very rare quality indeed."[112] JBY was agreeably surprised that his work was liked, as he had heard disquieting rumors that the portrait of John O'Leary had been "hung in an awful place." But he heard also that the portrait of Lily "looked splendid" and was better than that of Nannie Farrer Smith. "Does that gratify your female mind?" he asked Lily.[113] He hoped that if he remained available in London, commissions might come flooding in, especially as Hugh Lane had told his aunt he would try to find

customers; as usual nothing happened.[114] He learned that George Pollexfen was sick at a hospital in London where Willie had installed him, but when JBY tried to learn its name Willie "in his fussy way" wouldn't tell him. "I wish Willie had Jack's tender gracious manner, and did not sometimes treat me as if I was a black beetle," he told Lily.[115]

The financing of JBY's London visit is not clear. Lady Gregory may have had a hand in it, for she asked him to do sketches at a rehearsal he attended along with her, Willie, Maud MacBride and her sister, and Mrs. Victor Plarr.[116] On Sunday, June 26, the day of the performance, be dined beforehand with Willie, Miss Horniman, Charles Shannon, Charles Ricketts, Robert Gregory, and Florence Farr. Miss Horniman gave him her ticket, "the best seat in the house," he told Lily, "front row in the middle of the gallery," while she sat in WBY's box with Arthur Symons and his wife. The play (which because of its plot could hardly be offered in Dublin)[117] was "splendid, most stimulating," Papa wrote. There was one melancholy note. "Todhunter and his wife were there. I avoided the former because of the latter."[118] He was never to see Todhunter again.

Lane's offer to find commissions for JBY in London may have been genuine enough, but early in the year he had found it necessary to dismiss him as his Dublin court painter. JBY still thought he could improve on any painting if only given a little more time. He drove Lane almost mad with his constant reworking of faces and his careless disregard of clothing and background. Thomas Bodkin, later Director of the National Gallery of Ireland, wrote delicately that JBY "found it hard to work in harness."[119] When the year began he was busy painting Sir Anthony Macdonell—at the success of which he "was wallowing in glories," according to Lily[120] —Lord Dudley the Viceroy, and John Redmond. Each gave him three sittings, but he demanded more; "I cannot work miracles in three sittings," he told Lady Gregory. Redmond didn't show up after the third. Lane was dissatisfied at the lack of results, and JBY's attempts to explain himself in letters to Lady Gregory were fruitless.[121] He simply could not produce enough quickly enough to satisfy Lane.

The stratagem Lane designed to ease JBY out of his job was simple. He persuaded the old man to enter into a competition with William Orpen in painting a portrait of Lane's sister Ruth. JBY boasted to Willie that his own portrait, "modern and impressionist," was better than Orpen's, whose style was "learned and like an Old Master."[122] Of course Lane declared Orpen the winner and promptly commissioned him to do Macdonell, Mahaffy, and John Shawe-Taylor. Apparently JBY was still free to paint them too, if he could get down to work. Of the portraits originally assigned to JBY that made their way into the Dublin galleries—Synge, Plunkett, W. G. Fay—Lady Gregory said diplomatically that they were not "so good as some others of his in the Gallery and elsewhere." Then she added in magnificent understatement: "he has the artist's caprice of choosing his own subject, he does not work well in bonds."[123]

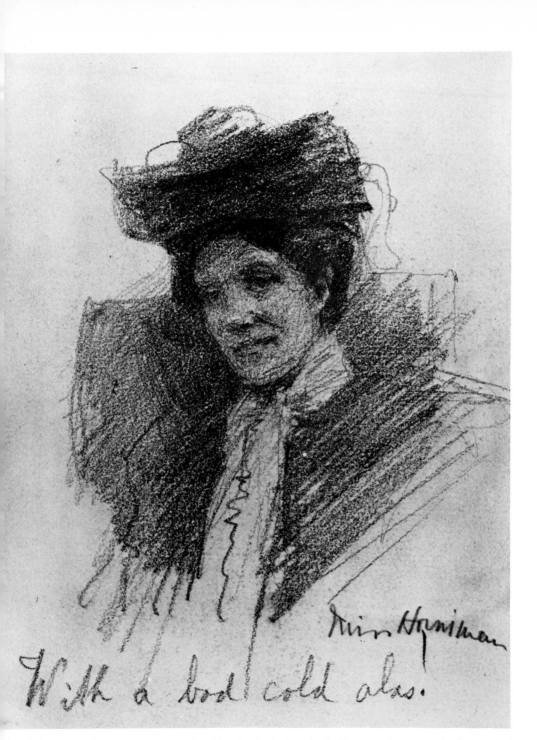

Annie E. F. Horniman, 1905. JBY. Identification in the hand of Lily Yeats. Comment in the hand of Miss Horniman. Collection: Michael B. Yeats.

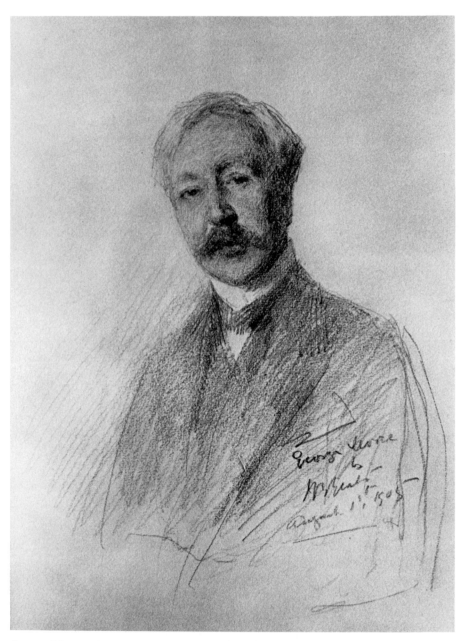

George Moore, August 1, 1905. Pencil. Signed and dated by JBY. James Augustine Healy Collection of Irish Literature, Colby College, Waterville, Maine. Permission J. Fraser Cocks III, Special Collections Librarian.

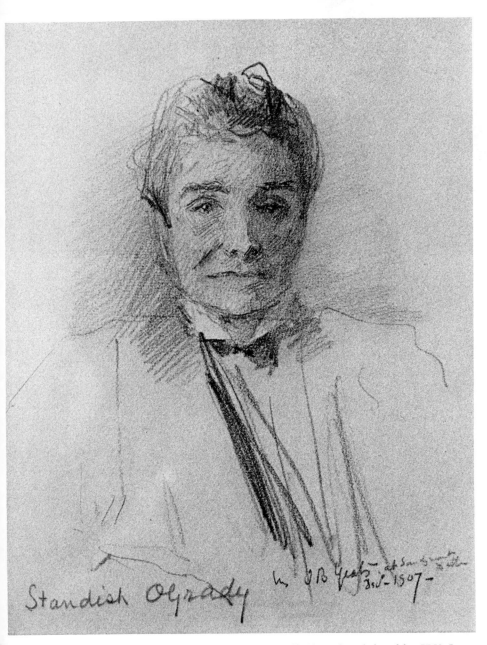

Standish O'Grady, at Sandymount, Dublin, 1907. Pencil. Signed and dated by JBY. James Augustine Healy Collection of Irish Literature, Colby College, Waterville, Maine. Permission J. Fraser Cocks III, Special Collections Librarian.

He also continued to be dogged by self-created bad luck. Years earlier he had begun an oil of D. H. Madden and his wife. The wife died and the portrait remained unfinished. When JBY at length sent the picture for Madden's approval—and payment—he did so on the very day his client was bringing home the second Mrs. Madden.[124]

Miss Horniman commissioned four sketches for the Abbey that year; in addition JBY painted her for nothing,[125] even though the effort was exhausting. ("He had done, I hear, a very fine portrait of her," Lily wrote Willie, "and they got on very well together, but she *is* fatiguing.")[126] He painted or sketched others on the same terms. Years later he wrote a friend: "I painted for nothing, when I could not get the money. In Dublin money is not easy to be got. No one has any—but nice people with affectionate friends like to be painted. . . . I have always said that if I was dying and anyone came in and asked to be painted, I could manage to put off the dying till the portrait was finished."[127]

The greatest disappointment of the year was also accompanied by personal tragedy. Quinn wanted JBY to paint a portrait of George Meredith, to Quinn "the one incomparable artist" in the novel.[128] The middleman in the negotiations was York Powell, who seemed to know everyone worth knowing. Powell urged JBY to get in touch with the novelist's son Will. "But don't lose the chance," he warned, knowing his friend's habits. "You will like G.M. He is a man who will do it for an American. He likes Americans."[129]

Two weeks later, on May 8, 1904, York Powell died at the age of fifty-four. His death meant far more to JBY than the loss of Meredith's portrait, which he would never pursue on his own. "For a long time after Powell's death," he wrote Willie, "I ceased to be able to think, and I feel now like a man recovering from some tremendous shock which has entirely altered his point of view."[130] Although JBY disliked Powell's British imperialism and his anti-Semitism, he thought the "real" Powell was something else, "an infinite spirit prisoned in a finite mind, a winged and aspiring Celt captured and put into the cage of an Oxford donship."[131]

It may have been Powell's death that brought on the first serious symptoms of illness that JBY experienced since the psychosomatic disorders of the days at Bedford Park. Whenever he was catching a cold or was "overworked and much worried," he was afflicted by "seizures" or "nervous attacks." They would come to him three or four times a night. He believed that they were epileptic seizures or the precursors of apoplexy, and he thought his "days were numbered." But he told nobody except Lily, Susan Mitchell, and Isaac.[132]

Still he remained at the center of Dublin life. On June 16, 1904, when Leopold Bloom wandered the streets of Dublin as a future fantasy in the imagination of James Joyce, John Butler Yeats presided in his studio on Stephen's Green, a monarch without authority, a magnet to which the artistic and merely human were attracted. When Hugh Lane held his Exhibition of Paintings for a Gallery of Modern and Contemporary Art at the Royal Hiber-

nian Academy in November and December, JBY was one of those chosen to give lectures in the evening, the others being George Russell, George Moore, and Sir Walter Armstrong.[133] Lane had resolved that Dublin should have a gallery of its own, separate from the National Gallery, to support a permanent collection of good paintings and thus stirred up another controversy that would lead to the long dispute over the "Lane Pictures" that was not to end until the 1960's.

John Butler Yeats, "the most loveable of all bearing the name," AE told Quinn,[134] was also at the center of another stirring event in the fall, the whirlwind visit of John Quinn, which his biographer describes as his "last significant visit to Ireland."[135] Quinn wrote Lily that he hoped to see O'Leary, go to Coole for a day or two, and see her father's "grand new studio." He also told her he missed JBY's letters while in Ireland, adding, "He's the best letter writer I know."[136] Quinn kept a diary of some of his days in Dublin, though it grew fragmented and disjointed toward the end. He called on JBY at Stephen's Green shortly after checking in at the Shelbourne Hotel on October 26. He saw portraits, in various stages of completeness, of Redmond, Dowden, Macdonell, Lily, and JBY himself. Willie took the two men and Padraic Colum to lunch. In the evening there was a reception and supper with the Abbey players at which Quinn met O'Grady. Before the party ended, at one in the morning, Mrs. O'Grady promised to get her husband to JBY's studio next morning to sit for a portrait commissioned by Quinn.[137]

Next morning Quinn returned to the studio. O'Grady came in at noon, and JBY got to work on his portrait. Quinn didn't like the color of O'Grady's tie, neither the blue one he wore nor the red one in the portrait, and went out to purchase a third tie, a white one, which he gave O'Grady. JBY dutifully scraped out the red tie and painted in the white one. It was characteristic behavior by Quinn, as JBY was to learn. That night Quinn dined with WBY and Lady Gregory before attending a rehearsal of her *Kincora* and a performance of Willie's *A Pot of Broth*. At George Russell's Quinn remarked that all the people in Dublin about whom he had heard nasty things turned out to be extremely pleasant, and that "the only three men in Dublin who have not said sharp things about others" were Russell, Standish O'Grady, and Douglas Hyde. Neither JBY nor his son was admitted to the saintly circle.[138]

On the evening of October 31, Quinn attended a rehearsal of the company at the new Abbey Theatre, not yet used for public performances, as its renovation was not completed. Almost everyone connected with Quinn or the theatre was there. The most conspicuous feature of the evening, in Holloway's opinion, was WBY's annoying behavior with the actors:

a more irritating play producer never directed a rehearsal. He's ever flitting about and interrupting the players in the middle of their speeches, showing them by illustration how he wishes it done, droningly reading the passage and that in monotonous preachy sing-song, or climbing up the ladder on to the stage and pacing the boards as he would

have the players do. . . . Ever and always he was on the fidgets, and made each and all of the players inwardly pray backwards. Frank Fay, I thought, would explode with suppressed rage at his frequent interruptions during the final speeches he had to utter.

He noted the difference in manner when Lady Gregory's *Spreading the News* was read through by the actors. Unlike "the great Yeats," Holloway wrote, she was "the very opposite . . . in sitting quietly and giving directions in quiet, almost apologetic tones."[139]

The high point of Quinn's visit came on the evening of Wednesday, November 2, when a combination dinner and theatre party was held at the Shelbourne in his honor.[140] At the main table were Quinn, Lady Gregory, WBY, JBY, Lily, Lollie, Synge, Douglas Hyde and Mrs. Hyde, Willie and Frank Fay, George Russell, T. W. Rolleston, John Shawe-Taylor, and the encyclopedist Denis J. O'Donoghue. Lollie produced a perfect but unbound copy of the Dun Emer edition of *Stories of Red Hanrahan* (the gatherings clipped together with a small brass rivet in the upper left-hand corner). Everyone at the table autographed the half-title page with the pencil that was passed around, and the book was then presented to Quinn as a souvenir.[141]

In November, a month before the first night at the Abbey, George Moore belatedly realized which way the dramatic winds were blowing and tried to insinuate himself back into the group through the Fays. WBY wrote Frank Fay crisply and decisively, making it clear that in his view Moore was a hornet who must be confined to his own nest. "Moore's return to the theatre is out of the question," he declared. "If there were not other reasons . . . it is enough that he represents a rival tradition of the stage and would upset your brother's plans at every turn."[142] It was a brilliant verbal display. It needs no reader of occult tongues to know whose plans WBY was worried about. Moore was not asked to return.

W. B. Yeats knew when he held the power in his hands and knew how to exercise it. "I am here, and for the moment at any rate master of the situation," he wrote to Lady Gregory a month before the Abbey opened.[143] He let nobody stand in his way. In December, when rehearsals were being held for his *On Baile's Strand*, which with Lady Gregory's *Spreading the News* was to baptize the Abbey, he took a firm public stand against Annie Horniman, humiliating her in the presence of the company. She had resumed her voluntary designing of costumes for the players, who still disliked her work. On the sixteenth Willie allowed a disagreement between himself and Annie to arise in the presence of the company. With everyone listening, he sharply criticized her work and would not desist until he had his own way.[144] It would be a few years before Miss Horniman discovered the nature of reality, but her intended prize had let her know clearly, before the first curtain went up, that no matter who was paying the piper he was calling the tune.

Miss Horniman was not to be swayed from her pleasure in the great event. She gave a tea party at the Abbey for her friends on the twentieth, just a week

Five hundred copies of this
book have been printed.

Page from *Stories of Red Hanrahan*, complete, unbound, proof sheets discarded by
printer. Gift to John Quinn. "Souvenir of Dinner at Shelbourne Hotel, Dublin,
November 2, 1904." Signatures from top to bottom in left column are: Elizabeth Corbet
Yeats ("Lollie"), Augusta Gregory, John Shawe Taylor, Geo. W. Russell, T. W. Rolles-
ton, D. J. O'Donoghue, F. J. Fay, An Craobhín Aobhín (Irish name of Douglas Hyde),
J. M. Synge, Lily Yeats, Will G. Fay, W. B. Yeats, Lucy C. Hyde; at right bottom, J. B.
Yeats, John Quinn. Collection: Foster-Murphy.

before the company presented its first production in the new theatre, to begin a tradition that continues to the present day.[145] On the twenty-seventh the program included *On Baile's Strand, Cathleen ni Houlihan*, and *Spreading the News*. Holloway was enraptured. "The opening of the Abbey Theatre was the most momentous event of the year in Dublin to my mind. History may come of it! Who can tell!"[146]

Lady Gregory and WBY had been wise to choose the bill they did, however, delaying the appearance of Synge's *The Well of the Saints*, a dark drama of a married blind couple who are given their sight through the working of a miraculous well, discover that the world is not what they had been deluded into believing, grow blind again and choose to forgo a repetition of the miracle. Holloway found the subject "scarcely a happy one" and thought the "working out" of the plot "rather irreverent on the whole." Then he put clearly in his journal the point of view of a large segment of the Dublin population— that segment which populated Joyce's *Dubliners*, as JBY was later to observe—which would try to wreck the Irish National Theatre: "Making a jeer at religion and a mock at chastity may be good fun, but it won't do for Irish drama. If there are two things ingrained in the Irish character above all else, they are their respect for all pertaining to their religious belief and their love of chastity, and these are the very subjects Mr. Synge has chosen to exercise his wit upon."[147]

Holloway had been convinced after seeing *In the Shadow of the Glen* that "Synge would be the rock on which the Society would come to grief."[148] The new play merely confirmed him in his opinion. Despite their own credentials as proponents of Gaelic culture, Lady Gregory and WBY knew the dangers that lurked ahead and preferred to avoid them for the moment. But the day of reckoning was not far off. The issues in dispute were to be both dramatic and artistic, the first led by the Abbey company for the right of playwrights to show the world as they saw it, the other by Hugh Lane for the right of Dubliners to possess their own paintings, native and foreign, without direction from Irishmen or Anglo-Irishmen with vested interests.

The paintings Hugh Lane had exhibited in late 1904 consisted of three separate collections. One of these Lane wished to present to the City of Dublin and sought funds to buy the others, works of continental art, for the same purpose. He proposed that a free gallery be established and that the city buy additional pictures for it. Lane hoped that a generous private subscription would encourage the Corporation (the legal body of the City) to cooperate in the birth and growth of what Lane conceived as a vast cultural asset for the city.[149]

He embarked on a whirlwind campaign for public support and immediately aroused the opposition of Sir Thomas Drew, who feared that money otherwise destined for the pockets of Irish artists would go instead to art collectors and

dealers, of whom the most obvious would be Hugh Lane. A battle was not long in developing, and early in 1905 the lines were drawn. On January 5 a letter urging donations for Lane's project was signed by a distinguished group including WBY, Lady Gregory, AE, and Douglas Hyde.[150] Almost simultaneously the Royal Hibernian Academy, under Drew's guidance, issued a "Manifesto" vigorously opposing purchase of the two continental collections. JBY, who had found himself in the minority in the R.H.A. since Walter Osborne's death, was dismayed at the Academy's action. He knew it represented the views of only a few people at the top. He wanted to write a letter to the newspapers but was at first dissuaded by Edward Martyn and Dermod O'Brien. Then Hugh Lane appeared with a letter from Lady Gregory suggesting the wording of an appropriate response, and JBY "at once took the hint," writing a long letter to the editor of the *Irish Times* attacking the Manifesto. On Lane's advice he tried to disguise his authorship under the pseudonym "Audi Alteram Partem" ("Listen to the Other Side"), but Drew and his cohorts knew perfectly well who wrote it and accused him of telling "the secrets of the confessional," declaring him to be "no gentleman." As JBY explained to Charles Fitzgerald, "sometimes one is not a gentleman because one is something more important than a gentleman." He insisted his "allegiance to good pictures" prevailed over that "to the Council of the R.H.A."[151]

The letter, which he boasted took "all the force out of the Manifesto," was part fact, part criticism, the details coming from his own knowledge, the argumentation from Lady Gregory. He revealed that the Manifesto issued from the deliberations of six people—two architects and four painters—and that one of the painters "vigorously dissented." He pointed out certain deceptions in it and called attention to past follies of the R.H.A. (like refusing to accept, "as not good enough for their exhibition," a Corot which later sold in Paris for five hundred pounds). "Were it possible to consider this manifesto seriously," he concluded, "one would be tempted to say that the Royal Hibernian Academy has again slipped into foolishness."[152]

Drew lost ground quickly. On February 11 the Prince of Wales offered two Constables and a Corot, and the Princess Consort chipped in with another Constable in her own name. Others fell into line with "gifts or promises" and on March 24 the Dublin Corporation unanimously voted five hundred pounds a year "'for the maintenance of a Municipal Gallery of Modern Art and for the reception of the valuable pictures which had been presented to the state.'"[153] Before the crowned heads nodded approval, JBY sought the aid of Dowden, who begged off on the grounds that he thought the collection one-sided, that he was ignorant of art, and that he preferred to remain uninvolved.[154] John Pentland Mahaffy waited prudently and came down, to nobody's surprise, on the side of the Royal Family. With thirty-three others, including such diverse representatives of the Irish people as John Redmond, William Butler Yeats, the Countess Constance Gore-Booth Markievicz, and Sir

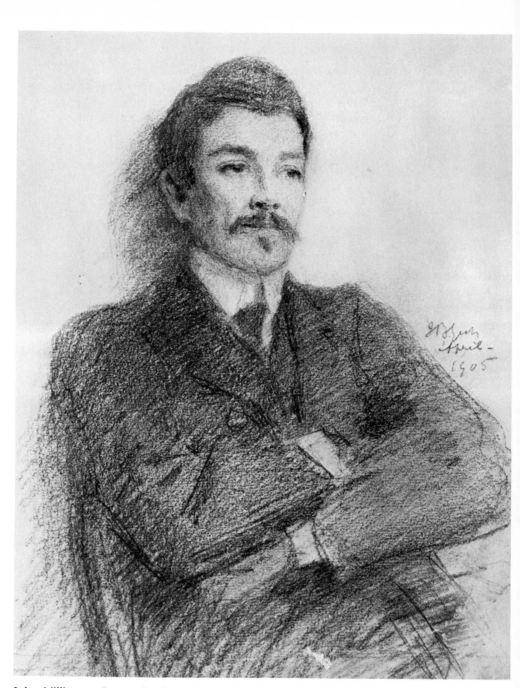

John Millington Synge, April, 1905. Pencil, JBY. Signed and dated by JBY. Commissioned by Annie Horniman for the Abbey Theatre. Courtesy of the Directors of the Abbey Theatre.

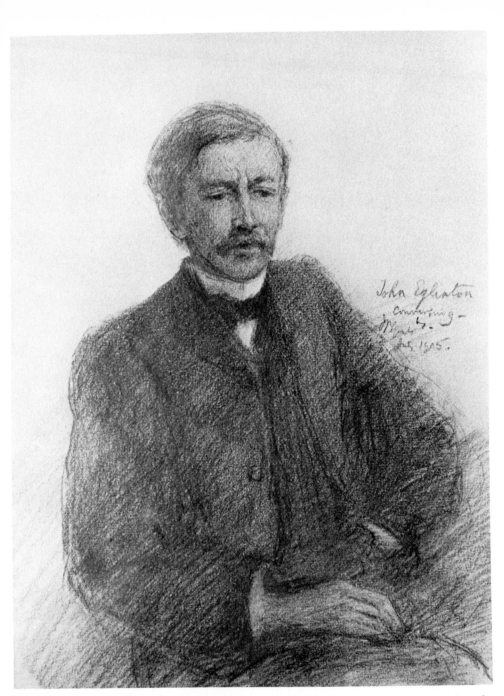

"John Eglinton [William Kirkpatrick Magee] conversing." July, 1905. Titled, signed, and dated by JBY. James Augustine Healy Collection of Irish Literature, Colby College, Waterville, Maine. Permission J. Fraser Cocks III, Special Collections Librarian.

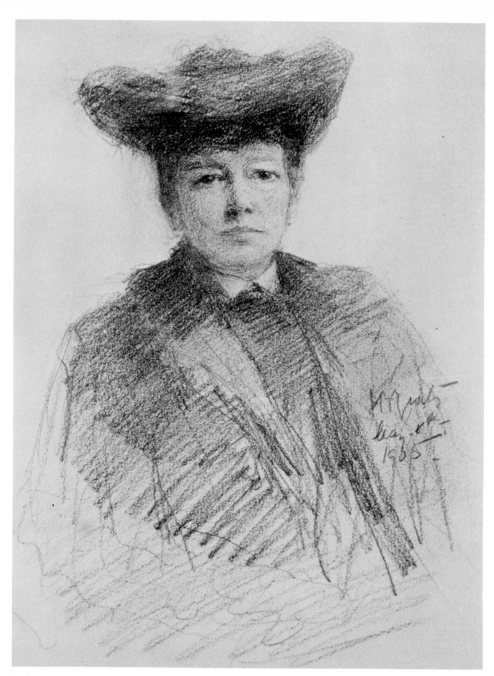

Lady Augusta Gregory, May 8, 1905. Pencil. JBY. Signed and dated by JBY. Commissioned by Annie Horniman for the Abbey Theatre. Courtesy of the Directors of the Abbey Theatre.

Horace Plunkett, he accepted membership on a committee to watch over the new gallery. For the moment the cause of art had been met by intelligent response.

JBY's involvement in the Lane campaign was a sequel to his defense of Synge's *In the Shadow of the Glen* and a counterpart to his activities in the Stephen's Green studio. Observing the passing scene and commenting on it was easier than producing commissioned paintings on schedule and easier still then getting paid for the ones he had already finished. Sir Anthony Macdonell refused to accept his portrait, even though Lane spoke for it earnestly, and Lane and JBY walked dejectedly from Phoenix Park to the city, Lane carrying the picture. Macdonell's wife and daughter were angry because JBY had made him "look like the devil." Others agreed, but thought the only fault with the portrait was that it resembled the subject too much.[155]

The refusals were understandable. Thinking of the rebuffs he suffered, JBY wrote Quinn years later: "I have always said of myself that I can only paint *friendship portraits*. The fact is my moral fibre is poor, the least thing flusters me, so that in painting I lose all sense of direction and find myself groping wildly to please someone other than myself."[156] During the year he completed the portrait of Mahaffy agreed upon earlier but reassigned by Lane to Orpen. Payment would come from the sitter, not from Lane, and then only if the portrait was accepted. Lily wrote Quinn in August that Mahaffy was to begin the sittings and that she wished she could be present, as "the conversation then would be worth listening to."[157] The two apparently got along amicably enough, though they disagreed on virtually everything, including the status of Edward Dowden.[158] When Orpen produced a portrait in which Mahaffy distinctly resembled Samuel Johnson, with a proper medallion hanging from his neck, it was the one Mahaffy chose and the one that ended up in the Municipal Gallery. JBY's remained unsigned in the family storeroom.[159]

In addition to pencil sketches in 1905—of, among others, Lady Gregory, Moore, Magee, Rolleston, Annie Horniman, and Padraic Colum[160] —he painted two important portraits, still unfinished at year's end, of John Millington Synge and George Moore. Synge and "old Yeats," as the younger man called him, got along beautifully. The painter didn't release Synge's portrait until just before he left for New York two years later, and Synge thought it *"not a good one."* In his customary way "old Yeats" dawdled over the painting, modifying it constantly and making pencil sketches of his subject at every opportunity. In 1905 he produced at least three pencil sketches of Synge,[161] who spent hours at the Stephen's Green studio sitting to the old man and conversing with him. Synge also visited on at least one occasion at Gurteen Dhas, where Lily vividly remembered talking to him while they sat on an oak chest.[162]

The portrait of Moore was commissioned in August. Quinn wanted it "not large," for the walls of his apartment in New York were already covered with

paintings. JBY began bravely enough but as usual couldn't finish it to his own satisfaction and kept asking for additional sittings. It was "well started" by early September, and Moore liked it. "He has given one sitting and gives another on Sunday," Lily told Quinn.[163] In November she added: "The George Moore is very good and does not make people laugh. All other portraits of him do."[164] But it remained unfinished. One day Moore offered JBY a choice: he would stay for a ten-minute sitting or come back another day. JBY suggested another day. As Moore was planning to leave Ireland, Quinn appealed to Lily for help:

> Isn't there some way by which you can induce Moore to come to the studio and have the portrait finished? Above all, if you manage to get Moore there, can't you so manoeuvre things that "irrelevant" and "immaterial" persons may be excluded? I remember the manoeuvering that I had to do to get Standish O'Grady there that last day, and then the precious hour and a half that he was there was largely taken up by the interruptions of five or six "irrelevant" persons, who seemed to have plenty of time to loaf and who didn't seem to care whether they wasted each other's time.[165]

Despite JBY's distrust of Moore as a companion for Willie and his dislike of his mannerisms, he nevertheless admired Moore's talents and saw in him an example of his own theory that artistic substance springs out of personality. When Mahaffy and Moore engaged in an unseemly slugging match in the newspapers, JBY supported Moore,[166] explaining his uniqueness to Charles Fitzgerald: "his is the most stimulating mind I ever met. It is because he always keeps his own point of view,—he is always like a man tumbled in among us out of some distant planet where everything is different from what it is here."[167]

A year later the canvas still stood on the easel. "I think the portrait as it is is remarkably good," Lily told Quinn, "and could not be more like, and AE agrees with me. . . . Papa of course does not agree with us, so don't tell him what I have just said. Another sitting with George Moore in a truculent mood would most likely spoil the portrait."[168]

Hyde's portrait remained unfinished too. By late April, Lily thought it was almost ready, but JBY dawdled. "I think it would be just as well," Lily advised Quinn, "if you wrote and gave Papa only till a certain date."[169] But JBY had other things to do. He decided once again that he was really a writer. In another outburst of misdirected energy he began a play, writing out scraps of scenes from time to time. He talked about it constantly; ten years later it was still uncompleted.[170] When he tried to interest his son in it, Willie merely "poo-poohed it."[171] Synge was more attentive. When the old man read portions to him in the studio, Synge said admiringly, "*You at any rate can write dialogue.*"[172] When JBY told him Willie had discouraged his writing the play because he didn't know the rules, Synge replied dryly, "Ask him if he himself obeys these Rules."[173] JBY was proud of Synge's praise and referred to it repeatedly over the years. Once he asked Lollie the rhetorical question, "Did anyone else ever receive a compliment from Synge?"[174]

He accepted none of the urgencies or tensions of other writers. He sent Willie a rough copy of his December, 1904, lecture at Lane's exhibition, expecting him to revise it. When Willie displayed annoyance at the unsolicited job, Father airily dismissed his complaints, implying that while he himself was the mighty river pouring to the sea, Willie was responsible for the dams and channels that would bring order out of its naked force.[175]

Matters at Dun Emer had quieted down, and for almost a year there was comparative calm. In addition to WBY's *Red Hanrahan*, the Press published three other books in 1905: *Twenty-One Poems*, by Lionel Johnson; *Some Essays and Passages*, by "John Eglinton"; and *Sixteen Poems*, by William Allingham. Quinn arranged for a display and sale in the fall of the sisters' goods at the Irish Industrial Exhibition in New York and achieved good sales by badgering his friends and acquaintances.[176] He also advised his American friends to visit Dun Emer when they traveled abroad. One of these was Mrs. Julia Ford, wife of Simeon Ford, who with her brother Samuel Shaw owned the Grand Union Hotel in New York. Quinn warned the sisters that Mrs. Ford, though extremely wealthy, was more interested in meeting famous people, whom she collected as others did stamps or butterflies, than in disbursing her capital: "the woman who aspires" was the way he described her to Florence Farr.[177] She very much wanted to meet William Butler Yeats, whose poetry she had studied in a women's club. She wrote Lily to announce her coming visit, and Lily told Quinn she hoped Mrs. Ford would buy some of their work: "We are tormented by flocks of people, mostly old ladies. They finger all the work, ask numerous questions and then go, some even with tears of emotion in their eyes at the thought of our noble work in such ideal surroundings, but they don't 'buy.' One week just lately we had thirty within a week, and between them all they spent 15/–." Mrs. Ford came and bought nothing. "We did wish she would listen more and talk less," Lily wrote Quinn.[178]

Willie still dealt heavily with others in his work at Dun Emer. When Magee agreed to allow publication of the selection from his essays, Willie proceeded to make the selection himself, and an annoyed Magee had to explain in a prefatory note that his own choices would have been different.[179]

Otherwise 1905 was a relatively placid year. Lily and Lollie spent the summer in different places, Lollie choosing London, Lily Sligo.[180] (Sligo was "too dreary and exasperating a situation for Lollie," Father explained to Willie.)[181] Jack's great adventure that year was a walking tour of the west of Ireland with Synge. Synge put himself at the head of the partnership by suggesting that the older of the two be considered the leader, knowing he was several months older than Jack.[182] Synge discovered that Jack was the shrewder businessman; he had extracted a higher fee from the *Manchester Guardian* for his drawings of the tour than Synge had for his writing about it.[183] Reflecting on the objections of the Gaelic purists to the characters of *In the Shadow of the Glen*, Synge

remarked sardonically to Stephen MacKenna that if he had made use of the people of County Mayo in his plays and presented their real behavior to the patrons of the Abbey, "God, wouldn't they hop!"[184]

Willie's relationship with his rivals at the Abbey had not improved. Holloway faithfully recorded the antics of his former poet-hero who now seemed all clay feet. Holloway knew nothing of and so could not chronicle WBY's plotting and executing of a coup that left him and his supporters in control of the Abbey company. There was ample excuse for a change in organization. Holloway began to notice dwindling crowds at the theatre after the excitement of the opening ceremonies. To his mind, it was the "harsh, irreverent, sensual representation of Irish peasant life" in Synge's *The Well of the Saints* that was the source of the trouble,[185] but there were other objections too. In the *Leader*, D. P. Moran asked why, if W. B. Yeats wanted a truly representative Irish organization, it "was left to a woman of the English to supply the Society with a theatre," and he continued the attack on the absence of sixpenny seats. The two points he raised had nothing whatever to do with the question of whether the plays or players had merit, but Moran had been drawn into the circle of irrelevance that was to entrap most of the critics of the Abbey.[186] As the influence of the carpers mounted, WBY and Lady Gregory felt a change of organization was necessary. Despite Lady Gregory's legal position as patentee of the Abbey, the Society was still an independent company operating as a democracy, and there were long wrangles about policy. To placate some of the less Bohemian members, the company offered a play called *The Building Fund*, by William Boyle. Boyle was a master of stagecraft, and his farcical comedies were amusing and lively. *The Building Fund* and his later *The Eloquent Dempsey* (produced in January, 1906) were to prove among the most popular in the repertory until Boyle withdrew them in 1907.[187] Yeats, however, viewed them as not worthy of appearance on the stage with *Cathleen ni Houlihan* and *The King's Threshold*, and the plays indeed have not left their mark on literary history. But they fulfilled Holloway's requirements for good drama and, more to the point, were in his view honest Irish plays. Boyle depicted characters from Irish homes and farms and chose, as Holloway admitted, the "most unsympathetic and unloveable specimens." Yet Holloway was delighted by their every speech and action. "Every word . . . fell on the ear with such a familiar ring that there was no mistaking their truth to life." "The truth," Holloway declared righteously, "so long as it is the plain, straight-forward, honest truth, no matter how unpalatably it may be put before us or rubbed into us, is never resented by Irish folk."[188]

Yet Holloway disliked Synge's plays (always excepting *Riders to the Sea*), even though Synge would have thought Holloway's remarks applied to them with equal force. The difference was that Synge spoke the wrong truths. Boyle's characters were slippery politicians and glib funny men committing venial

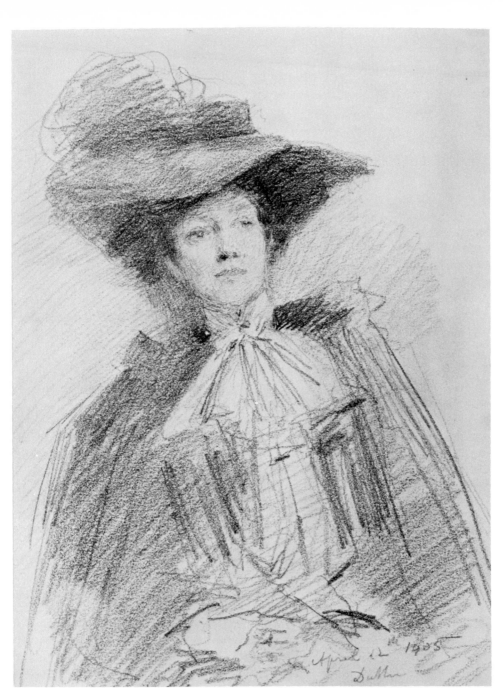

Annie E. F. Horniman, April 12, 1905. Pencil. JBY. Signed and dated by JBY. Commissioned by Miss Horniman for the Abbey Theatre. Courtesy of the Directors of the Abbey Theatre.

sins. If they pocketed a dubious shilling here or there, broke an oppressive law or two, or confused people with doubletalk, they were merely displaying the charming weaknesses of the lovable Irish. Synge, on the other hand, showed Irishmen as not always faithful to their marriage vows and occasionally as anticlerical, Irish ladies as untouchable in theory but not in fact.

The struggle for primacy between the two views marked the development of the company during its first year at the Abbey. Quinn's biographer describes his attitude toward the opponents of Yeats and Synge:

Quinn was tiring of the factionalism and the intellectual poverty of what he called "the little Irish" or loosely "the patriots" or "the pathriots," at home and abroad. He sickened of their jealousies, their self-service, their parochial small-mindedness, their windy rhetoric, their unreal visions of the Irish past and the Irish future, their general vulgarity of mind and manners. These qualities he attributed largely to the "medievalism," the repressive intellectual niggardliness of the Irish Catholic Church with its mortmain hold upon the minds of the people. The cultural movement in Ireland and in Irish-America would fail, he felt, until the powers of the Church could be diminished to the point where a free-minded education made possible a fit audience.[189]

Quinn had put his finger on the exposed nerve of the Irish cultural movement. In February WBY wrote him: "We will have a hard fight in Ireland before we get the right for every man to see the world in his own way admitted."[190]

Holloway squirmed when Synge exercised that right, believing that his writing rang "false to Irish ears," and that his "representation of Irish peasant life" was "harsh, irreverent," and "sensual." When he listened to the comments around him after the first performance of *The Well of the Saints*, he feared that his original suspicion that Synge was the rock that would split the Society had been sound. "No one, other than those connected with the theatre, has a good word to say for it, clever and all as it undoubtedly is, owing to its unsympathetic treatment and unnecessary loading with unpleasantly plain speech all through."[191]

So when in the fall of 1905 Yeats and Lady Gregory tired of the factionalism, they struck decisively, proposing a new system, to be decided at a special meeting, under which the Society would become a limited liability company with officers and directors, the votes apportioned according to shares that would be awarded not by purchase but by assignment. Before the meeting was held, Miss Horniman let it be known that she had decided to make an annual grant to pay the salaries of the artists and the managers,[192] thus turning the company into a purely professional one. There were loud objections from those who wanted to preserve the Fays' old ideal of a small band of dedicated amateurs, but these were swept under by the rising tide in Hudson's Bay. Willie disguised nothing in describing the realities of the situation to Florence Farr shortly before the meeting:

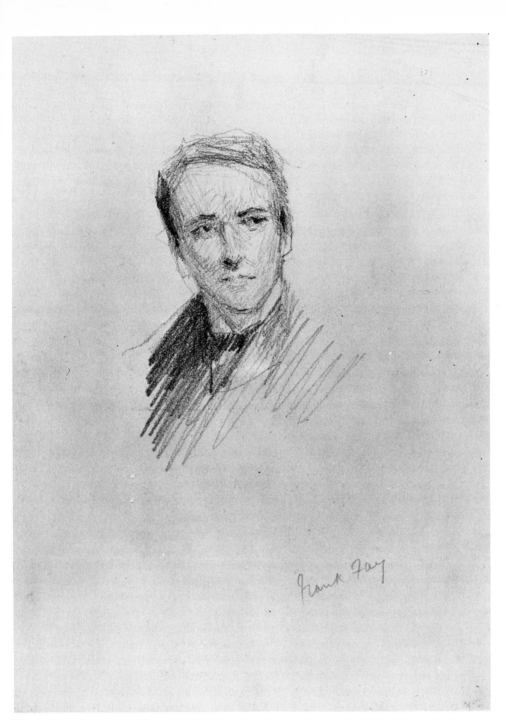

Frank Fay, about 1904. Pencil. JBY. Identification in the hand of Lily Yeats. Collection: Michael B. Yeats.

We are turning it into a private Limited Liability Co. in order to get control into a few hands. If all goes well Lady Gregory, Synge and myself will be the Directors in a few days and will appoint all Committees and have more votes between us than all the other Shareholders. I have foreseen that something of this kind was inevitable from the first, but it has come rather sooner than I hope[d] for. I am pretty confident that we have the majority of the members with us in the change. It has been a very slow business winning their confidence, but I think we have it now. We have all the really competent people with us certainly.[193]

The voting went according to Yeats's expectations, and the new company passed into the control of its three principal playwrights. The change aroused bitterness, and open dissension was not long in following. There were many Irishmen who believed in an "Irish" theatre as defined by themselves and not by an Anglo-Irish poet of supercilious manner supported by a haughty Anglo-Irishwoman and a middle-class English scold. Some objected to the new company's professionalism, others to its professed political neutrality. Unfortunately, among the unhappy were several excellent actors and actresses (many of whom acted under Irish names, often the equivalent of their English names): Frank Walker (Prionnsias MacShiubhlaigh); James Starkey (Seamus O'Sullivan); George Roberts, who was the most outspoken and provided leadership for the brewing revolt; Mary Garvey (Maire ni Gharbhaigh); and, considered by many the finest actress of all, Mary Walker (Maire nic Shiubhlaigh), Frank's sister. Holloway noticed in late October that Frank Fay fell into an ugly mood when Lady Gregory coached him during a rehearsal of her play *The White Cockade*, turned "crusty" and "sulked" under her instructions. He wrote mournfully: "Since the Society turned into a limited company some weeks ago, things have not gone so smoothly as heretofore, and a big change in the personnel of the players is likely to occur at any moment." For the time being Mary Walker was safe, as she had given up her job at Dun Emer and signed a contract with the new Abbey company for a salary; Frank Fay and Sara Allgood were similarly bound. But Francis Quinton McDonnell, who paradoxically acted under the name of Arthur Sinclair, was wavering, and two other actors were "not pleased with the new turn things have taken." Before the year was out Walker joined Sinclair in telling Holloway of their intention to leave the company.[194] In Joyce's metaphor, the barometer of the Abbey was set for a spell of riot.

There was another rival to the new leadership, more potent than Walker and Sinclair. James Flannery, scholar of the Abbey Theatre movement, describes the position of the third force: "Neither . . . the three Directors nor the Fays seem to have realized that by holding the purse strings of a new company which was hired on a purely professional basis, Miss Horniman viewed her own position in a new light. Now she was to assume, if not an active role in the artistic work of The Theatre, at least a stronger role in the shaping of its destinies."[195] Another drama was about to open, one which would end with

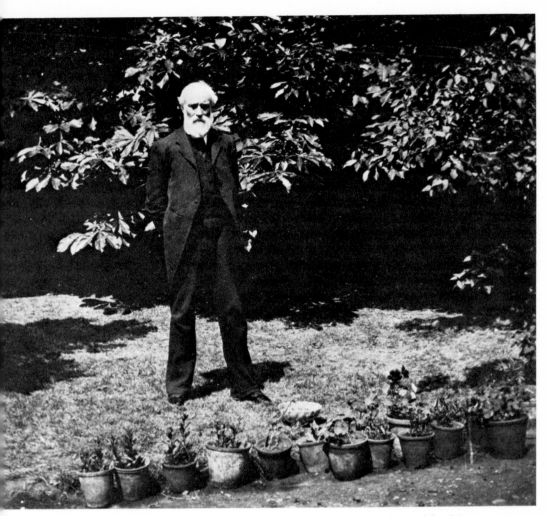

John Butler Yeats in the garden at Gurteen Dhas, about 1905. Collection: Michael B. Yeats.

the Fays and Miss Horniman not merely in the wings but out of the theatre completely and Yeats and Lady Gregory holding center stage.

Synge, the third director, was not to be among the victors. JBY had already noticed an air of the doomed about the playwright with the "dark eyebrows and very light grey eyes," and later realized that he lived most of his last years "in the presence of death, which he knew must come early in his life." [196] Synge had long been troubled by swollen glands in the neck. As early as 1897 one lump had been removed. Although not correctly diagnosed until 1907, the symptoms marked the onset of Hodgkin's disease, cancer of the lymphatic system, a slow-moving but—in those days—invariably fatal affliction.

To compound his difficulties, Synge was about to fall in love, and during the

long course of that bittersweet, joyful anguish, his illness grew worse. In the political infighting of the coming three years he was to be little more than a half-hearted participant. All his time was needed for writing and for the pursuit of an impossible love. If there were fights in the Abbey he would have to remain above them or outside them, though, ironically, it would be one of his own plays that would bring about the most notorious confrontation. The issue would be fought on the question of what was "Irish." Was it the thing seen by Synge and Yeats or by Holloway and Boyle? "Irish" would prove a difficult word to define.

CHAPTER TWELVE

1906–1907

I N THE OPENING months of 1906 JBY found himself in the middle of two Dublin events, one productive, the other divisive. In January, Lane got up an exhibition in honor of George Watts and asked JBY to give a lecture, as Watts had once visited JBY's studio in London.[1] Old Mr. Yeats, as he was now called throughout Dublin, fretted getting the lecture in order. "It is a nightmare," he told Lady Gregory,[2] and confessed he was worried how some of his remarks might be received. He had good reason to worry. Beatrice Elvery, an artist who as a young girl had listened to John Butler Yeats's impromptu lectures when they rode the train together from Howth to Dublin,[3] recalled with excitement how the old man had openly discussed matters "unusual for the time," speaking of "love, desire, women, and sex,"[4] though the speech in print hardly suggests the lurid effect her remarks implied. JBY told Lady Gregory he intended to say that "while all teachers tell us to shun temptation," "we are here to be tempted," and that he would conclude "by saluting Dublin as the home of logicians without love."[5] A few extracts reflect the hue of the whole:

the world itself is neither beautiful nor ugly: . . . the madman and the poet look out on the same scene, but where the one finds ugliness the other finds beauty. . . .

The moralist says: I teach morality, without which society would not hold together. The trader says: I teach trade, without which there would be no wealth, and life would not be worth living. The religious teacher: I teach religion, without which people would forget that there was another world or a judgment to come. And the scientist says: I teach truth, which is the basis of everything.

What can the artist say? . . . He works only to please himself, and regards it as the most egregious folly—indeed, a kind of wickedness—to try and please anybody else; he admires wrong as often as right; . . . he inculcates no lessons, and preaches no dogma. . . .

. . . Art . . . seems to say, with all its strength and with all its voices: "Seek temptation; run to meet it; we are here to be tempted." Art does not say—"Be happy, or be miserable, or be wise, or be prudent"; but it says—"Live, have it out with fortune, don't spare yourself, be no laggard or coward, have no fear."[6]

While preparing the lecture, he was involuntarily drawn into the controversy within the Irish National Theatre Company. The group opposed to WBY and Lady Gregory wanted "a theatre of the people,"[7] one nationalist in spirit if not obviously political which would appeal to the masses, even to those who couldn't tell the difference between poetry and prose. To this end sixpenny seats were essential, and Miss Horniman's prohibition of them gave the dissidents a visible target, even though their opponents wanted sixpenny seats too. William Butler Years envisioned a theatre as a medium for poetic drama of the highest and purest kind, the subject matter to be chosen from mythical, heroic Ireland or the Ireland of the simple peasant, and it was specifically to create a theatre for WBY's poetic drama that Miss Horniman gave her subsidy. Between the two views lay much room for works of other kinds. In practice *The Eloquent Dempsey* and *The Shadowy Waters* might exist side by side, but those plays represent the extremes. The dissidents, furthermore, were outraged at being displaced by a small group they regarded as upstarts and irritated at the diminution of their own influence. Perhaps if one of the Fays, or George Roberts, or Frank Walker had been appointed a director the schism might have been avoided. Those who had originally worked with the Fays now saw the two brothers as sergeants in a regiment led by three generals who were not even really "Irish," while over the generals, a grey eminence in the background, lurked a dictator in the person of a rich Englishwoman who hated the Irish.

The first clash came quickly. After Maire nic Shiubhlaigh had signed a contract with the company, her brother, Frank Walker, rejected a contract offered by Yeats because he thought the proposed salary of fifteen shillings a week was insultingly small.[8] While he was coming to a boil and heating up others with him,[9] his sister discovered that Sara Allgood was to be regarded as chief actress of the company. Maire protested, WBY upbraided her, and she promptly announced her withdrawal from the company, then fled to Gurteen Dhas to place her interests in the hands of John Butler Yeats. WBY responded by threatening her with a lawsuit for breach of contract, a threat never carried out but effective in reducing Maire ("Moira," as JBY persistently misspelled her name) to a mass of jangled nerves.

JBY heard her version of the dispute and, like the Good Samaritan, tried to argue her case against his son's, chiefly by working through Lady Gregory. The intricate negotiations were kept fairly quiet. Holloway, for example, knew nothing about them,[10] and very little survives of them except a paragraph naming no names in Joseph Hone's biography of WBY[11] and what appears in the letters between John Butler Yeats and Lady Gregory in the early months of 1906. He broached the matter to her cautiously: "I am very sorry Moira has committed suicide. Whether she will ever again come to life I know not. All her charm as an actress comes from her quality of *pride and self will*, and it is exactly this quality which is now in revolt. But into this thorny question I won't go, nor

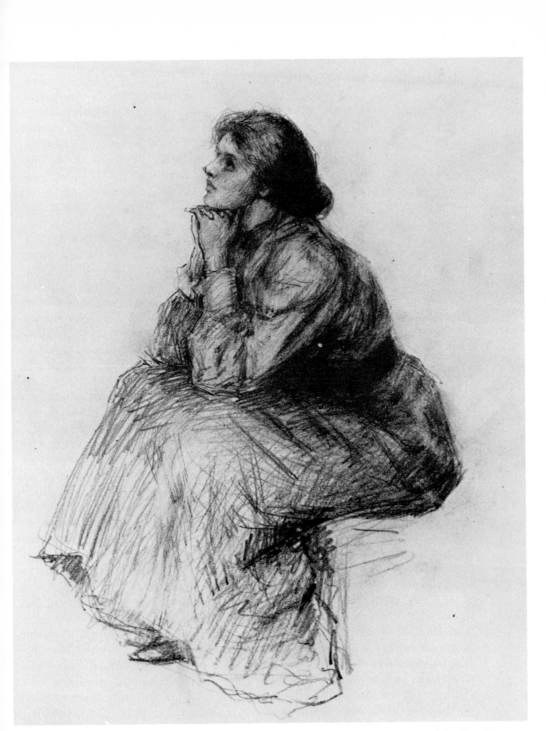

Mary Walker ("Maire nic Shiubhlaigh"), early 1906. Pencil. JBY. Collection: Michael B. Yeats.

say anything as to her side of the matter." What was needed now, he continued, was to bring Maire back into the Abbey as quickly as possible, and to this end he thought she should be left alone for a while, as the clash with Willie had been sharp and painful. She might try her hand with a new acting group her brother talked about forming. "If her society do what they say and produce plays she will stay with them, but if not or if these plays are failures it is to be hoped she will return to the Abbey Theatre." The loss, he advised her, was really to herself and Willie. "At the lowest estimate she is unique in the company." [12] It was not a merely personal view. Even Holloway thought Miss Walker had no peer as a tragic actress. [13]

JBY was sorry Lady Gregory had not been present when the difficulties with Maire arose, asking her, "What do Willie or the two Fays or Synge know about poor young girls? It is not intellect &c and gifts of words and arguments that are wanted." Willie, he said, had been particularly mean in talking to her and caused her to turn "*extraordinarily white* and languid." He closed with a bitter remark about his son, who was to prove more exasperating than usual during the coming year: "I am sometimes tempted to say that if a man has the gift of words he is thereby unfitted for every position in life except that of writing." [14]

Two days later he was at her again. "They that in quarrels interpose Will often wipe the bloody nose," he began. Five hundred words later he added: "It would diminish my chances of that bloody nose if you kept this letter to yourself." Between the noses he spoke with complete frankness about Willie and treated Lady Gregory as if she were Willie's wife—or his mother: "Shut Willie up that he may do his work, or send him to America. At any rate act on *your impulse and not on his*. . . . For everyone has the most entire trust in you—that is when *you are* you. They all feel that you have a man's mind, an invincible courage." He spoke of Maire's devotion to her, of Maire's loyalty to Willie "till he turned against her," and of the high praise he had heard from Mrs. Edward Dowden of Maire's acting. He told her how his son had called him "an ignoramus" for defending Maire. "No wonder he managed his diplomacy so badly with Moira that he lost her." Willie's threat of a lawsuit had not bothered her so much as the fact "that he at last tried to humiliate her, to make her think little of herself." [15]

JBY and Lollie (Lily was away in Germany during the early stages of the controversy) determined to keep Maire at Gurteen Dhas till the storm subsided, and while she was there JBY painted a "friendship" portrait of her as she sat in a chair in the backyard and did several sketches of her as well. [16] Despite JBY's appeals Lady Gregory did not talk to Maire until March, but then seemed to make progress. "I don't know what you said in your interview with Moira," JBY exclaimed, "but she is a new girl. The *distressing* dumbness is gone, and she is full of quick response and at times even talks. We have all noticed it." He spoke approvingly of Sara Allgood's abilities as an actress, but went on to say that the Irish people understood "oratory but not poetry." Compared to

Maire, Sara was nothing: "she will never touch the heart. She will not cast spells of listening wonder as Moira can."[17]

Ultimately nothing came of the defense of Maire. She was a pawn in a bigger game. The Allgoods, Sara and her younger sister Molly, were friends of the Fays and faithful members of his team. Maire was regarded as sympathetic to the enemy forces represented by her brother Frank, George Roberts, and Padraic Colum. While JBY was making his moves in an isolated corner of the board, Maire's brother and his colleagues worked hard to keep her at odds with the Yeats-Gregory faction. JBY told her that her advisers on the other side were "a pack of fools" (though privately he referred to them as "malicious and envious knaves") and she committed the indiscretion of telling them. They then tried to make it "a personal quarrel" with him.[18]

Some of those who seceded or threatened to secede showed a disposition to compromise. Colum wrote Lady Gregory offering to discuss the differences between the two groups, and JBY and AE, ostensibly meeting to discuss their lectures for Hugh Lane in January,[19] sought to mediate. No two better diplomats could have been found,[20] but Willie, then in England, and Lady Gregory showed no disposition to compromise. Russell had written Willie that he might lose the support of the Irish clubs. Willie's response betrayed a Nietzschean superiority that angered his father. "I desire the love of a very few people," he assured Russell loftily, "my equals or my superiors. The love of the rest would be a bond and an intrusion."[21] When Synge told him Colum threatened to give his play *The Land* to the rival group, Willie offered in reply not peace but a sword. "I am delighted. . . . Everything they do would only reveal the superiority of our work."[22]

Lady Gregory was equally adamant, regarding the dissidents as rebellious children. She wrote JBY a letter to show Russell:

I am quite ready to open peace negotiations . . . if any responsible person on the other side will say what they would have us do. Ed Martyn says Roberts told him he and his friends had struck because we were "Not national enough, did not have sixpenny seats or enough plays by Irish authors." Now what does that mean? . . . I am ready to resign as director in favour of any person accepted by the opposition (and of course accepted by my co-director[s]) if that would be of any use. But there must be some responsible person on the other side to deal with.

She accused JBY and Russell of attacking WBY when he wasn't present to defend himself. "Neither you nor Mr. Russell need give me a list of Willie's crimes," she wrote JBY coldly. "He is not so near being sainted that the 'devil's advocate' need thunder out the case against him."[23]

When there seemed no possibility of compromise, the dissidents played their high card, which WBY trumped. They insisted that, as members of the Fays' original group, they had the right to the name of the Irish National Theatre Society. But those who had already resigned had no vote. Willie

rounded up his forces; his skill as a practical politician is demonstrated by a letter he wrote Lily urging her and Lollie to attend the annual meeting on Thursday, May 24:

It is really important. It is to give us a clear ¾ majority over young Walker and Miss Garvey who remain on as members, and in the case of Roberts, who remains for the present, joining them in a vote we require six in the first case and nine in the second. There will be six of us old members—Synge will be away—and with you two and Harvey and Miss Harrison we shall be ready for all emergencies.[24]

JBY attended the meeting and spoke, but, being nervous, neglected to make all the points he wanted to, one of which was an assurance that Miss Horniman was not really running the company, as many of the dissidents claimed. He apologized to his son the next day. "I had a long passage carefully prepared for [the] end of my speech on the theatre and Miss Horniman, and would have rebuked those mutineers at the end of the room—but forgot. You remember I stopped rather confused, and I had somewhere mislaid my note *which consisted of the words written large* The Quaker Lady."[25]

Willie's forces won the vote, as he had calculated. Two days later the seceders founded the Theatre of Ireland. Edward Martyn was named president, and among the directors were Colum, Cousins, and a young nationalist named Padraic Pearse. Lady Gregory tried to persuade Colum to return; he replied that the two groups should try to iron out their differences and cooperate. She retorted dogmatically that there was only one course to follow, that chosen by herself and WBY:

I thought I might find in your letter what the complaint against us is, but I only find that we are becoming less and less a theatre of the people. I don't agree with you. . . . I was always against a 1/− pit, but it was decided to let Miss Horniman have her way about it for a year or so. I think we shall very soon be able to change it for a 6d one. What is wrong? . . . We refused and must still refuse the "one man one vote." . . . It gave too much power to lookers on.[26]

She either misread what Colum was saying or chose to disregard it. JBY had put it to her directly: "A wise aristocracy in my mind should aim at being itself the best kind of democracy."[27] Such advice was not what either she or WBY wanted to hear. In the end the Theatre of Ireland went its own way, giving its first performance at Molesworth Hall on December 7, with the broad-minded Lady Gregory conspicuously in attendance.[28] It lasted until 1916—by any standard a remarkable achievement—and faded out of existence at last perhaps only because, as Maire nic Shiubhlaigh was to write years later, its members were too interested in "the wider and, at the time, more important work of the Irish Volunteer Movement"—as the Yeats forces suspected at the time.[29] Maire disappointed all the Yeatses except Willie by casting her lot with the new theatre. Lily and Lollie were "disgusted" and "angry" with her choice, but JBY strongly hinted to Lady Gregory that it was the inconsiderate treat-

ment of Maire by Willie that caused the Abbey to lose "a commercial asset of the highest value."[30]

It is not clear what part Synge played in the dispute. The record is silent except for one remark he made in a letter to Lady Gregory, complaining that JBY was "harping back to that ridiculous cry" about Miss Walker—apparently JBY's claim that she was a better actress than Sara Allgood.[31] Synge was no longer an objective critic, for by this time, though continuously ill, he was hopelessly in love with Miss Allgood's sister Molly, who acted under the name of Maire O'Neill. It was a marvellous conjunction, begotten by despair upon impossibility. Synge was thirty-five, Molly scarcely nineteen. In religion he was Protestant by birth and pagan by choice; she was Catholic by both. He came from a long line of Anglo-Irish clergymen and upper-class folk with notions of their proper place in Ireland; she was at best Irish middle-class. When his attachment became unmistakable, others in the Synge group endured it and agreed not to talk about it, perhaps hoping it would go away.[32] Instead, as Synge's health worsened his love deepened.[33] Miss Horniman thought the attachment could not last; "three months of one girl on his knee doubtless leads him to wish for a change," she wrote WBY nastily.[34] She could not have been more wrong in her assessment.

Miss Horniman's meddling became worse than ever. Willie Yeats had boasted to Synge that they need "concede nothing" to the rival group. "We have now £400 a year to spend on salaries and a free theatre. All we have to [do] is hold firm."[35] But now Miss Horniman's voice, somewhat muffled before, became strident. She developed an intense dislike for Willie Fay and chided him for not keeping the company under control; she had heard that the actresses had talked "with intoxicated men out of the railway carriage window" and had taken down their hair on station platforms. When he rejected her rebuke, she wrote angrily to WBY, "As things stand now, I am in the position of having been told not to interfere in a matter which I am financing." Whether Fay's conduct amounted to rudeness one cannot know without more evidence, but, as Flannery remarks, "both as businesswoman and as an ardent feminist, Miss Horniman was scarcely likely to brook any insubordination from a man whom she now viewed merely as an employee."[36]

Managing Miss Horniman was like disciplining a fractious steed, but Willie Yeats had mastered the knack. If she was no pale horse, he was no pale rider. He knew when to let her have her head and when to pull the reins, as he had already demonstrated with the designing of the costumes. Now in her fury against Fay she resolved to dictate the choice of an actress for the title role in Yeats's *Deirdre*, scheduled for production in November. In June she presented a Miss Florence Darragh to WBY in London and insisted that she supplant Sara Allgood, Fay's choice, in the part. Willie let the company believe that Miss Darragh was his own discovery, but he knew she was not good enough for the part. Lady Gregory didn't take to her, nor did the Fays, and Synge regarded

her as a dangerous spy, warning Molly to be careful in her presence.[37] When Willie asked his father what he thought of her acting, JBY replied with apparent enthusiasm, probably because he thought his son was looking for a favorable opinion. His letter was a masterpiece of ambiguity. In the next-to-last sentence he declared: *"I think Miss Darragh the best piece of luck yet come to you"*; but the body of the letter bore another message: "I think in her present form she is a bad actress and the worst possible for your play. She is an actress born, an actress genius, possibly a great actress. But her present style is altogether too florid, what is called too stagy. She should not always be so intensive and so impressive—it is monotonous." Then, as if glancing at his son's own development as a poet, he added: "As you know we must all sow our intellectual wild oats. We begin with redundancy and end with severity. Were she and the impossible intractable Moira acting together, they would learn from each other. . . . She must prune her luxuriance."[38]

On a tide of unfavorable comment Miss Darragh was swept back to England. Willie had successfully weathered another crisis. That Miss Horniman was pulling the strings tied to Miss Darragh is made clear by a long letter the actress wrote to WBY detailing Miss Horniman's specific grievances with the Abbey company. She was dissatisfied, Miss Darragh revealed, "because the Theatre had made 'neither money nor acquired réclame from the public.'" Also, what Miss Horniman wanted was an international theatre of which the Abbey would be the nucleus and for which it would ultimately be the training school. She cared nothing for Irish plays or Ireland as such. "She hates not being sent all the details of the Theatre—even rehearsals and notes on productions. She, in short, wants to be treated as an equal manager and not as a bank—it is all very trifling but very human and very feminine."[39] In her continuing animosity to Willie Fay she insisted on the appointment of a business manager, and W. A. Henderson was brought in in August. She yielded on the issue of sixpenny seats, and before the end of the year the Abbey group was playing to packed houses. In the fall Willie wrote Florence Farr: "I have had a bad time with Miss Horniman, whose moon is always at the full of late, but hope a letter yesterday has quieted her."[40] He had to write quieting letters with increasing frequency.

With control of the theatre secure in the hands of the three directors, the Abbey Players could now proceed to pursue the dream that had come to William Butler Yeats in the early 1890's. In practice, however, the company discovered that the number of paying customers declined in direct proportion to the number of purely poetic and "mystic" plays produced; and by the time WBY, "worn out with dreams," had given up his vast commitment to the Abbey, the remorseless necessities of economics had made the theatre something other than what he wanted it to be.[41] Still, for many years he was able to control the choice of plays. Much to Holloway's annoyance he controlled it in such a way that his own works and those of his fellow directors predominated.

(Holloway kept careful count of the plays produced. He calculated that between opening night on December 27, 1904, and September 14, 1912, of 1,606 productions, 600 were of Lady Gregory's plays, 245 of Yeats's, and 182 of Synge's. The three directors thus accounted for more than 64 percent of the presentations.)[42]

When WBY put on a revised version of *On Baile's Strand*, Holloway tried to let him know the reaction to it of the ordinary playgoer who would see the play only once.

I frankly told him I did not care for it nearly as much as the original version, and thought it less clearly worked out, instancing that a person whom I had with me, who saw the play for the first time[,] could not follow it. He thereon spouted something about a poetic play needing to be seen more than once before it could be understood. So that settled that point.[43]

JBY knew better than to criticize his son's work directly. When he found the revised version of *The Shadowy Waters* less than satisfactory, he wrote Quinn in December:

To my mind there are defects in *The Shadowy Waters*. The character of Forgael, for instance, is extremely ambiguous. Is he in love or not in love with Dectora? Willie answers this by saying that his work is not the drama of character but of mood, and to this I reply that Forgael is very distinctively a character though not the one he means him to be. . . . But poetical drama interests me more than anything else, and provided it is good drama I don't care whether it is the drama of character or mood.[44]

The public impression of *The Shadowy Waters* was about the same as JBY's, but WBY airily attributed the falling attendance to the fact that the "modern audience has lost the habit of careful listening," and that "the difficulties of holding an audience with verse are ten times greater than with the prose play." Father wrote to Lady Gregory: "As to Willie's theories, there is not one of Shakespeare's dramas that does not reduce them to utter mockery."[45]

Willie was more difficult to deal with than ever. His combativeness with the Abbey dissidents, his overbearing manner toward Maire Walker, marked a new stage in his arrogance. With Annie Horniman he exercised his Nietzschean disdain by disregarding the complaints in her letters. She thought she knew where the blame lay. "Ever since you were so much with Mr. Quinn in America you have got into the way of trying to avoid what you don't like by simply ignoring what is said or written."[46] The effect on his family was unnerving. Dun Emer was a constant source of worry, and relations between the sisters and Miss Gleeson, whom they now called "The Mother Abbess" or "The Spider," were deteriorating badly. Lollie complained to Quinn that when people came to visit at Dun Emer, Miss Gleeson would intercept them at the front door and relieve them of their money before they got to the back room where the sisters were stationed. JBY told Elton that Dun Emer was "a terrible strain on them, a sort of ever eating acid."[47] Yet Willie and Lollie still could not

collaborate easily. Without consulting her brother, Lollie had asked George Russell to make another selection of his poems for a second Dun Emer book, then announced that she had a fair copy ready for the press. Willie promptly vetoed the edition, pronouncing the poems beneath his own standard of excellence. Lollie retorted that she would print them anyway, and the storm broke. Willie sent sharp letters arguing that his own reputation would be damaged, and JBY felt he should try to control matters before they got out of hand. He tacitly accepted Willie's estimate of the poems but wrote a letter suggesting that his son handle the dispute differently. Unless Lollie agreed otherwise, Father suggested, Willie should confine himself "to the mere giving of advice." He reminded his son of the financial difficulties and suggested that although Lollie may not have been "sufficiently alive to this consideration of reputation," other interests were involved also. As to Russell's manuscript: "In amicable contests you and Russell should agree about a selection. A poet's selection from his own poetry ought to carry with it a certain authority. I suppose it was your own case." The last sentence, though blurry, was a deft insertion of the needle, for WBY allowed no one to censor his own poems. Father concluded, "It is I think better that [Lily and Lollie] should know nothing of my interposition."[48]

Unfortunately, before Willie received his father's peace-making missive he had fired off a letter to Lollie in intemperate language, insulting not only her but Lily and Jack as well. An exasperated JBY wrote his son in the strongest terms:

Why *do you write such offensive letters*? There is nothing fine in a haughty and arrogant temper. It is Fred Pollexfen's characteristic and through it he got himself turned out of the family business. . . .

You treat Lollie as if she was dirt. She is as clever a woman as you are, and in some respects much cleverer. She very naturally stands high in her own esteem as well as in that of other people, and she is entitlted to be treated as a personage in her way.

When you advise about choice of books for the Press, it should be advice and not haughty dictation backed up by menaces. After all *the press is Lollie's business* and it means our means of living. And she has often other things to consider besides the literary excellence of a particular book. There are questions of convenience and commercial expedience and policy, matters for tactful consideration not to be decided offhand by a literary expert. . . .

I think you ought to write a frank apology. If you want to withdraw from the business of advising it is easy to do so in a temperate and kindly letter. This letter if not recalled *leaves a cleavage between you and Jack and Lily and Lollie*. I appeal from Philip drunk to Philip sober. I am quite sure that this letter would never have been written had you had to have it typewritten.

After signing his name he had second thoughts and added a postscript:

My own impression is that it would be best for all parties if you withdrew altogether from the position of literary adviser. Of course I know this letter means withdrawal. As

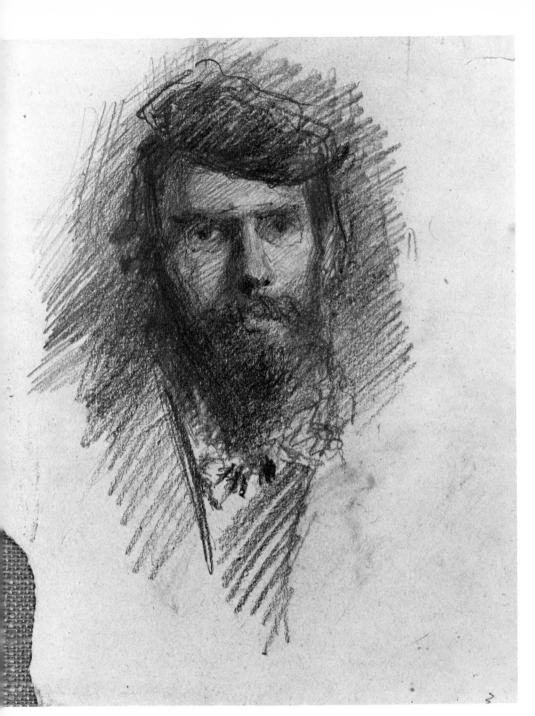

eorge Russell ("AE"). Pencil. JBY. Collection: Michael B. Yeats.

I have said, unrecalled it means a bitter quarrel. Only I hope you will recall it and do it handsomely and chivalrously, giving *honour where honour is due.*[49]

But Willie would not be pacified. Father wrote again in exasperation: "As you have dropped affection from the circle of your needs, have you also dropped love between man and woman? Is this the theory of the overman? If so your demigodship is after all but a doctrinaire demi-godship."[50] Willie's only response was to criticize the quality of the printing at the press and declare that he must have absolute control. Father warned him again that his relations with Lollie "must be put on some *workable* basis." If he insisted on being a dictator the house would come tumbling down. He tried a psychological approach. "Keeping strictly to your position of *adviser* and *taking Lollie into your confidence* while *at the same time you leave her perfectly free*, you will, I think, almost always get your way. She won't stand being dictated to. In this case you would not stand it yourself." If Dun Emer went under it was the girls who would "bear the consequences." He warned Willie that Lollie stood always at the edge of breakdown.[51] He tried to appeal to his son's sense of cosmic justice:

At present Lily and Lollie only see that they have to work very hard at a dull and slavish kind of work and that they get very little reward for what they do, and possibly or probably after all it may end in ghastly failure. And they see that you live very pleasantly, doing work which is your choice, getting plenty of public and private consideration, everyone anxious to help and make smooth your path. I also have a very pleasant though unprofitable profession.[52]

But Willie would not be moved. About the middle of August he resigned as adviser to the press, and before he returned, Russell's book of poems, *By Still Waters*, was completely set in type, scheduled for publication on December 14.

While the dispute was boiling, Lollie went to New York to sell Dun Emer goods at the Irish Exhibition, staying as the guest of Mrs. Julia Ford in Rye.[53] While she was away Willie began laying pipe to his former job. Lollie had asked Katharine Tynan Hinkson for a volume of verse for the Press. Willie immediately wrote Mrs. Hinkson about the "difference of opinion" between himself and his sister, and hinted that Lollie might yet come round to his way of thinking, but "she will certainly not do so if she thinks she can have me on her own terms."[54] He presented a plan to Mrs. Hinkson.

I want you to write to Lolly saying that you want me to edit the book, and will not give it otherwise. Now I know this is a hard thing to ask, and you may very fairly say to me that you know nothing of the merits of the dispute, but after all you do know something of my mind and purposes, and I hope what you do know may be a guarantee that I have not done anything capricious or illtempered.

If Mrs. Hinkson agreed, or even insisted only "on postponing the book for a few months till you saw if things were patched up between her and me," then Lollie would have to give in. "I am not dealing with logic," he assured her, "but with three very emotional people, my sisters and my father."[55]

He proposed a new agreement to Lollie, who promptly sought Quinn's advice. "Can you make any suggestions on my side?" she asked. "I mean I want to keep some control in my own Press." She was not eager to have books forced upon her, and she wanted copy ready to meet her deadlines. "Perhaps you can think of some way of introducing these points into this wonderful legal document." Lily urged her to stand fast. "Don't have W.B. on top whatever you do," she warned.[56] By mid-November a new arrangement had been entered into, with AE's and Quinn's help. Its details are not known, but apparently Willie had to give way on his demand for absolute control. Lollie, back in Dublin, reported to Quinn:

> AE and I between us made a little agreement on a half sheet of paper with about a tenth of the words in Willie's letter—saying very much what you suggest—and W.B. signed it like a lamb. He and "Aunt Augusta" had been to AE to try and find out what I intended doing—so six weeks silence on my part evidently was the very best policy. I saw Willie at the play last night and he was quite amiable.[57]

But the issue had not been clearly resolved. The arrangement was only a cease-fire, not a treaty of peace. Between the two Pollexfens of the Yeats family there would be an enduring civil war, punctuated now and then by such truces. Lollie was undoubtedly as responsible for the difficulties as Willie. When Susan Mitchell spoke frankly to JBY once about Lollie, she remarked that "she never met anyone who had such a longing for affection and regard notwithstanding her repellent ways,"[58] making use of the same adjective that sprang to the pen of Willie's Dublin high-school classmate.

Lollie's visit to New York was cut short because she was unable to enjoy herself. Lily wrote to her father five years later: "She wants some sort of inner life—religious—something, even some fad, postage stamps, anything."[59] Lollie sent streams of letters home, then shut them off abruptly and decided to return to Dublin, though Mrs. Ford urged her to stay.

But there was another reason for the sudden return, though Lollie told nobody about it at the time. While in New York she saw much of John Quinn, who then was involved with the third of the four important women in his life. He had recently switched mistresses, shedding Miss Ada Smith for Dorothy Coates. When Miss Coates saw Lollie and Quinn together she didn't like what she saw—or at least Lollie thought she didn't. Writing to her father years later, she alluded to her visit and the part played in it by Miss Coates and Quinn: "I thought her a horrid woman, mean and vindictive, and she hated me on sight. She of course feared J. Q. might get *interested in me*—and at that time (—*this is private of course*) I thought he was greatly interested in Lily, and so I was most anxious *not to annex him*, and couldn't get home to Ireland soon enough."[60]

The unhappy fact was that Lollie couldn't be satisfied anywhere. Lily, on the other hand, was still her father's favorite and everyone else's too. She was able to sense other people's problems and to sympathize with them. She went out of her way to tell Synge that she liked Molly Allgood.[61] She supported Lollie

against Willie's invasion of Dun Emer. And always she was the close companion of her father, sitting by the fire with him at Gurteen Dhas, "both of us getting away from the real point in the first five minutes and scoring off each other brilliantly."[62] She continued to experience "visions" of demonstrable predictiveness, much to the growing marvel of her father, who still disapproved of Willie's dabblings with the occult. Lily didn't dabble, she consulted no crystal balls, indulged in no arcane rituals like those of the Order of the Golden Dawn. Things happened to her, and John Butler Yeats, the disciple of Comte and Mill, had to accept the facts as pieces of evidence to be explained. While Lollie was on the steamship returning her to Ireland an extraordinary event occurred. Lily had written to her sister about a vision—not a dream but something perceived during consciousness—in which she saw a funeral procession with a light-colored coffin coming out of the Dun Emer gate. Then Miss Gleeson's brother died suddenly, and Lily told Lollie she was relieved "as she thought, 'Now my vision is out.'" She had been afraid one of the girls in Dun Emer might have been the unseen body in the coffin.

A few days later Miss Gleeson's seventeen-year-old nephew came to live at Dun Emer. He had been sent down by the officials at Clongowes School because he had been acting strangely. Miss Gleeson had the boy examined by three doctors in Dublin, who all declared him in perfect health and merely "hysterical." The next morning, when Lily approached Dun Emer, "she saw three doctors standing together at the gate and guessed at once what had happened." The boy had died suddenly of a brain tumor, and Lily realized that "the extraordinary thing" was what she "had seen in vision."[63]

Even though a small house, Gurteen Dhas was very much involved in the affairs of the Irish Renaissance. Gatherings formed there, and once in a while JBY would provide a bottle of liquor for the guests to get them talking. Lily, who hated drunks and drinking, would frown disapprovingly. At times a solitary guest would appear, like young Colum,[64] at others the whole theatre company after a Sunday picnic would stop by on the return to Dublin. Willie Fay records his memories affectionately:

there was always a welcome for us, and over a cup or two, or maybe three, of coffee a fresh debate would start, the last play would be criticized or the prospects of the next one discussed. All the time our host would be busy in a corner with his sketch book, rapidly pencilling one of those delightful portraits that he was always creating whenever he had the chance.[65]

It was JBY's home, not his son's, and seldom was Willie present at the gatherings, though none dared speak against him in the presence of his family, who fiercely defended him against others.[66] Once in a while the daughters would go into Dublin for a play, and JBY would "enjoy very much" the evening all by himself, "though I don't know how it would have been had I a month of such evenings."[67]

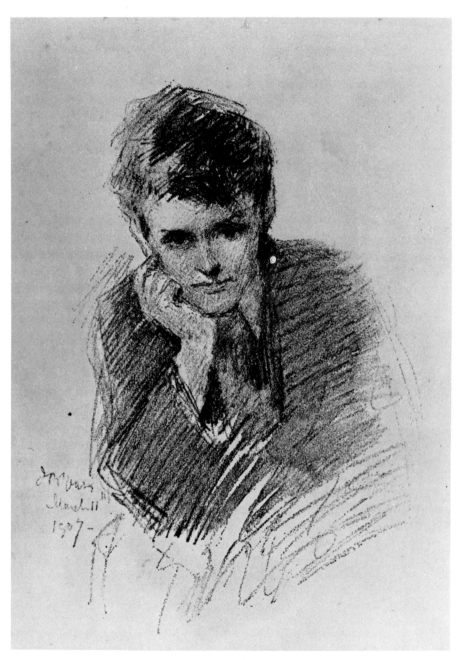

Padraic Colum, March 11, 1907. Pencil. JBY. From a print. Collection: Michael B. Yeats.

John Butler Yeats in Stephen's Green studio, 1906. Photograph given by Julia Ford to John Quinn, by Quinn to Jeanne Robert Foster. Collection: Foster-Murphy.

Nevertheless the tensions of life in general were fraying his nerves. He enjoyed Lily's company but, like everyone else, was exhausted by Lollie's. When he walked into Dublin with her he would take what he claimed was a quicker route than hers and pretend to make a race out of a desire to be beyond earshot.[68] He also felt agonies of conscience at not being able to contribute more than fifty pounds annually to the family coffers,[69] a sum he knew was not enough to pay for his board. He was full of remorse in explaining the state of affairs to Willie: "If only I could make a little success and a little money and help a little Dun Emer would be all right, and Lily and Lollie would be at ease. In a deeper sense than you will ever guess at, my want of success has made me the evil genius of the family."[70] He was constantly borrowing sums which he couldn't repay. The high hopes raised by the Hone-Yeats Exhibition had died. Life for him in Dublin was "a world of anxiety and care" which he could not "alleviate," a "weariness of personal debt and worry with everyone looking askance" at him.[71] He wrote to Elton asking whether he might do sketches of some members of his family for a few pounds and whether Elton, if agreeable to the plan, could make an advance. The generous Elton responded by return mail with a warm letter in which he enclosed a check for ten pounds. Another admirer, Lord Mayor Tim Harrington, agreed to sit for a commission to be paid by public subscription and even sought contributions himself.[72] But such maneuvers were demeaning. In March, as JBY passed his sixty-seventh birthday, he was troubled by nervous attacks[73] and became preternaturally sensitive. When Elton's book on York Powell appeared, he read that Powell had once made an unflattering remark about a friend who told him he dreaded old age only because he was afraid he could not "drink enough or eat enough." JBY was sure the criticism applied to him and wrote a long agonizing apologia to Elton, only to learn that Powell had been referring to "a most blatant philistine of an Englishman."[74]

The fault, as always, lay with himself. Sarah Purser complained that when a person came to his studio and asked the price of a portrait he would say, "Two hundred pounds, but rather than let you get away I'll do it for two pounds."[75] He sketched a young Irishman for nothing, and when the young man, Francis Hackett, arrived in America a few weeks later to begin a long and successful literary career, he gleefully reported his good luck to Quinn, who chided JBY. Another American, a Mr. Robinson, was about to descend on Dublin, and Quinn wanted JBY not to be so generous.[76] Yet when Mr. Robinson came he sat for a sketch, later brought a friend to be sketched too, and departed without paying a farthing. JBY lacked the effrontery to demand a fee. He also dawdled in the old way; by the end of the year he still hadn't finished the oil of George Moore commissioned by Quinn. He sketched Miss Agnes Tobin, a Californian, who was so pleased with the result that she asked for a copy in oils. Not eager for the work, he told her it would cost twenty-five pounds. "Oh, that's very little," she said, and promptly sent a check in advance.[77]

Despite his own conspicuous lack of success he took to writing advice to Willie, long letters in which through indirection he tried to shape his son's poetry and drama. He called to Willie's attention the tasteless attack by Swinburne on the volumes of Blake which WBY and Ellis had edited. Swinburne lashed out at the "fancifully delirious deliverance" of the "Celtic" author, unaware that Ellis and not WBY had written the passage he was attacking. Willie was undisturbed. "One practically never converts anyone of a generation older than one's own," he replied.[78] Father also attacked Swinburne's peculiar notion "that he and Shelley were the only great poets because they alone were gentlemen," and from that he moved to the observation that Swinburne had been right in at least one general criticism, "that the Celtic movement puts fever and fancy in the place of reason and imagination."[79] He indirectly glanced at his son's occultism through a commentary on the Catholic Church.

The mission of a church is not to teach Truth;—that difficult subject may well be left to the scientists—but to teach religion. The doctrines of the atonement, the resurrection of the dead, the Trinity, the holy spirit, the judgment to come, are all so many folk tales meant to impose only on those who wish to be imposed on, as we all do when listening to ghost stories, and as peasants do when talking about the "gentry" in the dusk on the hill side or sitting round the turf fire and listening to the howling of the wind. And all we ought to ask is that the Poetic spirit and the religious spirit be each true to its own essence.[80]

He also compared the work of artists to that of poets, making use of the language of metaphor that was to mark his reflective letters more and more as he moved from his position as lapsed court painter to that of artistic philosopher.

I think every work of art should *survive* after all the labour bestowed upon it, and *survive as a sketch*. To the last it must be something struck off at a first heat. This is the meaning of impressionism. I have lately been reading Shakespeare's *Cleopatra* and it has all the pregnancy of a sketch, because it is a sketch. The details are not filled in. No *conscientious* labour has been spent on it. It is all a riot and extravagance. Now, the essence of a sketch is that it leaves much to the imagination. . . . Your poet creates great spaces where the imagination must travel alone . . . unencumbered by the necessity to find words and reasons. Again, as to ideas in Poetry: these must never be expressed. They can only be implied.[81]

He was enjoying his correspondence with Quinn also, happy to have an appreciative audience. Quinn in turn kept JBY informed of the American visitors who threatened to invade the privacy of the Yeatses, and to JBY and Lily he disgorged his ready opinions on all the things that annoyed him about the Irish in America and in Ireland. In January he let Lily know of his dislike of the Ancient Order of Hibernians (the A.O.H.), founded in Ireland with branches transplanted in America, where its members were chiefly blue-collar working men whom Quinn found bigoted and narrow-minded.[82] In July he

wrote JBY a seven-page letter full of testy opinions, adding to the typed letter in his own hand: "Of course I wish you would regard this letter as personal and confidential. In fact I would not *keep* it at all. Dublin seems to me to be a whispering gallery and I don't want any echoes of my voice there."[83] JBY acceded to the first half of the request but not, happily, to the second.

In midsummer of 1906 there came to Dublin Judge Martin Keogh of the New York State Supreme Court and his family. The Yeatses held a big party at Gurteen Dhas, with Susan Mitchell, "Pixie" Smith, George Russell, and Padraic Colum also present. The Abbey gave a special performance for them. In the midst of the frivolities Mrs. Keogh turned to John Butler Yeats and pledged that she would sit to him for her portrait in the following year.[84] It may have been her remark that planted the seed of an idea in JBY's mind. She was destined to be late by only a few months in keeping her pledge. It was not kept in Dublin, however, as she thought it would be, but in New York.

During the late months of 1906 the Abbey players rehearsed a new play behind closed doors. Even Joseph Holloway was denied entrance. The work was J. M. Synge's three-act comedy, *The Playboy of the Western World*. Rumors about it had already spread. Holloway tried to pump one of the minor actors, Harry Young, but learned little. Young, however, had ominous news. He told Holloway he had heard there would be "organized opposition" to the play, that a crowd would be on hand to hiss the production. "I poo-poohed the idea," Holloway wrote in his diary.[85]

The author of the controversial work was not feeling well, yet on January 15, 1907, the day before the opening, he attended the rehearsal, where John Butler Yeats sketched him.[86] Although he attended some performances during the first week of the run, he quickly retreated to home and bed whenever he could. He was to be present at little of the public pandemonium that followed.

Young was right. On the twenty-sixth, when the fashionable of Dublin attended the opening, the audience hissed and hooted "amid counter-applause," and those present could not hear the ending of the play. On Monday night, the twenty-eighth, the fashionable were not present, the theatre packed instead with objectors who hooted through the whole performance.[87] As few had the opportunity to learn what the play was about, it seems clear that the demonstrations were directed against Synge and his fellow directors. Unruly crowds returned on succeeding nights and kept up their noisy objections. William Butler Yeats, who had been away in Scotland, hastily returned to face the crisis. Characteristically, instead of ordering a cancellation or postponement to allow tempers to settle, he directed that the play be continued through the remainder of the week. When commotion threatened to become riot, he and Lady Gregory called in the police. WBY scheduled a public meeting at the Abbey for Monday, February 4, so that everyone might have

the opportunity to voice his feelings about the play. By the time the fire had burned out, the name of J. M. Synge and *The Playboy of the Western World* were known throughout the English-speaking world as they would never otherwise have been. What appeared to some at the time as a near-disaster for the Abbey proved instead a triumph.[88]

The Playboy is regarded today as so innocuous that it is hard to imagine how it could have stirred up such indignation. Its plot is fairly simple. A young man named Christopher Mahon flees to a village in Mayo from his home town some miles away after killing his father with a "loy" (a type of spade used for cutting sods of turf). His father had tried to force him into marriage with a much older woman, and Christy had objected. When he tells his story in Mayo he is admired as a hero. A publican's daughter, Pegeen Mike, and an older woman, the Widow Quin, are strongly attracted to him. He participates in the villagers' sports and wins a contest. Rivalry for his favor among the women is approaching its peak when suddenly Christy's father, very much alive, appears with head bandaged to denounce his son. Christy rushes at his father and threatens to kill him, and this time to do the job properly. The villagers, horrified by the prospect of parricide before their very eyes, tie Christy up. In the end Christy, thoroughly discredited, returns with his father to become, despite his boasting that he will henceforth be the giver of orders, an ordinary Irish peasant again, a young man with no special future; and the trapped women of Mayo return to their barren dreams.

The causes of the violent disturbances at the Abbey are clearly to be found not in what was shown on the stage but in the spectators who watched it. Although the play clearly qualifies as "a comedy, an extravaganza, made to amuse," as Synge himself described it,[89] the Irish audience chose not to see it as such. Some found profanity and blasphemy in it,[90] and some objected to the use of the word "shift" (a lady's undergarment that would today be called a "slip"). The main objection, however, was that the play's plot and characters were "an outrageous insult to the West of Ireland and its people."[91] Holloway was one of those outraged on opening night. When Lady Gregory, who had been backstage, asked Holloway what had been "the cause of the disturbance," his answer (which he called "monosyllabic") was "Blackguardism!"

"To which she queried, 'On which side?'

"'The stage!' came from me pat, and then I passed on, and the incident was closed."

He had heard a voice in the pit cry out, "This is not Irish life!" And Holloway himself maintained, "*The Playboy* is not a truthful or just picture of the Irish peasants, but simply the outpouring of a morbid, unhealthy mind ever seeking on the dunghill of life for the nastiness that lies concealed there."[92] Although the noise level was high, obviously some in the audience heard what was said.

The directors made a number of tactical mistakes in trying to handle the detractors, like asking the police in to keep order. Some vocal protesters were

arrested, one of whom, later fined, was Padraic Colum's father. Since the police were the visible representatives of the occupying English powers, the Irish "patriots" were given a handy scourge to use on "the little knot of decadents" who presumed to speak for national drama. The police had not been well instructed: on one occasion they arrested two spectators for attempting to leave before the play was over.[93]

The important issue in the matter, imperfectly understood at the time (as it is today) was that of free speech, though it was complicated by pseudo-legal questions arising from the licensing requirements.[94] At the performance of Tuesday, January 29, when WBY announced the public discussion for the following Monday, he made the only clear declaration of the fundamental issues involved:

We have put this play before you to be heard and to be judged, as every play should be heard and judged. Every man has a right to hear it and condemn it if he pleases, but no man has a right to interfere with another man hearing a play and judging for himself. The country that condescends either to bully or to permit itself to be bullied soon ceases to have any fine qualities.

He ended with a practical warning: "I promise you that if there is any small section in this theatre that wish to deny the right of others to hear what they themselves don't want to hear we will play on, and our patience shall last longer than their patience." [95]

The opposing point of view, articulated in a variety of ways at the Monday meeting, was best expressed in a letter to Yeats from William Boyle (who had not seen or read the play) accusing the Abbey directors of "attempting to force a play—at the risk of a riot—upon the Dublin public contrary to their protests of its being a gross misrepresentation of the character of our western peasantry." Boyle, who simultaneously withdrew his own plays from the Abbey repertoire, neglected to explain how Dubliners were being forced to buy tickets to see what they did not want to see.[96]

During the loud public controversy Synge, ill at home, grew increasingly irritated by the objections to his play. He thought the less a writer said about his work the better but felt compelled to write to the *Irish Times*:

"The Playboy of the Western World" is not a play with "a purpose" in the modern sense of the word, but although parts of it are, or are meant to be, extravagant comedy, still a great deal that is in it, and a great deal more that is behind it, is perfectly serious, when looked at in a certain light. . . . There are, it may be hinted, several sides to "The Playboy." [97]

One of those darkly suggested sides was what Synge had mentioned in a letter to Stephen MacKenna three years earlier. MacKenna had objected that Ireland was not ready for *In the Shadow of the Glen*, and Synge had replied sharply that the peasants of Ireland were no more "blessedly unripe" than the Norwegians who survived Ibsen. He pointed out that Dublin audiences paid to

see "M[me] Rejane in Ibsen, Mrs. P. Campbell in Sudermann, Miss Olga Netherstink in Sappho." They wanted "to suck smut every evening and to rise up every morning and say, 'Behold we are the most virtuous nation in Europe. Thank God we are not as other men!' " Then he explained one of his contributions to Irish drama:

Heaven forbid that we should have a morbid sex-obsessed drama in Ireland, not because we have any peculiar sanctity which I utterly deny—blessed unripeness is sometimes akin to damned rottenness, see percentage of lunatics in Ireland and causes thereof—but because it is bad as drama and is played out. On [the] French stage you get sex without its balancing elements: on [the] Irish stage you [get] the other elements without sex. I restored sex and the people were so surprised they saw the sex only.[98]

During one of the performances, when the rioters were at their most unruly, a medical man drew Synge aside and said to him in anger, "I wish medical etiquette permitted me to go down and stand in front of that pit and point out, among the protesters in the name of Irish virtue, the patients I am treating for venereal disease."[99] (Almost twenty years later Holloway was to object to the inclusion in Sean O'Casey's *The Plough and the Stars* of the part of Ria Mooney, a prostitute, as "quite unnecessary," even though the police were chasing prostitutes away from the doors of the Abbey while the play was going on.)[100] The *Irish Times* had observed that the rioters "founded their objections on a theory of Celtic impeccability which is absurd in principle, and intolerable, when it is sought to be rigidly imposed as a canon of art." What they wanted to see at the Abbey was "the pulpit Irishman" as a substitute for the "stage Irishman."[101]

By January 31 a playgoer writing to *Freeman's Journal* had concluded that the Abbey was "dead and rotten as a National Theatre," that it could never be "accepted by the people of Ireland as a national institution of theirs."[102] Both sides were ready for the great debate at the Abbey on the night of Monday, February 4 (to which the directors craftily charged admission, earning a profit of sixteen pounds). Almost everyone of importance in Dublin was present except those of the Anglo-Irish Establishment and Synge, who felt too sick to come. Some of those who should have been present to support the Abbey cause were absent, like T. W. E. Russell, and others who were present, like George Russell, chose not to speak. Colum, in an ambiguous position—he defended the theoretical right of the company to be heard but fell politically in the opposite camp—found he had to attend a rehearsal and didn't show up.[103] Most of the others, JBY recalled to Lady Gregory years later, were like the people Joyce wrote about, a class of "cads" ("I knew there were such people but never met them and never thought about them").[104]

The meeting provided an interesting confrontation. "Pat" Kenny of the *Irish Times* was in the chair, though WBY occupied the stage with him. The crowded theatre, crackling with the hostility of Yeats's enemies, those he earned and those he desired, provided exactly the kind of battlefield he enjoyed.[105] As if to show how he regarded his own position, WBY chose to

wear immaculate evening clothes. When hisses filled the house as he rose to speak he loftily reminded his hearers that the man addressing them was the author of *Cathleen ni Houlihan*, a daring ploy that brought immediate silence, followed by some cheers. Mary Maguire (later Mrs. Padraic Colum) marveled at the skill with which the poet conducted himself. "I never witnessed a human being fight as Yeats fought that night, nor knew another with so many weapons in his armoury."[106]

Among those who spoke was Synge's first public advocate, John Butler Yeats. When he moved toward the stage he was received sympathetically, as even among "Joyce's people" he was regarded with admiration, chiefly because of his reputation for good humor and his known dissimilarity to his son. There was good-natured joshing. People called up to WBY on the stage, "Get the loy," and "Kill your father." At first the old painter was listened to with enthusiasm, but as his message began to penetrate, resentment took its place. Thirty years later WBY, in a poem, vividly remembered his father's imposing presence before "the raging crowd," "his beautiful mischievous head thrown back."[107] JBY began by saying that although he had not read the play he had seen it twice, then after a pause added slyly that he had not yet "heard it." He knew that Ireland was a Land of Saints, he declared, at which there were cheers of encouragement and applause, then added, "a land of Plaster Saints," at which the audience groaned. He knew Synge, he said, and knew of his great affection for the Irish peasant, whom he depicted with more truth and skill than William Carleton, the early-nineteenth-century writer. Carleton's peasant, he maintained, was "a real insult and degradation" (a remark which brought "noise") but Synge's "was a real, vigorous, vital man, though a sinner."[108] He also declared that "unfortunately in this country people cannot live or die except behind a curtain of deceit." In the uproar following these remarks both the chairman and WBY called out, "Time's up, Time's up," and JBY returned to his seat.[109]

The controversy over *The Playboy* was publicized all over the world, and those who hadn't heard of the Abbey before heard of it now. In the public mind Yeats and Synge rose to the top, except among the overseas defenders of Gaelic purity. Quinn found he could not persuade Irish-Americans of *The Playboy*'s harmlessness. Irish-American newspapers reprinted attacks from *Freeman's Journal*. In the absence of a voice on the other side, the work of the Abbey must have appeared to the average member of the Ancient Order of Hibernians as treasonable to the Irish cause. Even a well-read man like John Devoy, editor of the *Gaelic-American*, was impervious to Quinn's explanations. Devoy, however, had long disliked WBY.[110]

William Butler Yeats enjoyed the controversy immensely and felt one of its consequences would be to clear the field and let everyone recognize the real opponents of Irish culture. "It has been for some time inevitable that the intellectual element here in Dublin should fall out with the more brainless

patriotic element, and come into existence as a conscious force by doing so," he wrote Quinn airily.[111] Yet there is no evidence that any new "intellectual element" rose in Dublin and much that cooperation among groups desiring an "Irish" drama had been drastically reduced. It may be that neither side genuinely wished cooperation and that Synge's play merely proved the trigger in the dissidents' gun; the powder and shot were already there.

Synge, in his illness and loneliness, felt left out of the management of affairs and regarded himself as a minority of one against Yeats and Lady Gregory. He felt they looked down on his association with Molly Allgood and suspected they were undercutting him. When Charles Frohman, the American impresario, arrived in Dublin to inspect the Abbey offerings, he was shown five or six of Lady Gregory's plays and several of Yeats's, but only one of Synge's. "I am raging about it," Synge complained to Molly. He told her he might withdraw his plays from the Abbey if investigation proved he was being unfairly used. "It is getting past a joke the way they are treating me."[112] A few days later he asked Frank Fay to draw up a list of the number of performances the company had presented of Yeats's and Lady Gregory's plays. Although admitting that they had both "been very kind" to him and that he owed them "a great deal," still he was angry enough to threaten a row if the results of Fay's survey were unfavorable."[113] In May he threatened to resign when *The Playboy* was removed from the program at Birmingham. WBY responded with what Synge described to Molly as "a rather nasty letter."[114] His private attitude toward Lady Gregory may be judged by his referring to her as "Her Ladyship."[115] When William Poel, the English actor and producer, visited Dublin to talk to the Abbey directors, he declared himself "most enthusiastic" about Synge's work. But at dinner Synge noted with amusement that whenever Poel began talking of Synge's plays Lady Gregory would break in at once "with praise of Yeats's work."[116] It is clear that it was not only the Diggeses and Boyles and Colums who found Lady Gregory and WBY trying.

They had trouble with each other too. Lady Gregory thought WBY's "subservience" to Annie Horniman "a disgrace." Miss Horniman had sent him insulting letters, once even accusing him of cheating in the accounts. Since Willie was a guest at Coole when the last of these letters arrived, Lady Gregory insisted that Willie "would have to reply to that letter or leave her place." He reluctantly dictated a reply, but he looked so unhappy after giving it to her to mail that she returned it to him."[117]

With the tumult over *The Playboy* Miss Horniman grew ecstatic. "How little I expected that my hopes to annoy the Gaelic League into action would be so violently fulfilled. Would they be very pleased to know that they did just what I wanted them to?" These sentiments were recorded in a letter to Willie.[118] In order that others would know how she felt, she also sent him a telegram on Wednesday, January 30, in the middle of the week of riot, knowing that it would have the privacy of a post card and its contents be known throughout

Dublin within twenty-four hours.[119] It was partly because of his feelings about Miss Horniman that Boyle withdrew his plays from the Abbey repertoire. He wrote Denis O'Donoghue on February 13:

> It has surprised me that Miss Horniman's name has been kept out of the discussion. As a matter of fact, she is at the back of it. Her hatred of the Irish people almost amounts to lunacy. She wouldn't allow a word of patriotic sentiment to be brought out in what she calls her theatre! As I gathered this on several occasions at her own dinner table, I can't say it openly, but I know it and know that Yeats has not a free hand as he pretends. . . . You don't know how I have been boiling for some time; I assu[r]e you my design was not hasty. I should have spoken out sooner.[120]

Miss Horniman had flown too high too long. A series of events led to a sharpening of the antagonism between her and Lady Gregory, and William Butler Yeats was in effect forced to choose between the two. Well before the *Playboy* riots he had discovered how much time he had to take from his other enterprises to work on the business of the theatre. In December of 1906 he had sent a lengthy memorandum to the other two directors proposing a new scheme for the future operation of the Abbey which would guarantee "a National Theatre something after the continental pattern." He reluctantly admitted that his own plays would have to wait a long time for an audience and felt that the success of the theatre in late 1906, when the house was packed every night, depended on the plays of Lady Gregory and William Boyle, but that these "would eventually tire the audience or create a school of bad imitators." He therefore suggested a broad new program to include special training for actors, adoption of a repertory program, and the hiring of a managing director to coordinate the program. As immediate measures, he wanted to free Willie Fay from the business of managing, to have a verse teacher brought over once a year, and to be given the right to bring in players of his own choosing to act in his own plays, the only ones in verse and hence requiring special talent. He also wanted more "foreign masterpieces" to be produced.[121]

Whether the ideas were his or not, they sounded suspiciously like Miss Horniman's. His two co-directors sharply demurred, and eventually a compromise was reached, chiefly to get Willie Fay out of range of Annie Horniman's guns. Her hatred of him had by now risen to the level of paranoia, but Synge was in Fay's corner, partly out of admiration for his acting, partly because Fay was close to the Allgoods. In a letter to Lady Gregory, meant for WBY's eyes as well, Synge wrote: "I do not see a possibility of any workable arrangement in which Miss Horniman would have control of some of the departments." By midyear of 1907 Miss Horniman had officially added Lady Gregory to her "list of truly wicked people"[122] and now tried to bring the ultimate pressure to bear on WBY. She announced that at the end of the period for which she had agreed to provide a subsidy she would discontinue it; by December, 1910, the theatre would have to be made completely self-

supporting or face collapse. She begged Willie to abandon Dublin and come to Manchester. She charged the Irish audiences with not appreciating his work, preferring the "commonness" of Boyle and his ilk. "You and I," she declared melodramatically, "tried to make it an Art theatre and we had not the living material to do it with. Your genius and my money together were helpless. We must both keep our promises uprightly, but we must not waste our gifts, we have no right to do so."[123] Coupled with the notice about the subsidy, the friendly offer sounded like an ultimatum.

It was a development that had to come. Miss Horniman must have been waiting for what she thought was a propitious moment, though perhaps there never was nor ever could have been such a moment. Yeats's answer marked a turning point in the history of the Abbey, of his development as a poet, and of his relationship with Miss Horniman. In a choice between Ireland and England his response was decisive. Her proposal, he told Miss Horniman, was "impossible." "I am not young enough to change my nationality—it would really amount to that." If the theatre failed he could always return to lyric poetry, "but I shall write for my own people—whether in love or hate of them matters little—probably I shall not know which it is."[124]

The exchange marked the beginning of the end of Miss Horniman's influence. All she could do now was badger those who annoyed her; by the end of the year she had so undermined Fay's position that he issued an ultimatum that led to his own resignation, a development which Synge's biographers declare was not unwelcome to WBY.[125] She continued sniping at the company until 1910, when the complete severance came. After WBY's rejection her power was essentially destroyed.

Synge's health continued to deteriorate. The swollen glands in his neck were enlarging further. Although his doctor didn't associate them with the pains Synge felt elsewhere—for the neck swellings caused no pain—he urged their removal before Synge's marriage. On September 12 the surgeon scheduled the operation for two days later. Synge felt relieved that at last something would be done. He left the doctor's office, engaged a room for himself at the hospital, bought tea at O'Briens's, then dropped by at 7 Stephen's Green to see "old Yeats" in his studio.[126] To the old man Synge seemed "in good spirits" and talked about Jack and "a book on Irish types he is meditating."[127] We know no more about the visit, but one wonders why Synge paid it at all. Was he deliberately seeking out the one person in Dublin known pre-eminently for his vitality, his enthusiasm, his gaiety? John Butler Yeats at sixty-eight may have had the youngest mind in Dublin. Could Synge have subconsciously hoped that a little of that intensity, that apparent proof against mortality, might rub off on him? Earlier in the year, immediately after answering the "rather nasty letter" from Willie, he had gone to 7 Stephen's Green to visit Willie's father, who promptly did another sketch of him.[128] Yet Synge never went out of his way to see the painter's son.

The operation on the fourteenth was a success only in the sense that Synge survived it. Less than two months later he began to complain of "queer pains in a portion of my inside,"[129] and the remorseless process continued.

In March, JBY enjoyed a visit from his former Bedford Park neighbor Oliver Elton, who later recalled the excitement over the Abbey rows and the pride of JBY in his elder son, "the admitted chief, already, of living Irish men of letters."[130] They dined with Kuno Meyer, Professor of Celtic Studies at Liverpool, and JBY noticed with distaste Meyer's way of "taking his colour from his environment" like a "chameleon,"[131] a characteristic he would remember in New York a decade later.

JBY's outward enthusiasm and vitality still existed side by side with worry and fear over money and career. Two events early in 1907 were shattering to the already fragile stability of his world. On January 30, the very day when the immense crowds gathered outside the Abbey Theatre to protest against Synge's indignities, an affidavit was filed with the Land Commission by Frederick Gifford and Anne North, mortgagors, and John Butler Yeats, mortgagee, with a tentative accounting of assets and claims. The Land Commission held £226.14.1 in face value of stock in the Bank of Ireland, worth on that day in market value £992.2.7. To Frederick Gifford, for his mortgages of October 20, 1884, and December 31, 1890, there was owing £395.0.8, plus interest of £9.7.0, and to Anne North on her renewed mortgage of March 7, 1901, the sum of £100 plus interest of £3.13.6. After discharge of these liabilities the balance, according to the petition of John Butler Yeats, was "payable to me the Vendor in this matter."[132] It amounted to £427.1.11; by the time the final settlement was made on July 5 it had been reduced by charges of various kinds to £411.1.15,[133] and this was the amount paid JBY. The Vendor realized when he saw the figures in January that his accumulated debts would consume the whole sum. Before the end of the year all the money, representing the last holdings of the Ormonde Butler family that had passed to Parson John Yeats seventy years earlier, had disappeared down the "swalley-hole," and JBY was again in debt: twenty-five pounds to the Smyths for the studio, seventeen to Searle the tailor, ten to Egan the picture framer, eighty to Jacob Geoghegan (a relative of the Pursers), and additional sums to others.[134]

The other shattering event was the death of John O'Leary on March 16, 1907, JBY's sixty-eighth birthday. O'Leary, though only seventy-seven years old, had seemed more ancient, as he had seemed immortal. He had become a symbol to many groups of Irishmen. He was the first Irish leader after Butt to have given focus to the nationalistic feelings of the Yeatses. Even that great average Irishman Joseph Holloway was moved by the news of his death.[135]

At Gurteen Dhas, JBY and his daughters still struggled to meet the bills, now with no estate to fall back on. "If I could get rid of my money worries and if Lily and Lollie had their affairs on a securer basis," he told Willie, "I should be perfectly happy."[136] Yet he openly complained of his physical condition: "the

The workers at Dun Emer, about 1905. Evelyn Gleeson, in black, is in center. Lollie Yeats sits below her at right, her elbow on Lily's knee. Collection: Michael B. Yeats.

last few days I have not been very well. For the first time in my life I have to consider the moods and caprices of that thing—*my health*. Damn it! It is like a bad wife, and there is no possibility of divorce or even a separation, and were I to indulge in a frisk, it would only be the worse for me afterward. In my young days a gentleman did not bother either about his health or his finance."[137] He worried about Lollie; Louis Purser still hovered in the background but was no closer to slipping the ring on her finger than he had been five years ealier. Lollie did her best to stoke the fires in what was probably an insufficiently drafty furnace. Louis's niece Olive Purser remembered a pathetic visit Lollie paid to Louis's rooms at TCD to present him with a potted plant. Louis was out, and Lollie had to leave the offering with Olive.[138]

Every night too the daughters brought the problems of Dun Emer home with them. On March 20, Katharine Tynan's *Twenty-One Poems* was published with the words "Selected by W. B. Yeats" on the title page, an indication of the winner of that battle.[139] There was still the constant pressure to make sales,

and the rivalry with Miss Gleeson maintained its intensity. JBY was only too aware that by his own improvidence he was adding to his daughters' problems. He kept writing to Willie optimistically about his future as a painter,[140] but in fact by 1907 JBY was virtually out of business as a professional portraitist. He walked to the Stephen's Green studio from Dundrum every day ready to make money, but most of those who dropped in came not to buy but to talk. He did a watercolor of himself for Willie for two pounds, and he painted a member of the Jameson family, Mrs. Burke, for more than twenty-five pounds.[141] Otherwise there was little business. Unfinished portraits lined the studio walls. The fact was that the Dublin world was passing him by. Even a foreigner with a flair, like Antonio Mancini, could sweep into Dublin and make more of an impression on its inhabitants. Lane had met Mancini in Rome, and shortly afterward the Italian turned up in Dublin. He was an artist of supreme confidence. Of his grotesque portraits he would say, "If they want a likeness why do they employ a man of genius?"[142] Lane established Mancini in the house on Harcourt Street that would soon become the Municipal Gallery, and there the Italian justified his reputation for eccentricity. JBY "would see coming towards him the stout little man, hat in hand, bowing low every few steps, his Italian man servant walking behind him, also bowing, hat in hand," Lily wrote. "Papa took off his hat and did his best at the bowing. Mancini knew no English so they said some unintelligible sentences to each other and parted." He had a peculiar way of showing his regard. "If Mancini liked you very much he wrote you a letter in bad French, then to show that, being his, it was a thing of naught, he tore it up into small pieces, put the pieces into an envelope, posted it, and was deeply hurt if you did not answer by return post."[143]

JBY disliked Mancini's work. He may have been annoyed that Willie chose to use a Mancini portrait as a frontispiece in one of the volumes of Bullen's edition of his collected works.[144] He wrote Willie sharply:

I think you would make *a serious mistake* if you put Mancini's portrait into your book. You are not a Caliban publishing a volume of decadent verse, nor are you in any movement of revolt, that you should want to identify yourself in elaborate humility with the ugly and the disinherited.

Do you notice that in each of those three drawings at the Nassau, Mancini has put the left eye lower than the right? It has a curious ignobling effect. He is a wit rather than a serious artist, a wit painter as Whistler is a poet painter and Sargent a prose painter.[145]

Willie allowed it to be used anyway, though his opinion of it may be judged by the comment he made in the flyleaf to Quinn's copy of the volume, "If I only looked like the Manchini [*sic*] portrait I should have defeated all my enemies here in Dublin." He described the painter's method: "Manchini did it in an hour or so working at the last with great vehemence and constant cries, 'Cristo, O,' and so on."[146]

At Gurteen Dhas, Americans continued to visit. One night Charles Battell

Loomis, the American humorist, and Miss Marguerite Merrington, who had written successful plays, arrived at the same time. They listened to JBY's play and praised the dialogue just as Synge had done,[147] and JBY liked Loomis so much he urged him to see George Pollexfen in Sligo. "I am certain they will enjoy each other," he wrote Willie, "that is if George behaves properly and does not disappoint one as he is apt to do."[148] Quinn raised JBY's ego by commissioning an oil portrait of Willie for thirty pounds, to be about the same size as the O'Leary and Russell portraits.[149] JBY got Lady Gregory to persuade Willie to pose for it. It was begun on October 1 and finished in December.[150] Quinn paid a further compliment to the old man. Francis Hackett was planning an American edition of Synge's plays and asked Quinn to recommend someone to write an introduction. Quinn told Willie that he had at once written to Synge and his publishers "that the man of all others in Ireland to do this would be—can you guess—your Father." Quinn had been impressed by JBY's contribution to Elton's biography of York Powell as "a perfect piece of work." "Your Father would write a *winning* introduction—one that would help and tend to disarm criticism." Father told Willie he was quite ready to do it on approval—"by which I mean chiefly my own approval." The series never appeared, and nothing further was heard of the proposed introduction.[151]

Then, suddenly, John Butler Yeats left Dublin, never to return. Like almost every other major decision of his life, it was impulsive, and this time brought about by accident. Hugh Lane knew that the old man had never been to Italy, and he conceived the idea, with the artist Sarah Harrison, of raising a fund to send JBY there. The Harts, the Jamesons, the Pursers, and others cheerfully contributed. By early August the money was in hand, but JBY was reluctant as ever about being forced to do things other people planned for him. Lollie wrote to Quinn:

> It is a splendid idea and most generous of them. Mr. Lane asked me to get him off, so I said the thing was to get Lily to get him to go. . . . Papa I think had known of it for some time but did not tell us as he knew we would try to get him to make up his mind to go. They just want him to see Italy and the great pictures and enjoy himself in his own way. It will be very hard to get him off.[152]

Papa did nothing. "I can make no plans," he told Jeanne Robert Foster years later. "Always have the stars done what they liked."[153] This time they carried him westward. On September 18 he wrote Ruth Hart that Lily was to visit New York after Christmas to attend "some sale there" and was in "great spirits" as a result.[154] The "sale" was another Irish Exhibition in New York. Miss Gleeson had already decided to take a stall herself; Quinn suggested that Lily represent the Yeats branch of Dun Emer, selecting her because Willie, Jack, and Lollie had already had their time in America. No mention was made of JBY in Quinn's planning or in Lily's, and JBY's letters contain no hint of what he was finally to do. Indeed his letters at this time are filled with his concern about

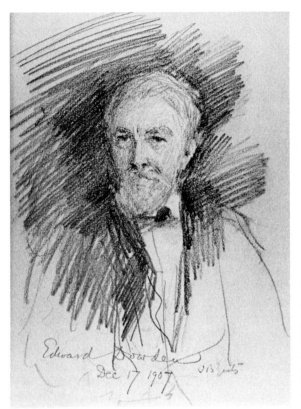

Edward Dowden,
December 17, 1907. Pencil.
Titled, signed, and dated by
JBY. James Augustine
Healy Collection of Irish
Literature, Colby College,
Waterville, Maine.
Permission J. Fraser Cocks
III, Special Collections
Librarian.

the machinations of Drew and Catterson Smith in the Royal Hibernian
Academy.[155]

Then, at virtually the eleventh hour, he decided to use the Italian money to
join Lily on the trip to New York. His plan—or the one he announced—was to
make a whirlwind invasion of the city and its environs, where his Irish-
American friends would find commissions for him, and, like Willie and
Douglas Hyde before him, to return in triumph with sheaves of American
dollars to wave in the eyes of his detractors. When Quinn heard the news, he
remembered that Mrs. Ford had invited JBY to visit New York and im-
mediately phoned to berate her.[156] He wrote Dublin to tell the Yeatses that it
was "the worst possible time to come out," for there was an economic slump in
the United States; he quoted his Uncle Jeremiah Quinlan's phrase, "Money is
tight in New York, but Hell is loose."[157] Having made up his mind, however,
the old man couldn't be dissuaded. A couple of days before leaving he
appeared on Stephen's Green and proudly showed Mrs. Constantine Curran a
new suit he had bought for the voyage; at his studio he did two farewell pencil
sketches of Edward Dowden.[158] Sarah Purser complained about the diversion

of the Italian fund money, but nobody else seemed to mind, and Mrs. Jameson even provided letters of introduction to people in New York.[159]

Then he and Lily were gone. In his studio JBY left his unfinished paintings, his brushes and paints neatly stowed but ready for use, and his unfinished play. He did not cancel or postpone a scheduled speech on March 4, as he said he planned to return in time to deliver it. What his own deeper plans may have been one cannot know. He later insisted he did not know himself. When he left Dublin, however, it was to be not for a few weeks but for ever. He was never to see Lollie again, or Jack, or brother Isaac, or any of the Pollexfens. The course of his future life was then as unplanned and unpredictable as any of his portraits. He let the stars carry him along.

In Liverpool he and Lily stayed with the Eltons. A letter from Quinn urging him to turn back reached him there the night before embarkation, but next morning a retracting telegram followed, Quinn remorsefully realizing that no change was possible at that late date. Papa wrote Lollie from Liverpool in high optimism. "I do not expect to fail. The Jamesons' introduction will I think alone suffice for success."[160] He may have left his paraphernalia in the studio on Stephen's Green, but he took his illusions with him.

On the morning of December 21 he and Lily boarded the *Campania*, the Eltons waving to them from the landing stage as the ship pulled away. The last John Butler Yeats saw of them was a tuft, a "red flower or feather" that ornamented Mrs. Elton's hat. She sensed what nobody else suspected. Turning to her husband she said, "He will never come back."[161]

There was a short stop outside the harbor at Queenstown; then the *Campania* headed west in the teeth of a gale. Lily spent four or five days in her stateroom trying not to be sick. When she emerged after Christmas she found, with Papa, all kinds of interesting people, among them a man named Grierson who asked Papa what he thought of "Yeats and this literary movement" and got a start when he discovered whom he was talking to, and a writer named John Cowper Powys, who was delighted with a sketch JBY did of him.[162]

On Sunday morning the twenty-ninth they arrived in New York. Quinn was at the pier to meet them, shepherd them through customs, and escort them to the Grand Union Hotel,[163] where they were to stay as guests of Mrs. Ford. They were given adjoining rooms of some splendor. On the night of December 30 Quinn took them to the Metropolitan Opera House, and as JBY saw the bustle of activity his spirits rose. It was good to have Lily close by, and she had the same feeling about him. "It is strange to be so far off," she wrote Lollie. "I am glad to have Papa."[164]

It was to be a great adventure for them both, but far more for him than for her. From now on he would experience Dublin through the letters of his children and friends, enjoying its follies without having to endure them. In moving to New York he did not substitute one life for another; rather he kept the best features of the first and added the fresh variety of the second. What

had been a tale of two cities was about to become a tale of three, the new one the story of "an old man who ran away from home and made good";[165] and the third city would provide riches even more rewarding than those of the other two.

CHAPTER THIRTEEN

1908–1910

H IS FIRST FEW WEEKS in New York were among the happiest of
JBY's life. Quinn was at the top of his philanthropic form. He
had paid the tariff on the pictures JBY had brought with him—among them
the oil of WBY he had commissioned for thirty pounds[1]—and treated him
and Lily to a whirlwind of hospitality, being "in the lightest spirits and very
fond of everyone of the name of Yeats."[2] The suite at the Grand Union was
elegant, and the Fords, who provided it free, were ready to take over where
Quinn left off. New York itself was a perpetual and ever changing delight.

Lily was kept busy at the month-long Irish Exhibition at Madison Square
Garden. The work was exhausting, but the goods were sold out at a net profit
of £218, which Lily sent home to Lollie in portions. Across the hall Miss
Gleeson managed her own stall: neither she nor Lily let the other know about
sales. At a luncheon given by Judge Byrne's wife at the Colony Club and
attended by both, Miss Gleeson made critical remarks about her colleague.[3]
Mrs. Annie Smith, mother of Quinn's displaced mistress, told JBY Miss
Gleeson was "the most disagreeable looking woman she ever saw," and Quinn
declared that he couldn't stand her.[4]

While Lily sold goods her father sought commissions. Somehow the instant
success he expected didn't materialize. In mid-January he wrote to Isaac,
"When oh when will the first commission come? I shan't sleep easy till I get my
sickle in the first swath." He was confident time would bring the business in,
and he told Lollie he wouldn't leave New York if he could help it, "because I
am convinced that fortune awaits me here." She surely could not have imag-
ined what his words meant, and he added to their confusion by the carefully
spaced ambiguities of his remarks. "I want very much to stay here," he wrote
her again on the twentieth, "but don't know how it is to be accomplished." Two
days later he added: "What I am going to do I don't know. It all depends. If
commissions come in I stay. I can't bear the thought of leaving New York, bad
as the times are. I feel here I can get lots to do somehow."[5] People failed to
come through with commissions. Despite the many promises made by visiting
Americans in Dublin and stay-at-home Americans in New York, he was sought

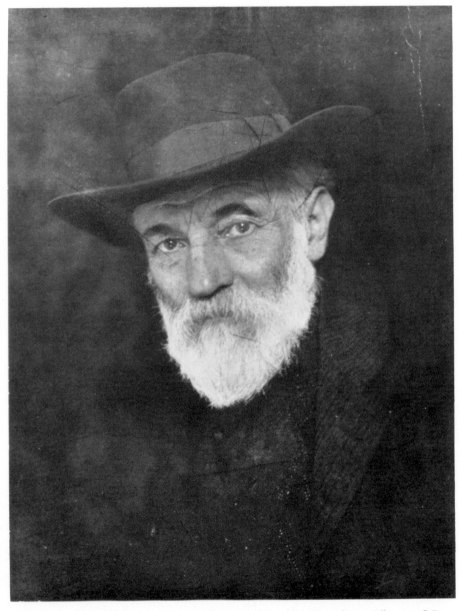

John Butler Yeats, December, 1907. Photograph by Alice Boughton. Library of Congress, Washington, D.C.

for his conversation rather than his painting. By January 13, he had no more than a dubious assurance from Mrs. Ford that she thought she had arranged for six sketches at fifteen dollars each.[6] As usual, he didn't help his own cause: Quinn discovered he was up to his old trick of sketching people for nothing. "Of course if that gets out," Quinn wrote sourly to Florence Farr, "other people will expect to have their sketches made on the same basis."[7] Still in New York there were always prospects. A barrister named Delehanty summarized JBY's situation: "In Dublin it is hopeless insolvency. Here it is hopeful insolvency." "Rather neat, and quite true, I think," Father wrote Willie.[8]

The upshot was that when the Irish Exhibition ended JBY refused to go home, sure that fortune waited around the next corner. He and Lily had to pay their own expenses after January,[9] but Lily decided to stay with him until he became discouraged enough to return. "Whatever happens," she wrote to Lollie, "he will have had his holiday. . . . It will be something gained."[10] She did not expect that the holiday would last fourteen years.

If business was bad, the other joys of New York were enough to make him unwilling to leave. Quinn saw to it that he met interesting people. One day young Francis Hackett and Whidden Grahame held a lunch in his honor at the Players Club with the naturalist John Burroughs in attendance. Quinn watched and listened and kept a record of what went on. He observed that Burroughs "looked at old man Yeats like one fox looking at another," and he made notes of a couple of JBY's anecdotes, of his reminiscences of his early days with Dowden and Nettleship, and of his making it clear to one of the men present that he did not consider the King of England to be his king.[11] People thought of him as another Walt Whitman, JBY told Lollie and Ruth before he had been in the country a week, and he was obviously amused by the comparison. "Papa is very popular here," Lily told the women at Dundrum, "and could be out at gatherings all day and night if he wished."[12] At after-dinner speeches at men's clubs and before Irish organizations he was a spectacular success. In mid-February he lectured at the Sinn Fein Society of New York. Quinn's secretary, Thomas Curtin, took the speech down in shorthand, and it later appeared as a two-column spread "with an appreciative editorial comment" in the *Evening Sun*.[13] With such companionship, such opportunity for good talk, such appreciation of his gifts, why should John Butler Yeats wish to return to the gray skies and minds of Dublin?

Yet he could not remain free of Dublin's problems. In early February the newspapers carried the story that William Butler Yeats was on his way to New York with "the Irish Theatrical Company," and the baffled JBY, Lily, and Quinn trooped to the pier to greet him. They should have been warned by the wording of the news story, which spoke of Yeats as one "who acts with the company in the leading role." It was not Willie Yeats but Willie Fay, accompanied by his wife, his brother Frank, and "a small secessionist group of

players,"[14] who stepped off the ship. Lily and Papa had known of Fay's ultimatum to the directors before they left Dublin but were ignorant of more recent events. Lily's views on her brother's role in the Abbey probably reflected her father's. The dissension had been "a serious thing for the Abbey," she wrote Lollie. "I sometimes wish it was all at an end. Willy is wasting so many valuable years over it and a lot of half-civilized people."[15]

Fay had quit his job with the Abbey after the rejection of his ultimatum, though he still kept his membership in the Irish National Theatre Society. With WBY's agreement, he had signed a contract with Frohman to act in New York and Chicago in Yeats's *The Pot of Broth*, Lady Gregory's *The Rising of the Moon*, and Synge's *Riders to the Sea*. WBY was eager to see how the plays would fare in America and was "in treaty with" Fay to send the rest of the company to join him if they were well received.[16]

Trouble developed almost at once. With Fay were Dudley Digges and Maire Quinn, whom John Quinn distrusted. Quinn was angered to learn that Fay was being paid forty pounds a week while WBY received only a flat thirty shillings for the use of *The Pot of Broth*; and his patience snapped when the marquee of the theatre declared that the players belonged to the Irish National Theatre Company. To his annoyance the newspapers used the terms "Abbey Theatre" and "Irish National Theatre" interchangeably. He objected to Fay's use of the Society's name and demanded that WBY receive thirty shillings a night for the use of the play.[17]

Then word reached New York that Fay was no longer employed at the Abbey, and even Papa, who had always liked and defended Willie Fay, grew disenchanted with him.[18] The Fays, insisting that Frohman was responsible for the use of the company's name, refused to go along with Quinn's demands. Were they not, after all, members of the Irish National Theatre Society and, in the eyes of many, its founders?

But William Butler Yeats held the upper hand. Spurred by Quinn's testy reports, he decided to break the last link with the Fays. On March 18 he wrote Quinn:

We cannot give him [W. G. Fay] plays [for Chicago] as it would only make the misunderstanding deeper. We wired not to give him "new plays" for we knew that his company would only spoil whatever we could give them as they have no woman worth anything and besides we cannot condone the fraud. Tonight a committee of the Irish National Theatre Society will suspend all three Fays from membership so that excuse will be gone.[19]

That night the Society carred out its intention. JBY was sorrowful but at the time thought the punishment just. The Fays wouldn't speak to him or Lily when they met, and they continued to insist that "the jew Frohman forces them to do his bidding." Father told Willie he thought "the Fays have acted treacherously and dishonourably."[20] Home again in Dublin, the Fays vilified Quinn as the cause of their failure in New York—for the performances had

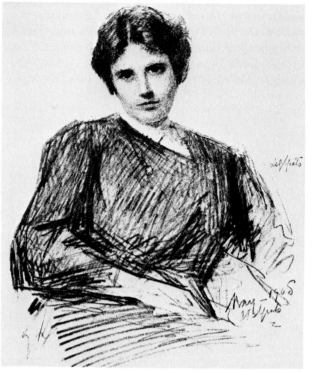

Lily Yeats, May, 1908, New York. Pencil. JBY. Signed and dated by JBY. Autographed by Lily Yeats. Collection: Michael B. Yeats.

not been successful[21]—just as they had "abused Willie in public as well as [in] private" in New York. JBY was morose: "Treacherous people like that seldom succeed. They go on being punished. How they must wish they had never quarreled with the Theatre."[22]

Then another blow fell. Synge's doctors discovered a new growth in his side,[23] and the two men in New York most concerned realized immediately what it meant. Quinn, writing to Willie on June 10, spoke of Synge as "doomed." JBY wrote to his son: "This is terrible news about Synge and I suppose means that he cannot recover. It seems to be the fate of every man who is especially important to Ireland."[24]

Lily enjoyed her extended stay in New York. It was the first long vacation she had had since leaving May Morris in 1894, and it always remained in memory the happiest time of her life. "I would take my visit to America again just as it was, " she told Quinn a decade later. "It was the time fullest of good things in all my life."[25] She shared with her father and Jack "an extraordinary gift for making herself popular." At the Grand Union everyone liked her, from the old ladies in the lobby to the bellboys and chambermaids. The photographer Alice Boughton told Papa that "Lily was her ideal of a beautiful

woman," and another lady spoke of her "dignity and presence." Judge Keogh referred to her constantly as "the most amusing girl." In New York, Father told Willie, she kept on "making friends, finding them in all sorts of unexpected places. Her experiences here have been a sort of university course for her. It is surprising how well she talks sometimes."[26]

Her hope that Papa would tire of New York was fruitless. "I am very unwilling to stay behind," he wrote Clare Marsh in early May, "but at the same time very unwilling to leave this." Next day he expressed his uncertainty to Willie: "I do not know whether to stay or go. [Lily] sees I am *making* a success (it is not altogether *made*, since I am only getting 15 dollars—£3—for each sketch) yet wants me to go back with her, thinks I ought to stay but that she ought to be with me. . . . To leave New York is to leave a huge fair where at any moment I might meet with some huge bit of luck."[27] To put pressure on him Lily made a reservation for both of them for a sailing on May 21. When her scheme didn't work she gave herself another two weeks, then, unable to persuade him, sailed without him on June 6.

It was a grim day in Papa's life, and Lily's. They would never see each other again. Some "*inner voice*" told JBY the separation would be long. When he was eighty years old, he insisted that only the slightest additional pressure was required to make him join her. "My coming was a miracle of folly judged by human standards. . . . I longed for someone to say to me that I should go away with you. But no one spoke, and it was again Providence that ordered the silence." He never forgot her departure, mentioning it almost every year on its anniversary. It was the one day in his life he remembered more clearly than any other.[28]

There was an unexpected compensation, for now Lily took to writing letters to her father regularly, an average of one a week. For the next fourteen years she poured out a stream of fascinatingly readable letters to Papa, which he took delight in reading aloud to his American friends. Quinn always asked JBY to be sure to save Lily's letters for him to read. Her memories of New York, though written years afterward, recall people and events vividly, as if the words were taken from a diary. She wrote in 1917 about a famous fellow-guest at the Grand Union. "I remember Peary at the hotel. I will never forget his voice. I heard it every morning ringing down the passage, 'The papers and my mail.' Then the door slammed. I used to think then that his wife might be the nearest thing to the North Pole he could ever get. You remember her, tall and cold and grim and handsome." She also recalled years later a bibulous evening at Quinn's when Townsend Walsh overindulged. "Yes, I remember Mr. Walsh. He was writing his book on Boucicault between drinks." Later that evening Walsh "was trying to light his cigar, never getting his match within a foot of it." There was a new confidence and assurance in her writing. "*I* always knew how well she could talk and how witty she was," Papa told Isaac. "After her visit to

America she herself had this knowledge, so that she is no longer afraid of anyone."[29]

One of the causes of her departure from New York was the news out of Dublin that Miss Gleeson was threatening to sue the sisters for some imagined violation of their agreement. While Lily was on her way home Papa received a letter from Lollie detailing Miss Gleeson's bullying. He urged her not to shrink from the battle. "If you keep up the fight with spirit it will make your friends think all the better of you, and you must not mind being nervous."[30] The details of the disagreement have been lost, but the differences were resolved by a complete break, from which Miss Gleeson seems to have emerged with the better part of the bargain.[31] The sisters allowed Miss Gleeson the right to the name "Dun Emer," found a house in Dundrum near Gurteen Dhas, and installed themselves there under a new designation, "The Cuala Industries," the name being taken from that of the old barony in which the house stood.[32] The last book published over the Dun Emer imprint was W. B. Yeats's *Discoveries*, dated December 15, 1907. The final publication was the first number of a new series called *Broadsides*, which appeared in June, 1908. The second number, in July, was issued by Cuala. The first Cuala book was *Poetry and Ireland*, by W. B. Yeats and Lionel Johnson, published December 1, 1908. The type face, paper, and binding of the volume were identical in all respects to those that bore the Dun Emer imprint. Only the name of the Press was different.

Papa learned of the settlement but wanted to know more about details. "Did she shake hands? Did she get red in the face? Was she flurried? . . . Did she furtively look around?" He advised them to be discreet in public about the dispute, diplomatically addressing the daughters jointly:

> Miss Gleeson will sink in an ocean of general contempt, firing broadsides of lies as she goes down. She has spirit enough for that. She is not a good Catholic—too lazy for that—so the Priests won't trouble about her. The less you say against her the better. If anyone became her champion it would be because you were against her.[33]

And so at last the sisters were free of the "Mother Abbess." Quinn observed that it must satisfy them not to have to note at the end of every book that it was printed "In the house of Evelyn Gleeson." By September Lily could report that they saw no more "of the Gleeson people."[34] From now on their only adversary in the Industries would be William Butler Yeats.

When JBY and Lily overstayed their time at the Grand Union, the Fords had gently eased them out of the free suite into smaller adjoining rooms, charging them a dollar a day each. Papa's room now became his home, and if it was sparsely furnished at least it was his own and did not have to be shared with others. At Gurteen Dhas he had had to come to dinner at a certain time,[35] contribute to the general upkeep, and conform to the rules necessary in any domestic establishment. In New York he could come and go as he pleased. Of

course it was a lonely freedom. He protested to Willie that *"living alone* in a vast solitude like New York is not just the form of it I like,"[36] yet he gave no indication over the next fourteen years that he seriously considered exchanging it for what he had left behind. He had plenty of time to write letters.[37] He could indulge his amateur interest in prophesying, spurred by Lily's visions; he consulted a Mrs. Beattie and other fortune-tellers regularly and peppered his letters with interpretations of signs and dreams.[38] He could read at leisure from the volumes of Keats's and Lamb's letters he had brought with him. He could accept or decline invitations. He could wander about as the spirit moved him. Once while a guest at Sheepshead Bay, he began walking and ended up at Coney Island, where he bought a ticket for a roller-coaster ride called "The Rocky Road to Dublin."[39] On another occasion he set out for Riverside Drive to work on an essay in the open air. At 134th Street he found a ferry about to cross the Hudson River, took it to the other side, then hopped on a trolley car and ended up in Paterson, New Jersey. He took a different trolley back and arrived home at six o'clock, having won the day for his soul while losing it for his essay. When he returned to the Grand Union, nobody noticed his lateness, and nobody had been inconvenienced by his absence. Exile had made him a free person for the first time in his life. Over the next fourteen years he was to make many such brief impulsive pilgrimages—though usually in Manhattan—wandering wherever his fancy took him. Every day without fail, unless bad weather or illness intervened, he walked for one or two hours.

Yet in one familiar way he was still not free. The bleak fact remained that he had little money and no more ability to accumulate it than he had had in London or Dublin. Few people realized he was a painter. John Quinn's apartment walls constituted the only museum in the country where his works were hung. He was principally regarded as the father of the poet, and he readily admitted to Willie that his "Open Sesame" came from that relationship, though by early May he thought he had "a little position" of his own.[40] He was an old man of sixty-eight when he landed in America. The "spells" he had suffered in Dublin still troubled him; once he made the mistake of telling one of his young friends about them, then quickly fired off a letter begging him not to mention the subject to anyone.[41] "It is too bad that Mr. Yeats is not a few years younger," Quinn wrote Florence Farr. "He is a man with a young heart in an aging body." Quinn did not hesitate to speak forthrightly to Lily about "the hopelessness of [his] making a career here in a new country at his age," although he wouldn't say so to her father, who was "perpetually hopeful and seems to be always on the eve of a great success."[42] Yet JBY failed to take advantage of opportunities. When he and Lily arrived in America, the nation's tongues were wagging about a spectacular murder trial that combined a heady mix of beauty, sex, and money among the socially prominent. Harry K. Thaw, a rich young heir of dubious mental stability, had murdered Stanford White, the gifted architect, in the rooftop restaurant of Madison Square Garden.

White had seduced Evelyn Nesbit, one of the beauties of New York, while she was still unmarried. Thaw, who became her husband, wormed the secret out of her, then, insanely jealous, shot and killed White in cold blood in full view of the other diners. At the trial his lawyers skilfully pleaded insanity and saved his life; but even his immense wealth could not save him from long imprisonment.

Quinn, friend of New York judges, arranged for JBY to have a special seat at the end of the jury box during the trial, but when the big day came, JBY simply wandered into the courtroom and placidly took a seat at the rear, where the court attendant put him, and sketched the participants from a distance. He might have sold the sketches for a goodly sum; but there is no record of his having done so, and the sketches have disappeared.[43]

The result of his lack of reputation, his age, and his inability to manage was that during the year he received only two important commissions, one from Quinn, the second—through Quinn—from Dorothy Coates. His reports on his finances echo those he had written to Uncle Matt twenty and thirty years earlier.[44] When he wrote to Lily in June, "I have a little cash, enough to carry on," he unwittingly provided an accurate summary of his average condition over the next fourteen years. Sometimes he might be as much as a hundred dollars ahead momentarily; sometimes, for longer periods, he might be a hundred dollars or more behind. Usually he simply had "a little cash, enough to carry on." Yet at the end of the year he wrote cheerfully to Lily: "So you see I am full of *hopes*—plenty of birds in the bush and all in full song. If I could only put some salt on their tails. But all in good time."[45]

John Quinn was his solid anchor to windward. Through the changing weather of fourteen years JBY always knew Quinn was not far away, always available when needed. "With him at hand it is impossible to lose confidence," he wrote Willie.[46] Yet Quinn from the beginning often sent his old friend into deep fits of depression and shaken nerves. The reasons are not far to seek. As B. L. Reid, Quinn's biographer, puts it: "Two natures so vivid and so different were bound to clash, and they did so frequently, with no fundamental damage to their mutual respect. Mr. Yeats called Quinn 'the crossest man in the world and the kindest.'" "Like God Almighty," Papa told Lily, "he is crossest with those he likes best."[47] Their natures were indeed different. JBY was easygoing, inclined to live and let live, with one eye opened to the good qualities in people, the other closed to the bad. Quinn was kindly and generous by nature, but he was quick to see the worst in others or to assume it. JBY endured people with commonplace minds and sometimes even enjoyed them. Quinn was intolerant of the stupid, the foolish, and the pushy, those who didn't fit into the pattern of the ideal world he had created in his own imagination years before. "Poor Quinn," mused the impecunious JBY of his wealthy and successful friend, "bewildered in a world that will do things he can't tolerate."[48]

Inevitably there was much of the finger-wagging teacher in Quinn, correctly identified by Reid as artist *manqué*, a man who had missed his calling. However

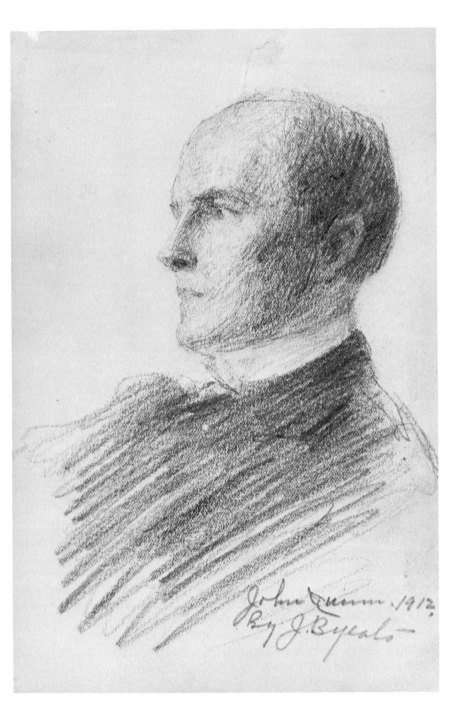

John Quinn, 1912. Pencil. JBY. Identification in the hand of Jeanne R. Foster.
Collection: Hirshhorn Museum and Sculpture Garden, Smithsonian Institution. By
permission.

great or trivial the work of his friends might be, Quinn was sure he could teach them to do it better. Before Lily's departure Quinn commissioned a portrait of himself from JBY for $150. Instead of limiting himself to the two or three sittings agreed on,[49] the old man kept returning for more than a dozen. Every Sunday he painted Quinn from eleven to one, then after lunch from two to five. "It was tiresome work," Quinn wrote testily to Florence Farr Emery. As in his Dublin studio, old Yeats kept a long distance between easel and subject and repeatedly made the long walk from the one to the other, discoursing the while on whatever vagrant thoughts seized his fancy, waving his brush about as he expostulated. Quinn revolted. "I kept telling him that I really ought to sit closer to him and the painting," he told Mrs. Emery. JBY gave in "and made more progress in two hours than he had made at the last four sittings the other way."[50] Quinn wasn't aware that another three weeks would pass before the portrait was declared finished. One of the problems facing the artist in this case was Quinn himself, slender and totally bald, who offered little to work with. "His face is made up with about three lines," Papa wrote Lollie years later, "and it is hard to draw anything and have only three lines with which to do it."[51]

Then Dorothy Coates ordered a portrait of herself in oils for one hundred dollars. She had just returned from Paris, where she had met and talked with William Butler Yeats,[52] and was now re-established in her suite at the Manhattan Square Hotel on West Seventy-seventh Street, within convenient distance of Quinn's apartment on Central Park West. Whether she gave him the commission "as a stroke to please Quinn or to please Willie I don't know," Papa confided to the girls. Miss Coates gave him only ten days for the job, as she had to go away. He was delighted that the painting would be done in her apartment, where Quinn couldn't criticize, but on the first day he had scarcely begun when Quinn entered. Instead of caviling, as JBY had expected, Quinn sat looking at the canvas and said, "I came to criticize and I remain to praise. That is my *amende honorable*." Soon Quinn liked the portrait as it was and wanted JBY to stop working on it. When the old man disregarded him, he badgered JBY constantly to change it to conform to his own ideas. Finally JBY put his foot down "very firmly" and demanded that Quinn leave. Miss Coates told him Quinn was "quite hurt" to learn that JBY didn't want him present during the sittings. Papa protested to Lily, "It is extraordinary that he should think I or anybody else should like to have anyone in the room who wants everything altered and does this the whole time. I should not have endured as much as I have done from anybody but Quinn."[53]

Miss Coates paid JBY his hundred dollars on August 14 and he signed the portrait, but he thought finishing touches were needed and began to make changes. Quinn, present at one of the sessions, "almost took the brush" out of JBY's hands. The painter "lost his temper" and charged he had never suffered "such treatment from anyone." Quinn left "in high dudgeon," announcing

that he would never again "take any interest in the portrait." "He is really a good deal of the backwoodsman," Papa told Lily, "and as no one has ever contradicted or opposed him, he does not attempt to control himself."[54] He wrote Quinn a long letter defending the same right his son had defended in Dublin during the *Playboy* controversy, the right of the artist to express himself in his own way. He complained to Lollie that Quinn and Miss Coates were never satisfied with the portrait "in its actual state," but always preferred "*what it had been.*"[55]

Papa neglected to tell Lily that he had been up to his old tricks. Quinn wrote a long letter in exasperation to Lily in December:

Finally it came to a point where [Miss Coates] was pleased with it and she had him stop and he signed it. . . . Then he coaxed her to give him "another hour or two at the outside," merely to "touch up the shoulders," and she said she would sit if he promised he wouldn't touch the head or hair or face or background. Well, he went at it and in an hour he had succeeded in ruining the picture. . . . Then she had to give him two or three more afternoons to try and bring it back to where it was, but he never succeeded in doing this and (*confidentially*) the picture was ruined beyond any repair.[56]

An understanding Lily replied:

No one knows Papa better than I do, and no one has suffered more than I have over portraits of myself ruined and seeing portraits of others ruined, and "bad blood" caused between him and his sitters, so I quite understand the story of Miss Coates's portrait. It is an old story and a painful one. My heart sinks whenever I hear of an order for an oil portrait. All this of course is in strict confidence. Papa would be very hurt if he knew I even had these *thoughts* of him, more than hurt if he knew I said them to you.[57]

The old man's habits may have cost him much. In mid-June, Quinn had told JBY he might ask President Theodore Roosevelt to sit for a portrait, but after the disasters of his own and Miss Coates's portraits he never raised the subject again.[58] Henceforth Quinn was wary of recommending JBY to others as a portrait painter in oils, suggesting pencil portraits instead, which were not so expensive and which had to be done at a single sitting.

The two men patched up their differences, as they genuinely liked each other. But the adventures of their first year together established the limits within which they worked out the details of their relationship. As long as Quinn didn't try to lecture the old man and JBY stayed clear of painting portraits in Quinn's presence, the two got along reasonably well, even, considering Quinn's short temper and JBY's stubborn imperturbability, remarkably so.

Mrs. Ford, from whom JBY had expected so much, proved a disappointment, finding him only small commissions for a sketch now and then. He wondered whether she was really sincere. On one occasion when he had been staying at her home he learned that two doctors were arriving for dinner. To him they were prospective clients; but Mrs. Ford had him escorted back to

Dinner at Delmonico's, June 24, 1908. John Butler Yeats is in left foreground, John Quinn at center background (with bald head). Collection: Michael B. Yeats.

town before they came. "Why the deuce I am not asked to stay and meet these people I cannot say," he lamented to his daughters.[59] From the Fords he learned much about American life. There were three children: Ellsworth, training to be a gentleman farmer; Lauren, the daughter, who had talent in drawing and wanted to be an artist; and Hobart, a boy frequently underfoot. From their behavior JBY concluded that in America children controlled the parents, a point he often made in his conversation. The Fords were enormously wealthy, having more than the Grand Union behind them. Simeon Ford, Julia's husband, had once received his wife's permission to speculate with a sixty-thousand-dollar windfall and lost it all in one day on Wall Street. He was aware of his wife's penchant for collecting famous people but refused to join in the sport. Simeon once said of his wife, "If you don't want to know Julia and she likes you, God help you." Since her conversation, which may

have reflected her intelligence, was not very interesting, Quinn naturally despised her. JBY found her "stingy" but concluded that he "liked" her and that the liking was "quite real and apart from a grateful sense of her goodness."[60] Once at a luncheon JBY read out to the guests two letters from Lily and one from Willie. Lily's were far more interesting, but Mrs. Ford paid little attention to them, waiting impatiently for Willie's, "not from any bad motive of course," Papa wrote mischievously to Lily, "only she does like a real famous poet."[61]

JBY's reputation as speaker continued to overshadow his achievement as painter. He boasted to those at Gurteen Dhas that old Rosenthal, the librarian at the Astor Library and a good friend of Turgenev's and Tolstoi's, told him after his speech at the Vagabond Club that "I had a second time hit the nail on the head, the first time being when I spoke before."[62] In late June, Quinn gave a dinner at Delmonico's for twenty-three guests, seven of them Justices of the New York State Supreme Court, and John Butler Yeats delivered the main address, an impromptu one on his impressions of America. One of the judges, the "scholarly and distinguished" William Jay Gaynor, thereupon made "a long and eloquent speech" on the subject of "After-dinner Speaking," in which he proclaimed that Americans had never been able to equal those from "the other side," and, JBY told Willie triumphantly, "*he used me as his example* and called my speech 'a gem of after-dinner speaking.'"[63] Gaynor was himself a man of charm, polish, and political skill who would soon become mayor of New York.

Unfortunately, the much-sought-after speaker received no payment for his talks beyond a free meal, the honor alone being considered sufficient by the wealthy men who managed such affairs. Had JBY found himself an agent he might have been able to profit handsomely, but what he was unable to do in London and Dublin he could not do in New York. He took to writing, hoping to augment his income, but aside from newspaper accounts of speeches nothing of his was published in 1908.

He moved from club to club and restaurant to restaurant with John Quinn, who went out of his way to keep the old man happy during his supposedly brief visit. In June they saw Edward Sothern the actor sitting at another table and joined him for cigars. JBY found him "very nice and talkative." Sothern considered himself "an American actor" and "talked about the stage in America and wished for more serious plays."[64] A month later, when Miss Coates accompanied them, they met Finley Peter Dunne, the Irish-American humorist who created "Mr. Dooley." Fortunately Quinn had to take Miss Coates home, and Dunne then invited JBY to his club for some after-hours talk. They sat till half-past one in the morning in the "very fashionable and select club," where the waiters were "gorgeously and elaborately got up in gold lace." Dunne told JBY he had read all of Katharine Tynan's poetry and was

"gratified" to hear she read him. He was "a good Catholic," Papa told Lily and Lollie, "the simplest, nicest fellow imaginable, extraordinarily naive, with an instictive modesty like a nicely brought up little boy." [65]

Gradually John Butler Yeats moved away from the clubs and the great homes in the suburbs and found his own society. One of his new friends was a writer, Frederick A. King, later the literary editor of the *Literary Digest.* King took JBY to the French section on Twenty-ninth Street between Eighth and Ninth Avenues where there were restaurants and boardinghouses, one of them, at 317 West Twenty-ninth Street, run by three Breton sisters named Petitpas. The neighborhood was a center of artists and writers. JBY found the French restaurants "cheaper" and more "sociable" than the hotel.[66] He soon came to spend more evenings at Twenty-ninth Street than at the Grand Union, five blocks east and thirteen blocks north.

When he and Lily first arrived, Quinn had brought them together with two of Willie's old schoolmates from the Erasmus Smith High School in Dublin, Frederick J. Gregg and Charles Johnston, the chess-playing companion with whom Willie had rowed to Ireland's Eye. Gregg was dour and taciturn, Johnston talkative and outgoing. Lily said of them, "Gregg has something to say but does not always say it. . . . Charlie has very little to say but says it at great length." [67] He also saw Charles Fitzgerald, grandson of old Dr. Fitzgerald of Dublin, and he met Miss Eulabee Dix, a painter of miniatures. In that year also a young man from Harvard, Van Wyck Brooks, sought out JBY at the Grand Union to begin a friendship of great consequence to the younger man;[68] in the circle of artists on the West Side JBY also met John Sloan, a young man of Jack's age who with his wife was to become his refuge and strength.[69]

His friendships with all these people were to ripen later. During 1908 he gradually moved in spirit toward the West Side while still corporeally anchored to the Grand Union. At a Twenty-ninth Street restaurant he met a young lady known on both sides of the city. Isadora Duncan, the daring young dancer who was revolutionizing her art, became enchanted at the old man's talk, suggested he might do a sketch of her, and then asked him to accompany her one day along with the young man who was her escort. He was inordinately proud. "I have just been walking down Broadway, *Miss Isadora Duncan leaning on my arm—fact, I assure you,*" he wrote Quinn, and at the foot of the letter he drew a sketch of himself and the dancer.[70] Quinn was unimpressed; he had already made up his mind that Miss Duncan had "beefy limbs" and danced "like a cow." Disregarding Quinn's objections, JBY attended one of her performances as her guest.[71]

Another acquaintance JBY would have preferred not to make in New York was the mosquito, about which he wrote dozens of amusing letters. Virtually unknown in Dublin and London, the mosquito was in New York the "millionfold Satan who pollutes every Eden." [72] Its bites left him with a fever, hands

and feet "swollen and hot and so itchy." His knuckles "had become dimples" and his ankles so "swollen" that his stockings "were too tight." "These things are a pest," he declared to Isaac, "and Beelzebub is their God. A single bite is enough to make me miserable for days." At the Fords' in Rye, where screens were not used, he went to bed early with the windows closed. He described one experience to Lollie. "I was busy till after one o'clock killing the brutes. I must have slain about four dozen. At first I used to miss them, but with practice I grew clever. Of course I shut all the windows. This morning on waking I found one that had escaped me, but he did not escape finally." A few nights later he was tricked by a closed curtain which concealed an open window, through which legions of the whining biters invaded his sanctuary. "I took my towel and slew the wretches when they walked on their long stilts on the ceiling. It took me half an hour." [73]

Safe behind the wall of the Atlantic, JBY increased his exhortations to Willie, urging him, among other things, to find his "destiny" in America. "You have a great position here. The ladies (the next Epoch in America belongs to them) meet together to study *Ideas of Good and Evil*. They go through it as if it was an Act of Parliament, where every monosyllable is important." When he heard WBY was writing a drama called *The Player Queen*, he mentioned again some of his misgivings about his son's approach. He thought the new work might be "a great play," but added: "You have found yourself and found your public in some of your plays, but not *quite triumphantly*." When he saw his chance he repeated his attacks on his son's Nietzscheanism: "I have long thought your idea of the superman quite mistaken. The true superman is such as Chas Lamb, Coleridge, Keats, and the Elizabethans who were a whole galaxy of true energies, in unforced possession of the true devotion to something greater than the individual." [74]

Willie was slow to acknowledge his father's communications, although he could write amusing letters when he wanted to. [75] Father groped for responses, wondering whether his handwriting, grown small and cramped, might be a bar. "I hope you will manage to read this," he wrote in one letter. "I am always afraid you don't read my letters, and this a little damps my letter-writing enthusiasm." [76] There was no reply. Later Father sent him two short stories for comment. After a long period without a response, he wrote Willie crossly: "I fear your not writing means that you don't care for my stories (possibly condemned unread). At any rate I should be much obliged if you would put them into a large envelope and send them back." Willie, however, had already sent a letter saying he had read Father's "story." "It has a charming idea, but I never feel your stories are as good as your essays." [77] The words only increased his father's fury. "You don't give me any clue as to which story of mine you read," he wrote coldly. "There were two. I am very sorry that I sent them, but I shall now be very much obliged if you will send them back to me as soon as possible." [78] A week later he was still boiling. "Willie poo-poohed" the story, he

wrote Lollie, "probably never read it, only 'glanced' at it. Besides I have long
known him to be a quite incompetent critic, though he writes so well on the
principles of criticism."[79] When *The Collected Works* and the new Cuala volume,
Poetry and Ireland, were about to appear, JBY wrote Lily, "I am watching for
reviews on Willie. I wonder does he know how many enemies he makes. I
fancy his book will arouse the fire of all these. Probably he will be very proud of
making these enemies, but it is not through any good or estimable qualities
that he makes these enemies, but the contrary." Remembering the past, he
added sardonically, "On this point Lady Gregory is no help to him."[80]

Lily hoped that by the end of the summer Papa would have had his fill of
New York. "And when do you come back to your family and hearth? Your
armchair and lamps are there waiting, and the Dublin papers full of the deaths
of Priests and the London papers crammed full of murders and motor
accidents all ready for you to read."[81] George Russell agreed with Quinn "that
JBY is altogether past the time for any new adventures in strange countries"
and told him that Lily and Lollie wanted "their 'Pilgrim Father' " home and
were "alarmed by his long absence." Russell suggested that Lily and Lollie send
a cable reading: "Family all dying. Come to receive last messages." The
daughters assured Russell he wouldn't come home for that.[82]

A rumor spread—originally from Helen Laird in Dublin to Willie, then to
Maud Gonne, then to Miss Coates, who personally delivered it to JBY—that
the old artist had found "a rich American widow" he planned to marry. JBY
denied the flattering impeachment. "So far I have not met the widow. I have
met widows but none that were rich."[83] In September he compared his
condition to that of a ship. "I am still afloat," he told Willie, "though with
damaged rigging. Quinn like a good storm tug has stood by all the time in a
sort of grim faithfulness." He liked the metaphor so much that he repeated
and embellished it in November: "I feel like a stranded ship," he wrote Quinn,
"so far up the beach that the ordinary tides don't stir her, but which a spring
tide is now reaching, so that hope stirs in her old timbers."[84]

The tide would sweep him to a fresh voyage with Ulyssean companions to
seek a newer world. New York, as Van Wyck Brooks wrote in retrospect, was
"on the verge" of a renaissance, "an American coming-of-age, an escape" from
"colonial dependence on England."[85] Having stirred the pot of broth in his
own country, the self-exiled painter was about to watch new ingredients come
to a boil in his adopted land, but a land in which he would always feel himself a
foster child. "I have never taken root here, or even made an approach to it," he
told Isaac years later. "Always I have been a stranger among strangers." Yet
only perhaps in that relationship could he enjoy "the repose of a complete
solitude."[86]

Occasionally JBY got direct news of his old haunts. Emery Walker's daugh-
ter Dolly, passing through New York in early 1909, told him of May Morris,

whose temper was "as bad as ever," so that Walker was "often afraid to go and see her on business."[87] Most news of Dublin, however, came in Lily's letters. In late March she told him that John Millington Synge had died on the twenty-fourth. The event came as a surprise, even to his doctors. "At four o'clock in the morning he said to his nurse: 'It is not good fighting death any longer,' turned on his side and died." Lily told Papa they thought Synge "would have lived in agony until Christmas." Instead he died unexpectedly without having reached the stage of severe suffering. He had asked Molly Allgood to send WBY in the next day to discuss his serving as literary executor, but the message came too late. "They think it must have been a clot of blood that ended it all so suddenly and so fortunately. He was spared the horrible suffering." When Lily first wrote (March 28) she had not known the cause of death except that it was "*not cancer*." A few days later she met Oliver St. John Gogarty and learned the truth. "He was in the hospital with appendicitis at the same time as Mr. Synge and it was cancer, but the dreadful name was never given to the disease in case he would hear it. Gogarty saw him and said that he cross questioned him as a doctor about his illness in a way that made him very sorry he knew."[88]

The funeral was unusually depressing. Except for "some two or three," as Willie put it to Lady Gregory, those who attended were "enemies or conventional images of gloom." The Abbey players were there. At the entrance to Mount Jerome Cemetery they waited for the Synge family, "a strange rigid people," Lily wrote, who did not seem "to recognize his genius at all." Everyone was shaken, even Joseph Holloway, who wrote: "Poor Synge, he was a gentle and lovable man personally and not at all like his works." After the burial he noted WBY's behavior, no longer showy, and described it without sarcastic commentary: "We left Yeats wandering about the tombs that surrounded the recently filled grave."[89]

The evening after the funeral Lily went into Dublin to see Willie, who wanted to talk to her. "He feels it deeply and says he now has no near friend left." Some months earlier he had heard that Arthur Symons had gone mad and would soon die[90] —a false prognosis, as Symons lived till 1945—and "now this," wrote Lily. The two of them went to the Abbey and found the company, with Molly Allgood, sitting in the Green Room "in silence," the men gathered in a group, "opposite them in the big chair the poor girl, shrunken, broken, and exhausted, but very brave and calm, her sister Sara by her, her face blotted by tears." Molly asked Lily "in a whisper" what she should do about all the letters she had received, and Lily offered to help her, going next morning to the Nassau, where she wrote letters which Molly "just copied," being "unable to think or speak."[91]

Through oversight, Quinn was not immediately informed of Synge's death, but he moved quickly to preserve his memory. He asked JBY to write an essay of appreciation, and to his surprise the old man completed the assignment at once. Quinn arranged for its publication in the *Evening Sun* of April 2. He was

pleased with JBY's interpretation of Synge as a victim of Ireland's follies (at that time Papa had been assured by Lily that cancer was not the cause of death). With his usual self-effacement, JBY made little mention of his own friendship with Synge but confined the essay to the personality of his subject. Synge loved the "peasants of the West of Ireland," he wrote. "And so highly did he esteem these poor people that he himself has told me he would rather live with them than in the best hotel." He went on to describe the nature of Synge's contribution to an understanding of the Irish.

> Synge found the people too full of paganism and Christianity of high poetical vitality—an island of sinners as well as of saints; also an island of poets. His plays revealed this manifold existence but because it was not the island of Carleton and priestly tradition all Dublin, Protestant and Catholic, went mad with riot and noise. They said the Faith was insulted and Ireland was ashamed. In holes and corners and in whispered colloquies these disturbers would admit that Synge's picture was a true rendering, that the facts were true but should not be revealed to the world.[92]

In America JBY could express more forcefully the views he had put in milder language in Dublin. He saw in Synge's experience the Irish preference for comfortable delusion rather than for the kind of unblinking self-analysis that might bring the freedom the Irish people professed to covet. In Synge's death he saw also another of his country's afflictions: "It is Ireland's luck always to lose her best men just when they are most needed."[93]

Quinn's anger took the form of the Shelleyan fallacy about Keats: he preferred to believe a national hatred of genius had killed Synge rather than the more mundane but unconquerable cancer. He offered his two JBY drawings of Synge to the National Gallery, along with a sum of money, hoping the Irish would commission a bust of him for the Gallery. He did his part for Synge's estate by republishing in America, to protect the copyright, the *Poems and Translations* which had just been issued by Cuala. "Send over all the news you can about Synge," Papa pleaded with Lily. "Quinn is always asking for particulars. He thinks people in Ireland don't care, and that he alone cares."[94]

Synge's death was not the only unhappy news out of Dublin. The feud between the two theatres was still simmering. When attendance at the Abbey began to decline after a long period of full houses,[95] the opposition pounced. On May 8, 1909, an article entitled "Dramatic Rivalry" appeared in Arthur Griffith's *Sinn Fein*. It contained an unusually clear and strong attack on W. B. Yeats, who was held up as the chief villain in the theatrical schism. What disturbed the Yeats family even more than the virulence of the assault was the authorship of it: for it was written by one of JBY's most devoted admirers and one of Lily's closest friends, Susan Mitchell, the onetime boarder at 3 Blenheim Road. "Mr. Yeats, you have been a fool," she wrote, accusing him of "allowing" Maire nic Shiubhlaigh to "get away" from the Abbey, and of fomenting the unnecessary rivalry between the two theatres, which should instead be work-

ing together against the common enemy, the commercial theatre. Observing that the Theatre of Ireland now played before packed houses while the Abbey had empty seats, she declared: "It is for you, Mr. Yeats, to make the next move if you can. Let it be a worthy move." She ended by attacking WBY's talents as a playwright and virtually invited his rejection of her advice.

Oh, Yeats, Yeats! with your broken-kneed heroes and barging heroines, even your drawing room Deirdre, tender, appealing, complex as she was, did not save you, who with all your talk of tradition, have only succeeded in producing in Kiltartan French and pidgin-English some few passably competent comic actors and actresses.

She counseled him: "Pull yourself together, Man of Genius, save your theatre. There is yet a little time."[96]

Lily was so angry that Miss Mitchell thought it wise to avoid her and soon wrote a letter saying that she was "really and genuinely sorry" to have offended the family. Lily reluctantly accepted the contrition but wrote Papa, "I think she is at bottom quite proud of her beastly article."[97] JBY was dismayed by Susan's treachery but convinced she had been pressed into service indirectly by the scheming George Moore, whom Miss Mitchell despised—"the big elderly blackguard who lives at Ely Place," JBY called him—through his "general utility man" George Russell, whom she admired. "There is a good deal of the serpent in these mystics," JBY told Lollie. Yet he was sure the attack would backfire since it was so outrageous. "It is very bad and low and treacherous. Fortunately it is so flagrantly lying as to defeat in some degree its own wicked, wantonly wicked purpose. One should lie with discretion."[98] He was so sure Russell had put Susan up to it that he questioned her directly on the subject; she declined to answer.[99] To Willie he wrote unflattering remarks about Russell's subservience to Moore:

Russell thinks G Moore a great man because, being from the North, he admires noblemen and he thinks Moore a sort of real nobleman, and because he is a successful writer of novels. He also admires Moore because Moore really has a poor opinion of Russell. Russell must either boss or be bossed. And then Russell is lonely. He has no friends, and he is exasperated against things, and so he likes to wade into the black puddle of the Moore cesspool, and to throw mud or get others to do it.

Yet JBY was aware that Russell's malice was not entirely unmotivated. "You have offended Russell's vanity, I fancy, more than once," he reminded Willie, "and though there is a Real Russell, which is magnanimous, one must not forget that Russell is a prophet and the centre of a circle, and therefore intensely *self-appreciative*." He added dryly: "Perhaps you have been too English in your methods."[100]

Such hints did little good. Others were forced into disliking Willie even when they didn't want to. Father observed that although Charles Johnston had been singing Willie's praises in New York, Willie had written him a letter

that was "rather laconic and cold."[101] Father was still worried too about Willie's relationship with Jack. "I would like to know about *Jack and Willie*," he wrote Lily in August, "though I don't suppose things there will ever alter. I am perfectly certain Willie is very fond of Jack and I suppose Jack has an affection for Willie. Of course Willie irritates Jack, whereas Jack never irritates anyone." In late summer, reverting to Miss Mitchell's article, Papa reminded Lily, "Willie from the time he was a baby was always doing and saying the wrong thing, and was only forgiven by the very few people who took the trouble to understand and like him." When Lily told Papa of her long, warm talk with Willie after Synge's death, he commented: "People say Willie is not human, but these people have not had a *tête-à-tête* with him."[102]

Willie did not take Miss Mitchell's advice, but the Abbey soon regained its audience. Then Willie's thoughtlessness and insensitivity erupted in a new and unlikely place. In early July JBY received an angry letter from Quinn with a "furious but veiled account" of rumors he had heard were circulating in Dublin. The old man, reading between the lines, inferred correctly that the unnamed target of Quinn's attack was William Butler Yeats. When Dorothy Coates had visited Paris, she and Willie had become warm friends, and Willie had apparently carried his tales of conquest to Dublin. Miss Coates gave a different, self-serving account to Quinn, depicting Willie as the aggressor and would-be seducer and herself as a stauch pillar of mistressly fidelity.[103] Even though the affair developed no further—Ezra Pound recalled that Willie received a letter from Miss Coates from Italy in which she wrote that she "was looking across the Bay of Naples at Vesuvius, and both were burning"[104]—the upshot was that Quinn accused Willie of trying to encroach upon his territory, which he had well and truly paid for.

John Butler Yeats tried to calm Quinn, urging him to pay no attention to "idle and excitable tongues." Without mentioning names, he counseled: "Forgive your enemies, and, which is harder, forgive your friends." The letter did no good; Quinn and WBY did not speak to each other again for five years.[105]

Thus Quinn joined the expanding group of those who for one reason or another, and with varying degrees of intensity, disliked William Butler Yeats while loving his father. Quinn never allowed his quarrel with Willie to sour his relationship with old Mr. Yeats or with the sisters. To Quinn's great credit he also never allowed his feelings to damp his ardor for WBY's works. As Quinn's biographer puts it, "Yeats and his poems were separable matters." On his brief visit to Dublin that year Quinn avoided Coole, where the poet and "Aunt Augusta" were collaborating.[106] But he made a point of visiting the daughters at Gurteen Dhas, where he was one of a party including Russell, Nathanial Hone, Jack Yeats, Sarah Purser, and Sir Walter Armstrong.[107] On his return to New York he conspicuously invited JBY to an evening at the Hippodrome with his sister Mrs. Julia Anderson and Mrs. Annie Smith. "Quinn was very nice,"

Papa told Lily, "and when he is nice he beats everyone because he is confiding and trusting. He likes to trust, but if he is betrayed, God help you. It is a despot's way."[108]

In January, 1909, Quinn had offered to take JBY with him on his trip to Europe, promising payment of his passage and an allowance of fifteen dollars a week for four weeks. The offer was viewed by JBY as an "ultimatum,"[109] but he slid out from under it. "Of course, I accept your offer," he replied to Quinn, then continued with a long and disarming sequel about his growing reputation in New York and other matters. By the end of the letter Quinn's offer lay awash in a sea of irrelevancies,[110] and Quinn departed without him. Father assured Jack he would come at once if he could make some money,[111] and he admitted that one potential development might tempt him to return. There was an opening at the University College in Dublin for a Lecturer in Literature, and Willie was being considered for it. It would bring him a fixed income, and Papa was quite prepared to help spend it, though he wasn't enthusiastic about the prospect for his son. "All universities are a curse to men who want to think their own thoughts," he wrote to Lily while the matter was still pending, "and Willie is already too much enamoured of the notions and traditions of authority."[112] The appointment did not come through, and JBY shed no tears.

John Butler Yeats never recovered from his initial love of New York, though he disliked the intense heat and cold, the humidity, the mosquitoes, the dead horses, the daily murders, and the unkept promises of its inhabitants to commission portraits. ("The Americans are a promising people, as I sometimes tell them, without letting them know that I speak in irony," he wrote Willie.)[113] One of the qualities he liked in Americans was the absence of "class," to him the worst of abominations. Every man considered himself as good as every other. "You can talk with a workman," he observed; "he does not want to insult you. You are equals, even if you are more learned than he is. What of it? He also knows a thing or two. We are different, and that is all, but we are both good men who mean well toward each other."[114] In Dublin the word had spread even to Dowden that the old man was enjoying himself immensely.[115] There was more variety and change in New York than in "dear, dirty Dublin," which was "a closed society" with "a village temperament" (as Olive Purser said of it), with its rigid orthodoxies, its kept institutions—and its creditors. In New York the freedom JBY found grew to be a comfort from which he hated to be driven. "America has cheered and encouraged me greatly," he wrote Lily. "It is exactly the contrary of Dublin. It is an encouraging place, and you feel you can and will do your best."[116]

For him the environment was perfect. He discovered that Americans liked "old men." "In the street, " he wrote Elton, "I am invariably addressed as Colonel, or Professor, or Doctor. All three titles will come to me in the same conversation." At the same time he saw "a delight in conversation" but not "the

art." "A want of finish pervades everything." Americans loved "to hear themselves praised," he told Willie, "They have just made their Debut in the world and want very much to know whether it has come off properly."[117] They particularly sought his approval, especially those above the rank of common laborer. For the great middle class in classless America worshiped class in others, and those of English origin, redolent of royalty, empire, and old money, were the most admired of all. Most Americans couldn't tell the difference between the accents of Oxford and East London. An English accent of any kind implied aristocracy. JBY, with his Anglo-Irish lilt, a speech modified by thirty years of London life, was a magnet for upwardly mobile Americans. "They always take me to be English," he wrote Willie, "and then get cross when they find out the truth."[118] For the Irish were as despised as the English were worshiped, and not without reason. JBY noticed the unhappy effect of American transplantation on his countrymen. "I know that out of his country an Irishman is not a delicious morsel," he told Isaac; and he avoided them. In New York one could avoid anything and substitute something else, for choices were multiple and varied. Quinn wrote of JBY fourteen years later: "He never became disillusioned with New York. Its movement and life interested him always."[119]

In 1909 the early successes he had scored as a speaker were repeated over and over, though among many Irish he was not well received. He discovered that in New York, despite the presence of enlightened Irishmen like Martin Keogh, there was a heavy deposit of the kind who hated Synge. At the Friendly Sons of St. Patrick, a kind of rich man's Ancient Order of Hibernians, he spoke with puckish humor of the difference between Catholic and Protestant in Ireland. The trouble with the Irish Catholics, he said, was that they wanted to make their sons saints. "What is the good of a saint?" he asked. The Protestants, who "always beat the Catholics because they had more efficiency, asked instead, 'Would he make a good husband or a good doctor?'" The speech created "a sensation," and after it, he told Lollie, there was "immense applause" and "innumerable handshakings and infinite introductions." But there were also mutterings and resentments. JBY told Matt's son Frank that "certain of the more bigoted were furious and said that if I had been a Catholic they would have thrown things at me."[120]

Not long afterward he spoke to the Alumnae of Barnard College, privileged women belonging generally to families which, like the Pollexfens, were dedicated to the principle of working hard and making money. To them he spoke not of saints and sinners but of the virtues of "idleness, conversation, and freedom of thought."[121] The two speeches were good examples of his general procedure: first he discovered the household gods of his audience, then, gently and with irresistible good humor, removed their fig leaves. It was a remarkably successful technique. He was so impressive at the Vagabond Club that he was made an honorary member, "*the first ever elected*," he told Lily

Van Wyck Brooks, June 1909, Plainfield, New Jersey. Pencil. JBY. Collection: Michael B. Yeats.

proudly. One member told him the only fault with his speech was that it was "too short." [122] At Plainfield, New Jersey, he gave a talk for seventy-five dollars at the home of Mrs. Francis DeLacey Hyde and was invited to give another for a hundred. [123] He spoke on the differences between the English and Americans as seen by an Irishman, genially dissecting the ideas of his audience. Most of the guests at Mrs. Hyde's were of English descent, and even if their ancestors were in reality Devonshire peasants or Lancashire shopkeepers, they liked to think that they were somehow connected to great houses lurking in the historical mists. The Plainfield lecture was later published in *Harper's Weekly*. A brief selection provides some sample of the flavor of the talk:

In the English and American home there is much discipline, as is right and necessary; but in the English home it is endured by the children that the parents and elders may have a good time; in the American home by the parents and elders, that the children may have a good time. . . .

 The English and the American both chase the dollar. The contrast lies in what they do with it when it is caught. The Englishman saves and husbands his dollar; the American spends it. Curiosity impels the American; he would exhaustively test life and see what it is made of; curiosity is his form of the primal and powerful instinct of growth. The Englishman has not this appetite; he is born blasé. Have not his ancestors discovered long ago the vanity of life and its pleasures? He is superior to these allurements, and places his happiness in a sort of solidified egoism, solidified and enlarged by the consciousness of unsunned heaps laid away in stocks and shares and sound business investments.

If the Englishman excelled in the drawing room, it was the American "backwoodsman" who was the better friend in an emergency—"at least," he added mischievously, "it was so stated to me by a lady who said she had tried both men." He took off on that dominant preoccupation of the English, class feeling. In America it was nonexistent.

In England it abounds, it circulates, it penetrates everywhere, and gets into every home. It is the air Englishmen breathe; the old men and old women give exhortations and the children prattle of it; forlorn unmarried maids live by it; they are the depositories of its traditions, its oracles, and its spokeswomen. It is the whale-bone in their stays. . . .

 Class pervades every relation in English life. A man chooses his friend and his sweetheart and his ideas by marks of class; even intellect must pay toll; no longer as in Elizabethan England do merry men associate with merry men, or melancholy men consort with those having a like passion, or active men unite with active men, or poets house with poets. No; "gentlemen" make it their business to "mix" only with "gentlemen."

Class feeling had one undeniable advantage, however: "it resembles religion in that it is within the reach of the most commonplace intellect." In Ireland, on the other hand, "the poor people have a sort of working hypothesis that a gentleman is a person of such tact and training that he can be trusted to protect as carefully as his own the dignity of every man, woman, and child with whom

"The Mademoiselles Petitpas." Pencil. JBY. Delaware Art Museum. By permission of
Delaware Art Museum and Helen Farr Sloan.

he deals." The life and ways of the Reverend William Butler Yeats cast a long
shadow.[124]

A man who entertained such ideas could not flourish long among the
Irish-American *nouveaux riches* or in the friendless confines of the Grand
Union. For one thing, Simeon Ford and Samuel Shaw ran their hotel as a
business and were not inclined to extend credit to unreliable painters, however
well connected. "The bill at the Hotel runs on," JBY wrote sorrowfully to Isaac,
"and I settle every now and then, when it gets big. The clerks at the desk talk to
me in a nice but very serious manner, like a physician who does not want you to
give up all hope."[125] In mid-July of 1909 the usually tight-fisted Julia Ford[126]
offered a way out of the mounting bills. Her son Ellsworth had just vacated a
studio with bedroom attached in a building at 12 West Forty-fourth Street. An
artist wanted to use it, but Mrs. Ford thought the rent he offered was too low
and preferred to let JBY have it for nothing from August through October. It
was opposite the Harvard Club, to which he was given visitor's privileges for a

month. Every morning he walked to the Grand Union for breakfast, and every night dined at the Petitpas lodging house on West Twenty-ninth Street. Mrs. Ford sailed to Europe in September, and as soon as she left, her husband, spurred by her son, evicted JBY in order to collect the low rent from the other artist. "It was to them disgusting," Papa told Lily, "to see a man enjoying something for nothing."[127] His exit was so hurried that he left an unfinished portrait of Van Wyck Brooks on the easel.[128]

Having nowhere else to turn, he asked the Petitpas sisters if he might become a lodger in one of the upstairs rooms of their four-story brownstone house. As he had dined there regularly for a year and attracted other guests to the dining table, they agreed. When he moved in around mid-October[129] he was to begin a residence that was to end only with his death in an upstairs bedroom more than twelve years later. He was seldom to spend more than a few nights at a time away from it. "It is so much nicer being here than at the Hotel," he wrote Lollie. "I wish I had come long ago. . . . Here it is always cheerful, and there is the minor interest of trying to talk French."[130]

The boardinghouse, which had opened in 1906, was one of the most successful of its kind in a notoriously risky business. JBY at first described it as "a queer French restaurant, where a large party gathers, mostly foreign, and dine without either coat or waistcoat, in a garden &c, which is a back yard."[131] The yard behind the house, used only in warm weather, was about fifteen feet deep and ran the width of the house. It was enclosed on three sides by a high brick wall separating it from adjacent houses and the abutting yard on Thirtieth Street. Over it was spread a large canvas awning to protect the long broad tables covered with white tablecloths, on which at mealtime were bottles of French wine. In the winter the diners moved into a large indoor room.

The establishment was owned by the two elder sisters, Marie, the "cook" and "brains," and Josephine, the "chucker out," who kept order and looked after the bills. Celestine, the youngest, had been only sixteen when she came to America with her sisters and was always under their domination, serving as waitress and chambermaid. She was pleasant and easy to deal with, but her sisters were "grim silent people," and JBY learned to "think twice" before addressing either of them. Celestine was in deadly fear of them, and they allowed her "no kind of life." They sent home money to their mother and a wastrel father who had given them a poor view of human nature. They were fiercely honest and gave good work for their pay. People who disputed their bills were held to be impugning their Breton honor and were not permitted to return. They built a reputation for excellent food and service; and their location was ideal, not only near the Hotel Chelsea but only two blocks away from the giant Post Office and the Pennsylvania Station. The sisters were economical: often his room grew so cold that JBY had to sit "wrapped up in coats" or flee to the waiting room at Penn Station.[132]

Although the Petitpas sisters were prospering before John Butler Yeats

*his is what
...in the studio
oct 22 09*

(Robert Henri)

"And this is what happened in the studio Oct 22 09." Pencil. Robert Henri. From left to right: JBY, John Sloan, Robert Henri, at Henri's Studio. (Sloan's Diary, page 344, dates this sketch October 23). Collection: Helen Farr Sloan.

became a boarder, their relationship with him was to become beautifully symbiotic. They soon learned that no matter how high his account ran, it would eventually be paid, and they knew that standing behind his credit was the rich lawyer, "Mistaire Queen," who, however, disdainfully declined to eat in their dining room.[133] They learned too that the bearded sage was a magnet who attracted customers. Almost every night unexpected guests turned up to dine with the Irish conversationalist whose reputation as a person in his own right was beginning to displace his earlier one as "father of the poet." At times he would listen to others. Often something would occur to him and he would give a monologue to which the guests would listen enthralled.[134] His needs were simple. He liked pea soup and red wine—or an occasional expensive French vermouth, his favorite—and seldom drank anything stronger.[135] All he wanted to do was talk: "I think it is as natural for men to talk as it is for birds to sing."[136]

The transfer from the Grand Union to the Petitpas boardinghouse was a

John Sloan. Collection: Helen Farr Sloan.

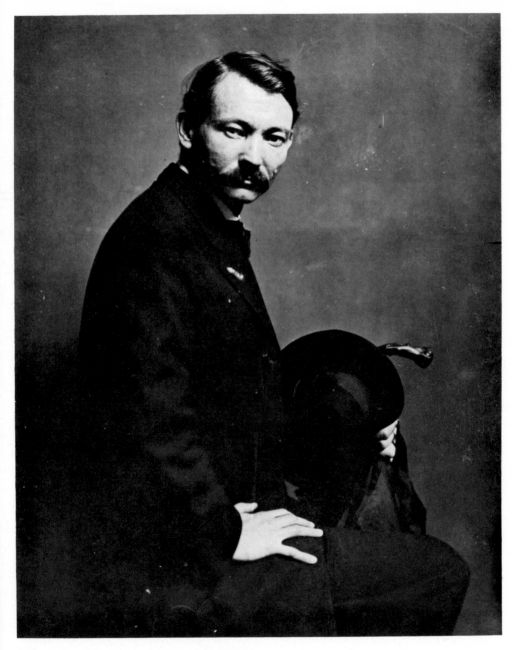

Robert Henri. Collection: Helen Farr Sloan.

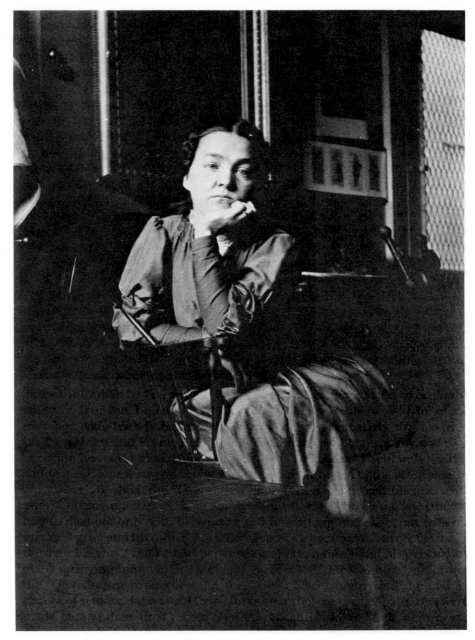

Dolly Sloan. Collection: Helen Farr Sloan. By her permission.

rite of passage. Those whom JBY first met in New York—the prominent Irish-American lawyers and judges, the name-dropping American women— gradually receded, though many continued as good friends. Their places were taken by artists and writers and intellectuals, the kind of people he felt comfortable with. Before the end of the year his circle of friends expanded to include two artists who struck him as the most original in America, Robert Henri and John Sloan. Henri was one of the Philadelphia painters who rebelled against the stuffiness of the Pennsylvania Academy, where students were compelled to paint nudes from plaster statues. (When Thomas Eakins substituted nude models he faced frowns of disapproval from those in the Establishment, and when in 1886 he removed the loin cloth he was forced to resign. Henri was one of his followers and supporters.) Henri and Sloan had come to New York to press their demands for artistic freedom. They, along with six other artists, known together as "the Eight" (Arthur B. Davies, Ernest Lawson, Everett Shinn, William Glackens, Maurice Prendergast, and George Luks) had already held one independent exhibition in 1908, were to hold another in 1910, and would be among the guiding spirits of the revolutionary Armory Show of 1913. Their choice of commonplace subjects—working people, city streets, elevated railways—earned them the name of "the Ashcan Group."[137] As a judge for the annual exhibition of the National Academy of Design in New York, an established, conservative institution, Henri had been unable to persuade his fellows to accept the work of Glackens, Luks, and Shinn, or of his own students Carl Sprinchorn and Rockwell Kent; once two of Henri's own entries were rated only "number 2," which relegated them to unfavorable hanging. Henri promptly withdrew his paintings and blasted the Academy's standards. The Academy in turn denied Henri a place on the jury the following year and refused membership in the Academy to several of his friends.

JBY's meeting with Sloan and Henri took place not at Petitpas but at another restaurant on Thirty-eighth Street, the Casalinga Club. Mary Fanton Roberts, who had met and been sketched by JBY the year before, brought them together. Sloan had been introduced to the old man in 1908, but not until the Casalinga meeting did they become closely acquainted. Sloan, who was keeping a diary, first mentions JBY in his entry of July 22, 1909: "Mr. Yeats was a very interesting old gentleman with white beard. Kindly and well informed, he is a painter, I believe, also a writer."[138] A week later JBY spent the whole afternoon with Henri and his second wife, Marjorie Organ, an artist who worked for the New York *Journal* and *World*. He told Lily he enjoyed Henri, "such a nice slow-speaking humorous man, and a very fine painter," and he reported to her Henri's theory that if a painter could spend two thousand dollars for a studio in New York he could get commissions automatically.[139]

Henri and Sloan were of an age with Willie and Jack. Sloan, who became almost like a son to JBY, shared one of WBY's peculiarities as an artist, an equal

interest in something outside his own artistic sphere. With WBY it was occultism, with Sloan socialism and pacifism. Just as JBY had warned his son against making his poetry the vehicle for occultism, so he urged Sloan to keep his politics and his art separate. Sloan generally succeeded in meeting the old man's standards, but he was contentious about his socialism, and his violence on the subject was to cost him many friends. He admitted in his diary that it had taken a "monopoly" of him but thought that by late 1909 he had "passed the feverish stage."[140]

A strong cement binding the friendship was Sloan's wife Dolly, born Anna Wall, a descendant of Irish Catholic immigrants. Her marriage in 1901 to the thirty-year-old Northern Irish Presbyterian Sloan was an unlikely one that nevertheless endured for forty-two years. Van Wyck Brooks described her shortcomings frankly after her death, and his remarks are essential to an understanding of the Sloans' relationship with JBY. She was a "tempestuous little soul, mercurial, unstable, but as bold as a jay in defense of her affections and beliefs." She was also "a manic-depressive and an alcoholic" who often came home drunk "without hat, purse, or key," and at such times her husband found that another person had come to the front, an "'evil, lying, mean' creature." But she had absolute confidence in her husband's artistic genius and insisted that he work "solely to please himself."[141] To John Butler Yeats she became, despite her age and addiction, almost like a second mother; his affection for her is made abundantly evident in his letters home.

After the dinner at the Casalinga, the friendship with the Sloans ripened, and JBY soon appeared regularly in Sloan's diary. On October 4, Sloan wrote: "Mr. Yeats called late in the afternoon and I enjoyed his company very much. He is a fine unspoiled old artist gentleman. His vest is slightly spotted; he is real." The relationship developed slowly. JBY told Sloan later of his procedure with strangers: "when you meet a new person you should make his acquaintance very carefully—as though you were holding an oyster in your hand and were opening it up, little by little, very patiently, very gently."[142]

By the end of the year the Sloan oyster had been opened almost completely, the Henri one slightly less so. One night the Henris dined at Petitpas and watched JBY do a sketch, Henri praising and encouraging him all the time. The following night he and they had dinner at the Sloans' flat on Twenty-third Street. Papa told Lily that Sloan's art was like Jack's, "that is, it is life and its humours, on this occasion New York life." As for Henri, John Butler Yeats thought him "the best painter in America" and told Jack so. "I am not sure if he is not one of the finest painters anywhere, and he is the most delightful companion anywhere."[143]

Thereafter Mrs. Ford and the others faded into the background. The new friends took over some of the functions of the old. Through Brooks and the Sloans, JBY gave a lecture at Henri's studio on December 14, and tickets at a dollar each were sold among the artistic and literary crowd. Isadora Duncan,

unable to attend because she was leaving on the *Lusitania* for Europe, bought ten tickets and distributed them among friends, and JBY sold twelve dollars' worth himself.[144] F. J. Gregg saw to it that a notice was put in the *Evening Sun*. JBY made almost one hundred dollars on the evening. He was nervous because he knew Quinn had bought a ticket and was afraid the stern presence would disturb him, but Quinn arrived late with Miss Coates in tow and explained afterward that his Irish friend Delehanty had delayed them at dinner. JBY suspected that "the charms of Miss Coates" had something to do with the delay. ("I don't like her a bit," he told Lily. "She is clever and successful, but so unreal—really a vapid person, unless you touch her temper or threaten her pleasures.") By the time Quinn arrived JBY was in full flow, holding his audience spellbound, and he was sorry Quinn hadn't been there to hear the whole speech.[145]

Van Wyck Brooks channeled work toward JBY whenever he could. He not only arranged the talk at the home of Mrs. Hyde, his Plainfield neighbor, but also introduced him to the Saunders family there. (The elder Saunders daughter, Louise, whom JBY sketched, was to marry Brooks's friend Maxwell Perkins, who later became the friend and literary adviser of Thomas Wolfe.)[146] Brooks was to become an accomplished and influential literary critic and historian. Like Sloan, Brooks was a socialist, a child of the age of reason who found in America a society of robber barons whose work was destructive of the principles on which America in his view had been founded. Already, in his early twenties, he was developing his judgment of Mark Twain as a native genius who had betrayed himself by yielding to the false gods of the Philistines. Brooks found in JBY something close to his ideal of what a complete man should be. Writing of him years later, he indicated the source of their recip- rocal affection: "He scouted the notion that man had fallen and that human nature was essentially bad, . . . for he had grown up regarding it as 'a gentle- manly trait to think well,' as he said, 'of our fellow creatures.' This was a part of the liberal faith to which I clung instinctively, and so was his belief in the idea of happiness, which he by no means connected with the notion of success."[147]

Not everyone saw JBY through the eyes of Sloan and Brooks. One of Sloan's friends, Rollin Kirby, a cartoonist, looked down on the impecunious old man and once contemptuously told Sloan that JBY was "an awful example of the artist's life" and a failure. Sloan exploded in his diary. "A failure!—The idiot. Mr. Yeats is a tremendous success. He has lived and had the poet's joy. He has 'known' people. He is still young in spirit, attracts young people around him."[148] Kirby saw success as George Pollexfen did, in terms of worldly goods. Sloan, the socialist visionary, saw it as something quite different, and whatever it was John Butler Yeats in his opinion had achieved it.

In the second half of 1909 Willie's letters to his father began to show a mellowing, perhaps because the impersonality of his father's strictures from such a long distance made them easier to take. When JBY criticized Russell's

poetry as being too wrapped up in the other world, Willie did not dispute the judgment but agreed. Father promptly tried to apply the same criticism to his son's work.[149] He was relieved that with the elimination of Willie's adversaries his interest in the Abbey seemed to be waning. "The theatre has been his old man of the sea," JBY told Ruth Hart, "but he hopes soon to get back to lyric poetry and away from it."[150]

Lily kept up her reports on the Dublin scene. The warring factions continued to communicate with one another. One evening Lily was a guest at AE's with Willie, Maud Gonne MacBride (legally separated from her husband since 1905), George Moore, Padraic Colum, the "new poet" James Stephens, and others. Lily wrote Papa:

> You know how difficult I always find it either to listen or talk to George Moore, so it was with no pleasure I saw him slowly draw his chair over to me. He then began in audible whispers to complain of his surroundings. "I hate all the vague nonsense that is talked here," and so on.
>
> He asked me if I knew May Morris, the rudest and ugliest women he had ever met, no conversation. "How could she have friends if she had nothing to say?" I said you once described her as "a good-looking guy." "That is good," he said. "What a witty sentence." He told me he liked Jack's pictures so much that he had gone over and over again to the exhibition and hungered to buy, but had no where to hang them. "Give them to the National Gallery," I murmured. But he just did not hear me.
>
> Willy and he were friendly together.

She reported too that Douglas Hyde had been named Professor of Irish at the new University College; D. J. O'Donoghue was appointed librarian, "so now I hope he will wash the gravy off his waistcoat."[151]

Cuala had enjoyed a good last quarter in 1908 after a poor preceding one.[152] Antagonism between the former partners still ran high. Maire nic Shiubhlaigh was doing embroidery for Evelyn Gleeson, hoping thereby to "ruin" Cuala, and Miss Gleeson had joined the Theatre of Ireland as "an acting member" and was to appear in the next play. "We must scrape up the money to go and see her," said Lily maliciously. Of old friends she had pleasant news. The Chestertons had made ten pounds for them by selling Cuala goods to their acquaintances in London.[153] When she was in Edinburgh in December at a sale which made forty-six pounds, Lily called on Bishop John Dowden, who questioned her closely about Papa. "He talked of everyone, and asked questions about everyone, you in particular, how you looked, did you hold yourself straight, etc." The family said little about Mrs. Dowden, who was out of sight, troubled with Agnes Gorman's affliction.[154] Agnes was still in an institution at Harrogate,[155] where her brother George had visited her and spent a day brooding with her. George had not changed. He could have done a good turn for his brother-in-law by sending him a hundred pounds, JBY observed sadly, but he enjoyed his money only "by looking at it."[156] George not only sent no money; he had long since ceased writing.

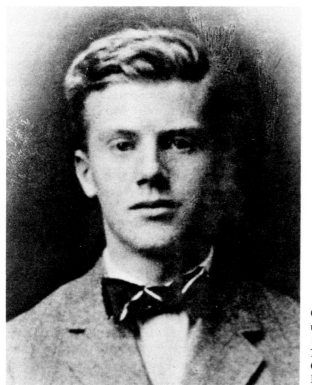

Conrad Aiken as a Harvard
undergraduate, about
1910. Photograph, from
The Clerk's Journal by
Conrad Aiken (New York:
Eakins Press, 1971).

On the New Year's Eve that ushered in 1910, John Butler Yeats enjoyed
himself with Quinn at his apartment on Central Park West, sharing dinner,
wine, and cigars. There he sketched Quinn's sister Julia Anderson, who with
her husband William and three-year-old daughter Mary was visiting him.
Then he returned to the congenial society of Petitpas, where, as Quinn wrote
Florence Farr, "he has his own little circle of friends, mostly artists and writers,
and enjoys himself very much."[157]

He was now a fixture at Petitpas, and "dining out" with John Butler Yeats
became almost a required activity for New York's literary and artistic world.
Several times a week large parties gathered at the long table where JBY sat at
the head as a tutelary graybeard. Before the year was out the sisters had been
compelled to enlarge the dining room by taking in the hallway. "This year I am
quite happy," he wrote Isaac. The "nervous attacks" he had suffered in Dublin,
the "seizures" three or four times a night, had disappeared in his new home.[158]
The place he had won in a strange land was clearly sufficient medicine to cure a
host of ills, especially psychosomatic ones. He had established a "position" of
his own, and on occasion pretended offense when his relationship to WBY was

thrown up at him by those who knew nothing of his own talents or achievements. Once a young man, introduced to him as he sat at the head of the table, innocently remarked, "So you're the father of the great Yeats." The old man drew himself up, looked sternly at the upstart, and retorted, "*I am the great Yeats.*"[159] He charmed and delighted his dinner companions with lucid, witty, and entertaining talk of a kind they had never heard before. "His conversation was all of human nature," Van Wyck Brooks wrote. "It flowed with every sort of engaging contradiction, with a wisdom by turns cheerful and tragic and a folly that was somehow wise." As he grew older, Brooks observed, he moved from the concrete toward the abstract, and "nothing annoyed him so much as to be pressed for a definition,"[160] though of course that had always been part of the secret of his success.

Combined with engaging brilliance was his spirit of eternal youth, which drew the young to him. Brooks was fifteen years younger than Sloan; and even younger ones than he flocked to Petitpas. Two of these were Eric Bell and Alan Seeger. The English Bell was the son of an artist who had studied with JBY at the Slade School forty years before. A brilliant, handsome, enthusiastic lad of literary taste and ambition, he completely captivated JBY, who loved him with the folly of a grandfather. Six-feet-two, blond, well-proportioned, well-bred, he had left England because he "hated" it. One of his brothers was an Oxford don, but Bell, having been expelled from a "great English public school" for calling the master an "Old Dog" in a private letter which the master intercepted, had effectively destroyed his own academic career. In him JBY thought he saw the "only man" in America "who has what I call genuine Literary sense." Bell was addicted to the pleasures of the flesh and cheerfully described his adventures to his companions, but his stories were so happy and unegotistical that nobody minded.[161]

Alan Seeger, two years younger than Brooks, was one of the young Harvard men drawn to the magnet of the Petitpas long table. Even before JBY knew that Seeger wanted to be a poet, he claimed to have recognized in him the "solitary," one who "had no desire to affect the minds of others, though so eager for the truth." Describing him to Willie, not without didactic purpose, Father declared: "A man is born solitary and dies solitary. Only the poet *lives* solitary."[162] Another young poet-to-be baptized in the wine of Petitpas was Conrad Aiken, also fresh from Harvard, a year younger than Seeger. Aiken was retiring and painfully shy. He occupied a room in Lloyd's boardinghouse at 223 West Twenty-third Street which he took over from Brooks in the summer of 1910, when Brooks couldn't keep up with the rent. Brooks left his library in the room, however, and would drop in on Aiken regularly to consult his books. Above Aiken lived R. W. Sneddon, a stammering redhead and aspiring playwright who did hackwork rewriting an encyclopedia.[163]

One day John Butler Yeats turned up at Lloyd's, at Brooks's behest, and met

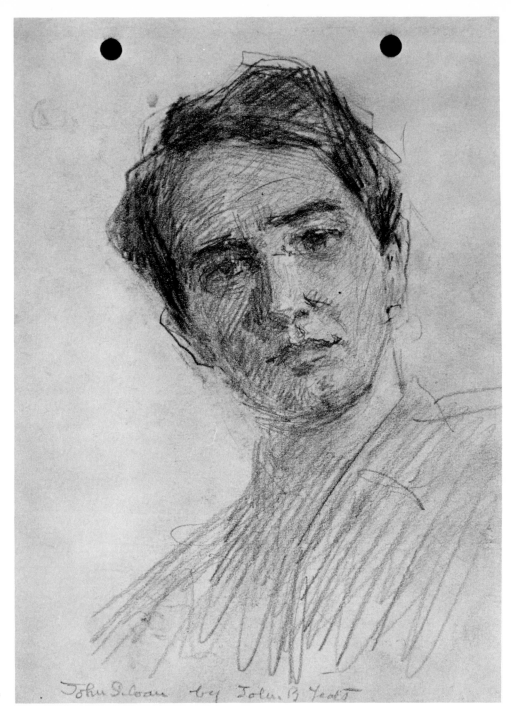

John Sloan. Pencil. JBY. Collection: Helen Farr Sloan.

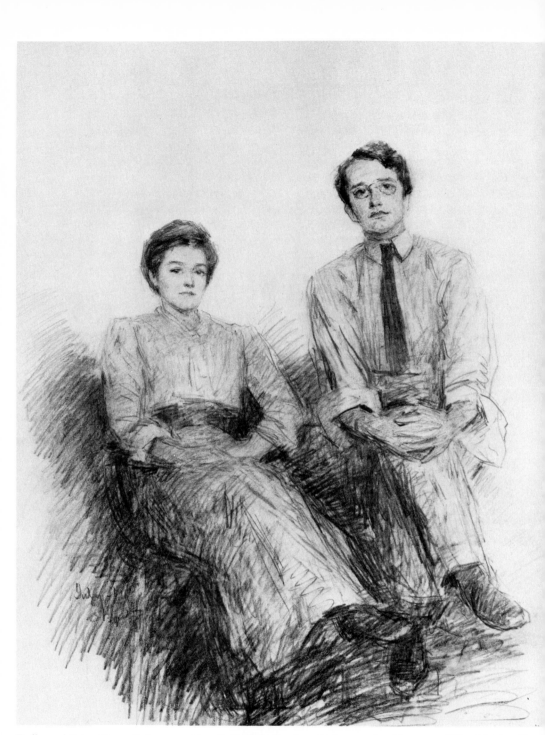

Dolly and John Sloan, July, 1910. Pencil. JBY. Collection: Delaware Art Museum. Gift of Helen Farr Sloan. By permission of Delaware Art Museum and Helen Farr Sloan.

Aiken, Seeger, and some other Harvard schoolmates, who all promptly repaired to West Twenty-ninth Street for dinner at "Mr. Yeats's table." Thereafter during the summer Aiken dined at Petitpas regularly. One day he was a witness to a formidable display of the old man's gifts. Seeger, described by Aiken as "a hippie ahead of his time," with long curly hair swept back, made a grand entrance into the dining room and declared, "War is beautiful." JBY, remembering the Franco-Prussian and Boer wars, was immediately aroused. "JBY proceeded to demolish him," Aiken recalled. "It took him about half an hour, but JBY polished him off."[164] As he seldom said anything himself, Aiken went almost unnoticed. One day JBY asked Brooks, "Who is the boy with the beautiful honest blue eyes?" ("They weren't honest at all," Aiken demurred, "but JBY didn't know that.") In those days Aiken had fiery red hair, and JBY offered to do a portrait or sketch of him, but "nothing ever came of it." Unlike the more self-assured Brooks—a confident talker who often came to Petitpas carrying a cane almost as tall as himself and "pirouetted around" while discoursing at length on almost anything—Aiken never corresponded with JBY and after the summer of 1910 never saw him again. Yet years later he remembered the events of the season vividly and enshrined them in a short story, "The Orange Moth," in which the old painter (whom Aiken also called "the leat great Yeat") appeared under a disguised name.[165]

Another friend of Brooks's introduced to old Mr. Yeats was John Hall Wheelock, the poet. Wheelock recalls that in those days he had achieved a strictly local notoriety for a comic clown act that evoked bursts of appreciative laughter from his contemporaries. Brooks persuaded him to perform for JBY: the old man stared uncomprehending and didn't laugh at all, and Wheelock felt like a fool.[166] It is an index of the impact the painter made on the young that they should attempt to include him in their private jokes.

It was John Sloan who became JBY's principal disciple. Sloan was to say later that Henri had been the chief influence during his "formative period" and that JBY had filled the role later. Sloan and Dolly saw JBY regularly, coddled him, talked with him, fed him. Sloan saw the old man's loneliness, saw how he loved the company at the table. He observed how cross JBY became one night when the guests, who included Fred King and Maxwell Perkins, had to leave before half-past nine.[167] "I don't really like to dine out," Papa informed Lollie. "Here I can talk or not talk, be amicable or cross, at my own sweet will."[168]

In Sloan's diary during 1910 JBY's name appears in 118 entries. The warmth of Sloan's feeling is obvious. When JBY called on the Sloans one day, "Mr. Yeats began in his brightest way to talk and he was a steady warm shower of reminiscences and ideas and kindliness and good humor for the rest of the day and evening." "His constant habit is to make pencil portraits," Sloan noted on June 5, and on that night JBY made one of each of the Sloans. In July he sketched the two of them together. The two men often went on long walks. One day they visited the Astor Library (part of what is now the main branch of

Letter from JBY to John Quinn, May 17, 1910. "My dear Quinn, I enclose Lilly's letter and press notices about the Abbey Theatre and the plays. They will I think interest you. Yours very truly, J. B. Yeats." Collection: Foster-Murphy.

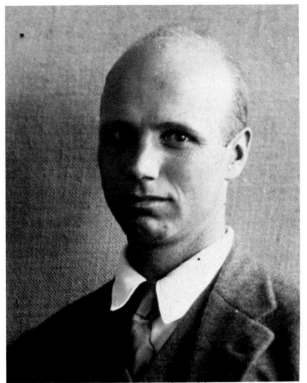

Rockwell Kent. Rockwell
Kent Papers. Archives of
American Art, Smithsonian
Institution. By permission.

the New York Public Library), and out of the expedition came Sloan's painting
Scrubwomen in the Old Astor Library.[169]

The best-known of Sloan's paintings of 1910 is the one called *Yeats at Petitpas*.
Begun on August 2, Sloan's thirty-ninth birthday, it shows the white-bearded
sage seated at the head of the table, smoking a cigar, head thrown back, as he
sketches in a book. Above and behind his head is the pinched tricolor of
France stretched across the awning between the rear door of the house and the
brick wall opposite. Celestine Petitpas stands with a bowl of fruit between Dolly
Sloan and R. W. Sneddon; on the table are several bottles of red wine and a
carafe of water. To the left of the old man (as one views the picture) is the
young, fresh-faced Van Wyck Brooks—who was added to the portrait in
Sloan's studio later[170] —and to his right, clockwise around the table, are Alan
Seeger, Dolly Sloan, Sneddon, Eulabee Dix, Sloan himself (also painted in later
at the extreme right as a counterweight to Brooks), Fred King, and, in the
foreground, Mrs. Charles Johnston. Characteristically, JBY said little about
the painting at the time, and wrote of it later in an article chiefly to speak of the
sympathetic rendering of Seeger.[171]

"These Sloans are to me a constant pleasure and comfort," Papa wrote Lily, calling both "great fighters against everybody and anything," yet *"they never lose a friend."* [172] He was wrong, for John Sloan lost many friends, one of them Rollin Kirby. Sloan argued too vehemently for socialism, and Kirby finally suggested that they part permanently. Sloan, who thought he had been "very good tempered about it," nevertheless "emphatically agreed." [173] Sloan didn't realize that he could not be good-tempered on socialism and, later, pacifism, and even JBY was to be sorely tried.

Sloan's liberal and democratic social views did not carry over into art, where his opinions sound suspiciously like those of John Butler Yeats: "It may be taken as an axiom that the majority is always wrong in cultural matters. . . . Voting on matters of taste always results in selection of the mediocre or commonplace. . . . Politically I believe in democracy but culturally not at all. . . . Whenever a cultural matter rolls up a majority I know it is wrong." [174] When Henri suggested to Sloan early in the year that they consider another Independent Exhibition like the 1908 show at the Macbeth Gallery, Sloan accepted the responsibility for organizing it, an exhausting and unprofitable task. The show, held in the beginning of April, was a great success with "splendid steady attendance," but it lost each of its backers $143,[175] proving to Sloan that the cost of independence was high. John Butler Yeats exhibited along with "the Independents" through the generosity of Quinn, who not only put up the fee—ten dollars for a painting and six drawings—but supplied the pictures too. He allowed the portrait of O'Leary to be hung, and it aroused much enthusiastic comment. The artist himself thought it more than carried its weight in the "rebel" display. "In this Exhibition of the cleverest artists in America," he wrote Willie, "I think it stands alone as the solitary bit of real and serious portrait painting, though I would not like to tell them so." He added with wistful optimism, "It *may* get me some work." [176]

Unlike JBY, Sloan was a good businessman. When he lent money to friends he was careful to record the transactions and to monitor the loans periodically, and he charged interest. But like JBY he found it difficult to accept money for his art. He did not sell his first serious painting until 1913, subsisting until then on the sale of picture puzzles to the Philadelphia newspapers. When Quinn, at JBY's urging, agreed to buy a painting, Sloan was simultaneously pleased and troubled: "I can't believe it will really come to pass that I sell a painting. I am not at all excited or elated even. I regret that the artist must *sell* his work." [177]

One day the two walked through Chinatown in lower Manhattan, the first time JBY had visited the place which his son Jack had enjoyed so much six years earlier.[178] On the way JBY bought a bill of exchange at a bank on Chambers Street and sent it to Dublin for the rent of his studio. He admitted it seemed "a great waste of money," but Sloan wrote in his diary that he could "appreciate how his heart strings keep him from severing the bond between him and his 'fine studio' at home." They attended baseball games together and

took long walks uptown and in New Jersey to correct Sloan's complaint of a bad back. By now JBY carried a cane with him always, and Sloan noticed that he had difficulty with his hearing. One night JBY started out with the Sloans at half-past ten to walk to their home on Twenty-third Street but "found he was too tired" and returned home.[179]

When JBY became privy to the secrets of Sloan's friends, he did not hesitate to apply the standards of the gentleman to them. One friend, who lived in the same building as the Sloans, was Rockwell Kent, vigorous and energetic, and, like Sloan, a socialist. One day in October, 1910, Kent, leaving his wife behind, departed for Newfoundland, ostensibly to see about founding a colony there.[180] There was another purpose too, as JBY learned from Dolly Sloan "under the seal of secrecy." Kent was going to Newfoundland not only to practice his skills "as a carpenter and building contractor," but to discover whether he loved a woman named Jenny as much as he did his twenty-year-old wife, who kept their baby with her. "The poor wife is heartbroken," Papa wrote Lily, "but that does not matter—of course! The artist's soul is something too serious. . . . And the poor wife is so pretty and young and devoted to her baby and to him." Kent was "not a bad fellow, only all theory and high faluting nonsense of various sorts, and *manly* as ever he can be. Of course he is to me a bore with his theories and nonsense." It wasn't long before Kent returned to New York. Mrs. Sloan had framed a letter for Mrs. Kent to send her wayward husband, and he sped home, "delighted . . . to find his wife so full of spirit."[181] What happened to "Jenny" is not recorded.

Sloan and Dolly seem to have made little attempt to convert JBY to their socialist views. One day at Sloan's he found Kent's copy of Bakunin's *God and the State* and "enjoyed reading" from it.[182] But on one whose political development had stopped with the displacement of Butt by Parnell no sophisticated theories were likely to make much of a mark. He remained, as Van Wyck Brooks clearly perceived, an Anglo-Irish gentleman, an artist interested in fruitful idleness, which he sought through "the way of poverty, freely embraced."[183] Save for his general belief that the Irish had the right to govern themselves, he held no strong views about politics. To him the "character" of Sloan and Kent was of far more importance than their political views, and he was to take pride in the one's and be dismayed at the other's.[184] His principal social interest continued to be class feeling, and he even went so far as to write Lily a reproving letter when he thought he detected symptoms of it in her.[185]

To Petitpas in the summer of 1910 came a friend of Willie's named Ezra Pound, "this queer creature," as WBY described him to Lady Gregory.[186] JBY arranged an evening in August when Pound was to dine at Petitpas to meet Sloan and others, and he even persuaded Quinn to make one of the party, tempting him by his description of Pound: "a poet, lived two years in London and met and dined with everybody and his poems published by English papers, friend of Willie &c." He warned Quinn the evening might not be

entirely pleasant, for Pound was "young, and being a poet as well as poor is probably discontented and bad company, though he is less so than others of the genus irritable."[187] Pound's individualism was so marked that he even *"quite appreciated* Mrs. Todhunter," whom he had met in London along with her husband. "I don't think he estimates very highly any poetry except his own," JBY told Elton. "What I saw of his I did not estimate very highly." The "young literary men" who met him found him "surly, supercilious and grumpy."[188]

Quinn loathed boardinghouses. At the last minute he backed down on the agreement to dine at West Twenty-ninth Street and suggested instead that JBY, the two Sloans, King (who was Pound's host), and Pound should meet him at the World Building downtown, where they all boarded a subway for Brighton Beach and walked from there to Coney Island. Quinn bought dinners for all—"at great expense, I'm sure," Sloan wrote in his diary. "We did 'everything' and saw 'everything,'" Papa wrote Lily. Pound sensed "it wasn't the kind of thing Quinn ordinarily did." JBY rode an elephant ("smiling with [the] apostolic joy of a pre-Christian prophet," Pound described him), as did Sloan, and everyone "shot the shutes." Quinn proved "a hot shot with rifle and target," and JBY, since Quinn was paying the bill, consulted a fortune-teller. He also drank "lots of beer" and wrote Lily delightedly next morning that he was "none the worse" for it. But he added a postscript the following day: "I am very much the worse of that beer."

Almost as exciting as Coney Island itself was the trip home. Quinn was staying at Sheepshead Bay for the night and ordered an automobile to take him and the others there, the journey to New York to be continued by train. At the last moment Quinn, who was in "uproarious spirits," ordered the chauffeur to proceed to New York with Mrs. Sloan and the four men. It was Sloan's "first long ride in an auto." "I see why the rich like them," he confided morosely to his diary. JBY had been in an automobile before, but never for such a long and swift passage in the middle of the night, as the car "overtook and passed everything on the road, taking us in no time to 23rd Street Broadway, where we all got out and dispersed to our various homes. Flying through the hot night was delicious. We all chatted like children, all well fed, and not one of us tired."[189]

It was not the kind of night JBY had been accustomed to spend in staid Dublin or London. Americans, he told Edward Dowden, "are too busy rushing about, goaded by an endless curiosity and an endless productivity, like distracted hens that lay eggs but won't hatch them." He cheerfully observed to Lily, "Curious to say, it is not disgraceful to be a pecuniary failure if otherwise you show yourself to be a man of mark. That is the wonderful thing about America."[190]

The letter to Dowden, the first between the old friends in many years, was occasioned by the death of Bishop John Dowden in Edinburgh on January 30,

1910, of which Papa had learned from Lily, who told him also that Edward Dowden was suffering from insomnia. The double news presented a perfect opportunity for the always friendly JBY to renew their association. He wrote warmly to Dowden about his memories of the happy days with John in Sligo, expressed sympathy for the insomnia, and wrote flatteringly of Dowden's talents as a writer. If only Dowden had lived in America, he said, he "would have been a force of marked power." Dowden replied at once, and the old friendship was rekindled. A lively correspondence ensued. When Dowden "confessed" that he had just finished writing eighty lyrics but didn't "feel moved to publish them," JBY urged that he do so. Yet he could not refrain from hinting at the source of whatever weaknesses might flaw the poems. "I have always felt sorry you did not write more poetry and believed you would have done so had it not been for the Professorship at TCD—TCD, the most unimaginative, the least original place in the world, which believes in nothing and teaches nothing except the gospel of getting on." [191]

In Dublin it was a troubling year for the Yeatses. Cuala was improving—the girls had a good year and had even laid in a second press—but there were "many bad years to square up." Lily was able to report with a cheerful spite on her former partner. "We never see the Gleeson people. At Xmas we heard that she had assembled the girls and told them that unless things improved she would have to close, but they are going on just as usual so she must have got money somehow. We hear she has cut wages down a good deal. Anyway she is an old beast and will be found out some day." Papa delighted in her remarks. "You are what Dr. Johnson called 'a good hater.'" [192]

Other problems of longer standing were growing worse. Lollie's emotional troubles were deepening, and the symptoms were exhausting to those around her. At Gurteen Dhas the intense mother-daughter relationship between Lily and Ruth had virtually set them apart from Lollie, or at least Lollie thought it had. When Ruth met and was wooed by Charles Lane-Poole, who worked with the British Forestry Service, it was to Lily she turned for advice and exhortation, and Lollie grew increasingly suspicious of what she regarded as a plot to isolate her. The real cause of her troubles was the old one. She was now completing her forty-second year; for more than half her life she had been the object of the unflagging but indecisive attentions of Louis Purser. Now in 1910 she was no nearer marriage than she had ever been. Lily decided on a bold attack. In March, Cuala held a public sale, and Louis sent a check for some purchases, asking Lily to send his "love" to Lollie, who he knew had been away from Cuala for some time because of an undefined illness. Lily replied with an astonishing letter.

March 22nd 1910

My dear Louis
 Thank you very much for the cheque for which I enclose receipt. I am so glad you like the work. Lolly is better and at work again. I gave her your "love" that you sent. I

think it must be as clear to you as to me that she gave hers to you in a real and serious sense more than seven years ago. The barrier that has arisen neither *she* nor I understand. It is yours, not hers. If it is removable remove it, if not leave things as they are. The little she sees and the little she hears from you is a pleasure to her, but it makes her most miserable and has spoilt years of her life, taking hope and colours out of everything. I mean every word I say and only say it after thought. Lolly and I are the most intimate of sisters, and I have known her love for you all along and how it has never changed, how happy it made her and how miserable the last few years have been.

Of course she has no idea I am writing to you and *will never know*, so please do not answer it *to me*. If you can make her even a little happy do so. I write only from my affection for her and my knowledge of her misery. I use the word "misery" as it is the only word that describes her state—and also from my own personal feeling and observation I gathered that your feeling for her was not that of a friend only.

Take this as I have written it. You *must* understand. You do know.

<div align="right">Yours very sincerely
Lily Yeats[193]</div>

The record contains no hint of Louis's reply or reaction beyond the silent fact of Lollie's continued spinsterhood. In Ireland it was traditional to marry late; Louis, at fifty-five, had paid in full his debt to an old custom. Yet he made no further move. Lily's impassioned plea, with its remarkable admissions and accusations, failed to stir him, and Lollie's slide toward breakdown continued.

The Abbey had been proceeding on its course with unusual calm. On January 13, 1910, Synge's last play, *Deirdre of the Sorrows*, was produced with Molly Allgood in the title role. There was "a fine crowded house," Lily told Papa, "and the play really very beautiful, tender and romantic, Deirdre not the big heroic woman of Willy's play, fighting against fate, but a girl Deirdre, knowing the tragedy coming, making no fight, almost going out to meet it."[194]

Miss Horniman, having been rejected by WBY, was seeking ways to disengage herself from the Irish theatre as soon as possible. When the Abbey's name was inadvertently used in publicity for a play at the Gaiety put on by the Theatre of Ireland she objected strenuously. She insisted that she hated politics and that the Theatre of Ireland was "political," yet, as James Flannery observes, "it is clear that the Nationalists were the political side which particularly aroused her vitriolic fluids, which even at the best were bubbling not too far below the surface of her personality."[195] She had suggested that the directors buy her out at the end of 1909 for the sum of fifteen hundred pounds, giving them control of the Abbey property, in return for releasing her from the subsidy of one thousand pounds payable in 1910. They would not agree, an arbitrator was called in, and at length it was agreed on all sides that the directors would buy the theatre for one thousand pounds and that she would continue her subsidy until December 1, 1910. The agreement contained the usual restrictions against the use of the theatre for political pur-

poses. JBY viewed the new development philosophically. "The breach with Miss Horniman I am sorry for," he wrote Willie. "Still, there are compensations. She is too odd, too strange, to be a comfortable friend. She would be a very rancorous enemy."[196]

On the night of May 6, Edward VII died quite unexpectedly of a surfeit of good living. Lennox Robinson, manager of the Abbey, was uncertain what he should do. He learned in the morning that all the other Dublin theatres were closing out of respect. He decided the "politics" of England was no affair of the Abbey; "I thought that if we closed," he explained to WBY, who was away in Scotland, "we would be throwing ourselves definitely on one political side." With a saving caution, however, he wired to Lady Gregory for advice. Her reply, "Close through courtesy," was delayed and did not arrive till the intermission before the last act of the matinee. As Robinson disingenuously put it later, "If there was any crime in having played, we had already committed it." So he allowed the evening performance to go on too.[197]

Miss Horniman, understandably, allowed herself to be outraged. She demanded an apology, threatening to end her subsidy immediately otherwise.[198] She received instead a deliberately cold and formal statement from the two directors, who regretted that, "owing to accident," the Theatre had remained open. The result was predictable. Spirited nationalists like Arthur Griffith and Francis Sheehy-Skeffington denounced the directors as bootlickers and flunkeys, and Miss Horniman proclaimed that the apology was too weak. She demanded deeper contrition from the directors and the immediate dismissal of Robinson. WBY flatly refused. She thereupon announced she would not pay the final two subsidy installments amounting to four hundred pounds, the directors responded by withholding the thousand pounds they owed her for the theatre, and she threatened a court suit. As neither side wished to be ruined by the costs of an English trial, the matter was submitted to arbitration, and the directors ultimately won their point. Having won it, they refused to accept her money.[199]

So Miss Horniman's long association with the Abbey came to an end. In later years she was to complain bitterly that Lady Gregory had been given most of the credit that rightly belonged to her; she justly pointed to her many hours and days of hard work in helping the company to become established. But the fact remains that her contribution was chiefly financial, and that has been acknowledged with gratitude by historians of the theatre as well as by its members. The fact is also that she opened her purse strings not for Ireland or an Irish theatre but for William Butler Yeats. In simple language, she had made a wager for him and lost. With her departure William Butler Yeats and Lady Gregory sat in lone splendor atop the dramatic edifice that so many hands had helped to build. Moore and Russell had long since been consigned to outer darkness, the Fays had been banished, Digges and Miss Quinn had

been insulted into departing, and Synge was dead. William Butler Yeats's skill as a strategist and tactician was proved beyond doubt. He played for high stakes, made all the right moves, and won the game.

Despite his successes, however, WBY still had no regular source of income. Lady Gregory and Edmund Gosse worked together to have him put on the English Civil List, and in 1910 an annual grant of £150 was approved. WBY was reluctant to accept funds from the English government. He insisted on and won assurance that he would be politically free.[200] For a long time he withheld the news of the grant from his father, perhaps fearing an attempted invasion of it. It was not until he saw Lily in Sligo in September that he told her both of the grant and of another equally startling piece of news: that Edward Dowden was about to leave his post as professor of literature at TCD and that WBY was being considered as his successor.

Willie and Lily met on a melancholy occasion. On September 26, George Pollexfen had died after several months of failing health. Lily had gone to Sligo for her vacation, found him in poor condition, and watched his decline, keeping her family informed by almost daily mail. George was the classic hypochondriac even in his final illness. "When he has no pain he is miserable," Lily wrote, "because he knows he is *going to have* a pain later. He might just die of low spirits." "Some people die very quickly," Papa observed to Lollie, "—nervous people do. But all the Pollexfens die slowly, like an empire." Willie wanted to know whether he should come to Sligo. "I don't like to suggest that I should go there to him," he wrote Lily. "I have been so long without going that it might make him think that I had heard his state was desperate."[201]

Every day George grew weaker; the doctors discovered an abdominal growth. Lily stayed with her dying uncle in his lonely house, moved by the perfect order its master had imposed on all its elements. In a room upstairs she found "his racing jacket and cap," and "all about in the room" were "pictures and photographs of race horses and yearlings, and then the interests of his later years, books on astrology, symbolism, and such." His Masonic orders were also there, "all in perfect order."[202]

On the morning of the twenty-fifth at half-past five, Lily heard the wail of the banshee, and twenty-four hours later George died, "just as the dawn was whiting and the cocks beginning to crow." "I am glad the Banshee cried," Willie wrote to his sister; "it seems a fitting thing. He had one of those instinctive natures that are close to the supernatural."[203] Willie arrived at Sligo the next day, staying at the Hotel Imperial, where his father had lodged forty-seven years earlier on the night before his marriage to George Pollexfen's sister. Willie's visit marked the end of almost half a century of close association between the Yeats children and the Sligo Pollexfens. Thereafter they came more as visitors than as members of the family. George was the last strong link binding them together.[204]

After the funeral, a great and splendid ceremony—"Such a funeral," wrote Lily, "was, they say, never seen in Sligo before"[205] —George's will was read to the family. George, a poor businessman himself, had long ago turned over his authority in the company to Arthur Jackson, but if George didn't know how to make money he knew how to keep it. An accounting showed that he had accumulated fifty thousand pounds.[206] In New York, John Butler Yeats lived in nervous excitement and suspense. Sloan recorded the old man's concern as he talked to him almost daily about his expectations.[207] For years he had hoped George would single out Lily for preferred treatment as she was the only one in the family (save Willie, his fellow occultist) who had done anything for him. Lily, wiser, "smiled" at her father's hopes,[208] and her instincts proved sounder than his. Unmoved by sentiment toward affectionate and helpful nieces and nephews, George had devised an almost perfect conservative document. He divided his estate into nine equal shares, one going to each of his sisters and brothers (except the hopelessly ill William) or their heirs. He did, however, impose two special conditions, that the share going to the Yeats children be divided so that Lily and Lollie receive a third each and Willie and Jack a sixth each, and that his brother Fredrick (who did not attend the funeral) should receive only half a share (and that to be held in trust for him), the other half to be reserved for his children. To John Butler Yeats, his oldest friend, alone in New York and in dire need of money, he left not a farthing.[209]

JBY railed against the will privately; the moment he learned its terms, he told Willie later, his fascination with George came to an end. At last he saw that he was really only "that Colossus the Pharisee, the moldy, old ancient Pharisee." It had troubled him equally that George had failed to write to him. "I wish ever so much that he had sent me some message, though I knew he wouldn't." Principle seized George and destroyed him; JBY saw him finally as one who succeeded in becoming no more than "a specialist in his own life."[210]

Willie, more realistic, was not surprised. "I think George made a very characteristic and just will," he wrote Lily. "I wrote to Lady Gregory from Sligo and said, 'He will leave something to everybody who has but the shadow of a right.'" He too wished the girls had got more "at Alice Jackson's expense," but "George would not have been himself if he had not given equally to those who wanted and to those who did not, to those he liked and to those he disliked. A preference would have been as impossible for him as taking a stall in a theatre instead of going to the pit."[211]

At the funeral Willie had told Lily about both the pension and the news of Dowden's intention to retire. Willie had been approached by Professor Robert Y. Tyrrell to be a candidate,[212] and Willie, indicating his availability,[213] promptly wrote to the power at the top, Vice-Provost John Pentland Mahaffy, asking for an interview. Although he wrote several drafts of the letter to improve its effectiveness, he nevertheless misspelled the word "Professorship"

in the version that reached Mahaffy.[214] Suddenly Trinity College became in Father's mind a splendid institution. "Willie in Dowden's place!" he exclaimed to Lily, bursting with pride and hope and assuming that his son already had the job. Yet he could not shake off his old doubts. "It would be a great gain to him and an honour to Old Trinity—old TCD—who produces Mathematics and Mahaffys and quiet scholars, but no poets, no men of imagination. I hope it will not swallow up in its prose Willie as it swallowed Edward Dowden. But there is no danger. There is in him an unextinguishable spark. Sometimes it is smothered as under damp wood, and then again it bursts into flame."[215]

He let his son know his fears for his artistic freedom:

The mere rumour of a chance of your getting Dowden's place has caused me great *excitement*, though I can hardly believe it. It would save you a world of anxiety, and I suppose that you will take care to keep yourself free so that those Trinity College people—(Mahaffy and such—I fancy they are a very queer lot—probably Dowden could tell you many strange things)—so that the TCD Board don't get such a tight hold over you that your freedom to write and say what you like should be lost. A poet without his freedom is a poet lost, and poetry is your best product and what people look for. Of course if you got the post and had some time hence to fight them, and the issue were a fine one, it would be very enjoyable. But they are a very astute people—like the Vatican their ideas are ignoble, but they make no mistakes in carrying them out.[216]

The matter of Dowden's successor was to be delayed for a long time. Dowden, in no haste to depart, was content to take a leave of absence. His choice of replacement was Olive Purser, niece of Sarah and Louis, Dowden calling her "an excellent deputy."[217] JBY's letters remained full of the subject: "£600 a year would be something in the family," he reflected to Isaac in the true spirit of sharing. Surely he had not embraced the "way of poverty" quite as freely as Brooks thought. "I wonder would his relations with the board be agreeable," he continued, and he reminded Isaac of Willie's love of fighting.[218] Willie was playing his cards well, and surprisingly he found Mahaffy in his corner, possibly because the Vice-Provost sensed Dowden's silent objections to him. In the inner politics of Trinity, Mahaffy was a power, and he regarded Dowden as something of a lightweight. When Willie explained to Mahaffy that his poor eyesight might be a handicap, "Oh," said Mahaffy, "that is all right. There is no work to do. Dowden never did any."[219] While the matter was still pending, Kuno Meyer discovered Willie in the British Museum brushing up on his Gower and Chaucer. "He would do splendidly," Elton told JBY, "if he were turned loose to talk about poetry as he chose."[220]

Elton attended a lecture of WBY's at Liverpool and said to him afterward, "I heard the voice of JBY."[221] Instead of being nettled by the comparison, Willie repeated it to his father. During the year the change in their relationship became more noticeable. After years of trying to reject his father's teachings, WBY had as it were emerged from the far end of a long tunnel to find that the

light there came from the same source as that at the entrance. Early in the year, after receiving one of his father's theoretical disquisitions on the function of the arts, he replied: "In the process of writing my third lecture I found it led up to the thought of your letter which I am going to quote at the end. It has made me realize with some surprise how fully my philosophy of Life has been inherited from you in all but its details and applications." [222] It was a remarkable if belated admission. As a result Father more and more filled his letters with random, often disorganized, but always wise comments on poetry. When Van Wyck Brooks happened to mention that all great literature is "written for small audiences," JBY immediately passed the observation on to his son. "I think this is a good remark. It does away with the notion of *a Democratic Literature.* . . . Yet there must be an audience. We express ourselves *to somebody*—the future—or God Almighty. Otherwise we should cease to express ourselves, and in this act of *ceasing to express ourselves perish*,—that is, either go mad or actually die." [223] Yet even if the audience had to consist of at least one other person, the poet himself must be alone. Paradoxically, good literature required at the same time a maximum of one person and a minimum of two. In the fall JBY wrote his son that for his next lecture he was working out his theory that "personal intimacy" was the "essence of literature." "I am contending that the solitary, the hermit, the recluse, the 'humourist,' is behind any poet. He is *also behind every man* leading a natural life." [224] Out of these reflections was to come his pronouncement that a poem is "the social act of a solitary man." [225]

With Willie he was now able to deal more easily as a familiar, writing him several letters about Lollie's troubles in an attempt to bring the family together behind the beleaguered sister and daughter. He kept hinting, but with no more conviction than he had the year before, that he might himself come home. To make a positive, affirmative decision to remain in New York would be more than could be expected of him. By allowing himself to believe that he was simply on an extended visit that would one day come to an end, he managed to secure the best of both worlds. Like Huck Finn on the raft with Jim, he knew that the river would carry him ashore some day somewhere, and that unsolved problems could wait until it stopped floating. All he had to do was keep alive on the raft and enjoy what was going on. It was a beautiful semi-self-deception that allowed him to remain in New York as simultaneously a permanent resident and a temporary visitor.

The estrangement between Willie and Quinn persisted. When JBY thanked Quinn for fifteen dollars for a framed sketch he had sent him, he tried to slip in a few words in his son's behalf. Writing him that Lily had just written of seeing Willie, he added, "He is a far better fellow than half those fellows whom, not being loose-tongued poets, we can trust better." [226] Perhaps by letting the raindrops of good report spill silent over Quinn's head, he might cause a reconciliation between the two old friends. Yet he realized how formidable the

difficulties were. He asked Lollie after the publication of WBY's *The Green Helmet* in December whether Susan Mitchell was now willing to change her tune about Willie and his achievements. "However," he added disconsolately, "Willie is not the most conciliating of people, and Lady Gregory would on the least provocation hit you over the head with the broomstick."[227]

CHAPTER FOURTEEN

1911–1913

L OLLIE'S CONDITION grew worse daily. Lily reported as fully as she dared about her sister's paranoid suspiciousness and her insane jealousy of Ruth Pollexfen. "I could write so much," she told Papa, "but after all it is better not. I might be sorry afterwards. Things are difficult, more and more so."[1] Papa was sure that all Lollie needed was "a short period of ease and luxury,"[2] and thought the necessary funds might be raised by borrowing against George's estate.[3] Eventually Lollie left Gurteen Dhas for Switzerland and Italy and stayed away for more than three months. For Lily the relief was overwhelming. One night she dreamt that Lollie had come unannounced "because she couldn't get enough to eat." Lily described the scene to Papa. "Then in the dream I sat down on the stone in the garden and cried and cried, saying, 'You are so disappointing,' which is what she always is."[4]

In writing to Willie, Father tried to minimize the seriousness of Lollie's condition. In mid-December of 1910 he suggested that she was "in some danger of some kind of mental disturbance," but clarified the remark next day: "I do not mean to suggest that she is in the least *out of her mind*."[5] With Isaac several months later he was more blunt: "She wrote to me from Florence an immensely long letter, full of bitter delusions about everybody. It was quite crazy, and I came to the conclusion that her trip had not done her good but on the contrary made her worse." He blamed her troubles on "the Pollexfen tendency to be morbid and unhappy." He worried about the prognosis. "As Lollie gets older the Pollexfen side strengthens, and I don't know how things will end."[6]

Fortunately Lollie improved, slowly.[7] Although she never achieved serenity, her condition thereafter did not sink below its low point of 1911. When she returned to Gurteen Dhas in mid-May she still had to be handled carefully. The preparations for Ruth's wedding to Charles Lane-Poole upset her, and Lily and Ruth tried to keep her busy outdoors. There were other difficulties involved with the wedding, which took place in July. The Lane-Pooles were a conventional family inclined to be disturbed by the unexplained disappearance of Ruth's mother.[8] Fred Pollexfen, still rankling at the provisions of his

brother's will, was angered when he learned he was being excluded from his daughter's wedding. It was not easy to be philosophical about Fred or to handle the matter of Ruth's parentage. When the notice of the wedding appeared in the *Irish Times* Fred's name was mentioned but not his former wife's.[9] William Butler Yeats was pressed into service to give Ruth away. (He was "admirable" at the job, JBY reported at second hand to Isaac, who hadn't attended the wedding. "He has a natural instinct for pomp and ceremony, and his theatrical career must have strengthened and informed it.")[10] As her last act before the wedding Ruth Pollexfen wrote a letter over her maiden name to John Butler Yeats. "Our great *big day*," she protested, "and my best uncle is not here for it. . . . I am sure you are thinking of us and giving us your blessing, and that is why I write, just to show you that I am also thinking of you and glad I have your approval and blessing."[11] Fred's contribution was to send two nasty telegrams to the bride and groom, which Lily intercepted and destroyed.[12] After it was all over Lily wrote a straightforward account and judgment of her own life to her father:

> I have a birthday this week and have been thinking back and come to the conclusion that the mistake with my life has been that I have not had a woman's life but an uncomfortable, unsatisfying mixture of a man's and a woman's, gone out all day earning my living, working like a man for a woman's pay, then kept house, the most difficult housekeeping on nothing certain a year, brought up Ruth, saw to Hilda, education, clothes and holidays, tried to see that Maria did her share of work and did not leave it all to Rose, and yet kept peace in the house—and above all never lived at home except when ill. Next incarnation I hope I will be all woman and have a woman's life.[13]

Her anxieties were compounded by her having to take care of the Cuala Industries virtually alone. Because of Lollie's condition, between December, 1910, when WBY's *The Green Helmet and Other Poems* was published, and August, 1912, only one book was issued, WBY's *Synge and the Ireland of His Time*. The standing debt in late 1911 was still five hundred pounds,[14] a staggering sum that further troubled Lily's peace. When she and Willie spoke in August, Cuala was very much on their minds. "He and I talked of our money affairs but, like Omar, came out by the same door as we went in."[15]

Another Yeats enterprise was flourishing. The Abbey seemed, as Quinn expressed it to Lily, "to have caught on and to have won a general public,"[16] a comment he could not make directly to Willie, with whom he was still not speaking. That year the Abbey company was invited to perform in America. Its reputation was so secure that WBY was able to exact unusually favorable terms, "a guarantee of all expenses and 35 percent of the profits." They would be given even better terms the following year, and after that would be free of agents and able to make any terms they liked.[17] All through the spring and summer JBY had the pleasure of looking forward to the double visit of his son and the company.

Meanwhile Willie's campaign for Dowden's post continued, even though it was still occupied. A week and a half after Ruth's wedding, Willie begged off visiting his sisters at Gurteen Dhas "because Lady Gregory had wired him to go and see Gogarty, who is working the T.C.D. affair."[18] Father incorrectly believed Mahaffy would not support his son, when in fact it was Dowden's benign neglect that was more damaging to WBY's chances. Dowden would have been less than human if he had supported Willie's candidacy, and in fact he did not. To JBY he hinted at his position diplomatically, and JBY's response revealed his own ambivalence:

> I think I wanted to say that I *quite understood* your opposition to Willie as candidate for the professorship, and I believe that were we to discuss it I would quite convince you that from the TCD point of view he is the very best appointment that could be made. I am also convinced that from the Yeats family point of view it would be everything. But as regards Willie himself I have all sorts of fears. In the first place he is naturally conservative, and I don't want to see that side of his character developed. I would rather keep him in the ranks, down among the poor soldiers fighting for sincerity and truth.[19]

Dowden wondered whether Willie realized what the business of teaching and scholarship meant, a "difficult and laborious trade, requiring a special training, constant vigilance, and perpetual study, and often of things that do not attract one." He thought Willie might make "a very inspiring Professor of Poetry, such as they have in Oxford, who may choose his own theme, and give a few annual lectures,"[20] but his letters made clear that he did not regard Willie as a scholar.

There was to be more uneasiness for Willie that year than the uncertainty over the TCD job. In October he read the first volume, *Ave*, of George Moore's memoirs, which dealt with the Irish theatrical movement, a mocking, sneering account that depicted William Butler Yeats as something of a fool. The sneer was poorly concealed under what Moore intended as an amused, disinterested impartiality. At first Willie didn't realize how nasty the book really was. "It is not at all malicious," he wrote to Lady Gregory. "Of course there isn't the smallest recognition of the difference between public and private life, except that the consciousness of sin in the matter may have made him unusually careful."[21] By the end of the year he had changed his tune: Lily told Papa that although Willie "laughed about" the book, "he nevertheless resented it."[22] Out of his feelings about Moore's account came the impulse for his own first volume of autobiography. Other forces had of course been driving WBY toward retrospection, chiefly a generalized feeling that time was running out for the Yeats family. "How much of the past has broken from one in these last three years," he had written to Lily a few days before Uncle George's death.[23] Lily and Papa had written to each other about a subject seldom alluded to earlier, the likelihood that the family line of John Butler Yeats would die out with his children. Lily was sad about the childlessness of her younger brother and his wife: "If only they had a little Jack or Cottie running about."[24] Father

expressed a hope that his older son might at least marry. Writing to Elton, who had seen Willie and found him unusually amiable, he said:

I am glad you found Willie cordial. He is really very affectionate, but had an unde-monstrative mother and a sort of scientific father. . . . If only the fates would send him a very affectionate wife who would insist on being visibly and audibly loved, . . . she would be like Aaron's rod striking the rock in the desert.[25]

Yet his strong feelings about his family were not enough to bring about his return to Ireland, despite the continued requests of his friends. "No one in Dublin knows how to talk or even look but you," Susan Mitchell told him. "Can't you come back?" "I long to come home," he assured Lily in March. "Sometimes I am really unhappy about it, but to come home means the old weariness of personal debt and worry with everyone looking askance at me." Six months later he repeated the remarks almost exactly. "I cannot come home," he told her. "In Dublin I have debts which I would have to face as soon as I got back. . . . I am always thinking about coming home, but am always stopped by hopelessness over the money question."[26]

Lily, thinking Papa depressed, inquired about his health, asking Quinn whether she should come to America to fetch him. He dissuaded her. "Like all persons of artistic temperament," he wrote, "he has his good days and his bad days—good days when he is full of hope, as you of course well know, and bad days when, if a manuscript is not accepted or a drawing . . . not ordered, he is depressed." Her father's health was good, he assured her, and he was re-markably accurate in his prediction of JBY's life expectancy. "Aside from his hair being a little whiter than it was gray a couple of years ago, I can really see no change. He has a good strong body, and barring accidents he ought to enjoy life for another ten years yet."[27]

Quinn was not to have another good opportunity to send his charge home for a long time to come. A month earlier he had in an almost offhand way suggested to JBY a project that was to turn into the biggest and longest of the artist's life. Lily and Quinn both agreed that giving JBY large sums of money at one time was futile, as "it would be gone in a week or two and things would be just where they were."[28] Quinn's plan was more subtle, one he thought would buttress the old man's pride and give him money with which to pay off his debts, with enough left over for a return passage to Dublin and a life of idleness for a short time thereafter. On the night of February 3, 1911, eleven years to the day before JBY's death, Quinn in his own apartment in the presence of John Sloan commissioned a self-portrait of JBY in oils for which he would pay whatever the artist asked. Although it was specified to be of the head only,[29] before long it had been magnified by JBY to a full-length, virtually life-size painting. The order filled him with a new sense of joy and purpose: "I am now once more a contented and tranquil spirit," he told Willie.[30]

The history of the portrait is one of the most fascinating and amusing in the

annals of art. B. L. Reid, Quinn's biographer, describes JBY's work on it as becoming in time "a sort of sad joke."[31] It was to prove the ultimate example of John Butler Yeats's belief that, as things constantly change, nothing is ever really finished. Sloan kept a detailed record in his diary of JBY's work on it during the first five months. Rather than paint in his own room at Petitpas, JBY used the more spacious studio in Sloan's upstairs flat on Twenty-third Street. Sloan went nearly mad watching its progress. For several weeks JBY merely talked about it. Nineteen days after Quinn had given the order Sloan noted that JBY had not lifted a brush. On March 3, one month after the commission, JBY set up easel and canvas in Sloan's studio and began his work. Next day he did no work at all as he had to give a lecture on the Gaelic Renaissance at the National Arts Club. On the ninth he dabbled at it, or, as Sloan put it guardedly, "painted in a way." A month later Sloan wrote with some irritation: "Mr. Yeats working on his portrait. It is an almost aggravating thing to watch the struggles of another man. He teaches me that concentration on the work is most necessary." Sloan's "aggravation" was understandable; a week later he placed in his diary a comment that would have brought grim smiles to the lips of Sarah Purser or Edward Dowden: "Mr. Yeats working on his own portrait. He gets it in a very interesting state and then piffles along and (I think) forgets to intend to paint it and at the end of each day it is just a mess." And three days later: "Mr. Yeats worked at his portrait from 3 o'clock on. Ars longa—vita—he is seventy-four years about?" JBY returned, sometimes daily, sometimes every other day, and puttered along. One day in early May he let himself in with Dolly's key when both the Sloans were out, and Sloan on returning found an unlit gascock turned on. There was a "horrible smell," Sloan noted with alarm. "He might have perhaps asphyxiated himself." Next day the portrait seemed "as far from a start as it ever was." When JBY told Sloan a fortune-teller had predicted he would have a "steady occupation in his future," Sloan remarked dryly that the forecast "evidently pointed to the present portrait of himself." The old man was amused by the sally but did not intensify his diligence. "He put in a good day's effort of his sort," Sloan wrote. I'm convinced it's not concentrated effort." One day when JBY was working along "in his idling fashion" he stopped constantly to chat with Dolly, and she at length "scolded him for it." Another day Sloan told him he could have the use of his studio for a full two and a half hours, but JBY preferred to talk and never painted at all. On May 27 he worked all day on the portrait and did so well that Robert Henri praised the result. JBY was pleased, but next day, instead of heeding Sloan's advice to "go easy and finish it," in Sloan's words "he got to work and beat it to death." Sloan lost his temper:

At lunch time I let out at him and scolded wickedly and with my own trouble in my own work in the back of my mind I talked cruelly and I'm sorry for it. For the thing was painted out and away, and no scolding could bring it back. I was ashamed and he was disheartened for the first time. I, in a glass house, threw cruel stones.

By the last day of May the portrait had become "a sort of boogaboo" to Sloan,[32] and perhaps it was good for his own peace of mind that the following morning he and Dolly moved to new quarters at 153 East Twenty-second Street. JBY continued his serenely dilatory work even as the movers were picking up the furniture from around him. Thereafter he worked on the canvas in his room at Petitpas, and Sloan was spared further agony. The painting, which developed at the same slow and irregular pace, was henceforth to be seen only by those who were invited to the small chamber that served as both bedroom and studio. When its creator died in 1922 it stood unfinished on the easel.

Quinn had played into JBY's hands by not specifying a time for completion. By never finishing the portrait John Butler Yeats would not have to claim the fee and would never have to make a decision about going home. Meantime the portrait was a professional assignment, a convenient excuse for declining unwanted invitations, for going home early from boring parties, for experimenting to his heart's content with variations of color, shape, and form—with no worries about the patience of the sitter. Quinn's act did not determine the casual and haphazard nature of JBY's life in New York, but it provided the perfect excuse for it.

Quinn's generosity was partly motivated by his learning on the night of the commission that JBY had agreed to do a frontispiece for a magazine story and told the woman he dealt with that the price would be fifteen dollars. Quinn wrote Lily that her father could have asked a hundred dollars and got it without question. "But don't tell him I said this," he cautioned. "Sloan and I rubbed it in enough."[33] When a bill collector from Dublin dunned JBY for a debt of fifteen dollars to Searle and Company, he replied politely: "I cannot complain of Messrs. Searle and Co., who have been most considerate. On or about the 15th of this month I shall be paid 75 dollars by the Harper's Weekly Magazine. It is promised for that date, and I shall immediately hand it over to you." He added a solemnly cheerful sentence that would have distressed the soul of George Pollexfen: "Except a few books I possess no property in the world."[34]

When he had a chance to make money he was reluctant to seize it. George Roberts, of the Maunsel publishing house in Dublin, wanted him to write his reminiscences. Like everyone else in Dublin, Roberts knew the power and charm of the old man's talk and was sure a printed version of it would make money. JBY was flattered but did nothing. The *Bookman* had made the same request, he told Lily. "But I have many doubts. The whole thing looks dubious. I would not know how to set about it." When *Harper's Weekly* asked him to do drawings he wrung his hands. They "won't get finished," he told her. "It is just like my articles. I am always starting fresh ones."[35] So he lived, troubled by lack of money but delighted by the big table at Petitpas, the days and evenings with the Sloans, the talks before women's clubs and church groups[36] which made

the subjects for his magazine articles—four were published in 1911[37]—and the delight of casual talk, long walks, and freedom.

In 1911 he made two of his infrequent journeys away from New York. The first was to the vast estate in Virginia of the wealthy financier Thomas Fortune Ryan. "*I took John Quinn with me*," Papa wrote Lily, "allowing him to pay all expenses." In December he visited Mrs. Eulabee Dix Becker in Buffalo and enjoyed the hospitality of the city.[38] During the year he met Josephine Preston Peabody, author of *The Pied Piper*; Edwin Arlington Robinson, "a very nice quiet man" who, he had heard, "drinks like a fish"; and Martha Idell Fletcher Bellinger, a novelist married to a German professor at Columbia. When the Andrew Jamesons visited from Dublin they came to see him at Petitpas. He thought Mrs. Jameson "simple and friendly" even though in Dublin she had seemed a "personage."[39] That year also he saw again his young friend from Dublin, Francis Hackett; the young Harvard instructor John Weare (whose student Jeanne Robert Foster was soon to meet him also); Mrs. Dorothy Brophy, a socialist even more contentious than John Sloan; an Englishman named Harold Vizzard; Fred King; and, when he was in town, Van Wyck Brooks.[40] Isadora Duncan sent him a couple of complimentary tickets for her farewell dance, and Percy MacKaye gave him tickets for a play.[41] The coming and going of new faces and the steady reappearance of old ones filled his life with the kind of endless surprise and reassurance his spirit required.

Eric Bell, ill with tuberculosis, turned up early in the year at Petitpas, staying up late nights, drinking "too many cognacs" and talking to the Petitpas sisters about his love affairs and his ill health.[42] He remained only briefly before departing to visit his brother the Oxford don, who was then teaching in Canada. By June he was in New York again, where he remained until mid-December. He was the perfect exemplar of JBY's maxim that a man with good manners was preferable to one with good morals. Speaking of Bell to Brooks, he wrote: "I know thousands of people whom I disapprove of and can't like that it is pleasant to know a man of whom I cannot approve and most entirely like."[43]

The Sloans continued to serve as his solace and comfort, even though their growing truculence alienated them from others.[44] JBY thought Sloan the only "serious" painter America had produced, as Hogarth and Blake were the only serious English ones.[45] Quinn had not yet delivered on his implied promise to buy a major oil from Sloan but told JBY one night that he was waiting for Sloan to produce "something great," at which the Sloans were "cheered," as they didn't want Quinn to order anything out of mere kindness or "good nature."[46] Sloan was still a good businessman, accepting a commission for a thousand dollars and expenses for a portrait of a rich brewer in Omaha.[47] JBY saw the kindly and generous side of Sloan, who in turn loved the disorganized old artist and sympathized with his plight as if it were his own. One night early in

the year JBY read to him and Dolly Willie's *The Green Helmet*, just published by Cuala. "It was a beautiful thing," wrote Sloan, "to see how old John B. Yeats the father filled up with proud tears as he brought it to a finish—his voice fairly crooned the words. He is proud of this son, Ireland's son, and proud of this particular poem."[48]

JBY made life in New York look so attractive to his correspondents that one of his Dublin students from Miss Manning's School on Ely Place, Clare Marsh, told him she might try her luck there also. He encouraged her, then moderated his views when he learned she might be serious, as he did not want to be "responsible for what might be a failure." Still, if she insisted on coming, he wished she would bring Lily with her. "There is nothing else I want."[49] By the end of November, Clare had arrived at White Plains, where she stayed with cousins, and soon JBY would be undergoing painful trials on her behalf.

The big event of the year was the visit of the Abbey Players and Willie, who was scheduled to accompany them for the opening of the tour. Their itinerary would include Boston, New York, Philadelphia, and Chicago,[50] where there were heavy populations of Irish-Americans. Before the first performance in Boston, there were fears of trouble. The signs lay all about, and John Butler Yeats saw and heard them. "I am sure there will be rows," he told Lily. "The Priests are eager to show that they are alive to 'the call of Church and Country.' I am very glad [of] Lady Gregory. Her strong sense and resolute courage will be a great aid."[51]

WBY and the players sailed from Liverpool on September 13. His pension from the Crown of £150 a year had just begun to be noised abroad, and that did not improve his standing with the Anglophobic Irish-Americans. On the first night in Boston, September 23, Willie could report to Father that the company had played "to an immense crowd and amid great enthusiasm,"[52] but the onslaught could not be delayed indefinitely. The Bostonians had been prepared to believe that the plays were wicked, and no one could deprive them of the fruits of their expectations, even though they were puzzled about what part of *The Playboy* they were supposed to riot against.[53] Someone, Willie told Father, wrote "a violent letter to a Boston paper calling *Hyacinth Halvey* anti-Christian and accusing us of producing our plays to stop Home Rule." The Irish Society in Boston officially denounced the Abbey, and Willie believed he was expected to appear in a debate with one of their representatives.[54] Father was cheered. "I hope he will wait for rotten eggs," he told Lollie. "It would be unpleasant, but it would be *great*—a mild form of lynching disagreeable for the victim, but *disgraceful to the Irish Society*, doing us little harm but doing them a great deal." The Abbey players soon came to the painful realization that they did not like the American Irish.[55]

On October 5 the New York *Evening Sun* printed a letter from a Mr. Kennedy denouncing Synge and all his works on the usual grounds. It was the kind of opportunity John Butler Yeats had been waiting for. He responded

with his own letter, printed on the ninth, stoutly defending Synge's honesty and integrity. "Remembering Synge," he declared, "I think of him as a giant among men, and he was gone before we knew his greatness."[56] In New York the opposition grew. One of WBY's *bêtes noires*, Seamus MacManus (" 'Shame us' MacManus" was Quinn's name for him), declared himself against the players and in favor of what JBY called "the sham Ireland." JBY told Lady Gregory he wished he could remember MacManus's face "as I do his wheedling smile and wheedling voice" so that he could draw a portrait for her. "He and the priests—what a lot!"[57] Papa told Lily what he had heard from sympathetic friends about the players. "Of course they represent a *real* Ireland and are against the sham Ireland of the priests. Two priests have denounced them from the altar. One said that anyone of the congregation going to the plays would be guilty of deadly sin, and the other said, also from the altar, that they should bring plenty of eggs." He concluded dryly, "In everything Irish truth always has a hard fight."[58] He began writing an article, published the following year, called "Ireland to be Saved by Intellect," a title both hopeful and sardonic.

Reid vividly describes the scene on opening night in New York, when *The Playboy* was presented.

The players could not be heard after the first few words. All the traditional vegetables were hurled onto the stage, and stink bombs and sneezing powders dropped in the audience. There was hissing, booing, loud coughing, and stamping of feet. Supporters of the play stood up and called for order. Ordinary neutral theatregoers looked on in fear and astonishment as men scuffled in the aisles and balconies. Policemen ejected some of the worst of the rowdies and peace was finally restored, but the evening lay in ruins.[59]

At the end Lady Gregory gave a speech, in the old Dublin manner, that delighted John Butler Yeats. "It was so clever, witty, with the good nature of what the Americans call 'perfect poise,' " he wrote her admiringly. "You gave the Giant Stupidity a mortal thrust with a courteous smile."[60]

New York was too big a city for petty judgments. On October 20 the opposition was dealt a stunning blow when former president Theodore Roosevelt attended the Abbey performance and applauded "loudly and often."[61] Ultimately the players carried the day with "a lively victory," as JBY described it to Isaac. A row had been planned by Devoy's followers for November 14, but JBY told Lily that "they thought better of it." "Our enemies are now sorry," he told Isaac, "and trying to get back into our favour. A priest called on Lady G. and asked leave to sit prominently in her box as an object lesson. The Catholic papers are toning [down]."[62]

In Philadelphia the company met further premeditated antagonism, and there the police and the district attorney were on the side of the opposition. The players were arrested on the grounds of "putting on a sacrilegious and

immoral performance"; and although Quinn went to Philadelphia to face their accusers in court and, by his own judgment, "skinned them alive," still the players had to remain in suspense until the case was tried.[63] When a priest testified to the questionable character of Shawn Keogh, whose part J. M. Kerrigan was playing, the actor was so astonished that he called out, "My God!" and the judge threatened to have him thrown out of the courtroom, "forgetting that he was speaking of a prisoner at the bar!" At another point Quinn in cross-examining a witness asked him if anything immoral had happened on the stage and received the astonishing answer, "Not while the curtain was up!"[64]

Willie returned to Europe on October 15, before the players reached New York. He had paid his promised visit to his father on the eleventh, arriving late in the afternoon and dining at Petitpas with JBY and a group assembled to meet the poet. Among those present were Mary Fanton Roberts, R. W. Sneddon, Fred King, Eric Bell, the Sloans, and a recently found friend, Miss Ann Squire, a highly paid interior decorator, who, as Sloan put it "just wanted to see young Mr. Yeats because old Mr. Yeats would like it." Another couple, the Frederick Chapmans, whom JBY found haughty and disdainful,[65] left fifteen minutes after Willie was supposed to appear, as they feared, according to Sloan, "that they would seem to lionize W. B. Yeats if they waited too long." There are maddeningly few records of the evening. Sloan wrote merely that Willie "talked a great deal and interestingly."[66] Papa told Lily that Willie praised the New York Repertory Theatre, which had just accepted a play of Sneddon's, and that Sneddon, "having a stammer, said what he could." The ladies were all delighted with WBY, for, "besides all his other charm, 'he is such a man of the world.' You know the N. York ladies." The next day, after a two-hour visit with Mrs. Beattie, the fortune-teller, Willie returned to Boston and then to Ireland.[67]

Willie had arranged his schedule so that he had no free time for seeing other people and escaped having to explain why he didn't visit Quinn. Neither man made a move at reconciliation, and the gulf between them remained as wide as ever. Quinn nevertheless showed a continuing interest in the Irish movement, writing for the *Outlook* an article on the Irish National Theatre, to which Theodore Roosevelt contributed the foreword.[68]

A bonus of the Abbey tour for JBY was that Quinn gave him a commission to do drawings of eight of the players, six men and two women.[69] Circumstances were not conducive to the kind of dawdling JBY liked. By the day before Christmas he had finished only two of the sketches; with the press of the season and the rush of the company to get to Philadelphia, it was not easy to get artist and subject together. One player, J. M. Kerrigan, got the wrong address and failed to keep his appointment, and on Christmas night JBY had to leave a party to catch another sitter in the Green Room and to extract promises of

appointments with others. It was not the kind of pressure he liked; but when the sketches were finished they were to prove among the most memorable and useful of all his work.

JBY was proud of the Abbey sketches, which Quinn intended to present to the theatre. He boasted to Lily of the sketch of Kerrigan, his "best portrait," then changed his mind and gave the laurel to the sketch of Arthur Sinclair.[70] Then Quinn sent him a jarring, undiplomatic letter critical of the sketches. The Abbey players would be in New York briefly before returning to Ireland, he told him: "You will have to look sharp to get O'Donovan and Kerrigan to sit over again. It would be a pity not to have them done right. If these two are done over, and Kerrigan, now looking like an old woman, is turned into a young man, I want to have them all reproduced."[71]

It was a cruel cuff, but more significant than the criticism was JBY's response. He backed down abjectly. "That these drawings are not good was not my fault," he complained to Lady Gregory. "Donovan did not let me know it was a matinee day, the day he sat to me, and so I let him linger at luncheon, &c, and Kerrigan failed to keep his appointment with me here." Fearful that Quinn might not allow the sketches to be reproduced, he begged her to persuade the actors to give him another sitting.[72]

She did her best, but there was little time when they returned, and JBY was forced to do the sketches on the *Campania* on the night of the sailing, working diligently until time came for the visitors to leave. "All were so merry," JBY wrote Clare Marsh, "Lady Gregory gracious, and Quinn overflowing with joy and life, and I myself *mournfully* happy." As usual, the father of William Butler Yeats was more popular with the company than the son would have been. Maire Walker, back with the company, urged the old man to return with them. "I will put you in my bunk," she told him in her "nice way."[73]

But Quinn's criticism of the sketches was hard to take. It was one of the blows that pushed JBY into unambiguous old age. His mind was as sharp and clear as ever, and ideas still flowed from it like water from the Mississippi. But the body was not the same. He now wore false teeth, which changed his speech somewhat, and he was growing increasingly deaf. Sloan noticed the affliction and called it "sad." "Such a fine intellect groping for connections in a conversation," he wrote.[74] JBY knew what was happening, complaining that he couldn't hear what people at his table said,[75] and he discovered that old friends were losing their charm. Sometimes he lost his good humor, and Sloan observed how he was amusing only before he had consumed his second bottle of cheap wine, becoming querulous afterward.[76] He succeeded in placing a couple of further articles in *Harper's Weekly*, one on Irish, English, and Scotch physiognomy, for which he was paid seventy-five dollars, and one in *The Independent*, for an "odious" twenty dollars, the analytical piece entitled "Ire-

land to be Saved by Intellect."[77] The demand for his writing was diminishing, and after 1912 he published little in American magazines.[78]

He was also less well able to withstand emotional blows. Clare Marsh had moved from her cousins' home in White Plains to a room next to his at Petitpas, just as Lily had stayed next door at the Grand Union.[79] Her Uncle Seymour, "a little dried-up old maid of a man,"[80] terrified of the Bohemian atmosphere of the house, talked the Breton sisters into forcing her out by telling her her room had been rented to somebody else. Instead of fighting her uncle, she returned home after only two months in America, pleading homesickness and lack of funds. JBY was depressed for months because of her departure and continued to write bitterly about it for years afterward.[81]

The most staggering blow of 1912 was the death of Eric Bell in Germany. His tuberculosis had grown worse, but JBY could not imagine when his young friend returned to England in the winter of 1911 that he was really dying. Bell wanted to write an article on the work of John Butler Yeats for *Studio*, an art magazine, with illustrations, but illness prevented him. From Gotha, Germany, where he had gone for purer air, he wrote a long affectionate letter in April to the old artist that showed clearly how strongly he had been influenced: "I am lonely here and miss your friendship and the stimulus you gave to my work. I will always feel flattered that you had faith in me. . . . There has been so very little real affection in my life that you mustn't think this letter girlish or sentimental. You are one of the few real friends I have ever had." On September 9 he wrote again. "Don't think I have forgotten you or ever will. You have entered too much into my life to be suddenly cast from it. I miss you more than I can say and I would give much to be able to have a talk with you tonight."[82] He died on October 25, 1912, having inscribed two books by Anatole France for his friend and asked that whatever money remained of his meager accumulation should be given to the indigent artist. JBY was overwhelmed. "I had the greatest affection for him," he told Isaac, "which would not surprise you did you know him, but why he should care so much for me I don't understand."[83]

In that year also Quinn drew up incorporation papers for the Association of American Painters and Sculptors, whose almost sole achievement was to produce the great Armory Show of 1913, but JBY was not to be involved in it.[84] He reflected again on his position as the sire of a famous writer. "It is great to be a poet's father," he wrote Mrs. Becker. "Old Priam was not much in himself, but then Hector was his son."[85] He began to complain of being old:

You know the story of the wandering Jew. I believe that once a man gets very old there is nothing for him to do but wander. People get so quickly interested in an old man and his table, and so quickly tire of it all. It is for just a day or two, and then he must wander on. It is not the young man but the old man who makes friends easily—only the young man keeps his friends, for he grows more interesting every day, and all his friends grow

First page of JBY's letter to John Quinn, February 9, 1912, with sketch of Douglas Hyde. Quinn had written the *Irish Times* opposing the attack by Hyde's group on WBY and Lady Gregory. Collection: Foster-Murphy.

PM May 28, 1917

Tuesday,
317. East 29. N.Y.

My dear Lewis:

I wish I had been at home last Tuesday and free to go with you to Mrs Knighton. but I have a sketch portrait of a school boy to do at Englewood — the day I had to break an engagement to go to Scarsdale — ~~and~~

How I ~~know~~ that young lady, what whirlwind time — I tremble to think what would have been the result — Kissing goes by favour even among the Socialists, & this young lady, for one she is a Socialist. I wish you had been in any place for this girl was very pretty & the little room was quiet, & only we two —

The better way —

and advance with him. The old man peddles his little store of wisdom, and like a peddler he gets a ready welcome provided that, having shown his goods, he is ready to go on his way.[86]

Yet in his more cheerful moments he saw himself as a paradoxical wanderer who stayed in the same place while others came and went. "I am a sort of fixture of the place," he declared. "My friends come, and I take care to be popular with people, easy for *an old man* whom nobody criticizes."[87] People still came from all over to meet the great conversationalist and amateur philosopher. Some, like Jack London, who dropped by with his wife and Michael Monahan, dined and left early.[88] Others, like Alfred Zimmern, the Oxford historian, would have stayed forever if duties at home had not beckoned. Zimmern told Ann Squire that if he ever returned to America it would be to hear John Butler Yeats talk.[89]

Still others came and stayed. One of these was Mrs. Jeanne Robert Foster, a beautiful, fascinating, and delightful woman who remained one of his closest friends until the day he died. Married to a man older than her father, Mrs. Foster had been rescued by her husband from a bleak and profitless life in a small village in upstate New York. By 1910 she had come by a series of chances to a life of literature in New York,[90] where she served as assistant editor of the *Review of Reviews* under Albert Shaw. When she first dined at Petitpas in 1911 her beauty and intelligence attracted JBY to her, and thereafter she was a regular member at the head table. JBY tried to persuade her to meet Quinn, perhaps hoping she would displace Miss Coates. Eventually his plan was to succeed, but only after many years had passed. She found devoted admirers also in such diverse people as T. P. O'Connor, Aleister Crowley, and Ezra Pound. When she was free to do so she dined at Petitpas two or three times a week.

Quinn continued to provide the old man's main moral (and, when necessary, financial) support. "Everyone in New York is tired of me," Papa told Lily, "except John Quinn, who seems never to tire of standing by his friends."[91]

(*Facing page*)

JBY's letter to Quinn of May 28, 1912, describing his encounter with the young lady at a socialist meeting: "I wish I had been at home on Sunday and free to go with you to the Keoghs, but I had a sketch portrait of a school boy to do at Englewood, and to do so I had to break an engagement to go to Scarsdale. Had I kissed that young lady who whispered to me—I tremble to think what would have been the result. Kissing goes by favour now among the Socialists, and this young lady told me she is a Socialist. I wish you had been in my place for the girl was very pretty and the little room was quiet, and only we two. (Sketch of girl with Quinn, caption reading: "The better way. Yours very truly, J. B. Yeats.") Collection: Foster-Murphy.

Despite the press of business and the many other claims made upon him, Quinn on occasion impulsively acted in unlawyerlike ways. One night he "routed" JBY "out of his roost," as Sloan expressed it, to call on the Sloans and dicker over purchasing an illustration which Sloan didn't want to sell.[92] After their early differences, Quinn and JBY had settled comfortably into a relationship of mutual acceptance and forbearance, though it was never free from the danger of Quinn's quick temper. JBY once quoted to Quinn what Goethe's mother had said of her son: "Wolfgang was never happy unless he had something to annoy him," and then added, "like unto a certain New York man I know."[93] He maintained a cheerful camaraderie with Quinn, who often merely terrified others. They had their private jokes, some mildly unconventional. Once when JBY found himself alone with a young lady at a socialist gathering he suspected her motives and wrote to Quinn: "Had I kissed that young lady who whispered to me—I tremble to think what would have been the result. Kissing goes by favour now among the Socialists, and this young lady told me she is a Socialist. I wish you had been in my place, for the girl was very pretty and the little room was quiet, and only we two." At the foot of the page he sketched Quinn holding the girl in his arms, and beside the sketch wrote the caption: "The better way."[94]

He carried on a correspondence with Quinn that delighted and baffled the harried lawyer. When Quinn sent JBY a two-volume set of George Meredith's letters, he accompanied the gift with a few words of critical commentary which he intended JBY to regard as definitive. JBY replied by raising questions and objections, tossing casual and airy speculations into the ordered world of Quinn's mind, and Quinn quit the unequal contest. "I can't follow you," he wrote impatiently of the old man's remark that "beauty and the infinite are identical terms." "I don't quite know what the infinite is."[95] Yet Quinn continued to accept the letters, "a marvelous leaven," Reid calls them, "in the mailbag of a busy law office." For, Reid adds, "Quinn valued them as a stream of civilization flowing generously in, and he performed his part in the correspondence in a manner appropriate, if not equal, to the quality of his good fortune."[96]

Realizing the slackening in his powers, the old man simply diverted his remaining energies into new channels. Discarding one set of weapons, he took up others which he had kept oiled and cleaned against the day when they would be needed for use in another arena where the important contests were held, the arena of ideas, of critical principles. He slipped into the task of trying to pin down exactly what it was he had been trying to do in all the years since he left the Four Courts of Dublin to seek the Holy Grail in London. He had discussed philosophy with Willie in letters before. Now these began to assume the form of lectures on abstract principles that might have been meant for anyone, not only his son. The typical letter began *in medias res*, pursued its

subject as far as the author wished to take it, perhaps included an after-thought, and ended. His letter of June 8 may be the first perfect example of the type:

<div align="right">June 8, 1912
317, W. 29.</div>

My dear Willie

I would make a distinction between opinions and convictions and beliefs. Opinions may be described as ideas to which men are attached polemically. They are snatched up in the heat of controversy for the purpose of defense or offense and abound in cities where men live together in such close contact that they become infected by mutual personal likings and dislikings craving expression. Convictions are ideas sought and maintained in the spirit of truth, yet these are limited to the sphere of the reason and the ethical will, and are the discoveries of enlightened and earnest-minded men.

Belief is in another category. Belief is neither offensive nor defensive. And involuntary poets, which include the saints, possess it. John Knox was never a believer in the high sense of the word. With him opinions grew into convictions and there stopped. There was too much noise and tumult in that formidable man for belief to have a chance. Belief is protean and can take many definite shapes, yet itself remains apart—a serenity, a great inner assurance. It is like the harvest when it waits ripening in the heat and silence of the long summer days, and when the harvest is full the harvesters will come. When there are many believers the poets will multiply. I was asked the other day scornfully if there was any poetry in the Yorkshire peasant, and I answered, "He and all his silent like are as full of poetry as the oak tree is of murmurs." Some day there will be good husbandry. The harvest of their silence will be reaped by the inarticulate poets.

George Russell is a true believer and for that reason a true poet, though his note be as monotonous as the woodpecker's, of whose monotony we do not easily tire. For all that, it is a monotony. Like the wood dove he lives partially in an Eutopia of his own, where there are no problems for the intellect. He is the reverse of Browning. Mahaffy told me he could not read him. When Russell faces intellectual problems he writes with extraordinary force and charm, but he has not learned how to be a poet in that difficult world. I have always wondered why.

<div align="right">Yours affectionately,
John Butler Yeats</div>

P.S. Obviously Russell's intellectual world is debating and striving and polemical. That is why to write poetry he must keep within the narrow world of mystical dreams, his poems like Turner's skies.[97]

Here is no word of Willie's chances for the professorship, no request for a loan, no expression of worry about Lollie. Here instead is something close to the subject matter of his conversation when he was expatiating with Brooks and Sneddon and King at Petitpas or with Sloan and Henri at their homes. As he grew older his language, as Brooks noted, tended to become somewhat more abstract and his arguments harder to follow.[98] Yet he seemed to feel closer to the truth of his subject as his expression of it grew vaguer. What made his answers to the basic questions so fascinating was that they were never quite the

same from one day to the next, that they were never final but always suggestive of something beyond, that they frequently appeared—even if they were not—inconsistent, that the philosopher who pursued the answers was quite willing to let his students follow every process of his thought as he arrived at them.

Formal or finished work was as repugnant to him as ever. When WBY seriously renewed his suggestion that his father write his memoirs,[99] JBY refused. It was an offer almost any man of normal vanity would have leaped at, but JBY felt that his portraits and sketches were enough to leave to posterity. He hinted at other good reasons in a letter to Mrs. Ford: "You don't know how I shrink from it. I always feel sorry for anyone who writes his autobiography. It is a false position."[100]

Quinn fared better than Willie. The self-portrait was at least in the process of creation. Papa told Lollie he had "a cherished ambition" to produce a work that "Sloan and Henri may recognize as something different from what they do. I want to give them just a touch of my quality as a portrait painter and artist."[101] In explaining Quinn's offer of "any price I like to ask," he told Lady Gregory: "Under these circumstances a self-portrait becomes a colossal business, a wild labyrinth of infinite effort. Sometimes I say I will satisfy myself with a mere impression, like Sargent's, and then I feel I must have emotion, and again I 'go' for clear outline and precise detail—after the antique."[102] He obviously enjoyed discussing the portrait as much as painting it, and it was no nearer completion at the end of 1912 than it was to be at the end of any other year. "I have spent months and months at it," he told Lily, "getting myself into dreadful pecuniary embarrassment in consequence with the Petitpas, who, however, watch its progress and pronounce it 'wonderful' and declare themselves quite ready to wait for their money."[103]

As always he earned little. When he sent Smyth the full twenty-five pounds back rent for the Stephen's Green studio, he wrote with wistful pride to Lollie: "I might easily have satisfied him with half of it for the present. If these people only knew what my honesty has cost me they would better appreciate it, whereas they only chuckle, and they rich men, the wretches." In the same letter he told her he was "very much" in debt at the boarding house, though the shrewd Breton sisters did not press him for payment.[104] For lack of funds he had to decline Mrs. Becker's invitation to revisit Buffalo.[105] When Susan Mitchell urged him to return as "all over Dublin" people wanted him back, he declined reluctantly. "Fancy 'all over Dublin' taking an interest in me," he answered delightedly. Yet even that was not enough to persuade him. "Dublin means pecuniary hopelessness. . . . While I long for Dublin, I dread it."[106]

In Dublin the Abbey was enjoying a resurgence of good fortune. The attack on the players in Philadelphia had backfired on the Irish-Americans. Willie told Father that the players themselves were greatly admired now (as distinct from the "Protestant and Pagan authors," who were still unpopular). The

Philadelphia outburst "was the thing 'too much' that made everybody ashamed."[107] Yet Holloway still fulminated in his journal, and even the scholarly Padraic Pearse thought the Abbey was "a freak theatre," although he felt there should be "freedom for all"; if people didn't like the Abbey they could simply stay away. Holloway noted with grim satisfaction that when great crowds came to the Abbey for the opening night of the reconciled William Boyle's *Failing Family* and showed their enthusiasm, Yeats looked "as glum and unhappy as could be."[108]

JBY was nevertheless proud of his son's achievement, and when W. J. Lawrence wrote what JBY thought was a "spiteful" attack on the Abbey, he found in it the paradigm of Dublin's weaknesses. "A perfectly disinterested, an absolutely unselfish love of making mischief, mischief for its own sake, is an Irish characteristic."[109] JBY was pleased that his son's role in the Abbey was diminishing. Always at the back of JBY's mind was his concern that Willie might not make proper use of his gifts, which he still believed were primarily lyric, not dramatic. Willie's work with the Abbey may have brought him fame and won him friends or enemies, but it was not the kind of thing he should have been doing. Like his forays into the occult, it was a diversion down a blind alley, as inappropriate as his acceptance of the Nietzschean notion of the superman. JBY observed to Lady Gregory that more than twenty years after it had been begun, *The Countess Cathleen* was again being rewritten.[110] It had never come right for the stage. When JBY accompanied Mrs. Bellinger to a showing of *The Hour-Glass* in April he felt he should tell her in advance what she would see. "*The Hour-Glass* is built on a well-known folk tale. If it were not for this fact, it would not have enough solidity, and even as it is I don't myself quite like it."[111] In fact Willie was working on both these plays as well as *The Land of Heart's Desire* "to get them as effective on the stage as possible."[112] Use of the Abbey Theatre as a testing ground for imperfect drama was not a courtesy WBY customarily extended to other playwrights.

WBY and Lady Gregory continued to arouse hostility even beyond the Abbey. A new coolness had settled over WBY's long friendship with George Russell. Father was philosophical. "I have long expected it," he told Lily. Then he offered a solution. "If they keep apart they won't hate each other, in fact will value each other, for both are necessary."[113] Learning that Cuala was about to release WBY's *Synge and the Ireland of His Time*, he told Mrs. Becker, "It will probably arouse controversy, but my son likes fights only too well."[114] He had long known also that his son's behavior was not improved by the presence of the Dame of Coole, who sprinkled her disdain upon the washed and unwashed alike. In October at the Abbey, Lollie was the target. "I spoke to Lady Gregory one night at the play," she told Papa, "but she was very cross and therefore rude, and dropped me or rather brushed by me without ever replying to my salutation."[115] Lollie had committed the fundamental indiscretion of being a woman. Mary Colum had noticed that of the foreign journalists

and scholars who came to Ireland, only the men visited Coole: "As Lady Gregory didn't care much for women, the ladies did not make the pilgrimage."[116]

The Abbey Players were scheduled to make another American tour in early 1913, and whether Lady Gregory or WBY would accompany them depended on whether Robert Gregory's next child were a boy or a girl; if the first, she would stay at Coole to watch over it, if the second she would go to America, abandoning the infant to its parents. "Lady G— does not like her sex—even as babies," JBY told Mrs. Becker.[117] Yet JBY refused to condemn her. "On the whole," he told Lily, "I am very glad that Lady Gregory 'got' Willie." The others were "all so prejudiced that they think her plays are put into shape by 'Willie,' which of course is nonsense. I for one won't turn against Lady Gregory. She is perfectly disinterested. That is one reason among many why she is so infernally haughty to lesser mortals."[118]

The general dislike of Lady Gregory added fuel to the fires of Quinn's wrath against the defenders of Gaelic-Irish causes. John Butler Yeats tried to cool his fury. Quinn was disgusted with Douglas Hyde for yielding to his colleagues in the Clan-na-Gael (the Irish-language cultural association) in their repudiation of an endorsement of the Abbey Theatre. Yet Quinn was convinced it was not Hyde who was at fault but "the priests and the Irish darkness of mind that followed from Catholic education." If the Irish insisted on driving "all ideas, all thought out of Ireland," they would, he believed, "go elsewhere."[119] There were times when Quinn thought the Irish hardly worth saving. Quinn himself, despite having a sister who was a nun and an uncle who was a priest—to both of whom he was devoted—was resolutely anti-Catholic and expended much nervous energy denouncing the church and its works and pomps. Shortly before his death in 1924, past the capacity for sin, he returned to the arms of his waiting Roman mother. He lived as a pagan and died as a Catholic, thereby getting the best of both worlds.

Up to a point JBY supported him, agreeing that in Philadelphia it was the priests who had preached against the Abbey and encouraged the rioters. But on the whole he looked on the bright side of Catholic ecclesiasticism and took, as Reid puts it, "far the more tolerant view of graces and flexibilities" in the close connection of the church with notions of nationality in Ireland.[120] When Padraic Pearse came to New York that year to seek Quinn's help for St. Enda's School in Rathfarnham, Quinn curtly refused, even though he allowed Pearse to spend an evening at his apartment, an occasion he remembered nostalgically after Pearse became a martyr three years later in the Easter Rising.[121]

JBY wanted to see the best in people and things. He liked the Abbey Theatre because it was "positive." "It is an affirmation in the midst of universal denial," he told Willie, "—Russell, Moore all infected with the spirit of denial. . . . I think Miss Purser is another affirmation."[122] It is no wonder the Americans liked him, who stressed the positive and was quick to overlook defects in

others. In his next-to-last letter to Edward Dowden, written on November 13, he sought to mimic Dowden's own methods by writing a letter about America as Dowden might have written about Ireland, one of "destructive self-criticism." In it he summarized all the faults and peculiarities he found in America, only to conclude he liked the place anyhow. The people were "like weather vanes," he said, "all in restless movement but all changing at exactly the same moment." Conversation was poor, there was "no sense for property, no sense of law, and no sense of civic duty." You could not extract an honest opinion from an American about another American. In politics everybody tried to be on the winning side, and "bosses" ruled because the people were too lazy to read political speeches, which as a result seldom appeared in the newspapers, as there was so much riper stuff available. "With us in England there is nothing else but speeches to put in the papers, and in Ireland nothing else except Priests' funerals." If good came out of the political system in America, he averred, "it is because in his mysterious way God Almighty takes a hand." Bad manners were a "cult, carefully taught and assiduously admired," and there was "a most damnable lot of teetotalism."

Yet all these remarks, he told Dowden, were "cheap, smart criticism of the sort that Englishmen write and think when they first arrive." The real virtues of Americans resided alongside their faults. They were a "most friendly and confiding and loveable people, who take you on your merits, asking no questions as to your class." He was never "at home," he assured Dowden, until he came to America.[123] As he entered on a new role as reflective observer and philosopher with a part-time avocation as artist, his fundamental instincts for seeking the good would prove a valuable ally. By the end of 1912 it was abundantly clear, if it had not been clear before, that this place where he felt "at home" for the first time in his life would remain his home, all his protestations to the contrary notwithstanding.

The two most exciting events of 1913 in New York were launched on the same day; John Butler Yeats was a spectator at both. On February 17 the International Exhibition of Modern Art opened at the 69th Regiment Armory on Lexington Avenue and Twenty-fifth Street, and that evening the Abbey Players, after stops in Chicago and Pittsburgh, opened in New York, with Lady Gregory presiding over them like a triumphant empress. JBY attended the opening performance with her, both cheerful that Quinn's routing of the theatre's enemies the year before had made its path smoother. "I don't think the patriots will be as ferocious this year as they were last year," Quinn boasted to Lily.[124] As an experienced watcher of Abbey plays JBY was able to comment on changes in the players and performances. He liked the new version of *The Countess Cathleen* better than the old, finding what had been "a beautiful dream in spectacle" now "a beautiful performance." But he could not resist offering further advice to his son.

I think the play should have a prologue. It would help the illusion and give the necessary atmosphere. All at once we are expected without any warning to enter the world of miracle and hobgoblin, and it is too much. Do you agree with me? I make the suggestion because I think it is exactly the kind of thing you could write. You have all the qualities for it, the fancy, the wit, and the *persuasiveness*—and then is it not according to the Shakespearean method?. . . . I think indeed the play should end with the Countess dying a lost soul, and then the angel's speech be given as an epilogue to comfort us all.[125]

Because of the Abbey shows JBY did not visit the Armory exhibition until February 23, its seventh day. By that time it had made its impact on the public. The exhibition was the sole product of the Association of American Painters and Sculptors, a group made up of Sloan's friends rebelling against American conventions in art. The Association was organized formally on December 9, 1911, and incorporated, with Quinn's help, on July 1, 1912. Frustrated by the continuing failure of the National Academy of Design to acknowledge their talents, its members wanted to mount a massive assault on conventionality by showing advanced and experimental art from all over the world. Walt Kuhn made a circuit of the continent to arrange for loans of pieces for the New York show. Many were considered ultra-radical by those whose tastes had been moulded by the Academy. The "Armory Show" became a byword for freedom and experimentation in art as well as for excellence of production, and it stamped itself in the national consciousness as the most important and influential art exhibition yet held in America.

On display were works by Jack Yeats, Henri, and Sloan, part of more than a thousand items by seventy American and fifty-seven European artists. Among the latter were Brancusi, Braque, Daumier, Dégas, Dérain, Duchamp, Epstein, Gauguin, Van Gogh, Augustus John, Gwen John, Manet, Matisse, Pascin, Picasso, Pissarro, Puvis de Chavannes, Rédon, Renoir, Rousseau, Segonzac, Seurat, Toulouse-Lautrec, and Vlaminck; Americans included Barnard, Bellows, Cassatt, Davies, Glackens, Hassam, Hopper, Inness, Kuhn, Luks, Pach, and Prendergast.[126] John Butler Yeats's work was not included. He was considered an old man swept aside by advancing forces, somewhat passé, and not even Quinn, Sloan, or Henri had the imagination to ask him to participate. Of course he would not ask for himself.

The impact of the exhibition went deeper than the Eight had anticipated, though Sloan realized even before the show opened what the prospects might be. Of Matisse, the "neo-Impressionists," and the Cubists he wrote: "I think these a splendid symptom, a bomb under conventions. Some of the painters are nothing but flying splinters imagining themselves highly explosive forces but the explosive force is there—revolution it is."[127] After the show, according to Milton Brown, the National Academy was never taken seriously again. "Those who had already become involved with the new tendencies were

strengthened by confirmation that they were part of the wave of the future. The younger men who saw the future for the first time were inspired to change directions. New gods moved onto the stage and the old disappeared almost overnight." Unhappily, as Brown also points out, among those washed away by the tide were Robert Henri himself and some of his followers in the Ashcan School. For years Henri had been leader of a small group of musketeers firing shot into the powerful rival army, softening it for the bigger attack to come. Then the Armory Show, which Henri had viewed with some suspicion,[128] moved in and swept over the weakened enemy, leaving Henri and his followers waving their victorious but tattered banners in the rear. As Brown expresses the melancholy development, "The former standard bearer of progressive art was in eclipse and his troops were irretrievably scattered."[129] But the troops were enrolled in the winning army.

When JBY attended the show, Quinn gave him and Lady Gregory a special tour,[130] just as he had done for President Theodore Roosevelt the week before. Roosevelt had helped put the stamp of respectability on the exhibition by acknowledging the value of showing to Americans "the art forces which of late have been at work in Europe." He favored only the less radical work, declaring that some of the artists shared with P. T. Barnum "the power to make folly lucrative." He reserved his most caustic remarks for what was probably the most notorious of all the works in the exhibition, Marcel Duchamp's oil, *Nu descendant un escalier*, which Roosevelt chose to translate "a naked man going downstairs" rather than the more common "nude descending a staircase." He maintained that a Navajo rug in his home was "a far more satisfactory and decorative picture" than Duchamp's work, and could just as well have been given the title "A well-dressed man going up a ladder." "From the standpoint of decorative value, of sincerity, and of artistic merit, the Navajo rug is infinitely ahead of the picture."[131]

JBY's reaction to the exhibition was more sympathetic than Roosevelt's in one way but just as uncertain in another. He was not nearly so surprised by its unusualness. "All the Americans think it overtops creation," he confided to Willie, "and it is extraordinarily interesting, but I think artists who have lived and studied abroad, in France and England, are not so much astonished and impressed. Matisse to my mind is an artistic humbug, though probably an honest man. If Edwin Ellis were a young man he would be one of these people." Many of the artists, he maintained, were too busy looking for disciples and strove to be different merely for the sake of being different; "and we who know are obliged to listen in silence—wisdom has no chance with clever folly."[132] He was proud of Jack's work in the show[133] and reported to Lily the praises he had heard. Quinn was "wild with enthusiasm" about the show, he added. If it hadn't been for that, JBY might have fallen into Roosevelt's tent, for he could not comprehend some of the works: "I mean to go to it very often,

and try try try and try again—to understand the Cubists, which at present seem to me largely damnable—for work which I recognize as the very best is by artists who I think are in sympathy with them."[134]

By the time the show closed on March 15 its victory was evident. Quinn and the artists who were present marched with their friends through all the rooms, with speeches and champagne both provided by Quinn. The celebration lasted until half-past three in the morning. At one stage in the proceedings, a sour and frustrated Sloan complained about the neglect of Henri and the attention paid to younger men who had not contributed nearly so much. Quinn answered: "Someone, I think perhaps it was Christ, is reported to have said that 'In my Father's House are many mansions,' "[135] and so disposed of the disgruntled Sloan, whose temper did not improve for the rest of the year.

Quinn gave Lady Gregory a guided tour of more than the Armory Show. After it closed she stayed at Quinn's apartment for several nights.[136] One morning at breakfast the two of them engaged in a hate session about their exasperating idol and protégé William Butler Yeats. Quinn, a ready listener, faithfully recorded all she told him[137] about the care and feeding of an Irish poet. She charged Willie with unseemly cowardice and boot-licking in his dealings with those who might be of help to him, like Annie Horniman, to whom his "subservience" had been "a disgrace." Miss Horniman had written insulting letters which he didn't want to answer, in one of them accusing him of "cheating in the accounts."[138] Lady Gregory was similarly angered when Edmund Gosse wrote her that she had no right intervening in the matter of WBY's pension. She demanded that Willie reply, but he temporized, looked very upset at being asked to write the letter, and finally wrote "a milk-and-water thing" which she pretended to mail but finally returned to him.

The two friends spent an enjoyable morning cutting up the poet who bound them together. For once their admiration for his poetry and plays and his talents at lecturing gave way to their pleasure at unshoeing his clay feet. Lady Gregory told Quinn that once during the Christmas season Willie had preferred spending a miserable evening dining alone rather than accept an invitation from Agnes Tobin, who had promised to send a carriage and serve him stuffed duck. Why that should have bothered Lady Gregory is hard to fathom unless she was implying that Willie would refuse a woman his company unless he found her attractive (like Florence Farr) or useful (like Annie Horniman). She recalled giving WBY in 1898 the material for "The Prisoners of the Gods" which he sold for fifteen pounds, then squandered the profits in visiting Maud Gonne in Belfast.[139] Quinn's comment suggests where his own sympathies lay:

Lady Gregory's cold, worldly-wise, intellectual way of putting it was: "There I had let him take my article to make the fifteen pounds to keep him in change, and he had gone off and spent it and 'no purpose served, no object to be gained, no work to do.'" Those

three phrases sum up Lady Gregory—work to be done, purpose to be served, object to be gained. She didn't seem to understand that Yeats went off to Belfast because he was in love with Maud Gonne and wanted to be with her.

Then, unburdened of their irritations, they proceeded once again to manage the affairs of their victim, and to do the job well. J. B. Pond, manager of Pond's Lyceum Bureau, had asked Lady Gregory to persuade WBY to make another American lecture tour. She cabled Willie for a yes or no answer, then departed for Boston and left the details to Quinn, who drove a hard bargain, securing for WBY a guaranteed profit of twenty-five hundred dollars.[140]

One of Lady Gregory's purposes in coming to America with the Abbey players was to seek American contributions to the Dublin gallery which her nephew, Hugh Lane, had insisted be built before he would give the city his paintings.[141] After much frustrating negotiation, Lane had announced that if a decision on building the gallery were not reached by January, 1913, he would remove the collection from Dublin altogether. Eleven days before the deadline the Dublin Corporation voted to impose a special tax through which a total of twenty-two thousand pounds could be raised, provided that matching contributions from private citizens defrayed the cost of a museum site.

Lady Gregory's public appeal in America was hugely successful. At a dinner at the Ritz-Carlton arranged by Quinn, Alexander Cochran agreed in five minutes to give five thousand dollars.[142] She returned to Ireland with commitments from Andrew Carnegie, Finley Peter Dunne, and George Pierce Baker of Harvard, and from the Mayor of Boston, John ("Honey Fitz") Fitzgerald, whose grandson would visit the land of his ancestors a half century later as President of the United States but would not see the pictures.[143]

In the campaign John Butler Yeats played a part. One of the fund-raising devices was the sale for a dollar of a decorated piece of Irish linen. The top half of the cloth contained a half-tone print of a scene from Shaw's *Blanco Posnet*; beneath it were some lines from a poem by WBY with his signature. At the bottom was a passage from a play by Lady Gregory with her signature. In the middle were eight reproductions of the pencil sketches of the Abbey players done by JBY. Seven were autographed by the subjects, and five were signed "J. B. Yeats."[144]

In Dublin, meanwhile, affairs with the gallery project were not going well. Lane had chosen as architect Sir Edward Lutyens, who was denounced as "foreign." Lutyens designed a double gallery to span the Liffey at the site of the Metal (or "Ha'penny") Bridge. Although Sir Thomas Drew and Catterson Smith were dead, their spiritual successors abounded, and opposition to the project was determined. Some warned the Corporation "not to supply Hugh Lane with a monument at the City's expense," others called Lutyens's design "inaesthetic"; some thought the costs outrageous, others maintained that the effluvia rising from the malodorous Liffey would destroy the paintings. JBY

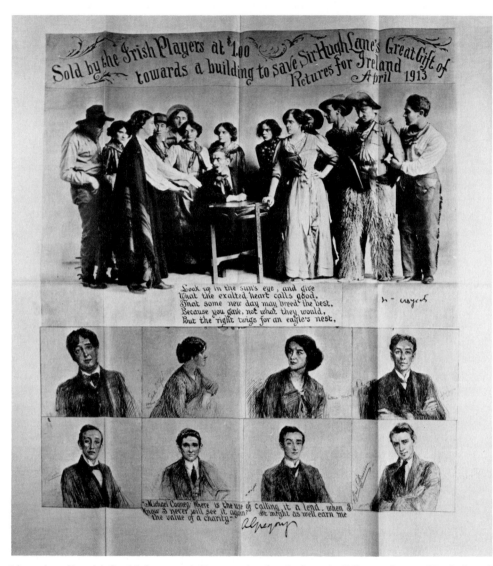

Linen handkerchief sold for one dollar to raise funds for a building to house Hugh Lane's pictures in Dublin. The eight Abbey players at the bottom are from pencil sketches by JBY done for John Quinn in 1911–1912. Top row, left to right: Arthur Sinclair, Sara Allgood, Eithne Magee, Sydney J. Morgan. Bottom row, left to right: J. A. O'Rourke, J. M. Kerrigan, Udolphus Wright, Fred O'Donovan. Collection: Foster-Murphy.

received all the news from Lily and could see exactly what was going on. "Poor Sir Thomas Drew," he commented. "If he were alive now what a pother he would be in opposing Hugh Lane and pretending to something else."[145] But the ghost of Sir Thomas triumphed; on September 19 the Corporation voted to reject the gift of the pictures. Lady Gregory was forced to return American contributions which, added to those abroad, had already reached £11,174.6.3. Eight days after the vote Lane removed the pictures from Clonmel House in Harcourt Street and sent them away, some to London, some to Belfast. Dublin was not to see the pictures again for more than half a century.[146]

Edward Dowden was not involved in the Lane controversy; on April 3, 1913, after some years of ill health, he died suddenly, having suffered the severe pains of a heart spasm for just half an hour.[147] JBY learned the news from the papers and immediately wrote to Mrs. Dowden and to Willie. "Among his own family and small circle of friends," he told his son, "it will be an event of very great importance."[148] But clearly he didn't feel the ripples would spread beyond Ireland. He wrote a long essay on Dowden that appeared as a letter to the editor in the *Evening Post* and the *Nation*. When he sent a copy of the *Nation* to Mrs. Dowden he protested that the editor had "cut out all the subtleties, intimacies, and amplifications that made my letter a personal tribute—that what I wrote in anxious leisure he had rewritten in Editorial haste."[149] Yet it is clear that he meant the article to be critical, of TCD if not of Dowden himself: "He looked the poet and was primarily the poet. In any other age . . . Dowden would have written poetry and left prose to others. . . . He once told me that when he wrote poetry he did it secretly and could not do it otherwise. For in the Ireland that he knew, men did this kind of good deed by stealth."[150] No abundant reference to Dowden's warmer side, to his unfailing courtesy and kindness and his undeniable talents as a writer of prose, could quite conceal JBY's conviction that his friend had been a failure.

Dowden's ghost was to harry the son of his old friend. About a month after Dowden's death his widow wrote JBY that she was arranging for publication of "more recent work of his in verse, lyrical poems mostly," and said she had visited Lollie at Cuala to discuss the matter. It wasn't until a month later that he learned that Lollie had read Dowden's lyrics and agreed to publish them as a volume in the Cuala series.[151] By the time Willie discovered what was going on, the poems had been set in type and Mrs. Dowden was looking at the proofs. Willie's nervous letter to Lily indicates his ignorance of what was happening. "If the Dowden book is merely privately printed, there is little harm done. If you have, however, to put it on the market, that is another matter, and we shall have to secure some form of circular that will protect me."[152] Lollie, without seeking further leave from her brother, continued working on the book. On September 30 the last comma was in place, three hundred copies were run off, and the volume, in standard Cuala size, type, and binding, was published on November 17 at ten shillings sixpence.

Lollie felt she was on solid ground. Willie had failed to provide on time either a promised selection of his own poems or a play by Rabindranath Tagore, and she felt she had to keep the press operating. She was sure the poems must have literary merit, for Dowden had been a distinguished professor of literature at TCD and had written in his younger days poetry admired by Papa and Todhunter and Ellis. An irritated Willie demanded to see the poems after the book was bound, then wrote sourly to Lollie that his darkest suspicions had been confirmed.

> I am sorry to say that the poems are even worse than I feared. There is no chance of my being mistaken for the fault is a general flaccidity of technique. The matter is beyond helping now. . . . Do not forget what I said about the circular. It is entirely necessary that your circular make it plain that I am not responsible for this book. Remember that my critical reputation is important to me. It is even financially important. I cannot have anyone suppose that I am responsible for the selection of this book.[153]

It is hard to dissent from his judgment of *A Woman's Reliquary*, a curious volume in every way. Although the lyrics were love poems written by Dowden to his second wife, he tried to conceal his authorship under the odd fiction that he was merely editing poems given him by the niece of the writer.[154] A reading of the poems proves that his wish for anonymity was a stroke of wisdom. All the poems are precise in form, correct in rhyme and rhythm, and unspeakably flat. The second poem, "Song a Shadow," stands as a fair example:

> The little breezes of my song
> Waft perfumes, each a pallid wraith
> Of hope, of memories treasured long,
> And ever love, and ever faith.
>
> Or think them shadows that across
> The everlasting hills that run,
> Whose life was merely sunshine's loss;
> Yet flying shades confess the sun.

The flaccidity of technique of which WBY spoke lay perhaps in Dowden's failure to move beyond a poetic diction that was already dead in his youth, and may in fact have never been alive. The quoted poem has only "pallid wraith" and "waft" to separate it from the speech of living people; as the lyrics proceed, the diction is drawn more and more from a language that never was on sea or land: "circumpos'd," "garth," "smatch of marish-weed," "crenell'd aperture," "fictile clay," "sulphurous scurf." In the first stanza of No. LXI, the two middle lines may well take the prize for language that never existed outside Joycean parody:

> Tumultuous splendours in the West,
> A brazier fuming chrysoprase,

Southward translucent amethyst
 Veils mountain-capes and mountain-bays.

Living language is the lifeblood of poetry. From the veins and arteries of *A Woman's Reliquary* drips only embalming fluid. As literature Dowden's book is an almost total disaster. Willie's instincts had not failed him; Lollie had chosen the wrong stick to beat him with.

But the book was out, and Willie could do nothing but rage. He wrote his father of the underhanded trick his sister had played. JBY urged his son to make no public remarks about Dowden. "I would ask you, indeed beg of you, to remember that he not only was a very old friend, but the best of friends."[155] Willie for once kept the peace, though he insisted that Lollie add the pre-scribed note to the Cuala Prospectus the following year: "This book is not a part of the Cuala series arranged by W. B. Yeats."[156] But the volume itself contains no disclaimer. Later in the year, when he announced that he would try to arrange for a book on Synge by John Masefield and get some translations from Lady Gregory, WBY wrote sarcastically to Lily: "I am hoping that this vision of the future will keep Lolly from cherishing any more 'a quiet literary taste.' "[157]

Willie wanted to find books for the sisters, and he also wanted his father to make something of his literary abilities. Having failed with the scheme for a JBY autobiography, he now devised an ingenious substitute. "I wonder if I may put together for Cuala a volume of criticism and philosophy extracted from your letters and lectures?" he asked. "It would help Cuala and be a most beautiful book." When Papa, predictably, failed to respond, he sought Lily's help. "Now what I want you to do is to get his leave—he hasn't answered me on the subject—or better still to tell him we are going on without leave if we don't hear. Then I want you to get all the likely letters of his you can."[158]

But Papa couldn't be hurried. "There can't be anything in my letters of interest," he told Lily, "except where I describe and comment on particular individuals, and this though interesting in 500 years *would not do now*."[159] Four years would elapse before the selection of letters appeared. When Quinn suggested that Lily urge her father to dictate his memoirs to a stenographer, she replied: "Jack said it would be of no use. If Papa disliked the girl he would not be able to think, if he liked her he would put her by the fire, get her to tell him her life story, . . . do a sketch of her and see her politely to the train."[160]

One reason why Willie did not make public protestations about Dowden's poems may have been that he was again a candidate for the Professorship of Literature at TCD. Lady Gregory told JBY before leaving New York that she thought his son had a good chance. Willie had been hesitant, but she found his vulnerable spot. "He will like the rooms and the dignity and be able to entertain." Papa, unrealistic as ever, allowed himself to believe that with Lady Gregory in Willie's corner he couldn't fail to win the appointment. He began decorating his letters with scenes of himself dining in splendor with his son.

"Fancy Willie my host," he wrote to Lily. "He will ask me to dine in college and I shall see him in cap and gown, the porters all touching their hats, a world of material greatness. The Pollexfen family will think him to be quite respectable and a somebody."[161]

Of course Willie never really had a chance for the job. As one who knew from his experience with the Abbey how power is wielded in the real world, he should have been aware of the distribution of forces. Mahaffy was still on his side, but Provost Traill and a majority of the Hebdomadal Board disapproved. A suggestion was made that the post be divided into two parts—a scholarly one to be handled by a trained professor, and a chair of poetry to be assigned to William Butler Yeats, who would deliver lectures on general subjects only—but it got nowhere.[162] The opposition to WBY was too strong. He was regarded widely as a traitor to his class, like his outspoken father. Furthermore, the members of the Board were aware that even the Dowden they disliked had refused to endorse him for the job. In the raw politics of Trinity College, Willie Yeats stood as much chance for the professorship as Willie Fay had stood for appointment by Annie Horniman to a directorship of the Abbey. After appropriate delay and a scrupulous observance of form, a committee to fill the vacancy announced the appointment of W. Wilberforce Trench. Trench was a good scholar and teacher and well merited the appointment; perhaps WBY's candidacy had helped force the committee into making a sound decision.[163]

About a week after the Armory Show opened in New York, Lily Yeats in Dublin experienced a strange sensory illusion—"in a sort of dream"—of a kind that had come to her before at the deaths of her mother, her Uncle John, and her Uncle George. She awoke one morning thinking a "sea-gull was flapping its wings" in her face. During the same month Lollie, who had never seen "Lily's bird" before, woke with a scream "and said there was a great wingless bird in her bed, a penguin, she thought." Lily kept awaiting the news of the death of a Pollexfen. She had almost forgotten the dream when, on July 8, the news came that her Uncle William Middleton Pollexfen had died on February 25, just about the time she had her vision.[164] The lawyers wrote to inform Lily that the Yeats children would all share in their mother's claim to a portion of the twenty-five hundred pounds which Grandfather Pollexfen had left for his son's care. "He, poor man," commented Lily to Papa, "had the life of a caged and wingless bird." She estimated they would each get about forty pounds from the estate. But Uncle Fredrick leaped in with a lawsuit and by the time the dispute was settled four years later, half of the money had "vanished by law."[165]

The Pollexfens continued to fascinate John Butler Yeats, and his letters were more and more sprinkled with his analyses of their characters and actions. When Clare Marsh sent him John Galsworthy's *The Man of Property* he saw the life of his in-laws in cold print. It was "a depressing but wonderful book," he wrote Lily; "in it an unhappy wife and a suicide—and such quantities

of dull rich English people, splendidly described and *shown up*—and all so like the Pollexfens." He kept reminding Lollie that she herself was more Pollexfen than Yeats, pointing out that she, like all Pollexfens, preferred to be alone. "Your mother did. They all do. They don't like being with people, for people irritate rather than amuse a Pollexfen." With Lily he was brutally frank. "You must not mind about Lollie. She will never be cured, although I don't think I have ever said so to you before. Her mother was just the same."[166] Cautiously, fourteen years after his wife's death, he admitted what Lily had always known.

Lily was still the rock of stability at Gurteen Dhas and Cuala, and her way with people, both in word and manner, was as charming and productive as ever. There was much of Papa in her. She told him how she had asked the clergyman at St. George's if she could borrow for the Arts and Crafts Exhibition at the August Horse Show a flag made for the church by Cuala. They demurred, arguing that "the flag had been consecrated and hung in the church and so could not be lent for exhibiting." Lily replied, "I see your point, but the rector and curate are also consecrated and they go out to tea." The next day they sent the flag "saying my letter had changed their point of view and made them laugh."[167] Tom Lyster told her she had a way of hitting the nail on the head without hurting her own fingers, and JBY agreed with him. She did it "so genially," Papa told her, "that I fancy the nail itself sometimes smiles. I know I often smiled when I myself was the nail. Jack also has this gift."[168]

Willie did not have the gift and would never get it. Holloway's journal in 1913 is as critical as it had been ten years earlier. After listening to WBY talk on Tagore, Holloway wrote acidly: "His answers, as a rule, are more mystifying than his original statements. He is so full of musical words that his sentences form themselves into rhapsodies of speech rather than clear explanations of basic fact." Yeats, he declared, "couldn't say yes or no to anything."[169] Yet Willie still had staunch friends, those who valued the other side of him more, the side few saw. Lady Gregory, despite her occasional irritations with him, was utterly devoted to him. When she heard that Alfred Noyes was doing well on his lecture tour in America, she told everyone Willie would do better. "With the light of battle in her eyes," Papa wrote Lily, "she predicts his triumph over all competitors." He told Lollie, "Willie will beat them all. His personality is far more interesting. Americans love the personality of the poets and will buy their books even though they don't read them."[170] He began advising Willie what to say in his forthcoming lectures: "When you come here you must raise your voice for poetry, and point out that it has nothing to do with happiness."[171] When later Willie wrote to his father, "The practical man has illusions about life, the artist creates because he has none," JBY seized on the epigram. "A lecture of which every sentence was that sentence said in innumerable forms would make an immense stir in America, destroying at one blow any quantity of bad art."[172] The poet must carry no message, seek no "uplift." He warmed to his subject in a series of letters, writing even on Christmas Eve and

Christmas Day. "The Americans are crazy about ideas," he wrote. " 'What is the idea' is the question always asked about a work of art. *Poetry embodies the ideas which cannot be expressed*." Aware of the long slow fight to win his son's ear, he tried to be modest.

If these ideas can be incorporated in your lectures, "changed no doubt in the process," I shall be glad. Only in your lectures don't make any allusion to me. My individuality must not "get in the way." *Nothing should intervene between a lecturer and his audience*. And there never can be any question of egotism between you and me.[173]

Jack, meanwhile, with whom Father's relationship had always been more distant,[174] was continuing to develop in his steady, deliberate way. In 1912 he had published *Life in the West of Ireland*; now in 1913 another volume appeared, *Irishmen All*, by "George Birmingham" (the pseudonym of Canon James O. Hannay), with twelve illustrations in color by Jack.[175] Jack sent Papa a copy but disappointed him by not autographing the flyleaf. Papa told Lily he thought Jack possessed an impenetrable reserve that made him, though so outwardly friendly and amusing, virtually inaccessible. "I sometimes think that while Jack is fond of his friends, he does not allow himself to be as fond of them as he would like *because he always thinks they are not fond* of him."[176]

As it happened, Papa learned much about Jack and the book when Canon Hannay visited New York late in the year to oversee the production of his play, *General O'Regan*. It was produced by Liebler and Company, which had played a part in the first visit of the Abbey players. Willie Fay and Maire O'Neill (Molly Allgood) appeared in the play, though her part was a small one. JBY was asked to help with the publicity[177] and responded by painting an oil of Molly, which was installed in the lobby. The arrangements were characteristically unbusinesslike. Liebler and Company made no attempt to pay him for the oil, though he thought they had commissioned it. After it was placed in the lobby, he was advised by Liebler to post a "For Sale" sign near it. "I believe if it is not sold they still hold themselves accountable to me," he explained hopefully to Lily. Nobody bought the picture. When Arnold Daly, the star, wanted it removed from the lobby because it drew attention from himself, the management told him to "go to blazes." Molly wanted it herself but had no funds, and Liebler showed no disposition to pay for it. "I think their intention is to pay me something small for it, and their hope is that some rich man may buy it and so relieve them from paying anything."[178] The "rich man" who finally bought it, after unpleasant negotiating colored by threats of legal action, was John Quinn.

Molly Allgood talked much with JBY, who reported to Lily on her problems. "She tells me Lady Gregory hates her," he wrote, urging Lily to keep in touch with Molly as she was "sometimes very unhappy and very lonely." His prescription was drawn from his own chest of simples. "Just write and tell her that you are fond of her and believe in her."[179] He continued to keep the friendship

and support even of those who still violently disliked his son. Dudley Digges and Maire Quinn (now Mrs. Digges) went out of their way to dine with him at Petitpas and brought him the cheering news that, should he return to Dublin, the Gaelic League, now occupying his Stephen's Green studio (which he had reluctantly given up), would vacate it in his favor. Before the Diggeses left they invited the old man to have tea with them.[180]

The rumor of his return was again strong in Dublin but with as little substance as ever. JBY knew he couldn't in good conscience impose the added burden of his presence on his daughters. He still couldn't make ends meet. His writing for magazines had virtually stopped, and his income from speaking had declined sharply. Yet when a Miss Clancy, who was between fifty-five and sixty, asked him to do an oil portrait of her to resemble one he had painted of a much younger Lily (which she had seen at the Whitechapel Gallery in London) he demurred. "*I can't paint* if my sitter is not pleased and sympathetic," he told Lily. "It is not that I won't paint but that I can't. I go all to pieces."[181]

Naturally his debts rose. When Lady Gregory came early in the year she managed to give him some money in Willie's name, cooking up some kind of excuse to justify the payment.[182] When Lollie sent Papa five pounds in June he did not even treat it as a loan. "I hope it is not too great a sacrifice," he wrote her, "It is a fact I am just now very hard up." In late September Willie sent him ten pounds, and later another ten. He took the money, he told Lily, "with a mixture of shame and delight."[183]

Nevertheless, the slowing old painter had good reason to be happy with the world. Robert Henri, on his annual tour abroad, had made a special visit to Dublin just to see JBY's works in the National Gallery and the Municipal Gallery and had been amazed by what he saw. "In my opinion," he wrote Sloan, "Yeats is the greatest British portrait painter of the Victorian era."[184] The paintings were superb, he said, calling JBY "the most modest portrait painter he had ever met."[185] Henri wondered why George Moore had not proclaimed JBY's superiority to the other painters of Dublin.[186] The old man mentioned Henri's praise to almost everyone he wrote for the next several months. It was a splendid tribute to a man finishing his seventy-fifth year— and a unique one: who else had been praised for his painting by Robert Henri and for his dialogue by J. M. Synge?

Despite his slowing down—in his correspondence that year he hardly mentions his self-portrait—he was still treated with affection by those who knew him best. Susan Mitchell dedicated a book of poems to him,[187] and on Thanksgiving Day, to his complete surprise, he found himself the guest of honor at the turkey dinner in the Petitpas dining room. All the other guests, wearing paper caps, rose to drink to him as he entered.[188]

1914–1916

WHEN CANNON HANNAY returned to Dublin in early 1914 he sought out Katharine Tynan Hinkson to tell her that old Mr. Yeats was living in deplorable circumstances, lodged in a shabby place, and badly nourished. The word got round in Dublin, and Susan Mitchell wrote Quinn at once: "Is it true that he is so badly off as to give any foundation for the story?"[1] Quinn reassured her, and the matter was dropped, but even Dolly Sloan had the same feeling as Hannay and before the year was out would attempt to do something about it.

Hannay's impression, however, had a basis in fact; JBY had not been feeling well. He was indeed malnourished because his teeth were bothering him. He had also been having trouble with his hand, which was "crippled with nervousness" so that he could "scarcely write."[2] The portrait of Maire O'Neill was still up for sale. When the theatre was cleared out after *General O'Regan* closed, the portrait was mislaid and for a time was thought to have been stolen. "I hope it was not for the sake of the frame," Father wrote Willie lugubriously.[3] When it was found there was still the unresolved question of payment. Quinn at first turned the matter over to another lawyer, then cut the Gordian knot by buying the painting himself for $150, Liebler & Co. adding $25 for the sketch drawn as a study for the portrait.[4]

Yet JBY was happy in his lodgings, despite what Hannay may have thought. The food at Petitpas was good,[5] and the lodgings adequate if spare: JBY found them satisfactory, even if others did not. Later in the year Mary Colum described what she saw as a "dingy room with an iron bed, a cheap worn rug, and an easel on which was always erected a portrait at which he tinkered day after day";[6] but the judgments are hers, not his. His physical malaise, however, was real enough, though he never consulted a doctor about it. Not until the second week in March could he write Clare Marsh that he was on the mend: "I am only just recovering from a long period of depression physical and mental such as I have never before experienced."[7] The mental anguish came partly from the failure of *Harper's Weekly* to pay for three articles it had promised to print; the magazine was changing management and did not feel bound by

earlier commitments.[8] His income from sketches had dwindled,[9] and it was clear that his financial condition had gone beyond its usual precariousness.

As usual in his life, fate intervened. Lily wrote of her father to Quinn in June, "He never does decide anything, just leaves things to fate and chance, and is always hopeful and generally happy."[10] Fate and chance in this case came to his aid through the two men closest to him. In late January William Butler Yeats sailed to America on the *Mauretania* for the Pond Lyceum tour. When he arrived in early February he took rooms at the Algonquin and there was jolted with a direct notice of his father's predicament. Dolly Sloan, concerned at JBY's floundering, decided to confront his eldest son. She knocked at his hotel room door and, when he opened it and allowed her to enter, blurted out that she thought he should do something for his father, who was in poor health and had no funds. William Butler Yeats, proud and haughty as ever with outsiders, considered the family's business private. Dominating the tiny woman from his great height, he merely glared at her with "cold contempt" and "bowed" her to the door, "uttering one phrase only, 'Good day, Madam.' "[11]

Father at first said nothing to his son of his plight. He was so delighted with an obvious change in Willie's attitude that he wished only to enjoy it while it lasted. He had been peppering his son with epistolary essays but hadn't been sure how they would be received. "The fact is not only am I an old man in a hurry," he apologized, "but all my life I have fancied myself just on the verge of discovering the primum mobile." He then went on to enlarge on his idea of Beauty as "much more than the lovable made visible."[12] To his delight Willie responded warmly, telling Father that again he had used many of his ideas in a lecture in London, and that his father's way of putting things had made some ideas more clear in his own mind.

> Your last letter came just in time to give me a most essential passage. The way in which you contrast pleasure which is personal and joy which is impersonal brought into my memory an essay of mine in *The Cutting of an Agate*. . . . The pleasurable element is the element of style, the conscious choice of words. It is, I suppose, all that remains of the ego. The curious thing is that this thought, which I feel quite certain of, has always, until I got your letter, refused to relate itself to the general facts of life.[13]

Under the circumstances it was hardly appropriate to raise unpleasant questions about money. Instead father and son enjoyed a happy companionship during the few days before the American tour began. When WBY gave a talk at the Poetry Society, JBY attended with Jeanne Robert Foster. It was "the most perfect gem of a speech I ever heard," he told brother Isaac, in sharp contrast to the "great flaming orations" of others.[14] Later Willie spent three evenings at Petitpas, where some of the ladies taught him dancing.[15] Not a word was said about the bills owing to the Breton sisters.

Meanwhile John Quinn was having second thoughts about his long es-

trangement from the poet. In the autumn of 1913, Dorothy Coates had fallen ill, and Quinn, fearing she might have tuberculosis, sent her off to the Adirondacks to recover. The senseless alienation she caused had now lasted five years, yet Quinn had continued to correspond with Lily and Jack and to treat Willie's father as a friend while arranging speeches for the poet and handling his American copyrights. Just before WBY embarked on his tour, Quinn sent him a letter that was to thaw the chill permanently:

> I wonder whether you will be surprised to receive this note from me. A good deal of water has flowed under the bridge since you and I parted. The lady to whom you talked has been very ill for months—almost at the point of death—and has been and is now away in the mountains making a brave fight for life and health, and from there she has written to me about you and hoped that you and I would be friends again.
>
> I have always felt that apart from intellect you were always generous in your sympathies and full of humanity and that your heart was in the right place.
>
> So if this suggestion appeals to you, I should be glad to shake hands with you and let by-gones be by-gones.[16]

It was a generous and, considering Quinn's temperament, a courageous move. The friendship was resumed and continued unabated until Quinn's death a decade later. The tragedy is that with so short a span of life allotted to him Quinn should have wasted so much of it in a quarrel with William Butler Yeats over a woman not worth the serious attention of either.

Willie was on the road before he could respond to Quinn's letter, and his pleasure in it was moderated by one received from his father as soon as he had left New York. "I am ashamed to say I owe the Petitpas 537 dollars," JBY confessed. "Could you let me have 250 dollars? The rest I can manage with commissions &c that I have in mind."[17] Willie was to clear about twenty-five hundred dollars from the speaking tour, and his father was asking for ten per cent of it, even though he owed twice as much as he wanted to borrow. The news was worse than Father made it appear, for the "commissions &c" consisted only of the unfinishable self-portrait and the uncertain payment for the oil of Maire O'Neill. The sum owed at Petitpas represented about thirty-five weeks of board and room at the flat rate of fifteen dollars a week, or about thirty weeks if extra items like wine and cigars were included. For John Butler Yeats it represented an enormous immovable mountain. He knew his son needed the profits from the tour for his own expenses. "Poetry is about as profitable as art," he told Clare Marsh.[18] Nevertheless Willie responded with a promise of forty pounds, only fifty dollars less than his father had asked. The effect on the old man was immediate. He planned to give thirty pounds at once to the Petitpas sisters and to reserve the rest for dental work.[19] When the check arrived, Father wrote as happily as a child with a new toy. "Thanks indeed for the £40. You don't know how pleasing it looks as it lies there in its fairness."[20]

When Willie returned briefly to New York in March he and Quinn had lunch together and made up. On his next stay he moved into Quinn's apart-

ment.[21] "I am more glad than I can tell you that peace is made with Quinn," JBY wrote his son. "Quinn is a man of genius—not a touch of the commonplace or any other kind of prose in his whole composition."[22] Now the man of genius and the poet proceeded to work out a scheme through which the old man would be taken care of without a sacrifice of Willie's pride and with no risk of Father's being able to upset the financial applecart. It is clear from Quinn's later dealings with the Petitpas sisters that the understanding involved at least three conditions. Quinn was to serve as go-between, and JBY himself was not to handle directly any large sums of money; the arrangement was to be kept confidential; and Quinn was not to contribute a penny of his own funds, Willie bearing the full burden. It was also understood that JBY was to contribute as much to his own support as possible, his son to meet the deficit only.

But how was Willie to get the money? Ultimately it came from Quinn, who for many years had been collecting not only paintings but literary manuscripts as well. Now he proposed to make regular purchases of the handwritten copies of WBY's works.

I will pay you so much a year for them, depending upon the quantity and the different things, taking articles as they are or poems as they are. I would put them in separate cases, and I would pay you a reasonable price for them, more perhaps than you would get of any dealer, who would pay you only a small price and then shop them around at a high price.[23]

Willie, who disliked the idea of selling the manuscripts for a fixed annual sum, nevertheless fell in with Quinn's scheme, agreeing to send what he had and let Quinn pay him whatever he thought each item worth.[24] Fortunately Lily, "something of a magpie," had saved much of her brother's early work, so there was a good bulk of material with which to establish the new system of support. Quinn set up in his books a "Trust Account, W. B. Yeats in account with John Quinn," and it was out of this that JBY's debts were paid.[25]

Quinn continued using JBY's services and paying for them, as when he commissioned drawings of his sister Julia Anderson and her daughter Mary.[26] But it was made clear on all sides that Willie, at his own insistence, was solely responsible for his father's primary care. Father was relieved when the details were worked out. "That load of care rolled off my back has done wonders, you will easily imagine," he told Lily; and he thanked Willie: "Your generous help has set me on my feet."[27] Quinn and Willie may both have had other motives in accepting the arrangement; perhaps it would be easier now to compel the old man to return to his family in Dublin. But if such was their subtle plan they had underestimated JBY's guile.

Father was given no lump sum, then or later. From mid-1914 until the day of his death, the debt at Petitpas was allowed to accumulate and was paid off or reduced only periodically, JBY being thus kept continuously aware of the realities. When Willie returned to Europe in early April he offered to pay all

his father's debts and buy his ticket for the ocean voyage as well, promising that he could return to New York after a season in Dublin. Father, wary as ever, declined. "No, when I come home it will be for good," he told Lily."[28]

The revived friendship between Quinn and WBY flowered. Willie stayed at Quinn's apartment as a regular guest. Quinn arranged for a photograph of the two together by Arnold Genthe, New York's most fashionable photographer,[29] as well as for one of W. B. Yeats alone. Quinn gave a lavish farewell dinner on April 1, and each of the guests received a copy of a specially printed edition, *Nine Poems*, of already published works of WBY selected by Quinn. For the frontispiece Quinn used Genthe's photograph of WBY.[30] "They are now like brothers," Papa wrote happily to Lollie, and his sigh of relief could almost be heard in Dublin. They were, he added, *very interesting to each other, which gives me great satisfaction*." One night Quinn came to Petitpas with WBY after dinner, and Papa judged that from "the amount of talk and laughter and the length of time the party kept together . . . they enjoyed themselves."[31]

When WBY first arrived in New York that year, there was one thorn in his mind that pricked him constantly. George Moore had finished *Vale*, the third and last volume of his rambling memoirs collectively entitled *Hail and Farewell*. His acquaintances awaited publication nervously, especially those whom Moore called his friends. Moore was an adept in describing people's behavior in a way designed to put them in the worst light. His principal technique was to skate on the thin ice of the inaccurate, sweeping at times close to the shore of truth but seldom touching it. He was aware of the costliness of libel suits and so allowed copies of his works to circulate privately before publication among those whose names appeared in them. When Lady Gregory threatened legal action if he repeated the canard that she had tried in her youth to convert the benighted Catholics of the district, he corrected the passage in such a way that the retraction was almost as damaging, if not as actionable, as the original: "I have pleasure in stating here, for my statement is implicated in an artistic movement, the Abbey Theatre, that the gospels were never read by Lady Gregory round Kiltartan."[32]

W. B. Yeats was as annoyed as Lady Gregory, finding Moore's accounts of his behavior "equally untrue but too indefinite for any action."[33] The general impression Moore left was that WBY was an unconscionable snob, a would-be aristocrat who was a traitor to his class. He recounted a speech in which Willie had denounced the "middle classes" with "hatred in his voice" and wondered archly why the poet should "denounce" the very group to which he belonged: "on one side excellent millers and shipowners, and on the other a portrait painter of rare talent." Moore made much of his own supposed relationship to Sir Thomas More yet mocked Willie's claims to descent from the Ormonde Butlers. He repeated a story Russell had told him of Willie's declaring that "if he had his rights he would be Duke of Ormonde," and of Russell's having

replied, "In any case, Willie, you are overlooking your father." Russell's comment, Moore continued, with his wicked grin almost visible on the page, was "a detestable remark to make to a poet in search of ancestry." Unhappily for Willie, life at Coole had indeed infected him with some notions of class feeling, and Moore knew the charges would find a sympathetic audience. He took delight in mentioning the "magnificent fur coat" which Willie had brought with him from America—with the subtle implication that it would have been more appropriate had he returned in rags—and in describing, at second hand, the poet's languishing on a couch at Coole, "a plate of strawberries on his knee, and three or four adoring ladies serving him with cream and sugar."[34]

Willie was smouldering when he arrived in New York. At Quinn's he showed his father a stanza he had written attacking Moore.[35] JBY, seeing his son's anger, urged him not to publish the lines and to disregard Moore's attack completely. "No one really minds what Moore says," he suggested soothingly, "so it does you no harm."[36]

Willie responded vehemently, charging that his father took no thought for his son's "honor and welfare" and ordering him in effect to keep henceforth out of his affairs. But Father would not be silenced:

Your letter has disturbed me very much. . . . I am just as much concerned for your honor and welfare as Lady Gregory, and *you might have credited me with the feeling*. I did not see Moore's article, only an extract from it in one of the papers. . . . I gather that Moore attacked Lady Gregory with calculated baseness and conscious mendacity—but you do not mention Lady Gregory as the source of your anger. Forgive me that I disobey your haughty command that I keep silent. Forgive me also that like Hamlet, who was Shakespeare, I am slow to hate. Not everyone is a Byron, who was a man of action and therefore a limited poet.[37]

Willie would not be mollified. Writing from the president's house at Amherst College, where he was spending the night, he answered: "I don't want to discuss the Moore affair because it would be useless. We take a different view of the obligations of public life, and as this difference has my whole life's work behind it, it is obvious discussion would be useless. I asked Lady Gregory's advice because a common work has given us the same view of public duty."[38] Nevertheless, in the end WBY heeded his father's advice. Except for what he wrote in his private diary and letters he remained silent. Perhaps his own instincts were right, for many readers, knowing nothing of the Dublin scene, accepted Moore's account as the truth. Of course Willie himself provided the corks for the popguns aimed against him. Moore simply pulled the trigger.

William Butler Yeats sublimated his revenge in a larger and more generous enterprise. Perhaps several circumstances helped bring about the decision. When Willie left New York for England after Quinn's farewell dinner it was to attend the wedding of Ezra Pound to Dorothy Shakespear, the twenty-nine-year-old daughter of Willie's good friend Olivia Shakespear. (The bride, JBY

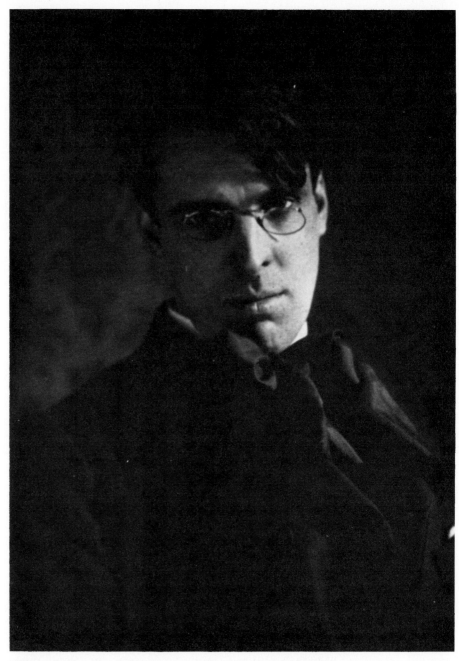

William Butler Yeats, about 1914. Collection: Foster-Murphy.

John Quinn and William Butler Yeats after their reconciliation, 1914. Photograph by Arnold Genthe. Quinn's inscribed copy to Jeanne Robert Foster. Collection: Foster-Murphy.

had learned, was beautiful and well off, but JBY wondered whether the two would get along. "Ezra has no money and no manners," he observed to Lily, and added, "I hope it will turn out that Ezra Pound is not an *uncomfortable* man of genius.")[39] Perhaps Willie saw in the wedding of his young friend the promise of the continuance of another family line, a happy development that looked increasingly unlikely for the descendants of John Butler Yeats. When Cuala published Willie's book of poems, *Responsibilities*, in May, he felt it important to apologize to his ancestors for having allowed his branch of the family tree to wither:

> Pardon that for a barren passion's sake,
> Although I have come close on forty-nine,
> I have no child, I have nothing but a book,
> Nothing but that to prove your blood and mine.[40]

Were such thoughts in his mind at the Pound wedding? Among the guests was a young relative by marriage of the bride's, Miss Bertha Georgie Hyde-Lees, twenty-two years old, a young lady with musical and literary interests"[41] and a taste for the occult. A few years later she would become Mrs. William Butler Yeats.

Yet in 1914 neither JBY nor anyone else thought such a miracle would occur. One night at Petitpas in mid-February someone asked JBY whether he thought his son would take a wife. Mrs. Foster recorded his reply:

No, I don't think Willie will marry. He has always been devoted to Maud Gonne. She didn't care for him! Maud Gonne could not love a poet. She would only love a man of action. She is a fine woman—a handsome woman—but doubtless she never looked at a line of Willie's verse. Besides Willie has no money. It was better he did not marry Maud Gonne; his unsatisfied love has made many fine poems. You know, "Who wins his love shall lose her."[42]

Willie had been aroused by Moore's work and by the desire perhaps to explain what, with no children of his own, might never be explained: the course and purpose of his own life. By early August he revealed to Lily that he had "all but finished the first draft" of a book for Cuala which would cover his life "up to twenty" and most of which would be "about Sligo."[43] He preferred to deal with Lily rather than Lollie, who still irritated him. He had found several misprints in *Responsibilities* and insisted that Lollie provide an errata slip, but when she dutifully did so, she added to at least one of them: "These are alterations my brother made after the book was printed—so are not our misprints."[44] She had tried in early May to enlist her father's support in the continuing fight over the Dowden book, but he had quietly taken his son's side. "After all he is Editor, and were he not Editor your press would fail. . . . And as Editor his authority ought to be respected, and besides no doubt it causes him a lot of trouble, for as you know he is poet rather than man of business."[45] Willie didn't want Lollie involved with the new work until the manuscript was completely typed and ready for the printer, even though he acknowledged she

"might very well be offended." He wanted Lily and Jack to read it before he sent it off to Cuala.[46] He hoped to entitle it *Memory Harbour*, after Jack's watercolor. ("You will remember it," Lily reminded her father, "everything happening and everything visible at once, and everything at its best, a picture of the Rosses Point.")[47] Later WBY learned that someone else had already used the title. "We may keep it as a subtitle," he informed Lollie.[48] Eventually the book was called *Reveries over Childhood and Youth*, with no subtitle.

"I wonder what will be in it," Papa wrote apprehensively when he heard the news, "I hope not the kind of comedy G. Moore writes."[49] Lily herself might have been concerned after Willie told her, "You and Lolly come in only slightly, Jack a little more definitively, but our father and mother occur again and again. I have written it in some sort as an 'apologia' for the Yeats family and to lead up to a selection of our father's letters (I now sometimes get three in one day so I think he likes the idea). . . . As Dowden and O'Leary are dealt with in some detail, it should interest Dublin."[50] What might interest Dublin might also frighten John Butler Yeats, and Father's apprehension remained high until the book appeared—when it rose higher.

In 1914 other matters were of greater import in Ireland and the rest of Europe. After decades of evasive promises, it appeared at last that England might be ready to offer Ireland the Home Rule it sought. At the same time events on the continent seemed to be moving toward war, as Prussian militarism made its power felt. Now the two movements intersected. Fearing that England might indeed go through with its plans, those people in Ulster, led by Sir Edward Carson, who feared union with the Catholic south, ran a cargo of arms to the port of Larne in northeast Ireland and distributed the weapons to their supporters. The English did nothing to stop them but as soon as the arms were safely stowed prohibited the further importation of weaponry into Ireland. The legislation struck the nationalists in the South as grossly discriminatory. In July the Dublin Volunteers, counterparts of Carson's Ulster forces, marched to the tip of Howth to receive a shipment of arms from a yacht that had sailed in from behind Ireland's Eye. British soldiers blocked their line of march back to Dublin, and the Volunteers scattered, though keeping their guns. That evening the Dublin citizens taunted a group of soldiers gathered near Bachelors Walk on the northwest bank of the Liffey just off the O'Connell Bridge. Tempers grew hot, and the flustered soldiers foolishly fired into the crowd of Irish. Four people were killed and about fifty wounded. A week and a half later the First World War broke out, and whatever chance England might have had for united Irish support was irretrievably lost.

John Butler Yeats, almost totally nonpolitical, was in an odd position when the war began. He wrote Jack: "England humiliated would not mean *for me* the end of the world. I could survive seeing her taste a little of that humiliation which she has considered it her mission to inflict on everybody else. After all I

am an Irishman first and a British citizen after."[51] But he took most of his
political positions from Quinn who, despite the Bachelors Walk massacre, very
quickly decided that in a serious conflict between England and Germany he
would have to back England. Before JBY learned Quinn's thoughts on the
subject he vaguely opposed Ireland's ancient enemy. When John Redmond
urged the Irish to enlist in the English cause he was outraged. It was "an
absurd speech," he told Jack, as it invited the Irish to enlist "in order to *mark
their gratitude* to England for a home rule that is so incomplete it is an insult."
Not that he favored the other side. "Of course I hate German militarism and
hope it will be crushed. But it is not for Irish nationalists to rally to the help of
England when she is quite resolved to refuse them everything for which they
ask."[52]

Yet more and more he swung around to Quinn's position that in a serious
conflict with Germany he would have to back England. "Better the rogue we
know than the one we don't know," he wrote Lollie.[53] While he was still
wavering between open support of England and benign neglect, he met in
Quinn's rooms a passionately anti-English Irish patriot named Roger Case-
ment who had come to America to seek Irish-American support for the
Germans. Quinn, who found it hard to endure visitors with a cause, invited
JBY to be present. Casement was something of a puzzle to both men, although
JBY told Lily he "liked him very much." He and Quinn observed both his
fervor and his emotional instability. Casement was not automatically popular
with the Irish. Russell called him "a romantic person of the picturesque kind,
with no heavy mentality to embarrass him in his actions," and expressed his
doubt about "the nationality of men who cannot live in Ireland but must
always be inventing grandiose schemes for us at the other ends of the earth."[54]

Papa wrote Lily a long letter about Casement and included a pen sketch of
him. His summary was crisp and pointed:

Sir Roger over here to promote the cause of the Nationalist Volunteers—in great
trouble over war, all his sympathies for Germany, partly because he really likes Ger-
many but chiefly because he hates England. . . . He is very high strung and over six feet.
Quinn is in high tension about him. . . . He talks all the time against England and is
about sick with grief over "poor Kaiser.". . . . He is well-educated and talks agreeably
even though so much on one subject.[55]

He found Casement a curious mixture of adolescent and fanatic, "like a very
nice girl who is just hysterical enough to be charming and interesting among
strangers and a trial to his own friends"; so he described him to Susan
Mitchell.[56] Quinn believed Casement was "seriously ill" and insisted that a
doctor take a look at him. The doctor told Quinn, "I have given Sir Roger a
great deal of advice which he won't take." "As you may guess," JBY wrote Isaac,
"Sir Roger is not a man open to advice on any subject."[57] Soon Casement left
New York for parts unknown, and shortly afterward Kuno Meyer arrived with

news that Casement was in Berlin.[58] Meyer was himself now in America as an agent for the German cause, much to the fury of Oliver Elton, who looked upon him as a traitor to the country in which he had spent thirty years as a teacher.[59]

Another Irish couple of ambiguous loyalties who turned up in New York before the war was a month old were Padraic Colum and his wife Mary ("Molly"), married since 1912. They had written ahead to JBY from Pittsburgh and sought him out as soon as they arrived. He found them delightful. Colum he had once described as "the only person in Dublin who is not a snob,"[60] and now he found Molly "very nice indeed," her attractiveness enhanced by her "warm-hearted alacrity" in speaking of Lily. They soon found a walk-up apartment on the fifth floor at 15 Beekman Place near East Fiftieth Street, overlooking the East River. Before long JBY was sketching Colum in his apartment, which he thereafter visited regularly. But Kuno Meyer visited often too, and JBY began to have uneasy feelings about the sympathies floating about in the atmosphere. By mid-December he assured Lily that "the Colums are not really pro-German," but Quinn was irritated by them both, and Dorothy Coates took a dislike to Molly. JBY felt that the Colums both had "a sort of cocksureness" that offended people. The differences of opinion over the war probably contributed to the edginess on both sides, but Quinn at length developed a respect for Colum.[61]

The war gave JBY another excuse for not returning to Dublin. Of course if Lily had been alone he might have joined her, but always there was Lollie. Hilda Pollexfen had taken her sister Ruth's room at Gurteen Dhas, though she spent most of her time away at school. For a time in 1914 Ruth Lane-Poole had returned to Dundrum and taken up lodgings nearby with her new baby. The one living room was not big enough for the two sisters. Several times Papa urged Lollie to establish separate sitting rooms, so that she could have the solitude she needed, but she disregarded his advice. Lily, fearful that her sister had been misrepresenting events to Papa, wrote at last in exasperation:

> Don't listen to a word Lollie says. She is not normal on any subject and more than abnormal on a few. Ruth and I are not in the least indirect. This is the sort of thing constantly happening. I went down to the village as I always do on a Saturday about 12, met Ruth accidentally. She asked me to go and look at a house she had heard was to let, so we did, rushed it and I got home 10 minutes late for lunch which had not even been set. Saturday is generally not very punctual. I told Lollie what we had done and gave her quite an amusing account of the ramshackle old house and the kind old owners. She received it all with a face like a wall, then broke out and attacked me, saying we "had planned it. She hated secrets. It made her sick, etc. etc." I hate writing all these tales, but I do want you not to pay the slightest attention to Lollie's letters. She has *neurasthenia, and living with her is an enormously difficult task for me as for anyone.* Whatever you do say nothing at all to Lollie on this, but read up neurasthenia. She is not [at] all as bad as she was and physically much better.[62]

To Papa's further anguish, the supply of letters from Lily began to drop off, and he had bad dreams about her health. The depth of his feeling shows in a letter in which he told of his dreaming of her "uttering a cry of distress, and someone said, 'That is your daughter,' and out you came from some inner room and fell into my arms, saying you were so tired, and I kissed your cheek wet with tears."[63] His psychic suspicions proved accurate, for Lily had developed painful boils and had to take a vacation from work. The illness brought benefits, for she was able to report on the doings of people she did not often see. While visiting the Chestertons at Beaconsfield she wrote Quinn of her host's odd habits: "He does not come to breakfast; I think he picnics in his room. Yesterday morning he sent down for a cup of hot milk and a bible. The first he got at once; the latter had to be hunted for."[64] That whetted the curiosity of Quinn, who had heard disquieting rumors about Chesterton which he reported to JBY. Papa promptly asked Lily whether it was true that Chesterton had made the leap to Rome. She replied in detail:

Mr. G. K. Chesterton is not R.C. He is always playing with the idea, and when I was there two years ago there was a priest on watch, a Father O'Connor, a common little Jackeen. He was far more at home in the house than Gilbert was, put his boots in the parlour and shut all the windows when he came down to breakfast in case he would feel a draft. They thought he was a delightful Irish peasant. I know he was the son of a publican or small shop keeper. He told old anecdotes and was quite uncultivated. He had a parish somewhere in the north of England. Belloc is a Catholic and a great friend of Gilbert's. He has thirst which he quenches and so Frances hates him to come near the house.

Lily was equally amusing about an evening with Lollie at Katharine Hinkson's. Henry Hinkson was supposed to be away, and Katharine thought the three girls might have a long talk together. But Hinkson arrived home unexpectedly and the evening was ruined. "He takes every subject and widdles it up till there is nothing left," Lily told Papa. "I really cannot endure him, and K.T. thinks him such a fine gentleman. There he sits, sunk down in his chair till he sits in his shoulder bones pretending to know everything."[65]

JBY wrote more and more letters himself—to Willie, Lily, Lollie, Jack, Isaac, Sloan, Quinn, Lady Gregory, Colum, Clare Marsh, Mrs. Becker, Mrs. Foster, Mrs. Ford, and others. Instead of diminishing as he aged, their volume swelled. Yet he was frightened—or pretended to be—at the thought that they might be digested for a Cuala book. "I tremble to think that my letters for ten years past are being typed," he complained to Willie. "I rather hope that if they appear it will be posthumously." Next day he added, "The resurrection of old letters that I thought dead and forgotten alarms me, as it would most men I think. I enjoy the self of the moment sometimes, but always hate my other selves. If I write a letter and do not post it at once, *it is never posted.* And this has been the fate of countless letters."[66]

Yet he kept at them, spending again what was already spent. The letters on

art and poetry were mixtures of the concrete and the abstract, with the latter more and more crowding out the former. Occasionally they could be specific. When Ezra Pound compared WBY's *The Two Kings* with Tennyson's *Idylls of the King*, JBY wondered "what the devil" Pound meant, saying his son's poem was full of "*intensity* and *concentration*," as well as of "another quality often sought by Tennyson, but never attained, and that is *splendor of imagination*, a *liberating* splendor, cold as sunrise." He concluded flatly, "I don't agree with Ezra Pound." Yet he conceded he might be wrong. "Ezra Pound is the best of critics and writes with such lucid force, and I am only an amateur."[67]

His remarks on Pound are the more interesting because they prefigure some of the things that were to be said of Pound later.

People everywhere (though not *all* people) are living the surface life, and Americans, led *by their women kind*, are leading the surface life with an absolute intensity. This is the gospel here and everywhere, and certain poets have taken it up and are also leading it though with nausea and a sense of its vacancy and futility. That I take to be the meaning of Ezra Pound's verses. In his work is no creation. . . . Here is only criticism of the observed facts. . . . By broken meanings and broken music and plentiful use of the ellipse he gives a portentous importance and menacing significance to all the trivialities of the surface life. . . . Among those who cannot live the surface life I would count *all* poets, Ezra Pound for instance. Yet their *effort to live this life shuts them out of the world of dream and desire*. Not for them the shaping power of imagination. They are exiles consoling themselves and others that they are superior beings, like poor devils in rags and out of elbows who would fain persuade you that they come of decent people, the only proof being that they are unhappy and speak with the accents of refinement and all the time professing to love their "method of existence."

Unlike Whitman, whom he resembled, Pound "degrades" the surface life, "showing it to be unworthy and doing it with a concentration of cleverness."[68]

The comments on Pound were mere footnotes to the larger ideas he was developing and throwing out in letters to his son. To his surprise he found he had a wider audience. Knoedler's Gallery had asked him to write an introduction for its exhibition of Whistler's works, and his essay was so good the honorarium was increased to fifty dollars from the originally agreed upon thirty-five.[69] He made the same arguments about Whistler's painting that he made to Willie about poetry. "All his life Whistler committed the unpardonable offense of being himself," he wrote in the opening paragraph. What he painted was not what the camera or the common eye might see but what he himself saw—"his function not to represent but always to suggest." "It may be said of art, that she carries no burthens; neither virtue nor carefulness nor the moral uplift nor patriotism, as irresponsible as some lovely girl who wants merely to be her winsome self; and it is with art as with women—while many admire, only the favored one understands."[70] Perhaps thinking of the Cubists and the radical Impressionists of the Armory Show, he was careful to add to Willie later in the year, "In every picture, in every poem, there must be somewhere an exact portraiture. Otherwise there is no work of art."[71]

In his letters to Willie he continually modified and expanded upon his basic belief that the poet must be an individual person making individual utterance. "Uplift" was deadly to a poem, "all ethical systems" were but "provisional arrangements." The poet was "an individualist, as is a man in love or a man with toothache." The writer of prose needs to use facts because he has an immediate audience; the poet writes for a distant audience. While his work was in process, the poet "must live alone in what may be called, not too grandiloquently, the spacious chambers of his own heart." He kept finding metaphors: "Poetry is the refuge and asylum of the individual man whose enemy is oratory."[72] "Poetry concerns itself with the creation of Paradises. I use the word in the plural, for there are as many paradises as there are individual men—nay, as many as there are separate feelings." In another figure he suggested the difference between the man of the world and the poet: "a people who do not dream never attain to inner sincerity, for only in his dreams is a man really himself. Only for his dreams is a man responsible." (Here he may unconsciously have borrowed from a quotation, attributed to "an old Play," which WBY had used earlier in the year in the Cuala edition of *Responsibilities*: "In dreams begins responsibility.") Declaring that he studied Shakespeare and other poets "exclusively that I may find myself," he added: "Science exists that man may overcome and control nature, and build up for himself habitations in which to live in ease and comfort. Art exists that man, cutting himself away from nature, may build in his free consciousness buildings vaster and more sumptuous than these, furnished too with all manner of winding passages and closets and boudoirs, and encircled with gardens well shaded and with everything that he can desire." It was a remarkable vision for the man who lived in the narrow room with the iron bedstead and the worn rug on the floor.[73]

While the life of Dublin was spilling over him in letters from abroad, he simultaneously lived the life of Bohemian New York on West Twenty-ninth Street. He observed the passing scene with detachment and amusement, making sure to take his long walk every day, as otherwise he would "have no health."[74] He occasionally visited Mrs. Ford, but her ignorance of and lack of interest in everything but money and famous people continued to annoy him. "When she is herself I like her greatly," he told Lily, "but she has got this bee in her bonnet, renown, fame, glory. That's what she is mooning after. Real literary people don't bother about such things."[75]

Among the "real literary people" who dined at Petitpas that year was Grove Wilson, a journalist who had come as a young Lochinvar from the midwest, where he had managed a small newspaper and gained a reputation as a wizard in chess. He was eager and ambitious and, tiring of his wife, had agreed with her to a divorce. According to him, she would sue on grounds of desertion alone, and he would leave everything to her except two hundred dollars, which he took to New York to begin a new life. Gossip at Petitpas held that he

had "made strong love" with two young ladies and had asked each to marry him. JBY believed he was in love with neither but was merely determined to make his way in the world; "like the great Duke of Marlborough he means to get by by making himself agreeable to ladies, and being good-looking and really extremely amiable and kind and clever in all sorts of ways, able in fact to do everything, whether in business or literature, he is sure to succeed, and I hope he will succeed. He will make good use of his success."[76]

One of the regulars at the Petitpas high table, Ann Squire, fell victim to Wilson's charms, and the two became constant companions. Suddenly Wilson departed, taking Miss Squire with him. He had been offered a job with McClure's in London, he said. But Josephine Petitpas told JBY that a few days after Wilson's departure a lady and gentleman had come looking for him "on behalf of his wife." They wanted to know if he had a woman with him, "for it was with a woman he left" the midwest, "leaving his wife," not quite the version Wilson had broadcast.[77] Later JBY learned that Wilson had remained in New York City, where he frequented a restaurant called "Polly's" along with Miss Squire, and there spent all his time and her money playing poker, squandering her annual salary of five thousand dollars.[78]

JBY continued to see the Sloans too, but not as regularly as before. Sloan's socialism was more violent than ever, and when Dolly suffered a kind of "mental breakdown" JBY blamed it on the strain of living among the socialists. She had to keep Sloan off his favorite subject. "But for her he'd talk nothing else, our silence itself an offense, even though he knows we are all sympathetic, except for his violence—and his violence is never in the same direction two days running."[79] JBY still thought him one of the greatest of American painters. He praised him to Jack and predicted that the landscapes he had painted on vacation in Maine would win the public over.[80] He saw Henri in the fall too and at his apartment met George Bellows, with whom he hit it off immediately, partly because he admired him as an artist and partly because Bellows was suffering from boils, just as Lily was; Bellows later produced a lithograph, *Artists' Evening*, that included the old man.[81] Another old friend returned after an unhappy absence of a year in England. Van Wyck Brooks had taken a job with the *Century* magazine, commuting to the city every day from his home in Plainfield, where he lived close to his friend Maxwell Perkins, now married to the Louise Saunders whom JBY had sketched many years before. Brooks hated Plainfield but couldn't afford to live in New York. Papa told Lily, "Plainfield is like Merville—everything in perfect order, but *no ideas*, nothing being respected but dollars."[82]

With life so busy the old man had little time to ply his trade. Rather he enjoyed the reputation he had already gained. He was delighted to learn that one of his pictures had been reproduced in the catalogue of the International Academy Exhibition in Rome, where it was displayed in the British section.[83] At Petitpas Henri told Ann Squire that old Mr. Yeats was "a better portrait

Studio Evening, by Marjorie Organ (Mrs. Robert Henri). Left to right: Robert Henri, John Butler Yeats, John Sloan. Collection: Ira and Nancy Glackens.

painter than Sargent or Watts "because of a fuller humanity.' "[84] Most pleasing of all was praise of his work by Jack in a glowing letter to Lily. "Jack's praise is just what I want," he assured Lily, "for somehow *I believe him*. Hitherto when people praised me I did not believe them. I thought they spoke out of good will or ignorance. *But Jack knows*. He is an independent thinker and a truthful man." He worked on his self-portrait, he told her, "only when the spirit moves me," though he was "constantly studying it" and knew that it would be "really a *masterpiece*."[85]

For John Quinn the old man was still a ready help, available not only for entertaining visiting Irishmen—Standish O'Grady came early in the year and enjoyed his talks with JBY[86]—but for weekends of companionship at Sheepshead Bay, where Quinn still visited his old love Ada Smith and her mother. On one of these visits Quinn showed him James Joyce's *Dubliners*. According to

Artists' Evening, by George Bellows. At Petitpas, in 1916; in the foreground are John Butler Yeats, George Bellows, and Robert Henri. Vassar College Art Gallery. By permission.

Quinn the old man read only half of it and returned it with the comment: "Good God, how depressing! One always knew there were such persons and places in Dublin, but one never wanted to see them." Yet he realized it was "a great book."[87]

One visitor who turned up at Quinn's toward the end of the year was Aleister Crowley, the "quite unspeakable person"[88] hired by MacGregor Mathers in 1900 to seize the headquarters of the Isis and Urania Temple of the Order of the Golden Dawn in London. JBY was unaware of Crowley's part in his son's life, and Quinn knew little of his past either, except that he had been driven out of England "by his notoriety" and was now "on his uppers in New York," hoping Quinn would assist him by purchasing his books and manuscripts.[89] Before long Crowley had met Jeanne Robert Foster, herself an occultist and theosophist, and JBY was to watch in horrified fascination as his son's old enemy proceeded to captivate the sensitive and vulnerable "loveliest woman ever."[90]

John Butler Yeats at Petitpas, 1914. Photograph by Caroline Geiger. Collection: Foster-Murphy.

Despite the financial rescue plan worked out by Quinn and Willie, no money changed hands before the end of 1914, as JBY was expected to generate income on his own and to receive help only when his debts became embarrassingly large. Suddenly in January, 1915, a sobering reappraisal became necessary. JBY, as headstrong on the highways as in the parlor, was notoriously cavalier as a pedestrian. On Monday the eighteenth he was "walking slowly" (as he described it) across Sixth Avenue at Forty-sixth Street when he suddenly "received a stunning blow" and found himself "crumpled up in the mud." He had been struck by a cart carrying goods for Greenhut and Company and knocked to the pavement. He remembered people trying to help him and remembered saying, "I am all right. Please don't make such a fuss. I can walk home all right." Then he was in an ambulance, and at the hospital discovered he was "the hero of a 'street accident.'" Thirty lawyers materialized at his bedside to offer their services, and he signed up with one of them without consulting Quinn, as he didn't wish to presume on their friendship.[91]

In letters to Dundrum he made light of his injuries, but they were much worse than he pretended. Damage to one eye caused double vision; one side of his nose was "completely without feeling, like a piece of wood"; he also developed "a slight paralysis" of the nerves of one eye.[92] For several months he was unable to work effectively, and he persuaded himself to believe that commissions were suddenly "begging" his "acceptance."[93] Collecting damages from Greenhut proved difficult, and for the first time in his life he was not only without money but without the means of making it.[94]

After the accident Elton quietly gave him a comission for a sketch that might fit into an envelope and enclosed five pounds in payment.[95] By the end of February, Willie had sent another ten pounds, and so he was temporarily out of trouble again, though obviously unable to support himself. Willie sought all the information he could get from Lily. "Do you know if he is in debt to his hotel again? Has Jack any idea on the subject?"[96] When Lady Gregory was in New York in March on the first of her two American visits in 1915, she pumped the old man dry at lunch at Quinn's. Papa complained to Lily that she put him "to the question" like a victim on a medieval rack and that Quinn had taken up the torture where she left off.[97] Father told Willie he was "quite prepared" to meet all obligations,[98] but Lady Gregory gave a different report: old Mr. Yeats was in debt to the boarding house for $529.80, and there was little prospect that his fortunes would improve. Willie immediately sent Quinn a hundred pounds (which Quinn converted to $478.75) and asked whether Quinn could supply the remainder. He wondered whether he should sell some of his Sligo Steamer shares, and Quinn advised him not to. Instead, Willie began the long series of transactions by which Quinn acquired most of WBY's original literary papers. In June, he received the manuscript of *Reveries over Childhood and Youth*, paid off the debt at Petitpas, and credited WBY with fifty pounds in the trust account.[99]

Quinn was careful to pay the money directly to the Petitpas sisters, making it clear to JBY that neither he nor Willie trusted him to handle it himself. As if to support their opinion, Papa wrote Lily expansively that after learning the board bill had been paid, he ordered fancy drinks for friends at his table and had three Scotches himself: "Prosperity opens the heart and loosens the tongue."[100]

Quinn had told JBY that Willie did not "complain or grumble" at parting with the hundred pounds and was quite willing to let JBY make up his own mind about whether he wished to return home. But Quinn wisely did not tell of Willie's further offer to pay eighty pounds a year toward expenses if JBY could supply the rest,[101] judging sensibly that if the old man were sure of a guaranteed specific income he might order yet more rounds of Scotches. Quinn watched over his old charge as if he were a feckless adolescent. When JBY let his beard grow too long Quinn made him have it trimmed, especially if he were to meet Quinn's friends at the apartment.[102]

April 26. 1915

367 W 29. St

My dear Mr̄ Baker,

I might have answered your note sooner — but — I have been making bad weather. Against adverse winds I have been taking my ship with all her tackle into port — she is now safe at anchor. & I am sitting ensconced in my favourite inn near the window of which I can see her sleeping on her shadow — a glass of warm punch at my elbow, while I am filling the room with peaceful tobacco smoke —

Then I am a picture of happy somnolence — relaxed to my finger tips.

After the accident the old man was never again able to contribute more than a small portion to his own support, but his optimism continued unabated. "I think in the near future," he wrote Willie, "I shall do much better and make money quite sufficient for my purposes and perhaps more than that."[103] Dolly Sloan arranged a lecture for him at a socialist hall in early March and drummed up the sale of tickets.[104] Late in the year, when he was scheduled to give a talk in Sewickley, Pennsylvania, he had to ask his hostess, Mrs. Edward Caughey, to send him the cost of the train ticket.[105]

JBY's letters made it clear, despite the usual ambiguities, that he had no intention of leaving America. In midsummer he wrote Mrs. Caughey: "I came to New York some eight years ago intending to stay three weeks or at most five. I have stayed ever since. Why? Were I to write my autobiography, the chapter in which I answered that question would be the most difficult in the whole book."[106] (When he at last wrote his autobiography he avoided the question altogether.) One reason for his refusal to return, of course, was the continuing tension at Gurteen Dhas, and Cuala hung as always on the edge of disaster. Willie tried to help Lily's embroidery department by enlisting Sturge Moore, the poet and engraver, to suggest designs. In his enthusiasm Moore thought each design should bring in thirty pounds. "I think that a dream," Willie told Lily, "but I think you should get £10 or £15." He thought she had "practically no rivals" if only he could get her the best designers, and he was quite willing to absorb the loss if the designs did not sell. He wanted to pay for the material and to compensate Lily for the time he might cause her to take from other work. At the same time he insisted that her "full profit must come from sales."[107] The arrangement was one he was to pursue, with indifferent success, for the next twenty years: he would provide funds where necessary to help his sisters over rough spots, but the profits must come from their own exertions. They were not to regard him as a wealthy gentleman supporting the hobby of poor relations.[108]

WBY sent the manuscript of *Reveries over Childhood and Youth*, the first volume of his autobiography, to Quinn after a typescript had been prepared for the Press.[109] Willie had succeeded in letting Lily see the manuscript

(*Facing page*)

JBY to Jeanne Robert Foster, April 26, 1915 (after his accident). "I ought to have answered your note sooner, but—I have been making bad weather against adverse winds. I have been taking my ship with all her tackle torn into port. She is now safe at anchor, and I am sitting ensconced in my favorite inn from the window of which I can see her sleeping on her shadow, a glass of warm punch at my elbow, while I am filling the room with peaceful tobacco smoke. There I am a picture of happy somnolence, relaxed to my finger tips." Collection: Foster-Murphy.

without Lollie's being aware that she was being denied access to it. He was frankly worried that the passages on Dowden might offend his father, but Lily's principal objection was to a description, which she wanted deleted, of the mental breakdown of Elizabeth Pollexfen Orr. WBY defended its inclusion with some spirit, observing that as he had disguised the details no one would be able to identify her. "It might be a Yeats," he argued. "I still think the incident should be left out," she retorted sharply, and continued, "I think it would give pain. The Pollexfens are not very tender of the feelings of others, and any of them might point it out to her." She added in a crushing rejoinder to his last point, "They know our Yeats relations to be all sane."[110] Willie, showing as always great respect for his sister's judgment, deleted the offending passage.

WBY did not want his father to see the book before it appeared in print. When Quinn received the manuscript he was careful not to let the old man inspect it. After dinner in his apartment one night he read selections aloud "from the last few pages" and from part of the account of John F. Taylor and John O'Leary, "but that was all," Quinn assured Willie. He flatly told JBY he would not show any other sections to him.[111] Although the printing was completed in October, Father was not to see a copy until February of 1916, a month before the official date of publication. WBY tried to quiet his father's apprehensions. "Lily approved the memoirs," he wrote, "and so you may judge from that I have not been too indiscreet.[112]

Indeed, Willie gave signs during the year of further mellowing. JBY was delighted to learn that he had visited Jack and Cottie; he longed to know how the visit had come about. "Did you invite him?" he asked Jack; "or did he come of himself? Did you make him happy and were you and Cottie happy?"[113] He hoped the visit would narrow the gulf between the brothers. "I was always wishing you would go," he wrote Willie, and drove the lesson home: "You will find as you get older that there is a particular value in brotherly regard—I mean between brother and brother. . . . In Jack is an *unsunned* well of affection. He won't let the light get down into it. I fancy Cottie knows all about it. There must be somebody to whom Jack unbosoms."[114] Willie acknowledged that he had again made use of his father's ideas in a lecture he gave before a distinguished audience in December,[115] and he continued to praise his letters, which he transcribed and had typed the moment they came.[116] Father had jestingly referred to his commentaries as a "valuable addition to inexact thought,"[117] an apt enough description for a gathering of ore from which his son was expected to extract the pure metal. One letter on Wordsworth was so good that Willie read it aloud at one of his Monday evening "at homes."[118] WBY's descent from haughtiness was also marked by his increasing concern for the family line. JBY's sisters, Jenny and Gracie, owned some family miniatures and Willie asked Lily to learn whether they might give them to him. "I have a strong feeling for family memory and tradition," he told her. He promised that if he did not marry he would leave them to someone in the

family likely to carry on the family tradition, perhaps the son of Uncle Willy in Brazil.[119]

Willie thought he recognized other changes in himself. He told Quinn he had recovered from the "obsession of the supernatural," having "got my thoughts in order and ranged on paper."[120] Yet two months later, when Lollie told him that Lily was ill, he wrote to Lily: "I wonder if this is what George Pollexfen's ghost meant when it asked after you and Lolly and said, 'Ah, poor Lilly.' It may have known what was coming. By the by it insisted that it would appear to me when alone and insisted that I would be able to see. I have seen nothing yet."[121] Clearly, he was not free of the supernatural, nor would he ever be. Uncle George had been dead five years.

Lily's letters were as mordantly critical and observant as ever. At a party in Dublin she saw an uneasy George Moore, freshly returned from a pilgrimage to the Near East, a guest along with Oliver St. John Gogarty and Susan Mitchell. She described the scene to her father:

I sat between Moore and Gogarty, an almost overpowering position, Gogarty brilliant, Moore slow and fumbling for his words. The talk was more or less general. Moore is fat and white, not unlike an old sheep, his hands very fat and womanish. . . . He simmered with pleasure whenever the talk touched a book of his.

He handed me an olive branch to pass on to Willy. Without preamble he said he did not know how he stood with Willy and said, "I write humorous books or what are supposed to be humorous books and do not mean to hurt people."[122]

Earlier in the year she had brought Quinn up to date on the condition of G. K. Chesterton, who had been almost ruined by drink:

The doctors and nurses say they will pull Gilbert through—but [his wife Frances] is very hopeless. He is still unconscious, sometimes says a coherent sentence and then relapses again into unconsciousness. I am sure she feels if they do pull him through it will only be for a while; he will at once begin to slip back. He must be poisoned through and through. The drinking is an old story, a very sad, old story. He looks as if something was wrong from his birth—his great body abnormal in size and build. He cannot walk more than a few yards and then uses a stick. He pants, he perspires, he wheezes, he looks far older than Papa—nothing young about him but his hair and eyes and centre of his face. The rest is all double chins and hanging cheeks—and with it all and in spite of it all he is wonderful and so very very likeable. He looks at one as if begging you not to see all that is wrong—just go on listening *but not looking.*[123]

Such accounts were tempting to the old man. He got pleasure from photographs of the interior of Gurteen Dhas. "I looked especially at the one which contained *my corner*, where I could see Willie's 'Collected Edition' shining white on the shelves." But though the sight made him "homesick" he dreaded "reviving old Dublin days."[124] He worried about Lily, whose illness, originally manifesting itself in the boils, proved to be anthrax,[125] but not even fear for her health could bring him home.

As soon as Quinn and JBY learned from Willie about Aleister Crowley's character they hastened to disengage themselves from him. "He is a perfect misfit here of course," Quinn wrote WBY. "His writings have no popular appeal. One hears awful things about him but beyond a big capacity for strong drink I have seen nothing crooked about him."[126] Those words were written before Crowley had an opportunity to display his talents in America. In Europe he had already succeeded in acquiring a bad name for himself among almost every group that knew him and created about himself an aura of mystery: he held in some quarters a reputation as "the wickedest man in the world," a title he helped encourage by writing such works as *Diary of a Drug Fiend*.[127] Crowley was a poet who wrote verse of a certain grace and compactness when he limited himself to a strict form like the sonnet. But he had trouble with prose, for his mind was essentially disorganized and unable to control vast sweeps of data and thought. It was ostensibly for the purpose of improving his prose that he sought the help of Jeanne Robert Foster. By the spring of 1915 it was clear that his pretended purpose was not his real one. He had met her through a "journalist friend" at a dinner party where Mrs. Foster and another woman were fellow guests. Crowley, who had a way of characterizing every woman he met, described Mrs. Foster as "ideally beautiful beyond my dearest dream" and found her speech "starred with spirituality." He promptly nicknamed her "the Cat." At the same time he dubbed the other woman "the Snake" and described her as glittering "with the loveliness of lust, but worn and weary with the disappointment of insatiable desire." Crowley thereupon proceeded to entrap each of them, using "the Snake" as an outlet for his frustrations when he failed to achieve his ends with "the Cat."[128]

For a time he succeeded in duping Jeanne Foster, who was betrayed by his ugly good looks, his charisma, his position as leader of a magical cult, and his reputation as poet. She was disturbed and fascinated by him, alternately attracted and repelled. He called her, at her request, "Hilarion," a name he used in sonnets to her. During the early stages of their relationship she wrote poems to him, one of which, entitled "Wife to a Husband," is an autobiographical sonnet in which she expresses her distress at Crowley's earlier marriage.[129] When JBY wanted to paint her portrait she pleaded illness. Wanting his advice but afraid to ask for it directly, she sent him instead one of her sonnets, hoping he would take the hint and ask questions. He remained the Irish gentleman.

> The poem you enclose I have read several times. I do not exactly make it out, but I like the difficulty, because it seems to me the expression of an intensely interesting mind at an intensely interesting moment. . . . I will *perhaps* ask you about it when I meet you. I say *perhaps* because in this poem there is apparently an "inner something" not to be disclosed except behind the veils.[130]

She then asked him directly about Aleister Crowley, from whom, she explained, she hoped to learn the secrets of magic. He pretended not to see the

Jeanne Robert Foster, 1916. Collection: Foster-Murphy.

connection between the poem and the question. Carefully weighing his words so as not to wound the spirit of a woman obviously infatuated and yet wishing her not to become involved with Crowley, he replied:

> I have met Crowley and enjoyed his conversation very very much, principally I think because of my profound distrust of the talker. I think he is a man to beware of. No one seems to think well of him. He has an ambiguous history—queer happenings, which probably rumour has further distorted. Learn magic by all means, but be careful of the magician. They that sup with the devil must have a long spoon.[131]

His strong hints did no good. Suddenly Mrs. Foster and Crowley disappeared from New York, and when she returned some weeks later she was badly shaken. JBY either did not know the details of her adventures or chose not to speak about them. Crowley had persuaded her to accompany him to California, and even to bring her invalid husband along "to spice the romance and adventure." Crowley describes the curious hegira, during which Mrs. Foster presented herself to him at intervals. One time he met her "in the dusk just beyond the town limits" at Santa Cruz; at another time in Los Angeles she spent two hours with him during the morning. His innate cruelty soon destroyed her illusions. He was vicious of tongue, constantly berating people he considered his inferiors, and the pressure became too great for Mrs. Foster, a kindly and idealistic person, to bear. To Crowley's fury she left him and with her husband returned to New York. Crowley had wanted to have a child by her, and when his hopes were dashed, he deluded himself into believing that by a series of magical acts he had begotten with her on the "celebration of the autumnal equinox" a mystical child who was born "on a plane other than the material," and who proved to be in the flesh one of Crowley's followers, C. Standfield Jones, already a grown man but now mystically reborn during the summer solstice of 1916.[132]

Clearly, Jeanne Foster was well rid of Aleister Crowley, but he was not willing to be rid of her. After she rejected him he began to persecute her, "sending her husband anonymous letters" in which he accused her of "living with a wealthy lawyer" and warning him that she intended to poison him. Failing to bring about her return, he waited outside her office at closing time in midtown Manhattan and, when she came out on the street, threatened her with a "curious-looking knife." Only the fact that a crowd quickly closed in enabled her to escape.[133] Eventually Crowley disappeared from her life and JBY's, and all that remains of their sudden, intense, and peculiar affair—except for the reborn Jones—is in his *Confessions*, her poems, and a few letters of John Butler Yeats.

Though the war had slowed the annual influx of foreign visitors to America—the Abbey company, for instance, was not to return to America until 1931—many old and new ones appeared or reappeared. Lady Gregory visited twice in 1915, early in the year and again in the fall. It was on her first

stop in New York that she put JBY "to the question" about his finances. She dined with former president Theodore Roosevelt and asked him point-blank whether he had ever publicly denied Kuno Meyer's quoting him as saying that the Germans would win the war. "He said no, but pointing his finger at her he said, 'I authorize you to contradict it whenever and wheresoever you like.'"[134] Her friendship with Quinn deepened, as Father reported to Willie. Even if Quinn was sometimes "crude," JBY told him, he was still "the perfect American," and Lady Gregory gave him the care and praise he needed, for "notwithstanding his *baldness* he is a curly-headed boy, also very susceptible to any charming woman who will pat his curls."[135]

During her second visit JBY confided to Lily that Lady Gregory and Quinn "are now quite like mother and son. She calls him, quite naturally, 'John.'" But, he warned her, "*Please don't tell this to anybody in that whispering gallery called Dublin*, where her enemies abound."[136] Lady Gregory still showed her preference for men. During her fall visit, JBY noted, she spoke often of Willie and Jack but never of Lily and Lollie.[137] When Eulabee Dix Becker, a difficult woman herself, asked JBY to introduce her to Lady Gregory he declined emphatically. "I am quite ready to face ordinary dangers such as stopping a runaway horse, etc., but won't try to bring about your and Lady Gregory's meeting."[138]

Her presence in America made her friends acutely aware of the war. Quinn worried about her safety on the return voyage, having heard through the German Embassy in Washington of German plans to sink English civilian ships. She told him her chief worry was the short voyage from Liverpool to Kingstown.[139] Despite her fears, however, she arrived safely.

Her nephew Hugh Lane was not so lucky. He had come to America to buy pictures shortly after his aunt's return. The banker J. P. Morgan treated Lane superciliously until he realized that Lane knew more than he about his own pictures. He ended up asking Lane to dinner.[140] Lane visited JBY and told him gleefully of his triumph. During his last eleven days in New York he stayed with Quinn, "both mad about art and pictures, and both collectors, and with personality alike and very affectionate."[141]

Quinn urged Lane to return by an American ship, the *Philadelphia*, rather than the *Lusitania*, as disquieting rumors still floated out of Washington. Lane scoffed at the idea of danger—JBY thought he might have been "too proud" to heed such a suggestion—and refused to change his reservation. Many people asked him to remain longer and later blamed themselves for not being more insistent. Ten minutes before boarding the *Lusitania* he told friends "he hated leaving the sunshine of New York for the gloom of London."[142] Off the coast of Ireland the torpedo of which the Germans had boasted found its mark. Lane walked about on the deck of the sloping ship, pale and without a life belt, calmly helping those he could. "This is a sad end for us all," he told Lady Allan, who was rescued.[143] Lane went down with the ship. When Quinn

heard the news some days later he became ill and pale from the "shock"; he had long since lost his ability to accept untimely death with equanimity.[144]

Lane's death was a blow not only to his friends but to Ireland as well. Piqued at the Dublin Corporation for its refusal to accept his paintings, Lane had written a will in which he bequeathed to London many paintings originally meant for Dublin. Just before embarking on his American voyage he had a change of heart and added a codicil returning the paintings to Dublin, provided only that "a suitable building" for them be erected. The "sole trustee" was to be his aunt, Lady Gregory. With characteristic contempt for the forms of law he allowed his signature to the codicil to go unwitnessed, although he took care to sign each page, and he put the whole document in a sealed envelope in his desk at the National Gallery. At the probate hearing the English judges solemnly declared the codicil invalid, even though there was no dispute about its authenticity or intent and no doubt about the genuineness of Lane's signature. The pictures were assigned to England. Lady Gregory was to spend fruitless years in trying to shame England into returning the paintings but was no more successful than the Greeks had been with the Elgin marbles.[145]

At Lady Gregory's request JBY later wrote out his recollections of Hugh Lane for her use in a biography. She gratefully sent him a check, and the substance of his remarks appeared in her book on Lane, published in 1921.[146] The sinking of the *Lusitania* served to harden JBY's position on the war, which had come to him chiefly from Theodore Roosevelt by way of John Quinn. Both hated Woodrow Wilson, and JBY accepted their assessment. To WBY he described Wilson as "a third-rate literary professor, who is just now inditing some fine words where form will be everything and the substance trivial."[147] During the course of the year he was to refer to him as "a timid man of the *sort common everywhere*, hiding his poltroonery under the well-chosen words of a second-class literary professor"; "a maiden aunt"; and a "feeble long-tongued trickster."[148] William Jennings Bryan, about to be displaced as Secretary of State, he dismissed as "a great windbag."[149] He explained the shift from his long-standing abhorrence of war: "I tell all my English friends that England and Germany are both rogues, but that for the first time in her long and wicked history England has on her hands a righteous war."[150] To Lily he forecast what would happen if Germany won the war:

Denounce England by all means, as much as you like, but don't walk into the spider's parlour to be devoured by the Germans, who if Irishmen did not do as they were told would shoot them down like dogs. . . . They would bring over their soldiers and machine guns and make mince-meat of everyone except people of Belfast, and then colonize the place with Germans.[151]

At a library luncheon he found himself opposite George Sylvester Viereck, editor of the *Fatherland*, a German propaganda journal. JBY, speaking of the

Lusitania, wondered, in a voice loud enough for those around him to hear, how "an officer and presumably a gentleman could have been procured to do the foul deed." Viereck retorted coldly, "I would have done it myself." "Yes, Mr. Viereck, very probably," answered JBY, "but then you are not a member of a profession which is supposed to contain none who are not men of honor."[152] His sympathy with Kuno Meyer, whom he had defended in letters to Elton, evaporated. Meyer wanted to visit him, but JBY wouldn't agree, explaining to Isaac, "The *Lusitania* stands forever between me and Kuno Meyer."[153] Quinn was for a time interested in buying Augustus John's portrait of Meyer, but the picture proved nonvendable when it was discovered that someone had fired a bullet through it.[154] The war aroused strange passions.

An Irish visitor whom JBY met at the Colums' in 1915 was to assume greater significance to JBY the following year. She was Nora Connolly, the attractive young daughter of James Connolly, Irish labor leader and socialist. She had come to America on a secret mission, perhaps in connection with the abortive rising that was to occur the following Easter. She and the old man liked each other at once, and she remembered him vividly decades later.[155] Neither JBY nor Quinn was likely at that time to be aroused by the cause of Irish independence. Quinn had openly told a group of Irishmen in New York: "To Hell with Home Rule. The question now is whether Ireland is to be ruled by some Duke Swartburgh or by a Polo Player from Eton"[156] When Casement complained that the New York *World* had called him a paid agent of the Germans and sought Quinn's intercession, Quinn replied that he could not prove damages "as it was no disgrace for him to be paid by the Germans." He set forth his attitude toward Casement and other anti-English pro-Germans in a letter to Willie: "When he was here I told him that Irishmen who were anxious to save Ireland should go back to Ireland and save her and that I didn't agree with the policy of saving Ireland on this side of the Atlantic or in Berlin."[157]

Quinn's testiness against the pro-Germans was matched by a sudden enthusiasm for a project which troubled old Mr. Yeats. "He has no more control of himself than a child, but gives way to emotion just as they do," Papa told Jack.[158] Quinn had determined to have a weekend home to which he could invite his friends. He bought a large house in Westchester which had been the home of the Westchester Hunt Club. With characteristic extravagance he put out $42,500 for the property (which soon bore among his amused friends the nickname of "Purchase Street") and by the time he abandoned it two years later had spent $26,000 more on it.[159] Papa described the feverish activity to Lily: "He is like a child with a new toy. Of course he is going to spend a lot of money, removing barns &c from one part of the land to put them somewhere else &c. . . . New rooms to be built, even though the house is already large enough for anybody." He confided that his reasons for hating the house were "*mean, personal, and selfish*"—that Quinn would want him to go there and he wouldn't want to.[160] The years were catching up with him. "I am not and never

have been comfortable with a lot of men," was the surprising remark from the once faithful member of the Contemporary Club and the Calumets. "To be with riotous young fellows is a strain on me. It is like being with people who speak a different language, which yet you are expected to understand."[161]

Nevertheless JBY remained spectacularly active. After declining the offers of three publishers to write his autobiography—"I have no wish to unwind that mangled yarn"—he impulsively began it in a letter to Willie. It is hard to think of that letter as a formal memoir, though it is full of detail about his career as an artist, and about Todhunter and Dowden ("wild birds who lost in captivity their gift of song"), George Pollexfen and York Powell.[162] He raised specters of the difficulties he would encounter. "It is comparatively easy to write of my own people, but how will it be when I come to write about the Sligo people? My own people I know from within. The Sligo people I know from without, and am bound to misunderstand, just as they always misunderstood us."[163] He went no further with the autobiography then, but during the year worked sporadically at the self-portrait.[164] He urged Jack to imitate him by painting himself from a mirror, and Jack, who did not paint portraits, took his father's advice and produced an unusual full-length oil of himself.[165]

His own ideas, like the self-portrait, he was content to let remain unfinished, though he kept pouring them out in letters to Willie, modifying them as he went, developing new lines of thought suggested by old ones, wandering from one topic to another without bothering to tie up the loose ends. Yet through all there was a unifying thread: that art (whether in poetry or in painting) was a something, a quality, that resided in and among ideas and objects but was independent of them: every poem had to begin in a prose idea, every painting in a likeness to something visible. He delivered an opinion about "opinions": "Of these the artist is never the devotee. He plays with them. He treats them as a wealthy nobleman does his various Castles, which he inhabits from time to time but never permanently. And the reason is obvious. He is interested in personality, which is infinite, whereas 'opinions' are always finite."[166] He continued to fire arrows into what he regarded as his son's most vulnerable area:

I know that Blake's poetry is not intelligible without a knowledge of Blake's mystical doctrines. Yet mysticism was never the *substance of his poetry*, only its machinery. . . . His mysticism was a make-believe, a sort of working hypothesis as good as another. . . .

All the beliefs, all the creeds that have ever been are to the artistic mind a machinery and a vehicle for his own *creed*—which is that of all artists that have ever existed—that he himself exists, and that what he wants is more and still more existence.[167]

The day before he had written: "A mystic is a man who believes what he likes to believe and plumes himself on doing so."[168] To Mrs. Edward Caughey he expressed the same idea more strongly: "I hate mysticism, which to me is muddled thinking. Either we know or we don't know. But a mystic neither

knows [n]or not knows—he just wishes that things be so and then according to him they are so."[169] Defending his own views of the "extremists" of contemporary art he wrote: "Don't you think these brand new theories about art a little ridiculous—'high-browed' and ridiculous? Art without representation is to me a contradiction in terms. . . . Art is nine-tenths the finite and only one-tenth the infinite, and were the finite not there I should have no craving for the infinite. Damn all these artists who would get rid of their imitation of nature."[170] His reflections made an impression on Quinn, who was not bashful about appropriating the ideas of others. In a letter to James G. Huneker, Quinn echoed JBY in describing the difference between a painter and an artist. "If he paints to please someone else he paints to order, and a man who paints to order is no artist. The difference between an artist and a tradesman is that the artist paints to please himself or satisfy his conscience, and the tradesman supplies goods to order."[171]

The substance of JBY's letters was the stuff of his lectures. In March, at his talk in the socialist hall arranged by Dolly Sloan, a large crowd cheered and applauded. His lecture on art, he told Lollie, "was original, *all my own, my very own*." When it ended he gave by request a short account of Synge and read *Riders to the Sea*, evoking tears from the audience.[172] Yet as a painter he had the same poor luck as always. He produced only a few serious sketches in 1915, including one of Mrs. Maurice Leon, wife of the legal adviser in the United States to the French government, his friend Martha Fletcher Bellinger (with whom he had almost broken off earlier in the year when he mistakenly thought she and her husband had condoned the sinking of the *Lusitania*), and Quinn's sister and niece.[173] Otherwise he found himself less and less the painter and more and more the critic and sage.

In December he ran into another foreign visitor and self-proclaimed genius almost as obnoxious as Aleister Crowley. It was Frank Harris, whose egotism equaled the other's paranoia.[174] He and JBY were introduced on Fifth Avenue, and JBY, worried about Lily's health, was "for the time being ripe for quarreling," a condition chronic with Harris. They talked and wrangled on the street, Harris shouting, "American poetry—it is gangrene." The mutual dislike was intense and immediate. "He is an orator," wrote JBY to Elton, "a rhetorician, that's the worst kind of literary man though the most successful." They parted, "each hoping probably never to meet the other."[175] Later they did meet again, at Petitpas, and JBY sketched him. As with most people he did not care for, the picture did not come out as he wanted it to. He ripped the page out of his sketchbook and impaled it on a spindle, where it was later found and rescued by Jeanne Foster.[176] Harris, fortunately, passed out of his life.

The years were exacting their toll from John Butler Yeats. His hearing grew continually worse, and his teeth continued to deteriorate. His footing was so

unsure that in cold weather he always carried a cane. He refused invitations to dine, even those from the imperious Quinn, especially in winter. "The years have secluded me," he explained to Eulabee Becker, "and I am on the shelf. I prefer to rust, though I don't like other people to see how I rust."[177] He floated with the tides, accepting the inevitable with a becoming grace. He even assured Jack that he was deliberately following a plan. In his earlier days, he told him, "*I failed because I worked too hard.*" Now he had learned better. "Since I came to N. York I have taken things easily, *never worked at anything a moment longer than I was interested in it.*" He hoped Jack would heed one lesson: "*never interest yourself in anything you don't care about.*" It was not a good rule "for conduct," he cautioned, but the only "rule for art."[178] He compared ideal artists, as he had "opinions" earlier, to "wealthy noblemen" who own many castles "which they may occupy from time to time but never permanently."[179] Now he became the most splendid example of his own metaphor, the castles dotted on the peaks and slopes of his imagination.

As the time approached for publication of *Reveries over Childhood and Youth*, Papa grew more and more apprehensive, worried about the treatment of both himself and Edward Dowden. Willie tried to reassure him but admitted that he had to show Dowden "as a little unreal, a specious moral image, set up for contrast beside the real image of O'Leary."[180] But he knew his father's fears were really justified and hedged his apologies as publication day drew near. "I am afraid you will very much dislike my chapter on Dowden. It is the only chapter which is a little harsh, not, I think, really so, but as compared to the rest." He felt he had to use Dowden as a symbol "for the whole structure in Dublin, Lord Chancellors and all the rest," even though there was a distinction. "They were ungracious unrealities and he was a gracious one and I do not think I have robbed him of the saving adjective."[181]

Most will agree with JBY that the portrait was an unflattering one. Willie did indeed acknowledge Dowden's help but only in the most desultory way. "Dowden was wise in his encouragement," he wrote, "never overpraising and never unsympathetic, and he would sometimes lend me books."[182] There is no strong expression of gratitude to an older man whose encouragement had come at precisely the right time. One senses instead an air of condescension and dismissal; the total treatment is a brilliant example of damning with faint praise.[183]

John Butler Yeats disliked the book. He was embarrassed at the revelation that he had once thrown a book at young Willie's head, an event which his own memory had completely rejected. "Did you ever throw a book at your daughter or your husband?" he asked Mrs. Caughey. "If so be careful. They may write their memoirs."[184] The total portrait the son drew of his father, though a perfectly fair one from Willie's point of view, must have hurt the old man, who withheld his praise from the book. WBY leaves no doubt in the minds of his readers of his father's enormous influence on him; and he describes without

Frank Harris, 1915–1916. Pencil. JBY. Identification in the hand of Jeanne Robert Foster. Collection: Foster-Murphy.

rancor the eventual rebellion he mounted—or thought he did—against his father's teachings. Yet he leaves the impression of a parent who, despite a head bursting with ideas, was feckless and disorganized, one who could not command a son's deepest respect. There is little doubt that the character in *Reveries* was the one seen by William Butler Yeats, and little question either that the volume lacks even a single expression of love or gratitude from a son on whom the father had lavished such care and affection and energy. When WBY wrote of his father, the Pollexfen in him was in the ascendant, the part of him that didn't "mind in the least" how he wounded the feelings of another. For years afterward JBY repeated in one form or another the comment that inevitably sprang to his lips when he thought of the book, that it was "as bad to be a poet's father as the intimate friend of George Moore."[185]

He had more to worry about in 1916 than Willie's autobiography. He knew that a selection of his own letters was being made for Cuala, and even though he did nothing to stop the project he fretted about it. By early March the work was under way, and Willie let him know that there was no turning back. WBY had turned a preselected batch of the letters over to Ezra Pound for winnowing and editing: "I thought he would make the selection better than I should. I am almost too familiar with the thought." And there was a stronger reason: Pound's approval, "representing as he does the most aggressive contemporary school of the young, would be of greater value than my approval, which would seem perhaps but family feeling."[186] The information alarmed the author: "In all I wrote," he told Willie, "there is I fancy a latent polemic against much the he values." He hoped Pound would consult with Willie on the selections.[187] Pound proved enthusiastic about his part in the project, writing Quinn about "the high and mountainous parts of old Pop Yeats's letters, some of which are quite fine."[188] He didn't share JBY's view that the letters, having been written "earlier than yesterday," were inferior, full of "*intellectual wild oats*" and "crude thoughts, crudely expressed."[189]

The book would not be published until the following year, but while Pound was working on it he was also tying up the loose ends on his own Cuala offering, *Certain Noble Plays of Japan*. The circumstances surrounding its preparation and publication gave rise to another clash between Lollie and Willie. She had agreed to publish 400 copies of the book and pay Pound a twelve-per-cent royalty. Then, at the eleventh hour, the quixotic Pound sent an additional Noble Play, and Lollie discovered she lacked sufficient paper to print 400 copies if it was added to the book. She complained to Willie, who was unsympathetic, insisting that she should have warned Pound about the paper, and that if she should now print only 350 copies she should increase the royalty to fourteen per cent. "He agreed on certain terms and has kept his part of the bargain, I think."[190]

While Cuala was struggling with Pound's book, forces of dissent in Ireland were gathering toward a climax. Frustrated by the refusal of England to

The workers at Cuala Industries, about 1916. Collection: Anne B. Yeats.

grant Home Rule even after it had been agreed to, members of the Irish Republican Brotherhood, the Irish Volunteers, and the Irish Citizens Army agreed to coordinate their efforts against the occupying powers. Despite some eleventh-hour defections that caused a day's postponement, a well-coordinated band of Irish patriots moved swiftly on Easter Monday morning, April 24, to seize strategic positions in the city of Dublin and on the outskirts, and to defend them by force. So the Easter Rising was born. From the central headquarters in the seized General Post Office on Sackville Street (now O'Connell Street), the leaders proclaimed the establishment of an Irish Republic. For several days they held their ground while fighting raged within the city. But although it was a remarkably successful demonstration, as a military operation it was doomed. The patriots had no chance against the armed might

of England, which that country was never slow in using against those who questioned its supremacy. After several days of bloody fighting, the English sent gunboats up the Liffey and blew the center of Dublin to bits. "Sackville Street from the bridge to the Pillar is said to be just smoking ruins," Lily wrote Papa. "There have been great fires I know because I have seen them at night. . . . The G.P.O. is said to be no more than four walls."[191] The Rising was put down, the leaders compelled to surrender, and Ireland again placed under the military rule of England. General Sir John Maxwell was brought in to deal with the leaders. On May 3, less than a week after the Rising had ended, Padraic Pearse and Thomas MacDonagh were executed by a firing squad in the courtyard of Kilmainham Jail. One by one in the days that followed, others identified by the English as ringleaders, including Maud Gonne's alienated husband John MacBride, were similarly disposed of. The treatment accorded James Connolly, father of the Nora Connolly who had met JBY at the Colums' house in New York the year before, was one that burned itself in the Irish memory and converted the victim into a national hero and martyr. Badly wounded in the fighting at the Post Office, Connolly had suffered a shattered leg and was unable to stand. Instead of giving the wounded limb a chance to heal, the English had Connolly carried to the courtyard, ignominiously strapped into a chair, and shot. The deaths of the others were no less final, yet the manner of his sent a thrill of horror and rage throughout Ireland and through Irishmen and their sympathizers abroad.[192]

The events of the Rising and its aftermath have been well chronicled and need no repeating. What is important from the point of view of the Yeatses is that none of them knew anything about it until it happened. The author of *Cathleen ni Houlihan* was never consulted by the aspiring patriots and indeed was out of the country when the Rising took place. Lollie was away on vacation in Scotland, much to Lily's relief.[193] Lily was caught in Dundrum, where she spent her time writing detailed letters to her father as the news came to her. Jack and Cottie, at Greystones, were kept equally in the dark. Their exclusion from the conspiracy was not surprising. Although the Yeatses were all to a certain extent fervid nationalists, all—except Jack—abhorred violence as a means to achieve independence. Lily's view of events is suggested by her comments on one of the participants, Constance Gore-Booth of Lissadell, now Countess Markievicz, whose father before her had achieved a notoriety also:

What a pity Madam Markeviecz's madness changed its form when she inherited it. In her father it meant looking for the North Pole in an open boat, very cooling for him and safe for others. Her followers are said to have been either small boys or drunken dock workers out of work, called the Citizens Army. I don't think any others could have followed her. I would not have followed her across a road. I often heard the older Pearse speak at his school prize days and such things. I thought he was a dreamer and sentimentalist. MacDonagh was clever and hard and full of self-conceit. He was I think a spoilt priest.—Maud Gonne is at last a widow, made so by an English bullet.[194]

Countess Constance Gore-Booth Markievicz, about 1895. Pencil. JBY. Identification (misspelled) in the hand of Lily Yeats. Collection: Michael B. Yeats.

In her first letter to Papa while the battle still raged, she referred to the leaders of the Rising as "poor fools" and wondered what they thought "they were going to get by it all." When JBY wrote to Willie on April 29 he echoed his daughter's thoughts and added some of his own. "It is sufficient comment on the Irish uprising to say that Countess Markeviecz leads it and that P. Colum and his mother are sympathetic. It is not sunlight but moonlight, unwholesome moonlight."[195]

For days debate about the wisdom of the action enlivened the streets and the pubs, as the Irish themselves had been divided about the merits of the Rising. Lily was astonished to be invited to a party along with Susan Mitchell and others at William F. Bailey's house only to find that one of the guests was General Maxwell, "the man sent over to quell the rebellion," as Lily described him to Papa, but, she added, "in fact the public executioner."

He came with Lady Fingall very late, about 20 to 11 o'clock. There was a silence and a gasp when he came in. If he had not been in uniform the shock would have been less. I felt myself looking at his boots for bloodstains. James Stephens turned a yellow green and looked as if he would be sick. Susan left at once. Molly O'Neill immediately put forth all her charm and recited at him and for him alone a ballad. He is a stout short ruddy man, looking as many of the men in uniform do, rather unwashed and overheated.[196]

To the outrage of the executions the English added another. Sir Roger Casement, who had spent the year in Germany, tried to land secretly on the west coast of Ireland shortly before the Rising. His purpose, surprisingly, was to warn the patriots to desist, as he had learned that the Germans, who had promised help, would not give it. The English, forewarned, captured him soon after he was dropped ashore at Banna Strand. By May 15 he was in London accused of high treason. As the charge might have been a difficult one to sustain, the English allowed rumors to circulate that Casement's confiscated diaries gave clear evidence that the accused was a homosexual. The revelations, while not introduced at the trial, fatally damaged Casement's defense, even though Casement was charged not with homosexuality but with another offense altogether. On June 29 he was found guilty and, although he had taken nobody's life, sentenced to death.[197]

The shooting of the patriots proved a serious miscalculation. As Lily wrote in her scrapbook: "Till the first executions the feeling was all against Sinn Fein, but at the first execution feeling went round with a rush. The strongest Unionists shivered. A great mistake had been made."[198] Even before learning of the English retribution JBY shrewdly analyzed its consequences in a letter to Willie: "I think," he said of the patriots, "that in the ultimate their 'wisdom' will be more apparent than their 'folly.' The English legislate for Ireland always by forgetting that she exists. That's the whole of their policy.... This new rebellion has come again to disturb [John Bull's] hearty slumbers—and if he

executes Casement and the others it will be worse for him." America's sympathies, he said, were all with "Casement and the rebels."[199]

The volunteers had a clear vision of the realities, knowing that they would die—as the writings of Padraic Pearse make clear—and that their hopeless fight would serve as a symbol and a challenge, not an act of liberation. They had become convinced that only by a show of force could their case be brought to the attention of the world and of their own people. There had been too many empty promises in the past, too many betrayals. "There was one law for those who hated and another for those who loved their own land," Holloway wrote.[200]

The Volunteers also had a vision of the future, which they expressed in their proclamation, "To the People of Ireland," announcing the establishment of an Irish Republic. Beginning and ending with the customary obeisances to the deity, it was otherwise a completely secular document. The new Republic claimed "the allegiance of every Irishman and Irishwoman." It guaranteed "religious and civil liberty, equal rights and equal opportunities to all its citizens," and it made a direct appeal to "the whole nation" and "all its parts," "oblivious of the differences carefully fostered by an alien government, which have divided a minority from the majority in the past."

When word of the executions reached John Butler Yeats he expanded on his earlier prophecy. "So these poor rebels have been executed," he wrote Lily. "The government has done the logical thing, the average thing. . . . And yet they have done the wrong thing. These men are now embalmed in the Irish memory, and hatred of England, which might have died out, is now revived. Kept alive in prison, Ireland would have pitied and loved and smiled at these men, knowing them to be mad fools. In the end they would have come to see that fools are the worst criminals." For weeks afterward JBY dreamt every night of the executions.[201]

As soon as Quinn heard about the indictment of Casement he set about writing a long brief for the defense. He described Casement as "a highly strung, nervously organized man" who "was thrown off his balance by the war," and he vigorously defended Casement against the charges of homosexuality, of which he had seen no evidence. It was a magnificent plea, but before the English received it Casement had been executed.[202] John Butler Yeats wrote to Elton: "Of course England has to kill and kill and still even more to kill. Any country with an Empire over unwilling people must practice, though she be too astute to preach, the doctrine of frightfulness. That's my comment on the execution of the fifteen, and of Casement."[203]

JBY heard that one of his sketches, showing Horace Plunkett, Edward Martyn, and WBY together, had been lost in the offices of Maunsel and Company on Middle Abbey Street.[204] Lily described the devastation across the Liffey: "Sackville Street is gone. The Pillar stands up alone in a rugged plain. You cannot find Abbey Street or Earl Street. The R.H.A. is gone . . . —all the

pictures gone. They are already pulling down the bits of wall that are stand-ing. . . . Some of it is smoking still." Later she learned that four of the burned R.H.A. pictures were Jack's.[205]

Lollie worried that Willie would "feel" the event "greatly," for he had known many of the people involved. Her instincts were right. He wrote from London to Lady Gregory that he hadn't realized "any public event" could move him so deeply and that he was "despondent about the future." He told her he was trying to write a poem on the martyred men and quoted one of its tentative passages to her: "Terrible beauty has been born again." Maud Gonne had had a prevision of the whole thing, he told her. Willie didn't know how she felt about the death of her husband; he knew only that her main thought was that "tragic dignity [had] returned to Ireland."[206]

Out of the bitter events came his tragic ode, "Easter 1916," finished on September 25. Out of it too came his determination to spend less time in England and more in Ireland. He was afraid that some of his own writings, as well as his absence during the troublesome years, might have contributed to the tragedy. "I keep going over the past in my mind," he wrote to Quinn, "and wondering if I could have done anything to turn those young men in some other direction."[207] He seemed unaware that the leaders of the Rising, as their own writings make clear, cared little for him or his ideas and would have followed their own course had he never written a line.

To carry out his purpose, WBY bought, with Lady Gregory's advice and help, a ruined castle, Thor Ballylee, near Gort, which he eventually restored as a residence, though it would be some years before he settled in. He did not return to Ireland immediately after the Rising, preferring to remain with Maud Gonne in France, where he wrote not only the Easter Ode but the poem "In Memory of Alfred Pollexfen."[208]

Alfred's death in August aroused deep responses in the Yeatses, perhaps because he was the most lovable of his strange family, perhaps also because he represented the last significant tie with Sligo. John Butler Yeats wrote letters about Alfred to his children and to Isaac and was moved to philosophical generalizations about the two families from which his children were de-scended. Over against George Pollexfen he set his uncle Thomas Yeats, who gave up the promising career at TCD to take care of relatives in Sligo and who was admired and loved by everyone who knew him. "There can be no ques-tion," he told Willie, "as to who got the most out of life, my Uncle or G. Pollexfen." Tom Yeats "with all those burthens had an unbroken spirit." George Pollexfen's "spirit was broken, ground to powder." "It is a keen regret to me," he told his son, "that you did not know Thomas Yeats. It is a pleasure to me even to write his name. I often think you are very like him."[209] The old man was not above wry humor in discussing other differences between the families. When Quinn sent JBY an unexpected check from his son, Papa wrote Lily: "It may be endlessly debated whether Willie (whom the Pollexfens used

to hate, declaring over and over again that he was exactly like his father) is a Pollexfen or a Yeats. The fact is he is both, one side of him not one bit like a Pollexfen, and another side not a bit like a Yeats. It was like a Yeats to send this money and make no fuss about it. It was like a Pollexfen to have it to send."[210]

His worry over the Pollexfen strain in his children had also spread to Jack. Early in the year Papa heard from Lily that Jack was not well,[211] and he suspected it was the old family malady, "black melancholy." He encouraged Jack to think of the non-Pollexfen part of his nature. "Remember Corbet ancestors who were joyous people, with lots of sunshine in their hearts. The Middletons also are happy people. . . . Your grandfather sometimes was gloomy, . . . but you are mainly a Yeats and a Middleton and therefore have no excuse."[212] Jack was on his way to recovery when the Rising pushed him deeper into depression. He was the most radical politically of the Yeatses.[213] He had become a dedicated Irish nationalist, and since moving to Ireland six years earlier had attended Sinn Fein meetings regularly. His sense of horror at the barbarity of the Bachelors Walk massacre was communicated starkly in his painting entitled simply, *Bachelor's Walk: In Memory*. Papa was kept pretty much in the dark about his son's condition and fretted all the more. By the end of the year Jack seemed to have regained his emotional strength, but his father remained worried.

One of the effects of Alfred's death and Jack's illness was to intensify John Butler Yeats's melancholy as he contemplated the extinction of his line. When he learned of the death of Lord Chief Justice Hugh Holmes, he recalled the dinner Holmes had given for him just before he left Dublin for the life of an artist in London. Four other barristers had been guests also. Now all but himself were dead, "forgotten except in the fond memory of their children and grandchildren." "If only I had grandchildren," he wrote to Lily. "That is my chief disappointment, though there are others which I won't mention."[214]

Willie, quietly if not cheerfully, still bore the burden of his expenses. "My son for the last year and a half has been sending me money," Papa wrote Clare Marsh. "He is not well off and I don't know how he manages it. But it relieves me of a lot of anxiety." And to Mrs. Foster he wrote: "he is his family's constant aid & help & mine also. It is done in such a way that one is left to think he is not himself conscious that he is doing anything."[215] His own ability to earn had not recovered since the street accident. Dolly Sloan came to the rescue again, as she had the year before, arranging a lecture for him on April 14 and undertaking to sell most of the tickets herself.[216] The evening was profitable, and JBY found himself with seven dollars after paying off his debt at the boarding-house. Yet by June 1 he was asking Mrs. Bellinger whether she could find anyone for him to sketch "for $5 upwards or downwards." In September he was again reduced to a single dollar, when by a stroke of luck he got fifteen dollars for a sketch and a promise of a commission.[217]

Yet life was pleasant. "There are things for which I would thank God if I

knew where to find him," he wrote cheerfully to Mrs. Bellinger.[218] He had endless projects to divert him. He might have accomplished more with his self-portrait that year if he had not returned to his long-neglected play. One project served as an excuse for not working on the other, and both served to keep him from his memoirs. After telling Willie he was planning to put all the play down on paper, he wrote shortly afterward that he was busy on the portrait.[219] Two weeks later both play and portrait had been shoved aside for the lecture to be given on April 14.

Yet somehow he finished the play by early June. "It is destiny and must be fulfilled," he had told Willie in March.[220] One night at the Sloans' he read the play to them and their guests, who included the Henris, Miss Squire, Grove Wilson, and others. Everyone praised it and told him he read it so well that he would have made a good actor.[221] Unfortunately, no copy of the play has yet been found, so it is not possible to know whether the praises of it were owing to mere politeness, to the magnificence of JBY's reading voice, or to a real splendor in the play. JBY summarized the plot in a long letter to Lily of November 29, 1916:

My play is all about a celebrated young poet—the scene is laid in Merrion Square— who is a woman hater and a defiant *materialist*, very scornful of the spiritual and the occult. He ends by being betrothed to a very beautiful heroine who has waited ten years for him, and by believing in ghosts. At the end of the play he bids them all to listen—for that he hears "celestial voices" and that now there is one voice speaking. All are hushed in awed silence. Then follows some poetry sung by the "celestial" voice, and this is the last verse which refers to my heroine, who is a haughty beauty now made tame, since her poet loves her. These words also tell that the house is now to be a lucky house and no more haunted—

> As snowy lawn about her throat,
> Her lovely throat,
> As doves aflutter round their cote,
> Their sunny cote,
> Unto her love shall clustering rise
> Soft hands that reach and suppliant eyes.
> And bending low she will surrender,
> Her children's children shall commend her.

The last of all words are said by an Englishman, a professor of mathematics, who comes in knowing nothing about "the celestial voices"—he is host and is giving a house-warming, and for over twenty years, it being a haunted house, no one would take it, till this "brave Englishman" had the courage &c. He suddenly enters among his guests who are all trembling with ghost fright, and says:

> "Well, my friends, we have had an entertaining
> and *instructive* (he has been talking a lot)

evening and let me tell you that this [is]
a haunted house, but I being an Englishman &c."

He also announces that that very night he will sleep alone in the haunted chamber. When he finishes his speech he is surprised and startled by everyone remaining obstinately silent, but is relieved when the whole crowd breaks into loud laughter in which he joins, thinking it a tribute to himself.

Having satisfied himself with the play's virtues, he laid it aside, but he made indirect use of it when he wrote to Willie after learning of the death in London of his old friend Todhunter, whose literary works suffered because he would never take advice. When Willie read his play, JBY said, he would never write another without consulting his father. "I think I shall be able to help you. I remember of old how quick you are to take a hint. You are receptive as well as creative. The minor poet and artist cannot take a *hint*."[222]

When he sought relief from other pursuits there was always the portrait. In October he told Mrs. Becker he had "painted it all over afresh," and added a sentence he would never utter within earshot of Quinn. "This portrait will last my lifetime and get better and better and never be finished." Two months later he told her he had started on it "afresh."[223]

He saw less of the Sloans because of the artist's increasing bellicosity on domestic politics and the war. He tried to get them to avoid the subjects in his presence. One night when he visited with them at a friend's house in Montclair, New Jersey, Sloan strayed into forbidden territory, holding forth on the war and the Germans, and his object seemed to be "to insult and humiliate everyone." Dolly sat in silence. JBY overheard the hostess asking her if she was enjoying herself, and she replied, "No, I am not." "Ah, why?" "Because of Sloan." A few nights later Sloan brought Dolly to dine at Petitpas. "I am sure it was Sloan's way of saying he was penitent, for he must have seen how bored we all were."[224]

JBY could forgive Sloan nearly anything, but another old acquaintance infuriated him almost beyond endurance. JBY ran into Rockwell Kent early in January and remembered his caddish behavior to his wife and baby a few years earlier. Now JBY was enthusiastically outlining his doctrine of personality when Kent broke in to announce that he had been working as a German spy and that he fully condoned the sinking of the *Lusitania*.[225] JBY fired off a letter to Sloan, as if to warn him that if his views on peace and war were the same as Kent's he had better not utter them in the old man's presence.

There is no excuse for a man like Rockwell Kent and his like. For these live in the United States and have been blown upon by the winds and *storms* of absolute liberty, so that each man is free to select his opinions and judgments. He has not been like the Germans kept in childhood and wrought upon in dependence. There is something inherently bad in a man like Rockwell Kent—or to put it differently and more indulgently and more accurately—there is something wanting.[226]

His views on the war still reflected those of Quinn, who was angered and disappointed that the "pusillanimous" Woodrow Wilson had been elected to a second term as president, even though he had, as JBY expressed Quinn's idea to Willie, "only a professional conceit sustained by a gift for empty professional verbiage, yet a sort of low cunning."[227]

Quinn's irascibility rose in 1916. He had recently lost "*a very important client*," JBY told Lily, because of his "aristocratic manner of doing business," a kind of "Napoleonic arrogance that was hard to put up with." Conversations on Central Park West too quickly turned into cross-examinations. JBY found himself at a disadvantage, for, as he innocently put it to Lily, "the fact is I am indefinite and vague and Quinn always precise and definite." Quinn, annoyed by the demands on his time by the "Purchase Street" house, put it up for sale.[228] It is not hard to see in Quinn's fatigue and irritability the first signs of the illness that would take his life eight years later.

John Butler Yeats sent his friend flattering and soothing letters. "I respect your ideals and standards," he wrote in April. "They are genuine and founded on knowledge, and you have the constant self-doubt and self-examination which the true artist as well as the true critic have in abundant measure." Quinn was a "true patron" not because he paid but because he understood. "Whenever you buy a picture my first thought is as to why you bought it. Again and again your judgment has led mine." He also tried to divert Quinn with letters of mock scholarship. Two of these involved the American mispronunciation of "arse" as "ass," for which JBY blamed the English. "The modern Englishman cannot pronounce the letter 'r.' He has not the necessary force." The Irishman made a clear distinction between the two words, knowing which one stood for "the animal with the handsome ears." "The Englishman feels compelled to call him 'donkey' lest he cause the ladies to blush. In Ireland ladies know the difference between 'arse' and 'ass.' " A few days later he returned to the subject, charging that "as England waxed in greatness and in the strength of her soul, 'erse' [the Chaucerian word] became 'arse'—at what exact moment the change took place I commend to the students of history as a new field for research. The change from 'arse' to 'ass' meant a falling away of national vigour." He thought the change was probably "consentaneous with the substitution of tea for beer."[229]

The letters of which he was proudest but which gave him most cause for alarm were those he sent to Willie. He thought them a "great improvement on the previous ones," which unfortunately were the ones Pound was preparing for the Cuala edition. "I have read more, thought more, idled more, and so I have more to say." He repeated his insistence that the poet must be a "solitary" even while "sociable," as he was sure Shakespeare had been, and that the poet, like Shakespeare, must shun "the controversies of his age." The poet and his poem were interesting but not, he reminded his son for the twentieth time, his "opinions." "Opinions are finite, and I discuss them. But you are yourself

infinite and belong to the region where everything is possible." Consequently "religious poetry" was a contradiction in terms. It "is poor and always will be so, because it asserts a definite belief where such a thing is impossible." He indirectly encouraged Willie to avoid mysticism by maintaining he was so "entirely of the poetic race" that he escaped its dangers. If the reader took mysticism seriously, it would call "for a very active exercise" of his attention and would interfere with the poetry. A poet had to presume a belief to give his poem substance, but "I do not ask of the poet that he find the truth, for if so where would I place any of the great poets?" Men seek in poetry "the *desire of growth*," which was "the law of man." By midyear he had found another way to express his feeling of the meaning of art: "All my theories point to one conclusion, that art and poetry are the effort to recover naturalness, which is forever to be lost and forever to be found. This and not joy or gladness is the pursuit of the artist and the poet."[230]

The ideas flowed on, consistent if paradoxical. The painter who openly professed himself to be both "democrat" and "socialist" nevertheless held that "the artist must always be an aristocrat and disdain the street." He declared: "I measure a people not by its number or their amount of well-being—*but by the number of its aristocrats*." In America there were great opportunities in poetry but no poets. "An aristocrat always issues from a dark cave, and in the ultra-modern electric-lighted America there are no caves." Some time later he wrote to Elton that three things "must exist together" if the age were to be a great one for poets: "1. *unlimited conversation*, 2. *freedom of thought*, and 3. *a spacious idleness*."[231]

He spoke of other matters too, now that he was past his mid-seventies and pressing thoughts intruded. The Darwinian materialist of the 1860's and 1870's had given way to the optimistic agnostic who didn't know exactly what the truth was but who was sure it was there and that it meant something. He told Willie that always at the bottom of his own "cup of . . . sorrows" there was a "residuum," a conviction,

an intuition inseparable from life, that nothing is ever really lost, and that if we could see our world and all that takes place on its surface, and see it from a distance and as if from the centre of the sun, we should find it to be a fine piece of machinery working to certain ends with an absolute precision. That is my only philosophy—a faith founded like that of Socrates upon the basis of my conscious ignorance. It is a sort of sublime optimism, and I am as well satisfied with my ignorance as my betters are with their knowledge.[232]

He hedged on the question of personal immortality. "As to whether we live after death and in what form we continue our existence I know nothing. Yet my conception of the meaning of the word 'causation' forces me to believe that nothing is ever wasted. Beyond that I have no beliefs and no ideas. Whether or not we sink back into that dark abysm of primal human nature I know not."[233]

He spent more time on the life he knew than the one he was unsure about. With few deadlines to meet and certain that Quinn or Willie or God would provide, he was free, like his imagined nobleman, to move about "in spacious idleness" from one castle to another. His only regret about his age was that he no longer had the energy to do what he once could. "If I was ten years younger," he wrote Isaac, "I could make a great success here painting portraits, but I am too old for the effort. I now know the ropes. I did not know them when I first arrived." The old man of seventy-seven was just beginning to learn his way around—when it was too late to prove himself. "I am an exile and a stranger," he told Susan Mitchell. "I am not alluding to my exile in America, but with the fact only too obvious, that I am a survivor, a late lingerer from another generation—and so demodé."[234]

CHAPTER SIXTEEN

1917–1919

TIME'S WINGED CHARIOT was overtaking John Butler Yeats as he approached his seventy-eighth birthday, and he knew it. "I am ashamed to be so old," he complained to Mrs. Hart. "It is disgusting. All the pagan that is in me arises in denunciation." He insisted that nevertheless he was "in good health and spirits."[1] Yet he didn't like to go out Sundays and evenings unless he thought a commission might result. He explained his feelings to an irascible Quinn, who couldn't understand why anyone should decline his hospitality. "In the morning I am a radiant youth of promise; in midday and afternoon a virile man; in the evening a depressed old fellow; like an old rooster I become somnolent. I don't eat much at dinner, but drink two bottles (half bottles) of California wine, which makes me rather more somnolent, but with a cheerful quality, like good dreams."[2]

One of his metaphors on old age, written to Willie, deeply impressed Maud Gonne. "The young do not see death and the old see nothing else. . . . In youth we don't see death. The stage is too crowded. In old age all the actors have left, and they were only actors, and death remains sitting patient on the stool." A couple of months later he played a turn on the figure:

Have you noticed that old men are almost invariably cheerful, and it is discipline, stern discipline, that does it. The King of Terrors stands so close to one's elbow that to digest one's food or to live at all one must be cheerful. A sad old man would not last a week. . . . Every time he opens his eyes he sees the bony structure which waits him and into whose image and likeness he will very soon be transformed, and that beyond question of any doubt. Therefore he turns his back on it and is merry."[3]

Yet 1917 brought John Butler Yeats his greatest public triumph and placed his name before a world that knew there was a poet named William Butler Yeats but was unaware that he had a father. For a time the older man's name replaced the younger's in the leading newspapers and literary journals of England and Ireland, and of some in America. Paradoxically, it was not for the paintings produced out of his lifelong genius that he was noticed and praised but for the snippets of miscellaneous prose which Willie and Ezra Pound had

put together for the Cuala Press. *Passages from the Letters of John Butler Yeats*, finished in February, 1917, was published on April 30.[4] Within a few months it had become a sort of sensation in the upper world of critics and poets, and for the first time in his life John Butler Yeats enjoyed the kind of international fame that had always eluded him. Yet the source of his new distinction existed in only 400 copies, and those not lucky enough to own one had to rely on the reviews, for there was no second edition.

The collection was an immediate success and a thorough one. Before the end of May it had been reviewed in the *New Statesman*, the *Daily News*, the *Sphere*, the *Irish Times*, and the *Manchester Guardian*, and other reviews appeared throughout the year. AE was "delighted" with the book, and D. H. Madden and Andrew Jameson sent congratulatory telegrams to Willie.[5] Many Dublin friends bought the book even though the price—eleven shillings—was high.[6] By July 17, 260 copies had gone out, and by the end of the year old Mr. Yeats proudly informed Mrs. Caughey, "Except for one or two copies, all the 400 of my book have been sold."[7]

The passages ranged in length from a few lines to a few pages. None was a complete letter. Pound provided in a charming preface a comment on the letters themselves:

In making a selection from them my great fear is not that I shall leave out something, for I must leave out a great deal, but that I shall lose the personality of the author; that by snatching at salient thoughts I shall seem to show him as hurried, or even sententious. The making of sages is dangerous, and even the humane and delightful Confucius has been spoken of in my hearing as a dealer in platitude, which he was not. If Mr. Yeats senior is shown in these pages as a preacher, and the vigour of his thought might at times warrant this loathsome suspicion, the fault is in reality mine, for in the letters themselves there is only the air of leisure. The thought drifts up as easily as a cloud in the heavens, and as clear cut as clouds on bright days.[8]

John Butler Yeats glowed as the notices and comments came to him. Some he heard of only by report, others he was sent copies of. "Chesterton," he told Mrs. Becker, "says it is 'a beautiful book' and that I am 'a great critic,' and the *London Times* is enthusiastic, and *The New Age* [says] that I am outside the poets the best critic of poetry the writer ever met, and a better critic than most of the poets he knows."[9] He had the right criticism but the wrong journal. The *New Age* praised the letters but was "filled with animosity for Ezra Pound."[10] The other review had appeared in the *Egoist* and contained even more laudatory phrases than those JBY alluded to:

Mr. J. B. Yeats is a highly civilized man; and he has the kingdom of leisure within him. Leisure for Mr. Yeats means writing well even when not writing for publication: writing with dignity and ease and reserve. And letter-writing for him means the grace and urbanity of the talker and the depth of the solitary; it means a resolute return to a few important issues, not ceaseless loquacity about novelties. . . .

Perhaps New York, encircling the writer with loneliness, has done him a service. Mr.

Yeats could do New York a service, if New York would listen, but America will probably succeed in shutting its ears. . . .

Mr. Yeats understands poetry better than any one I have ever known who was not a poet, and better than most of those who have the reputation of poets.[11]

This remarkable encomium was the work of a writer who was himself relatively unknown, and whose name either had not been mentioned to JBY or was forgotten by him when he wrote to Mrs. Becker. The perceptive and admiring critic was the twenty-nine-year-old T. S. Eliot, like Ezra Pound an expatriate, a college friend of Conrad Aiken and John Hall Wheelock. He was to publish his own first volume of verse during 1917 and, years later, write a classic essay on the poetry of William Butler Yeats.

Papa was delighted with the reviews. "I am awfully pleased with my book," he wrote Lollie, "and rather astonished. It is so much better than I expected."[12] The old demon of inferiority possessed him still. He hadn't known whether Edwin Ellis's poetry was good until Dowden's opinion told him what to think; now he knew his writing had merit only because the world told him so. It was a curious failure of nerve for an artist who insisted all his life that the poet should not heed the crowd. "Now I think it is a good book," he wrote Mrs. Bellinger, "and my conceit and vanity keep growing as is the way with weeds generally. Is there anything that equals the vanity of an author over his first book, except a young mother with her first baby?"[13] Of course it was not his first book. That, his address to the Law Students' Debating Society, had been published fifty years earlier, but he had long since forgotten about it.[14]

The publication of the book was itself something of a marvel. The author provided nothing but the material, waiting until he saw the finished copy before registering his complaints, not even reading the proofs. His two daughters took care of the details, even to substituting initials for names when the proofs were returned. (Willie and Pound had wanted all proper names spelled out, not caring who might be embarrassed.) The harried author worried about the inclusion of the names but did nothing, expressing his relief to his daughters only after the book was published. "There are no indiscretions," he wrote Lollie, "thanks to your italics."[15] (They were not italics but capitals followed by a short dash, but Papa persisted in calling them by the wrong word.) Quinn insisted that JBY identify the names but the old man begged that the identities remain confidential. "I don't think I should like to see those italics lifted for the general public. My criticisms were a little scornful of men who were old friends. It will be all right hereafter, when their widows, etc., are dead and forgotten."[16]

There were a few misprints in the book,[17] but Papa objected strongly to only one, thereby smoking out the full story of Pound's idiosyncrasies as an editor. JBY had written: "A man on his death-bed or after he has been snubbed by his wife may enjoy a few moments of solitude, the rest of his life is self-deserting gregariousness." In the Cuala text "self-deserting" was replaced by "self-

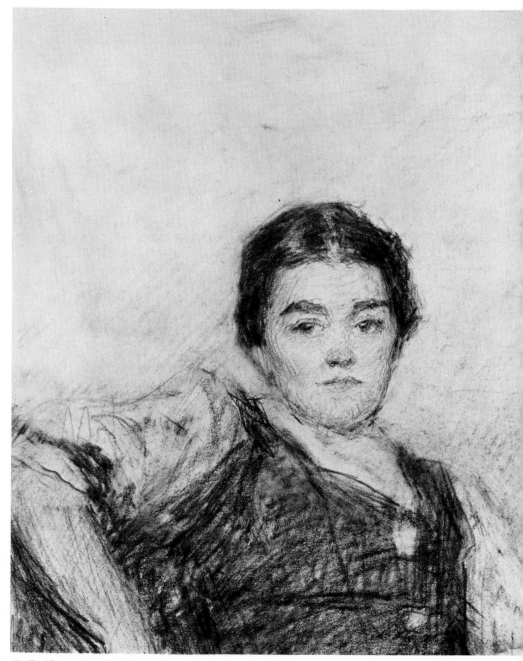

Dolly Sloan. Pencil. JBY. Collection: Helen Farr Sloan. By permission.

deserving," which, Papa said, "is nonsense."[18] The fault was Pound's. Lollie explained that when the typed copy came to her she sent it to Louis Purser for a general overview. As he didn't have the original letters he could only call attention to what seemed to him typographical mistakes or faulty transcriptions. He caught "self-deserving" immediately and questioned it in the margin. When the copy was returned to Pound he grandly swept his pencil through Purser's query, guaranteeing immortality for the error. Pound had also let stand a passage from Vergil incompletely remembered by JBY: "Sunt lachrymae rerum et mortalia me tangunt." In the original the word "mentem" appears before "mortalia." Purser called the omission to Pound's attention after the printed proofs had been returned. By then it would have been difficult and costly to make a change. Pound cleverly made a virtue of necessity by pretending to have been aware of the mistake from the beginning, adding a paragraph to the "Editor's Note" which preceded the letters:

The omission of "mentem" in the quotation on page fifty five is, so far as I am concerned, deliberate. Anyone might have quoted the line correctly and any editor might have emended it. As it stands now the Latin is, to my mind at least, more a part of the writer's own thought. The unessential word has been worn away, and with such attrition I leave it.[19]

Lollie, who had been irritated by Pound since the incident of the extra Noble Play, let him know her feelings. She also wrote her father: "Mr. Pound is the worst proof-reader I ever met, and the book would have been full of mistakes if we had not been careful, and also got Louis to do it. He had a maddening way of putting back mistakes that we had carefully corrected. He has a kind of impudent cocksureness. Indeed I rather objected to this manner of his, hence the more modest tone of the preface."[20] Pound airily dismissed her indictment, suggesting the mistakes be corrected in a cheaper edition "for those who can't pay 11/–." He nonchalantly accepted her judgment of his proofreading. "With the exception of your august brother I am about the worst corrector of proofs known to man."[21]

Despite the mistakes, JBY liked the job Pound had done and wrote to tell him so, receiving a long letter in reply. "I am glad you like the book and that you are satisfied with the editing. It gave me great pleasure to do, but an editor's pleasure need not of necessity mean a corresponding pleasure to the edited." He ended the letter, "I still continue to reread the book, *even* after editing it and correcting the proofs."[22] Pound had written earlier to Lollie of her father's letters: "If I had not found in them a certain vigour of phrase and a certain contempt for the consummate imbecility of America and for the Dowden type I would not have consented to edit them. If I had thought them tainted with the Victorian era I would have refused the job." Lollie sent the letter to Lady Gregory, who in turn passed on the laudatory words to the newly arrived author.[23]

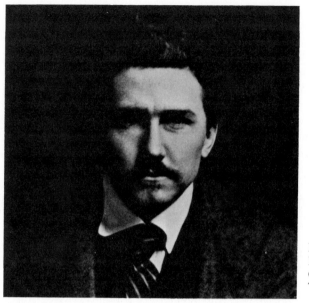

Ezra Pound, 1916.
Humanities Research
Center, University of
Texas. By permission.

Papa had been afraid Pound's anti-Americanism might offend his New York friends. "Ezra Pound is an American aversion," he told Mrs. Bellinger, "and I don't wonder for he challenges them and denounces their ideas, and I don't think he is far wrong." Since he agreed with Pound on many matters he thought they might dislike him too. His own philosophy, he told Lady Gregory, "is opposed to everything they think and believe here."[24]

Although people were annoyed with Pound, Quinn defended him stoutly. "I think he is a man of genius," he wrote Lily, who had expressed her own disapproval of him, and he praised his handling of Papa's book. He also suggested that another selection of letters might follow in either the *Seven Arts* or the *Little Review*.[25] But nothing came of the plan. JBY was proud of his later letters, those written in 1916, but Pound perversely saw them as inferior to the others. The old man's attempt to "explain" his ideas, Pound wrote to Quinn, had resulted in "a fatal new 'journalistic' wordiness and abstractness."[26]

The widespread public praise of the Cuala volume, the sincere adulation from so many quarters, lent a pleasure to the old man, almost enough to compensate for the disabilities of encroaching age. "Both sides of the Atlantic applaud you," Lily wrote him, "and Willy and Jack are not the only famous men in the family." JBY wrote to Elton: "I am awfully glad to be an 'author,' and stand in with you big fellows."[27]

But his old diffidence returned quickly. When Mrs. Bellinger, pleased by the success of the Pound selection, wanted to arrange the publication of some of his earlier printed essays, he backed away. She had already gathered a number

Lily (seated) and Lollie Yeats at Gurteen Dhas, about 1917. Collection: Michael B. Yeats.

together and wanted more. He wrote to her nervously: "I wish such a thing were possible, but alas! I have written very few articles. The 10 you have discovered are mostly by some other Yeats, perhaps my son, who I know has written for American magazines. Many thanks to you."[28] Mrs. Bellinger persisted but had to work without his help, and in the following year, when his *Essays Irish and American* appeared, it was with his "frank disapproval."[29]

Van Wyck Brooks urged him to do articles for the *Seven Arts* on Samuel Butler, William Glackens, and Ignacio Zuloaga,[30] and JBY partly complied; but when Brooks offered him a regular job, writing a monthly column on art, he declined. He clearly did not wish to wear the "harness" which, as Lady

Gregory had long since observed, he carried uneasily. He wrote that year a piece of semifiction of which he boasted: "The Wizard's Daughter," his private title for which was "A Fabulous Story of the Birth of Susan Mitchell."[31] A light and amiable piece of fluff which gave him a chance to express his admiration of the woman whom, next to Lily, he loved most, it was to call forth a talk by her on him later that would further add to his growing reputation.

When Lily scraped a pound together to send him along with £3.15, the net sum of the award for the loss of his drawing at Maunsel's during the Rising, he thanked her by saying, "It is all I have. It is still unspent."[32] He at first forwent the opportunity to buy a new pair of shoes at a bargain price and relented only when another pound and a half arrived from Lily. By March 6 he had to borrow five dollars from the Petitpas sisters and two weeks later accepted a standing offer from Mrs. Caughey to borrow money from her whenever he needed it: this time he owed seven dollars to Montrose, the art suppliers.[33] In April, however, he was the recipient of an enormous sum, £137, from an undisclosed source. Perhaps it was the legacy from Eric Bell, as no other likely benefactor is known.[34] Out of it he paid the Petitpas sisters $418 in full payment of his debt and had a balance of $246 left over. But when he received in August a bill for twelve pounds from Egan's, the Dublin company that had been storing his paintings, he couldn't pay it.[35] Where the $246 went is a mystery.

He had two commissions that year, one from Harriet Bryant, who ran the Carroll Gallery,[36] the other from Maxwell Perkins's mother, Mrs. Charles Perkins, who had been persuaded to sit by Van Wyck Brooks. Her experiences with him proved that his methods hadn't changed. He began the painting in May, but it was still unfinished in the fall.[37] Mrs. Perkins has not given her side of the story, but one can imagine it. By fall she was refusing to sit for more than an hour and a half a day; he wanted two. He complained to Lily that he had to paint "in a small neat apartment" and that he couldn't "smoke or swear, or step back to see how I am getting on." He felt "caged in on all sides." Mrs. Perkins he described as "a very nice elderly lady, with a New England mind—that is to say, very much interested in other people doing their duty."[38]

More successful, since they involved no pressure, were pencil sketches of Jeanne Robert Foster, which he made as studies in anticipation of a large oil for which she never sat. He had urged her for years to let him paint her portrait, but she couldn't afford a commission at any price and didn't want to tell him so. She knew he would insist on painting her for nothing, a generosity she would not accept.[39] After many delays he finished three large pencil portraits, two of which he had completed by the middle of March.[40] One was done on the back of a theatrical poster advertising Somerset Maugham's three-act comedy, *Our Betters*, at the Lyceum, the other on inexpensive paper that turned somewhat brown over the years. Despite her shattering experience with Aleister Crowley, Mrs. Foster had returned safely to the literary life in New York. In 1917

Jeanne Robert Foster, 1917. Pencil. JBY. Collection: Foster-Murphy.

she published her second book of poetry, *Neighbors of Yesterday*, a series of narrative poems based on memories of her childhood in the Adirondacks. A third volume she was planning, *Rock-Flower*, which was published in 1923, dedicated to the memory of JBY, carried one of his pencil portraits of her as the frontispiece.[41]

JBY's chief artistic triumph in 1917 came from a private exhibition of miscellaneous paintings at Mrs. Gertrude Vanderbilt Whitney's. Quinn once again lent the portrait of George Moore—"merely a sketch never finished and the work of two very short sittings," he described it deprecatingly to Mrs. Caughey—and it was praised by many, including the critic of the *New York Times*, who said it had "distinction" and did not "catalog" with the rest, which were "by the most illustrious painters of England as well as America." "I am always afraid to see my work at a show," he told Lily. "It is nearly always a shock. But this time I was pleased."[42]

With his new fame as a "critic," JBY was asked by Quinn to help on a legal matter involving free speech. In October the *Little Review* had been suppressed

by the Post Office because of its publication of Wyndham Lewis's "Cantleman's Spring Mate." Its editors had also been planning to publish Joyce's *Ulysses* in segments, and Quinn sought from his old friend comments on modern literature generally that he might be able to use in his brief. JBY had been baffled by *Dubliners* some years earlier, even while recognizing its power, but he had merely looked into it during a weekend at Sheepshead Bay and hadn't finished it. Now Quinn gave him *A Portrait of the Artist as a Young Man*, and JBY responded with comments that show how perceptive were those who called him a good critic. What he saw in Joyce chiefly was the poetry, though he answered Quinn's legal question too. "Joyce is a master of the pungent phrase. It is a part of his harshness; and there is poetry, plenty of it—a stormy sort of poetry, cloudy and wild, like the Irish skies in the winter months. . . . And he is a thinker, a man looking for a principle, his purpose other than mere mischief. And he is not a propagandist." Next day he added:

> I think what I enjoy most in that book is a conversation among the students. It is so medieval and Ireland is a medieval country. It is like a torch left on the horizon after a great thunderstorm. These young men are saturated with their religion, in spite of themselves and in spite of their free thinking, and that boy Latin they talked. . . .
> It is the first book out of Ireland which could be intelligible only among Irish Catholics. It is written for the Irish public and intelligible to others only by an effort. I showed it last night to Courtenay, the Englishman from Oxford, and after reading some pages he said, in his very English way, "Rather weird, is it not?"—that's all he could make of it.[43]

Much later he gave Quinn a fuller report:

> I have re-read Joyce's book of *The Artist as a Young Man*. What a wonderful book it is! Not a sentence, not a line, not a word would I blot. And what a style he has! It mutters and murmurs and sometimes sings. I find myself saying over to myself many of his sentences. And he is never long-winded, never says too much. That book will live forever, preserved like a fly in amber by its incomparable style—that style born spontaneously out of the strength and intensity of his complex personality. I don't think people have yet discovered that book. I have met many who have read it, but none of them had a guess as to its value.[44]

It would be many years before the world caught up to John Butler Yeats in his perception of Joyce, whose work henceforth he followed with the greatest interest.

On the alleged "indecency" of Wyndham Lewis's story JBY had equally illuminating comments. It expressed "not sensuality and selfishness," he maintained, "but the *loathesomeness* of both." The society of "respectability" and "social order" was shocked by such work, as it was by Swift's. "Such writers are without pity, but are of enormous value in breaking up the strength of hypocrisy and sentimental decency." He insisted that the Post Office "must withdraw its ban," and added, "though I *like hypocrisy*, I am not so utterly

abandoned as to help it destroy truth and honesty." Later in the day he sent Quinn a second letter in which he virtually repeated what he had said years before in his lecture on Watts: "It is not possible and it is not desirable to remove temptation from our path. It is by temptation we grow (and sometimes by yielding to it)—and *a frank and courageous statement of the facts of life* is one of the duties of Literature, indeed the very foundation of all literature." Lewis's work must be circulated, he maintained: "Everything in *that article* is true, and the *truth must be told, for the sake of the virtuous*."[45] When the case was lost he excoriated the judge who issued the decision. "The whole thing is laughable were it not sad to see Literature obliged to bow down before an incorrigible old woman."[46]

While in the midst of the fight over the *Little Review*, he also let Quinn have his thoughts on Ezra Pound, whose *Lustra* Quinn had sent him to read. The essays, JBY said, had "a queer kind of magic or startlingness and challenge"; Pound was "a powerful astringent." "Who reads him will discard the loose phrase and the flabby paragraph. It is his deliberate intention to inflict pain. And one does not mind, for it is salutary." He marveled at the depth of people's hatred of Pound. "But hatred is the harvest he wants to gather."[47]

With all Quinn's bustling about, JBY noticed even more the disquieting signs that had first come to his attention the year before. The lawyer was more than ever "too nervous and too *tense*,"[48] and he took so long to answer letters that AE had to ask Lily whether something might be wrong with him. By the middle of the year he was almost a medical case. "I saw Quinn on Sunday," JBY wrote Lady Gregory on June 20. "He looks badly, as if his nerves were all stretched and tired, . . . worn out by things that don't matter." Three months later he made to Lady Gregory what proved to be an accurate prophecy: "He can't possibly live to be an old man."[49] By the end of the year Quinn was worse. At one of his Sunday lunches he sat with "face pale and drawn" while all around sat "the wicked and the healthy."[50] Miss Coates had changed too, having "lost *all* her elegance" and become "a stout middle-aged woman with a reddish-brown face,"[51] and Quinn was obviously disenchanted with her. "I hardly ever mention a woman to him," JBY confided to Mrs. Becker, "for I never know who he likes. Bachelors are all odd about women."[52]

Father kept up his letters to Willie, though the stream was diminishing. Lollie had told him that many subscribers to the Cuala series were looking forward to "another book of letters,"[53] so he may have had an eye on the future. The basic message was still there: that art existed for itself and the artist, not for society or social betterment. Now JBY simply supplied further arguments and examples or looked at matters from a different point of view. He devised an ingenious apologia for the design of wallpaper. The wallpaper itself was not the art any more than iambic pentameter or rhyme was the poem. The art resided in the people in the room beneath the wallpaper who were acting upon one another or sat in solemn contemplation there. "A finely

decorated room, a finely designed and beautiful cathedral, are to me frames within which I can see humanity as a picture."[54] Hence he disliked free verse, then at the beginning of its rise to perpetual vogue in America. He had seen it "described learnedly, imposingly, and plausibly," yet was still "suspicious." He asked whether it was not just "another attempt on the part of Democracy to make poetry as clamorous and common as itself," and whether it did not attempt to "insult the past." "All that Free Verse can claim for itself is the credit of having discovered sensations and experiences that have been forgotten by the poets, and for which poets must enlarge their synthesis. This does not entitle Free Verse to call itself poetry."[55]

He continued his assaults on mysticism, even when he wandered into the forbidden field himself. Recalling Keats, whose letters he had been reading, he wondered, if poetry should come naturally like the leaves to a tree, whether the highest enjoyment might be silence. "And who knows but that death itself may be our re-entry into this silence of pure enjoyment." Then he added, "This of course is rank sentimentality, even though it be caught from the mystics, who are sentimentalists first and last."[56] This was in effect Father's answer to a flattering yet disturbing remark Willie had made a couple of months earlier in describing his new work, initially called "An Alphabet." He told his father, "Much of your thought resembles mine . . . but mine is part of a religious system more or less logically worked out, a system which will I hope interest you as a form of poetry."[57] When Willie spoke of religious systems Father shuddered.

Having occupied and enjoyed the castles where the letters and the play were stored, the carefree nobleman now turned to another, where a long-delayed project awaited him: his autobiography or memoirs. Lollie had persuaded him that it would make a good publication for Cuala, and he reluctantly determined to compose it by beginning with notes for a lecture and then simply writing as the spirit prompted. It was a formula that made his letters delightful, but it was not to work so well with the memoirs. "I shrink so much from this autobiographical business," he told Lollie, "that it is only by binding myself down in a promise that I can force myself to it."[58] He armed himself with a hard-covered notebook and proceeded to write.[59] With the enthusiasm he could always summon for a new project he began bravely:

My son and all my friends urge me to write my autobiography, saying that I have reached a certain period of life and can write grammatically and ought to tell about my insignificant past. If I can do nothing else I can do that. It is the last squeeze to be got out of the orange. Yet I have had my opportunities and might have known things worth telling. In the year 1857 and thereabouts I was in TCD, and when preparing for examinations I being of a sociable turn used to carry my books into the drawing room, so that I could carry on some sort of conversation whereby to relieve the tedium of hunting up words in the Greek Lexicon. In that drawing room would sit two old sisters, my grandmother who was verging on 94, and her sister, almost as old. I can see now

what I ought to have done. I should have abandoned the examination and got out a large ream of foolscap and interrogated those two old ladies. Their memory was good, the best possible, and like all Irishwomen and Irishmen, though they had read little except the novels of Fielding, they had the gift of conversation. It would have delighted these two idle but active-minded old ladies to travel back, taking me along, into the stirring times of '98, and of Emmett's rebellion and the French Wars and the O'Connell agitation, and all the tragedies and comedies which they had witnessed with their sharp eyes, and into which they and their friends had entered with partisanship on one side or the other. In other words I wish I had induced them to do what I am now doing and tell us about their past. Only in their case there would have been much to tell, whereas in my case there is nothing. Still I am the father of a poet, and if the poet is inaccessible, it is the next best thing to get hold of his father, and here I am.

It is a sprightly and engaging start. But the writer soon wanders, gets lost down side alleys, and grows as amiable and aimless as ever. "I think I have the right kind of narrative power," he boasted to Lily, "with philosophical theory put in here and there." [60] It was really the other way round, with the memoirs "put in" among the vast stretches of philosophy and sweeping generalizations—about the character of the Scotch and the English, the Irish peasant mind, the Ulster passion to "get on." Particular matters the reader would like to know more about—the Reverend William Butler Yeats's retirement from Tullylish parish, what Susan Pollexfen Yeats was really like, how JBY lost his estate—of these we learn nothing. There is much about George Pollexfen, a fairly full account of the days at Atholl (usually about others, seldom about himself), something of the Four Courts, and some nice anecdotes about Willie—the chess playing, the day at Ireland's Eye, the overflowing bathtub, the first poetry shown to Sarah Purser—but virtually nothing about Willie's mysticism or Maud Gonne or Lady Gregory. The "Memoirs" are on the whole a disappointment, though one is grateful for the odd fact that might otherwise have been lost.

There are magnificent aphorisms and splendid passages which we would not willingly let die, but they are not memoir. The author, not wishing to write a real autobiography, sought some other unifying theme and told Willie in the fall of 1918 that he had found one: the contrast between "two civilizations," the sophisticated and genteel one of the Yeatses and the "primitive" one of the Pollexfens. [61] But even that failed to draw the scattered threads together. While Lollie hungered for the text, hatching vain deadlines, her father proceeded at his own pace—"Some days it goes along very fast and some days very slowly," he wrote Willie [62] —and the book that was to result, *Early Memories*, would not be published till after his death. [63]

The only residence the old man avoided was the Castle of Indolence. He continued to move from one dwelling place to another during the year, however, returning to the self-portrait when he tired of the memoirs, and moving back again. His interest in the portrait was rekindled when Quinn commissioned Walt Kuhn to do a portrait of him, and the old man had to

endure the agonies of the sitter. Remembering Lily's stories about the long hours she had to sit for the female figures in the Defoe series, Quinn wrote her, "You are likely to get your revenge, but don't tell him about it. Let him learn it gradually." His plan was to have Kuhn do several sketches and studies, then eight to ten days of sitting, but he wouldn't let JBY in on the details for fear of scaring him off.[64]

JBY thought the Kuhn painting would be amusing but bad. "I know his style," he told Lollie, including a sketch in his letter, "something like this—*only more monstrous*." To his surprise he discovered that Kuhn's portrait taught him something. It was so interesting, he told Jack, "that I have just remodelled my own portrait of self to catch some of its merits."[65]

Lily's accounts of Dublin were as fascinating as ever. She told Papa of attending the Abbey performance of Gogarty's *Blight*,[66] where the house was so packed that she and Susan Mitchell had to sit "far on the side and under the balcony," Lily in a regular seat and Susan in a chair next to her. She saw Lady Gregory there, "but her mouth looked tight and her eye unfriendly so we did not talk."[67] Frank Fay was back in Dublin doing small parts at the Abbey. "I think Willie will get him to coach the company," Lily confided to Papa. "He is very hard up. The Shakespearean Company he was with came to an end."[68] She and Lollie still spoke bitingly of the patriots, preferring an effective Home Rule to government by "lunatics like Madame Markievicz."[69]

Lily missed Papa, wanting him home by the fire where they could sit "scoring off each other brilliantly" as they discussed Henry James's *The Middle Years*, which they were both reading.[70] When John Quinn wrote Lily about her father's general health and the happiness the success of his book had brought him, she replied in terms she would never have used to her father but which must have made even the grim and crusty Quinn swallow hard:

> I appreciate very much what you say about Papa. Not only do I love him as my father but as my greatest friend. When I think of his age and the distance he is off I cannot keep away my tears, and then the thought of the sixty years of hard struggle he has had for the money that never came! He doesn't know what a success he is, how fine his work is, what a big man he is.[71]

On April 16 the United States finally entered the war. Quinn, seeing vindication of his own position, was infuriated that the despised Woodrow Wilson should have taken the action, however belated, and received the credit; but he was pleased that when Arthur Balfour came to America he sought out Quinn's views on the Irish question.[72] The Clan-na-Gael crowd, led by Daniel Cohalan, was sympathetic to Germany, and Quinn was annoyed. His dislike for the Colums increased also as he still suspected they were pro-German and were being led down the wrong path by the Clan-na-Gael.[73] JBY told Susan Mitchell he was careful when with the Irish-Americans to talk only of "Life and Literature." "I know something of people like Cohalan and loathe them as I do

John Butler Yeats on the northwest corner of Twenty-ninth Street and Eighth Avenue, New York, about 1916. 317 West Twenty-ninth Street is at right in background. Collection: Foster-Murphy.

serpents." He told Lollie that the Colums were of "much finer fibre" than the others, "who are without *morals* and without dignity." He reminded her: "J. O'Leary always denounced the American Irish."[74]

John Butler Yeats could disregard the Cohalans, as he had no close ties with them. But with the entrance of America into the war his friendship with the Sloans almost foundered. As it was no longer fashionable, not to say legal, to support the Germans and their *Kultur* against the English, pacifism became the cloak behind which pro-Germans could hide their feelings. Sloan, of course, had always been a pacifist and his position neither pro-English nor pro-German; but now his vehemence became shrill. JBY wrote frankly to Van Wyck Brooks, perhaps hoping his message might get through to Sloan: "Sloan likes to be in a minority of one, and by Jove he generally succeeds in his wish. He is now a pacifist. I am waiting to see him separate from all the other pacifists and become his own particular pacifist." Shortly afterward there was a violent quarrel between the two painters. "Unwittingly I roused him," JBY wrote sorrowfully to Lily, "and he went off in a torrent of rage, his face getting black."[75] They had differed before, but this time the rift went deep. Dolly tried to patch things up, and JBY wrote mollifying letters. It was a long time before Sloan came round. The old man urged as his chief argument that "to become a fighter is to desert art," and added, "This would not trouble me if I thought you a minor artist."[76] Not until the couple was safely away in Maine did Sloan write a "kindly and friendly letter" to end the estrangement,[77] and by the end of 1917 all was well again. When JBY gave a lecture to artists and art students arranged by Dolly, Sloan gave him a warm introduction. "His pictures are the finest in America," JBY told Lily, but "he offends so many people and so constantly that he will never have any reputation till he is dead."[78]

Of all events grave or joyous that were to affect John Butler Yeats in that year of triumph, the most fateful was sudden and totally unexpected, if long desired. In the early fall William Butler Yeats got married. The bride, twenty-seven years his junior, was related by marriage to Ezra Pound's wife. Her name was Bertha Georgie Hyde-Lees, and although Willie had known her for many years he had never mentioned her by name to the family. Indeed, to their knowledge he was still interested chiefly in Maud MacBride and her daughter Iseult; a marriage to either one of them would not have surprised the family. Willie had apparently decided quite deliberately to marry and told Lady Gregory that he was sounding out Iseult as a possible bride.[79] In July JBY had a strange dream in which Willie appeared with a wife, "a foolish and forever chattering woman." The whole family was present as Willie was "threatened with a quick-coming death," and "all felt that he would recover if we could get rid of the wife." He was glad to wake up and discover that it was a dream.[80] That was during the period when Willie was negotiating with Iseult, who refused him.

Then Willie married Miss Hyde-Lees. He didn't notify the family until

the eleventh hour. Father received Willie's letter informing him of the coming event only after it had taken place. Rose the maid had been annoyed at the wording of the notice Willie had placed in the paper. "He did not say whose son he was, or nothing," she sniffed.[81] Lily and Lollie were not to meet the bride until the following year and found it hard even to get information about her from Willie. When Lily asked him whether she was short or tall, he replied with inscrutable Yeatsian vagueness, "She says she is short, but that is a question of definition."[82]

Papa wrote to Lily about the marriage with a mixture of skepticism, annoyance, and fear: "Though I am more than delighted—ten times more than delighted—to see him married, I don't like the young lady being only 24 years of age. If she were 34 it would be all right." But he was glad she was "clever and well-educated" and that she had "tradition coming from her family." He thought "Willie's luck" would "carry him through."

I hope I shall live to see Willie "moulded" by marriage. I contend that every man is a kind of wild animal, an antlered stag or it may be like the Prussian, a tiger, or like some men I have known, a monkey, until a woman has laid on him her hand. . . . Willie won't need a heavy hand, but his abstract and self-concentrated mind has produced a kind of *personal isolation*. Therefore his wife must do a little guiding and forewarning. He would surrender to her instantly, and be greatly improved in himself and in his poetry.[83]

He congratulated Willie: "No one really knows human nature, men as well as women, who has not lived in the bondage of marriage, that is to say, the enforced study of a fellow-creature." He hoped Willie had written to Quinn. "He is sensitive in these matters and likes to get the first news of his friends, and to have it sent from the friends themselves."[84] But it was from JBY first, and then Lily, that Quinn heard the news. On November 14 he arrived at Petitpas all excited to know what had happened.[85] Papa theorized to Lily about Lady Gregory's reaction. The marriage would be to her "a great relief. . . . She had known for some years that he had been longing for a home and family and that she could do nothing, all her time being taken up with the children. . . . What a good and kind woman she is." He added, "It is a pity she does not like her own son."[86]

So the new bride remained a mystery. JBY wrote to her to "brag" about the family, "but I think delicately," he explained to Lollie, "so as not to set her back up."[87] Besides learning that Willie intended calling her "George" rather than "Georgie," as her family had addressed her over her protests, he learned little about her except that she was five feet seven inches tall. He took some comfort in the statistical information, perhaps because he remembered his own experiences with Susan Pollexfen, who was small:

I was prepared for a little woman. This is a tall woman, or rather a tall girl. I think tall women are easier to get on with and live with than little women. They have more sentiment and gentleness, and because they are more conspicuous are more watchful

of themselves. The little women are constantly out of sight so that you don't know what they are up to.[88]

He was obviously fully prepared to like his new daughter-in-law, and fortunately she took the same attitude toward him. It would be more than a year before they met, and he came within a whisker of not being able to keep the appointment.

Although JBY might occasionally accept Quinn's imperious invitations, he still tried to avoid going out to dinner,[89] Quinn thought partly because of his hearing. When Quinn asked him to go to the theatre the old man would say, "Ah no, Quinn, I don't enjoy the theatre now and I will be happier down at my place or in my room."[90] When he caught a touch of the flu early in the year he couldn't shake off its effects on his right nostril, the one damaged in the street accident.[91] Yet he continued his daily walk whenever the weather permitted, "a beastly necessity," and his ailments were really no more than the effects of age. "He has lost some weight and grown whiter," Quinn reported to Willie, "but he is cheerful and hopeful and as alert, mentally and physically, as ever."[92]

Quinn, young enough to be JBY's son, could not say the same for himself. The old man's prophecy that he would not live to be old was prefigured early in the year. Quinn had first noticed symptoms of rectal bleeding "three or four years" before but had taken Russian oil and the bleeding had stopped.[93] Now it started again. On New Year's Day when JBY lunched at his apartment Quinn "seemed silent and sad." "I hate going to lunch with him," Papa told Jack. "He is always on nerves and never looks well or really happy. It is always like a visit to a sick house." Quinn's flesh grew "whiter and the bones of his skull and face" became "more prominent."[94]

Despite the symptoms, Quinn avoided medical treatment. As B. L. Reid has pointed out, Quinn had a preternaturally "morbid horror of death and an active hatred of disease."[95] His father had died in 1897 when Quinn was only twenty-six, and in 1902 his mother and two sisters died. In 1906 his brother Jim died and in April of 1916 his first love, Annie Foster. Early in 1918 he learned of the death of Florence Farr Emery in Ceylon. All his life was lived, it seemed, nervously and fearfully in the presence of early death. Now he had to face a possibly unpleasant truth about his own condition. Unable to ignore the signs any longer, he consulted a physician who diagnosed a rectal ulcer and recommended immediate surgery involving part of the colon. Quinn, ever the lawyer, sought a second opinion, which confirmed the first. Both doctors told Quinn his chance of surviving the operation was eighty to eighty-five per cent, but he knew that the real issue lay not in the surgery but in the nature of the ulcer. He took five days in which to settle his affairs, working night and day in his office to tidy up his business and arrange for the disposition of his goods.

Letter from JBY to John Quinn, January 16, 1918 (misdated 1917), with sketch of JBY reading to Quinn and his guests. The caption beneath the sketch reads, "Suspense is kept alive." Collection: Foster-Murphy.

Two days before the operation, with other matters cared for, he turned to the question of John Butler Yeats and his son, writing Willie a letter of seven typewritten pages. The coolness of the language is a testimony to his simple personal courage in the face of terrible fears. Not until the fifth page of the letter did he turn to his own problems, explaining precisely what they were. "I don't want to make too much of this thing, but I felt that you, as one of my oldest and best friends, would not be bored by this. I have written briefly to Lady Gregory." Then, at the end, aware that he might well be writing his last words, he casually added: "Well, my dear Yeats, don't think that because I have not written to you often that I have not often thought of you. You have older friends than I, but I doubt if you ever had a more sincere friend."[96]

Quinn survived the operation, which he underwent in February, 1918, but a large section of his intestine had to be removed, and for the six years of life remaining to him he had to wear a vest or corset to support his abdomen.[97] Thenceforth he lived in fear, in his case a justifiable one, that the growth would return. The Quinn who emerged from the operation was a different man from the one who went into it, more determined to relax and enjoy the beauties of the world, yet more testy and fretful at the unconquerable forebodings. He wrote WBY:

My illness has made me horribly sensitive and tender of suffering in others. Before, when I did kind or considerate things, they were perhaps mostly intellectually kind, kind without tenderness, except of course to my sisters and my parents and my brother when he lived. . . . I never before realized what a power for good money could be if there were tenderness and love as well as intellect in its use.[98]

He had hoped to be quiet and unbothered in the hospital, "to be free, while I was there, from telephone messages, and from letters and from calls, to be free for a few days, during the time I was in the hospital, to be a free man, as I had not been free for twenty years."[99] Despite his specific request, John Butler Yeats serenely sent him a letter on February 17, commenting on Quinn's "prison of silence," informing him of a lecture he was to give in Princeton, and allowing himself a paragraph of reflections on John Morley's *Recollections*.[100] Next day, over the pointed prohibition of Thomas Curtin, Quinn's secretary, he sent another which the nurse brought to Quinn with a "silly grin" on her face, telling him it was from the same person who had written "the day before."[101] A furious Quinn, unable to strike back at JBY, fired the nurse. He was to remember these events later in the year when the tables were turned.

Quinn's letter to Willie just before the operation was the first he had written to him in a year. WBY was troubled by his ignorance of his father's financial condition, not knowing that Quinn had carefully set down to WBY's account every penny he had spent for JBY. Willie turned to Lily for information and revealed to her for the first time his arrangement with Quinn about the purchase of manuscripts.[102] Then Quinn's long clarifying letter arrived. Only

a few days earlier JBY told Quinn he owed the Petitpas sisters $250. Quinn proposed to Willie that he advance the old man $200 against the purchase price of the manuscripts which Willie had mentioned to him the year before—*The Wild Swans at Coole*, "An Alphabet" (an early version of *Per Amica Silentia Lunae*), *At the Hawk's Well*, and *The Player Queen*, and Lady Gregory's *Visions and Beliefs*. Quinn didn't know how much they were worth, but the $200 he credited WBY's account would be considered an advance.[103] He was still aware that paying JBY's entire debt at once would only lead to cigars and brandies all round. Once in a while Lily sent something to her father, and Clare Marsh, finding some old drawings of his, sold them and sent him the proceeds. Yet in June JBY confessed to Mrs. Caughey that the Petitpas sisters had been paid nothing since Quinn's $200 on account in February.[104]

He had not changed, either with pence or portraits. An exasperated Mrs. Perkins had returned his easel and other materials, and her son Maxwell paid him in full, declaring the portrait "practically finished." JBY was offended,[105] but Mrs. Perkins and her son were merely doing what their counterparts in London and Dublin had learned to do long ago: "to snatch the painting from the easel" before it could be ruined. Besides the fee for the Perkins portrait JBY's only other sizable earnings were nine pounds in royalties, which he received from Lollie in July and promptly turned over to the Petitpas sisters.[106] The royalty was not for the Cuala letters but for the volume of JBY's essays which Mrs. Bellinger had persisted in compiling and seeing through the press. Working through Lollie, she persuaded the Talbot Press in Dublin and Fisher Unwin in London to copublish it, and Lollie got George Russell to do the introduction. Lollie found an old pencil self-portrait, signed and dated December, 1902, for use as a frontispiece. The book, ninety-five pages long, contained six of the twelve essays Mrs. Bellinger had collected.[107] Characteristically, the author was apprehensive up to the moment of publication. "I don't think that those articles that were published here should now be published in their entirety," he wrote in a worried note to Lollie. "They should be judiciously edited, for there is in them a lot of rubbish, intellectual wild oats, as it were," the same description he had given of the letters published by Cuala.[108] At seventy-nine his convictions had not yet hardened.

To his surprise the book was a smashing success. It was published in the middle of June, and by mid-September the first edition of a thousand copies was sold out. A second printing was at once run off, this time with a photograph of the author rather than a sketch.[109] Quinn had protested that the drawing had made JBY "look like a Jew from a ghetto." He told the old man it was a libel on himself. JBY replied that a man should be permitted to libel himself. Possibly, Quinn replied dogmatically, "but not if it hurts his friends."[110]

"Mr. Yeats is a real literary find," declared the reviewer for the *Manchester Guardian*, and the *New Statesman* and the *Observer* gave it friendly notices.[111]

Perhaps some of the credit belonged to AE's wise and affectionate introduction, which conditioned the reader to view the essays sympathetically. Russell, praising in public "the best of those bearing the name" of Yeats, graciously omitted reference to his squabbles with the author's son. He spoke of JBY not as artist or writer but as person, citing his "enchanting flow of conversation . . . with which we did not always agree but which always excited us and started us thinking on our own account." On JBY's delightful inconsistencies AE remarked sagaciously: "How witty Mr. Yeats is those who read these essays will discover. 'When a belief rests on nothing you cannot knock away its foundations,' he says, perhaps half slyly thinking how secure were some of his own best sayings from attack. I refuse to argue over or criticise the philosophy of the man who wrote that, for I do not know how to get at him."[112]

Van Wyck Brooks and Maxwell Perkins praised the book, and Oliver Elton wrote admiringly and with good humor from Liverpool. "I am amazed all through at the energy, combined with subtlety, of your writing. I am never tired of your pictures of the bad, class-minded Englishman who was so solitary and sulky that he nevertheless managed to produce Shakespeare."[113] Elkin Mathews was another Englishman who didn't mind JBY's "sly hits" at his countrymen, and who offered him the opportunity "to work off some more charming persiflage." "Can't you put together some 'Memoirs' of your life— Irish, English, and American? I should consider it a pleasure to publish it." And he added admiringly, "Here is a man, I said to myself, who can never become old, but who has been young a very long time."[114] Ernest Boyd also sought first refusal on an autobiography.[115] Suddenly John Butler Yeats had become a hot literary property.

Quinn professed to be pleased but not surprised at the reviews. Then he sternly drew the moral lesson. "That's why you must go on with the autobiography."[116] He and Willie agreed to pay five dollars for every thousand words of typescript delivered into their hands.[117] Yet the old difficulty remained. JBY constantly found excuses. "It takes a lot of time," he told Lily. "I have to think out things and my memory is a faded photograph. It takes a lot of 'doctoring' to revive the faded lines and colours." He found no trouble with the writing itself. "It flows in an easy narrative," he told Isaac. "Of course I attempt no fine writing, yet sometimes there is for a few sentences a lyrical flow."[118] In late May he estimated that he had finished 19,000 words, and a month later, in typed form, 30,000.[119]

The greatest difficulty was neither the memory nor the labor. The trouble was that the John Butler Yeats who wrote the life was the John Butler Yeats who had lived it. "I am telling the truth," he wrote Susan Mitchell, "the subtle and reconciling truth, and that is difficult and takes a lot of thinking. I don't want to offend people." "I mean to wound neither the dead nor the living and yet tell the truth," he declared to Isaac.[120] His approach was the opposite of George Moore's. Sensationalists like Moore falsified by exaggerating weak-

nesses and follies, John Butler Yeats by keeping the unpleasant at arm's length and omitting the seedy and the seamy. To that extent his memoirs were no more accurate than Moore's, and a good deal less diverting.

Because of the writing he hardly touched the self-portrait all year. But now, as a device for distracting attention from the autobiography, he began to advertise his play and insist that it was marketable. He had finally persuaded Quinn to listen to it one night in mid-January, when it "drew a spark" out of his "flinty bosom."[121] Father thereupon began a campaign to get Willie to read the play, but three months passed and Father heard nothing. As the silence continued his annoyance rose. In late May he wrote heatedly to Lily:

Willie I know has a curious idea that he is an extraordinarily wise person, and that I and everybody else are puppets to be moved about hither and thither as his wisdom directs. Possibly therefore he is withholding his opinion for reasons connected with the higher diplomacy. Possibly he thinks that if he praised the play I might set about another and neglect my autobiography. I have no such idea in my mind, and it is absolutely certain that I shall not have any such idea. Where did Willie get this idea that he is wiser than any one else—from Lady Gregory?[122]

Lily's requests to Willie went ignored. Papa grew angrier. "Why don't you tell me about my play?" he demanded of his son.[123] But even as he wrote, Willie's reply was in the mails, five months after he had first received the manuscript. The letter added no luster to whatever reputation for simple charity WBY may have enjoyed. Couched in what the son thought diplomatic language, it spoke in the Pollexfen voice:

My dear Father—I have never written to you about your play. You chose a very difficult subject and the most difficult of all forms, and as was to be foreseen, it is the least good of all your writings. I have been reading plays for the Abbey Theatre for years now, and so know the matter practically. A play looks easy, but is full of problems, which are almost a part of Mathematics. French Dramatists display this structure and 17th century English Novelists disguise it, but it is always there. In some strange way, which I have never understood, a play does not ever read well if it has not this mathematics. You are a most accomplished critic, and I believe your autobiography will be very good, and this is enough for one man. It takes a lifetime to master dramatic form. I am full of curiosity about the memoirs, but of course I cannot see them until the war is over.[124]

It was a cruel and quite unnecessary criticism, much like some he wrote to Abbey playwrights earlier, and one in particular to Sean O'Casey later when commenting on *The Silver Tassie*. In those cases the critic had the excuse of having to make a professional judgment and perhaps a commercial one. John Butler Yeats, on the other hand, was going nowhere with his play. Nothing was to be gained by damning it, and much to be lost in an old man's happiness by not praising it. Even Quinn, Russell, and Susan Mitchell spoke well of it, whatever their private feelings might have been. Since the play has not survived (or has not yet surfaced) one can hardly accept or reject WBY's

judgment. But what purpose is served by telling a homely woman she is homely? Papa swallowed the words, but they did not go down easily. He told Lollie he was "not one bit discouraged" and that he was sure the play would reach the public some day. "I don't know whether Willie showed you my play," he wrote Lady Gregory, "to which he is quite unjust.. . . . He is full of 'rules.' He is 'critic-bitten.' Shakespeare read in this spirit would not have a chance."[125]

Other news from Dublin that year was more interesting if not always more pleasant. Early in the year Lady Gregory's son Robert was killed in the crash of his airplane in Italy, and JBY wrote to assure her that Robert's memory would live "to generations unborn."[126] The excitement of Willie's marriage was still fresh, and the sisters in Dundrum celebrated as if it were a national holiday when the newlyweds made their visit to Ireland in March. Jack and Cottie came over from 61 Marlborough Road, to which they had moved in the fall of 1917. "We like George *greatly*," Lollie told Papa in a long letter. "You feel that she has plenty of personality but that her disposition is so amiable that she does not often assert herself—not from inertness, but because she is happiest in agreement with the people about her." On Sunday, March 12, Lily and Lollie went with Willie and George to the Abbey, where tea was served in the Green Room for the first time in years and where all were "charmed" with Willie's bride. Then the happy couple left for Glendalough and Coole. Lily later added to her sister's report on George: "She is that comfortable and pleasant thing, a good woman with brains, and no axe of her own to grind. After all, this is the best mixture to make a good wife and the best of mothers."[127]

Lily's remark was apt. Well before the year was out all the family knew there was to be a grandchild for John Butler Yeats after all. Most of the references to the welcome unborn were in the masculine gender. Everyone became protective, worried that some mischance might ruin this late hope for the establishment of a family line. The mischance almost materialized. Maud MacBride had long been living in France, unwanted by the English though still a British subject. Willie had finally arranged for her return to England, in the fall of 1917, but under the Defense of the Realm Act she was not allowed in Ireland. In a complicated arrangement which underwent many changes, Willie allowed Maud and Iseult to live free in his flat in Woburn Buildings while he rented a house on Stephen's Green on which Maud held the lease. Her son Séan was allowed to come to Ireland, where he stayed with AE. At the Stephen's Green home George awaited her firstborn while Willie worried. If anything were to go wrong, JBY wrote Quinn, "Willie would be in an insane asylum in six months. He could show no other sign of feeling."[128]

Then Maud made her move. Pleading tuberculosis, she asked Ezra Pound to seek help from the English authorities to enable her to move about freely. Pound wrote Quinn, Quinn cabled to friends in England, and the government agreed to let Maud go to Switzerland or Spain. Neither country would have

her. She really wanted to go to Dublin, Pound told Quinn. Quinn replied sarcastically that the "climate of Ireland was unsuitable for her trouble."[129] That was the last Quinn knew until Lily wrote him that Maud had illegally entered Ireland in disguise.[130] She could not have arrived at a worse time, for George had developed influenza and inflammation of the lungs and needed rest and quiet. When Maud suddenly appeared at the front door dressed as a beggar woman, her children with her, and asked to be admitted, Willie declined. Maud refused to leave. The doctor appeared and declared that Maud's continued presence might endanger George's life. "Still the lunatic refused to go," Lily wrote Quinn. Willie "had a scene with her and turned her out."[131] Pound had made to Quinn an amusing comparison between Maud Gonne's intensity on Irish nationalism and Willie's on mysticism. She was mad on Irish politics, Pound told Quinn, "just like Yeats on his ghosts." He noticed that "Yeats will be quite sensible till some question of ghosts or occultism comes up, and then he is subject to a curious excitement, twists everything to his theory, usually quality of mind goes. So with M.G."[132]

Just as Maud's nationalism still dominated her, so Willie still pursued his demons. One of the talents of Miss Hyde-Lees that had attracted the poet was her ability to do "spirit writing," the copying out of messages that came somehow from beyond. The atmosphere created by her talent was not favorable to the frank and open exchange of ideas between father and son. When Lady Gregory sent JBY clippings of reviews of WBY's newly published book *Per Amica Silentia Lunae*, he expressed his opinions of it in almost the same language he had used with Sarah Purser about *The Shadowy Waters* twenty years earlier. "I doubt if I shall ever understand his book, at least with my reason, but in time I shall get his 'point of view.'"[133] Earlier in the year he had boasted to Isaac that he had helped Willie grow by abolishing "religion and *insincerity*."[134] Now he had cause to wonder. After reading the clippings he wrote sadly to Willie:

I am sorry you are returning to mysticism. Mysticism means a relaxed intellect. It [is] of course very different from the sentimentalism of the affections and the senses which is the common sort, but it is sentimentalism all the same, a sentimentalism of the intellect. *"I will make the unknown known, for I will present it under such symmetrical forms that everyone will be convinced—and what is more important* I shall convince myself." So speaks the mystic, according to my idea. AE is a man of genius marred by mysticism, at least forced down into a lower grade. I must respect my poet, I must feel to my core that he has a vigorous character and an intellect clear as crystal. Otherwise I am soon tired of his melodious verses.[135]

Aside from the play and the memoirs and the occasional lecture—like the one at Princeton, where he was allowed to choose any subject except Woodrow Wilson[136] —John Butler Yeats's activities were pretty much as they had always been, if greatly slowed down. He did sketches for pay occasionally and

John Butler Yeats on the rear roof of 317 West Twenty-ninth Street, about 1917. Collection: Foster-Murphy.

dreamed of great portraits that were never painted. At Petitpas few of the "old gang," as JBY called them, still came regularly. When Harold Vizzard, one of his earliest New York companions, came one night early in the year, JBY made a special point of telling Lily. The new ones who came were only "temporary," he complained. "They never last beyond a few weeks."[137] One night the Sloans dined there, a rare visit now, since JBY was still annoyed by the "repulsive politics" of Sloan and his friends, and because Dolly's alcoholism had led her to the verge of breakdown.[138] A rival table had been set up by Henry Gallup Paine, editor of the old *Life* magazine, but JBY paid no attention to it.[139] His own table was now frequented chiefly by the female admirers who were the staple of his emotional support—Mrs. Bellinger, Mrs. Foster, Mrs. Brophy, Ann Squire—and only now and then were the chairs filled by the young and eager, including many who came once or twice in order not to miss the experience of the old man's conversation, men like Witter Bynner, Oliver Herford, Heywood Broun. In September the price of dinner went from ninety cents to a dollar, driving away even more of the down-at-heel artists and writers who had lent an air of Bohemian interest to the place. Quinn, who still refused to dine there, thought it a poor place for a man of JBY's age to live. There was no ventilation in the basement, and the upstairs was becoming seedy. The sisters were uneasy at what might happen when the new prohibition against alcoholic beverages went into effect the following year.[140] Talk of JBY's return to Dublin was revived, and he joined in it himself, telling Lollie in April that he might be home in the fall.[141] Lily was delighted and drew a pretty picture of what life would be like at Gurteen Dhas. "What a talk we will have! Your chair is ready and the little hole in the bookshelf for your tobacco box—cigar box now, I suppose. Your room is quiet as quiet. No sound comes through the 18-inch walls."[142]

Then the tide of his life suddenly turned. On October 30 he wrote Lily that a guest at Petitpas had caught flu but that no one was doing anything to help him. On Saturday, November 9, having enjoyed a dinner and talk with the Englishman Charles Courtenay and his wife, he staggered while leaving the table and had to go to his room. Soon he had a fever, and the Petitpas sisters became worried. On Monday, November 11, while the rest of New York celebrated the Armistice, John Butler Yeats lay close to death in his small upstairs bedroom. Quinn got the news that day and immediately telephoned one of his own physicians, Dr. C. C. Rice, and ordered him to send JBY to the hospital with a special nurse. Quinn himself found the boardinghouse so unpleasant that after an initial visit he did not return to it, and his absence weakened his control over events. Dr. Rice discovered how headstrong a patient he had when the feverish old man flatly refused to go to the hospital and even talked him out of ordering a nurse. Next day Quinn and Dr. Rice had a fearful row, and a nurse, Miss Finch-Smith, was immediately hired. Quinn, knowing that Jeanne Robert Foster (whom he had not yet met) was a special

friend of the old man's, wrote to ask her whether she would oversee affairs at 317 West Twenty-ninth Street, which for more than a week became a medical outpost.[143]

John Butler Yeats had come down with influenza and was soon to develop pneumonia. The influenza epidemic that year ravaged the country and carried off thousands.[144] Possibly the mild attack earlier in the year had given JBY a partial resistance which saved him, but for more than a week his condition was grave. When he got back on his feet it was with a weakened heart and a damaged lung.

The chief interest of the illness lies in the responses to it of both the old man and his guardian John Quinn. Papa was not an easy patient. "To put it bluntly," Quinn wrote Lily when it was all over, "I have had a devil of a time with your father." He told her he had left the unpleasant details out of the periodic cables he sent, and that even now "I have not time to tell the whole truth."[145] The patient himself denied knowledge of his transgressions during the early days of the illness. "Never did I feel so ill," he wrote Isaac. "I was quite crazy, trying to spell 'pneumonia,' puzzled also over what could be the meaning of six o'clock or seven o'clock. I was fed constantly with hot milk in which they sometimes put whiskey. I hated food." To him the nurse was worse than the pneumonia, and was the cause of the intransigent orneriness that so annoyed Quinn. JBY described her to Quinn (who never saw her) as "a tall, big woman, with an immensely long face, and a very small cranium." Although admitting that she carried out "the routine," yet "she was bad-tempered" and had "no intelligence, though cunning and untruthful." JBY persistently referred to her as "the orang-utang" and refused to follow her instructions. "I think her the most despicable woman I ever met," he told Lily. "Even when half-delirious I would say to myself, 'Thank God,' every time she left the room." She purchased a bedpan, but he insisted on getting up and staggering to the bathroom down the hall. Sometimes when she left the room he would lock the door and refuse to let her re-enter.[146]

But Miss Finch-Smith was as tough as her adversary. JBY complained to Quinn that she had struck him, and she replied that indeed she had, but only after he insisted on drying his hands on the sheet instead of the towel she had pinned to the sheet for the purpose. Thereafter he was careful always to use the towel. She was not afraid of him and let him know it, telling Quinn, "I have nursed many artists and find them all alike, impracticable and untidy, interesting to us if they do not belong to our own family." In the early stages of their battle JBY complained that she treated him like a child. "That is what you behave like," she retorted.[147]

Quinn was openly annoyed with his old charge and frankly sympathized with Miss Finch-Smith. He felt Lily should be told the truth:

I do not know how much experience you have had with old people, but they are just as difficult to handle as children, only one can spank children whereas one can hardly

spank old people. Your father is difficult to do much with when he is well. So long as he is interested or satisfied or amused it is all right, but he has not for years tried to adjust himself to others.[148]

Quinn's irritation at JBY arose naturally out of his own perception of life's inequities. Having had serious surgery himself and having seen so many of his own family die, he was simply unable to accept JBY's tantrums. He wrote him sternly:

> The game is all in your hands now. The wise thing for you to do is to play the game *as the doctor and nurse wish you to.* Any sickness with a person your age is no joke. . . . You have had a very pleasant and, in fact, a very happy life. Surely, with the large number of pleasant and agreeable hours, days, months, and years behind you, you ought to be able to be patient and considerate of the doctor and the nurse for a few days, just a few days more.

Next day he added in high satirical style: "I know that patience is a thing almost unknown to you, and therefore its cultivation will give you a new sensation."[149] Miss Finch-Smith told Quinn that JBY read only a few words from his letters, refusing to go further when he saw they were unpleasant.[150]

When the time came for convalescence Quinn proposed that he go for a time to the country with Miss Finch-Smith as his nurse. The old man refused. As for going anywhere with that "detestable dragon, I would as soon travel with an orang-utang."[151] Quinn responded with cold satire of the Swiftean kind:

> Of course, if you have some soubrette in mind who is willing to go with you, or some ex-cabaret dancer or some other sort of ex-parlor entertainer who has the qualities that you apparently looked for in your nurse, and if such a female is willing to go with you, either at no wages, which would mean going with you for love, or at wages not to exceed that of the nurse, which is $35 a week, and if that female can supply me with a reasonably satisfactory certificate of hygienic purity and competence, I am willing to agree to have her go with you.
>
> But somehow cleanliness and cabaret entertainers do not seem to go together. Hygiene and chorus girls do not seem to me to be synonymous. Knowledge of nursing and verbal pyrotechnics do not always exist in the same female uniform.[152]

JBY acknowledged that the letter was amusing and had made him laugh, but he still refused to go to the country. Even when Quinn offered Mrs. Foster as a companion JBY would not budge. "You are treating the matter whimsically, romantically, arbitrarily," Quinn wrote in exasperation. "I look at it coldly and scientifically." The doomed younger man who would have done anything to stay the hand of death looked on in fury as the weak and sick old man refused to lift a finger to save himself. Quinn described his own feelings after his surgery.

> I will never forget the Saturday afternoon in March of last year when I left the hospital, so sore and so weak that I could hardly drag my legs after me into the taxi. But

what happiness it seemed just to be out and to be alive! I never loved the streets of New York and the buildings and the grayness of things as I did on that March Saturday afternoon. . . . Everything seemed right and sweet, and it was so good to be out again and to be human and to be snatched back from the darkness.

He recalled an article he had written after Synge's death which he had concluded with the words of George Borrow: "There is the sun, and the moon, and the stars. All good things. And there is likewise a wind on the heath. Who would wish to die?"[153]

But all was in vain. The old man wanted only to be left alone in the smelly, damp, unwholesome airs of the shabby boardinghouse. Quinn, who saw in Synge a paradigm of himself, would do and was to do anything humanly possible to keep himself able to see the sun, the moon, and the stars, to feel the wind on the heath. The old painter, who found no paradigms of himself anywhere and sensed only remotely the interconnections of things, continued living as he pleased. To Quinn it was an infuriating paradox. For as of December, 1918, the wealthy, intelligent, brilliantly successful lawyer and art lover, at the age of forty-seven not yet at what should have been the height of his career, had but a little more than six years to live, and those in the shadow of uncertainty and fear. The wine-drinking, cigar-smoking, impoverished old painter, half-broken from an almost fatal illness at the age of seventy-nine, still had more than three, and he did pretty much as he wanted until the end came.

Quinn then turned his energies to getting JBY back to Dublin, and so began the last battle of maneuver and countermaneuver, Quinn and the Yeats children on one side, JBY on the other. In the end, as Quinn probably knew then, the old man would win. But the lawyer would not give up the fight until near the very end, only after it became absolutely clear that the serene old philosopher would continue blithely to go his way, headstrong, resolute, and content.

Lily did her part to tempt Papa, reporting on the exciting parties at Gurteen Dhas. In September, thirty-four people attended for a party in honor of the Chestertons. Only the Standish O'Gradys, who were away, and Alice Stopford Green (widow of the historian J. R. Green), whose invitation was misaddressed, failed to appear. Susan Mitchell as always was "one of the successes of the evening," which ended in a debate between Chesterton and Russell, "the rest of the company forming a ring four deep round them, Mr. [Ernest] Boyd on the outskirts throwing a well-aimed stone into the centre every now and then." Next day Chesterton and WBY spoke at the Arts Club. "He is nowhere as a speaker compared to Willy," Lily told her father proudly. This time Mrs. Green was there, and Lily recalled that Mrs. Green's mother had once declined a proposal of marriage from the Reverend William Butler Yeats. "Every time I see her with her red eye like a very old mastiff the more glad I am that her mother said 'no' to your father. You might have had that eye. Worse still, I might have had that eye. Think of us, each side of the fire,

looking at each other with our ruby eyes, and our little chins running away with our necks."[154] With him at home there would be the pleasure and excitement of discussing Lily's dreams and visions, those unforced, unsolicited images to which she assigned no supernatural causes. "She is too intelligent and too well taught to believe in the supernatural," Papa told Uncle Matthew's son Frank, now a successful physician practicing near Montreal, "so her words are, 'It is something the Marconis of the future will make use of.'"[155] She told him that in the spring, long before she knew that there was to be a grandchild, she had a dream in which she saw "a high stone tower, on the top of it a Herald blowing a trumpet. Out of the trumpet came not notes but the words, 'The Yeatses are not dead.'"[156]

But Papa began to hedge. "I am afraid of Dublin and Ireland," he wrote to Susan Mitchell.[157] He blew hot and cold in his letters to Isaac. "What a long talk we shall have!" he wrote enthusiastically in mid-September, then changed his tune six weeks later. "But I am afraid, afraid, afraid. The horrors of my time in Dublin still burn in my memory."[158]

Quinn knew the job of persuasion would not be easy. The target of the campaign resumed his old courses. On December 18, while he should have stayed in bed recuperating, he walked to the Post Office and Pennsylvania Station and found the exertion not too taxing.[159] On Christmas Day and the day after he wrote letters to Sloan as though nothing had happened. On the twenty-sixth he wrote Van Wyck Brooks that he was looking forward eagerly to his book on Mark Twain. During the last week of the year he wrote to Padraic Colum and Mrs. Caughey as if he had never been ill.[160] The serenity of John Butler Yeats's prose and the imperturbability of his demeanor in the face of Quinn's growing irritation gave sufficient evidence of who would win the long struggle.

Early in January, 1919, JBY discovered that his debt at Petitpas had reached $453 and wrote to Quinn in alarm and dejection. "I have been living in a fool's paradise, so that the amount is a shock." He asked Quinn to reassure the Breton sisters that the bill would be paid.[161] Quinn thought he saw a perfect opportunity and replied the same day in a letter remarkably transparent for a lawyer who should have known better. "I cannot and will not undertake to bring pressure upon you to return to Ireland," he began loftily, then proceeded to bring pressure. JBY could tell the Breton sisters the bill would be paid, but Quinn would not pay it in whole or in part "unless there is a definite understanding from you as to your going and when you go. . . . I know you well enough to know that if the $453 matter is taken care of you will want to settle down to another long period here."[162]

Yet JBY continued to throw everyone off balance. He assured friends and relatives of his intention to return but always found good reason for staying a few more months. In cold weather he promised to come home when the

mercury rose—"I don't want a dreary winter passage or a dreary winter landing in Ireland," he wrote Lily in January. In the early summer he thought it best to wait until fall and in July pushed the date ahead to winter.[163] Since he refused to say that he would not return, it was hard to persuade him to change his mind. Always he found excuses—"too many things to do and finish," he told Lady Gregory. He wrote Lily he would sail when he had finished the tasks he was busy about, especially his self-portrait. He gave Jack the impression that his homecoming was inevitable: "When I get home I am sure I will often say to myself, 'Why did I not return long ago?' " He gave instructions to Lollie about his needs, which included a studio facing the light; and when the Henris left for their summer travel he told them he did not expect to be in New York when they returned in the fall.[164]

Yet he left warning signals. "I am a little anxious as to whether I won't find a world of anxiety and care such as I remember and which I could not alleviate," he wrote Lily in early April, and added a few days later: "I have always dreaded returning to Dublin when I thought I could not help you while sharing all your anxieties."[165]

The family did not press JBY as firmly as Quinn thought they should. As the months wore on, Quinn, who had started the year so much like a dominant general who intended having his own way with compliant soldiers, became increasingly exasperated by the failure of the troops to follow his orders. By early April he flatly declared that he had made up his mind "not to worry about the matter any more."[166] JBY had by letter deftly turned aside Quinn's threat about the unpaid bill, certain that in the end it would be paid. He thanked Quinn for the advice, told him he preferred not to take a sea voyage in winter, and then gracefully slid into other subjects.[167] Shortly afterward Quinn wrote a long pseudo-fictional account of JBY's refusal to go home. He called it "A Scenario of an Unfinished Novel by Henry James, Entitled 'The Deferred Return' or 'The Return Deferred.' " It shows Quinn at his satiric best and shows vividly the picture which John Butler Yeats presented to his good friend.

He would call himself "The Ambassador," Quinn wrote. "You would be called—I had about settled on 'The Philanderer'; then I had thought of the 'Play-Boy of New York,' but I finally will name you the 'Grand Lama of 29th Street.' " The novel would continue with an account of JBY's arrival in New York, "the wonder and surprise and delight of it all," and of "the Confucian calm" with which he settled down in his newly found home, "of the eternality of your aspirations to make a reputation here, of the long campaign which you deliberately planned, the long vista of freedom from family cares, freedom from home ties, freedom to gamble and talk and be entertained and be amused and to write letters and to talk and talk and talk, and to be invited out and never have a worry about troubles of any kind—a regular Confucian earthly paradise built for yourself in New York."

The novel would carry the Lama through the years. "Only once or twice did the Lama wake up to mere sordid and vulgar finance. Then the Lama's poet son responded, but more often of late years the Ambassador, acting for the poet son." The illness would be described, an incident in which "the nurse comes out the best." Then Quinn suggests how James would have explained the Lama's secret:

underneath that apparent indifference, his failure to read unpleasant letters, was a consciousness that down in the Confucian depths of his being was a determination to have his way, never to do anything that did not please him, never to go out of his way an inch when it had ceased to amuse him. . . . The Lama presents an amalgam which is unique . . . the amalgam, Henry James would show, of quicksilver and iron, his iron determination to have his own way, to do as he pleased, never to think of other people's worries or cares or efforts.

When it was all over there would be a scene which Quinn was sure James would "hugely enjoy":

And so the book comes to a triumphant close with the victory of the Lama over his family, over the Ambassador, over the Doctor, over the nurse, and over his friends, it all being a triumphant indication of the philosophy of the ego, of the victory of the man who regards only himself, of the man who does not care for others when they cease to amuse him, the artist's ego, the ego parading in the poet's singing robes, the consummate artist, the play-boy of West 29th Street, the youth of eighty without a care, with never a thought of his family or of his friends, with eternal self-indulgence, with an appetite for food and drink at the age of eighty that is the envy of his younger friends and the despair of the Ambassador; this young man who has enjoyed fifty years of play and talk and health and high spirits and wine and drink and cigars, the man who enjoys the evasions of the artist—he "gets away with it," as Henry James would say. And so the book closes with him enthroned triumphant, monarch of the Petitpas' dining room, bottles of red wine in front of him and strangely colored liquors beside him, the music of the victrola going, the scraping of dancing feet upon the dusty floor, a reincarnated Walt Whitman at the head of the table, eternally young, always poetical, the artist in excelsis, talking beautifully—and he "gets away with it."[168]

JBY pretended ignorance of the faults Quinn laid upon him, explaining to Willie that there was simply a conflict of natures.

I think Quinn has developed a certain antagonism and irritation against me. He tries his best to get rid of it. He as a lawyer reasons deductively, and I reason inductively. Out of a whole complexity of circumstances I make a generalization, and he attacks me. And I succumb. I have not a chance against his vital arraignments and his logical ferocity. But it fatigues him to be constantly called upon to destroy my "sweeping" generalizations. Unless I forget myself (as I often do), I keep my mouth shut when with him. He is besides extraordinarily tense like a bow that is always strung ready for the arrow to be fitted to it, and I am always relaxed and defenseless, careless of logic and argument, like a man enjoying summer weather. I think that I present a spectacle that stirs his bile.[169]

To Quinn he wrote, "I am not at all the man you think I am, not at all the happy, indifferent, reckless man with 'healthy' nerves." He too had nerves, "only yours rouse your will into action, and [mine] paralyse my will."[170]

Just before his illness, JBY had written Quinn that he wanted to send him a part of his autobiography which could never be printed. He called it "A Suppressed Chapter of My Memoirs," and described it as "a short account of my life from 1885 till 1900." It had been, he said, "not pleasant to write it nor is it pleasant reading, so it cannot appear in my memoirs."[171] There is no further mention of the chapter, but in the spring of 1919, at about the same time JBY was complaining of being misunderstood, he wrote a long, emotionally charged letter to Quinn which appears to have reflected the suppressed chapter. He recounted his arrival in London in 1886, his wife's collapse, his lack of money, his own psychosomatic illness:

> I had the pain and humiliation of seeing Lily and Lollie hard at work to keep the house—Lily all day with that she-cat May Morris, saving her 15/s a week and bringing it home to keep *my* house; Lollie also hard at work lecturing and teaching—these young girls cut off from the pleasant life that belonged to their station, without girl friends or men friends—and all my fault. And there behind all was my poor wife. *I knew perfectly well* that it was this terrible struggle with *want of means that had upset her* mind.—You may say I had Willie's success and growing fame to comfort me. Yes, but I had not his respect. How could I have it? I had not my own.[172]

For the rest of the year Quinn treated JBY with unusual kindness and sympathy, and his letters became more friendly and understanding. He dropped in at West Twenty-ninth Street more often, and on one occasion placed an order for two self-sketches at twenty-five dollars each.[173] He included JBY as a guest at dinner in his apartment with Clement Shorter, H. W. Massingham (editor of the London *Nation*), Lawrence Godkin the younger, son of the editor and owner of the New York *Evening Post* and *Nation*, and C. C. Burlingham, an international and admiralty lawyer. When the old man had to leave early—no longer able to stay up late—Quinn wrote him at length about the conversation that followed his departure. Even JBY noticed Quinn's kindness to him. "Quinn was proud of me," he told Lily. "There I was, a miracle of health and years, and he told how I had pneumonia and influenza—and I blinked with modesty like the prize boy of the school."[174] Quinn passed on a compliment of Massingham's. "Among other things he said: 'How pregnant his questions are!' 'How much to the point his statements were!' Also, and this will astonish you: 'And what a good listener he is!' "[175] Earlier in the year Chesterton had made the same point about JBY in an article in the *Sun*, and JBY wrote Quinn: "I am right in thinking Chesterton the greatest of all writers living or dead."[176]

Willie seemed to have mellowed further also. He refused to become angry at his father's continued dependence and on his unwillingness to do what others

told him. "If we live long enough we shall all be trials," he wrote Quinn philosophically and calmly.[177] Perhaps marriage had worked a magic on him. Perhaps too it had given him a wiser head for finances. He sold most of his shares in the Sligo Steam Navigation Company for £234 and sent the sum to Quinn, asking that it be set aside for his father's use and that the sums for the manuscripts be kept separate. He explained to his father that the earlier arrangement "might not be fair to Quinn, who might not really want the MSS."[178]

His wife's talent at spirit writing had enriched WBY's occult life further. In late January of 1919 he gave a talk before the Theosophical Society in Dublin. At Con Curran's a few days before the talk, AE had regaled the guests about Willie's activities in mysticism, in which he had been for so many years an active partner. Holloway was present and recorded AE's comments with relish: "he told many strange and droll incidents of Yeats's adventures in search of 'spookish' experiences. . . . AE has the saving grace of humour to keep him sane and cool on such subjects. He thinks they [i.e., *mystics generally*] must be very ill-informed if they can't give clearer messages from the Unknown than those."[179] Russell commented on WBY's latest work, "His mind is subtle but never very clear in its thought."[180] Later in the year Ezra Pound talked with Yeats about his work and wrote to Quinn about his fellow poet what was, all things considered, an astonishing comment: "Bit queer in his head about 'moon'; whole new metaphysics about 'moon,' very very very bughouse."[181]

The "new metaphysics about 'moon' " was the vast theory about world history and human personality that would ultimately become *A Vision*, the strange work in which the twenty-eight phases of the moon are made use of to explain the world's phenomena.[182] The ideas may have been fermenting in WBY's drama *The Player Queen*, which Joseph Holloway saw at the Abbey in December. His comment on it reminds one of JBY's on *The Shadowy Waters*: "Its strange story baffles me," Holloway confessed. Yet the effect was telling. "Though its purport is wrapt in mystery, its beauty won home."[183]

The most important family news out of Dublin that year was of the arrival on February 26, in a nursing home on Upper Fitzwilliam Street,[184] of Anne Butler Yeats. JBY had been expecting a grandson[185] and was at first baffled when he received a cable on his eightieth birthday from all the members of the family, including "Anne Butler." Then he realized "that it was the little creature."[186] Willie, almost fifty-four years old, was "full of talk about her."[187] Just before she was to be baptized in St. Mary's Donnybrook (the church where John Butler Yeats's parents had been married), Lily told Papa, "Willie looks at her shyly but is writing a poem on her."[188] Most of the talk about little Anne thereafter came from Lily, who occasionally had the baby in her charge. The new grandfather was virtually mute on the subject. Sixty years earlier Uncle Matt's wife Aunt Gracie had deliberately put her young baby Frank out of sight when John Butler Yeats visited them at Celbridge, and Leonard Elton

remembered how the sixty-year-old JBY had paid no attention to the children in his house during a visit there with York Powell, who devoted himself to them.[189] The intervening years had made JBY no more responsive to babies, who were conversationalists and thinkers only potentially.

The baby and the new wife were just what the middle-aged poet needed. He moved with them to Thor Ballylee, which he described to Quinn as "a place full of history and romance, with plenty to do every day." He thought it a good place for a child "to grow up in."[190] It was an ancient structure, prehistoric in the sense that its history was imperfectly known.[191] One could imagine Norman lords inhabiting its mysterious rooms, ancient Irish chieftains roaming the acres, and the Little People hovering around the mounds. Ballylee was a kind of Merville without Pollexfens, a dream castle which WBY had always longed for but never been able to inhabit. Perhaps it provided him some semblance of a permanent home, which he had never known as a boy, in surroundings he loved.[192] It may well be that one of the happiest days of his life was July 16, 1919. Fishing in the stream by the tower, with George sewing and "Anne lying wide awake in her seventeenth-century cradle," he saw an otter chasing a trout. He described the scene to his father, and then spoke of the round room on the ground floor, the "pleasantest room I have yet seen." Feeling he couldn't picture it properly in words, he drew a sketch, which he did not like. His comment on the sketch is of interest to those concerned with the imagery in his poems: "A very bad drawing, but I am put out by having the object in front of me. I could do it all right from memory."[193] The world looked good. His reputation as a speaker was growing, and he looked forward to his lecture tour in America the next year, on which he would be accompanied by his wife.

Lily and Lollie were preparing for Cuala JBY's third book, a selection of his letters chosen by Lennox Robinson of the Abbey company. This time the author was not consulted until after the project was under way.[194] He sent a hasty warning to Lollie. "I charge you, suppress every allusion to John Quinn. He is a man who likes to be praised, but it must be praise without any qualification. Otherwise he is furious. For the least criticism he cannot stand."[195] Robinson selected letters full not of personalities but of ideas, those which JBY had claimed were better than the ones in Pound's edition. All names, even those of his daughters, were disguised by initials and dashes, and the text was converted into a series of independent essays on general subjects in art and poetry. Heeding objections to the earlier volume, Robinson chose whole letters or big chunks of them. The selection is more readable than Pound's and gives a better picture of the mind of the author. Papa asked whether he might see a proof before publication,[196] but Lollie either forgot the request or ignored it.

In Dublin in December, Susan Mitchell delivered a lecture entitled simply "John Butler Yeats." It was such an important event that even the

Morehampton Road Yeatses came—conservatives all, Gracie, Jenny, Fanny, Isaac—and Jack and Cottie from Marlborough Road. Willie and George were out of town and could not attend. "I never saw the Aunts out at an evening affair before," Lily reported to Papa. "Susan had written it all with great care and read it sitting. It was clever and not too personal. You would have liked it. We all did and were very proud. Dr. Sigerson was in the chair . . . and it was a really big success—a great evening for Susan and you."[197]

Having brought the old man safely through his illness, Quinn went back to his old obsession that JBY must get his memoirs finished. The author, contrary as always, refused to oblige. Quinn complained to Willie that Father spent his time "reading what amuses or interests him" as if "he had many years of life before him." He admitted that perhaps no one had the right to insist that he "give up his days of amusement and pleasure," yet he concluded in exasperation that JBY seemed "to get amusement and pleasure out of every *other* kind of work."[198] He believed the memoirs would constitute JBY's most important contribution to world culture and could not forbear nagging the old man about them. He also knew, and JBY knew, that Lollie wanted them for Cuala.

But the memoirs were not going well. The author still could not reconcile the conflicting demands of truth and diplomacy. In discussing the friends who had been close to him—the Dowdens, Nettleship, Todhunter, the Ellises—he was simply unable to write critically. Where he could not praise he preferred to remain silent. In August he sent Quinn a section of 8,000 words and announced that that was the end. "The fountain which is my memory is now dry."[199]

In the notebooks from which the typed revisions were drawn there were in the end 88,000 words, enough to fill about 350 typewritten pages. Yet the batch submitted to Quinn in August brought the total of typed pages to only 123, a considerable distillation by JBY of the original handwritten text.[200] The pages Quinn received were those typed by a stenographer from JBY's dictation as he read from his notebooks. Before submitting them, JBY made revisions or added new material in his own handwriting. Quinn's assistant, Thomas Curtin, was given the task of putting the typescripts in order, but occasionally neither he nor Quinn could decipher the scrawl. Once JBY was asked to come to the office to help them out. To Curtin's relief and amusement the old man was unable to decipher many of the passages himself. When Curtin informed Quinn, Quinn wrote sardonically to JBY, "I smiled."[201]

Quinn's behavior toward the old man changed from day to day; he was kindly sometimes, more often angry. "I am irritable and easily tired, and when I get tired I go all to pieces," he wrote WBY.[202] In his weakness he seized on imagined enemies, having Willie's need for specific targets for the arrows of his wrath. One of these was Dolly Sloan, whom Quinn came to dislike more and more. According to him, whenever JBY was about to work on the memoirs, "some pest like the horrible Mrs. Sloan" would intervene and divert

his attention to something else, like a lecture.[203] As time passed his remarks about her grew more venomous, intensified perhaps because the old man worshiped her and refused to share Quinn's views. ("Mrs. Sloan has a head like a foetus," Quinn wrote to Willie some years later. "When she walks, she goose-steps, that is, she sticks up her ugly feet, as all dwarfs do. She is an intriguing little cat.")[204] He allowed his animus against her to distort his judgment about her husband. In complaining to Willie about his father's lack of progress on the memoirs, he wrote: "He appears to be writing essays, tinkering away on stuff about John Sloan, a very third-rate American painter, and reading and talking and amusing himself and not getting forward with the Memoirs."[205] Quinn also spent much energy denouncing the Wilsonites, the liberal "asses," the "political Quakers," whose follies he believed would bring about another war within twenty years to be started by the Germans and the Japanese.[206]

He was annoyed too by the continuing attacks on artistic expression by the public guardians of private morality. He had written a brief in support of the *Little Review* against a charge of indecency for having published a section of *Ulysses*. At the last minute the solicitor-general shifted his ground and ruled against the magazine because of the illustrations in it. Quinn was disgusted, calling to JBY's attention the "lingerie advertisements" in the newspapers, which he thought more vulgar and repulsive than anything in the *Little Review*.[207] Before long JBY joined him in fighting the censors and proved that if the years had slowed his step they had not dimmed his intelligence.

In midsummer JBY was given the largest single commission since he had come to New York, four hundred dollars for the portrait of a long-dead judge to be done for his granddaughter.[208] As usual, he dawdled over the portrait, had to borrow a robe, through Quinn's good offices, from a judge,[209] but still was uncertain whether it would be finished by September 2, when the family wanted it. He would be paid the four hundred dollars on the spot, he was told, if he produced it by that date, but otherwise might have to wait. "Rich men cannot understand why anybody should want money in a hurry," he told Quinn plaintively.[210] He didn't get his money till November, then promptly turned it over to the Petitpas sisters.[211] Out of that work came another commission from the judge's granddaughter, who was delighted because he made her look forty-six when she was fifty-eight.[212] During the year he also did many pencil self-sketches, and for Quinn he drew a splendid almost full-length pencil sketch, which he dated "Oct 1919" and signed under the words, "Myself seen through a glass darkly."[213]

He dabbled at the self-portrait. "Every day I study it," he told Jack, "and occasionally I paint."[214] He wrote Quinn cheerfully, "The head is, I think, good, its merit a clear intention carried out to the very limit. In it I will live in my habit as I lived and it will hold its own among your masterpieces. It is an

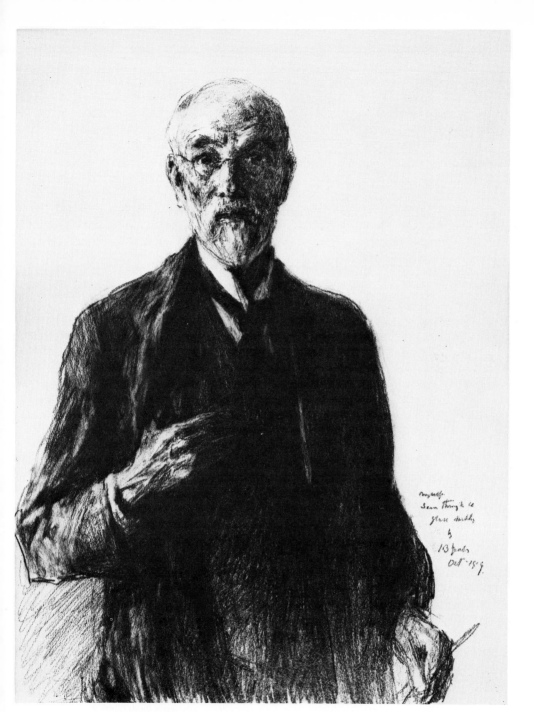

John Butler Yeats, pencil self-portrait, October, 1919. In JBY's hand: "Myself seen through a glass darkly." Collection: Foster-Murphy.

Letter from JBY to Jeanne Robert Foster, February 6, 1919, with sketch of Kahlil Gibran.
Collection: Foster-Murphy.

honest portrait." A short time later he wrote with unruffled humor: "It is the child of my old age and ought to be a remarkable infant since it has had such a long gestation."[215] Nothing could keep the wandering nobleman from enjoying his castles. He told Lily he had been accustomed to smoking a five-cent cigar after dinner but had become "a little shy" about the expense. When she sent him four pounds in January he declared, "Now I am a millionaire." In September he was asking Mrs. Bellinger if he could borrow five dollars with no security and at no interest.[216]

The burden of years and illness did not stop his campaign against Willie's mystic pursuits. When he met a young Syrian named Kahlil Gibran, about whom Mrs. Foster had spoken enthusiastically, he wrote her that although he liked Gibran as a person, he found him vague and therefore insincere.[217] The following day he passed on his views about Gibran to Willie, introducing indirectly arguments he did not wish to launch broadside:

> Vagueness is always insincerity. . . . When a man does not take the trouble to think or to know precisely, he is vague . . . and great poets have shown themselves not averse—only with this condition, that as honest men they must not pretend that it is a conviction, or, as some of your second-class mystics, that it is a religion. . . . Of course the Poet rules over a wide kingdom and may at will and according to his artistic judgment practice all the insincerities; only he must never be their dupe.[218]

But he would not join others in finding fault with the new tone in WBY's poetry. Indeed, he thought that now that Willie had produced the kind of personal poetry that had marked *Responsibilities* and *The Wild Swans at Coole* he was ready for further movement: "Take a long period of rest. I am waiting for a new efflorescence. The first you have had—it is over and gone. You have passed away from it. Let some new model shape itself in your mind, the more slowly the better."[219]

Obviously, there was nothing wrong with the old man's brain, but other parts of his remarkable machine were not functioning as they should have been. By the end of the year the last of his remaining teeth had been extracted and a complete set of dentures installed.[220] In May, Quinn described him to WBY as "thinner" than he had been a year earlier.[221] Through the early months of 1919 he suffered from a sore throat, and in the summer he came down with what he called "indigestion" brought on, he thought, by eating yellow cake.[222] "I feel as young and healthy as when I was twenty," he boasted to Lily, "but facts are facts and are not to be denied." It frightened him to look in the mirror—"and it has all come about in the last year and a half."[223] Nevertheless he returned to his claret and cigars and pipe and continued working on an assortment of projects. "The secret of health is activity," he confided to Lily. "If you only keep the machinery going and well oiled, imperfections will cure themselves."[224] Such happy but inaccurate medical philosophizing was all very well for a man of eighty, who didn't notice that

My dear Mr Foster —

It is what time I wish & thanks for [...] your [...] & [...]

[...]

Yours affectionately

J B Yeats —

while the theory applied to himself it did not to Quinn, who was even more active and who was dying.

During JBY's long illness in late 1918 Quinn had finally met Mrs. Jeanne Foster and been attracted by her intelligence and beauty. Through her he kept in touch with the personal activities of the old man. When he received an alarming letter from her in November, he invited JBY to lunch, then, after picking him up at West Twenty-ninth Street, carried him off to Dr. Rice instead.[225] Before JBY knew what was going on, the doctor was prodding and thumping him. Dr. Rice praised JBY for his "refusal to lose cheerfulness under any circumstances," and told him, "You don't need Christian Science." He tactfully suggested that his patient "go abroad" and warned him of lung damage.[226] To Quinn the doctor spoke more bluntly. "I thought it best to speak encouragingly to him about his condition," he wrote; but the facts were worse.

> Now his condition, as I found it last Sunday, is as follows: Lower part of right lung has never fully recovered from last winter's pneumonia. He has a fairly serious valvular leakage of the heart, the heart omitting a beat about once in ten times.
>
> I appreciate your anxiety about him and would suggest that it would be well for him to avoid the rough winter of New York. Nothing more can be done for him beyond tonics and good living.[227]

But the old man's tonics were still wine and tobacco, his good living the talk at the boardinghouse table. To them he added a third medicine which Dr. Rice had noted, invincible cheerfulness. "When a man is old," Papa wrote Lily, "he has such a habit of living that it is hard to break him of it." He wrote with pride to Jeanne Foster: "I find I write better as the years increase and pass. I have a better brain now than I had six months ago. The oak whose acorn took root in

(Facing page)

Letter from JBY to Mrs. Jeanne Robert Foster, December 29, 1919, with sketch of Quinn reading, JBY looking over his shoulder: "It is about time I wrote and thanked you for your Xmas box and it was so welcome. J. Quinn called yesterday morning and as he looked at the book of Russian tales—he murmured over to himself. 'She is an awful nice woman,' saying the words twice over—and I repeated them again to myself. There you have it pictorially. When Quinn is happy he is an angel of light. I have written a lot more of my autobiography in a form that I will offer to the North American Review— with the title, 'Talkers whom I have known.' I find I write better as the years increase and pass—I have a better brain now than I had six months ago. The oak whose acorn took root in the times of the Georges still grows—and is taller and more umbrageous with every year. My son and his wife leave for America on Jan^y 6th. Yrs affectionately, J. B. Yeats." Collection: Foster-Murphy.

the time of the Georges still grows—and is taller and more umbrageous every year."[228] Jeanne Foster looked at the remarkable old man and saw an eternal youth:

> Keen eyed, young, eager to live a thousand years,
> Unwearied of life,
> Sheltered beneath the green tree of his own thoughts, . . .
> Ripening like an apple in quiet sunshine.[229]

CHAPTER SEVENTEEN

1920–1922

W ILLIE AND GEORGE sailed for America on January 6, 1920,[1]
leaving baby Anne with her Aunt Lily in Dundrum. Willie was
to make another round of the American lecture circuit, this time a series of
short tours outside New York City in addition to a talk or two there. It was
planned that George should spend as much time as possible in New York to get
to know her father-in-law and her husband's friend John Quinn. Father was
apprehensive about the meeting. "First impressions are always important," he
told Lily. He dreamed of the meeting and even sent his shabby topcoat to an
expert renovator. It proved an unnecessary expense, as Quinn presented him
with a "magnificent" new one a few days later.[2]

There was no need to worry. George had been equally uneasy, but each
wanted to like the other, and each was likable. As soon as she and Willie had
settled in at the Algonquin she telephoned her father-in-law at Petitpas and
introduced herself.[3] JBY called Quinn, who immediately went to the Algon-
quin to escort WBY and his wife to West Twenty-ninth Street. "When we got to
the Petitpas," Quinn told Lily, "I led the way in, and there your father was
standing in the lighted room in the basement, with his best clothes on, but in a
sort of dancing slippers. WBY shook hands, introduced his wife, and after a
moment's hesitation she kissed your father. We chatted a few minutes and then
I left."[4] Next day Papa submitted his observations to Lily. "She looked at me so
searchingly that I said to myself that I was under observation. But no, she was
really wanting to find out what I thought of her." He thought she was
"good-looking" and could be "very good-looking" but for "a certain *drawn look*
that slightly disfigures her mouth."[5] All went well from the beginning. "I like
her, I think, very much," JBY told Isaac, "but am cautious, as *I think she is with
me*. We have not yet tested each other, although we are both of us quite frank.
But *liking needs time*."[6]

Fortunately George had a taste for the absurd, was not pompous herself,
and was unimpressed by pomposity in others. On January 29 the annual
dinner of the Poetry Society of America was held at the Hotel Astor in honor
of William Butler Yeats. At the head table, along with Willie and George, were

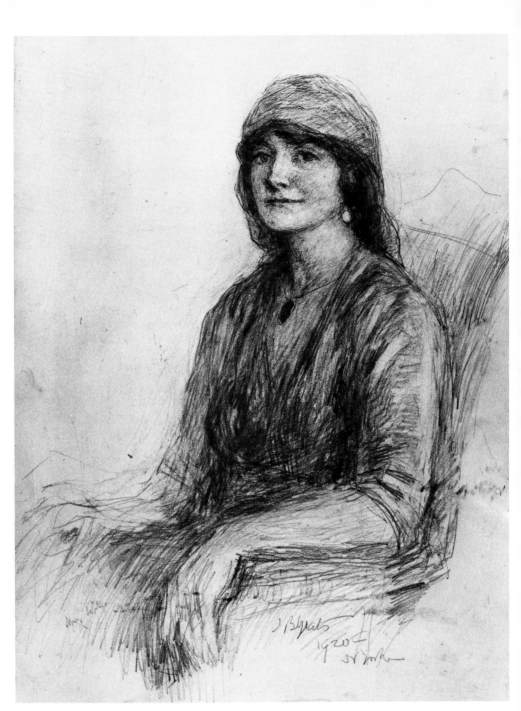

George Hyde-Lees (Mrs. William Butler) Yeats, [February] 1920. Pencil. JBY. Collection: Michael B. Yeats.

Edwin Markham and his wife, Yone Noguchi, Siegfried Sassoon, John Livingston Lowes, Laurence Housman, Arthur Guiterman, Robert Haven Schauffler and his wife Margaret Widdemer, Charles Hanson Towne, Grace Hazard Conkling, Jessie B. Rittenhouse, and Edwin Arlington Robinson. At the tables below were Mrs. Bellinger, Witter Bynner, Julia Ford, Percy Mac-Kaye, Belle da Costa Greene, and Lady Speyer. John Butler Yeats sat with Jeanne Foster at Table 21.[7] George Yeats made notes in her program which suggest the flavor of her mind. Mrs. Bellinger was described simply as "father's friend," Mrs. Ford she called "a ghastly bore." Schauffler was also "an awful bore!" and Margaret Widdemer "a dreadful woman." Jessie B. Rittenhouse was "another dreadful woman." Beside the name of Lady Speyer she simply copied out, without comment but with proper attribution, Max Beerbohm's lines, "I love to think of Lady Speyer, Climbing ever higher and higher."

She was also free in her opinions about America and Americans. She informed JBY that of all the women in America only Jeanne Foster was able to carry on a conversation properly.[8] She found Julia Ford an insufferable social climber. When she attended one of Mrs. Ford's "at homes" in Rye with her father-in-law she heard her going about among the guests uttering the holy words "Mrs. William Butler Yeats" "in her shrill strident voice" until she "got sick of her own name."[9] Papa was delighted with that side of his new relation and reported to Lily: "George, who is not without the salt of malice, says that Mrs. Ford's breath smelt of whiskey the last time they met. In these prohibition days there are men who would kiss any woman for the sake of that smell, though George thinks that Mrs. Ford even with that addition would not tempt anyone."[10]

While Willie was away on the first of his tours, extending from Toronto to Quebec to New York, with stopovers along the way (one at Vassar, where Padraic Colum had also spoken—"a great contrast I should say," Papa judged)[11] George visited JBY almost daily, even when she had to walk eighteen blocks through the streets of a city crippled by a gigantic snowstorm. During the visits he learned how valuable she was to his son, devoting her energies to making his life smoother, answering the telephone for him, writing letters to his dictation, fending off undesirable intruders, arranging his schedules, and otherwise relieving him of the administrative chores which he disliked and which tired him.[12] "I like George more and more," he told Lily. "There are no vast depths in her, but endless kindness and sympathy and I fancy a lot of practical talent."[13]

As a favor to him, she conspired to set up a tea with the Bellingers at their uptown apartment on February 22. JBY liked the Bellingers and very much wanted them to meet Willie and George privately. After the date had been fixed, he worried that the Bellingers might try to make the affair into a big party and hastily wrote a "submissive suggestion" that there be nobody present but the five of them, so that the occasion "would be intimate, confidential, and

friendly, taxing no one's nerves." He was aware of the different impressions his son could make. "Willie is at his best—whatever that may be—when there are very few and all friends."[14]

Despite the precautions the tea ended in disaster. Willie had been eating at many banquets and on the twenty-first had suffered an upset stomach after a luncheon of the Society of Political Education. At the Bellingers' tea next day, "just as Willie was getting into good conversational stride," he became ill and had to lie down. The Bellingers lived far uptown and urged him to remain overnight. He insisted on returning to the Algonquin by taxi, and a doctor was called to be in readiness at the hotel. The taxi got stuck in the snow, and everyone, including the sick passenger, had to stand shivering outside while the chauffeur "did mysterious things" with wood under the tires until the cab could be got moving again. Next morning the patient was back to normal, but the visit to the Bellingers' was spoiled, and there was no opportunity to arrange another.[15]

The poet and his wife left New York for a long swing through the west and were away till mid-April.[16] From then until their return to Europe in May they stayed with Quinn, who had been offended at their earlier preference for the Algonquin.[17] It was a pleasant three weeks. Willie said he had never felt better in his life. During the last week there were two dinner parties, at one of which only men were present and the speaking was good, "Willie having it all his own way." JBY spoke also. If he had known how magnanimous the English speakers would later be toward Willie and the Irish, he told Lollie, he would have made his own speech even better, outdoing the others in compliments. H. W. Nevinson spoke "with great tenderness and affection" of Dora Sigerson Shorter, who had "died for Ireland." At the second dinner there were lady speakers, and the speaking was "more copious and not nearly so good." The speakers tried to be amusing, telling "lots of Joe Millers." "Willie's more elevated tone was lost on them." Gutzon Borglum the sculptor was there, lashing out at America, which he said hadn't suffered enough in the war and "so could go on being as materialistic as before."[18]

The subject closest to Quinn's mind was raised, but the results were inconclusive. He tried to persuade Willie to take his father home with him, but WBY told Quinn he could not demand that his father return after having personally guaranteed his expenses in New York; he might appear to be trying merely to save himself money.[19] Willie yielded to Quinn to the extent of inviting his father to accompany him, but the invitation was a mild one, and when Father refused nobody got excited.

Willie and George sailed from Montreal on the *Megantic*, arranging to cross the border into Canada at half-past four in the morning in the hope that they could escape the U.S. tax of eight per cent on their earnings.[20] George made a favorable report to Lily about the American visit. "She wanted you to like her and she wanted John Quinn to like her," Lily told Papa. "You liked her at once

and John Quinn liked her in the end in spite of her being his friend's wife."[21] JBY was obviously pleased when he told Isaac, "George is the only woman I have met who is not scared of Lady Gregory. I fancy Lady Gregory is extra-civil with her—naturally."[22] He observed her attitude whenever Lady Gregory's name came up: "I could see that she was always on the watch with Lady Gregory, too intelligent not to see her great merit, but yet alive to the necessities of self-defense."[23] He refrained from passing on to Lollie the more painful discovery that her new sister-in-law didn't like her.[24] Apparently Lollie's compulsive talking got on George's nerves as on everyone else's.

Quinn waited until summer to launch a new campaign to get JBY to go home and based it on two developments, one old, one new. The old was money. As the year opened JBY still basked in the glow of the $400 fee for the judge's portrait, but that bonanza would not recur. During 1920 he reported in his letters receiving sums of $145, $25, and £31 for a total of about $300.[25] The bill at Petitpas mounted inexorably, reaching $200 by the end of February, and it was clear that WBY's "trustee account" held by Quinn for his father would not last much longer. Then came another blow, which Quinn thought would be compelling. On July 26, 1920, the Petitpas sisters sold their boardinghouse, and the two older ones decided to return to France with what they said was a profit of a quarter of a million dollars made in sixteen years.[26] The following day Celestine came to "arranger" his room for the last time, and the event was like a funeral. "New York without the Petitpas is like New York homeless," he wrote Lily. "I did not know till now how necessary they had become." In the anxiety of the moment he thought he had made a decision. "It has brought my mind to a point," he declared. "I shall come home."[27]

The sisters had been unable to operate profitably after prohibition took effect on July 1, 1919. Early in 1920 they had been compelled to open the restaurant to the public for lunch.[28] When a Swiss couple turned up with money in hand they took it and got out. To the consternation of the older sisters, Celestine refused to return to France with them, preferring instead to marry Henri Eschmann, a Swiss chauffeur who had long been a boarder at the house.[29] Even when the frequenters of the dining room threw a farewell surprise party for the sisters, Josephine and Marie refused to be reconciled to Celestine. To present the gift to the sisters, JBY was chosen "as the Eldest and longest-back diner in the Petitpas Restaurant."[30] He told Sloan he loved the sisters despite their crankiness, because they were always at his side when he needed them. He compared them to roses with a circle of thorns—"terrible cranks, whom one approached with caution as we do the roses."[31] When the elder sisters left New York on August 28 he walked to the pier to see them off, standing with them for about an hour before he "tore" himself away.[32] Later he visited Celestine and her husband at their flat on West Twenty-eighth Street.

Quinn pounced upon the happy accident to further his plans for JBY. He

wrote WBY in September that JBY's balance was only $71.18 and that he could not possibly "stand another winter in New York." When Ernest Boyd stayed at Petitpas, Quinn used him as a spy to learn what it would take to get JBY to return home. Boyd reported he was sure JBY would leave New York if guaranteed a studio in Dublin, and Quinn so advised Willie in a long and eloquent letter. "A comfortable room, with fairly good light and heat, in Dublin would be heaven in comparison with the dingy, ill-lighted and often unheated and cold room that he has two flights up in the rear."[33]

When Quinn's convincing letter arrived, Willie was in bed with swollen tonsils which required an operation.[34] Instead of a strong command to his father, WBY responded with a cable—to Quinn: "AGREE TO ALL CONTENTS OF LETTER DATED SEPTEMBER TWENTY ONE YEATS." The cablegram naturally annoyed Quinn, who immediately responded that the idea "must come from you and must be based upon the reasons and promises suggested in my letter." He was deliberately letting JBY's bill pile up with the new owners in order to embarrass him into leaving.[35]

Willie's "urgent" letter, which he could hardly refuse to write, must also have irritated Quinn greatly. The strong, direct language which Quinn wanted was nowhere in evidence. Except for the signature, the letter was in George's hand—and her hand may have been in it in more ways than one.

My dear Father

I am dictating this because I am still merely convalescent. I was operated on in Dublin ten days ago, lost a good deal of blood and came back here very soon after because of the threat of a railway strike. . . . When you return to Dublin I shall see to it that you have a studio. I think Lily has written to you about this. It may possibly be at the Arts Club but one cannot settle details yet. I am quite clear in my mind that you ought to return. Now the Petitpas are gone you are not comfortable nor likely to be. George will meet you at Liverpool and bring you here if you care to for a short time before you go over to Dublin.

Yours affly
W. B. Yeats[36]

Father's reply has disappeared, but its purport can be gleaned from his son's answer. "I gather from your letters to myself and to Lily—by the bye that 'self-portrait' could quite well have been finished in a Dublin studio—that you have no present intention of returning. It is for you to decide. I can say no more." Again the note of urgency was conspicuously absent. Worse, Willie followed with a threat that he might have to arrange another lecture tour in the winter of 1921–22 if his father ran out of money.[37] It was a serious strategical error, for he had given his father a terminal date of March, 1922, before he need worry, and by that time the question of his return would be moot.

Despite his years JBY was as young in spirit as ever. When Sloan complained

that the postwar short skirts of women showed too many ugly ankles JBY retorted: "I am surprised to hear you say that, Sloan. I think they're all beautiful, and I'm glad I've lived to see them."[38] He continued to boast of his good health; were it not for the "almanac," he told Frank Yeats, he could believe himself to be "not more than forty."[39] But it was really only his brain that was still functioning well. He told Lily of being afraid he would not hear what Willie was saying in his lecture in Carnegie Hall. At gatherings he often missed amusing remarks and sat "like 'Tom-fool' while everyone else laughed." When he inhaled smoke from Quinn's cigars, he told Lollie, it "set his heart beating so that" he "could not sleep." "This is a grumbling letter," he wrote to Lily in April, "but I was 81 last March." He enjoyed the Petitpas dining room less. "At my table, there are seldom any but strangers," he wrote despondently to Isaac. "As you grow older the ghosts congregate, and if I did not keep very busy they would strangle me."[40]

In Dublin he would have been no healthier and would have run into other problems. The aftermath of the Easter Rising and the executions was not pleasant. The Sinn Fein Party had run candidates for seats in the English Parliament and, to the surprise of many in England and Ireland, swept the elections. Then the winning candidates refused their seats in Westminster and instead established their own government in Ireland as a counterweight to the official one imposed by the English. The violence begun in earlier years as a result of the executions intensified. England responded in the only way it knew, importing military forces to keep the peace. Lily risked censorship of her letter to write Papa in mid-July of the activities of the soldiers camped out in the village of Dundrum "with a barricade across the road." By September the situation had worsened. "I can't write about things here," she told Papa guardedly, "as my letter may never reach you, or I might blow up from suppressed fury as I write."[41]

At first old friendships were strained. Lily, a political moderate, frowned on the radicalism of Susan Mitchell. Papa learned early in the year that Miss Mitchell had become not only a Sinn Feiner but a "rabid" one. "Fancy Susan *rabid* about anything," he remarked to Lily. "I do not recognize her. It is a nightmare. Her tonsils must be out of order." That was in March. Nine months later Lily wrote her father, "As you know I was no Sinn Feiner a year ago, just a mild nationalist—but—now—."[42]

The single event that tipped the balance away from civil calm was the death in prison of Terence MacSwiney, Lord Mayor of Cork, who had gone on a hunger strike in protest against English methods. Cuala Industries was under contract to Mrs. MacSwiney to embroider a Gaelic national dress for her, and the fabric had just arrived when the news of his death came.[43] Within a month total insurrection had broken out. The English sent a ragtag bunch of military forces, known by their uniforms as the Black and Tans, as a supplement to the Emperor's drunken soldiery, and they and the Sinn Feiners began shooting

indiscriminately at one another, neither side seeming to care who got hurt. Lily described it as "a state of barbarism."[44] No one in the family felt compelled to urge John Butler Yeats to return home.

All the news out of Dublin was not bad. Early in the year Cuala issued *Further Letters of John Butler Yeats*, edited by Lennox Robinson. Everyone involved in its production thought it superior to the Pound edition. All the reviews were favorable, even the one in the *Manchester Guardian*, which had been lukewarm about the Pound selection.[45] The *Times Literary Supplement* carried a long review, and there were friendly notices in the *New Statesman* and the *Irish Homestead*, the last by Susan Mitchell.[46] Lollie had sent the entire £26.12 royalty in advance, as she knew Papa needed the money and saw that the edition would be sold out quickly. But a month after Papa received and acknowledged the draft, he asked Lollie for another copy of the book, to be charged "to my royalties."[47] Lollie, mellowing with the years, chose not to cavil. She sent the book and wrote simply, "We won't charge you with it." Many people, including booksellers in London, wrote to ask about the book, and some wanted the Pound selection too.[48] The old man was even more gratified with the new volume than he had been with the other. "I am foolish over my own book," he confessed to Lollie. "I have a copy which I constantly read and find very illuminating. Swift confesses to something of the sort with his own compositions."[49]

In at least two copies of the new edition the author added a touch of his own. John Quinn gave one of his six copies to Jeanne Foster, inscribing it to her by the initials of her maiden name, Jean Julie Oliviere, with the note, "These letters of an old friend of hers from a friend of both. *J.Q.* April 16, 1920." Mrs. Foster brought the book to JBY, who thereupon drew a beautiful self-sketch in ink of his head and shoulders on the blank space beneath, with his signature next it, and at the top of the page the inscription: "I write my name with great pleasure at Mrs. Foster's request. J. B. Yeats." On the first blank page at the end of the book he drew another self-sketch, this one almost full-length, again in ink. For the Sloans' volume he did another sketch in the same way.[50]

There was chatty news from Dublin too. Lily, like her sister-in-law, was "not without the salt of malice," and her observations on people were as fluoroscopic as ever. Clare Marsh had told her she was making money and didn't know what to do with it. "One glance at her suggested many things she could buy and be the better for." Katharine Tynan Hinkson was now a widow, and Lily wrote: "The air is free and warm since her husband died—such a difference. Before it was electric and Katharine always anxious and working to keep the peace and her own temper." Lily thought Katharine's goals were the wrong ones. She "is always a disappointed woman, I think, because she is always looking for social success and never gets it."[51]

Lollie filled Papa in on Louis Purser, who, denied the provostship of TCD after Mahaffy's death, had been named bursar. As he served on the Heb-

To J. J. O.
These letters
of an old
friend of hers
from a friend
of both. J. Q.
April 16.
1920.

[handwritten note upper right, JBY's hand]

John Butler Yeats, self-sketch in ink, April, 1920. On the flyleaf of *Further Letters of John Butler Yeats* (Dublin: Cuala, 1920). In JBY's hand at upper right: "I write my name with great pleasure at Mrs. Foster's request." At upper left the inscription is in Quinn's hand. "J.J.O." is for Jean Julie Oliviere, JRF's maiden name. Collection: Foster-Murphy.

domadal Board, which still operated much as it had when JBY was a student, his income lay in the range of two thousand pounds a year. Lollie's description of him is filled with resigned frustration and suggests why he chose not to marry:

> Louis *looks* as if he had £150 a year at most and found it difficult to live at all. Perhaps he lets his income lapse into the University funds? If he doesn't he must hoard it, for he does *not* spend it. He never even gets new clothes. They are covered with dust and shine with age. But he [is] still an exhilarating person to spend an afternoon with, his energy is so infectious, and his joy in a lovely day. . . . He will do anything for his friends but he *goes nowhere*, and gets more and more of a recluse.[52]

Perhaps age had calmed Lollie down. For a period in 1920 she seemed relatively at peace. "Lollie is . . . a reformed and changed woman," Lily wrote Papa in November. "Some people do it by 'getting religion' or taking the pledge, but Lollie has done it by taking to knitting. Instead of being on the rampage every evening from 7 to 11 she sits and counts and peace reigns. Long may it last."[53] Lily also reported about her visit to George and Willie at Oxford and of having tea there with Edwin Ellis's sister, who had come into Edwin's money on his death in 1918. Lily thought her "a queer old woman." She read aloud to Lily from her brother's poems, stopping every now and then to say, "I taught him that," "I gave him that."[54] On August 16 she and Willie visited Robert Bridges at Boar's Hill, then "walked the whole way home and were two hours over it and lost our way."[55] It must have been like a replay of the early days in London when they walked through Holland Park in Kensington and sailed Willie's boat in the pond, and it may have spurred her intention, announced to Papa earlier in the year, to record those very memories as well as stories others had told her. These eventually would make a sizable collection of disjointed but spirited mini-memoirs.[56]

For his own memoirs, however, JBY was simply unable to keep up a sufficient head of steam. When he wrote a commissioned article on the Petitpas boardinghouse, William Rose Benet, editor of the *Literary Review*, found it too "philosophical," although he accepted it. "What he wanted," Papa wrote Lily, "was a picturesque and vivid account of all the celebrities that dined here. I did hear that Col. House's sister once came, and there have been poets. But none of these said anything, just gobbled and, before prohibition, guzzled and then went their ways. They did not come near to me nor know of my existence."[57] When the article at length appeared it contained brief mention of Jack London, Bliss Carman, Allan Benson, old Perry the painter (another boarder), and the Petitpas sisters, but not a word about Sloan, Henri, Colum, Seeger, Bell, Brooks, or the others whom JBY knew well.[58] He could write safely only of those from whom he was emotionally distant. When Quinn complained that in his memoirs were too many generalities and not enough facts, he agreed. "You are right, emphatically so. But I have no facts, only

generalities." He did not care to remember the facts. "My memoirs are to me a place of the tomb," he told Quinn.[59] When Quinn tried, "tactfully and considerately," to press JBY about resuming his dictation of the memoirs, the old man would fall silent and, after a period, say, "Well, Quinn, I think I shall be going home." Quinn got the message, he told Willie, "I have stopped discussing his memoirs with him."[60]

Naturally JBY didn't like the new owners of the boardinghouse, whose ways were different from those of the Petitpas sisters. Under the Bretons, if there was a phone call for him one of the sisters would patiently climb the stairs and knock at his door.[61] The new owners simply shouted up the stairs. Wine, sold illegally, cost sixty cents a bottle where it had once been ten, and the dinners were "inferior, very."[62] Within six weeks the Swiss owners sold out to an Italian couple with a teen-aged daughter. JBY thought no one could match the sisters. "I fancy," he told Sloan, "that this place will have a long succession of failures, each beginning in rosy hope, and then selling out to another dupe. The wand of the Petitpas is broken. They could not hand that on with their house."[63] Yet he stayed on, and soon the new owners seemed as much a part of his life as the old had been.

Still in the upstairs bedroom stood the unfinished portrait, like a medieval cathedral, always abuilding. It and its maker lived together, each in movement toward an impossible perfection. In August he confessed to Lollie that he had not worked on it "for months" but was preparing himself by black-and-white sketch studies. Two weeks later he told Quinn: "I mean very shortly to get to work on the painting. I think that now I see my way, and not till now." A resigned Quinn wrote to Willie: "There speaks the true artist."[64] Nothing more is heard of the portrait that year.

JBY got into constant arguments with Sloan and Quinn on the subject of sketches and their relationship to portraits. He thought Quinn had been taken in by Walt Kuhn, whom JBY described as an "advanced cubist or Futurist," a follower of the "new heresy" to which Quinn had been attracted.[65] He thought Sloan had been seduced also, as many of his pictures were left incomplete. He disagreed with the theory of Ezra Pound and Hilda Doolittle and Amy Lowell as they expressed it in theory and practice—that the instant, sudden flash of insight, brilliantly recorded, was the ultimate in art. Yet he himself thought a good drawing should leave just such an impression. In a long letter to Quinn on Christmas Day he reworked the paradox in a typically Yeatsian way that would have delighted George Russell:

The fact is, as I look at it, you crave for the implicit, and I for the explicit. A sketch is the one; a finished portrait painted to the farthest is the other, or rather mostly so, like a portrait by Rembrandt. I am not sympathetic toward the sketch. It is, to me, merely a beginning and of no particular value in itself. . . . I positively dislike a sketch if it is offered to me as a finished work of art. . . . I have been a painter all my days, that is, a

worker in the explicit, and never a sketcher. My sketches are not sketches. The sketch is a modern invention. A sketch is an affair of twenty minutes. A portrait is the result of many efforts, all of them tentative, its object the subtle truth of portraiture. *In its final form it becomes a sketch.*[66]

One is reminded of the young man who combs his hair for fifteen minutes to make it look as if it hadn't been combed. A portrait must ultimately be a sketch; but a sketch can never be a portrait. JBY stuck to his guns against the two younger men "'caught' by the new heresy." He continued to insist that ultimately art had to come from imitation, yet it could not be mere reproduction. A photograph could not compete with a portrait. Modern artists, he told Sloan, tried to glorify themselves while making painting "something to be obtained without labour." That was their weakness. "It is so much easier to sit among your friends spinning theories flattering to your conceit, that of yourselves and your companions, than it is to set to work copying nature—elusive nature, shy and modest as a maiden, who timid though she be, will not let herself be as much as kissed by any vulgar or insolent lover, nor by any weakling either, and cubists, etc., are always of one or other of these classes."[67]

It was a good year for JBY and the Sloans. "I have renewed old relations with them," he told Lily, "as they have given up fighting and arguing and can now talk sensibly." Sloan was "gradually growing more mellow and companionable," and the two resumed their old practice of attending exhibitions together.[68]

Just as he instructed Sloan in the ways of art, so he continued to define the poet's role to his son. He asked Willie whether he didn't believe his comment that "a poem is a social act done by a solitary man" cut one of "the Gordian knots."[69] One of his fresh metaphors came from the sea. There were "two kinds of mariners," he noted, those who always beat to windward and those who always went free before the wind, and both were bound to come to grief. The good mariner knew when to do one and when the other. There were also two kinds of poets.

There is the writer in prose or verse who never supposed himself to be on the right track if he was not resisting his own natural inclination, his own natural talent, and again another sort who thought that to write well in prose and verse is to be happy in doing it. There is in fact and has always been the literature of self-indulgence. In art and in the navigation of seas, the poet like the true mariner will sometimes indulge himself and sometimes refrain, as a wise judgment may direct.[70]

Four months later the metaphor was ornithological. He wrote to Willie of a remark he had made about painters and sculptors: "The last sentence is vague because on this subject my mind only guesses, like a hawk long circling and hovering before it pounces."[71] There was no uncertainty in his admiration for WBY's latest poetry in the November, 1920, issue of the *Dial*. Among the new poems were "Michael Robartes and the Dancer," "Easter 1916," "The Second

Coming," "A Prayer for My Daughter," "A Meditation in Time of War," and "To Be Carved in a Stone at Ballylee." "They are magnificent," he wrote George. "There is no other word for them—cut deep in marble and destined to last forever. Beside them so much poetry seems scratched on the surface of clay. The critics must be dumbfounded who said he had written himself out."[72] Yet he wondered whether he himself had really had any influence on his son. To Lily he repeated an observation he had made earlier, that neither of them had really known Willie for the past thirty years, the poet having concealed himself from the two members of his family closest to him as successfully as from anyone else. "I am quite as curious about him as is the great public of America and England."[73] Coming from one who had worked on his son longer and harder than he had on any of his portraits it was a curious but revealing remark.

Again in 1920 the issue of literary freedom was being fought in America through the pioneering indiscretions of the *Little Review*, which was still publishing sections of James Joyce's *Ulysses*, a work the author was painfully producing in enormous fragments, hoping that he could complete it and see it published by his fortieth birthday on February 2, 1922. Previous troubles with censorship were trivial, Quinn knew, compared to what would happen when the postal authorities read in the July-August (1920) issue the "Nausicaa" episode, in which Leopold Bloom enjoys a pleasurable if unspeakable sensation at the sight of Gertie MacDowell's undergarments. Quinn knew that with its appearance the gauntlet would be flung down, and during the second half of the year much of his time and effort was devoted to legal maneuverings to protect Joyce's right to publish the novel in its complete form.[74] For his argument at a preliminary hearing Quinn used the opinions and judgments of John Butler Yeats, who nowhere better demonstrated his triumph over origin and upbringing than in his final position on *Ulysses*.

The antagonists in the case made an interesting contrast. Arrayed against the book were the Anglo-American defenders of "decency," like John Sumner, secretary of the New York Society for the Prevention of Vice. Allied with them were the Irish-American cousins of Joyce who had left their country but not their church—the very kind who in Dublin, as JBY had already observed, had raised their hands and voices against Synge. On the other side was Joyce himself, the Irish genius writing in magnificent English out of an artist's vision of his own people, and joined with him were the lapsed Catholic John Quinn, brother of a nun and nephew of a priest, and the lapsed Anglo-Irish landlord who disliked bad taste and scarcely knew the kind of Irishman who prowled the murky streets of Joyce's Dublin. Yet old Mr. Yeats saw in Joyce not a muckraker but a moralist, an artist with a vision. JBY didn't always like the naked truth, he admitted to Lady Gregory, but he had "profound respect" for Joyce and his "awful fiction." "Joyce's writing is a revelation of that obscenity, the mind of the Dublin 'cad.' In old days I knew there were

such people, but never met them and never thought about them, and it was so with us all. We ignored these creatures. Now Joyce has dragged them into the light, and it had to be done, for they are powerful and making themselves felt."[75]

The real question was whether such books were to be broadcast to the world. JBY read the offending pages, shuddered, reflected on Joyce's earlier novel, and gave his answer. It was contained in a long letter to Quinn of October 14, 1920, a document that would have been remarkable at any time but was particularly noteworthy as coming from a Victorian in his eighty-second year. The main body of the letter was of two typewritten pages followed by more than ten pages of postscript.

Christ said somewhere that "you must leave father and mother and follow Me." That is Joyce's cry; only that the "me" is not Christ but the voice of each man's inner spirit. In other words, it is the gospel of individualism. Just now individualism is in great danger of being overthrown by its enemy, collectivism. . . .

Joyce . . . is the artist and the poet, as he has always been, and his gospel is the freedom of the individual . . . *it is each man's right to be himself. That such a man should write filth is incredible.* . . . All the conservatives and all the priests, both domestic and ecclesiastical, are in arms against him; and the heads of families with their tyrannical instincts. It is one man against many.

. . . His influence is a bracing one. There is no great book or great literature that would not be dangerous reading to some people. There are the corrupt-minded who, whatever they read, are sure to find the wherewithal of becoming more corrupt. For them we can do nothing. As to the young and immature, let their parents and guardians take care of them. And indeed Joyce brings with him what will protect him from the silly, whether they are so by ingrained corruption or by immaturity, for Joyce is very difficult reading. . . . His books are for the few, and these the elite. . . .

The fact is, man has two good friends to accompany him in life: beauty and ugliness. And he must not give his whole attention to either. He must remain his own master, consulting first one and then the other. . . . There have been terrible satirists, some of them painters and some poets, whose noble effort has been to make us see that life is hideous, that women are not beautiful, and that love itself is not romantic and poetical and tender, but repulsive. And against these men public opinion shrieks till it is hoarse. Yet these men are good physicians. . . .

. . . The whole movement against Joyce and his terrible veracity, naked and unashamed, has its origin in the desire of people to live comfortably, and, that they may live comfortably, to live superficially. . . . Joyce is a man of genius, inspired by an intense feeling for what is actual and true, and he sees the whole world, especially in his own native city, Dublin, living luxuriously in the lap of falsehood. He would awaken these people. He is a patriot, above all an Irish patriot. He is working for Irish regeneration. . . . He has exquisite gifts of writing by which he could make a great deal of money if only he would praise what readers like to see praised.

It was a restatement of his commentary on *In The Shadow of the Glen*. Was Gaelic Ireland to be saved by intellect, as he hoped? Was it to negotiate a cease-fire with the open mind, its mortal and historic enemy?

John Quinn, about 1921. Collection: Foster-Murphy.

Sketch in a letter from JBY to John Quinn, March 14, 1920. "Napoleon—an incident in the life of the great Napoleon lovingly recorded by an admirer. J. B. Yeats." It was to the main body of this letter that Quinn wrote in reply (March 23, 1920) the long defense of his own life. Collection: Foster-Murphy.

I am told that at the present time the man most hated in Dublin is this writer Joyce. That, to my mind, is a good sign. They are feeling their punishment and it is salutary. There are many shams in Dublin, as elsewhere, and Joyce, the student of Dante, is in hot pursuit and every honest man ought to be on his side. . . .

I know Dublin well. I know the pleasant falsehoods that are cherished by its good citizens, and I am not surprised to hear that they hate Joyce.

. . . People now are attacking Joyce, not in the least because they think his writings filthy or provocative of sin, but because they dislike his philosophy and his attack on established conventionality. It is because of this all Dublin is in arms. He should be helped and not hindered. No place needs him more than Dublin.[76]

This astonishing document, written at top speed in an almost illegible hand, was produced by an eighty-one-year-old man so frail that friends and family were fearful that the breezes of winter might carry him off.

Quinn made good use of JBY's arguments, and in one of his finest hours in court charged that the prosecuting attorney, Joseph Forrester, stood as the best testimony that *Ulysses* did not excite men to prurient behavior but angered them. "Is he filled with lewd desires?" Quinn asked the court, pointing contemptuously to Forrester. "Not at all. He wants to murder somebody. . . . He is full of hatred, venom, anger and uncharitableness. He is my chief exhibit as to the effect of 'Ulysses.' It may make people angry and make them feel as though they wanted to go out and tomahawk someone or put someone in jail, but it does not fill them with sexual desires."[77] He lost the case but saved the *Little Review*. The editors were fined fifty dollars each, and it was stipulated that no further selections from *Ulysses* should appear in it. The ultimate right of Joyce's novel to publication was not brought into the decision. Quinn thereupon dropped the case. He was a pragmatic lawyer, not a judicial theorist. His old artist friend might fashion a philosophical defense of free speech which Quinn could have used to establish his eternal fame as a defender of high principle. Instead he accomplished a narrow but necessary purpose and retired from the field.

Quinn became increasingly irritable as the year passed, and it was clear that his worries about his health had not abated. Papa remarked to Lily about the two different Quinns. "When Quinn is serene and happy it is very nice to be with him. When he is otherwise I wish myself back in my room. I have undergone tortures sometimes with him." He noted that when Quinn sat in an armchair he was tightly coiled like a cobra ready to strike. "Willie sits in a chair as if he intended to make it his home, and so do I."[78] When JBY sent Quinn a trifle of a letter with an amusing sketch of Napoleon standing by a French roadside, Quinn replied with an astonishing nine-page essay on his own merits. "There is no man of my years who has plunged into life and who has lived so varied and rich a life," he declared, then detailed his efforts on behalf of Willie and Douglas Hyde, of his arranging for the publication and copyright of WBY's works and those of Synge, Russell, Pound, Eliot, and

Joyce, of his defense of the Irish players, of his success in persuading Congress to remove the duty from modern works of art and his championing of modern art generally. The letter sounded suspiciously like a pre-mortem obituary by one who was afraid he wouldn't be properly written up. "In my full and busy life, I have tried to be as helpful to others as I could. I may not have succeeded always, but the will to help has been there. I may not have the genius for friendship, but I have helped many friends and many who are not my friends. I have been considerate of others where they have forfeited the right to any consideration. I know that I have done these things, and therefore it does not disturb me to feel that others may hold a different opinion."[79]

It was a peculiar but remarkable document—a testy and tempestuous man insisting that the world remember the heart of gold underneath, the acts of generosity, the gifts of time and patience with others. In reading the letter, one can see how Quinn wished himself to be regarded; and since no one else had shown a disposition to write about him in *Harper's Weekly* or the *Dial* or the *Little Review*, he would undertake to fill the gap himself. The saving grace in what is on the surface a grossly egotistical letter is that all of it is quite true. And despite his almost paranoid intensity—"He is really a perfect child in his tantrums, a temperament he mistakes for personality," JBY told Lily[80] —he yet remained JBY's best and closest friend in New York and his unyielding base of support.

At the end of 1920 the intrepid old painter remained secure on his precarious little throne in the boardinghouse, insisting on remaining in every way his own man. It was a life he did not wish to exchange for another. He told Susan Mitchell in June what Miss Emma Davenport had said in the Seaforth School in the 1840's, "that even if we got to heaven we should not enjoy ourselves." He quite agreed: "I do not believe in the mystics' heaven, because to me to enjoy it is to assault my human nature." "Yes, I do love this life, and to such a degree I have never taken any interest in theories about the immortality of the soul, since these would separate the soul from the body. Were I placed among the cold lunar beams of a purely spiritual existence, how I should sigh for the old life with its sins and temptations and its hot sun."[81]

If John Butler Yeats could have tasted the sweet of 1921 and been spared the bitter he might have chosen to sacrifice an extra few months of a fast-fading life. By some standards the year was successful. He boasted that during it five of his essays (some written earlier) had been published,[82] a greater number than in any other year, and *Measure* printed his poem on death, "Autumn."[83] He also had the pleasure of following the latest skirmish in the running battle between Susan Mitchell and George Moore, an unequal struggle in which the portly, puffy smirker tried unsuccessfully to escape the hot needles she fired in his direction. All in Dublin enjoyed the pinking of Moore. Miss Mitchell's earlier volume, *George Moore*, accurately described by Alan Denson as "a collection of jokes against Moore, disguised as a biography,"[84] had delighted

his enemies. Her approach may have been less than scrupulous, but she and others considered it quite within the rules of a game which Moore had himself invented in *Hail and Farewell*.[85] Moore had never forgiven her but disliked facing her in public, as JBY learned from Ernest Boyd. "Every year he visits Dublin for a short time to collect his rents," he told Mrs. Bellinger. "If he enters a room and finds Susan there he immediately goes away." Boyd hated Moore, "as does everyone else."[86] Now Moore presented himself to the public with a fictionalized account of the celebrated medieval lovers and sinners, *Héloïse and Abélard*. Miss Mitchell had always been annoyed by Moore's habit of describing in mixed company what he purported to be his sexual adventures, which she believed purely imaginary. The *Dial*, rather unfairly, asked her to review the book, and she did, with deadly results. The key passage in the review must have infuriated Moore:

What is the use of spancelling himself with the love story of Abélard and Héloïse, a thing he cannot remotely understand, for Moore has had too many love adventures in the imagination to have had any in the flesh, and a man with whom a girl might walk in safety through the desert of Sahara, knowing that he and not she would be the one who was afraid, has no business to be meddling with a passionate human story like Abélard's. Moore brings to love affairs the noxious mind of a prude and is curious where he should be reverent. In *Héloïse and Abélard* he is rewriting in afternoon tea what has been written in heart's blood.

She concluded with a damning final blast: "After the dedication I like nothing so well as the last sentence."[87]

The review caused a stir. Boyd thought it rather turned the advantage in the controversy to Moore because of its "fierceness," but John Butler Yeats liked it. "You put your finger on the very centre," he congratulated her.[88] "I am very impudent," she replied, "assailing one of his great literary reputation, but his Abelard would annoy you too. It is a stifling book, no air in it."[89]

He heard good news about Jack and Cottie, who visited occasionally at Gurteen Dhas, where Jack was as puckishly humorous, and as distant and private, as ever. When he held a show in February, Lollie wondered whether he would sell anything. "He has lately put very high prices on his pictures, but he always knows what he is about—or at any rate it is no use discussing prices etc. with him. He goes his own way, and apparently sees his own road clear before him." When Jack learned that Lily had suffered a recurrence of her boils, he paid for a week's stay at a hotel in Malahide and packed her off there. He also attended regularly a class in Irish, the only member of the family to attempt seriously to learn the language.[90]

The best news of all out of Dublin was that George was to have another child.[91] Everyone accepted Quinn's prediction, a correct one, that it would be a boy. By March, George was speaking of the expected child as "John Michael," leaving little doubt that the first name was to honor the expatriate father-in-law who had caught her fancy. Lollie, who expected to be named godmother,

confirmed the obvious inference, writing Papa, "I hope it will be a son so that he can have your name."[92] Willie, however, had other plans.

In New York JBY visited, read, and wrote. He enjoyed the compliment of an invitation to visit the Chestertons, who were passing through on a lecture tour,[93] and his account of the meeting is amusing. He expected the famous novelist and talker to say something, but after exchanging greetings all three fell silent. Papa had good intentions. "I began by keeping silent," he explained to Lily, "and meant to keep it all the time."[94] Finally he caved in. "The silence grew oppressive," he told Mrs. Caughey, "so I had to speak, and my tongue once loose—well, you know the rest. I felt like a man who had been gambling and lost all his money." JBY praised his host's talents:

> I fancy [he] never talks at all unless he has had a cocktail and that he is at other times shy and bashful. He did say to me that he never ceased to wonder why Americans should want to hear a man who was "only a journalist." I hastened to speak of his "magnificent gift of expression," and from the eager welcome Mrs. Chesterton gave to this phrase, I fancy she has to keep busy encouraging him.[95]

He still worked at the self-portrait in the customary way, writing a cheerful description of it to a frustrated Quinn: "It fills my life. I have never an idle moment or idle thought. It is a long revel, just as satisfying to me as Gibbon's *Decline and Fall of the Roman Empire*, and I think I have been at it almost as many years." He added blithely, "This morning I scraped away all the paint, but now it looks very promising."[96]

Early in the year he read a collection of essays, *The Sacred Wood*, by a little-known writer named T. S. Eliot, and another set, *Little Essays*, by George Santayana, which he found a contrast to the other. Eliot came off better, he thought, because he had had the benefit of leaving America. He found the "concentrated prose" of Eliot's book—"every sentence a riddle"—easier to read. "T. S. Eliot hits the nail on the head and does so at once, Santayana after many trials." Both men wrote "American"—"but *Eliot has lived in England*. The American intellect has a taste for 'floundering about.'"[97]

He had an opportunity also to comment on a poem of Willie's, "All Souls' Night," which appeared in the *New Republic*.[98] In it the poet suggested that he possessed arcane truths known only to those like himself who had delved in magic and mysticism:

> . . . I have a marvellous thing to say,
> A certain marvellous thing
> None but the living mock,
> Though not for sober ear;
>
>
>
> I have mummy truths to tell
> Whereat the living mock,
> Though not for sober ear.

It was a magnificent poem, evocative and beautiful, with what JBY called "wonderfully poignant felicities of musical phrase." But he was still disturbed by his son's attitude about poetry as poetry on the one hand and poetry as philosophical assertion on the other. Writing of it to Quinn, he confidently analyzed the relation between the poet and his materials:

In mysticism one can be as ingenious as one wants to be and indulge in any kind of theory—for in that thought is not an attempt to discover truth, but merely a medium of expression—and the thing expressed our eternal wonder in presence of the beyond. Regarded thus I enjoy immensely Willie's mystical theories, so far, at least, as I can follow out their intricacies.[99]

A couple of months later he expanded to Quinn on his view of the relationship between the poet and his materials, saying that the poet wants to express "whatever enters into his mind and imagination. He keeps a workshop and searches round for raw material. He is not himself a thinker or critic; at least that is not his business. He, if he is wise, leaves that to others."[100]

The Sloans kept in touch with JBY regularly and Dolly still tried to arrange lectures.[101] Henri continued to visit. Van Wyck Brooks saw him regularly and arranged for some of his articles to be taken by the *Freeman*, of which Brooks was an editor. When Alfred Zimmern returned to New York after a long absence he immediately sought out John Butler Yeats, who failed to recognize him; "it must be prohibition that has weakened my memory," JBY joked to Brooks.[102] Mrs. Eulabee Becker returned to dine at Petitpas,[103] and old and faithful friends like the Bellingers and Mrs. Foster watched over him. Ann Squire, who shared Dolly Sloan's problem with drinking, had been taken in by two old maids who tried to keep her busy so she wouldn't be tempted to toy with her demons.[104] JBY corresponded with her regularly. All were aware that he was failing rapidly, and nobody was surprised when Quinn reopened his campaign to get him to return to Dublin.

The old man had been spared Quinn's nagging during the first half of 1921 because of the troubles in Dublin. The fighting with the Black and Tans was worse than ever, and a curfew had been imposed on the city. WBY told Lily he dreaded Father's "inability to recognize" it.[105] The brutality of the English forces aroused a countering resentment among the Sinn Feiners, who, having proclaimed the Irish Republic, wished to show that they could command the allegiance of their people. One of their measures, simply conceived and perfectly executed, was the destruction of the interior of the Customs House on the Liffey. The president of the new, unrecognized nation, Eamon de Valera, hiding out as best he could from the English, fully concurred in the action. One night in May the horrified Yeats sisters watched from Gurteen Dhas as the fire rising from the beautiful long building lighted up the sky to the north.[106]

John Butler Yeats was appalled, sure the burning must have been the work

of "a sprinkling of Bolshevists who hate everything and everybody." He thought the act a stupid one. It was an Irish building that was destroyed, after all, not an English one, a building that had been constructed during the one brief period, in the last two decades of the eighteenth century, "when Ireland had her own government and held her own course," as he put it to WBY. "No one ever crossed that bridge who did not lovingly look towards it. . . . How the English rascals must chuckle with triumph."[107]

Father wanted Willie to remain aloof from the troubles, for, as he wrote Quinn, "In a violent time no one is listened to except the men of violence."[108] He was glad that Willie's recently published poem, "The Leaders of the Crowd," seemed to support that position:

The true Poet lives on an island. There may be many rides to the mainland, but he always returns to his island, to which the city noises cannot penetrate. . . .

You must keep away from the partisans. The aloofness may at first enrage both sides, but it is your natural bent. Of course I mean a qualified aloofness. No one living in Ireland could escape certain detestations and certain affections and hopes.[109]

Nineteen days later, after JBY's letter had had time to reach him and be transcribed for reading—his handwriting had become increasingly illegible—WBY wrote to George Russell: "We writers are not politicians, the present is not in our charge but some part of the future is."[110]

Willie spent the year in England, but his distance from Dublin did not diminish the acrimony between him and Lollie over the Cuala Press. Once again she wanted more freedom to choose titles, and Willie had to threaten to resign in order to preserve the old system. Since it was Willie who made good the annual deficits—doing so quietly and privately, as with his father's debts in New York—and since it was his reputation that partly accounted for the sale of the Cuala editions, there was only one possible winner in the struggle. He had to write sternly to Lily, who seemed to be supporting her sister: "Lollie and you must both recognize that I am a man of letters and that as a matter of conscience I will not pass bad work on any financial plea. This is not a quixotic idea of mine, but a prejudice I share with many other men of letters."[111] When Lollie sought her father's help, he sided with Willie,[112] who was as unobliging and censorious as ever with his sister, though he had good reason to be. When he sent her the text of *Four Years*, the second volume of his autobiography, it was not the customary typescript but a printed version from the *Dial*, with his own corrections and changes added. Yet at two places in the Cuala edition, passages were placed between inverted commas (or quotation marks, to use the American term) when the material was not quoted and called for no marks. Further, instead of the single inverted comma Willie preferred, Lollie used the double, thereby generating deeper acid in her brother's criticisms. He placed full responsibility for the errors on her. If she insisted on having a girl at the press do the proofreading, he said, she should be made to undergo

instruction and take a test to prove she knew what she was doing. Inverted commas were a typographical device with a specific, precise function. "Your girls seem to consider them as ornaments put in according to taste alone, double when they want a richer effect."[113]

Clearly, William Butler Yeats was not in one of his rare euphoric moods during 1921, and unhappily his dying father became along with Lollie the recipient of his sour emanations. The beginning of the end for the old painter can be fixed at midyear of 1921, when a combination of circumstances brought a close to his tenuous happiness. Just as his health took a sharp downward turn, and his family and Quinn resumed their campaign to force him to return to Dublin, WBY's account of the Bedford Park period in his *Four Years* laid a burden of distress on his father that he could not shake off. Had John Butler Yeats died in June of 1921 he would have been spared many unhappy months.

His health had been bad when the year opened. "My only cure is to eat little and take exercise," he told Lollie in early January, "and both are unpleasant," and added, "Old age is in itself a calamity that dwarfs all the minor ills of life."[114] His handwriting, always bad, grew worse, and his syntax occasionally went awry.[115] Through it all his mind remained sharp, but the mind was no match for the fading body. In June, just before Quinn left for a quick and quiet vacation in Europe—he kept it secret so that Dorothy Coates wouldn't know he was gone, for Jeanne Foster was to turn up in France as his traveling secretary[116] —he invited JBY to lunch at his Central Park West apartment. What he saw distressed him so much that he kept it from JBY's children until after their father's death, when he sent a detailed account:

When he was in my apartment one Sunday, I witnessed a tragic thing. . . . I had gone to the room in my apartment where the telephone is to answer a telephone call. While I was talking on the telephone he passed down the corridor to the end of the hall and into my bath-room. Just as I had finished talking I met him in the hallway coming back. His lips were red. I thought that he had a fever, then I got the odor of creosote which I realized that he had taken. . . . I saw that he had had a great shock but the kind thing was to say nothing. He said, "Well, Quinn, I think I will be going now." But I asked him to sit down for a little while and kept him talking, not wanting him to leave in that shocked condition. So we smoked and talked for an hour or longer. . . .

When I came back to my bathroom afterwards I found traces of blood on the toilet seat. He had wiped most of it off but there were traces of a hemorrhage. It was a tragic thing and very brave of him not to speak of it. I knew what that hemorrhage meant.[117]

The use of creosote—employed medicinally for indigestion and other forms of dyspepsia—showed that the old man had been prescribing for himself and was in much worse condition than he would let on to others, except indirectly. He had trouble sleeping, and remembrance of things past came to him vividly in the half-sleep of night. Sometimes when he "lapsed into subconsciousness" he fancied that "Willie's mother" was with him. "I was so convinced of her presence that sitting up and as wide awake as I am now I looked for her, and

once *remained for some time* looking for her, and *wondering that I did not find her.*"[118]

The clues to his perception of his own condition lay open in his letters. Not for anything would he say directly that he felt doomed, but the message was there for anyone who wanted to receive it.

I often meditate on the next world. In former days old men saved their souls by dreary meditation on the last judgment, but the times are changed and we old men are permitted to be more cheerful.

Young people are sad and sometimes commit suicide, but old men are naturally cheerful. Why? Because the first are oppressed by the menace of life, and of the long road before them. We are delivered from that terror. [To Lily, May 22]

I have never thought about my soul. I am neither an early Christian nor a modern. I am as little interested in my soul as if I were a vegetable—just to live and go on clinging to my environment is all I want. [To Mrs. Bellinger, June 10]

When I go home, I shall feel I am entering on the last stretch before that harbour which sooner or later will receive us all. *Measure*, a magazine, has just published a poem by me. It is called "Autumn," its subject the enigma Death. [To Isaac, July 29]

My most comfortable thought is, that there is no freedom of the will. I am like a little wheel in a watch, who says to itself that it must keep running, the wherefore not its business. [To Mrs. Bellinger, October 26]

I am glad poor Ada Mathews is dead and offer her my congratulations. [To Lily, November 8]

It was while he was aware of the closeness of death that he was delivered a blow that destroyed whatever serenity he might have retained. The *Dial* published in July as an article Willie's "Four Years," which was about to be published in book form by Cuala. The reminiscences filled John Butler Yeats with pain, and bitter memories of the differences between his son and himself flooded the shores of his imagination. One passage filled him with an agitation virtually incomprehensible to an objective reader of the text. Of a time away from home during the Bedford Park years the poet wrote: "I spent a few days at Oxford copying out a seventeenth-century translation . . . and returned very pale to my enraged family."[119] As he gave no elaboration, the reader might wonder why he wrote "enraged," but to Father the word brought back the unhappy memories of an aloof and imperious son who held himself superior to his family. His long-checked reserve weakened by age and illness, JBY exploded in a delayed burst of anger that had been kept under control for three decades. His letter to Willie in mid-June began mildly before rising to the subject.

Tristie Ellis and his sister will be pleased and grateful when they read your account of Edwin, although neither will say so. And I like very much what you say of Jack Nettleship. But why "enraged" family? I remember when you came back from Oxford how glad I was to see you and to hear your account of your visit and how during the fortnight you talked with no one, living all the time in solitude in empty Oxford. . . .

As to Lily and Lollie, they were too busy to be "enraged" about anything, Lily working all day at the Morrises, and Lollie dashing about giving lectures on picture painting and earning close on 300 pounds a year, and one year more than 300, while both gave all their earnings to the house. And besides all this work, of course, they did the house-keeping, and had to contrive things and see to things for their invalid mother—and all this when quite young girls, and cut off from living like other young ladies of their age and standing. They paid the penalty of having a father who did not earn enough and was besides an Irish landlord. I am sure that "enraged family" was a slip of the pen. I fancy you yourself did regard us as having the brand of inferiority, but that they didn't mind. What woman does?[120]

Women indeed might not mind, in those days. But John Butler Yeats was a man, and was Willie's father and head of the household. He had known in the 1890's, as he still knew, that his son regarded him as a failure, a mere dreamer unable to make his mark in the real world, and the knowledge still rankled. He knew also that as a result Willie had abandoned him and his philosophy—or had tried to. The next day Father returned to the subject again, attempting to explain and justify his life and art to a son who, he was sure, found both wanting. "I did so want to put myself right with your mother and her family. That was why I turned from the things of the imagination and did not go to see Rossetti. . . . I did not know that self-indulgence of a certain kind is much better than conscience. And of course I got no thanks, and can't complain, for stupidity is of all crimes the worst." He returned with satirical bitterness to the offensive phrase, "that chimera of the imagination, the 'enraged family.' I suppose it is one of your dramatis personae. We are necessary to the pic-ture."[121] To Lollie he wrote: "We must submit and pay the penalty for knowing a poet. . . . I am quite sure Willie has no malice against us, but just wants to tell histories. . . . I don't really now complain of his contempt, but it should not be revived in his book and written about for the benefit of his glory." The offending phrase, a "vivid" one, he charged, "will delight all his young lady friends in America and elsewhere and will please Lady Gregory and evoke that smile."[122]

Then, next day, with the rankling adjective still burning like a hot coal, he expressed to Willie openly and strongly what he had before approached only indirectly:

Had you stayed with me and not left me for Lady Gregory and her friends and associations you would have loved and adored concrete life for which as I know you have a real affection. What would have resulted? Realistic and poetical plays, and poetry in closest and most intimate union with the positive realities and complexities of life. And that is the world that waits, so far in vain, its poet. . . .

Had you stayed with me we would have collaborated and York Powell would have helped. We should have loved the opportunity of a poet among us to handle the concrete which is now left in the hands of the humorists and the preachers.[123]

Willie received the resentments as a Pollexfen. When he returned the Cuala proofs to Lollie, he suggested that she change the word "enraged" to

"troubled," but added, "Do not make it if it upsets type too much."[124] It was all very well to mollify the old man if no inconvenience were involved, but not otherwise. He refused to pursue the matter further with his father.

On August 22 JBY received a cablegram: "SON BORN TODAY BOTH WELL YEATS." Lily immediately wrote Papa, "So our distinguished name now has someone to carry it on."[125] The grandfather wrote Willie, "I can't tell you how pleased I am to hear of my grandson. Like a hidden rivulet the thought was with me all day at the back of my mind, and it is still there and will remain."[126] Nothing was said about the child's name, which up to then had been assumed to be "John." When the birth was recorded, the name enrolled was "William Michael Butler Yeats." At the christening in December, the "William" was quietly dropped, being, as WBY put it, "a soft wish washy moist day sort of name." So through a couple of distracting maneuvers Willie succeeded in detaching his father's name from the newest generation. Lollie was eased out as godmother too.[127]

Willie's crustiness may have been a result of the newest, and last, campaign to get father home. In midyear the political situation in Ireland changed suddenly. British policy seemed to reverse itself overnight—"No British Government in modern times has ever appeared to make so sudden and complete a reversal of policy," Winston Churchill said.[128] De Valera, who had been imprisoned, was released with the offer that he and the representatives of Ulster and England should come together to work out a *modus vivendi.* JBY wrote of "John Bull" to Mrs. Caughey: "I bet he is now regretting that he did not listen to me and William Gladstone when we advised Home Rule long ago."[129]

The new stability brought a change in Papa's position, for now he had no excuse for not returning to Dublin. Quinn tried again to get him aboard an eastbound liner. Although JBY stubbornly resisted and won his way, he was no longer able to carry out his stratagems with Buddhist calm. Now he suffered an almost complete collapse of self-confidence which led him into suspicions that people were out to get him, especially Willie and Quinn, the two on whom he depended most and whose sovereignty he both required and resented. In May, Willie instructed Quinn to book passage for late September or early October and told him he had sent his father a "stern letter" which he was sure would send him rushing in alarm to Quinn at once.[130]

But the old man at first tried his old tricks. In bland language, he acknowledged Willie's letter, "in which sympathetically and sweetly you tell me I must come home. I must have foreseen it, for two days ago I wrote to Mrs. Bellinger that it was possible I would never see her again." Then he launched into a long discussion of Dorothy Coates and Ann Squire, and added a postscript about lawyers and engineers as critics, another postscript about the logical mind of W. K. Magee, which led him into a discussion of Sir William Wilde, then a further postscript on Magee, to which, after signing the letter, he added still

another postscript, this one on Bolshevism. By the end of the letter the subject of his return to Dublin had been buried under a mountain of delightful but irrelevant verbiage.[131] When Quinn spoke to him on June 11, the old man did not fight but agreed to go—as soon as he finished the self-portrait. Quinn asked WBY to write his father as soon as the sailing date was confirmed and let JBY know Lily would meet him at Liverpool. As for the excuse of the self-portrait, "I am very fond of your father but, confidentially, the thing has become a bore to me."[132]

Before Quinn sailed on his "secret" voyage to Europe in June, he sent his assistant, John Watson, to the offices of the Cunard Line to place a deposit in the name of John Butler Yeats for the sailing of the *Carmania* on October 5.[133] When JBY demurred and brought up the portrait, Quinn rejected the tactic. He would take the portrait even though the painter insisted it was in "an embryonic condition." It was, Quinn told WBY, the "most 'venerable embryo,' overdue for delivery."[134]

Then Quinn sailed for Europe, and JBY seemed resigned to his fate. But in August he began to complain of feeling ill. One night he stayed up till eleven o'clock after having walked home from a theatre on Forty-seventh Street. Next day he told Lily, "I feel half dead and besides have a cold." A few days later he told Mrs. Bellinger that he was "awfully ill and at death's door," the metaphor being not entirely poetic.[135] He did not improve. When Quinn, home from Europe in late summer, invited him to dine, Mme Adèle Jais, wife of the new proprietor of the boardinghouse, reported that he was in poor condition. That night at ten o'clock there was a knock on the door, and, Papa wrote Lily, "There were two figures, Quinn and a doctor, the doctor all smiles and Quinn looking like an emissary from a secret tribunal." Quinn described the sight when he opened the door: "a frightful mess, clothes with sleeves turned inside out all over the couch, room almost hermetically sealed. . . . Hot light burning. Papers and books piled up and covered with dust and a litter of things, tobacco stubs and ashes all over the place. The room an almost indescribable sight, dust, door closed and only one of the two windows open about eight inches at the top. Sweat pouring down over your father's face. . . ."[136] Papa insisted there was nothing wrong, "only indigestion." The doctor told Quinn the important thing was "to pull him through the hot spell, which was very hard on old people generally and particularly on people as old and feeble" as JBY.[137]

JBY seized his opportunity with the doctor present. "With violent and vehement asseverations" (his own words to Lily), he declared that he was ill only because of the nervous tension brought on by Quinn's insistence that he go home. Quinn, afraid to bear the responsibility for disaster, was forced to delay the scheduled sailing.[138] When Willie got the news he was furious, but tried to write calmly to his father. "Lily and Lollie want you home, I want you home, and, what should be decisive, John Quinn wants you home. The

responsibility falls heavily upon him, and he has a right to decide this matter."
He promised Father that in Dublin he would have the University Club and
many friends, "and Lily will take great care of you."[139] A few days later,
hearing more news of his father's stubbornness, he wrote perhaps the
strongest letter ever:

Every month of delay involves Quinn, who is at present overworked and worried, in
loss of time, and in a responsibility which makes him extremely angry. I cannot
understand your remaining a single unnecessary day after receiving letters of the kind
which I know you have received from both Quinn and Watson. If at any time in my life I
had placed myself voluntarily (and remained voluntarily) in a situation where such
letters were a recurring event, you would have been angry with me, and very rightly
angry.

It was not merely "the expense of New York" that mattered; it was the
imposition on Quinn. "The present condition of things is an altogether unfit-
ting sunset for a laborious and dignified life. You must yourself feel how
undignified it is."[140]

WBY was exasperated at the need to write such letters, especially knowing
they would probably be fruitless. He wrote in disgust to Quinn that it wasn't
illness or the self-portrait that was keeping his father in New York, but what he
called "sheer infirmity of will."

It is this infirmity of will which has prevented him from finishing his pictures and
ruined his career. He even hates the sign of will in others. It used to cause quarrels
between me and him, for the qualities which I thought necessary to success in art or in
life seemed to him "egotism" or "selfishness" or "brutality." I had to escape this family
drifting, innocent and helpless, and the need for that drew me to dominating men like
Henley and Morris and estranged me from his friends, even from sympathetic unique
York Powell. I find even from letters written in the last few months that he has not quite
forgiven me.[141]

There was little spirit of forgiveness in Willie either, and little understanding.
To JBY the term "infirmity of will" would have been merely a degrading way
of expressing his unwillingness to compete in the marketplace, to yield to the
Pollexfen principle of "getting on," just as to Willie the notion of a totally
isolated, private artist had to be, ultimately, unthinkable.

What could one finally say about this father, the artist who wanted nothing
to do with the grubby necessities of making money, who generally shunned the
factionalism of political disputes, who kept at arm's length the journalists and
the "uplifters"—in short, the movers and shapers? Perhaps at least this much
may be said: that in a perfect world in which "getting on" has become unneces-
sary and irrelevant, John Butler Yeats might be its perfect citizen, the end
product of a beneficent evolution, wise, tolerant, liking and likable, witty,
intelligent, full of shifting but always exciting ideas, a delight to the hearts and
minds of those around him. Perhaps it was not he who was defective but the

world he lived in. What his son called "infirmity of will" could also have been described as a different way of approaching life. JBY's noninvolvement in causes, in "opinions," left him free to live as a whole person, and, paradoxically, to enrage his son into the kind of action he himself rejected. Each life bore its own fruit, one chiefly in the literary remains, the other—neglecting for the moment its considerable achievements in art—in the life itself.

JBY's refusal to sail was, furthermore, hardly the result of "infirmity of will." He kept everyone off balance by his apparent acceptance.[142] When Quinn made a new reservation for November 5, JBY, working through "a friend who knows about ships and their queer ways," managed "stealthily" to get it changed to a date in December.[143] When Willie got the news from Lily, and a copy of a letter Quinn had sent his father, he was reduced to a rage that made even his earlier letters seem mild.

You misunderstand. I thought I had made it plain in my letter that I consider your present position undignified because it places upon Quinn a responsibility which he greatly objects to. Do not deceive yourself on that point. He resents your delays most intensely. His letters to me make that plain; and I should have thought that the letter he dictated to Watson would have made it plain to you. I cannot understand a single needless hour after that letter. . . . You cannot stay on with any dignity while Quinn resents the necessary claims upon his thought and upon his time, the necessary anxiety which it forces upon him.[144]

It was all to no purpose. JBY hedged, avoiding a meeting with Watson to go for a photograph and a passport application,[145] spoke of a lecture being arranged for him by Mrs. Sloan ("damned little sluttish nuisance," Quinn fumed) and of a drawing he had been asked to do.[146] As he was leaving Quinn's apartment on Thanksgiving Day, he told Quinn "quietly, and with a little air of defiance," that he would not sail on December 3; and next day he repeated his position in a letter.[147]

So the old painter won out in the end, defeating family and friends alike. He refused to discuss another date for departure, saying simply to Quinn when the subject was raised, "I will not leave America."[148] Quinn surrendered. He saw that the old man had failed badly—he was coughing "dreadfully"—and warned him that his health "and perhaps even life" might be at stake. But he sent a messenger to pick up the sixty-five-dollar deposit from the Cunard Line, and that closed the matter.[149] Quinn's last word to Willie on the subject is of interest. "It was not infirmity of will that made his decision this time. It was strength of will, sheer stubbornness." JBY suggested a third word for it: he told Mrs. Bellinger that it was his "energy" that kept him in New York.[150]

So again, at the end of another year, he was still in New York, snug in his rabbit warren in the upstairs room at West Twenty-ninth Street. He still dabbled with his portrait, still wrote good letters. "I do not attach any great importance to my letters," he had told Willie modestly, "but think that if they

were boiled down there must result an essence of good."[151] He proved his point by writing a long and brilliant letter to Edward Caughey on the advisability of letting his daughter Mary "sow her wild oats" in Greenwich Village.[152]

Yet he knew the end was near. His mind was as good as ever, or almost as good, and to him the mind was Quinn's "wind on the heath." Having that, who would wish to die? Yet there was also the weakening heart, the collapsed lung, the damaged digestive system. There were times when he gave evidence of wanting to hasten the end. After Christmas dinner at the Boyds', he left early and refused Colum's offer to accompany him home, choosing to walk alone through the cold streets.[153] One wonders whether he consciously wished the extra effort might exact a special toll. "I don't want to die in New York," he had told his cousin Frank a year earlier;[154] but he didn't seem eager to delay his appointment in Samarra.

The end was not long in coming. Although JBY stayed in his room more than usual, he insisted on meeting what he felt were obligations. Quinn was the only one he deliberately avoided, fearing his pitiless schoolmasterism and perhaps afraid of being hauled off to a doctor. He continued sketching, doing pencils of Mary Caughey and one of her friends,[155] and trying to the end to capture the essence of Jeanne Foster. "Give me another chance to save my soul, and your face," he begged her in the middle of January. "Both are for eternity."[156] The subject of eternity was much on his mind, and he carried on a spirited dialogue with Mrs. Foster while she sat to him. He asked whether she thought one could know what was going on shortly after one died. She replied that although she didn't think much about the subject, she felt "sure" that *she* would know. "Willie would have a good deal to say about it, I daresay," he responded. Then, after some seconds he added, "By Jove, I'd like to believe it." "Why?" she asked. "Because I would enjoy going to my own funeral," he replied, and then continued "with great animation":

Yes, I'd enjoy seeing all the strangeness, looking at myself, watching the people, hearing what they said. I'd like to go through it all with my sketchbook. Think of what a sketchbook a man would have! Sketches of his friends at his own funeral! And I'd have such a curiosity about everything. By Jove! I would be interested. I might even do a sketch of myself.[157]

A lifelong conviction that personal oblivion was inescapable softened. "I have a firm belief," he told Susan Mitchell, "that we are part and parcel of some great machinery which is working smoothly and with no waste. Somewhere, somewhen, Keats and Shelley and thousands of others are still alive, and to doubt it is to be an atheist—that is, an unbeliever in final goodness."[158] It was hardly a conventional definition of "atheist," but his belief in "final goodness" was one he had held all his life, and one his life reflected.

He kept his interest in ideas and events and, as his last month proved to be an important one in the history of Ireland, he had much to say. Negotiations had begun between the Sinn Fein Party and the English to arrange for an orderly transfer of power. De Valera sent a team of negotiators to London under specific orders to agree only to membership in a kind of association of which the King of England would be the chief titular officer, but under no circumstances to admit allegiance to the King. Lloyd George, representing the old imperialist position, had other ideas. He closeted the Irish delegates in conference and threatened war on Ireland if they did not agree to his terms. Eventually the delegates broke down and signed the document.[159] De Valera, feeling that his own position had been undermined if not betrayed, now had to lead the opposition to the treaty his own emissaries had signed.[160] A civil war broke out between the two nationalist groups, those who accepted partition and allegiance and those who did not.

Lily, as a moderate nationalist, sided with Griffith and Collins, two of the London delegation, and told Papa that de Valera and his party were "trying to make mischief."[161] JBY urged his daughters to be careful to get the facts before taking a position: "I myself believe that de Valera is an honest man, and Colum, who knows him, says he is the most truthful man he ever met."[162]

But along with JBY's sharp mind and clear vision went the developing paranoia that had begun to manifest itself with the comments on *Four Years.* JBY complained to Lily that George Yeats never wrote to him and that he was unsure of her attitude. "I don't in the least know how she and Willie regard me, and that doubt is fatal to letter-writing. They make me uneasy."[163] He also protested angrily to the generous and considerate Van Wyck Brooks at receiving a check for only $17.50 from the *Freeman* for an article on John Sloan. "This payment is so inadequate that I cannot write any more for the *Freeman*," he wrote indignantly.[164]

A touch of the irrational was distorting his perceptions. He seemed more careless than ever. Mme Jais told Quinn that he would sometimes walk without an overcoat to the restaurant around the corner where he ate breakfast, and once she saw him going in his slippers.[165] Now he embarked on a series of exhausting activities that were to hasten the end. Late in the week of January 15 he went at Mrs. Becker's suggestion to see an exhibition of Laszlo's works at Knoedler's. Though he returned home exhausted he had not lost his sense of humor. He wrote to Mrs. Becker of Laszlo's works: "I had quite forgotten what horrors they are—bad in *drawing*, worse in *modeling* and worst of all in spirit and intention—in fact a magnificent skill in vulgarity and pretense. . . . But that I always express myself with great moderation and reserve I could write more strongly." To Quinn he wrote: "My self-portrait has been facing me for a long time lying against the wall of my room and filling me with despondency. I now see that it is the making of a masterpiece. To know good you must have seen evil. I have seen Laszlo and now I appreciate Yeats."[166]

He made another blunder on Sunday the twentieth by agreeing to attend an afternoon gathering at 137th Street in Manhattan. He took the wrong subway line and found himself at 135th Street in the Bronx, some two miles from his destination. There had been a blizzard, the weather was cold, and the snow still lay deep on the streets. Nevertheless he walked the long distance, which included a big hill, and when he arrived he was exhausted. Home at the boardinghouse, he should have gone to bed but stayed up with friends until eleven o'clock.[167]

Next day he was "at the lowest ebb of energy and good spirits,"[168] but that night had to attend a meeting of the MacDowell Club, where he was one of ten poets, among them Amy Lowell, to read from their own works. His poem, "Autumn," he read without giving the title and later wondered whether the audience knew what it was all about.[169] Although the Colums saw to it that he got away early, the next day he was again at "low ebb."[170] On the twenty-fourth he felt compelled to attend a meeting of the Poetry Society with Mrs. Foster, and was again "knocked up" after it. When she reported to Quinn that the old man required socks, handkerchiefs, and other small items, Quinn suggested combining a shopping trip with a visit to Kelekian's Galleries. After the viewing Quinn allowed JBY and Mrs. Foster to do their shopping and drive up Fifth Avenue in the hired car.[171] The next day, January 28, JBY wrote Mrs. Bellinger that he had been through "a week of physical misery, exhausted vitality and spirits down to zero." Then, with customary optimism, he declared that he was now "much better and in a sort of convalescence."[172]

He stayed quiet over the weekend. On Monday the thirtieth he walked downtown to see the Sloans, and Dolly noticed that he was faint after the long climb up the stairs, "the first time since she knew him."[173] She was so concerned that she begged him to let her take him to her own physician, a Dr. Adams, on Wednesday, and he felt so ill he agreed.

On Tuesday the thirty-first he sketched Mrs. Foster in his room after they lunched downstairs. She left at two o'clock, when Mrs. Bellinger's husband Frans came and stayed until five. Then he went down to dinner and sat up with friends until about eleven.[174]

On the morning of Wednesday, February 1, he went around the corner for breakfast as usual, then returned home to wait for Dolly Sloan to fetch him for the visit to Dr. Adams. Having just heard from Lily that Hilda Pollexfen was "seeing" much of an educated Englishman and that something might develop from the association, he filled the time by writing a letter to Lily on the family that had always fascinated him so much. It was his last letter and one of his best—and, for a man not forty-eight hours from death, quite remarkable.

I am glad to hear your news about Hilda. I hope it may come off. A Pollexfen married to a man of education has always good results. The family need education and will not submit to it unless it comes by marriage. Of course Fredrick is not interested. He once

said to me that "they might all be butchers as far as the governor cared." A parental solicitude is not among the Pollexfen traits. What did Elizabeth Orr, or your mother, or even clever Agnes care as to what became of their offspring? And because I did care and worried myself about you (with no money) I am pilloried as a man of violence &c. All the same my insistence on the fact that money was of small account compared to spiritual and artistic matters has borne its fruit, and I am content. The Pollexfens all disliked Willie. In their eyes he was not only abnormal, but he seemed to take after me. But however irritable ("the crossest people I ever met," my sister Ellen called them) they were slothful and so let him alone. And therefore in Willie's eyes they appear something grand like the figures at Stonehenge seen by moonlight.

He drew a sketch of Stonehenge with the moon behind it, added some comments about George Pollexfen and his clerk Doyle, and then broke gently to her the news of his health. "I am just recovering from Influenza. Not since I was ill have I felt so bad—and a few days ago I consented to go today with Mrs. Sloan to see a Doctor at 12 o'clock. I felt very bad when I gave consent. Till last night I have had no sleep." But today of course he was feeling "quite different," and he boasted of two pencil sketches of Mrs. Foster, and of a new fountain pen which Mrs. Ford had given him. Then, in two postscripts he added, "I must stop and go and see that Doctor," and "How I hate N York and its winter!"[175]

Those were the last words he wrote. Mrs. Sloan duly took her patient to Dr. Adams, who pronounced him to be suffering from "a tired heart."[176] That night the heart gave way. Early in the evening Mrs. Foster received a phone call from Mme Jais that Mr. Yeats was sitting on the edge of his bed in severe pain and breathing with difficulty. She immediately telephoned two doctors, then, finding neither in, called Quinn. She and he arrived together at the boardinghouse about nine o'clock. Mme Jais had herself summoned a local doctor who administered a morphine hypodermic. The pain ceased, the difficulty with the breathing subsided, and the patient fell asleep. When he awoke an hour later he seemed as chipper as ever and asked only to be reassured that the pain would not return. Mrs. Foster promised that there would be no more pain of any kind, that the doctor stood ready to administer a shot whenever needed. When he awakened he had looked at Mrs. Foster and Quinn and said, "I thought I was in hell and I awaken to find myself in heaven and you are all here with me." He fell asleep occasionally, and in the morning he awoke "bright and seemed better." For breakfast he took three cups of tea with cream and had milk and biscuits at noon. Mrs. Foster stayed with him all day, and he reminded her that she was to sit to him next morning.[177]

Quinn had secured a physician of his own choosing, a Dr. David S. Likely, who found edema of the lungs caused by the malfunctioning heart and prescribed camphor as a stimulant as well as hypodermic injections for relief from pain. At ten o'clock Wednesday night he hinted that the old man might not live more than three or four more hours. Quinn arranged for a nurse, a

Swedish woman named Mrs. Agda E. Lindstrand, whom the patient liked almost at once after a momentary distrust.[178] On Thursday morning Quinn joined Mrs. Foster in the sick room, where the old man conversed brilliantly, fended off an alcoholic illustrator who lived down the hall, and repeated his low opinion of Laszlo's paintings. He spoke of his days with Samuel Butler a half-century earlier and told stories about him.

In Paris that very day, Sylvia Beach succeeded in bringing out James Joyce's *Ulysses* on the author's fortieth birthday. Appropriately, the first day of life for the great Irish novel was the last full one for the great Irish portraitist. That night, to everyone's surprise, JBY was still alive, being kept comfortable by injections of drugs. Quinn recorded that "his brain was clear to the end."[179] When his friends left him that night, there were no "good-byes," no "last words." Everyone expected to be back listening to the talk the next morning.

That night he took his final turn for the worse. At eight o'clock he was very tired and asked the nurse to give him a bath, hoping that might make him sleep better. When his respiration became heavy he was given another shot of morphine. He fell asleep for a few hours, but between two and five on the morning of February 3, according to the nurse's report, he was "more or less restless." He fell asleep again at five. Then, at 6:40, in the nurse's words, "he woke up and tossed restlessly back and forth for a few minutes. As his pulse was very weak I was just about to give him some heart stimulant (which he had had several times during the night) when he suddenly turned over on his right side, closed his eyes and went into his last and eternal sleep. It was then 6:50 A.M."[180]

Staring down at the lifeless body on the bed was the "unfinished portrait," commissioned eleven years to the day before the painter could no longer stand as the model for it. It was an appropriate companion to the scene and a perfect symbol of its subject, but the word "unfinished" was really the wrong one. "I think every work of art should *survive* after all the labour bestowed upon it," JBY had once written William Butler Yeats, "and *survive as a sketch*. To the last it must be something struck off at a first heat."[181] The portrait was both finished and unfinished simultaneously, as were the life and works of John Butler Yeats. No idea was ever perfect. No good artist, no good poet, no good philosopher, ever achieved perfection, but rather moved toward it through changing states, "like a hawk long circling and hovering before it pounces," as he had expressed it not long before—and perhaps never pouncing at all, always seeking the perfect quarry but never finding it.[182] The self-portrait could never be finished, because the ever developing John Butler Yeats was never finished. So, paradoxically, it had always been finished, always the sketch that looked toward the final portrait that would itself be a sketch. To imagine that John Butler Yeats would ever have "finished" it would be to misunderstand all that he stood for. It didn't matter where the portrait stopped. As a

Death mask of JBY done by Edmund J. Quinn. Collection: The Yeats Society, Sligo, Ireland.

work of art it was always complete and incomplete at the same time, as a moment is a thing in itself and yet only a sequel to what went before and a prelude to what would come after. Seven years earlier John Butler Yeats had written to Willie about the thing he saw in the mirror, "this ghost," as he called it. "He continually eludes me, the fault not in him but in myself. I may be found some day dead at the foot of that mirror, after which the ghost will never be seen of mortal. Poor painter, poor ghost."[183]

George Pollexfen would not have approved of his brother-in-law's last years as he had not approved of the first. "He was very happy," Mary Colum said of JBY, "and he lived his own life to the end, a free enfranchised spirit."[184] When

he died he had fourteen dollars in a bank account established in more hopeful days.[185] Setting aside the sums his son had paid toward his support and a few "permanent" loans, he was clear of debt. In his art he had given far more than he had received. In the National Gallery of Ireland and the Municipal Gallery of Dublin are collections of his portraits unrivaled in number and spirit by any of his countrymen. To painters and writers in England, Ireland, and America, he had given idea and spirit and encouragement as well as a gift of selfless friendship. To his country he had left Ireland's greatest poet, possibly its greatest painter, and two daughters of magnificent distinction in their chosen vocations. To the world at large he left an example of a life beautifully lived, especially in its autumn years, on his own terms, compounded of imagination, intelligence, and sympathy. All these gifts were bequeathed to a world which regarded him as a "failure." How many "successful" men have left a legacy as great?

Epilogue

A FEW HOURS after JBY's death a sculptor, Edmund Quinn, took a death mask, which is now in the building of the Yeats Society in Sligo. On Sunday, February 5, an Episcopal service was held at the Church of the Holy Apostle. There were 250 people present, including the Irish Consul and the New York representative of the Irish Free State.[1] John Quinn sent the unfinished self-portrait, along with JBY's letters, papers, and other effects, to WBY in Dublin. As it was inconvenient and expensive to transport the body to Ireland for burial, the Yeats children accepted Mrs. Foster's offer of a gravesite next to the Foster family plot in the Rural Cemetery in Chestertown, New York, in the Adirondacks not far from Lake George. Because the ground there was frozen, the body was placed in a receiving vault at Woodlawn Cemetery to await burial later. On March 29, a memorial dinner in JBY's honor was held at 317 West Twenty-ninth Street with more than eighty friends present. In late July the coffin containing JBY's body was sent by train to Chestertown, where, with Mrs. Foster present, a Methodist minister read the committal service. A simple stone of Adirondack granite, chosen by Mrs. Foster, was erected over the grave. On it was incised a Celtic Cross with the letters "I H S" within, and under the cross an inscription written by William Butler Yeats: "In remembrance of John Butler Yeats of Dublin, Ireland. Painter and Writer. Born in Ireland Mar. 16, 1839. Died in N.Y. City Feb. 3, 1922."[2]

In September, 1923, the Cuala Press published *Early Memories*, a condensation of his memoirs. Less than a year later, on July 28, 1924, John Quinn died; his vast collection of paintings and sketches, including those of JBY, were sold at auction and dispersed.[3] In 1946, Joseph Hone edited a full-length book, *J. B. Yeats: Letters to His Son W. B. Yeats and Others, 1869–1922*, which received universally favorable reviews.

In 1972 the National Gallery of Ireland held an exhibition of 138 of JBY's paintings and drawings, with an illustrated catalogue and critique by James White, Director of the National Gallery. Finally, fifty years after his death, the great Irish painter had his first one-man show.

IN REMEMBRANCE OF
JOHN BUTLER YEATS
OF DUBLIN IRELAND
PAINTER AND WRITER
BORN IN IRELAND MAR. 16, 1839
DIED IN N.Y. CITY FEB. 3, 1922

Gravestone of John Butler Yeats, Chestertown Rural Cemetery, Chestertown, New York. Courtesy Caroline H. Fish and *Adirondack Life*.

Abbreviations and References

Abbreviations

BOOKS AND MANUSCRIPTS

Dowden, *Letters*	Edward Dowden. *Letters of Edward Dowden and His Correspondents.* London: J. M. Dent; New York: E. P. Dutton, 1914.
EM	John Butler Yeats. *Early Memories.* Dublin: Cuala, 1923.
Flannery	James Flannery. *Miss Annie F. Horniman and the Abbey Theatre.* Dublin: Dolmen, 1970.
Fragments	[Edward Dowden]. *Fragments from Old Letters: E.D. to E.D.W., 1869–1892.* 2 vols. London: J. M. Dent; New York: E. P. Dutton, 1914.
Frayne	John Frayne, ed. *Uncollected Prose of William Butler Yeats.* New York: Columbia University, 1970.
Greene and Stephens	David H. Greene and Edward M. Stephens. *J. M. Synge, 1871–1909.* New York: Columbia University Press, 1970.
Holloway	Robert Hogan and Michael J. O'Neill, eds. *Joseph Holloway's Abbey Theatre: A Selection from His Unpublished Journal, "Impressions of a Dublin Playgoer."* Carbondale and Edwardsville: Southern Illinois University Press; London and Amsterdam: Feffer and Simons, 1967.
Hone, *WBY*	Joseph Hone, *W. B. Yeats: 1865–1939.* London: Macmillan, 1965.
Irish Renaissance	Robin Skelton and David R. Clark, eds. *Irish Renaissance: A Gathering of Essays, Memoirs, and Letters from the Massachusetts Review.* Dublin: Dolmen, 1965.
JBYL	Joseph Hone. *J. B. Yeats: Letters to His Son W. B. Yeats and Others, 1869–1922.* New York: E. P. Dutton, 1946.
LBP	John Butler Yeats. *Letters from Bedford Park: A Selection from the Correspondence (1890–1901) of John Butler Yeats.* Edited with an introduction and notes by William M. Murphy. Dublin: Cuala, 1972.
Letters to Molly	Ann Saddlemyer, ed. *Letters to Molly: John Millington Synge to Maire O'Neill, 1906–1909.* Cambridge, Mass.: Harvard University Press, 1971.
Lily, Diary	Lily Yeats's unpublished diary, 1 Aug. 1895 to 26 June

	1897. Manuscript notebook, collection of Michael B. Yeats.
Lollie, Diary	"Diary kept by Lolly in 1888, 3 Blenheim Road, Bedford Park, London, W." 6 Sept. 1888 to 20 Jan. 1891. A small part of the diary was printed by Joseph Hone as "A Scattered Fair," *Wind and the Rain*, III, 3 (Autumn 1946) and reprinted in his *JBYL* (see above), pp. 291–298. Manuscript notebook, collection of Michael B. Yeats.
LY, DS	Lily Yeats, Draft Scrapbook. A manuscript notebook later partly revised and made part of Lily Yeats's Scrapbook. Date uncertain.
LY, OE	Lily Yeats, "Odds and Ends." Another notebook begun or ended on or about 29 April 1941. Independent of Lily Yeats's Scrapbook and Draft Scrapbook.
LYS	Lily Yeats's Scrapbook. An album containing photographs, newspaper clippings, genealogical charts, and other miscellaneous material about the Yeats family, as well as Lily's revised version of some of the material in the Draft Scrapbook and some new information not found in the earlier work.
Mem. (I, II, or III)	John Butler Yeats, Memoirs. The first of these (I), which bears no title, was intended to be an "autobiography," as the word is mentioned on the first page. It is handwritten in a hard-covered notebook. Mem. II and Mem. III are handwritten in a second hard-covered notebook and called "Memoirs, October 1918." Mem. II is written from the front of the book to the back on rectos (right-hand pages) only. Mem. III is written from back to front with the book turned upside down so that the rectos are the reverse versos.
Miller	Liam Miller. *The Dun Emer Press, Later the Cuala Press*. Dublin: Dolmen, 1973.
Pyle	Hilary Pyle. *Jack B. Yeats*. London: Routledge and Kegan Paul, 1970.
Reid	B. L. Reid. *The Man from New York: John Quinn and His Friends*. New York: Oxford University Press, 1968.
Robinson	Lennox Robinson. *Ireland's Abbey Theatre*. London: Sidgwick and Jackson, 1951.
Sloan, Diary	Bruce St. John, ed. *John Sloan's New York Scene*. New York: Harper and Row, 1965.
Wade, Bibliography	Allan Wade. *A Bibliography of the Writings of W. B. Yeats*. 3d ed., revised and edited by Russell K. Anspach. London: Rupert Hart-Davis, 1968.
Wade, Letters	Allan Wade. *The Letters of W. B. Yeats*. London: Rupert Hart-Davis, 1968.
WBY, Autobiographies	William Butler Yeats. *Autobiographies*. London: Macmillan, 1966.
WBY, Memoirs	William Butler Yeats. *Memoirs*. Transcribed and edited by Denis Donoghue. New York: Macmillan, 1972.
World of WBY, The	Robin Skelton and Ann Saddlemyer, eds. *The World of W. B. Yeats*. Rev. ed. Seattle: University of Washington Press, 1965.

NAMES

ABY	Anne Butler Yeats
AE	George Russell
C	Mary Tower Lapsley (Mrs. Edward) Caughey
Cottie	Mrs. Jack Yeats
ED	Edward Dowden
EDB	Eulabee Dix Becker
EDW, EDWD	Elizabeth Dickinson West, later the second Mrs. Edward Dowden
EE	Edwin Ellis
FYP	[Frederick] York Powell
George Yeats	[Bertha] Georgie Hyde-Lees (Mrs. William Butler) Yeats
Isaac	Isaac Butt Yeats
Jack	Jack Yeats (John Butler Yeats, Junior)
JBY	John Butler Yeats
JD	John Dowden
JMS	John Millington Synge
JO'L	John O'Leary
JRF	Jeanne Robert Foster
JS	John Sloan
JT	John Todhunter
KT	Katharine Tynan [Hinkson]
LAG	Lady Augusta Gregory
Lily	Susan Mary ("Lily") Yeats (daughter of JBY)
Lollie	Elizabeth Corbet ("Lollie") Yeats (daughter of JBY)
Matt Yeats	Matthew Yeats
MBY	Michael Butler Yeats
MFB	Martha Fletcher Bellinger
Q	John Quinn
RHJ	Ruth Hart (Mrs. Andrew) Jameson
SM	Susan Mitchell
SP	Sarah Purser
SPY	Susan [Mary] Pollexfen Yeats (wife of JBY)
VWB	Van Wyck Brooks
WBY	William Butler Yeats
WMM	William M[ichael] Murphy

LETTERS

Unless otherwise indicated, all material is from the collection of Michael B. Yeats, except JBY's letters to Jack and Isaac, which are in the collection of Anne B. Yeats. Most of the letters quoted or referred to are unpublished. When John Butler Yeats is the sender, only the name of the recipient or his initials is given, followed by the date and the source. For example: "Clare Marsh 9 March 1914, TCD" indicates a letter from John Butler Yeats to Clare Marsh of March 9, 1914, the original of which is in the Library of Trinity College, Dublin (see Collections, below). If the sender is someone other than JBY, the names of both sender and recipient are given: e.g., "Q to WBY 16

July 1915" indicates a letter from John Quinn to William Butler Yeats dated July 16, 1915, from the collection of Michael B. Yeats. "Lily to Q 12 Aug. 1913, NYPL" indicates a letter from Lily Yeats to John Quinn of August 12, 1913, from the Berg Collection of the New York Public Library.

Undated unpublished letters are described in different ways. If the date can be adduced from a postmark or definitive internal evidence it will be given within brackets, with the opening words of the letter added: WBY [5 Feb. 1904], "I forgot in yesterday's . . ." If part of the date appears in the original but not all, the missing parts are provided (where they are known or can be estimated) within brackets, followed by the opening words. If the date cannot be determined precisely but can be fairly estimated, the abbreviation "ca." (about) will be used: Lily [ca. 12 June 1908], "You may measure . . ." If the estimated date is less certain but the probabilities point to a likely date, the word "probably" will be used, again followed by the suggested date and the opening words of the letter. The author assumes responsibility for such dates but warns that they are only estimates. If no date can be established I have used "n.d."

Many of the quoted letters have been published. Those involving members of the Yeats family appear chiefly in Joseph Hone's *J. B. Yeats: Letters to His Son* (*JBYL*) or in Allan Wade's *Letters of W. B. Yeats* (Wade, *Letters*). Most of these are extant in the collections of Michael Yeats and Anne Yeats, and I have used the original letter whenever possible. I have tried to indicate the location of all published letters, however, and often the published versions do not agree with my own reading of the original. I have of course been compelled to use the published version where the original has not been available to me. These are cited as follows: WBY 11 Dec. 1913 (also in *JBYL*, pp. 168–169), or WBY 6 Jan. 1914 (quoted from *JBYL*, pp. 168–169). For the dating of William Butler Yeats's undated letters I have usually followed Wade. When the dating is more complicated or there is a difference of opinion I have discussed the problem in the appropriate note.

If there is more than one letter from a sender to a recipient on the same date, the opening words are given to distinguish one from the other, and the order (e.g., no. 1) if it can be determined.

COLLECTIONS

Brown	Library, Brown University, Providence, Rhode Island
Foster-Murphy	The Jeanne R. Foster–William M. Murphy Collection of Irish and Anglo-Irish Miscellanea, collection of William M. Murphy
Harry Yeats	Harry Yeats, grandson of Matthew Yeats, Montreal
Leeds	Brotherton Library, University of Leeds, England
Leonard Elton	Leonard Elton, son of Oliver Elton, London
NLI	National Library of Ireland, Dublin
NYPL	The Berg Collection, New York Public Library
Pennsylvania	Library, the University of Pennsylvania, Philadelphia
Princeton	Library, Princeton University, Princeton, New Jersey
Reading	Library, University of Reading, England
RHJ	Ruth Hart (Mrs. Andrew) Jameson, Dublin
TCD	Library of Trinity College, Dublin
Toronto	Library, University of Toronto
Yale	Beinecke Library, Yale University, New Haven, Connecticut

A Note on Names and Spellings

The nicknames of JBY's daughters are variously spelled in published and unpublished materials. I have followed JBY's practice in the salutation of his letters, using

"Lily" for Susan Mary, "Lollie" for Elizabeth Corbet, "Willie" for William Butler Yeats. When quoting from letters or documents I generally preserve the spelling of the writer. Since the Yeatses were carefree about punctuation, I have silently added what seemed necessary to establish proper syntax. When quoting from WBY's original letters I have silently corrected the spelling.

A Note on the Illustrations of John Butler Yeats's Works

The author has an esthetic objection to black-and-white reproductions of color paintings. All the illustrations in the text are therefore of black-and-white originals. The Cornell University Press has generously allowed for the color reproduction of the unfinished self-portrait as the frontispiece, the first time it has been so reproduced.

The sketches have been chosen from among those regarded by John Butler Yeats as finished (to the extent that he could so regard any of his works) and those which are merely casual. Those interested in his oil portraits should consult the originals in the Dublin Municipal Gallery and the National Gallery of Ireland.

Notes

Prologue

1. The handwritten original is in the Foster-Murphy Collection.
2. Ernest Boyd, "John Butler Yeats," *Literary Review*, 11 Feb. 1922.
3. JS to Lily 8 Feb. 1922.
4. VWB to WMM: conversation.

Chapter One: 1839–1862

1. Inland Revenue Register K.3., no. 1862, Folio 401 (7 Nov. 1865). There is no record of his birth in the Tullylish records. At the age of seventy-five he complained because a friend had called him an Ulsterman (Jack 19 March 1914).
2. Mem. II.
3. WBY, *Autobiographies*, p.22.
4. LYS, "Grandfather Yeats."
5. When the English departed in late 1921 the Irish destroyed most of the Castle records, so the precise room in which the Reverend William Butler Yeats was born is not known.
6. Isaac 1 July 1915, no. 1, "It is a long time . . . "
7. Lord Dunboyne, *Butler Family History*, 2d ed. (Kilkenny Castle: n. pub. 1966), pp. 16–17, 29. See William M. Murphy, "The Ancestry of William Butler Yeats," *Yeats Studies: An International Journal* (Galway and Toronto), no. 1, Bealtaine (spring) 1971, pp. 1–19.
8. LYS; see also A. N. Jeffares, *W. B. Yeats: Man and Poet* (London: Routledge and Kegan Paul, 1962), p. 1.
9. Among the Anglo-Irish the Yeatses lacked prestige because the man who gave his name to the family was a tradesman. In the peculiar logic of the class-conscious, Ireland's greatest poet would have been held in higher regard if the surnames of his great-great-grandparents had been reversed.
10. Humphry allowed the "life owner" to settle no more than £100 on the security of the property as a widow's jointure, and Parson John did so as soon as possible. When his eldest son, the Reverend William Butler Yeats, married, Parson John made a further agreement through three trustees guaranteeing a similar jointure for his daughter-in-law, Jane Grace Corbet Yeats, should she survive her husband after he became owner (Dublin Records Office, 23 March 1839, bk. 6, no. 19; the filing date is four days after JBY's birth, and the settlement itself is dated 4 Nov. 1835). Parson John Yeats's mother also enjoyed a pension and "other means" and lived comfortably in Great Cumberland Street in Dublin. Through her grandfather, Abraham Voisin, Mary Yeats was de-

scended from a Huguenot named Claude Voisin, who had come to Dublin in 1634. Abraham's daughter Mary married Edmond Butler. In later years John Butler Yeats was to attribute his family's "well-mannered Evangelicism," otherwise unaccountable in "a family so intelligent," to the Huguenot strain (Joseph Hone 29 Dec. 1915; *JBYL*, p. 214).

11. WBY 18 Nov. 1913.

12. Mem. I.

13. Mem. I.

14. LY, OE, "Death of Greatgrandfather Yeats."

15. LYS, "Grandfather Yeats." The Reverend W. B. Yeats lived with the Rector, who had objected to the appointment of the tall, horse-loving clergyman because he seemed more jockey than curate. The Rector also disapproved strongly of his curate's evangelicism. During one long dispute the Rector, not trusting his hot temper, carried on the argument by letter, the two rising at six in the morning, "each in his own room writing to the other." Before his marriage to Jane Grace Corbet, William Butler Yeats had proposed unsuccessfully to a woman whose daughter later married the historian J. R. Green. See Lily to JBY 28 Sept. 1918 and Chapter Sixteen, pp. 490–491.

16. LYS, "Grandfather Yeats."

17. Lily 15 March 1919.

18. There is no record of the birth in the Tullylish records, which were kept by the Reverend William Butler Yeats.

19. Prof. Alfred De Lury 21 Jan. 1921, Toronto; also LYS. JBY's aunt Eleanor Yeats was born at Drumcliff in 1813. Her husband later became Archdeacon Elwood. Their descendants—Elwoods, Middletons, and Holts—now live in Canada.

20. WBY [ca. 1920], "I think I ought . . . "

21. *EM*, p. 60.

22. WBY [ca. 1920], "I think I ought . . . "

23. Lily 13 April 1919. One sorrowful memory stood out sharply. When JBY was seven, his father's servant Sam Matchett (the strong man who could lift William Butler Yeats on the palm of his hand [*EM*, p. 3]) appeared and said, "Shame for you, Master Johnny, to be running around like that and your grandfather lying dead." The boy entered the house to find his mother packing his father's bag and "heard her say she was glad he would not get to Sligo in time for the funeral as he would feel it too much" (LY, OE, "Death of Grandfather Yeats"). The year was 1846.

24. Mem. II.

25. LY, OE, "The Famine."

26. Mem. I.

27. *EM*, pp. 4, 5.

28. Mem. I.

29. Lily 25 Sept. 1917.

30. Lily 28 June 1921 (*JBYL*, p. 280, contains part of this letter but not the passage quoted here).

31. Mem. II. The passage is crossed out in the notebook in which the Memoirs are written.

32. Mem. I.

33. Mem. II.

34. Mem. I.

35. *EM*, pp. 2–3.

36. Mem. I.

37. *EM*, p. 1.

38. *EM*, p.5.

39. SM 19 June 1920.

40. *EM*, pp. 8–10.
41. Mem. I.
42. *EM*, p. 10; Mem. I.
43. Mem. I.
44. Q 5 Apr. 1916.
45. Mem. II.
46. Lily 16 Sept. 1918; WBY 4 Feb. 1921; Isaac 17 Feb. 1921. I have been unable to find the records of the school, and the school itself has disappeared.
47. Julia Ford 1 May 1919, Yale.
48. Mem. I.
49. WBY 20 Sept. 1916.
50. To separate evidence based on hard documentation from that merely suggested by fiction, passages from JBY's fiction and conclusions inferred therefrom are enclosed within parentheses and italicized. In one of two fairly long stories Harry Bentley is the hero, in the other Harry Revell. Shorter stories involve Fred Roland and Dick Morton in one and John Whiteside in another (the only completed story). Sometimes the names become confused as JBY forgets what he has written or decides to strike out on a new road. The stories resemble in technique the two novels of William Butler Yeats, *John Sherman* (1891) and *The Speckled Bird* (not published till 1973–74). Among the fictional characters in JBY's work one can piece together JBY himself, George and Charles Pollexfen, Uncle Robert Corbet, Susan Pollexfen Yeats, and the young William Butler Yeats, as well as friends from his later days at Trinity College like John and Edward Dowden and John Todhunter. Places can be identified with Sandymount Castle, Sligo, and Fitzroy Road. See Chapter Two, n. 66.
51. Mem. I.
52. *EM*, pp. 13, 16, 17, 18.
53. A characteristic, embellished misquotation of Wordsworth's *Excursion*, I, 80 (Mem. I).
54. WBY 20 Sept. 1916.
55. Mem. I.
56. *EM*, p. 13.
57. Mem. I. "When George told you a story, it was a three-volume novel, and it would be all about nothing, and yet so minutely detailed that you hung upon every word."
58. Mem. I.
59. Lily 18 Sept. 1911. The letter includes a sketch by JBY of himself at sixteen.
60. WBY 23 Feb. 1916.
61. *EM*, p. 10.
62. Mem. II. Ill health was the reason always given by the members of the Yeats family, and nowhere in their records does any other appear. But in a review of Richard Ellmann's *Yeats: The Man and the Masks* (London: Macmillan, 1949), St. John Ervine remarks of the Reverend W. B. Yeats: "[His] parishioners in Tullylish were far from respecting and loving him 'for his piety and humanity.' He was, as Professor Ellmann's account of him makes plain, a very stupid, opinionated man, and his parishioners were delighted to see the back of him when, at too long last, he departed from Down" (*Spectator*, 11 Nov. 1949, p. 642). The late Constantine P. Curran privately remarked to WMM that Ervine was a thoroughly untrustworthy reporter of facts whose gossip was never to be taken at face value; and as Ervine does not openly charge that JBY's father was dismissed from his post his implication is perhaps better left unregarded. Yet there is an interestingly suggestive passage in a letter JBY wrote to Van Wyck Brooks (n.d., ca. 1910, "Many thanks . . . ") in which he referred to his "poor"

father's having "made such a mess of his life." As the Reverend William Butler Yeats held no parish after the age of fifty, perhaps there is fire beneath Ervine's smoke. Ervine, of course, could have known of his career only through hearsay.

Van Wyck Brooks stoutly attacked Ervine's unfavorable view of the Yeatses (*Spectator*, 9 Dec. 1949, p. 814).

63. *EM*, p. 56.

64. Mem. II.

65. *EM*, p. 54.

66. Mem. II; LY, OE, "My Father at Trinity." Robert was named stockbroker to the Court of Chancery, a minor post when he was appointed. After the Landed Estates Court was established, all purchase money passed through his hands and he was entitlted to large fees. He had also been appointed agent of the Royal Exchange Assurance Company, "securing the appointment by being a man of a certain social position and family." According to his nephew, he had little faculty for business, "but he was good-looking and genial and of honorable purpose."

67. Mem. II.

68. LAG 20 Oct. 1917, NYPL.

69. Mem. II.

70. Mem. II. *EM*, p. 59, contains a similar passage.

71. For a fuller account see William M. Murphy, "The Ancestry of William Butler Yeats."

72. Lily *or* Lollie, fragment [ca. 1918], "I can't tell you how . . . "

73. Mem. II.

74. WBY 13 June 1921.

75. WBY 30 May 1921 (*JBYL*, pp. 277–278). Because of excusably inaccurate transcription, Hone's account is garbled, and one would never suspect what a delicious tidbit lies concealed in it. What JBY wrote was: "When she was Miss Elgee, Mrs. Butt found her with her husband when the circumstances were not doubtful, and told my mother about it." Hone transcribes the passage: "When she was Miss Elgee, Mr. Bate found her with her husband when her circumstances were not doubtful," etc., a meaningless sentence.

76. Mrs. George Hart 4 June 1917, Coll.: RHJ. This letter, which does not appear in *JBYL*, was kindly lent me by Mrs. Ruth Hart (Mrs. Andrew) Jameson, as were all the letters to the Hart family.

77. ED, fragment, [ca. 1912]. "Eckermann's conversation . . . "

78. Mem. II.

79. Isidore Auguste Marie Francois Xavier Comte (1798–1857).

80. Mem. I.

81. WBY 26 March 1919 (Ellmann, *Yeats*, p. 10). I have not seen the original. Ellmann hints, and I suspect, that the date given by JBY may be somewhat early.

82. Mem. II.

83. Mem. II. The corresponding passage in *EM*, pp. 72–73, is almost identical.

84. Mem. II.

85. Mem. I.

86. Ingram's famous poem, entitled "The Memory of the Dead (1798)," was published in an early edition of Gavan Duffy's *Nation*. It had "such frightful seditious power," according to one critic, that it was partly responsible for Duffy's going to jail. Ingram did not acknowledge his authorship until fifty-seven years later (Malcolm Brown, *The Politics of Irish Literature* [Seattle: University of Washington Press, 1972], p. 63; Brown identifies Ingram as "a Dublin doctor").

87. Mem. I, II.

88. An account of the riot, the injuries, and the subsequent trial is to be found in *Freeman's Journal* (Dublin), issues from 12 March to 26 June 1858. JBY's passive role in the events is recounted in Mem. I.

89. Mem. I, II.

90. Mem. I.

91. When JBY's father took the land he had to purchase the sum of £5,500 from the Royal Exchange Assurance Company to meet a debt to Richard Gethin of £3,200; the balance of £2,300 he presumably devoted to his own purposes. As his part of the bargain the Reverend Mr. Yeats had to pay the company £474.8.0 a year until death, with the Kildare lands as security against the annual payments. He lived for fifteen years after the agreement and thus paid £1,880 more than he received (Dublin Registry 1847, bk. 15, no. 231 [6 Oct.]).

92. JBY, fiction, "Harry and Stringer got on . . . "

93. Mem. I, II.

94. EE to JBY 16 Feb. 1870. At least one of JBY's short pieces of fiction, the completed "John Whiteside," appears to be a disguised account of the hopeless affair. JBY had first experienced puppy love for a cousin when he was thirteen (WBY 12 March 1918).

95. Mem. II.

96. *EM*, p. 84.

97. *EM*, p. 85.

98. LYS, "Mama's Health and Other Things."

99. SPY 20 April 1863.

100. *Ibid.*

101. WBY 10 Feb. 1918.

102. For the Pollexfen ancestry and the history of the family in Sligo, see William M. Murphy, *The Yeats Family and the Pollexfens of Sligo* (Dublin: Dolmen, 1971).

103. Lily Yeats, who had a brother named William and a sister named Elizabeth, makes the point in her scrapbook about the number of Williams and Elizabeths in the family.

104. Lily 1 Feb. 1922.

105. Mem. I.

106. Q 31 Dec. 1915. In one unfinished story written about 1869 or 1870, JBY's hero Harry Bentley writes a friend: "A most strange midadventure has just befallen me. *I am engaged to be married*—two hours ago. I no more expected such an event than I did a trip to the moon. I am not a bit in love and I have not any expectations of fortune with the young lady. . . . Did I live a few years ago I should believe it was the work of Fate—and that I had no part in the matter. . . . Her rurality and simplicity and unsophisticated ways at any rate are better than the graces and charms of Laura Charteris with whom I was once entangled. . . .

"She will never suspect that I was not really in love. . . . I have suddenly altered my circumstances in a way that will inevitably strengthen my character on the side where it is weakest."

107. Mem. I.

108. The capital value is an estimate based on annual rentals multiplied by twenty, a common measurement.

109. Inland Revenue Office, Residuary Account, 7 Nov. 1865.

110. SPY 29 Nov. 1862.

111. SPY 20 April 1863.

112. SPY 16 June 1863.

Chapter Two: 1863–1867

1. SPY 9 June 1863.
2. Alice Dowden, "Biographical Sketch," in John Dowden, *The Medieval Church in Scotland: Its Constitution, Organization, and Law* (Glasgow: J. Maclehose and Sons, 1910), pp. [xv]–xliii. He won the Wray Prize, a senior Moderatorship, and a gold medal. He took a First Class in the examination in the divinity course and in 1862 gave an inaugural address before the Theological Society, "Aid to Personal Religion Afforded by Mental Science," and served as president of the society during the 1862–63 academic year.
3. Mem. II.
4. Dublin University Calendar, 1906, p. 1450.
5. Brigid J. P. McDermott. "John Todhunter, M.D., a Minor Figure in Anglo-Irish Literature" (Master's thesis, University College, Dublin, 1968), pp. 2–3. See also W. B. Yeats, "Notice of John Todhunter," *Magazine of Poetry* (Buffalo), April 1889; it is reprinted in full in Roger McHugh, ed., *W. B. Yeats: Letters to Katharine Tynan* (Dublin: Clonmore and Reynolds, 1953), pp. 152–154.
6. Dublin University Calendar, 1906, pp. 67–68.
7. JT to ED 9 Dec. 1868, TCD.
8. JBY, fiction, "A young mother was playing . . ."
9. SPY 23 March 1863. The photograph referred to here has not been identified. The one reproduced on p. 41 was taken in Sligo around the time of the wedding in Sept. 1863.
10. The Middle Temple Admission Registers show that he was admitted 24 Jan. 1863. I thank Charlotte R. Lutyens, LL.B., F.L.A., Librarian and Keeper of the Records, Middle Temple, for this information.
11. The mortgagors were Joseph Hall and Edward Singleton; see Dublin Registry 1863, bk. 23, no. 105, Library of the King's Inns.
12. SPY 16 Feb. 1863.
13. SPY [ca. 1 or 5 July 1863]. "You are a goose . . ."
14. Dublin Registry 1863, bk. 30, no. 163 (9 Sept.), Library of the King's Inns. Many in the Pollexfen family came to believe that William Pollexfen settled a sizable dowry on his daughter; rumors placed the figure as high as ten thousand pounds. A careful study of JBY's financial affairs from 1862 to 1907 reveals no dowry of such a size, or indeed of any significant magnitude.
15. Mem. II.
16. Lily 4 Feb. 1913. Had he died then in Galway, JBY wrote, "you would not now have been in existence. But the family property would have been saved, and it would have been better for my [your?] poor mother, and I'd have been saved a lot of trouble—and George Russell would have been the great Irish poet, having it all his own way.—And Lady Gregory? I don't know what she would have done with her energy. And Synge perhaps never would have discovered himself."
17. See Dublin *Evening Herald*, 19 Feb. 1965. Robert Corbet's epithet appears in LYS, "Where We Lived."
18. ED 10 July 1867.
19. Joseph Hone, "Memoir," *JBYL*, p. 29. His weight remained fairly constant at 11 stone all his life. He wrote Lily in 1920 (11 Jan.) that he weighed 156 pounds. He had also written Lollie 7 Sept. 1915, "At school long ago I was always regarded as delicate. I have kept myself alive by my intelligence." Once in the late 1870's he reached his maximum of 12 stone 4 pounds (Jack 7 March 1920).

20. JS 18 March 1919. "My chin is not visible but I can remember."

21. Mem. I.

22. JBY, fiction, "Harry and Stringer got on . . . "

23. JBY, fiction, "A young mother was playing . . . "

24. JBY, fiction, "My dear Dick . . . "

25. JT to ED 28 Sept. 1864, TCD.

26. Mem. I.

27. JBY, "John Dowden" (typescript fragment), "Among my most . . . "

28. ED to JD 5 Oct. [1864] (Dowden, *Letters*, p. 15).

29. JBY, "The Two Dowdens" (unpublished; this exists in both manuscript and typescript). The passage on rocking his cradle is from WBY 23 Feb. 1916.

30. Alice Dowden, Preface, *The Medieval Church in Scotland*, p. xxxi.

31. JT to ED 28 Sept. 1864, TCD; ED to Richard Garnett 22 May 1888 (R. S. Garnett, ed., *Letters about Shelley* [London: Hodder and Stoughton, 1917], pp. 165–166).

32. JT to JBY 27 May 1869.

33. ED to JBY 6 Dec. 1869, 3 July 1867.

34. He attended more than half the debates between 11 Nov. 1864 and 16 June 1865, and took an active part in them, generally arguing what would today be called the "liberal" or "progressive" position.

35. Registry of Births, Marriages, and Deaths, Customs House, Dublin: William Butler Yeats, b. at 5 Sandymount Avenue, Dublin, 13 June 1865. Registered 20 June 1865, by father, who is listed as "law student." I thank Dr. Oliver Edwards for this information.

36. Thomas Beatty was related to the Reverend Mr. Beatty who years before had waived his rights to the rectorate at Tullylish so that the first William Butler Yeats might take it. The Beattys were related to the Armstrongs.

37. LY, OE, "W. B. Yeats's Birth." The note was written by Lily 3 May 1941. From his displeasure JBY exempted relatives, who were allowed to touch the boy physically.

38. WBY 13 Dec. 1917. The event convinced him that he was "born to be a public speaker," though he gave no further public speeches till he was an old man. "It was the presence of the big crowds and the judges on the platform and the Lord Chancellor in the chair that magically endowed me with such power of memory. . . . It showed I was born to catch the kind of inspiration that makes the speaker."

39. The word "fruit" appears as "fruits" in the printed edition, but in JBY's presentation copy to Charles Pollexfen it has been corrected to the singular.

40. John Butler Yeats, *An Address Delivered Before the Law Students' Debating Society of Dublin at the Opening Meeting of the Fourteenth Session, in the Lecture Hall, King's Inns, on Tuesday Evening, November 21st, 1865, By the Auditor John Butler Yeats A.B., Student of the King's Inns, Dublin, and of the Middle Temple, London*. (Dublin: Joseph Dollard, 9 Dame St., 1865), pp. 9–33.

41. *Freeman's Journal*, 10 and 19 Jan. 1866. In the 1867 edition of *Thom's Irish Almanac and Official Directory of the United Kingdom of Great Britain and Ireland*, JBY was duly listed as a Barrister-at-Law as of H[ilary] 1866, with his name misspelled "Yeates." The entry appears in the directory annually until 1937, fifteen years after his death.

42. Mem. I.

43. The sketch of Whiteside (p. 49) is now in the National Gallery of Ireland, no. 2675. It is dated Feb. 1866 and is identified as "James Whiteside, Lord Chief Justice, 1804–1876." I thank Dr. James White and Hilary Pyle for giving me access to this and other drawings by JBY in the National Gallery.

44. *Freeman's Journal*, 20 Jan. 1866.

45. JS 17 July 1917, Princeton.

46. Isaac 29 Dec. 1915; Registry of Births, Marriages, and Deaths, Customs House, Dublin: Susan Mary Yeats, b. at Enniscrone, Co. Sligo, 25 Aug. 1866. Registered by George Boyd (medical student who supervised delivery) on 7 Sept. 1866. I am grateful to Dr. Oliver Edwards for sharing this information with me.

47. WBY, fragment [ca. 1913], "What I write is prose . . . "; EDB 15 Oct. 1912: "If you stay too much and too long with that baby, it may be serious. Nervous exhaustion is easily cured and forgotten, but it is a very serious thing indeed. I have reasons for knowing this. . . . As a rule Doctors come too late into the field—only after the mischief is done. In my mind you ought to wean your baby. . . . I am haunted by what I know."

48. JD to JBY 16 Nov. 1866.

49. "Biographical Note," Dowden, *Letters*, p. 395; ED to JD 3 July 1867 (*ibid.*, p. 39).

50. JBY, fiction, "In London in one . . . "

51. *EM*, p. 62; also Mem. II. Terence de Vere White told WMM he believed he remembered seeing JBY's name listed as a participant in a minor case, which would perhaps be his only known appearance; Constantine P. Curran told WMM he had a similar feeling. In a letter to Lily (5 Jan. 1909) JBY included a sketch of himself in a gown and under it the caption: "I return to the Bar and win my first case." See on the subject A. N. Jeffares, *W. B. Yeats: Man and Poet* (London: Routledge and Kegan Paul, 1962), p. 301.

52. Mem. I.

53. *Ibid.*

54. Mrs. George Hart 25 May 1916 (also in *JBYL*, pp. 226–227). See also Lily 17 May 1916 (also in *JBYL*, p. 225).

55. Lily 30 Oct. 1912. See Sheelah Kirby, *The Yeats Country* (Dublin: Dolmen, 1969) for a full account of Sligo and its environs.

56. Mem. I.

57. ED to JBY 3 July 1867.

58. ED 8 July 1867.

59. ED to JBY 28 July 1867.

60. JBY's first letter from Fitzroy Road, to Edward Dowden, was dated 4 Aug. 1867.

61. Mem. I.

62. Mem. I contains a long account of T. W. G. Butler.

63. John Butler Yeats, *Essays Irish and American* (Dublin: Talbot; London: T. Fisher Unwin, 1918), pp. 9–10.

64. Oliver Elton 13 June 1916, Coll.: Leonard Elton.

65. SM 24 Sept. 1921.

66. ED 8 Dec. 1867. Like his other enterprises, the story remained unfinished, giving way instead to another, also unfinished. During the next few years he wrote more than 60,000 words of fiction but finished only a couple of short pieces. He provided none with a title. See Chapter One. n. 50. Their principal interest to posterity is that they are transparently autobiographical, disguised under the most diaphanous of fictional gauzes. From them we get a better picture than from the letters of what was going on in his mind.

67. See Dowden, *Letters*, pp. 39–45 *et seq.*

68. Dublin Registry 1867, bk. 37, no. 241 (25 Nov.). See also ED to JBY 28 July 1867.

69. The two sketches are in the collection of Michael B. Yeats. One is reproduced in WBY, *Autobiographies*, both in William M. Murphy, *The Yeats Family and the Pollexfens of Sligo* (Dublin: Dolmen, 1971). See sketch on p. 54.

70. ED to JBY 28 July, 4 Aug., and 8 Dec. 1867.

71. ED 8 July 1867. The poem was published in Dowden's *Poems* (London: Henry S. King, 1876), pp. 30–37. JBY hoped that Dowden had "crowned with immortality a place very dear" to him. His wish went unfulfilled, as the poem is never read except by

students of Dowden—not a numerous breed—and except for the correspondence between the two the world would never know that it was about Sandymount Castle.

72. ED to JBY 1 Dec. 1867.
73. ED 8 Dec. 1867.

Chapter Three: 1868–1870

1. Lollie's aunt, Elizabeth Pollexfen, was called "Lolla," and her great-uncle Matthew's daughter Laura shared the nickname "Lollie." The birth is recorded in General Registrar House, Registration District Pancras, Sub-district Regent's Park, County Middlesex: 11 Mar. 1868, 23 Fitzroy Road, Elizabeth Corbet, father John Butler Yeats, mother Susan Pollexfen Yeats. I thank Dr. Oliver Edwards for providing me with the record of birth.

2. Dublin Registry 1868 bk. 12, no. 37 (31 March). The solicitors charged £20 for their services, and other expenses came to £10.4.0, so more than 10 percent of the principal amount of the loan disappeared before JBY saw it (memo from Vincent and Buckley, 31 South Frederick Street, 11 April 1868).

3. JBY often admitted his lack of interest in children. Others noticed it too. Leonard Elton spoke to WMM of a visit to his home in the late 1890's by JBY and York Powell. Powell went to the children immediately. JBY ignored them.

4. Isaac 29 Dec. 1915.
5. ED 4 Sept. 1867, 17 May 1868.
6. ED to JBY 6 Dec. 1869.
7. ED 6 Jan. 1868.
8. JT to ED 9 Dec. 1868, TCD.
9. JT to JBY 17 June 1869.
10. ED to JBY [ca. 20 May 1868], "I have but this . . . "
11. ED 30 May 1868.
12. EE 7 Jan. 1869.
13. JT 21 June 1868, Reading.
14. ED 18 Jan. 1868.
15. London: Macmillan, 1868.
16. ED to JD 30 Mar. 1868 (Dowden, *Letters*, pp. 39–40).
17. EE to JBY 31 Aug. 1869.
18. EE 27 Aug. 1868.
19. JD to JBY 27 Feb. 1868.
20. Isaac 17 Feb. 1921. At Atholl he discovered he could sing only two notes.
21. JBY, "John Dowden" (typescript fragment) "Among my most . . . "
22. Mem. I. Also in JBY, "John Dowden."
23. SM 14 Jan. 1922: The congregation "would have cheerfully crucified him, and his wife would have helped, had he not been too clever for them." See also LAG 20 Oct. 1917, NYPL; ED 24 Feb. and 19 May 1910.
24. Oliver Elton 11 April 1911, Coll.: Leonard Elton.
25. See the account of *A Woman's Reliquary* (the collection of lyrics Dowden wrote to his second wife) in Chapter Fourteen, pp. 407–409. See also *Fragments from Old Letters*, 2 vols. (London: Dent; New York: Dutton, 1914), a selection of his letters to her from 1869 to 1892.
26. JT 21 June 1869, Reading.
27. EE to JBY 3 Sept. 1868.
28. ED 18 Jan. 1869.
29. Mem. II.
30. ED 18 Jan. 1869. See Mem. I, III.

31. ED 18 Jan. 1869.
32. EE to ED 8 Dec. 1869, TCD.
33. See *Art Journal*, 1905, p. 277.
34. EE to JBY 12 July 1869.
35. EE 7 Jan. 1869; EE to JBY 8 Jan. 1869.
36. EE to ED 8 Dec. 1869, TCD.
37. EE 7 Jan. 1869.
38. EE to JBY 12 July 1869.
39. JT to ED 27 Sept. 1869, TCD.
40. Mem. I.
41. JT to ED 14 Jan. 1870, TCD.
42. Mem. II.
43. WBY, fragment [ca. 1918], "Armed wars and . . . "
44. Mem. I.
45. EE 25 June 1869.
46. See Mem. I, and WBY, *Autobiographies*, p. 170.WBY writes that his father thought Ellis "lacked all ambition," but the context makes clear that he meant the ambition to work at perfecting his art. WBY's account confirms his father's opinion that Ellis was brilliant if difficult.
47. Oliver Edwards, "A Few Chapters from 'Yeats: His Life and Poetry'" (unpublished typescript), p. 20. I am grateful to Dr. Edwards for permission to quote from this illuminating account, which is based in large part on recollections of Lily Yeats and of people who knew WBY as a boy and a young man.
48. EE to JBY 8 Jan. 1869.
49. JT to ED 14 Jan. 1870, TCD.
50. Mem. II.
51. The account book and other papers relating to the Thomastown estate were discovered in the files of a Dublin solicitor in 1970. They are now part of the MBY Collection.
52. Matt Yeats to JBY 10 and 29 Nov. 1869. See the curious incident in WBY's *The Speckled Bird*, ed. William H. O'Donnell, I (Dublin: Cuala, 1973), 4–5. Michael Hearne's father witnessed just such a shooting but pretended not to see who fired the gun. (In Thomastown no one could identify the assassin, not even John Doran, who was nearby.) In view of the many other parallels to events in real life in the fiction of both JBY and WBY, it is not impossible that the incident in the novel was modeled on the real shooting. See also Chapter Six, pp. 126–127: John Butler Yeats hid in his desk a gun belonging to one of "the Invincibles" and withheld the information from the authorities. Perhaps WBY combined the two events. Prof. O'Donnell is compiling a second, annotated edition of *The Speckled Bird*, which will consider such questions. I hope to publish in another place my own discoveries of the identifications in WBY's *John Sherman* (1891), in which similar use is made of autobiographical materials.
53. JT 17 May 1869.
54. JD to JBY 14 Oct. 1869.
55. EE to JBY 24 May 1869.
56. EE to JBY 7 June 1869.
57. Mem. I.
58. EE 6 June 1869.
59. JT to JBY 13 June 1870.
60. EE 6 June 1869.
61. EE to JBY 7 June 1869.
62. JT to JBY 17 June 1869.
63. JT to ED 8 Aug. 1869, TCD.

64. JT to ED 27 Sept. 1869, TCD.
65. JBY, fiction, "In London in one . . . "
66. JT 25 Nov. 1869, Reading.
67. WBY 10 May 1914.
68. JT to ED 27 Sept. 1869, TCD.
69. JT to ED 14 Jan. 1870, TCD.
70. ED to JBY 6 Dec. 1869 (also in Dowden, *Letters*, p. 45).
71. EE 1 Sept. 1869.
72. JT 25 Nov. 1869, Reading.
73. EE to JBY 4 Oct. 1869; also JBY's letters to Ellis of [29] Aug. and [25] Sept. 1869.
74. Mem. I.
75. LY, OE, "The Moonbeam."
76. JT 23 June 1870, Reading: "After tomorrow my studio will be in my own house." A week later he assured Ellis that he had the back rent in his pocket and would "pay the landlord at the first opportunity" (EE 2 July 1870).
77. Mem. III.
78. JT 2 March 1870, Reading.
79. *Ibid.* If the events involving the fictional Harry Bentley are to be accepted as parallels, he never sold many of these anyway.
80. Lily 12 Sept. [1911].
81. JT 2 March, 4 April, 24 April, and 2 May 1870, Reading.
82. ED to JBY 10 and 20 June 1870. There were many studies for the work. James White, *John Butler Yeats and the Irish Renaissance* (Dublin: Dolmen, 1972), p. 67, lists a drawing called "Pippa" and a watercolor called "Pippa Passes," both in the National Gallery of Ireland.
83. JT 16 May 1870, Reading.
84. JT to JBY 20 June 1870.
85. JT 14 June 1870, Reading.
86. JT to JBY 13 June 1870.
87. JT 14 June and 2 Aug. 1870, Reading.
88. JT 27 Aug. 1870 (written from Merville in Sligo), Reading.
89. JT 16 Nov. 1870, Reading.
90. JT 6 Jan. 1871, Reading. *Pippa* is now in the National Gallery of Ireland.
91. C 28 July 1916, Princeton.
92. Mem. III. Cf. Mem. I, written in 1918: "I came to read J. S. Mill's two volumes of Political Economy, and then all his books that began the long climb of accurate and careful logical thinking never to be abandoned. His methods are still my methods, though it is many years since I took interest in anything except Art and Literature."
93. Mem. II. William Morris told JBY that Nettleship was "too much of the west front" (Mem. I).
94. Mem. III.
95. *Ibid.* It may have been that very evening when JBY, observing that a silence had fallen over the house as the overture to *Faust* began, asked Ellis the reason. Ellis, knowing of JBY's tin ear, replied with a straight face that the orchestra was playing "The Wearing of the Green."
96. Mem. I.
97. Mem. III.
98. Edward Dowden's notebook, TCD.
99. JT to ED 1 Nov. 1870, TCD.
100. JT 2 Aug. 1870, Reading. Todhunter told Dowden he agreed with Yeats. "While he hates dogmatical art, he delights in art with ideas in it—but these must be

imaginative ideas, i.e., emotional as well as intellectual. But mere emotion he hates cordially as Ruskin does" (4 Aug. 1870, TCD).

101. JT to ED 12 Dec. 1869, TCD.
102. ED 21 Sept. 1870.
103. EE 2 July 1870.
104. WBY 9 Aug. 1916, no. 2, "There is another . . . "
105. ED to JBY 10 Dec. 1869.
106. JT to JBY 20 June 1870.
107. ED to JBY 22 Sept. 1870.
108. JT 17 and 27 Aug. 1870 (written from Merville in Sligo), Reading.
109. JT to ED 14 Jan. 1870, TCD.
110. Ellis kept JBY's letters in order sewn together in a folder; these are now in the collection of MBY. Perhaps significantly, the "monumental letter" here referred to was not preserved.
111. EE to JBY 16 Feb. 1870.
112. Isaac 28 Feb. 1916.
113. Lily 28 Dec. 1916. See also WBY, *Memoirs*, p. 29. I first read the memoirs in the typescript prepared by the late Curtis Bradford, who graciously allowed me to consult it.
114. John Doran to Matt Yeats 4 April [1870].
115. Matt Yeats to JBY 6 April 1870.
116. William Butler Yeats (brother) to JBY 10 Sept. 1870.
117. JT 24 April 1870, Reading.
118. The dates of the lease are given in JT 24 April 1870, Reading.

Chapter Four: 1871–1873

1. Lollie 21 Oct. 1921.
2. JT 6 Jan. 1871, Reading; Mem. I.
3. William Pollexfen to JBY 7 Feb. 1871. The old man was no Lord Chesterfield as a letter writer. He described the check as "as good as cash to your Butcher, if you give it to him," and he added, "Glad to hear your picture is well hung this time, that it's thought a good deal of, hope it will be the means of selling some (to be painted) for you."
4. JT 6 Jan. and 3 Feb. 1871, Reading.
5. Mem. I.
6. JD to JBY 16 Nov. 1866; Dublin University Calendar, 1906. On 6 April 1867, when Edward Dowden won the newly created post, the salary was set at £100. On 29 March 1869 it was increased to £140, and on 9 Dec. 1871 to £300. On 6 May 1885 it rose to £500, where it remained till his death.
7. Jane Grace Corbet Yeats to JBY 18 June [1875]. See also WBY [probably 4 June 1904], "It is the easiest thing . . . " (also in *JBYL*, p. 79): "We supported Aunt Ellen and enabled her to bring up a large family of little children. Among us we gave her an income for about 30 years. There was no fuss. No one in Sligo, above all none of the Pollexfens, knew of it."
8. Mem. I; JT to ED 11 Nov. 1878, TCD.
9. ED 20 Nov. 1872.
10. SPY 6 Feb. 1873.
11. SPY n.d. [probably late 1872 or early 1873], "My chief anxiety . . . "
12. The son, Arthur Henry, died in 1874; see Brigid McDermott, "John Todhunter, M.D., a Minor Figure in Ango-Irish Literature" (Master's thesis, Trinity College,

Dublin, 1968), p. 6. The basement of the house became headquarters of the Cuala Press after Mrs. William Butler Yeats's death in 1968 and continued so till 1975, when Cuala moved to Dalkey.

13. ED 6 April 1871.

14. ED to EDW 17 May 1872 (*Fragments*, II, 4).

15. ED 5 Nov. 1871.

16. Internal Revenue, Legacy Receipt, 1873, Folio 503, where the date of death is given as 7 April 1872; WBY [probably 4 June 1904], "It is the easiest thing . . . " (*JBYL*, p. 79).

17. Lily 15 Sept. 1916.

18. Mem. II. The account is from WBY, *Autobiographies*, p. 21. JBY could never bring himself to give the details of his uncle's death. His son gave the details but withheld the name.

19. ED 5 Nov. 1871.

20. *Ibid.* See Lily 7 Jan. 1917: "I have always wished to be a landscape painter." See also WBY's account of a later painting of the pond between Slough and Farnham Royal, done some years later (Chapter Five, p. 112).

21. Edward John Poynter (1836–1919) was later knighted and was made a baronet in 1902.

22. ED to JD 26 June 1872 (Dowden, *Letters*, p. 61).

23. WBY, *Autobiographies*, p. 5. Willie remembered looking out a window and seeing boys playing in the road, among them one in uniform, perhaps a telegraph boy. The servant told him it was someone who was going to blow the town up, and the young child went to sleep that night in terror. Lily recalls only "faint memories" of the house, "Lollie throwing a stool out of the nursery window, seeing Jack sleeping by Mama in her bed, he rolled in a pale blue shawl" (LYS, "Where We Lived"). She also remembered Edwin Ellis with his books and candle (Oliver Edwards, "A Few Chapters from 'Yeats: His Life and Poetry'" [unpublished typescript], p. 20). The Fitzroy Road house is honored by a plaque identifying it as the home of William Butler Yeats, while the more important later residences in Bedford Park bear no notice.

24. Alice Dowden, Preface, in John Dowden, *The Medieval Church in Scotland: Its Constitution, Organization, and Law* (Glasgow: J. Maclehose and Sons, 1910), p. xix.

25. SM n.d., ca. Oct. 1916, "A thousand thanks . . . "

26. Lily 10 April 1913.

27. WBY [probably 4 June 1904], "It is the easiest thing . . . " (*JBYL*, p. 80).

28. ED 19 July 1872.

29. Lloyd's Register. I thank K. G. Mason of Lloyd's for this information. See William M. Murphy, "'In Memory of Alfred Pollexfen': W. B. Yeats and the Theme of Family," *Irish University Review*, I, no. 1 (autumn 1970), pp. 30–47. For a further treatment of the Pollexfens, see William M. Murphy, *The Yeats Family and the Pollexfens of Sligo* (Dublin: Dolmen, 1971), *passim*.

30. WBY, *Autobiographies*, p. 10.

31. Lily 3 Nov. 1910.

32. Lily 23 June 1915; quote is from WBY 20 Sept. 1916. Fredrick in later life resented his father's way of bringing up his children, for William Pollexfen had no interest in educating them for anything but business. As a result he usually neglected them. JBY thought Charles, the surly "evil" Charles, was the one who had ruined Fredrick (Lily 6 Nov. 1910, 1 Feb. 1922).

33. Lollie 30 Dec. 1921.

34. WBY n.d. [probably Aug. 1916], "This is why I said . . . "

35. WBY 6 Sept. 1915, no. 1, "I am writing . . . "

36. WBY 21 Sept. 1916.

37. WBY 11 Aug. 1908.

38. Mem. I.
39. EE to JBY 8 Sept. 1872. Also SPY, fragment, n.d., "I hope you continue . . . "
40. Lily 28 Dec. 1916.
41. SPY 10 Nov. 1872
42. Mem. III; SPY 3 Nov. 1872.
43. SPY n.d. (probably 5 Dec.) 1872.
44. SPY 21 Feb. 1873.
45. SPY [probably early 1873], "My chief anxiety . . . "
46. SPY 28 Oct. 1872.
47. SPY [probably early 1873], "My chief anxiety . . . "
48. SPY n.d. in envelope postmarked 20 Jan. 1873.
49. SPY 1 Nov. 1872. The portions of the letter quoted here, with punctuation silently supplied or corrected, are taken from the original in the collection of Michael Yeats. (JBY's spelling of "termagant" is preserved.) A copy by Lily Yeats, not quite accurate, is in the National Library of Ireland, and another copy, also inaccurate, in her Scrapbook. Joseph Hone, in his *WBY* (pp. 17–18), gives yet another incorrect version, perhaps based on information given him by Lily.
50. SPY 13 Jan. 1873 (misdated 1872).
51. Lily to WBY 23 Feb. 1922; Mary Jane (Mrs. John) Pollexfen to SPY 4 March 1873.
52. I am grateful to Dr. Oliver Edwards for calling this fascinating piece of information to my attention.
53. SPY 22 March 1873.
54. WBY 11 Dec. 1913. *JBYL*, pp. 168–169, reprints part of the letter but omits the passage about the loan. In April 1875 Uncle Matt paid Dowden fifty pounds out of the income of the estate (Accounting no. 7, 1875, April to Sept.).
55. London: 1873. In addition to paintings done in his early teens, Brown (1855–1874) also produced *The Dwale Bluth, Hebditch's Legacy, and other literary remains* (London: Tinsley Bros., 1876). See John H. Ingram, *Oliver Madox Brown* (London: E. Stock, 1883).
56. *JBYL*, p. 49, headnote.
57. ED to EDW 24 April 1873 (*Fragments*, I, 64–65).
58. SPY 1 May 1873.
59. ED to EDW 18 July 1873 (*Fragments*, II, 23–25).
60. John Quinn, "John Butler Yeats" (unpublished typescript, 1922). Quinn was describing the JBY he knew as an old man. The qualities he noted must have been even more marked in the artist in his mid-thirties.
61. LYS, "Mama's Health and Other Things."
62. WBY, *Autobiographies*, p. 167.
63. WBY [1906], "Many thanks for your letters . . . "
64. LYS, "The Wry-Mouth Family."
65. LY, OE, "A bailiff must . . . "
66. WBY, *Autobiographies*, p. 9.
67. LYS, "Grandfather William Pollexfen."
68. LY, OE, "The Big Noise."
69. LY, DS. "Grandfather Pollexfen"; WBY, *Autobiographies*, pp. 7, 6, 8.
70. LY, DS, "Grandfather Pollexfen."
71. LYS, "Our Grandmother Elizabeth Pollexfen—Born Middleton."
72. LY, DS, "Grandmother Yeats." See also LYS, "Grandmother Yeats."
73. WBY, *Autobiographies*, p. 11 and *passim*; the first section (pp. 5–106) appeared as *Reveries over Childhood and Youth* (Dublin: Cuala, 1916).
74. WBY, *Autobiographies*, p. 52.
75. This account was told me by Joseph Doty, who heard WBY tell the story in 1921

or 1922 at a session of a social club at Oxford, where Dr. Doty was then a Rhodes Scholar.

76. WBY, *Autobiographies*, p. 17.

77. *Ibid.* In the text Lucy's name is not given.

78. LYS, "Grandmother Pollexfen's Brothers and Sister."

79. LYS, "Our Grandmother Elizabeth Pollexfen—Born Middleton."

80. LYS, "Great Aunt Mary Yeats."

81. LYS, "The Fight of the Wynnes and Yeats [*sic*]."

82. LYS, "Our Grandmother Elizabeth Pollexfen—Born Middleton"; LY, OE, "The Moonbeam."

83. LYS, "Our Grandmother Elizabeth Pollexfen—Born Middleton"; see also Hone, *WBY*, p. 16.

84. WBY, *Autobiographies*, pp. 22, 52. See also George Mills Harper, *"Go Back to Where you Belong": Yeats's Return from Exile* (Dublin: Dolmen, 1973). This paper, a model of creative scholarship, was read at the Yeats International Summer School in Sligo under the title "'Go Back to Where You Belong': Yeats and the Theme of Exile," on 16 Aug. 1968.

85. WBY, *Autobiographies*, p. 7.

86. LYS, "I remember when . . . "

87. LY, OE, "The Tenth Bridesmaid."

88. WBY 8 April 1910.

89. Lily 25 June 1910; WBY 18 Sept. 1916, no. 2, "Why am I writing . . . "

90. Isaac 3 April 1916.

91. Lily 25 June 1910.

92. The account of the wedding is taken almost literatim from LY, OE, "The Tenth Bridesmaid."

93. Lily 15 Sept. 1916. *JBYL*, p. 229, contains part of the letter but not this passage.

94. Oliver Elton 9 April 1911, Coll.: Leonard Elton.

95. WBY, *Autobiographies*, p. 23.

96. *Ibid.*, p. 24.

97. *Ibid.* JBY was angered by the recollection when it appeared in *Reveries over Childhood and Youth*. He could not remember the incident of the thrown book at all. See Chapter Fifteen, p. 446.

98. *Ibid.*; Mem. I.

99. Mem. I.

100. WBY, *Autobiographies*, p. 46.

101. *Ibid.*, pp. 24–25. The date of his attendance at the "dame school" is uncertain but was almost surely either brief or sporadic or both. Perhaps the futility of the music lessons—at "singing school" in Sligo—is reflected in the second stanza of "Sailing to Byzantium."

102. Oliver Edwards, "A Few Chapters," pp. 16–17.

103. In later years JBY was to date the visit to Muckross as 1872 (see Lily 5 Oct., Jack 22 Nov., C 4 Oct., and Isaac 1 Oct. 1916). But two letters of EE to JBY (23 Oct. and 18 Nov. 1873) and ED to EDW 2 Nov. 1873 (*Fragments*, I, 76–77) fix the date accurately.

104. Lily [ca. Oct. 1873], "I was very glad . . . "; ED to EDW 2 Nov. 1873 (*Fragments*, I, 76–77); Lily 16 Dec. 1908. See also Sloan, *Diary*, 18 Jan. 1910, p. 376: "[Mr. Yeats's] side comments were fine too. He told of his experience in 1870 [*sic*] painting in the home of an Irish Lord (uncle of Balfour) Herbert, of the confidences which they placed with him, of the Rabelaisian jokes, etc. and of a visiting lady who 'threw herself at him' and he was too much awed by [her] to accept besides having a wife and children." Helen Farr (Mrs. John) Sloan in conversation with WMM 17 May 1972 said JBY described the guests as "like animals." Sloan was shocked by JBY's story. JBY was shocked that Sloan

was shocked. (See also Van Wyck Brooks's account, *John Sloan* [New York: Dutton, 1955], pp. 108–109).

105. JBY left the painting with Edward Dowden at his rooms in Trinity, where it was found after his death by the second Mrs. Dowden, who returned it to the daughters. It hangs today in the music room in the home of Michael Yeats in Dalkey. Family tradition has it that the gallant who whisked Mrs. Herbert to a higher happiness was the footman.

106. EE 18 Dec. 1873. The Cosbys were distant relatives, and JBY knew them when he was eight years old (Isaac 4 May 1920, no. 2, "Willie dined here . . . ").

107. EE 18 Dec. 1873. Stradbally Hall, with its pictures, still stands. I am grateful to Maj. E. A. S. Cosby for having shown me, in the company of Sen. Michael Yeats, about the house and let us inspect the guest book in which the name of John Butler Yeats is signed, 14 Dec. 1873, as well as that of his distant cousin, William H. Yeats, of Ballincar House, Sligo, 4 Jan. 1874. Major Cosby also has a copy of WBY's *Celtic Twilight* (1893), a gift of JBY in Sept. 1895.

Chapter Five: 1874–1881

1. Robert Catterson Smith to JT 3 March 1874, Reading.
2. ED to JBY 17 March 1874.
3. ED [ca. 20 March 1874], "I have never . . . "
4. ED to EDW 23 May 1874 (*Fragments*, II, 55).
5. Almost as if in verification of Dowden's Bolingbrokism is his advice to Aubrey De Vere just five months later to avoid Irish heroes as subjects of poetry. "As a fact, *whether it ought to be so or not*, the choice of an Irish mythical, or early historical, subject confines the full enjoyment of a poem to a little circle" (22 Aug. 1874; Dowden, *Letters*, p. 68; WMM's italics).
6. See WBY's essay "At Stratford-on-Avon," *Essays and Introductions* (New York: Macmillan, 1961), pp. 96–110. The ideas expressed there are completely his father's, though not specifically acknowledged. See Chapter Ten, pp. 229–230.
7. Alice Dowden, Preface, in John Dowden, *The Medieval Church in Scotland; Its Constitution, Organization, and Law* (Glasgow: J. Maclehose and Sons, 1910), pp. xix–xx, xl.
8. ED to EDW 22 Dec. 1874 (*Fragments*, I, 119).
9. At least one of these was of the group of children to which he referred in his letter to Edward Dowden (ca, 20 March 1874, "I have never . . . "). Unhappily, no work of JBY seems to hang in Stradbally now.
10. Matt Yeats to JBY 15 April 1875.
11. Lloyd's Records 1 Jan. 1874. I thank K. R. Mason of Lloyd's for this information.
12. WBY, *Autobiographies*, pp. 47–48.
13. LY, OE, "Walks with Papa."
14. Matt Yeats 27 Aug. 1875.
15. ED to EDW 23 May 1874 (*Fragments*, II, 55–56).
16. Robert Catterson Smith to JT 30 Oct. (or 1 Nov.) 1874, Reading. Edith Villas, a block-long street, still survives, a short distance north of the Kensington Underground Station, but No. 14 fell to German bombing during the Second World War.
17. ED to EDW 23 May 1874 (*Fragments*, II, 55–56).
18. WBY, *Autobiographies*, p. 27.
19. Robert Catterson Smith to JT 30 Oct. (or 1 Nov.) 1874, Reading.
20. JT to ED 1 July 1875, TCD.
21. EE 9 April 1875.
22. JT to JBY 15 April 1875.

23. EE 9 April 1875.
24. JT to ED 2 March 1876, TCD.
25. ED to JBY 11 May 1876.
26. LY, OE, "The Moonbeam."
27. LY, OE, "The National Gallery."
28. WBY, *Autobiographies*, p. 31.
29. LYS, "Our Grandmother Elizabeth Pollexfen—Born Middleton."
30. Registration was made in October, in district and subdistrict of Fulham, before George Finck, Registrar. Place of birth was 14 Edith Villas. I am indebted to Dr. Oliver Edwards for this information.
31. John Doran to JBY [probably fall 1874], "Your uncle was here . . . "
32. Matt Yeats 27 Aug. 1875.
33. Jane Grace Corbet Yeats to JBY 18 June [1875], "This letter should be . . . "
34. JT to ED 14 Jan. 1876, TCD.
35. JT to ED 21 March 1876, TCD.
36. See James White, *John Butler Yeats and the Irish Renaissance* (Dublin: Dolmen, 1972), p. 71. The picture is now in the National Gallery of Ireland.
37. Isaac Butt 14 and 23 May 1876, NLI, MS 13151. The terms of the commission are not recorded. See also White, *JBY and the Irish Renaissance*, p. 67.
38. JT to ED 2 March 1876, TCD.
39. Matt Yeats 21 Oct. 1885.
40. ED to JBY 11 May 1876.
41. The death was recorded on 7 June at Fulham. The cause was given as "teething broncho-pneumonia, cerebral effusion." I thank Dr. Oliver Edwards for providing me with this record. The illness was apparently so severe that relatives accepted the death as a blessing. Grandmother Pollexfen felt the child would not have been "wise" if it had survived (Elizabeth Pollexfen to JBY 6 June 1876).
42. LY, DS, "Grandmother Yeats."
43. ED 3 Jan. 1877. John Addington Symonds (to JT 23 Jan. 1877, Reading) spoke guardedly but accurately of Todhunter's work, *Laurella and Other Poems* (London: 1876); "I thought to myself: the noisy world will not very likely heed the poet: his work will be disinterred hereafter when scholars gather up the volumes of the great Victorian age of song, and rate our present for its deadness. I may be wrong. I hope I shall be wrong." So far he has been proved right. Even though he was a far better poet than Dowden, Todhunter's reputation is equally dead. Dowden's *Poems* was published in London by Henry S. King in 1876.
44. ED 3 Jan. 1877.
45. ED to JT 1 Dec. 1875 (Dowden, *Letters*, p. 87); 13 March 1875, TCD.
46. Estate Accounting, half-year ending March 1876.
47. ED [probably late 1876], "I am greatly obliged . . . "
48. Dublin Registry, 1877, bk. 35, no. 290. The purchaser was Patrick Byrne, the witnesses to the document Charles K. Wright and William Butler Yeats, "merchant." The actual swearing and registration did not occur until 13 Aug. The purchase price was not given; six hundred pounds is simply the annual rent multipled by twenty.
49. ED 9 Nov. 1876.
50. ED [probably late 1876], "I send you a letter . . . " In his memoirs, written forty years later, JBY declares that the chemistry primer came first, and that WBY learned to read by going through it (Mem. I). But the letter to Dowden establishes that it was the second lesson book, not the first. As an adult, WBY remembered "a small, green-covered book given to my father by a Dublin man of science," which "gave an account of the strange sea creatures the man of science had discovered among the rocks at Howth or dredged out of Dublin Bay" (*Autobiographies*, p. 32). WBY's account of his early years,

Notes to Pages 110–117 565

both in Sligo and London, is a jumble of impressions, a telescoping of events far separated in time. He mentions the North End house (Edith Villas) as "the first house we lived in," forgetting Fitzroy Road; and he puts the Burnham Beeches episode before rather than after the move to Edith Villas.

51. VWB n.d. [ca. Aug. 1910], "Many thanks for . . . "; Pennsylvania: "My poor father, who made such a mess of his life, was splendid in giving advice. I inherit both gifts."

52. Lily, fragment [probably fall 1876], ". . . today it rained . . ." JBY had already read Marryat's *The Dog Fiend* and was started on *Midshipman Easy*.

53. WBY, *Autobiographies*, pp. 28–29.

54. At the top of the letter the key to Uncle Alfred's cipher is given. Also at the top is a sketch of a ship, and, at the right, of a lighthouse. At the bottom of the first page is a sketch of a large house, possibly Merville. On the second page is another sketch of two sailing vessels and a steamer. Neither letter is dated. The one in cipher seems to be addressed to both Lily and Lollie. The other, to Lily alone, is written on black-bordered stationery. In the passages quoted here I have as usual corrected WBY's spelling.

55. WBY, *Autobiographies*, p. 28, repeats the account of Mrs. Earle and the newts.

56. *Ibid.*, pp. 28, 31.

57. LY, OE, "Miss Jowitt."

58. WBY, *Autobiographies*, pp. 32–35.

59. See George M. Harper, *"Go Back to Where You Belong": Yeats's Return from Exile* (Dublin: Dolmen, 1973).

60. Lily 10 March 1920.

61. Lily 19 Dec. 1913.

62. Godolphin School, Hammersmith, Half-Yearly Report of Conduct and Progress. Lent term, 1877. The report was signed by Rupert H. Morris, Headmaster.

63. Dolly Sloan 3 June 1917. Van Wyck Brooks quotes the passage in *John Sloan* (New York: Dutton, 1955), p. 114.

64. Robert Catterson Smith to JT 2 July 1877, Reading.

65. A niece described Woodroffe as a "difficult dilettante." When he died he left the family silver to a male friend of his who promptly sold it and allowed it to become dispersed, not even giving the relatives first refusal. To some nieces who had "been very good to him" in his declining years and could have used a legacy he left nothing (Jane Woodroffe to WMM: conversation).

66. Oliver Elton [23 Feb.] 1918.

67. Matt Yeats 5 Oct. 1880.

68. WBY [ca. 17 Sept. 1902], "I was at Moore's . . ." (partly reprinted in *JBYL*, p. 66, where it is dated 1901).

69. Lollie 21 Oct. 1921. JBY had a studio during this time at 55a Bedford Gardens, in the same house as Adrian Stokes, and later at Holland Park Road, where Ellis lived (Oliver Edwards, "A Few Chapters from 'Yeats: His Life and Poetry'" [unpublished typescript], pp. 16–17).

70. Mem. I.

71. JRF 22 June 1919.

72. JT to ED 4 March 1878, TCD.

73. ED 17 May 1878; JT to ED 11 Nov. 1878, TCD.

74. JBY, "Frank Potter" (holograph manuscript, unpublished).

75. JT to ED 11 Nov. 1878, TCD; Mem. II.

76. Godolphin School, Hammersmith, Terminal Report of Conduct and Progress, summer term, 1878. The report for the summer of 1877 has not been found.

77. Mem. I. Willie was often concerned with non-academic happenings in school. One day, for example, he made a noise in class and a friend of his, an athlete, was

accused (*Autobiographies*, p. 36). (The friend, whose name WBY does not give, is identified in Lily Yeats's copy of *Reveries over Childhood and Youth* as Cyril Veasey. I thank Anne Yeats for calling this to my attention.)

78. LYS, "Our Grandmother Elizabeth Pollexfen—Born Middleton." The explanation of his illness given to the grandchildren was that he had fallen from a quay in the harbor and injured his head. This was the version given by Isabella Pollexfen Varley's daughter, Mrs. Ida Varley Dewar-Durie to WMM: conversation, Lyne, Scotland, 18 July 1968.

79. See Moncure Conway, "Bedford Park," *Harper's New Monthly*, LXII, no. 370 (March 1881), pp. 481–490; St. James's Gazette, 17 Dec. 1881; Phyllis Austin, "The Enchanted Circle," *Architectural Review*, March 1963, pp. 205–207; Sir Reginald Theodore Bloomfield, *Richard Norman Shaw, R.A., Architect, 1831–1912: A Study* (London: B. T. Batsford, 1940), chapter 5, "Bedford Park"; Mark Glazebrook, ed., *Artists and Architecture of Bedford Park, 1875–1900* (London: 1967); "The Bedford Park Festival Souvenir Program," 1968. See also Ian Fletcher, "Bedford Park: Aesthete's Elysium?" in his *Romantic Mythologies* (New York: Barnes and Noble, 1967), pp. 169–209; and *LBP*. The "Saffron Park" that appears in the first chapter of G. K. Chesterton's *The Man Who Was Thursday* is modeled on Bedford Park.

80. WBY, *Autobiographies*, p. 43.

81. LY, OE, "Miss Jowitt"; WBY, *Autobiographies*, pp. 43–44.

82. Mem. I. I thank Brigid Westenra for allowing me and Janet Lambe, great-granddaughter of John Todhunter, to inspect 8 Woodstock Road from top to bottom in the summer of 1975.

83. ED 11 May and 10 April 1879.

84. ED 11 May 1879.

85. WBY 2 April 1915 (also in *JBYL*, p. 207). In the margin of the original is the identifying word "Todhunter," omitted by Hone. Todhunter's residences are described in JT to ED 5 Sept. 1888, TCD.

86. Lily 28 Dec. 1920.

87. Matt Yeats 26 June 1879.

88. WBY 25 April 1915. They stayed at Friar's Park, a small farm near the sea (Oliver Edwards, "A Few Chapters," p. 21).

89. LY, OE, "Branscombe, Devon." An earlier version appears in LY, DS, "In the summer . . ." Virginia Moore, in *The Unicorn: William Butler Yeats' Search for Reality* (New York: Macmillan, 1954), p. 13, suggests that the Branscombe mackerel were the source of the second half of the fourth line ("the mackerel-crowded seas") of "Sailing to Byzantium."

90. The vacation is described in LY, OE, "Branscombe, Devon." JBY tells the story about Potter also in his unpublished essay "Frank Potter," remarking that Potter hated violent colors. Potter's *The Dormouse*, which hung for a long time in the Yeats home, is in the Tate Gallery. The note on Potter in the Tate Gallery catalogue was written by JBY (Joseph Hone, "Memoir," in *JBYL*, p. 31). Lily kept an album of the children's sketches. See illustration, p. 119.

91. ED [ca. Sept. 1879], "No doubt you . . . " Essie's portrait hangs today in the National Gallery of Ireland.

92. ED 17 Oct. 1879.

93. Oliver Edwards, "A Few Chapters," p. 19. Anne Yeats still has her father's trophy.

94. The dates 1879–1887 are usually given for Jack's long stay with his grandparents in Sligo, usually regarded as uninterrupted. But there is indisputable evidence (SPY to Matt Yeats [ca. 21 Aug. 1880], "John asked me . . . ") that in Aug. 1880 Jack was in London with Lollie and his mother while Willie and Lily were in Sligo.

95. Mem. I.

96. ED to J. Ashcroft Noble 12 June 1880 (Dowden, *Letters*, p. 158).

97. ED 24 July 1880. JBY did not forget the rankling experience, for almost forty years later he wrote of it again (Mem. II). See also ED to Edmund Gosse 2 Jan. 1880 (Dowden, *Letters*, pp. 146–149).

98. Mem. II.

99. SPY to Matt Yeats [ca. 21 Aug. 1880], "John asked me . . . " The letter is undated but beneath the heading is written in an alien hand "Received 23 August 1880," and attached to the letter is a column of figures in Susan Yeats's hand dated by her from January through May of 1880.

100. ED 24 July 1880.

101. ED to JT 3 Dec. 1881 (Dowden, *Letters*, p. 178).

102. ED to JT 4 March 1881, TCD; 14 May 1881 (*ibid.*, p. 172).

103. JT 10 April 1881, Reading.

104. ED 24 July 1880.

105. Mem. I.

106. WBY 22 Feb. 1881.

107. Matt Yeats 2 Nov. 1880.

108. Matt Yeats 26 April 1881.

109. The house no longer stands, though it did as late as 1966.

110. WBY, *Autobiographies*, p. 61. The note about SPY's enjoyment of satire is unique in the records about her. Years later WBY wrote an essay, "Village Ghosts," for his *Celtic Twilight* (1893), which was "but a record of one such afternoon, and many a fine tale has been lost because it had not occurred to me soon enough to keep notes" (*Autobiographies*, p. 61).

Chapter Six: *1882–1886*

1. For an excellent account of Irish political history from O'Connell to the early W. B. Yeats, see Malcolm Brown, *The Politics of Irish Literature* (Seattle: University of Washington Press, 1972).

2. *Ibid.*, p. 243.

3. WBY 6 Nov. 1914.

4. Brown, *Politics*, p. 273.

5. LY, OE, "The Phoenix Park Murders."

6. ED to William Knight 15 Dec. 1887 (Dowden, *Letters*, p. 230).

7. LY, OE, "The York Street Studio." In Q 4 March 1920 (NYPL) JBY writes that the "drunken young carpenter was friendly with some of the Invincibles."

8. JBY gave the sketches to Dr. Charles Fitzgerald. Four of them, of Judge O'Brien, Invincibles Chief Joe Brady, and two witnesses, are reproduced in *JBYL*, facing pp. 34 and 40.

9. Brigid J. P. McDermott, "John Todhunter, M.D., a Minor Figure in Anglo-Irish Literature" (Master's thesis, University College, Dublin, 1968), p. 12.

10. Lollie to JBY 6 Aug. 1920. On Sarah Purser, see Elizabeth Coxhead, "Sarah Purser and the Tower of Glass," in her *Daughters of Erin* (London: Secker and Warburg, 1965), pp. 127–165. Three sketches of SP by JBY appear there facing p. 160.

11. Thomas MacGreevy to WMM. conversation, 1966.

12. SP 7 June 1883, NLI.

13. SM 5 Nov. 1916.

14. "W. B. Yeats at School: Interesting Reminiscences of the Irish Poet's School-days," by a Classmate, *T.P.'s Weekly*, 7 June 1912, p. 709. The classmate is not identified.

15. John Eglinton [William Kirkpatrick Magee], "Early Memories of Yeats," *Dublin Magazine*, July–Sept. 1953, pp. 22–26. See also letter from M. A. Christy, quoting his uncle John McNeill, in the *Times* (London) *Literary Supplement*, 20 May 1965. An interesting comment, written years after the event, is that of the Reverend Dr. F. R. Montgomery Hitchcock: "He was a gentlemanly dreamy fellow, lackadaisical too, didn't go in for games . . . was a good talker. He would argue and discuss matters with the master. . . . He was a favourite, I should say, everyone liked him and he used to spout reams of poetry to us, which none of us could comprehend, as his delivery was so fast. . . . And when we were ordered to write English verse, his was always astounding to us. . . . He was really a charming fellow, rather fond of attitudinizing. . . . His father was an artist, and the boy was not properly looked after" (Oliver Edwards, "A Few Chapters from 'Yeats: His Life and Poetry'" [unpublished typescript], p. 25).

16. Quoted by Pamela Hinkson, "The Friendship of Yeats and Katharine Tynan, I: Early Days of the Irish Literary Revival," *Fortnightly Review*, Oct. 1953, p. 253.

17. Edwards, "A Few Chapters," p. 24.

18. "W. B. Yeats at School."

19. *Ibid.*

20. Lily 26 Jan. 1909.

21. ED to JD 15 May 1882 (Dowden, *Letters*, p. 179). He also wrote to Aubrey De Vere that he came to Irish subjects "neither as an Englishman nor as an Irishman, but as a half-breed" (13 Sept. 1882; *ibid.*, p. 183).

22. For a description of the painting see JT to ED 19 Sept. 1882, TCD.

23. ED to JT 22 Sept. 1882, TCD (also in Dowden, *Letters*, p. 188).

24. SP 7 June 1883, NLI.

25. ED to JT 22 Sept. 1882, TCD (also in Dowden, *Letters*, p. 187).

26. JT to ED 27 Oct. 1882, TCD; ED to JT 29 Dec. 1882, TCD.

27. ED to JT 14 Dec. 1882, TCD (also in Dowden, *Letters* p. 190).

28. The portrait now hangs in the Queen's University Museum, Belfast. See James White, *John Butler Yeats and the Irish Renaissance* (Dublin: Dolmen, 1972), p. 71. I am grateful to James Ford-Smith of the Museum for calling my attention to this picture and providing a photograph.

29. WBY, *Autobiographies*, p. 66.

30. Q 12 Aug. 1919, no. 1, "I enclose . . . "; NYPL.

31. WBY, *Autobiographies*, p. 55: "Rents had fallen more and more, we had to sell to pay some charge or mortgage." This is another example of WBY's unreliability with facts. No parcel of land was sold until all parcels were sold together under the Ashbourne Act in 1887; the difficulty with the rents was that the tenants couldn't pay them.

32. Matt Yeats 18 Sept. 1883, 9 Oct. 1882, 1 Nov. 1882, 18 Feb. 1883.

33. WBY *Autobiographies*, pp. 57–58.

34. Mem. I. The chess-playing incidents reappear in WBY's *John Sherman*. See Chapter Three, n. 52, above.

35. Mem. I.

36. WBY, *Autobiographies*, p. 60.

37. WBY, *Memoirs*, pp. 71–72.

38. WBY, *Autobiographies*, p. 76; (Wade, *Letters*, p. 117n.). Wade calls Laura a "distant cousin" through the Corbet family; he gives no source for the information but I presume he got it from one of the Yeatses, probably Lily. The information is quite detailed, and Wade was a careful scholar who did not create biographical information out of his own imagination.

39. Q 3 Dec. 1917, NYPL.

40. WBY to KT 21 March 1889 (Wade, *Letters*, p. 117); Q 3 Dec. 1917, NYPL.

41. Only one such letter is known, 10 Aug. 1884, from her to him (Wade, *Letters*, p. 117 n).

42. Marguerite Wilkinson, "A Talk with John Butler Yeats about His Son William Butler Yeats," *Touchstone*, VI (Oct. 1919), pp. 10–17. Miss Wilkinson quotes JBY as saying Willie was "sixteen years old" at the time, fixing the date (if JBY's memory can be trusted) between 13 June 1881 and a year later. He said nothing to Miss Wilkinson about Laura Armstrong.

43. Marriage Record, St. Peter's Church, Dublin, 17 Sept. 1884: Edith Laura Armstrong and Henry Morgan Byrne. Her address is given as 60 Stephen's Green, the same from which she wrote the letter to "Clarin." Her age was given as "full," that is, twenty-one or over. The Dublin *Daily Express* (26 April 1862) lists the birth on 26 April of a daughter to Sergeant Armstrong of 9 Lower Dominick Street. This may refer to Laura, though I am not sure.

44. WBY to KT 21 March 1889 (Wade, *Letters*, p. 117); Q 3 Dec. 1917. After her marriage to Byrne, Laura Armstrong married a Welsh gardener, according to what JBY learned in New York thirty years later from an old Dublin friend, Jack Ayre. Her second husband was "a very decent and intelligent man," but she nagged him and was taken by whims which she insisted on exercising, such as suddenly altering all the furniture on the spot (Lily 24 Dec. 1915). He was forced to leave her, allowing her £120 per year (WBY 12 Feb. 1916), but she told everyone she was a widow with two children, a story nobody believed (Lily 24 Dec. 1915).

45. WBY to KT 21 March 1889 (Wade, *Letters*, p. 118).

46. WBY, *Autobiographies*, p. 67.

47. "Extracts from a MS Book Begun at Oxford 7 April 1921" (transcribed by Curtis Bradford), p. 526.

48. WBY 12 Sept. 1917.

49. Mem. I.

50. Matt Yeats 20 and 22 Nov. 1883.

51. LY, OE, "The York Street Studio."

52. [Erasmus Smith] High School, Dublin, report for quarter ending 15 Oct. 1883. The number in the class is not given. WBY is listed as absent five times during the year.

53. WBY 12 Sept. 1917.

54. WBY, *Autobiographies*, p. 65.

55. ED 8 Jan. 1884. This is the first occurrence of the famous sentence, the only praise, as WBY put it, that ever turned his head (*Autobiographies*, p. 23). Later JBY substituted the first-person singular for the infinitive: "If the seacliffs had a tongue what a wild babbling there would be! I have given a tongue to the sea-cliffs" (Mem. I).

56. ED 7 Jan. 1884 (from *JBYL*, pp. 52–53).

57. WBY to JBY [probably Feb. 1916] (Wade, *Letters*, pp. 605–606, where it is dated "[? early 1916]").

58. WBY, *Autobiographies*, p. 87. Dowden's work on Shelley had consumed many years of his life. His mild complaints to the Yeatses will be better understood by anyone who reads the unpublished correspondence on the subject in the Dowden file at the Library of TCD.

59. WBY, *Autobiographies*, pp. 85–86. Cf. LAG 10 Nov. 1914, NYPL: "It was TCD and Unionism and Anglo-Irishism (very different from the real English) that weakened him. From the three influences I escaped, as he never did."

60. Matt Yeats 10 Jan. 1884 (misdated "8" with "9" superposed). JBY had trouble with dates that week. A letter to Edward Dowden is dated "7" Jan. with "8" written over the "7." It is possible, on the evidence of the letter to Matt, written on a Thursday (which fell on 10 Jan.), that the letter to Dowden beginning "Thank you for . . . " should be dated 9 Jan.

61. Oliver Edwards, "A Few Chapters," p. 22.

62. Now 418 Harold's Cross Road.

63. Matt Yeats [1884], "As you know . . . "; 10 Jan. 1884; 15 May 1884; [ca. July 1884], "At the beginning . . . "; 21 Oct. 1885. Similar desperation is expressed in letters to Matt in 1884 dated 29 March, 12 April, 7 and 11 Aug., 27 Sept., and 23 Oct.; and, in 1885, 8 March and 30 May.

64. Matt Yeats 21 Oct. 1885.

65. Susan L. Mitchell, in *New Ireland*, 2 Nov. 1918; quoted from Richard M. Kain, *Susan L. Mitchell* (Lewisburg, Pa.: Bucknell University Press, 1972), pp. 79–80.

66. Katharine Tynan, *Twenty-Five Years: Reminiscences* (New York: Devis Adair, 1913), p. 214.

67. White, *JBY and the Irish Renaissance*, pp. 7–29; Hone, *WBY*, p. 244; Dr. Thomas MacGreevy to WMM: conversation.

68. Matt Yeats 8 March 1885.

69. Mem. I.

70. Oliver Edwards to WMM: conversation. See WBY, *Autobiographies*, pp. 89–92.

71. The first meeting is dated as 16 June 1885; see Ernest Boyd, *Ireland's Literary Renaissance* (New York: Knopf, 1922), pp. 213–214.

72. Frank Yeats 23 Dec. 1920. Although this passage on Catholicism and Protestant-ism was written slightly more than a year before JBY died, it is so succinct and so characteristic of a position that changed little if at all during his mature life that I have presumed to make use of it here. If anything, it represents a mellowed distillation of his earlier views. It is also perfectly consistent with the ideas on the subject expressed by his son in the late 1880's. On the notion that the Irish would have been better off politically as Protestants, he writes in the same letter: "M. David once said to Miss Purser that the mistake the Irish made was in being Catholic and then she told this to John O'Leary. He agreed with David. Both of these men are Catholics." William V. Shannon, an Irish-American Catholic, remarked in "The Lasting Hurrah," *New York Times Magazine*, 14 March 1976, pp. 73–74: "A cynic might speculate that if the Irish had been, let us say, Unitarians, there would be no telling what worldly heights they might have scaled."

73. WBY, *Autobiographies*, pp. 24, 25–26.

74. WBY to Ernest Boyd Feb. 1915 (Wade, *Letters*, p. 592).

75. WBY, *Autobiographies*, pp. 90, 91–92.

76. Although WBY's autobiographical works are filled with accounts of his "mysti-cal" pursuits and *The Speckled Bird* is a fictional account of his experiences, the letters and memoirs of JBY say little on a subject that pained him. Such letters as WBY to JBY 5 Aug. 1913 (Wade, *Letters*, pp. 583–584) are untypical. See William M. Murphy, "Psychic Daughter, Mystic Son, Sceptic Father," in *Yeats and the Occult*, ed. George Mills Harper (Toronto: Macmillan of Canada, 1975), pp. 11–26.

77. WBY, *Autobiographies*, pp. 79–80.

78. Metropolitan School of Art, Index Register, Session 1882–1883, nos. 2996–2997.

79. Matt Yeats 3 Oct. 1883.

80. Mem. I.

81. Metropolitan School of Art, Registers 1883–1886. WBY, whose number was 3232, inexplicably gave his father's occupation as "Ecclesiastical Sculptor."

82. WBY, *Autobiographies*, pp. 79–83.

83. Mem. I. Hone (*WBY*, p. 41) gives the story of "a rich Dublin woman, who was an artist," urging JBY to train his son for a doctor, but does not identify her. "The Priest and the Fairy" first appeared in print in *The Wanderings of Oisin* in 1889 (see Wade, *Bibliography*, no. 2, p. 20).

84. The account of the Contemporary Club is taken from a number of sources: JBY's unpublished memoirs and some of his letters; Harry Nichols, "Memoirs of the Contemporary Club," *Irish Times*, 20 and 21 Dec. 1965; Mary M. Macken, "John O'Leary, W. B. Yeats, and the Contemporary Club," *Studies* (Dublin), no. 28 (March 1939), pp. 136–142. Both quotations are from Nichols.

85. C 26 Aug. 1916.

86. Brown (*Politics*, pp. 213–216) gives an excellent account of O'Leary, Yeats, and Fenianism. See also pp. 153–160, 312–316, and elsewhere. Brown's splendid work is flecked with small errors that cast an unnecessary and in most cases unjustifiable doubt on his general conclusions. He speaks of WBY's being "hurried out of Sligo in his crib during the Fenian troubles" (p. 314, a strange passage); of the "Cosmopolitan" Club for the "Contemporary" (p. 314); and of the Yeatses' leaving Dublin "shortly after" meeting O'Leary (p. 315), when they left almost two years after meeting him—a period most eventful and significant for WBY, who in any event saw O'Leary regularly both in London and Dublin thereafter. Brown declares that JBY was "called home by the outburst of the land war in 1880, threatened with poverty at the loss of his Kildare rents" (p. 374), when the cause was otherwise. As Brown himself writes (p. ix): "A foreigner . . . must expect to commit an occasional solecism that will hover about his text like a gnat"; I must take refuge in the same apology for the gnats that populate these pages, and simultaneously pay tribute to his brilliant and stimulating book.

87. The portrait (1904) is in the National Gallery of Ireland. The description of O'Leary's head is in WBY, *Memoirs*, p. 42.

88. WBY, *Autobiographies*, pp. 95–96.

89. Hone, *WBY*, p. 52.

90. *Irish Times*, 2 Sept. 1967. See John Unterecker, *Yeats and Patrick McCartan: A Fenian Friendship* (Dublin: Dolmen, 1967), pp. 428–429.

91. Brown, *Politics*, p. 406, quoting from Macken, "John O'Leary."

92. Isaac 1 Dec. 1910.

93. Nichols, "Memoirs."

94. Quoted in Hone, *WBY*, p. 46.

95. WBY, *Autobiographies*, p. 101.

96. See Wade, *Bibliography*, p. 327. Both poems were reprinted in act II, scene iii of "The Island of Statues" in the July issue of the *Dublin University Review* and in *The Wanderings of Oisin* (1889). The second poem, revised, was reprinted as "The Cloak, the Boat, and the Shoes" in *Poems* (1895).

97. ED to JT 23 July 1885, TCD.

98. JT to ED 28 May 1885, TCD; ED to JT 26 Aug. 1886.

99. Roger McHugh, ed., *W. B. Yeats: Letters to Katharine Tynan* (Dublin: Clonmore and Reynolds, 1953), p. 11. See also Katharine Tynan, *Poems*, ed. Monk Gibbon (Dublin: Allen Figgis, 1963), p. 98.

100. McHugh, *Letters to KT*, p. 11. WBY in *Reveries over Childhood and Youth* (*Autobiographies*, p. 96) gives the meeting place as the house of John O'Leary and his sister Ellen and says nothing of Oldham in connection with Miss Tynan.

101. Quoted by Pamela Hinkson, "The Friendship of Yeats and Katharine Tynan," pp. 253–264.

102. WBY, *Memoirs*, p. 32.

103. Katharine Tynan, *Poems*, p. 98.

104. Frayne, p. 21; Frayne points out that "all copies of this paper save one fragment have disappeared."

105. These began appearing in 1887 and 1888. They are reprinted in *Letters to the New Island*, ed. Horace Reynolds (Cambridge: Harvard University Press, 1934).

106. Wade, *Bibliography*, p. 19. The booklet is extremely rare. Only about fourteen copies have been traced.

107. KT to Gerard Manley Hopkins 6 Nov. 1886 (*Further Letters of Gerard Manley Hopkins*, ed. Claude Colleer Abbott [London: Oxford, 1956], p. 430).

108. Gerard Manley Hopkins to Coventry Patmore 7 Nov. 1886 (*ibid*, pp. 373–374).

109. WBY to Robert Bridges 16 March 1897 (Wade, *Letters*, p. 281).

110. Frayne, p. 89.

111. *Ibid*, p. 87. On Mahaffy, see the excellent *Mahaffy: A Biography of an Anglo-Irishman*, by W. B. Stanford and R. B. McDowell (London: Routledge and Kegan Paul, 1971).

112. Frayne, p. 84.

113. *Ibid.*, pp. 85, 88–89. In his scholarly and witty introduction Frayne points out that when Dowden years later rose to the bait, he attacked the writings of the Irish Literary Society for "rhetorical failures, sentimentality, and bad technique," and that WBY's "honor roll of younger Irish writers," offered in rebuttal to Dowden, included Rolleston, Hyde, A. P. Graves ("an older man"), and Lionel Johnson. The list, Frayne notes perceptively, "is not very impressive today and it would seem to have borne out Dowden's point" (p. 43).

114. Mem. I.

115. [John Butler Yeats], "The Education of Jack B. Yeats," *Christian Science Monitor*, 20 Nov. 1920.

116. The sale of the Middleton ships is recorded in Lloyd's Records, which show seven disposed of between 1882 and 1884. I thank K. R. Mason for providing me with information about them.

117. Lily 30 Aug. 1916. See also my *Yeats Family and The Pollexfens of Sligo*, much of the material of which has been incorporated into this book.

118. Hone, "Memoir," *JBYL*, p. 32.

119. Isaac 28 Feb. 1916: "You know how I have always hated what people call religion. Uncle Matt would have lived another ten years or so had it not been for religion. His religion was a religion of fear, and he was constantly praying, and *there is nothing so fatiguing and so exhausting as praying*." To Matt's son Frank he wrote (11 June 1920): "Bible Christianity did your father a great deal of injury. It spoiled him and made him unhappy, and I have not the least doubt that it shortened his life. *But for it he would have lived another 15 or 20 years.*"

120. Account no. 1, I. W. Mullins, Agent, Year Ending 1 May 1886. Disbursements to JBY are given for the period 23 Nov. 1885 to 13 Sept. 1886.

121. Katharine Tynan, *Twenty-Five Years*, p. 214.

122. Oliver Elton [23 Feb.] 1918, Coll.: Leonard Elton.

123. ED to JD 9 Aug. 1886 (Dowden, *Letters*, p. 221).

Chapter Seven: 1887–1891

1. JBY, *Essays Irish and American* (Dublin: Talbot; London: T. Fisher Unwin, 1918), p. 21.

2. MFB 4 June 1915, Princeton. Potter kept accurate accounts, and his executors discovered a debt of five pounds to JBY. "Fancy anyone owing *me* money," wrote JBY to Alfred Zimmern (3 Jan. 1916, Yale). JBY was of course unaware of the debt.

3. JO'L 23 May 1887, NLI.

4. WBY to KT 27 April 1887 (Roger McHugh, ed., *W. B. Yeats: Letters to Katharine Tynan* [Dublin: Clonmore and Reynolds, 1953], p. 26).

5. JO'L 20 March 1888, NLI.

6. LY, DS, "In 1887 . . . "; also in LYS, "Return to London, 1887."

7. *Ibid.*

8. ED to Richard Garnett 22 May 1888 (R. S. Garnett, ed., *Letters about Shelley* [London: Hodder and Stoughton, 1917], pp. 165–166).

9. JO'L 23 May 1887, NLI.

10. Wade, *Bibliography*, pp. 329–330. Wade lists nine items published in 1887, including a poem in the *Boston Pilot*, edited by O'Leary's friend John Boyle O'Reilly. In the Sept. *Leisure Hour* appeared "King Goll: An Irish Legend," with an illustration of King Goll by JBY done in 1885 with Willie serving as model. See WBY to Olivia Shakespear 26 May 1924 (Wade, *Letters*, p. 705). Wade (*Bibliography*, p. 330) notes in the sketch "a resemblance to the youthful bearded W. B. Yeats." He notes too that the poem and illustration were reprinted in *A Celtic Christmas* (*Irish Homestead*, Christmas number) in Dec. 1898.

11. JO'L 20 March 1888, NLI: WBY to KT 14 March 1888 (McHugh, *Letters to KT*, p. 49).

12. Oliver Elton, *Frederick York Powell: A Life and a Selection of His Letters and Occasional Writings* (Oxford: Clarendon, 1906), I, 64.

13. See Mark Glazebrook, ed, *Artists and Architecture of Bedford Park 1875–1900* (London: n. pub., 1967), and Ian Fletcher, "Bedford Park: Aesthete's Elysium?" in his *Romantic Mythologies* (New York: Barnes and Noble, 1967), pp. 169–208.

14. Mem. III.

15. Susan's signature appears on legal documents during the 1890's (see, e.g., Mortgage JBY to Frederick Gifford 31 Dec. 1890: Dublin Registry Office, Abstract of Deeds, 1891 bk. 4, no. 73), and these appear to have been executed at a solicitor's office in central London. But it may well be that such papers were signed at home. There is no other indication that Susan Yeats left the Blenheim Road house.

16. Pyle, pp. 25–26. Jack attended the School of Art at South Kensington, the Chiswick Art School in Bedford Park, and the Westminster School.

17. WBY to KT 12 Feb. 1888 (Wade, *Letters*, pp. 57–60).

18. WBY, *Memoirs*, p. 31: "I wanted to do something that would bring in money at once, for my people were poor and I saw my father sometimes sitting over the fire in great gloom, and yet I had no money-making faculty. Our neighbour, York Powell, at last offered to recommend me for the sub-editorship of, I think, [the] *Manchester Courier*. I took some days to think it over; it meant an immediate income, but it was a Unionist paper. At last I told my father that I could not accept and he said, 'You have taken a great weight off my mind.'"

19. The protagonist of *John Sherman* was a combination of, among others, Henry Middleton (a cousin), and William Butler Yeats, but chiefly (almost entirely) the latter. The Reverend William Howard was modeled on John Dowden, Charles Johnston, and John Butler Yeats. The firm of Sherman and Saunders was both Middleton and Pollexfen and the Sligo Steam Navigation Company, and Uncle Michael Sherman was a combination of Charles, George, and Alfred Pollexfen. Margaret Leland, the flighty and inconsiderate heroine, was modeled on Laura Armstrong, and Mary Carton on Katharine Tynan. I expanded upon these identifications in a paper delivered at the Yeats International Summer School in Sligo, 15 Aug. 1975.

20. JO'L 20 March 1888, NLI; WBY to KT 14 March 1888, postscript 15 March (Wade, *Letters*, p. 64). In one letter alone (to Halliday Sparling ca. 10 Sept. 1889, "You asked me . . .") occur the following misspellings: descreetly, complementary, readible, capatalists, writting, grubb, momentos.

21. Wade, *Letters*, p. 57 n.; Wade, *Bibliography*, pp. 21–23.

22. JT to ED 5 June 1888, TCD.

23. Mem. I.

24. WBY, *Autobiographies*, pp. 143–144..

25. *Ibid.*, pp. 140–141. See also WBY, *Memoirs*, p. 20.

26. LYS, "My Six Years I Spent with May Morris." See also Lily to JBY 9 Oct. 1910: "I never saw much sympathy between the members of the Morris household. There was always the barrier of uncontrolled bad temper between them."

27. LYS, "My Six Years I Spent with May Morris."

28. WBY to KT 11 April 1888 (Wade, *Letters*, p. 66).

29. WBY, *Memoirs*, p. 32. WBY conveniently forgot the proposal, but Miss Tynan's sister Nora remembered it well; see footnote in *Memoirs*, p. 32.

30. A copy of the Christmas 1887 issue, now in the Library of TCD, is bound in cardboard and silk. Viva Sherman was the editor. It is a remarkable publication, done with great care, containing works by the young ladies in what they called a "mutual improvement society" as well as by better known contributors. There was an illustrated piece by Gerard Manley Hopkins's brother Everard, an appreciation of Frank Potter (which appeared under "Editor's Notes" but was no doubt inspired by John Butler Yeats), a poem by Katharine Tynan ("At Parting"), a piece by Jack B. Yeats called "The Diary of Sir Long Lean Clatterly Bones," and a work of short fiction by Lollie entitled "A Story Without a Plot." An issue of another date is in the NLI.

31. The last four entries are of two lines or fewer. Portions of the diary have been printed in *JBYL*, pp. 291–298; and also in *The Wind and the Rain*, III, no. 3 (autumn 1946), where it appears under Joseph Hone's editorship as "A Scattered Fair." After 1946 until her death in 1968, Mrs. W. B. Yeats denied access to the diary to "other investigators," in A.N. Jeffares's words (*W. B. Yeats: Man and Poet* [London: Routledge and Kegan Paul, 1962], p. 305). All quotations herein are from the original MS.

32. Lollie, Diary 16 Oct. 1888.

33. *Ibid.*, 24, 26, and 28 Dec. 1888.

34. *Ibid*, entries from 8 Oct. 1888 to 20 Jan. 1889.

35. A set of the chalk and charcoal drawings is in the house of Michael Yeats in Dalkey. The story itself seems to have disappeared. In the *Leisure Hour*, April 1889, is a full-page illustration, *The Cavalier's Wife*, showing the cavalier ministering to his wife, who has apparently fainted. She sits in a chair by a table on which are candle, bottle, glass, and books. Beneath the title is a passage from Blake: "I thought Love lived in the hot sunshine;/But, oh, she lives in the moony light."

36. The effect on JBY may be judged from an entry many years later in John Sloan's diary (15 Nov. 1910): the "smell of the Collier building [in New York] depressed him as it brought back his visits to Cassell & Co's in London, where he submitted his drawings with I suppose varying success" (Sloan, *Diary*, p. 447).

37. Lollie, Diary 11 Nov. and 23 Dec. 1888. Lily's portrait is part of Michael Yeats's collection.

38. *Ibid*, 27 Nov. 1888.

39. Charles Kenney, Account, 7 Feb. 1890. Of the allowed sum the Commission immediately laid out £5,580.19.4 in discharge of debts and some mortgages. It also retained £1,419 as a guarantee deposit (security against the tenants' nonpayment), which was used to purchase Bank of Ireland stock in JBY's name, subject first to the claims of Charles Knox Kirkland and John Singleton Darling, Jr., on their mortgage of 20 Oct. 1884, and second to the claim of Susan P. Yeats for her contingent survivor's jointure.

40. Lollie, Diary 5 Nov. 1888. Beneath this, a note by Lily reads: "I don't know how much of the land was left in 1888 as farms had been sold several times in my memory." The records show no such sales. Lily may have been thinking of the transfers of leases and the troubles attendant upon them.

41. *Ibid.*

42. *Ibid.*, 8 Dec. 1888.

43. WBY's account in *Autobiographies*, p. 123, records that she had an introduction to JBY from O'Leary.

44. Lollie, Diary 30 Jan. 1889.

45. Lily to JBY 14 Nov. 1910.

46. Lollie, Diary 31 Jan. 1889.

47. WBY, *Autobiographies*, p. 123. WBY seldom wavered from this description of her. In 1928, when Mrs. Jeanne Robert Foster was traveling across London with him in a cab on their way to dinner with Lily, she asked what he "really" thought of Maud Gonne, and he repeated the remark about the translucent apple blossoms (JRF to WMM: conversation, 1970). In WBY, *Memoirs*, p. 40, the phrase is "a complexion like the blossom of apples."

48. In the more than two million words of family correspondence (not including WBY's writings) there cannot be more than half a dozen or so references to Maud Gonne. See JBY's letter to LAG, 2 Aug. 1898 (*LBP*, p. 43 and note on p. 75). Many of the references appear in a single group of letters from Lily to her father in 1918 when Maud tried to use WBY as a cat's-paw in entering Ireland illegally.

49. For WBY's account of Maud Gonne's story as she told it to him see WBY, *Memoirs*, pp. 132–134.

50. Elizabeth Coxhead, *Daughters of Erin* (London: Secker and Warburg, 1965), p. 26. Maud signed her letters to WBY "Always your friend, Maud Gonne," and, later, "Yours affectionately, Maud Gonne MacBride."

51. Lollie, Diary 4 Feb. 1889.

52. Dublin: Cuala, 1921. It appears in *Autobiographies* as "Four Years: 1887–1891," pp. 111–195. The counting is unclear, as 1887–1891 involves five years, not four. The first section opens with the residence in Bedford Park, which began 25 March 1888. In section XX, WBY discusses his induction into the Hermetic Society in 1887. The next book of the autobiography, "Ireland after Parnell," opens with events of 1889. The organization is characteristically Yeatsian.

53. Q [ca April 1919] "All thro' the worst part of my illness . . . "

54. Lollie, Diary 8 and 18 Sept. 1888.

55. WBY to Lollie 13 July 1921.

56. WBY, *Memoirs*, p. 19.

57. WBY to Lollie 13 July 1921.

58. WBY, *Memoirs*, p. 19.

59. WBY to Q 30 Sept. 1921, NYPL (Reid, pp. 493–494).

60. WBY 24 June 1921.

61. John Eglinton [William Kirkpatrick Magee] also wrote: "No one could say he was without humour, but it was a saturnine humour, and he was certainly not one who suffered gladly the numerous people whom he considered fools" ("Early Memories of Yeats," *Dublin Magazine*, July-Sept. 1953, p. 24).

62. Lily 25 Aug. 1909.

63. WBY to KT 10 April 1889 (Wade, *Letters*, p. 121). Paget's portrait is reproduced in black and white in Glazebrook's *Artists and Architecture of Bedford Park*, p. 25.

64. WBY, *Autobiographies*, p. 188.

65. Mem. III. Powell, a Welshman, pronounced his name "Poe´ell."

66. Elton, *Frederick York Powell*, pp. 312, 279.

67. Lily 20 May 1909. A fragment of the original of this letter is pasted in Lily Yeats's scrapbook.

68. [JBY], "The Education of Jack B. Yeats," *Christian Science Monitor*, 20 Nov. 1920.

69. Lollie, Diary 25 and 26 Sept. 1888.

70. *Ibid.*, 7 Nov. 1888.

71. JO'L 1 Dec. 1891 (*LBP*, p. 6); Lollie, Diary 28 Oct., 5 Nov., 2 Dec. 1888, 13 Jan. 1889.

72. Lollie kept an account of Jack's and Willie's earnings in the last pages of the notebook in which she kept her diary. She lists twenty-three payments to Jack. The accounts seem to have been kept sporadically and are far from complete, though presumably accurate within short spans. The record of Jack's payments runs, apparently without a break, from 10 Dec. 1889 to 1 May 1890. From Dec. 1889 until 10 Nov. 1890, Willie received £28.16.8, the principal sources being the *Manchester Courier*, the *Boston Pilot*, and the *Scots Observer*. There was one payment from *Weekly Review*, another from *America*—neither of which is indexed in Wade's *Bibliography*—and a third of three pounds for the "Stephenson fairy article."

73. Ida Varley Dewar-Durie to WMM: conversation, 18 July 1968. See also Richard Ellmann, *Yeats: The Man and the Masks* (London: Faber and Faber, 1961), for the definitive treatment of WBY's problem with his image of himself. Ida Varley was not the only one who saw the affectation. Halliday Sparling was amused at Willie's pronunciation of French, and when the teacher at the Kelmscott class said to him, "Mr. Yeats, you don't read poetry like that, do you?" Sparling interjected, "Yes he does, yes he does." Lollie adds, "And in truth it was like his natural way of reading" (Diary 18 Jan. 1889)

74. Q [ca. April 1919], "All thro' the worst part of my illness . . . "

75. LYS, "My Six Years I Spent with May Morris."

76. Lily told the story to Dr. Oliver Edwards, who passed it on to me.

77. LYS, "My Six Years I Spent With May Morris."

78. Q [ca. April 1919], "All thro' the worst part of my illness . . . " Lily didn't like Maria Brien, whom she found lazy and dishonest, according to "My Wishes," a kind of petition sent to WBY during her illness in 1923.

79. LYS, "Our Education." Lily also writes that Lollie "went as student mistress to the High School in Bedford Park," but whether this was a separate wage-earning job or whether Lily was thinking of her sister's kindergarten training is not clear. She says nothing of the latter; but there is nothing else in the family records about the high-school association.

80. WBY to KT 10 April 1889 (Wade, *Letters*, p. 126).

81. WBY to KT 9 May 1889 (*ibid.*, p. 126).

82. LYS, "Mama's Health and Other Things."

83. WBY to KT 31 Jan. 1889 (Wade, *Letters*, p. 107).

84. LYS, "Mama's Health and Other Things."

85. WBY, *Autobiographies*, p. 183, where, however, the full name is not given. Oliver Edwards, in his unpublished "Annals of W. B. Yeats" gives the date as May or June. George M. Harper, *Yeats's Golden Dawn* (London: Macmillan, 1974), p. 6, gives the date as a week after 27 Feb. 1890, or 6 March.

86. Oliver Edwards, "Annals," *sub anno* 1890.

87. Wade, *Letters*, p. 200 n.

88. Mem. III. Ian Fletcher declares that the membership was limited to twelve ("Bedford Park: Aesthete's Elysium?" p. 207).

89. Mem. III.

90. Leonard Elton to WMM: conversation, Sept. 1968. Lollie (Diary 10 March 1889) refers to Mrs. Elton as "the six weeks bride" and describes her: "She is very pretty, dark, and graceful [of] figure; has a face that ought to be animated, but she seems rather of the sleepy, dreamy kind."

91. "Dr. Todhunter's New Play," *Nation*, 17 May 1890; quoted in Brigid J. P. McDermott, "John Todhunter, M.D., A Minor Figure in Anglo-Irish Literature"

(Master's thesis, University College, Dublin, 1968), pp. 31–32. See also WBY's judgment of it in *Autobiographies*, p. 120.

92. WBY to KT 31 Jan. 1889 (Wade, *Letters*, p. 106).

93. WBY to JO'L 1 Feb. 1889 (*ibid.*, p. 107); WBY to KT [end of Feb.-March 8] 1889 (*ibid.* p. 114).

94. For an account of her career, see Josephine Johnson, *Florence Farr: Bernard Shaw's "New Woman"* (Totowa, N.J.: Rowman and Littlefield, 1975).

95. *Fortnightly Review*, 1 Feb. 1889, p. 175.

96. JT to ED 4 Feb. 1889, TCD.

97. ED to JD 5 Feb. 1889 (Dowden, *Letters*, p. 241).

98. Lollie, Diary 4 and 27 Nov. 1888.

99. "Biographical Note," in Dowden, *Letters*, p. 396.

100. Lily 15 Nov. 1916.

101. Lollie 8 Aug. 1918.

102. *National Observer*, 13 Dec. 1890 (Wade, *Bibliography*, p. 26). See Hone, *WBY*, p. 81; Wade, *Letters*, p. 100. In *John Sherman*, WBY gives a fictional account of how the poem came to be composed. In later years he grew tired of the poem, which he was invariably asked to recite, and came to regard it as a youthful discretion.

103. ED to Richard Garnett 22 May 1888 (*Letters about Shelley*, pp. 165–166). Dowden continued: "His son is a boy—a young man now—who fills one with hopes and fears. He is taking to authorship as one of the pleasantest professions to starve on,—and I believe before long will publish a volume of verses."

104. WBY to KT 21 April [1889] (Wade, *Letters*, pp. 121–122).

105. Q [ca. April 1919] "All thro' the worst part of my illness . . . "

Chapter Eight: 1892–1896

1. Wade, *Bibliography*, pp. 19–35, nos. 1–15 (the last of these was published four months after his thirtieth birthday, but the preface is dated 24 March 1895), pp. 233–245, 279–284, nos. 212–225, 289–294. Of the Blake edition WBY wrote: "The writing . . . is mainly Ellis's, the thinking is as much mine as his. . . . The greater part of the 'symbolic system' is my writing; the rest of the book was written by Ellis working over short accounts of the book by me" (*ibid.*, pp. 240–241).

2. Joseph Hone, "Memoir," *JBYL*, p. 32.

3. See WBY, *Autobiographies*, pp. 165 ff., and *Memoirs, passim*.

4. WBY, *Autobiographies*, pp. 201–202.

5. Lily, Diary 1 Sept., 23 Aug., and 2 Sept. 1895; Susan Orr to Lily 22 March [1896].

6. WBY to JO'L, week ending 23 July 1892 (Wade, *Letters*, pp. 210–211). I have not seen the original but suspect that "chose" in the second sentence is a misreading or misspelling of "choose."

7. For a fuller discussion, see William M. Murphy, "Psychic Daughter, Mystic Son, Sceptic Father," in *Yeats and the Occult*, ed. George Mills Harper (Toronto: Macmillan of Canada, 1975), pp. 11–26.

8. This is not the most famous of JBY's portraits of O'Leary, which now hangs in the National Gallery of Ireland. See James White, *John Butler Yeats and the Irish Renaissance* (Dublin: Dolmen, 1972), pp. 44, 70.

9. JO'L 22 Nov. 1891, NLI (*LBP*, p. 5).

10. WBY 30 May 1899 (also in *JBYL*, p. 57): "Remember that from 1890 to 1897 I never touched a paint brush." It is hard to accept the dates literally. In SP 19 Feb. 1891

he mentions "thinking of my next start at the portrait painting" (*LBP*, p. 3). In JO'L 22 Nov. 1891 (*LBP*, p. 5) he mentions as if it were not too far removed in time a portrait painted in Lincolnshire. In Lily 1 Aug. 1894 (*LBP*, p. 12) he writes: "Cottie is sitting to me for her portrait," though this could refer to a pencil or pen sketch. In Dec. 1895 he presented Mrs. Sergius Stepniac with a portrait on which he had been working for some time (Lily 29 Dec. 1895; *LBP*, p. 21). In *Artists and Architecture of Bedford Park* (ed. Mark Glazebrook; London: n. pub., 1967) is a portrait of Jack with the attributed date of 1895 (p. 14).

11. WBY to Lily [no day] Nov. 1892. "I am afraid . . . "

12. See William M. Murphy, "'In Memory of Alfred Pollexfen': W. B. Yeats and the Theme of Family," *Irish University Review*, I, no. 1 (autumn 1970), pp. 30–47.

13. Lily to Q 19 Feb. 1915, NYPL.

14. Isaac 1 Dec. 1910. See WBY's entry in his "A Journal, 1908–1914," item 44, written between 31 Jan. and 3 Feb. 1909: "I begin to wonder whether I have and always have had some nervous weakness inherited from my mother. (I have noticed my own form of excitability in my sister Lolly, exaggerated in her by fits of prolonged gloom. She has [Mars in square with Saturn] while I have [the Moon in opposition to Mars].) [*Note: WBY uses astrological figures here. I use Curtis Bradford's transcription of them*]. In Paris I felt that if the strain were but a little more I would hit the woman who irritated me, and I often have long periods during which Irish things—it is always Irish things and people that vex, slight follies enough—make life nearly unendurable. The feeling is always the same: a consciousness of energy, of certainty, and of transforming power stopped by a wall, by something one must either submit to or rage against helplessly. It often alarms me; is it the root of madness? So violent it is, and all the more because I seldom lose my temper in the ordinary affairs of life. . . . There was a time when [my writings] were threatened by it; I had to subdue a kind of Jacobin rage. I escaped from it all as a writer through my sense of style."

I have made use of the typed transcription of the "Journal" by Curtis Bradford. The passage appears in WBY, *Memoirs*, pp. 156–157.

15. LYS, "Our Grandmother Elizabeth Pollexfen—Born Middleton."

16. The will and accounting are in the collection of Michael Yeats.

17. Ida Varley Dewar-Durie to WMM: conversation.

18. One of George's unfortunate investments was in the steamer *Ballina*, which, registered in his name, disappeared without trace off the Isle of Man in 1882. Its bell was found by divers in the early 1960's (K. R. Mason, Lloyd's Records).

19. WBY 23 July 1921.

20. WBY, *Memoirs*, p. 75.

21. *EM*, p. 97.

22. Edward Fawcett Brown, son-in-law of Agnes Pollexfen Gorman, to WMM: conversation 14 Aug. 1968.

23. WBY, *Memoirs*, p. 79. See my treatment of George Pollexfen in *The Yeats Family and the Pollexfens of Sligo* (Dublin: Dolmen, 1971).

24. Lily 13 July 1917.

25. Clare Marsh 24 Oct. 1912; Lily 1 Aug. 1894 (*LBP*, p. 12). Her self-assurance was not improved in the early days by JBY's consistently calling her "Dottie" (Pyle, pp. 38–39).

26. Pyle, p. 37.

27. Lily 1 Aug. 1894 (*LBP*, p. 12). "Swalley hole," a Sligo term, appears in WBY to KT 21 April [1889] (Wade, *Letters*, p. 121).

28. From the marriage record, for which I am indebted to Dr. Oliver Edwards. Jack's age was given as "22 years," hers as "about 25 years." Not until after Cottie's death in

April 1947 did Jack discover that his wife was eight years older than he (Anne Yeats to WMM: conversation).

29. "The Chestnuts," Eastwort, Chertsey, Surrey (Pyle, p. 39).

30. Jack to Q 13 Dec. 1904 (Coll.: Foster-Murphy) includes an overhead view of "Snaile's Castle." See p. 200.

31. WBY 24 June 1921.

32. Lily 7 Dec. 1895; Lily 20 and 22 Jan. 1896 (*LBP*, pp. 22–24). The book was *Brush Work* (London: G. Philip and Son, 1895). The same publisher later produced her *Brushwork Studies of Flowers, Fruits, and Animals* (1898), *Brushwork Copy Book* (1899), and *Elementary Brushwork Studies* (1900 [1899]).

33. Lollie to Lily 19 April 1896.

34. Lily 20 Jan. 1896 (*LBP*, p. 23).

35. Lily 26 June 1894 (*ibid.*, pp. 11–12).

36. See, e.g., Lollie, Diary 14 Sept. 1888, and Lily 6 April 1896.

37. Albert C. Clark, "Louis Purser, 1854–1932," *Proceedings of the British Academy*, pp. 3–17.

38. *Ibid.*, p. 9.

39. LYS, "My Six Years I Spent with May Morris."

40. WBY 2 Sept. 1892 (*LBP*, p. 7).

41. LYS, "My Six Years I Spent with May Morris."

42. Lily to JBY 30 Oct. 1910: "I used to think I had sat for everything you did but man Friday. As time goes on I begin to think I sat for him also. Do you remember how old Dent recognized me in the lady who had died of the plague?" The Dent collection was *Romances and Narratives by Daniel Defoe*, edited by George A. Aitken, with illustrations by J. B. Yeats, in 16 volumes.

43. LYS, "My Six Years I Spent with May Morris."

44. By Lily's own admission. She did, however, keep a journal some time later with brief jottings.

45. The words, referring to Lily's spoken rather than written comments, are from WBY, *Memoirs*, p. 20. JBY's references to the high regard in which Lily's writings were held abound: e.g., among the earlier ones, Lily 1 Aug. 1894; 19 Nov. and 29 Dec. 1895; and 27 April 1896.

46. Lily, Diary 10 Aug., 21 Aug., 11 Aug., and 3 Sept. 1895. I correct Lily's spelling of "Shakespeare."

47. 13 Aug. 1895.

48. Isaac 5 Aug. 1911.

49. WBY 11 Aug. 1908; Isaac 22 Oct. 1910.

50. WBY 20 Sept. 1916.

51. Isaac 5 Aug. 1911.

52. Lily, Diary 14 Sept. 1895. The answer to Lily's question is that it ended only with death. Agnes continued in and out of mental hospitals during a long life which did not come to a close until thirty-one years later. In her lucid moments she was the bright, sharp, clear, and affectionate woman who had been equally affectionate, if misunderstood, as a child. Her marriage to Robert Gorman was not accepted by her family, and between her and her younger sister Alice Jackson there was no real affection. Agnes's daughter, Elma Brown, inherited some of her mother's problems. Clearly some kind of "nervous tendency" was present in the Pollexfen genes, a tendency both JBY and Willie recognized. See n. 14 above.

53. WBY 30 July 1915.

54. Lily, Diary 25 Aug. 1895.

55. 9 Oct. 1895. See also Q [ca. April 1919], "All thro' the worst part of my illness . . ."

56. 4 Oct. 1895. Another four lines in the entry were scratched out so vigorously that they challenge decipherment.

57. The entries from 21 Sept. to 8 Oct. 1895 cover Lily's stay in Sligo.

58. End of diary, after entry for 26 June 1897.

59. Entry for 9 Oct. 1895 (Lily bunches the entries from Wednesday through Sunday under the single date of 9 Oct., a Wednesday).

60. Miss Wardle's given name was "Mildred" but she was called "Martha." She and Lily remained friends all their lives.

61. JO'L 9 Nov. 1891 (*LBP*, p. 4). The portrait of Morris was later bought by the uncle of a man named Buchanan, who took it to New York, where it hung on a wall in his home (Lily 11 May 1916). Its present location is unknown.

62. T. W. Rolleston to C. Elkin Mathews 9 May 1894, Reading.

63. Lily 19 Nov. 1895.

64. Lily 27 April 1896 (*LBP*, p. 32). The illustration showed "an Irish long-haired chief in chain armor stalking slowly along using his spear as a staff and leaning heavily on it, an Irish wolfhound following him, its tail between its legs, the place a wood of oak trees black with *forest darkness*" (*ibid.*). The warrior greatly resembles WBY. I thank Warwick Gould for supplying me with a photograph of this drawing.

65. Lily to JBY 5 Dec. 1921; WBY 28 Aug. 1917.

66. When the sisters decided on a place on Flanders Road, along the southern boundary of Bedford Park, for thirty-eight pounds a year, Mathews objected strenuously, wanting them further off (Lollie to Lily 24 March 1896).

67. Henry Richard Fox Bourne was the author of *English Newspapers* (London: Chatto and Windus, 1887), and wrote on African subjects also.

68. Lily 17 Feb. 1896 (*LBP*, p. 25).

69. Lily 29 Dec. 1895 (*ibid.* pp. 20–21). Ian Fletcher ("Bedford Park: Esthete's Elysium?" in his *Romantic Mythologies* [New York: Barnes and Noble, 1967], p. 170) gives the account of Stepniac's death substantially as it appears in JBY's letter (which he did not see), adding that Stepniac was reading the agenda for a meeting of fellow exiles when the train struck him. After reading the inquest report in the newspapers I agree with JBY about the verdict. I thank Dr. Fletcher for providing me with a copy of the report.

70. In *Artists and Architecture of Bedford Park* Mark Glazebrook, accepting Prof. D. J. Gordon's phrase describing the activities at Bedford Park as "peripheral" (p.22) is, it seems to me, somewhat modest about the Park and its contributions, perhaps from a becoming humility in a resident. Virtually all the literary works of William Butler Yeats during his twenties, including "The Lake Isle of Innisfree," were produced while he lived at Bedford Park. Artists, scholars, philosophers, and other intellectuals met and mingled there, a historian like York Powell rubbed shoulders with a literary scholar like Oliver Elton, John Todhunter came to know O'Leary because the Yeatses were his neighbors, Willie Yeats himself was able to test his poetry and drama and his positions on Irish matters against the standards of a variety of intelligent Englishmen. It seems to me that Bedford Park as a workshop in which monuments of the soul's magnificence were produced more than justified the faith of its founders. It is easy to be misled by the opening paragraphs of *The Man Who Was Thursday*, in which G. K. Chesterton describes Saffron Park as a place of genial and slightly ridiculous dilettantes. Bedford Park was Chesterton's model, but Saffron Park is a literary construct, not a real geographical location.

71. Lily 10 June 1892.

72. Lily 26 June 1894.

73. Lily 1 Aug. 1894 (*LBP*, p. 13).

74. Lily 26 June 1894 (*ibid*, p. 11); Reid, p. 76 n. May did not surface again until she came to New York and fell in love with John Quinn some years later. See Reid, pp. 80–84, *et passim*.

75. WBY to JO'L 15 April 1894 (Wade, *Letters*, p. 231). See Brigid J. P. McDermott, "John Todhunter, M.D., a Minor Figure in Anglo-Irish Literature" (Master's thesis, University College, Dublin, 1968), chapter 5, n. 33.

76. Lily 13 Dec. 1895 (*LBP*, p. 18).

77. Lily 29 Dec. 1895 (*ibid.*, p. 20).

78. Lily 16 July 1896 (*ibid.* p. 34).

79. Lily [ca. April 1896], "Willie has been staying . . . " (*ibid*, p. 29)

80. See WBY [ca. Dec. 1899] (*ibid.*, p. 56), and WBY, *Autobiographies*, p. 228, where the allusion in the last paragraph of section IX is to Rolleston.

81. Lollie 21 Feb. 1921. *JBYL*, p. 273, contains part of the letter, which Hone dates 20 Feb., but omits the story about Mrs. Farrer.

82. WBY 2 Sept. 1892. Part of the letter, including what is quoted here, appears in *JBYL*, p. 53. In his *WBY* Hone also quotes from the letter and declares (p. 93) that "Yeats had been at quarrel" with Davidson. He does not tell us what the quarrel was about, nor does JBY define the "tat" he alludes to in his letter.

83. *Bookman*, Oct. 1895 (Frayne, pp. 383–387; the long quoted passage is from p. 384).

84. Lily 13 Dec. 1895 (*LBP*, p. 19).

85. Lily 29 Dec. 1895 (*ibid*, p. 21).

86. Hone, *WBY*, p. 105.

87. April 1894 (Frayne, pp. 320–325).

88. WBY to JO'L 5 Jan. 1894 (Wade, *Letters*, p. 229).

89. Lily 15 Jan. 1896 (misdated 1895).

90. Wade gives 3 Nov. 1895 as the date of the first letter from Fountain's Court, Temple (WBY to T. Fisher Unwin; *Letters*, p. 258), but it is clear from Lily's diary that WBY had left Blenheim Road by 4 Oct. at the latest. The first letter in Wade from 18 Woburn Buildings is 13 April 1896 (pp. 260–261). An undated letter from WBY to Elkin Mathews (ca. Feb. 1896, but possibly later; Reading), speaks of his "carrying all manner of goods here" (i.e., to Woburn Buildings) from the Temple. Lollie writes to Lily 19 April 1896 of Willie's being "still excited about the furnishing of his rooms," and of her own plan to have lunch with him there, after which she can tell Lily what his rooms are like. JBY wrote Lily 13 Dec. 1895 that Willie planned to move into different quarters in March. Perhaps a date between late February and late March of 1896 can be assumed for the move to Woburn Buildings.

91. Lily 7 Dec. 1895 (*LBP*, p. 18).

92. Unpublished in WBY's lifetime. See William H. O'Donnell's two-volume edition, *The Speckled Bird* (Dublin: Cuala, 1973–74).

93. WBY, *Memoirs*, pp. 28–31. The quoted words are on p. 30.

94. Lily [ca. April 1896], "Willie has been staying . . . " (*LBP*, pp. 29–30).

95. Hone, *WBY*, pp. 131–132.

96. Elizabeth Coxhead, *Lady Gregory* (London: Secker and Warburg, 1966), p. 43.

97. The notion of Lady Gregory as a surrogate father was first expressed, to the best of my knowledge, by Douglas Archibald in a talk at Ann Arbor before the American Committee on Irish Studies on May 4, 1973. It is a brilliant conception, paradoxical but wholly valid. See his published paper, "Father and Son: John Butler Yeats and William Butler Yeats," *Massachusetts Review*, summer 1974, pp. 481–501.

98. Lily 20 Sept. 1896 (*LBP*, pp. 35–36).

99. Coxhead, *Lady Gregory*, p. 45.

100. Lily 22 Oct. 1912. The letter appears in *JBYL*, pp. 151–152, with Agnes Tobin's name omitted. Hone omits the period after "know."

101. Hone (*JBYL*, p. 152) has the typographical error of "which" for "witch."

102. *Ibid.*

Chapter Nine: 1897–1900

1. The account and the quotation, which appeared as part of WBY's preface to Synge's *The Well of the Saints* (London: A. H. Bullen, 1905), pp. v–vii, are taken from Greene and Stephens pp. 69–70. The biographers note that Synge recorded the date of his meeting with Yeats as 21 Dec. 1896, and that WBY in the preface puts the date two years later (although he subsequently corrected himself). Such mistakes are characteristic of WBY and pepper his writings. As I have pointed out elsewhere (see my "'In Memory of Alfred Pollexfen': W. B. Yeats and the Theme of Family," *Irish University Review*, I, no. 1 [autumn 1970], pp. 45–46), no fact or figure or name or title or ascription of any kind given by W. B. Yeats should be accepted without independent verification.

2. Greene and Stephens, p. 71.

3. Wade, *Letters*, Introduction to Part Three, p. 271.

4. Robinson, p. 2.

5. William J. Feeney, Introduction, *The Heather Field*, by Edward Martyn (Chicago: De Paul University, 1966), p. 14.

6. SP 7 July 1897, NLI (partially reprinted in *LBP*, p. 37).

7. WBY to Fiona MacLeod [pseudonym and alter ego of William Sharp] Jan. 1897 (Wade, *Letters*, p. 280). After the Irish National Theatre had been established as a going concern, WBY in 1903 elaborated on his views. Robinson (pp. 32–33) summarizes them: "They [the Irish Theatre players and company] were endeavouring to restore the theatre as an intellectual institution. . . . Great plays were written for actors capable of speaking great things greatly. . . . Gesture should be treated rather as a part of decorative art. . . . As for scenery, it should be inexacting to the eye, so that the great attention might be paid by the ear. . . ." All that remains of JBY's theory of poetry as he expounded it during WBY's youth is to be found—distantly—in the words: "Great plays were written for actors capable of speaking great things greatly."

8. SP 7 July 1897, NLI (partially reprinted in *LBP*, p. 37).

9. WBY to LAG 3 Oct. 1897 (Wade, *Letters*, p. 287).

10. Hone, *WBY*, p. 165. Elizabeth Coxhead, in *Daughters of Erin* (London: Secker and Warburg, 1965), p. 37, observes that this story rests on Miss Gonne's authority alone. The two women disliked each other.

11. Wade, *Bibliography*, p. 354. In a note on p. 362 Wade suggests that WBY may have intended reprinting the essay later, but in fact he never did. See Wade, *Letters*, p. 289 n.

12. John Quinn, "Statement by L.G. to J.Q." (typescript, Coll.: Foster-Murphy). tries to put the account in the third person but slips up on the second page and reveals his authorship. The date of the memo is about 16–20 March 1913. See Chapter Fourteen, n. 137.

13. Prof. Alfred De Lury 21 Jan. 1921, Toronto.

14. EDB 6 Jan. 1913.

15. Lily 22 Nov. 1917.

16. Pyle, pp. 42, 200; WBY to LAG 20 Nov. 1897 (Wade, *Letters*, p. 292).

17. In *Romantic Mythologies* (New York: Barnes and Noble, 1967), p. 207, Ian

Fletcher quotes from Lady Gregory's draft autobiography an account of the evening.

18. LAG 9 and 10 Dec. 1897, NYPL (*LBP*, pp. 39, 40).

19. Pyle, pp. 175 ff.

20. Anne Yeats to WMM: conversation.

21. Following this entry are some pages of genealogical data and a final entry dated 26 June 1897 telling of a letter from Willie about the anti-Jubilee riots in Dublin: "The police batoned the people—200 in hospital in consequence."

22. The death record (Brentford-Acton 3 Jan. 1900) gives the cause of death as "general paralysis, 6 years."

23. WBY, *Autobiographies*, p. 62.

24. WBY 25 April 1915.

25. Lollie 15 Aug. 1897 (*LBP*, p. 38).

26. Lollie 5 and 15 Aug. 1897 (*ibid.*, pp. 37, 38). Isaac was in temperament and imagination almost the polar opposite of his eldest brother. After taking his degree from TCD he became secretary to the Artisan Drilling Company and lived a quiet, almost anonymous life on the same street in Donnybrook (Morehampton Road) as his maiden sisters Jenny and Gracie. Lily described him as "a delightful man" (LYS), and JBY's affection for him was strong. Yet if he ever had a daring idea he successfully concealed it. He remained cautiously but resolutely Unionist, avoided the movements in which his brother and nephew were so prominent, and deliberately lived a life of quiet if frightened ease, a kind of Louis Purser without scholarship. His occasional timely contributions to the Bedford Park till were always welcome.

27. The publisher was James Bowden, London, 1897. JBY's sketches appear as the frontispiece and on pp. 4, 119, and 296. The title page identifies the artist as JBY, but the British Museum Catalogue omits the identification. I thank Warwick Gould for calling this to my attention.

28. SP 7 July 1897, NLI (partially reprinted in *LBP*, p. 36).

29. *Ibid.*

30. ED 24 Feb. 1910. The Bishop had apparently heard of York Powell's remark about the difficulty of finding men of sufficient "intellectual distinction" to make bishops of them (Lily 20 May 1909).

31. LAG 20 June 1898, NYPL (partially reprinted in *LBP*, p. 41); LAG 23 June 1898, NYPL. WBY to LAG 11 Aug. 1898 (Wade, *Letters*, p. 303).

32. Coxhead, *Lady Gregory* (London: Secker and Warburg, 1966), pp. 50–51.

33. WBY to LAG 6 Nov. 1898 (Wade, *Letters*, p. 304).

34. WBY to LAG 29 June 1898 (*ibid.*, p. 301).

35. WBY to Dorothy Hunter 1 Jan. 1898 (*ibid.*, pp. 293–294).

36. WBY to George Russell 22 Jan. 1898 (*ibid*, p. 295).

37. WBY 15 Sept. 1898; part of the letter appears in *JBYL*, p. 55, but not the passage with this information. See also WBY to Lily 11 July 1898 (Wade, *Letters*, p. 302).

38. LAG 2 Aug. 1898 ("Jack does not know," etc. in *LBP*, p. 43).

39. LAG 20 June 1898 (*ibid.* p. 41). This is perhaps the portrait which is reproduced in Mark Glazebrook, ed., *Artists and Architecture of Bedford Park, 1875–1900* (London: 1967), p. 14, where it is assigned the date "c. 1895." JBY's portraits of his children (not to mention his other subjects, especially women) frequently made them appear younger than they were; there is no reason to question a date of late 1897 or 1898 for the portrait (see *Artists and Architecture*, p. 37).

40. Clare Marsh [July 1900], "Can you forgive me"; Clare Marsh 21 July 1899, both TCD.

41. LAG 18 June 1898 (in Glenn O'Malley and Donald T. Torchiana, ed., "John Butler Yeats to Lady Gregory: New Letters," in *Irish Renaissance*, p. 67). The sketch of

Hyde is reproduced in Elizabeth Coxhead's *Lady Gregory,* facing p. 52. The original is in the National Gallery of Ireland. Another work of this period, a sketch of Nathaniel Hone, R.H.A., is owned by Frances-Jane French of Dublin.

42. LAG 23 June 1898, NYPL. WBY was becoming a favorite subject for artists. A young one named William Rothenstein had also done a head of Willie for Lady Gregory, and as she sent it to JBY for framing he got a chance to see it. She evidently told him she did not care for it, and he quite agreed with her opinion. "I do not think it is any good," he wrote her, "and Walter Osborne is as emphatic as you are. Curiously the drawing has all the faults of the young student" (LAG 12 July 1898; *Irish Renaissance,* pp. 58–59). Characteristically, when he met Rothenstein later in the year he liked him so much—"he is wonderfully clever and amiable, and pleasing to look upon"—that he was sorry he didn't like the portrait. He thought him much like Edwin Ellis (WBY 23 Dec. 1898).

43. WBY to Lily 11 July 1898 (Wade, *Letters,* p. 302).

44. Many of JBY's sketches of Abbey players were of course done in New York after 1907. To attempt to list all his subjects involves the risk of overlooking some, but to mention the names merely of Lady Gregory, Douglas Hyde, George Russell, George Moore, W. G. Fay, Frank Fay, J. M. Synge, Annie Horniman, Maire nic Shiubhlaigh, Lord Mayor Tim Harrington, George Hart, T. Arnold Harvey, and John Pentland Mahaffy gives some idea of the range of his subjects. The only persons of major importance of whom a sketch or portrait is not known to me are James Joyce, whom he met but once briefly on the street, and Maud Gonne. (A painting of JBY's in the National Gallery of Ireland dated 1907 has been said to be of Maud Gonne, but I cannot agree with the identification.)

45. LAG 18 June 1898 (*Irish Renaissance,* p. 57). He thought people should be sketched from life but sometimes worked from photographs of the dead, something he disliked doing (*ibid.*).

46. I make this judgment on a sampling of the works in the collection of Michael Yeats in Dalkey.

47. LAG 29 July 1898 (*LBP,* p. 41). According to JBY, Plunkett didn't talk much, and JBY chose to compliment him for his reticence, maintaining, in complete contradiction of his known habits, that "such good sitting as he gives tends to silence."

48. WBY 23 Dec. 1898. (portions in *JBYL,* pp. 55–56).

49. WBY to George Russell 27 March 1898 (Wade, *Letters,* p. 297).

50. WBY 23 Dec. 1898 (also in *JBYL,* p. 56).

51. Account of Executors of Estate of William Pollexfen 22 Dec. 1898. In 1894, JBY had discovered that he owned a forty-acre bog of whose existence he was unaware until More O'Ferrall offered to buy it. It brought him £14.12 net. See Lily to JBY 26 Oct. 1918, and JBY to [T. W. Hardman] 18 April 1894 in the Dublin Public Records Office.

52. Frank Yeats 23 Dec. 1920, Coll.: Harry Yeats.

53. Susan Mitchell, "John Butler Yeats," unpublished manuscript of talk delivered in Dublin, Dec. 1919. Nora Niland, Director of the Yeats Museum in County Sligo, generously provided me with a copy of Miss Mitchell's holograph manuscript. Another, virtually identical holograph copy is in the collection of Michael Yeats.

54. Gilbert Keith Chesterton, *The Autobiography of G. K. Chesterton* (New York: Sheed and Ward, 1936), pp. 139–141. Willie later claimed in a letter to Cyril Clemens (24 Feb. 1937, TCD) that he hardly knew Chesterton. The explanation may be that while Chesterton listened to and remembered WBY, Willie, already famous, was unaware of the large, insecure young man who was then a nobody.

55. Both Laura Frank (now Mrs. Robert Chudd), in an unpublished dissertation on John Butler Yeats, and Douglas Archibald, in two studies of JBY which I have seen in manuscript, present perceptive insights and conclusions on the sources of JBY's power and influence on others, and I am indebted to both for letting me read their essays.

Prof. Archibald's studies have since been published: "Father and Son: John Butler Yeats and William Butler Yeats," *Massachusetts Review*, summer 1974; and *John Butler Yeats* (Lewisburg, Pa.: Bucknell University Press), 1974.

56. LAG 29 July 1898 (*LBP*, p. 42).

57. LAG 28 Aug. 1898 (*ibid.*, p. 44).

58. Lily 10 March 1914.

59. Lollie 7 July 1920. Pyle (p. 56) notes that Jack "appears to have attached himself to the younger group." He and T. Arnold Harvey became lifelong friends.

60. LAG 19 May 1899 (*LBP*, p. 47); Bishop T. Arnold Harvey to WMM: conversation.

61. WBY 30 May 1899 (part of the letter, but not the section concerning Jack, is quoted in *JBYL*, pp. 56–58). JBY told Lily years later that Jack may have been responding subtly to Lady Gregory's "too obvious dislike—at least *repulse*—of Cottie." "He ought to be much attached to her for all her goodness, but he can't forget that she 'snubbed' Cottie" (Lily 22 Nov. 1917).

62. The announcement and appeal of the Theatre Committee have been quoted in many places. For it and the list of names, as well as for some other details of the year's events, I have relied on Robinson, pp. 2–3. All the founders, self-proclaimed or otherwise, have had their day in print about the "true" history of the theatre; the titles of their works can be found in any standard bibliography. The most thorough, convenient, sound, and brief summary, and an excellent critical study, is Ann Saddlemyer's "'Worn Out with Dreams': Dublin's Abbey Theatre," in *The World of WBY*, pp. 74–102.

63. Not to be confused with the later playwright of the same name.

64. The plot of the play, reduced to its barest outlines, is simply told: the Countess Cathleen (changed from Kathleen), having already given away her riches to the impoverished Irish peasants, makes a pact with the devils (disguised as merchants) to sell her soul in order that the peasants might be saved—saved for earthly life, not eternal bliss.

65. WBY to Dr. William Barry 24 March 1899 (Wade, *Letters*, p. 316).

66. Holloway's chronicle has been skillfully condensed and edited by Robert Hogan and Michael J. O'Neill in an indispensable volume entitled *Joseph Holloway's Abbey Theatre: A Selection from His Unpublished Journal, "Impressions of a Dublin Playgoer"* (Carbondale and Edwardsville: Southern Illinois University Press; London and Amsterdam: Feffer and Simons, 1967). Like other students of the Irish National Theatre I owe the editors an immeasurable debt which I am happy to acknoweldge here.

67. *Ibid.*, Preface, p. [3].

68. *Ibid.*, 8 May 1899, p. 6, and note on p. 273. The students came from University College, where James Joyce was a student, but Joyce refused to join them.

69. *Ibid.*, 6 May 1899, p. 5; 8 May 1899, p. 6. Todhunter too was surprised to learn that the play had gone well on the stage (WBY 30 May 1899; *JBYL*, p. 57).

70. Holloway, 8 May 1899, p. 7.

71. LAG 19 May 1899 (*LBP*, p. 47).

72. Quoted in Robinson, p. 8.

73. LY, DS, "The Rabbit Bolter."

74. LAG 9 Jan. 1899 (*LBP*, p. 45).

75. SP 7 July 1897, NLI (*ibid.*, p. 37).

76. LAG 9 Jan. 1899 (*ibid.*, p. 45).

77. WBY, *Memoirs*, p. 44; George Pollexfen to WBY 24 Feb. 1899 (Hone, *WBY*, p. 156, where the date is not given).

78. WBY to LAG 4 Feb. 1899 (Wade, *Letters*, p. 311; see also Hone, *WBY*, pp. 155–157).

79. JO'L 24 June 1899 (*LBP*, p. 53).

80. WBY 23 Nov. 1899 (*ibid.*, p. 55). Shorter wasn't the only one with a poor opinion of Unwin. On the flyleaf of the first volume of the presentation copy to John Quinn of Douglas Hyde's *The Religious Songs of Connacht*, 2 vols. (London: T. Fisher Unwin; Dublin: M. H. Gill and Son, 1906), Hyde refers to the publisher as "Fishy-Unwin." The copy is part of the Foster-Murphy Collection.

81. WBY [ca. 15 June 1899], "Some time ago York Powell . . . " (partly quoted in *JBYL*, p. 58).

82. The sketchbooks in Michael Yeats's collection contain many of the sketches mentioned here; others are clearly identified in correspondence. The sketch of the Elton sons is in the possession of Leonard Elton, who graciously let me see it and other Yeats memorabilia in his possession, and provided me with copies of JBY's letters to his father, some of which in whole or in part are printed in *JBYL*.

83. WBY [ca. 15 Aug. 1899], "I send you a *Chronicle* . . . " (also in *JBYL*, p. 59); Lily [ca. 20 Aug. 1899], "There is no news . . . "

84. WBY [ca. 15 Aug. 1899], "I send you a *Chronicle* . . . " (also in *JBYL*, p. 59).

85. WBY 30 May 1899 (*JBYL*, p. 57).

86. LAG 15 April 1899, NYPL. Comments on his paintings that year are also in WBY 16 July 1899; LAG 11 April 1899, NYPL..

87. WBY [ca. 15 June 1899], "Some time ago York Powell . . . " (*JBYL*, p. 58).

88. LAG 16 June 1899 (*LBP*, pp. 50–51). He wrote Isaac (27 March 1916): "She [Lollie] ought to have been a man. The monotonous life woman is condemned to live is her hell."

89. JO'L 24 June 1899, NLI (*LBP*, p. 53).

90. JS 14 Aug. 1918.

91. Frank Yeats 8 Sept. 1920, Coll.: Harry Yeats.

92. JO'L 24 June 1899 (*LBP*, p. 52).

93. Mrs. William Butler Yeats (sister-in-law) to JBY 31 July 1899.

94. LAG 2 Jan. 1900 (*LBP*, p. 59).

95. On the death certificate, district of Brentford-Acton, Susan Mary Yeats is listed as fifty-eight years old. J. B. Yeats, widower, "artist (painter)," is listed as present at the death. I thank Dr. Oliver Edwards for providing me with a copy. The cemetery is at Willesden Lane, in the Parish of Acton. The grave is E/I 13, sold to JBY for £3.8.0.

96. LYS, "Mama's Health and Other Things."

97. WBY, *Autobiographies*, p. 31.

98. WBY 2 Feb. 1921. A. Norman Jeffares discusses JBY's view of marriage in *The Circus Animals: Essays on W. B. Yeats* (Stanford: Stanford University Press, 1970), pp. 117–146, and in his earlier "John Butler Yeats," in *In Excited Reverie* (London: Macmillan, 1965), pp. 24–27.

99. Padraic Colum to WMM: conversation. JBY repeated the observation to Quinn and compared her to Willie (Reid, pp. 425–426). Oliver Elton 30 Sept. 1914, Coll.: Leonard Elton.

100. WBY 15 Jan. 1916. Of conjugal love JBY wrote to Lady Gregory 30 Sept. 1919 (NYPL): "the man and woman become bound together by the interchange of gifts—like great chiefs—the man's strength for the woman's subtlety, his slowness quickened by her rapidity, his longing helped by her fancy that seems to possess what he desires. He is self-centered, she is sympathetic. And so it goes on, each keeping the other alive. . . . *Love . . . is really the highest form of companionship.*"

101. Lily 20 Sept. 1912.

102. I am grateful to the Reverend W. Jack Jenner, Rector of St. Michael and All Angels, for showing me a copy of the issue in the Rectory files.

103. Oliver Elton, Preface, *JBYL*, p. 5.

104. Pyle, p. 58.

105. Jack chose to wait until Papa was in Paris to write to Lily about the plaque (Jack to Lily 16 April 1900). It was affixed to the left of the pulpit as one faces the altar, a brass tablet bearing the inscription: "To the Memory of Susan Mary, wife of John Butler Yeats and eldest daughter of the late William and Elizabeth Pollexfen, of this Town. Born July 13, 1841, Died in London Jan 3ʳᵈ 1900. Erected by her Four Children."

106. WBY to Mabel Dickinson 11 May 1908, Bancroft Library, University of California at Berkeley. I thank Phillip L. Marcus for calling this passage to my attention.

107. See my "'In Memory of Alfred Pollexfen,'" pp. 30–47, for a study of the poem in which WBY makes prominent if somewhat baffling use of "the sailor John" Pollexfen. I thank Dr. Oliver Edwards for providing me with the notice of John's death. Further information appears in *Lloyd's List* of 30 Jan. 1900, for a copy of which I thank K. R. Mason, Shipping Editor of Lloyd's.

108. Irish Land Commission, Frederick Gifford and Son, Solicitor, Affidavit, 24 Jan. 1900.

109. Lily Yeats, note in Lollie Yeats's diary beside the entry for 5 Nov. 1888; WBY to LAG 10 April 1900 (Wade, *Letters*, p. 339).

110. Lily [ca. 16 April 1900], "Yesterday being Sunday . . . " JBY believed that Ellis "never forgave" him because he had seen how his wife had "humiliated him" (WBY 25 July 1921).

111. Lollie 12 April 1900; WBY 27 July 1901 (*LBP*, p. 66). He thought Ellis would waste the studio in the new house, as his wife wouldn't "let him do any real work." In a later letter to Willie he again complains that Ellis got the house, and continues with a comment about his career: "His work is awful, and yet he is so clever. If only he had some knowledge. Mrs. Ellis is an amusement to the models. They say, 'Oh, that is the funny lady who stays in the room all through the sitting and henpecks her husband.' It is a real heartbreak to go and see Ellis so surrounded and producing these miserable pictures. At Henley he has his orders to stay out all day and paint landscapes. Mrs. Ellis' practical mind wants potboilers and does not recognize that the best of all potboilers is good work. Ellis himself is only one half an artist. The other half is a species of practical man. 'He looks on Truth askance and strangely.' That is why he pays a sort of divided allegiance between his wife and truth" (WBY 29 Aug. 1901; *LBP*, pp. 67–68).

112. Ida Varley Dewar-Durie to WMM: conversation.

113. WBY 19 July 1907.

114. Her daughter told Michael Yeats of her mother's remark, and he relayed it to WMM.

115. WBY to LAG 10 April 1900 (Wade *Letters*, p. 339).

116. WBY [probably spring 1900], "Did I tell you . . . " (*LBP*, no. LIII, pp. 56–57, where it is erroneously dated "1899, ca Dec."). See also JBY's letter to LAG 7 May 1902 (*Irish Renaissance*, p. 61), and Marilyn Gaddis Rose, *Jack B. Yeats: Painter and Poet* (Bern: Herbert Lang, and Frankfurt: Peter Lang, 1972).

117. WBY [ca. spring 1900] (*LBP*, no. LIV, p. 58, where it is erroneously dated "1899, late December"). JBY continues: "I wonder did he show it to Russell. It is too delicate for Moore."

118. Jack to Lily 24 March 1900. Jack's letters to Lily were filled with such family humor. When he learned that Lollie had bought a bicycle he confided to Lily: "The bicycle would do Lolly good, particularly—but only whisper this to the bicycle, *not* to Lolly—it is *difficult to talk on a bicycle*" (31 March 1900).

119. WBY to LAG 31 Jan. 1900 (Wade, *Letters*, p. 334).

120. WBY to editor of the *United Irishman* 20 Jan. 1900 (*ibid.*, p. 333).

121. WBY to *Freeman's Journal*, 20 March 1900 (*ibid.*, p. 336); ED to Richard Dowden 26 June 1899, and ED to E. Gosse 9 April 1900 (Dowden, *Letters*, pp. 290–291, 295–296); WBY [ca. Dec. 1899] (*LBP*, p. 56).

122. WBY 3 Feb. 1900.

123. JO'L [ca. June 1900], "I got your letter . . . "; NLI.

124. Hone, *WBY*, pp. 163–164.

125. *Lady Gregory*, p. 33. Among the initials on the tree, which still stands, are those of J. M. Synge, G. B. Shaw, WBY, JBY, Jack, AE, Sean O'Casey (carved much later than the others), Robert Gregory, John Quinn, and Lady Gregory herself.

126. The pictures hang on the wall of Michael Yeats's dining room in Dalkey.

127. See Donald T. Torchiana, *W. B. Yeats and Georgian Ireland* (Evanston: Northwestern University Press, 1966).

128. "Upon a House Shaken by the Land Agitation," WBY, *Poems*, p. 107.

129. *Poems*, p. 225. WBY is not describing Coole itself.

130. WBY to LAG 25 April 1900 (Wade, *Letters*, p. 340). See also WBY to AE [ca. 1900](*ibid.*, pp. 343–344).

131. WBY to LAG 6 June 1900 (*ibid.*, p. 346).

132. JO'L 29 Oct. 1900 (*LBP*, pp. 62–63).

133. WBY 3 Feb. 1900.

134. Lily 7 July 1900; part of the letter appears in *LBP*, pp. 60–61.

135. WBY 28 July 1900; part of the letter, including this passage, is printed in *JBYL*, p. 64, where Hone repeats the word "Editor" instead of the correct "Expert." Searches for this sketch have been fruitless so far.

136. JO'L 29 Oct. 1900 (*LBP*, p. 63).

137. Jack to Lily 16 April 1900. I suggest JBY's failure to cooperate because it is so in character. His Dublin exhibition of late 1901 was managed almost completely by Sarah Purser. When passages from his letters were published by Cuala in 1917 and 1920, others did the collecting and editing. *Essays Irish and American* was put together by Martha Fletcher Bellinger. JBY could never be bothered with the trivial details without which business enterprise is impossible.

138. SP 24 Dec. 1900 (*LBP*, p. 64).

139. Clare Marsh 26 July 1900 and [July 1900] "Can you forgive me . . .", both TCD.

140. WBY [15 Dec. 1900] (*LBP*, p. 63); SP [24 Dec. 1900] (*ibid.*, p. 64).

Chapter Ten: 1901–1902

1. WBY [probably spring 1900], "Did I tell you . . ." (part of the letter, including the passage quoted, is in *JBYL*, p. 65).

2. FYP to JBY 25 Dec. 1901.

3. Mem. III; Q 19 Jan. 1919 (from *JBYL*, pp. 259–260). In *The Man Who Was Thursday* Chesterton's use of "Saffron Park" (Bedford Park) is limited to the first chapter. It is tempting to speculate that the "old gentleman with the wild, white beard and the wild, white hat" might be loosely modeled on JBY. Mr. Lucian Gregory, "the red-haired poet" who was also an anarchist, could easily be a mild caricature of WBY. Gregory's sister Rosamond, as likable as Lily, wonders whether her brother really means what he says. She has red hair; Susan Mitchell also had red hair. Could Rosamond have been a reflection of the two young women? The matter is probably of no interest, as neither Gregory nor his sister is deeply involved in the plot of the novel, nor is Saffron Park. Still one wonders.

4. SP 24 Dec. 1900, NLI (this quotation is not included in *LBP*). A rumor circulated in Dublin for years that the widowed JBY proposed marriage to Rosa Butt and was rejected. On the face of it there is nothing unreasonable or unlikely about the story, but no evidence of it has surfaced. JBY's letters to Miss Butt are in the Bodleian Library at Oxford under lock and key till 1979 (R. W. Hunt, Keeper of Western MSS, to WMM 5 May 1966). In them perhaps may lie the truth about the rumor.

5. SP 14 March 1901 (*LBP*, p. 64).

6. WBY [probably spring 1900] "Did I tell you . . . " Hone incorrectly dates this letter "1899" (*JBYL*, p. 62) and prints only part of it. He prints part of the same letter as a separate one (pp. 65–66) which he dates "(1901)" and tacks to it part of yet another letter (WBY 27 July 1901). He errs in transcribing the words "my taking Ellis' house" as "my taking Oliver Elton's house." The squiggles of JBY's writing make a distinction between "Ellis" and "Elton" difficult. The word "Oliver" does not appear in the original. A fragment of the letter also appears in *LBP* (no. LIII, pp. 56–57), where it is, I regret to say, also misdated "[1899, ca. Dec.]." See also Chapter Nine, n. 111.

7. WBY [probably spring 1900] (*JBYL*, p. 62); see preceding note. In this letter JBY writes of having dreamed of his father, who gave "a wonderful sermon," and having later found on a piece of paper the words "The apple tree has been made free," which he thought "a consequence of my father's sermon." It seemed to him "a good omen." In semiconsciousness he thought "that it meant the apple tree that was in Eden, which seemed to me a very tremendous and beautiful revelation" (p. 63).

8. Irish Land Commission Records no. 822, 12 March 1901: Application of F. Gifford.

9. Lily 7 July 1900. See also Lollie ca. 15 June 1901 (*LBP*, p. 65).

10. LAG 19 Jan. 1901 (*Irish Renaissance*, p. 60).

11. Lollie [probably 15 June 1901] (*LBP*, p. 65).

12. *Dublin Daily Express*, 21 Oct. 1901; Elizabeth Coxhead, *Daughters of Erin* (London: Secker and Warburg, 1965), p. 136. The dates are taken from the catalogue. Miss Coxhead gives "ten days" as the duration of the exhibition.

13. WBY to George Moore [ca. Jan. 1901] (Wade, *Letters*, p. 347).

14. WBY to JBY 12 July 1901; see also Hone, *WBY*, pp. 183–184. WBY's play was first called *Where There Is Nothing* and later, when revised, *The Unicorn from the Stars*.

15. WBY to LAG 21 May 1901 (Wade, *Letters*, p. 350); WBY, *Memoirs*, p. 55.

16. Holloway, 21 Oct. 1901, pp. 13–14.

17. Robinson, p. 21.

18. WBY to LAG ca. Oct. 1901 (Wade, *Letters*, pp. 355–356).

19. See James Kilroy, *The 'Playboy' Riots* (Dublin: Dolmen, 1971), p. 86. George Moore, attempting to pacify at least some of the theatre's natural enemies, proposed in a letter to the *Freeman's Journal* that the church might wish to provide a censor to approve plays before they reached the stage. WBY was quick to dissociate himself from Moore's proposition; what was needed in Ireland, he insisted, was more discussion about such matters, not less (WBY to *Freeman's Journal*, 14 Nov. 1901; Wade, *Letters*, p. 356).

20. See Wade, *Bibliography*, pp. 245 ff.; quoted by Ann Saddlemyer, "Worn Out With Dreams,'" in *The World of WBY*, p. 81. "Samhain," the Irish word for "Autumn" (as "Beltaine" is for "Spring"), is pronounced "sow´in" to rhyme with "cow in."

21. Robinson, pp. 25–26.

22. WBY to Arthur Griffith 16 July [1901] (Wade, *Letters*, p. 352). Willie wrote a long letter to his father (12 July 1901) on the reports about the American production of *The Land of Heart's Desire*, part of a bill that included Browning's *In a Balcony*.

23. WBY to Frank Fay 1 Aug. 1901 (Wade, *Letters*, p. 355).

24. William Dumbleton, ed., *"The Sleep of the King" and "The Sword of Dermot" by James Cousins* (Chicago: De Paul University, 1973), pp. 1–2.

25. WBY to LAG 25 April and 21 May 1901 (Wade, *Letters*, pp. 349–350).

26. ED [ca. 20 March 1874], "I have never . . . ": see Chapter Five, pp. 97–100.

27. *Essays and Introductions* (New York: Macmillan, 1961), pp. 105–106. In Quinn's copy of *Ideas of Good and Evil* (1908 edition) WBY wrote: "I think the best of these Essays is that on Shakespeare. It is a family exasperation with the Dowden point of view, which

rather filled Dublin in my youth. There is a good deal of my father in it, though nothing is just as he would have put it" (Wade, *Bibliography*, no. 80, p. 90). The basic conflict so sharply enunciated by Dowden and the Yeatses has become so fixed in Shakespearean criticism that its origins have been forgotten. See Sidney Homan's excellent "*Richard II*: The Aesthetics of Judgment," *Studies in the Literary Imagination* (Georgia State University), V, no. 1 (April 1972), pp. 65–71, in which the very language echoes that of Dowden and the Yeatses but which mentions none of them in text or footnotes.

28. *The Histories and Poems of Shakespeare* (Oxford: University Press, 1922), pp. 85–86. A splendid account of the Yeats-Dowden conflict can be found in Phillip L. Marcus, *Yeats and the Beginning of the Irish Renaissance* (Ithaca and London: Cornell University Press, 1970), pp. 104 ff.

29. WBY to JBY [ca. 8 June 1901], "I enclose £3 . . . "

30. WBY to Clement Shorter [? March 1901] (Wade, *Letters*, p. 348).

31. WBY to Lily [ca. 28 June 1901], "I sent you some roses . . . "

32. SM to Lily 11 Oct. 1901.

33. WBY to JBY 12 July 1901.

34. Quoted from a carbon typescript in the Foster-Murphy Collection; see Wade, *Bibliography*, p. 52. For the story of the pamphlet see George Mills Harper, *Yeats's Golden Dawn* (London: Macmillan, 1974), pp. 69–92.

35. FYP to JBY ca. 20 Dec. 1901; SM to Lily 11 Oct. 1901.

36. SM to Lily, *ibid.*

37. Others, less well known, who lent works of JBY were a Miss Webb, Dr. Pearsall, George Prescott, Lord Justice Fitzgibbon, and J. Hogg.

38. The last JBY letter from London I have been able to trace is WBY 27 July 1901 (written from Blenheim Road). The next of his letters known to me is Q 19 Nov. 1901, written from 52 Morehampton Road, Dublin.

39. The title page of the sixteen-page catalogue reads: "*A Loan Collection of Pictures by Nathaniel Hone, R.H.A., and John Butler Yeats, R.H.A.*, will be on view at 6 Stephens Green, October 21st to November 3rd." Thomas Bodkin declares in his *Hugh Lane and His Pictures* (Dublin: The Arts Council 1956), p. 4, that the catalogue is "a great rarity." I am grateful to Anne Yeats for letting me see the copy in her collection. Sarah Purser's general introduction is on p. 3. George Moore's "Modern Landscape Painters: A Propos of Mr. Hone" is on pp. 4–7. Powell's "John Butler Yeats: An Appreciation" fills pp. 8–11. The catalogue of paintings begins on p. 12 and ends on p. 15. Powell mentions *Echo* as if it were part of the exhbition but it is not listed in the catalogue. I give titles as listed in the catalogue.

40. Dublin *Daily Express*, 21 Oct. 1901.

41. E.J.G., "Loan Exhibition of Paintings by Mr. Hone, R.H.A., and Mr. Yeats, R.H.A." *Irish Times*, 21 Oct. 1901. The critic thought the portrait of "Essie" Dowden "the most successful work of art among Mr. Yeats's contributions."

42. *Irish Times*, 22 Oct. 1901, which reported a "constant stream of visitors throughout the day." The account of the distinguished visitors is in *Daily Express*, 25 Oct. 1901.

43. Lily 24 Dec. 1901; Lily [ca. 28 Dec. 1901], "Your letter and postcard . . . "

44. Unless otherwise specified, all details about Quinn are taken from Reid.

45. Many are still confused. The father never called himself "Jack" Yeats or "John" Yeats or "John B." Yeats; he was always "J. B. Yeats" or "John Butler Yeats." The son never referred to himself as "J. B. " Yeats or "John" Yeats, preferring "Jack" Yeats or "Jack B." Yeats. (On legal documents only he signed himself "John Butler Yeats, Junior.") Catalogues and learned journals, including the *PMLA*, consistently confuse the two.

46. Q 19 Nov. 1901, Coll.: Foster-Murphy.

47. Lily 9 April 1919.

48. Lollie 7 Jan. 1902; Lily 21 Jan. 1902.

49. I have not been able to identify the other barrister. *Thom's Directory* is not always reliable for establishing seniority.

50. Lily, fragment [ca. Jan.-Feb. 1902], "I told you all this . . . "

51. Lollie 7 Jan. 1902.

52. Mrs. Andrew Jameson (née Ruth Hart) to WMM: conversation.

53. Lily [ca. 28 Dec. 1901], "Your letter and postcard . . ."

54. Lily 9 Jan.; Jack 15 Jan.; Lily n.d., "I am glad . . . "; Lily [ca. 11 July], "No letter this several days . . . "; Lollie [ca. 4 June], "I am much obliged . . . "; all 1902.

55. Lollie [ca 4 June 1902], "I am much obliged . . . "

56. WBY 21 March 1902 (also in *JBYL*, p. 69). Only a month earlier he had boasted with his old optimism, "These months of *exclusive* application to portrait painting have wrought miracles in me. I now feel like a master" (WBY 22 Feb. 1902). A month earlier still he told Lily he hoped that after the R.H.A. showing "the Dublin public may awake to the fact that I am a wonderful portrait painter" (Lily 21 Jan. 1902).

57. WBY to LAG 20 Nov. 1901 (Wade, *Letters*, p. 359).

58. Q [11 April] Good Friday 1903, NYPL.

59. Reid, pp. 7–11.

60. Lollie to JBY 19 March 1921.

61. LAG 4 May 1902 (*Irish Renaissance*, p. 60). JBY spells "Martin."

62. LAG 7 May 1902 (*ibid.*, p. 61). The picture of O'Grady is in the National Gallery of Ireland. It appears as item no. 55 in James White, *John Butler Yeats and the Irish Renaissance* (Dublin: Dolmen, 1972), p. 69.

63. Lily 21 Jan. 1902; WBY 22 Feb. 1902. Andrew Jameson later took as his second wife Ruth Hart (daughter of Mr. and Mrs. George Hart), one of JBY's young friends. Her reminiscences to the author have been invaluable, as her hospitality has been gracious and unsparing. As I have acknowledged elsewhere, she allowed me full use of the letters sent by JBY to herself and her mother, selections from which also appear in *JBYL*.

64. WBY 22 Feb.; WBY [ca. 15 May], "I am awfully sorry . . . "; WBY [ca. 2 July], "I only write . . . "; WBY [1902], "Thanks for £2 . . . "; WBY [ca. 15 Aug.], "I send you . . . "; all 1902.

65. WBY 10 April 1902.

66. See Lily [ca. summer], "I am glad . . . " (also in *JBYL*, p. 71); Lollie [ca. 4 June], "I am much obliged . . . "; Lily 9 and 20 Jan.; WBY 22 March; Lily [ca. summer], "A day without . . . " (also in *JBYL*, p. 71); Lollie [ca. 15 Aug.], "I don't wonder . . . "; WBY [ca. 15 May], "I am awfully sorry . . . "; all 1902.

67. Liam Miller, *The Dun Emer Press, Later the Cuala Press* (Dublin: Dolmen, 1973), p. 15. The book is the culmination of Mr. Miller's long study of the history of Dun Emer and Cuala. Earlier publications of his which have been absorbed into the 1973 book are "The Dun Emer and the Cuala Press" in *The World of WBY*, pp. 111–133; *A Brief Account of the Cuala Press, Formerly the Dun Emer Press, Founded by Elizabeth Yeats in MCMIII* (Dublin: Cuala, 1971); and an account in *The Irish Book* (Dublin: Dolmen, 1963), pp. 43–52, 81–90. (On Dun Emer and Cuala see also Michael J. Durkan, "The Dun Emer and the Cuala Press," *Wesleyan Library Notes* [Middletown, Conn.], no. 4 [spring 1970], pp. 7–18; and Robin Skelton, "Twentieth-Century Irish Literature and the Private Press Tradition: Dun Emer, Cuala, and Dolmen Presses, 1902–1963," in *Irish Renaissance*, pp. 158–167.)

As a printer, artist, and publisher himself (he is editor of the Dolmen Press) Mr. Miller's interest in Dun Emer and Cuala has been focused chiefly on their contribution to the graphic arts, and he has unearthed a vast treasure of information about the details of the early history of the Industries. Since the publication of his works, further

information has come to light about the financial arrangements and the personal difficulties between Miss Gleeson and the Yeats sisters, and between WBY and Lollie. Unless otherwise specified, the material used here comes from the Yeats family papers.

68. Miller, p. 22.

69. Lily Yeats, *Elizabeth Corbet Yeats* (Dublin: Cuala, 1 Feb. 1940); quoted in Miller, p. 95. See also Lollie to "Dear Sir" [? Holbrook Jackson] 11 Nov. 1903 (Lockwood Memorial Library, State University of New York at Buffalo): "I had never even seen a Press worked until we had nearly finished 'In The Seven Woods.'" I thank K. C. Gay, Curator, for his kindness in showing me the library's Yeats materials.

70. WBY to LAG 8 Feb. 1904 (Wade, *Letters*, p. 431).

71. "I believe that Doctor from China has advanced £200 on which they have paid him regularly, without once failing, five percent. They also pay Miss Gleeson £30 a year rent" (WBY [ca. 6 or 13 Aug. 1906], "Many thanks for your letters . . ."). "Lollie was in constant correspondence with Dr. Henry. He was Miss Gleeson's friend and Lollie's and friend to Dun Emer. He guaranteed their salaries and paid their salaries" (WBY [probably 1906], "It was at the commencement . . ."; *JBYL*, p. 97, omits this passage).

Augustine Henry (1857–1930) was not a doctor but an official in the Chinese Imperial Maritime Customs (1882–1900), a botanist specializing in Oriental flora. At his death he was Professor of Forestry at University College, Dublin.

72. WBY [ca. Aug. 1904], "I should be very much . . ."

73. Jack to Lily 10 May 1902. The wording fixes the terminal date of the beginning of negotiations.

74. Lollie [1902], "Just got your letter . . ."; written from Harrington Street, Dublin.

75. When the first Dun Emer volume, *In the Seven Woods*, appeared, Yeats wrote on the flyleaf of the copy he gave John Quinn: "This is the first book of mine that it is a pleasure to look at—a pleasure whether open or shut" (Wade, *Bibliography*, p. 67). WBY's letters to Elkin Mathews (mostly undated) in the Brotherton Library at Leeds University reveal his intense interest in the shapes and sizes of typefaces.

76. Katharine MacCormack, in a letter to the editor of the *Irish Times*, 16 Sept. 1953, gives her aunt Miss Gleeson credit for the name (Miller, p. 54). Lollie told Philip Darrell Sherman (1 July 1918, Brown) that she and Lily chose it.

77. Lollie to P.D. Sherman 1 July 1918, Brown.

78. WBY [ca. 15 Aug. 1902] "I send you . . ."

79. Minnie Mathews to JBY 2 Sept. 1902, postscript of 4 Oct.

80. Lollie to JBY 24 June 1921.

81. WBY to LAG 4 Dec. 1902 (Wade, *Letters*, p. 387).

82. WBY [ca. 6 or 13 Aug. 1906], "Many thanks for your letters . . ."

83. Van Wyck Brooks, *John Sloan* (New York: Dutton, 1955), p. 108.

84. Lily to Louis Purser 22 March 1910. This remarkable letter, which provides the key to the relationship between Lollie and Louis, was in the possession of the late Olive Purser, who generously let me have a copy of it. See Chapter Thirteen, pp. 373–374, where it is quoted in full. Miss Purser, niece of Sarah and Louis, was the brilliant young student of English literature who was called upon to fill in for Edward Dowden at TCD when he was taken ill a year or two before he died. Her Aunt Sarah painted a magnificent oil portrait of her.

85. *An Claidheamh Soluis*, 30 Aug. 1902, unsigned. I have quoted from a translation from the Irish made for me by Mrs. Michael B. Yeats (the daughter of P. S. O'Hegarty), whose native tongue is Irish. The clumsiness of the writing in the original and its occasional inaccuracies she attributes to the probability that the piece was written by an English-speaking Irishman who had learned Irish as a second language under the influence of Hyde's program and was unsure of the language.

86. Pyle, p. 68.

87. Jack to Q 15 Dec. 1902, Coll.: Foster-Murphy. On Jack's collaborator, see Joan Coldwell's introduction to *Pamela Colman Smith: An Exhibition of her Work, arranged by Joan Coldwell and Ann Saddlemyer* (Hamilton, Ontario: McMaster University, 1977).

88. WBY 21 March [1902] (also in *JBYL*, pp. 68–69); WBY 22 March 1902 (also in *ibid.*, p. 69). He adds: "Latin and Greek and learning never affected Jack since by the mercy of God he never paid any attention to them."

89. From Lady Gregory, *Our Irish Theatre* (1913) (New York: Capricorn, 1965), p. 301.

90. See n. 20 above.

91. This account and much of what follows are taken from the invaluable monograph of James Flannery, *Miss Annie F. Horniman and the Abbey Theatre* (Dublin: Dolmen, 1970), the material here from pp. 7 ff. A great many of her letters to WBY are in the National Library of Ireland, MS 13068. I thank Dr. Patrick Henchy, Director of the Library, for allowing me to consult them at leisure.

92. WBY to Frank Fay 21 April 1902 (Wade, *Letters*, pp. 371–372). See Flannery, p. 8. Wade describes the letter simply as "dictated."

93. Holloway, 3 April 1902, pp. 16–17.

94. Quoted by Robinson, p. 27.

95. *Ibid.*, pp. 27–28. The Irish play is translated "Elizabeth and the Beggar Woman."

96. Dumbleton, *The Sleep of the King*," pp. 2–3; WBY to LAG [? 26 Sept. 1902] (Wade, *Letters*, p. 379; Dumbleton, pp. 2–3); WBY to Lily 25 Dec. 1903 (Wade, *Letters*, p. 417); Frank Fay to WBY 26 Sept. 1902 (Robinson, pp. 28–29).

97. WBY [ca. 17 Sept. 1902], "I was at Moore's . . . " (partly reprinted in *JBYL*, p. 66, where it is dated 1901).

98. Wade, *Letters*, p. 379 n. The play was *Where There Is Nothing*.

99. Richard Ellmann, *James Joyce* (New York: Oxford University Press, 1959), pp. 102–104, 106 n., 108.

100. James Joyce to Mary Colum 29 March 1939 (*Letters of James Joyce*, ed. Richard Ellmann [New York: Viking, 1966], III, 438). One letter of JBY's suggests that JBY didn't remember the meeting. When he saw a portrait of Joyce in the *Little Review* in 1920, JBY noticed a resemblance to Synge. "I wonder has he Synge's equal and gentle temper?" he asked Lady Gregory (14 Aug. 1920, NYPL). Had he remembered Joyce it would hardly have taken him so long to notice the resemblance, and he might already have had some notion of Joyce's temper. In New York, when he praised Joyce's work to Quinn, he did not claim friendship or even acquaintance with Joyce and acknowledged that the people Joyce wrote about were not the kind he and his people associated with in Dublin.

Joyce was active in Dublin among those the Yeatses knew. Lily wrote to Quinn (1 June 1917; Reid, pp. 309–310): "I remember Joyce. He used to be in and out among us all at the start of the Abbey and all its movements. I remember him one night—very cheerful—he thought drink would soon end his father, then he would give his six little sisters to Archbishop Walsh to make nuns of, leaving him free. Then I remember him—tall, slim, and dark, darting past me in a doorway in white tennis shoes."

101. Ellmann (*Joyce*, 179) quotes the story from Gogarty's *It Isn't This Time of Year at All* (London: 1954), pp. 69–70. Considering the richness of Gogarty's wit and inventiveness, I am skeptical of his account and would welcome further evidence.

Chapter Eleven: 1903–1905

1. LAG 6 Jan 1903, NYPL.
2. Memorandum of Principal and Interest Due F.G., 6 Aug. 1903.
3. George Russell to Q 17 May 1903 (Alan Denson, *Letters from AE* [London:

Abelard-Schuman, 1961], p. 49). Quinn wanted to reproduce the sketch, and Russell wanted to make sure he chose the right one.

4. Lollie 7 Sept. 1903.

5. *Ibid.*

6. LAG to Q 3 Jan. 1909 (Reid, pp. 88–89).

7. Anne Yeats to WMM: conversation. She got the information from Lily. No matter how disorganized his studio might seem, at the end of the day JBY cleaned his brushes and palette and stored his oils.

8. FYP to JBY 30 Oct. 1903.

9. Lollie 7 Sept. 1903.

10. WBY [*ca.* summer 1903], "I am very glad ... " Norah Holland (1876–1925) granddaughter of Matthew Yeats, later gained fame as a minor poet. A selection of her verse, with a reproduction of JBY's sketch of her, appears in John W. Garvin, ed., *Canadian Poets* (Toronto: McClelland and Stewart, 1926), pp. 295 ff. I am grateful to Mrs. Arthur Wickens of Bear Point, Nova Scotia, for calling this publication to my attention.

11. Many of the sketches survive in dated sketchbooks in the collection of Michael B. Yeats.

12. LAG 3 Jan. 1903 (misdated 1902), NYPL.

13. William George Fay and Catherine Carswell, *The Fays of the Abbey Theatre*; (New York: Harcourt Brace, 1935), pp. 160–161. The portrait, not finished till 1904, is in the National Gallery of Ireland; see James White, *John Butler Yeats and the Irish Renaissance* (Dublin: Dolmen, 1972), pp. 64, 70.

14. Q 11 April 1903, NYPL.

15. Jack to Q 15 Dec. 1903, Coll.: Foster-Murphy.

16. I am grateful to the late Dr. Thomas MacGreevy, Director of the National Gallery of Ireland, for having told me this characteristic story.

17. Thomas Bodkin, *Hugh Lane and His Pictures* (Dublin: The Arts Council, 1956), p. 4. WBY thought Lane "slightly foppish, and tainted with snobbery," to use Bodkin's words; Lane found Willie "aloof and pretentious."

18. Stephen Catterson Smith's father (1806–1872), who bore the same name, was an earlier president of the R.H.A. (1859–1864, and for a short time in 1868). Another son, Robert Catterson Smith, the good friend of JBY and Todhunter, became head of the Birmingham School of Art. I am grateful to Mr. and Mrs. J. F. Crowder, W. A. Taylor, Charles Thomas, and John Murdoch, all of Birmingham, for their kindness in providing me with information about the Catterson Smiths.

19. Isaac 21 Jan. 1917.

20. Lily 10 Oct. 1917.

21. Mem. II.

22. When Lady Gregory quotes from JBY's letter (LAG 8 July 1920, no. 1, "Many thanks for the £2 ... "; NYPL), she mercifully disguises Mrs. Catterson Smith as "Mrs. Blank." See her *Hugh Lane's Life and Achievements, with Some Account of the Dublin Galleries* (New York: Dutton; London: Murray, 1921), p. 36.

23. JBY described Mrs. Catterson Smith at length in a letter to Lollie 19 Oct. 1921, in the letter referred to in the previous note, and in LAG [ca. 1919], "Altho' Hugh Lane ... " (see Chapter Fifteen, n. 146).

24. LAG to WBY 21 Dec. 1903, Coll.: Foster-Murphy; LAG 8 July 1920, no. 1, "Many thanks for the £2 ... " (NYPL); LAG [ca. 1919], "Altho' Hugh Lane ... " In a letter to Lily (10 Oct. 1917) Papa wrote: "I think I could have been happy with any woman except Mrs. Edwin Ellis or Mrs. Catterson Smith."

25. Lollie 19 Oct. 1921. See also LAG [ca. 1919], "Altho' Hugh Lane ... "

26. LAG 2 Jan. 1903 (misdated 1902), NYPL. The story, "The Luck of the

O'Beirnes" (about an Anglo-Irish landlord who supported the nationalist cause during the disturbances of 1798), appeared in the *Irish Homestead,* vol VIII (Christmas number), Dec. 1902, pp. 26–28.

27. FYP to JBY 29 March 1903.
28. Q 11 April 1903, NYPL.
29. WBY 7 Aug. 1903.
30. Q 7 Aug. 1903, Coll.: Foster-Murphy.
31. Quoted by Reid, pp. 13–14.
32. Quoted by Pamela Hinkson in "The Friendship of Yeats and Katharine Ty-nan, II," *Fortnightly Review,* Nov. 1953, p. 329, from a letter of WBY to KT.
33. Q 11 April 1903, NYPL
34. WBY to Q 20 March [1903], Coll.: Foster-Murphy.
35. Holloway, 14 March 1903, pp. 21, 23.
36. A. E. Horniman to WBY 1 March 1903 (from Flannery, p. 8).
37. Robinson, p. 40.
38. Reid, p. 16.
39. A. E. Horniman to WBY 1 May 1903, NLI, MS 13068 (Flannery, p. 9).
40. WBY to LAG 4 May 1903 (Wade, *Letters,* p. 399).
41. WBY to Q 20 March [1903], Coll.: Foster-Murphy.
42. Holloway, 4 Sept. 1903, p. 25.
43. Greene and Stephens, pp. 152–153. See also Robinson, p. 36. The two accounts differ in details.
44. Not related to the author of this book.
45. Greene and Stephens, pp. 150–151.
46. *United Irishman,* 10 Oct. 1903. The issue, which bore its official publication date, a Saturday, appeared on the streets two days earlier.
47. Holloway, 8 Oct. 1903, p. 27. Holloway also expressed his annoyance at WBY as a commentator: "Mr. W. B. Yeats was called after both his plays, and held forth at the end of *Cathleen ni Houlihan* in his usual thumpety-thigh, monotonous, affected, preachy style, and ended by making a fool of himself in 'going' for an article that appeared in this morning's *Independent.* He generally makes a mess of it when he orates. Kind friends ought to advise him to hold his tongue."
48. *United Irishman,* 31 Oct. 1903.
49. A. E. Horniman to WBY 9 Oct. 1903, NLI, MS 13068 (Flannery, pp. 9,14–15).
50. Lily 25 June 1910.
51. Lollie to P. D. Sherman, fragment [ca. Oct. 1918], Brown.
52. FYP to JBY 30 June 1903.
53. See Miller, pp. 25 ff. and *passim.*
54. George Russell to Q 17 May 1903 (Denson, *Letters from AE,* p. 48).
55. WBY to Lily 25 Dec. 1903 (also in Wade, *Letters,* pp. 416–417).
56. Reid, pp. 18 ff.
57. WBY [Spring 1903], "I would be very . . . "
58. Reid, p. 19. Mrs. W. B. Yeats supplied the figure.
59. *Poems,* p. 87. See WBY to LAG 21 Jan. 1904 (Wade, *Letters,* p. 427, and n.).
60. George Mills Harper, *Yeats's Golden Dawn* (London: Macmillan, 1974), p. 168.
61. WBY to LAG 8 Feb. 1904 (Wade, *Letters,* pp. 430-431).
62. WBY 4 Feb. 1904.
63. LAG to WBY 2 Feb. 1904, Coll.: Foster-Murphy.
64. WBY to Lily 2 Jan. 1904 (Wade, *Letters,* p. 419).
65. WBY 4 Feb. 1904; WBY 5 Feb. 1904. The second of these appears in *JBYL* as no. 34, pp. 74-75. Hone dates it "(1903)" even though the context makes clear that it was written 5 Feb. 1904, the day after the letter quoted in Hone, *WBY,* p. 199.

66. George Russell to George Moore [6 April 1916] (Denson, *Letters from AE*, pp. 109–110).

67. Edmund Dulac, "Without the Twilight," in *Scattering Branches: Tributes to the Memory of William Butler Yeats*, ed. Stephen Lucius Gwynn (New York: Macmillan, 1946), p. 138.

68. L. A. G. Strong, "William Butler Yeats," in *Scattering Branches*, p. 221.

69. WBY to Stephen Gwynn 13 June 1906 (quoted in Joan Coldwell, "'The Art of Happy Desire': Yeats and the Little Magazine," in *The World of WBY*, p. 37). William Watson the poet-epigrammatist was another of those who saw only the mask:

> I met a poet lately, one of those
> To whom his life was one continual pose.
> A wise man this, for, take the pose away,
> What else were left 'twould pose the gods to say.

When Terence de Vere White accepted Conor Cruise O'Brien's suggestion that "Yeats' snobbery and remoteness from revolutionary Ireland were due to the influence of Lady Gregory and her circle," Elizabeth Coxhead sprang to the defense of the Lady of Coole: "Yeats was a snob by his own nature, with the unpleasant snobbery of those who feel themselves to be not quite out of the top drawer; it was a weakness from which his delightful father and brother were completely free" (letter to the editor of the Dublin *Evening Herald*, 14 Sept. 1965).

WBY wrote to Q 6 Feb. [1903] (Coll.: Foster-Murphy): "I don't know how I can thank you too much for the three volumes of Nietzsche. I had never read him before, but find that I had come to the same conclusions on several cardinal matters. He is exaggerated and violent but has helped me very greatly to build up in my mind an imagination of the heroic life."

70. See WBY to LAG 2 Jan. 1904 (Wade, *Letters*, pp. 420–422).

71. The dinner took place 10 May 1904. I copy these words from Dr. Oliver Edwards's unpublished "Annals of W. B. Yeats," to which he generously gave me access.

72. Charles Ricketts, *Self-Portrait*, p. 198 (quoted in Joan Coldwell, "'The Art of Happy Desire,'" in *The World of WBY*, p. 33).

73. WBY 1 June 1904.

74. WBY to Elkin Mathews 19 July 1904, Reading.

75. WBY [probably 4 June 1904]. Hone (*JBYL*, pp. 79–80) quotes part of this letter, which he dates merely "Saturday" in 1904.

76. The bickering went on to the end. Lollie, in a letter to Willie dated 30 Nov. 1937, urged him to appoint another editor to work with himself and take some of the work load away. "You want someone who understands the *purely practical side*, the daily working of the place. You say *yourself* that you do not understand the practical side, yet you will not listen to me, and I *do* understand *that side* of Cuala." In the Michael Yeats collection is the draft of a letter (2 Jan. 1938) from WBY to a Mr. Scroope, a banker, discussing his sisters' overdrafts and hinting at the reorganization which would take place not long afterward. Only two days before WBY died Lollie mailed him a letter complaining of the new directors of Cuala (26 Jan. 1939).

77. Samples of Lily's work are not easy to find. I have seen a beautiful firescreen in the home of Sir Robert and Lady Scott in Peebleshire, Scotland (Lady Rosalind Scott is the granddaughter of Isabella Pollexfen Varley), and a magnificent velvet jacket given by Lily Yeats to Jeanne Robert Foster for her care of JBY in his later years. Mrs. Foster gave the jacket to Caitríona Dill Yeats, the poet's granddaughter, in 1970. Banners for the cathedral of Loughrea were designed by Jack and Cottie, the Dun Emer girls

embroidering the silk and wool background, Lily the main figures (Pyle, p. 69).

78. WBY 1 June 1904.

79. In April, Russell had to postpone a visit to Gurteen Dhas in order to settle "a most infernal row" in County Kerry (George Russell to Lily 23 April 1904).

80. Lily to Q 11 Oct. 1904 and 31 Jan. 1905, NYPL.

81. Lily 2 Oct. 1904.

82. WBY [ca. 3 Oct. 1904], "I should be very much . . . "

83. WBY [probably 6 or 13 Aug. 1906] "Many thanks for . . . "; Q 30 Aug. 1906, Coll.: Foster-Murphy.

84. Lily to JBY 27 July 1904.

85. See the vivid description of his wanderings in Pyle, pp. 83–86; Reid, p. 21.

86. Reid, *ibid.*

87. Lily to JBY 27 July 1904. Jack was only six years younger than Willie, not seven, but the error is of a kind one finds throughout the letters and memoirs of the insouciant Yeatses. It is an amiable if sometimes maddening family weakness. Lily's prophecy has been fulfilled: Jack Yeats's paintings have for many years brought extremely high prices.

88. Lily to JBY 27 July 1904; WBY [ca. 3 Oct. 1904], "I should be very much . . . "

89. WBY 22 Sept. 1904.

90. Lily Yeats, "My Wishes," in envelope addressed to "W. B. Yeats Esq, 82 Merrion Sq., Dublin."

91. Lily to George Pollexfen 19 Dec. 1904.

92. Holloway, 14 Jan. 1904, pp. 32–33.

93. Dowden's feelings about Willie's work in the theatre were expressed a few years later: "I wish that he were wholly out of it, and consulting his genius" (ED to Rosalind Travers 14 April 1907; Dowden, *Letters*, p. 351).

94. Holloway, 13 Nov. 1903, p. 29.

95. JMS to Stephen MacKenna ca. 20 Jan. 1904 (Ann Saddlemyer, ed., "Synge to MacKenna: The Mature Years," in *Irish Renaissance*, p. 67).

96. Holloway, 16 Jan. 1904, p. 33.

97. LAG to WBY 2 Feb. 1904, Coll.: Foster-Murphy.

98. Holloway, 26 Feb. 1904, p. 35.

99. Robinson, pp. 44–45. JBY did a sketch of the old Mechanics Institute which Miss Horniman purchased (Holloway, 25 Sept. 1907, p. 61).

100. Robinson, p. 44; WBY to LAG 24 Nov. 1904 (Wade, *Letters*, p. 445).

101. LAG [7 Jan. 1904] (*Irish Renaissance*, pp. 62–63).

102. Quoted in Holloway, 20 Aug. 1904, p. 42.

103. *Ibid.*, p. 275, n. 6 (1904).

104. George Russell to Q 14 March 1914 (Denson, *Letters from AE*, pp. 95–97); Holloway, 27 Dec. 1904, pp. 50–51.

105. Hone, *WBY*, p. 203 n.

106. WBY to Frank Fay [? 20 Jan. 1904] (Wade, *Letters*, pp. 425–426): "Miss Horniman has to learn her work . . . and must have freedom to experiment." That was before she had put her money on the counter.

107. Hone, *WBY*, p. 204.

108. Lily 26 June 1904.

109. Flannery, p. 8.

110. Even before the name "Abbey" was associated with the Irish National Theatre Society, the Irish players were favorably known throughout the English-speaking world. The managers of the St. Louis World's Fair invited the players to perform but were refused. Dudley Digges and Maire Quinn let it be known that they were available,

and Violet Mervyn and P. J. Kelley joined them. A special meeting of the Society was held on 6 April to expel Kelley for treachery (Holloway, 6 April 1904, p. 38). The officials at St. Louis, unaware of the split in the Society, put the name of the Irish National Theatre Society on its marquees. Digges and Miss Quinn, by then engaged to be married, proceeded to find fault with everything and everybody. John Quinn, learning through WBY of the damage being done to the Society's reputation, demanded that things be straightened out. Myles Murphy, the manager in St. Louis, assured Quinn he would correct the mistakes and wrote him a long letter on the troubles Digges and Miss Quinn were causing (7 June 1904). Next day Quinn received another letter (fragmentary, with no signature, but possibly again from Murphy) with the interesting passage: "They will never get any good, either in acting or anything else, out of Miss Quinn, who is a perfect vixen, and as she and Digges are engaged to be married they can't have one without the other." Digges didn't like the Theatre Society but had no compunction about profiting from its reputation.

111. Bodkin, *Hugh Lane*, pp. 8–11. Five of the pictures were of Lily, Nannie Smith, John O'Leary, Douglas Hyde, and Mary Walker. I do not know the sixth.

112. Q 18 Jan. 1909, NYPL. Lady Gregory gave Shannon's letter to JBY, who cherished it. The quotation here is from JBY's account to Quinn. As Shannon's letter is lost or mislaid one cannot know what his exact words were.

113. Lily 26 June 1904.

114. Lily [ca. 25 June 1904], "It is 8 o'clock . . . "

115. Lily 27 June 1904; a portion of the letter, including what is quoted here, is in *JBYL*, p. 78.

116. Lily [ca. 25 June 1904], "It is 8 o'clock . . . "

117. Dealing with philosophy and full of a questioning spirit about the mysteries of the universe, it was perhaps not the kind of play that would be welcomed by a Dublin audience that had raised such howls at *The Countess Cathleen* and *In the Shadow of the Glen*. Papa wrote of it: "There is no doubt the play is splendid. I would give anything to have the play acted in Dublin, and I should like to be there to see it acted. There would be such a row, for it does knock about the Church and all the venerable orthodoxies" (Lily [ca. 25 June 1904], . "It is 8 o'clock . . . ").

118. Lily 27 June 1904.

119. Bodkin, *Hugh Lane and His Pictures*, p. 5.

120. Lily to WBY 2 Feb. 1904.

121. LAG [7 Jan. 1904] (*Irish Renaissance*, pp. 62–63): "Your nephew has an extraordinary knowledge of pictures and tho perhaps we don't see eye to eye, as the expression is, his errors are always corrigible and at the same [time] I learn a good deal from him. I thoroughly respect his opinion tho I don't always share it."

122. WBY [ca. 3 Oct. 1904], "I should be very much . . . " Lane's mother, "a grim old matron," viewed the rival portraits and said of JBY's that his was "at least human" (EDB 18 Aug. 1919, Princeton). But JBY could never satisfy Lane's demand for discipline. "We never quarreled," JBY explained to Lady Gregory, then chastised her nephew for trying to make him change his habits. "He was often exasperating, wanting me to do things his way rather than mine, asking the impossible" (LAG 29 Sept. 1919, NYPL).

123. LAG, *Hugh Lane's Life and Achievements*, pp. 40–41.

124. Hone, "Memoir," *JBYL*, p. 27. I presume Hone got the story from Lily, who provided him with most of the details for his account.

125. WBY 4 Feb. 1904 (also partly in Hone, *WBY*, p. 199).

126. Lily to WBY 2 Feb. 1904. A black-and-white reproduction of the portrait appears in Robinson, opposite p. 40. The original is in the Abbey Theatre.

127. EDB 21 May 1917. The night before he died JBY reminded Jeanne Robert

Foster that she was to sit to him in the morning; but he could not "manage to put off the dying."

128. Reid, p. 29.

129. FYP to JBY 24 April 1904, "My letter to you . . . "

130. WBY [before 27 June 1904] (*JBYL*, p. 76, where it is described as "Undated 1904"). JBY wrote a long essay on Powell which Oliver Elton included in his *Frederick York Powell: A Life and a Selection of His Letters and Occasional Writings* (Oxford: Clarendon, 1906), I, 439-455. Part of the essay is reprinted in *JBYL*, pp. 84–89.

131. WBY 22 Sept. 1904 (also in *JBYL*, p. 79).

132. Isaac 14 Jan. 1910.

133. Bodkin, *Hugh Lane*, pp. 12-13.

134. George Russell to Q [May 1904] (quoted from Reid, p. 22). Russell was afraid old Yeats's sight was failing, as he found bad drawing and color in his recent work.

135. Reid, p. 23.

136. Q to Lily 11 Oct. 1904.

137. Reid, p. 25.

138. *Ibid.*, pp. 26-27, 31. The summary of Quinn's diary, greatly condensed, is from pp. 24–31, unless otherwise noted.

139. Holloway, 31 Oct. 1904, p. 45; see also 15 April 1904, p. 39.

140. After the dinner, according to the menu (which was slipped between the pages of *Red Hanrahan*: see next note) the guests could attend either the Theatre Royal or the Gaiety.

141. The autographed volume is part of the Foster-Murphy Collection. Hyde's name is signed in Irish ("An Craobhin Aobhin"). The item is unique, one of the most interesting associated with the Irish Renaissance. *Stories of Red Hanrahan* (Wade, *Bibliography*, p. 74) was completed in Aug. 1904, but not published until May of the following year. The unusually long delay was occasioned by the complications arising from the reorganization of Dun Emer.

142. WBY to Frank Fay 13 Nov. 1904 (Wade, *Letters*, p. 443).The relationship of WBY and Moore at this time is made clear in a letter from Lily to Q 12 June 1904: "He met George Moore the other day at Arthur Symons and he refused to shake hands, so that bone is still unburied." Lily's second "he" is ambiguous, but a note in Quinn's diary (Reid, pp. 25–26) makes clear that Moore refused WBY's hand and left Symons's flat immediately. On 8 Dec. the two antagonists were forced to share the platform at the Royal Hibernian Academy and were correct in behavior (Holloway, 8 Dec. 1904, p. 48).

143. WBY to LAG 24 Nov. 1904 (Wade, *Letters*, p. 444).

144. Holloway, 16 Dec. 1904, pp. 49–50; Flannery, p. 15. Holloway characterizes the dispute as "an exciting and amusing exchange of difference of opinion."

145. Robinson, p. 45.

146. Holloway, 28 Dec. 1904, p. 51.

147. *Ibid.*, 17 June 1904, p. 41. Ironically, Holloway sat next to Synge before the rehearsal, and the discussion turned to O'Donnell's pamphlet attacking *The Countess Cathleen* for heresy. Holloway, who five years earlier was on Yeats's side ("what poor things mortals can become when the seat of reason is knocked awry by animus, spite, and bigotry," he had written of the claque opposed to WBY [8 May 1899, p. 6]), had now been won over to the opposition, largely because he had come to dislike Yeats the man so much. He told Synge that in his opinion "very rightly Yeats had been attacked for his treatment of priests, the Catholic religion, and Irish peasants," and he expressed his "condemnation of people meddling with subjects they knew little about." Synge listened, apparently without commenting.

148. Holloway, 7 Feb. 1905, p. 53.

149. Bodkin, *Hugh Lane*, pp. 11–13.

150. *Irish Times*, 5 Jan. 1905, p. 8.

151. Charles Fitzgerald 30 Jan. 1905 (quoted from *JBYL*, p. 81). I have not seen the original.

152. *Irish Times*, 14 Jan. 1905, p. 5.

153. Bodkin, *Hugh Lane*, pp. 13–14; the wording is from the Corporation's resolution. The Royal Family had been wisely advised to take the liberal course, as the dispute was a purely local one. In this case the Crown had nothing to lose by taking the right side, an opportunity seldom afforded it in Ireland.

154. WBY [either 21 or 28 Jan. 1905] (also in *JBYL*, pp. 82–83, where the date is given as "Saturday [1905]").

155. LAG 27 Jan. 1920, NYPL.

156. Q 15 Dec. 1920, Coll.: Foster-Murphy.

157. Lily to Q 13 Aug. 1905, NYPL.

158. See WBY to Sydney Cockerell 6 March 1911 (Wade, *Letters*, p. 557).

159. Orpen's portrait is reproduced in black and white as the frontispiece in W. B. Stanford and R. B. McDowell, *Mahaffy: A Biography of an Anglo-Irishman* (London: Routledge and Kegan Paul, 1971). JBY's was hung in the National Gallery of Ireland in the 1972 exhibition of JBY's works, where it was identified by Terence de Vere White.

160. Colum visited often at Gurteen Dhas. See Lily to Q 11 Oct. 1905, NYPL: "Young Colum is here this evening and is reading a newspaper cutting book of mine and trying for politeness sake to talk to us at the same time. Lollie is struggling through an Irish exercise, and Papa has the paper." The May 1905 sketch of Colum is reproduced in Robinson, opposite p. 28. In Michael Yeats's collection is a sketch of Colum with Mary Walker.

161. *Letters to Molly*, p. 148, lists six drawings of Synge by JBY in addition to the oil, and gives Jan., April, and Dec. as the dates of the sketches done in 1905. The April sketch (signed "J. B. Yeats, April, 1905") was later turned into a print in photogravure by Emery Walker and, with Synge's signature reproduced beneath it, was published "by Elizabeth C. Yeats at the Cuala Press, Dundrum, Co. Dublin." See Miller, p. 63. A seventh pencil sketch is in the Colby College Library (James Augustine Healy Collection of Irish Literature).

162. Lily to Oliver Edwards in conversation; Oliver Edwards to WMM: conversation.

163. Lily to Q 7 Sept. 1905, NYPL.

164. Lily to Q 26 Nov. 1905, NYPL.

165. Q to Lily 23 Jan. 1906.

166. Stanford and McDowell, *Mahaffy*, pp. 111–112. "Moore is a good Irishman and doing far more for the country than a bushel of Mahaffys" (Lollie [probably 1902], "I don't wonder . . . ").

167. Charles Fitzgerald 30 Jan. 1905 (quoted from *JBYL*, pp. 81–82).

168. Lily to Q 8 May 1906, NYPL.

169. Lily to Q 28 [?] April 1905, NYPL (the date could be 20 or 25 April; the handwriting is unclear).

170. JBY wrote a friend that he had finished the play in mid-1916 (C 3 June 1916, Princeton).

171. Lollie 6 Feb. 1909.

172. Lollie 14 July 1916.

173. WBY [after 8 July] 1918. Hone refers to the letter in a footnote in *JBYL*, p. 248, but does not date it.

174. Lollie 14 July 1916; see also WBY 19 Feb. 1913.

175. WBY 1 July 1905.

176. Reid, p. 39. Quinn paid Dun Emer £6.6 for 1,500 bookplates designed by Jack and printed on Irish-made paper (Lollie to Q, bill, 25 Nov. 1903, NYPL).

177. Q to Florence Farr 9 Dec. 1907, NYPL. I thank Josephine Johnson for this note.

178. Lily to Q 13 Aug. and 10 Oct. 1905, NYPL.

179. Miller, p. 43.

180. Lily to Q 13 Aug. 1905, NYPL.

181. WBY 1 July 1905.

182. Pyle, p. 87.

183. JMS to Stephen MacKenna 13 July 1905 (*Irish Renaissance*, p. 72). From his earliest days Jack was a good businessman; perhaps he learned from the Pollexfens by example and from his father in reverse. In his mature days when he had completed a painting he would set a price on it, have it photographed, send the photograph (pasted on cardboard) and the pertinent details in a folder to prospective customers, and await the results. There are two such folders in the Foster-Murphy Collection, both with the size and price written in Jack's hand. One concerns *On the Road to Croke Park*, price £21, the other *The Dark Man*, price 250 gns.

184. JMS to Stephen MacKenna 13 July 1905 (*Irish Renaissance*, p. 73).

185. Holloway, 7 and 11 Feb. 1905, p. 53.

186. Flannery, pp. 16–17.

187. Holloway, 1 and 10 Feb. 1907, pp. 86–87.

188. *Ibid.*, 25 April 1905, p. 57.

189. Reid, p. 43.

190. WBY to Q 15 Feb. 1905 (Wade, *Letters*, pp. 447-448).

191. Holloway, 25 April 1905, p. 57; 11 Feb. 1905, p. 53; 7 Feb. 1905, p. 53.

192. *Ibid.*, 27 Sept. 1905, p. 61.

193. WBY to Florence Farr 6 Oct. 1905 (Wade, *Letters*, p. 463).

194. Holloway, 25 Oct. 1905, p. 62; 10 Nov. 1905, p. 62; 19 Dec. 1905, p. 65.

195. Flannery, p. 18. Flannery has published, unfortunately too late for my uses here, a full-length book, *W. B. Yeats and the Idea of a Theatre* (New Haven: Yale University Press, 1977); to it I direct the curious reader.

196. JS 8 Aug. 1920. In a letter to the New York *Evening Sun*, JBY describes Synge as having "hazel eyes" (2 April 1909, Coll.: Foster-Murphy).

Chapter Twelve: 1906–1907

1. John Butler Yeats, *Essays Irish and American* (Dublin: Talbot; London: T. Fisher Unwin, 1918), p. 78. The lecture, "Watts and the Method of Art," appears on pp. 75–95. A footnote (p. 75) gives the date of the lecture as spring 1907. But the letters of JBY to LAG 18 Jan. 1906 and Lily to Q 11 Jan. 1906 (both NYPL) fix the date conclusively.

2. LAG 6 Jan. 1906 (misdated 1905); see also 10 Jan. 1906; both NYPL.

3. At the time (late 1901 and early and mid-1902) JBY was staying from time to time with the Harts at Howth, and Miss Elvery was an art student.

4. Beatrice Lady Glenavy (née Elvery) to WMM: conversation.

5. LAG 18 Jan. 1906, NYPL.

6. JBY, "Watts and the Method of Art," pp. 79–86. Since JBY did not edit the copy, I have reparagraphed for easier reading. JBY made a number of supplementary remarks about the lecture. He wrote Willie two years later (9 June 1909); "Do you remember I said we are all here to be tempted? Lust and spite are obvious violations of nature. Love and anger are often our strongest and completest fulfilment. . . . I said . . . It followed from this principle that artists are the real leaders of mankind, and that

when a clash occurred between the artist and the moralist, the moralist must give way, because the artist in his work embodies human desire." A dozen years after the Watts lecture he would apply the same principles to a consideration of Joyce's *Ulysses*.

7. LAG to Colum, n.d. (Greene and Stephens, p. 201).

8. Holloway, 12 Jan. 1906, p. 68.

9. *Ibid.*, pp. 67–68. Holloway also suggests in this entry that Miss Walker was in love with James Starkey, another disaffected member of the original group.

10. Nor did anyone else except, to some degree, Synge. See p. 301 and n. 32 below.

11. Hone, *WBY*, pp. 207–208. According to Hone, WBY did not continue with the lawsuit because of a horoscope of Maire done at JBY's request by George Pollexfen. George was proud of the horoscope but discovered later that he had been given the wrong date of birth (WBY 29 April 1921).

12. LAG 6 Jan. 1906 (misdated 1905), NYPL.

13. Holloway, 24 Nov. 1906, p. 75.

14. LAG 6 Jan. 1906 (misdated 1905), NYPL.

15. *Ibid.*, The Mrs. Dowden was of course the second, Elizabeth Dickinson West Dowden.

16. The oil was in 1973 in the possession of Leo Smith of the Dawson Gallery, Dublin, who bought it at an auction from the Adams Gallery for £360. I am grateful to Mr. Smith for showing me the oil and giving me the information about the price.

17. LAG [7, 14, 21, or 28 March 1906], "I don't know . . . "; NYPL.

18. WBY 16 March 1913. Part of the letter appears in *JBYL*, p. 158, but this passage is omitted.

19. LAG 10 Jan. 1906, NYPL.

20. Russell thought JBY "the most loveable of all bearing the name" of Yeats (Russell to Q May 1904; Reid, p. 22) and JBY repaid the compliment, describing Russell as "always serene, clean-minded and self-reliant, watched over by good angels" (Q 30 Aug. 1906, Coll.: Foster-Murphy). After their attempts at mediation had failed JBY wrote of Russell to Quinn: "He has the most lucid, humourous and magnanimous mind I ever met. The rest of us will have to stay a long time in Purgatory to get rid of our ingrained vicious habits of unfairness, but Russell will be allowed to pass on" (Q 11 Dec. 1906).

21. WBY to George Russell [8 Jan. 1906] (Wade, *Letters*, p. 466).

22. WBY to JMS 6 Jan. 1906 (Greene and Stephens, p. 199).

23. LAG to JBY 11 Jan. 1906, NYPL.

24. WBY to Lily 21 May 1906. The letter is written on the printed stationery of "The National Theatre Society, Ltd., Abbey Theatre, Dublin." Yeats, Synge, and Lady Gregory are listed as directors, W. G. Fay as stage manager, and F. J. Fay as secretary.

25. WBY [25 May 1906], "I had a long passage . . . "

26. LAG to P. Colum, n.d. (Greene and Stephens, pp. 200–201). I have supplied the question mark.

27. LAG 8 Jan. 1906, NYPL.

28. Holloway, 7 Dec. 1906, p. 77. Holloway had mixed feelings about "the new offshoot of the prolific dramatic tree of the Irish literary movement." He wasn't sure he liked it. "Personally I should like to see the branches lopped off, and all the sap restored to the parent tree."

29. Maire nic Shiubhlaigh, *The Splendid Years* (Dublin: James Duffy, 1955), p. 77. The frontispiece is a black-and-white reproduction of a JBY oil of her sitting in a wooden armchair indoors. It is dated 1906.

30. LAG 18 [15?] Oct. 1906, NYPL.

31. JMS to LAG 11 Jan. 1906 (Ann Saddlemyer, ed., *Some Letters of John M. Synge to*

Lady Gregory and W. B. Yeats [Dublin: Cuala, 1971], p. 21). Unfortunately I have found no record of the discussions between them.

32. WBY to Florence Farr [Jan. 1906] (Wade, *Letters*, pp. 467–468).

33. See Ann Saddlemyer's indispensable *Letters to Molly* (Cambridge, Mass.: Harvard, 1971), where the melancholy and heartrending course of Synge's luckless affair with Molly and with life is set forth in his own words. Examples of his almost insane jealousy are evident from virtually the beginning of the correspondence. "Dossy" Wright was his principal rival, he thought. The references to his physical discomfort begin early and continue with increasing frequency: "I've a cramp in my back and my hip's asleep" (20 July 1906, p. 6); "I'm dead tired" (17 Aug., p. 13); "I've a bit of a headache" (26 Aug., p. 15); "I am very lonesome too, and not very well. . . . My head is aching a good deal" (28 Aug., p. 17). One senses from the letters that, even though he occasionally mentions no symptoms specifically, he never had a day of perfect health.

34. Flannery, p. 22.

35. Quoted in Greene and Stephens, pp. 201–202.

36. Flannery, pp. 21–22.

37. LAG 29 Aug. 1906, NYPL; WBY to JBY 21 July 1906 (Wade, *Letters*, pp. 474–476); JMS to Molly Allgood 6 Nov. 1906 (*Letters to Molly*, p. 48). Miss Darragh's real name was Letitia Marion Dallas. According to WBY she was Irish.

38. WBY [ca. 25 Nov. 1906] "As you asked my opinion . . . " (also in *JBYL*, pp. 99–100, where the two adjectives describing Miss Walker are deleted, and the letter is dated Dec. 1906).

39. Florence Darragh to WBY 22 Sept. 1906, NLI, MS 13068 (Flannery, p. 23).

40. WBY to Florence Farr 30 Sept. [1906] (Wade, *Letters*, p. 479).

41. For a thorough discussion of the Abbey's history in which this thesis is developed, see Ann Saddlemyer, " 'Worn Out With Dreams,' " in *The World of WBY*, pp. 74–102.

42. Holloway, p. 283 n.

43. *Ibid.*, 17 April 1906, p. 71.

44. Q 11 Dec. 1906, NYPL.

45. WBY to KT (Wade, *Letters*, p. 482, where it is dated ["late 1906 or early 1907"]); LAG [7, 14, 21, or 28 March 1906], "I don't know . . . "; NYPL. Russell's theories differed from WBY's. He thought every Irish writer should be heard on the stage of the Irish National Theatre Society whether he had talent or not. JBY thought both his views and WBY's wrong. "It is a pity that these two protagonists should neither have a true theory as to the theatre," he complained to Lady Gregory in the March letter cited. "Russell despises it frankly. He regards it as 'a mere Peep show.' "

46. Annie Horniman to WBY 19 Sept. 1906, NLI, MS 13068.

47. Lollie to Q 17 Aug. 1906. NYPL; Oliver Elton 28 June 1906, Coll.: Leonard Elton.

48. WBY [probably 2 Aug. 1906], "My letter written . . . "

49. WBY 3 Aug. 1906.

50. WBY n.d. [1906]. The passage quoted appears in *JBYL* (no. 50, p. 97), but Hone in another part of the letter misreads "philosopher" for "philosophe." JBY had also used the word "doctrinaire" in a letter to Lady Gregory (n.d., 1906, "I understand all about it . . . "; NYPL) in which he said his son was "fond of placing all his trust in some inchoate theory instead of following his intuition."

51. WBY [ca. 6 or 13 Aug. 1906], "Many thanks for your letters . . . "

52. WBY 8 Aug. 1906. Hone reprints the letter, badly edited, as no. 51 in *JBYL*, pp. 97–98, where he dates it 6 Aug.

53. Julia Ford 6 Jan. 1911, Yale.

54. WBY to KT 24 Aug. 1906 (Miller, pp. 46-47).

55. WBY to KT 28 Aug. 1906. From a draft copy, written from Coole, a fragment of two pages with corrections in WBY's hand.

56. Lollie to Q 29 Oct. 1906, NYPL.

57. Lollie to Q 25 Nov. 1906, NYPL.

58. WBY [ca. 6 or 13 Aug. 1906], "Many thanks for your letters . . . "

59. Lily to JBY 3 Jan. 1911.

60. Lollie to JBY 19 March 1921.

61. JMS to Molly Allgood 30 Aug. 1906 (*Letters to Molly*, p. 19).

62. Lily to JBY 8 Nov. 1917.

63. Lollie to Q 25 Nov. 1906, NYPL. I have discussed Lily's visions in another place: "Psychic Daughter, Mystic Son, Sceptic Father," in George Mills Harper, ed., *Yeats and the Occult* (Toronto: Macmillan of Canada, 1975), pp. 11-26.

64. See Chapter Eleven, note 160.

65. W. G. Fay and Catherine Carswell, *The Fays of the Abbey Theatre* (New York: Harcourt Brace, 1935), p. 150.

66. Olive Purser to WMM: conversation.

67. Lollie 15 April 1913.

68. Joseph Hone, "Memoir," *JBYL*, p. 36. The interpretation of the difference of opinion about routes I take from Dr. Thomas MacGreevy, who called Lollie a "nonstop talker."

69. WBY 3 Aug. 1906.

70. WBY [ca. 6 or 13 Aug. 1906], "Many thanks for your letters . . . "

71. Lily 9 April 1919; Lily 31 March 1911.

72. Oliver Elton 28 June 1906, Coll.: Leonard Elton; WBY [ca. 1 June 1906], "Miss Tobin is a princess . . . " (*JBYL*, p. 91, where it is dated simply 1906). The oil portrait of Harrington hangs in the Mansion House in Dublin.

73. F. A. King [ca. 1908], Yale.

74. Oliver Elton [ca. mid-May 1906] "I did not sent it . . . ", Coll.: Leonard Elton; WBY [ca. 1 June 1906], "Miss Tobin is a princess . . . " (also in *JBYL*, p. 90).

75. Beatrice Lady Glenavy to WMM: conversation.

76. Q to JBY 9 July 1906.

77. WBY [ca. 1 June 1906), "Miss Tobin is a princess . . . " (also in *JBYL*, p. 90).

78. WBY to JBY 21 July 1906. The passage from Swinburne is reprinted in *JBYL*. p. 92.

79. WBY 2 July 1906 (also in *JBYL*, p. 93).

80. WBY (probably between 30 June and 5 July 1906), "I send a letter . . . "; he continues the discussion in his letter of 5 July (*JBYL*, pp. 94–95).

81. WBY [ca. 1 June 1906], "Miss Tobin is a princess . . . " (also in *JBYL*, p. 91).

82. Q to Lily 23 Jan. 1906.

83. Q to JBY 9 July 1906.

84. LAG 29 Aug. 1906, NYPL.

85. Quoted in Greene and Stephens, p. 237.

86. *Letters to Molly*, p. 149 n.

87. Holloway, 26 Jan. 1907, p. 81; 28 Jan. 1907, p. 83.

88. The story of the Dublin row over *The Playboy* has been told often, and I give only a brief account of it here, chiefly of JBY's part in it. Most valuable among contemporary sources are Holloway's diary and the collection of newspaper accounts and connective comment in James Kilroy's *The 'Playboy' Riots* (Dublin: Dolmen, 1971). See also Robinson.

89. *Evening Mail*, 29 Jan. 1907, p. 2 (Kilroy, p. 24).

90. See Kilroy, pp. 9, 67; Robinson, p. 53.

91. These were the objections given by the *Irish Times*, 30 Jan. 1907, p. 6 (Kilroy, p.

35), in an editorial which took the demonstrators to task for their refusal to let others be heard.

92. Holloway, 26 Jan. 1907, pp. 81–82.

93. *Evening Herald*, 31 Jan. 1907 (Kilroy, pp. 47–48); *Freeman's Journal*, 31 Jan. 1907, p. 7 (*ibid.*, p. 41); Holloway, 31 Jan. 1907, p. 86.

94. Synge himself made the rather curious defense to W. J. Lawrence that "the Abbey was a subsidized theatre in which the audience had no rights" (Holloway, 25 April 1907, p. 92), an unpersuasive answer to a customer who had paid for his ticket. Synge was ill during all these months and hardly had the opportunity to think through his position.

In *Miller* v *California* (21 June 1973) the U.S. Supreme Court held that juries are allowed to apply "contemporary community standards" in determining obscenity or pornography. It thus seems to have adopted the position of *The Playboy's* detractors that if a majority doesn't approve of a play or movie it has the right to prevent others from seeing it. This was the position taken also by William Boyle.

95. Quoted in Greene and Stephens, pp. 245–246.

96. William Boyle to WBY 31 Jan. 1907 (quoted from Holloway, 10 Feb. 1907, p. 87).

97. *Irish Times*, 31 Jan. 1907, p. 5 (Kilroy, p. 41).

98. JMS to Stephen MacKenna, n.d., draft (postscript dated 1 Feb.), probably 1904 (*Irish Renaissance*, pp. 66–67). I have written "obsessed" for "obseded."

99. WBY to Q 18 Feb. 1907 (Reid, p. 48).

100. Holloway, 7 and 8 Feb. 1926, pp. 251–252.

101. *Irish Times*, 30 Jan. 1907, p. 6 (Kilroy, p. 36); *Freeman's Journal*, 5 Feb. 1907, pp. 6–7 (*ibid.*, p. 86).

102. Pp. 7–8 (Kilroy, p. 46).

103. LAG to JMS [ca. 5 Feb. 1907], NLI, Microfilm no. 5380, Synge Papers (quoted from Kilroy, pp. 88–89).

104. LAG 14 Aug. 1920, NYPL.

105. Greene and Stephens (p. 250) describe those in the theatre as "almost entirely hostile and threatening."

106. Mary Colum, "Memories of Yeats," *Saturday Review of Literature*, 25 Feb. 1939, p. 4 (quoted in Greene and Stephens, p. 250).

107. "Beautiful, Lofty Things," not published until a year before Yeats's death, in *New Poems* (Dublin: Cuala, 1938); *Collected Poems* (London: Macmillan, 1965), p. 398.

108. *Freeman's Journal*, 5 Feb. 1907 (Kilroy, p. 85). Also LAG to JMS 5 Feb. 1907 (*ibid.*, pp. 88–90).

109. Explaining his own role JBY wrote years later to Joseph Hone (29 Dec. 1915): "The sentence about the curtain of deceit flashed on my mind at the moment, and was a good sentence, but manifestly a blunder, although I did enjoy it" (*JBYL*, p. 214).

110. See Malcolm Brown, *The Politics of Irish Literature* (Seattle: University of Washington Press, 1972), pp. 363–364. Brown notes that Yeats's biographers "have told us wrongly that he 'had a sensible impatience of internecine quarrels,' " and it is hard to take exception to his disagreement, as readers of the present book can judge.

111. WBY to Q 18 Feb. 1907 (Reid, p. 48).

112. JMS to Molly Allgood 18 March 1907 (*Letters to Molly*, p. 113).

113. JMS to Molly Allgood 21 March [1907] (*ibid.*, p. 114). A few days later he told Molly he was reassured by the list and would "make no row for the present at least" ([23 March]; p. 116).

114. JMS to Molly Allgood 26 and 28 May 1907 (*ibid.*, pp. 145, 148).

115. JMS to Molly Allgood 22 Oct. 1907 (*ibid.*, p. 206). The following year, when the members of the Abbey company were sending a card of some kind which all members

were supposed to sign, Synge advised Molly: "I think you had better *not* ask Lady G. and W.B.Y. to sign the card, they might think it below their dignity" ([17] Sept. 1908; p. 278).

116. JMS to Molly Allgood 19 Nov. [1907] (*ibid.*, p. 215).

117. "Statement by L.G. to J.Q." (ca. 16–20 March 1913, Coll.: Foster-Murphy). For a full description of the typed memorandum see Chapter Fourteen, n. 137.

118. Quoted in Flannery, p. 27.

119. Holloway, 30 Jan. 1907, p. 85.

120. William Boyle to D. J. O'Donoghue 13 Feb. 1907 (Holloway, pp. 87–88, under entry for 10 [*sic*] Feb).

121. Saddlemyer, "Worn Out With Dreams," in *The World of WBY*, pp. 89–90.

122. JMS to LAG 13 Dec. 1906 (Saddlemyer, ed., *Some Letters of John M. Synge*, p. 43); the "list of truly wicked people" is WBY's phrase (to F. Farr, ?July 1907; Wade, *Letters*, p. 490).

123. Quoted by Saddlemyer, "Worn Out With Dreams," in *The World of WBY*, p. 92.

124. WBY to Annie Horniman, n.d. (Wade, *Letters*, pp. 500–501). Wade gives "[? early 1908]," but I believe the letter is more likely to have been written in the fall of 1907.

125. Greene and Stephens, p. 280. No longer managing director but regarded merely as a fellow employee under the directors, Fay felt he could not reasonably be expected to keep the members of the company in line. The fall tour to Manchester, Edinburgh, and Glasgow exasperated him beyond endurance. Consequently he sent to the directors what amounted to an ultimatum: that all actors be put under contract to him and that he be given power of dismissal. It was not an unreasonable request. In the past Fay had been able to count on Synge's support, but now Molly had complained about Fay's strictness. Perhaps partly out of weariness of spirit caused by bad health, Synge refused to take Fay's side. The upshot was that Fay had placed himself in an untenable position—"the opportunity that Yeats had been waiting for," according to Synge's biographers—and his future with the Abbey was to be brief.

126. JMS to Molly Allgood 12 Sept. 1907 (*Letters to Molly*, p. 194).

127. WBY [ca. 15 Sept. 1907], "I have had a long letter . . ." (also in *JBYL*, where it is dated simply "[1907]"). Synge had earlier suggested to Molly that they buy the portrait of her by JBY, as he was afraid it would go to the Abbey and they would "see no more of it" (15 Nov. 1907; *Letters to Molly*, p. 215). Five days later he reported his bitter disappointment at discovering they had lost "the sketch," which he thought Lady Gregory must have paid for (20 Nov. 1907; p. 216). I have been unable to trace this picture; the portrait of Molly by J. B. Yeats now hanging in the Abbey is dated 1913.

128. JMS to Molly Allgood 28 May 1907 (*Letters to Molly*, p. 148).

129. JMS to Molly Allgood 6 Dec. 1907 (*ibid.*, p. 227).

130. Oliver Elton, Preface, *JBYL*, p. 8.

131. Oliver Elton 20 Dec. 1915, Coll.: Leonard Elton.

132. JBY Affidavit: Court of Irish Land Commission, Record no. (i.e. account no.) 822, 30 Jan. 1907.

133. Irish Land Commission, no. 822, Final Schedule no. 42, 5 July 1907.

134. Lily 31 March 1911; Lollie 8 April 1919. In LAG 27 Jan. 1920 (NYPL), JBY wrote that in his last years in Dublin he "did not owe a penny to anyone," but he must have been thinking of some brief period, perhaps after receipt of the estate money, when he was technically debtless.

135. Holloway, 17 March 1907, pp. 89–90.

136. WBY [1907], "There are no domestic worries . . ."

137. WBY [1907], "Could you manage . . ."; *JBYL*, pp. 83–84, reprints part of this letter, giving its date as "(1905)."

138. Olive Purser to WMM: conversation.

139. Miller, p. 47.

140. WBY [1907], "There are no domestic worries . . . "

141. WBY [1907], "I send you down . . . " The portrait of Mrs. Burke is reproduced in sepia in *JBYL*, facing p. 264.

142. Lollie 29 Oct. 1908.

143. LY, OE, "Mancini." She miswrites "intelligible" for "unintelligible."

144. Wade, *Bibliography*, no. 77, p. 87.

145. WBY 21 Oct. 1907 (also in *JBYL*, p. 102). The painting is in the possession of Michael B. Yeats.

146. Wade, *Bibliography*, no. 79, p. 90.

147. LAG 22 Aug. 1907.

148. WBY 12 Aug. 1907.

149. Q to WBY 23 Aug. 1907. The old man's pride at the commission might have suffered had he known that later in the year Quinn would offer Charles Shannon one hundred pounds for a similar portrait (Q to WBY 8 Dec. 1907). "I want to help your father," Quinn had told Willie in the earlier letter.

150. LAG 23 Sept. 1907 (*Irish Renaissance*, p. 23). It was "finished" so quickly only because JBY took it to America and gave it to Quinn. Under normal circumstances he would have asked for additional sittings and "improved" it. The portrait is now in the possession of WMM. It was exhibited in 1976 at the National Portrait Gallery in Washington as part of a bicentennial exhibition. See Marc Pachter and Frances Wein, ed., *Abroad in America: Visitors to the New Nation, 1776–1914* (Reading, Mass.: Addison-Wesley, 1976), where it is reproduced in black and white on p. 268.

151. Q to WBY 23 Aug. 1907; WBY [ca. 15 Sept. 1907], "I have had a long letter . . . " Maunsel published *The Playboy* in 1907, and Quinn published a limited number of copies of the second act only, for protection of copyright, in the same year. Elkin Mathews and Maunsel simultaneously published *The Aran Islands* in 1907 also. But no collected edition was issued until 1910, by Maunsel in Dublin.

152. Lollie to Q 11 Aug. 1907, NYPL. In addition to specific acknowledgements in the notes, I am indebted to Mrs. Andrew Jameson and Padraic Colum for information about the JBY Italian fund.

153. JRF 22 April 1919.

154. Ruth Hart (later Mrs. Andrew Jameson) 18 Sept. 1907, Coll.: RHJ (also in *JBYL*, p. 102).

155. WBY 23 Oct. 1907 (*JBYL*, p. 103). On 23 Sept. he thanked Lady Gregory for persuading Willie to sit for the oil but said nothing about New York. When he wrote Willie about the Mancini portrait on 21 Oct. he also said nothing, as he said nothing in a letter of ca. 1 Nov. to Lady Gregory about her *Dervorgilla* (n.d., "Sarah my messenger . . . "; NYPL).

156. Q to Florence Farr 9 Dec .1907, NYPL. I thank Josephine Johnson for calling this letter to my attention.

157. Lollie 21 Dec. 1907.

158. Constantine P. Curran to WMM: conversation. The sketches of Dowden, dated 17 Dec. 1907, are in the James A. Healy Collection at Colby College.

159. Lollie 21 Dec. 1907.

160. *Ibid.*

161. Oliver Elton 30 July 1921, Coll.: Leonard Elton; Oliver Elton, Preface, *JBYL*, pp. 8–9.

162. Lily to Lollie 28 Dec. 1907.

163. Reid, p. 56.

164. Lily to Lollie 28 Dec. 1907.

165. Denis Donoghue, "John Butler Yeats," in *Abroad in America*, p. 263, where the remark is attributed to a "Dublin wit."

Chapter Thirteen: 1908–1910

1. WBY wrote to Quinn of the oil: "My father always sees me through a mist of domestic emotion" (WBY to Q 7 Jan. 1908). The painting shows a handsome young man who looks not a day over thirty, though at the time WBY was forty-two. With it should be compared Augustus John's portrait done only a few months earlier, which shows a rugged, uneven Yeats, hardly a distant relative of JBY's figure. Mary Colum remarked on Yeats's appearance on the night of the *Playboy* debate: "He was then in his forties, but he looked under thirty" (*Life and the Dream* [Chester Springs, Pa.: Dufour, 1966], p. 121).
2. Lollie n.d. (early 1908), "We are here . . . "
3. Lily to Lollie 28 Jan. 1908.
4. Lily and Lollie 23 June 1908; Lollie [ca. 4 Feb. 1908], "I am a long time . . . "
5. Isaac 16 Jan.; Lollie 13, 20 and 22 Jan. 1908.
6. Lollie 13 Jan. 1908.
7. Q to Florence Farr 25 Jan. 1908, NYPL. I thank Josephine Johnson for calling this passage to my attention. All references herein to Quinn's letters to Florence Farr I owe to Dr. Johnson's kindness. "I did lots of sketches . . . on this friendly basis, which of course is a mistake," JBY told Lily (10 June 1909). "If I did not do it I should be miserable from having nothing to do."
8. WBY 9 June 1909.
9. Q to Florence Farr 5 June 1908, NYPL.
10. Lily to Lollie 25 Feb. 1908.
11. Q, typescript dated 21 Feb. 1908, Coll.: Foster-Murphy. At the top, in the handwriting of JRF, is written "By J.Q."
12. Lollie and Ruth Pollexfen 4 Jan. 1908; Lily to Lollie 28 Jan. 1908.
13. Reid, p. 57.
14. *Ibid.*
15. Lily to Lollie 28 Jan. 1908.
16. See Holloway, 6 and 10 Feb. 1908, pp. 100–102. Fay angered Boyle, with whom he stayed in Paris, by not letting Frohman see *The Eloquent Dempsey*, which was not made part of the bill in New York. He was the more incensed as Fay was cadging food and lodging from the Boyles. Fay neglected to tell Boyle about his agreement with Yeats, instead suggesting enmity toward the Abbey leaders.
17. Lily to Lollie 25 Feb. 1908; Lollie 24 Feb. 1908.
18. Lollie 24 Feb. 1908.
19. WBY to Q 18 March 1908, Coll.: Foster-Murphy. The letter was written from the Nassau Hotel, Dublin, and the date is added in pencil in an alien hand. There is an amusing postscript to the letter, apparently a reply to a question by Quinn, perhaps glancing at the dispute over *The Playboy*: "Yes, tolerably virtuous—this theatre keeps me in virtuous Ireland."
20. WBY 9 May 1908. Part of the letter, but not the passage quoted here, appears in *JBYL*, pp. 103–106.
21. Lollie 24 Feb. and 9 June 1908.
22. Lily and Lollie 19 July 1908. Lily, always loyal to her brother when outsiders attacked him, dismissed Fay with the words, "Wretched little man" (Lily to JBY 11 Oct. 1908), but JBY thought Fay should not have been "snuffed out" (Lily 23 Oct. 1908). To WBY he wrote (25 Oct. 1908): "I am very sorry indeed to hear of W. Fay's trouble. He

behaved very badly, but he is a man of genius, in his way as good as any of them, and morally not so bad as many of them, and therefore must be forgiven and helped."

23. JMS to Molly Allgood (?)25 April 1908 (*Letters to Molly*, p. 246); Holloway, 30 April 1908, pp. 110–111; Reid, p. 60.

24. Reid, p. 60; WBY 30 May 1908.

25. Lily to Q 14 Oct. 1918.

26. Isaac 2 July; Lily and Lollie 6 July; Lily, Lollie, and Ruth Pollexfen 13 July; WBY 9 May 1908 also in *JBYL*, p. 105. Miss Boughton photographed both JBY and Lily. I am indebted to Ira Glackens for calling my attention to her photographs and providing me with copies. See p. 329.

27. Clare Marsh 8 May 1908, TCD; WBY 9 May 1908 (quoted in *JBYL*, p. 104; the letter, abridged, is badly transcribed).

28. Lily 14 June 1915; Lily 24 April 1919. JBY never sent birthday cards to any of his children and detested Christmas cards, preferring letters (VWB 24 Dec. 1921). It is interesting to note, therefore, that, as his letter of 14 June 1915 to Lily shows, he came to confuse June 6, the date of her departure, with June 13, Willie's birthday, a day which he otherwise is not known to have celebrated.

29. Lily to JBY 30 Jan. and 3 Jan. 1917; Isaac 11 July 1912. See also Isaac 11 Dec. 1909: "Her letters are my solace and comfort. No one ever wrote better. They have all the graces of fine literary style and yet remain just letters. It is only a nice woman who can do that sort of miracle." He told Isaac also (18 May 1910) that his friends in New York thought her letters "as such" were "superior to Willie's." Later he added to Isaac (11 July 1912): "I could make money out of those she sends to me. They are all good literature and at the same time always letters, dashed off in a moment."

30. Lollie 9 June 1908.

31. See Lollie 25 July 1908, and Q to Lily 20 Dec. 1908. "What you say about the money is painfully interesting," Papa wrote Lollie; and Quinn chided Lily: "the mistake was made in the beginning of assuming an obligation, upon you and your sister's part of the work, which was unfair, as you shouldn't have assumed a debt contracted prior to your management." The syntax is Quinn's.

32. Lollie to Philip D. Sherman 1 July 1918, Brown.

33. Lily and Lollie 18 July 1908 and 24 July 1908, no. 1, "This is the day. . . . "

34. Q to Lily 20 Dec. 1908; Lily to JBY 9 Sept. 1908.

35. WBY 30 Aug. 1907: "Lily is put out if I am very late." *JBYL*, p. 101, reprints part of this letter, but not this passage.

36. WBY 30 May 1908.

37. About eighty percent of JBY's surviving letters were written from New York. Van Wyck Brooks, when asked how JBY could find the time to write so many, shrugged his shoulders and replied, "He had nothing else to do" (VWB to WMM: conversation).

38. John Sloan was surprised but impressed by JBY's enthusiasm for forecasting. "His interest in clairvoyance, palm reading and fortune telling is very great. When a man of his great intelligence takes stock in this sort of thing it rather makes me feel inclined to give it credence myself" (*Diary* 29 Nov. 1910, p. 481).

39. Lily and Lollie 23 June 1908.

40. WBY 9 May 1908 (also in *JBYL*, p. 105).

41. F. A. King [late 1908 or early 1909], "I hope you and Miss Holly . . . ", Yale.

42. Q to Florence Farr 25 Jan. 1908, NYPL; Q to Lily 20 Dec. 1908.

43. Lollie 20 and 22 Jan. 1908.

44. Lollie 20 Jan. 1908: "I have not written because I had no money to send." Clare Marsh 8 May: "Just now things are very bad. Suddenly all my clients have fallen off, one because her brother committed suicide, and others I suppose because they are off to the country fleeing from this New York summer." Similar complaints appear in Lily and

Lollie 23 June, Isaac 2 July, Lily 14 Aug., Lily 18 Sept., Lily 4 Nov., and Julia Ford 24 Dec. 1908.

45. Lily 12 June and 2 Dec. 1908.

46. WBY 9 May 1908 (also in *JBYL*, p. 105).

47. Reid, p. 58; Lily 23 June 1908.

48. Lollie 5 Sept. 1908.

49. Reid, p. 58.

50. Q to Florence Farr 5 June 1908, NYPL. The portrait is reproduced in black and white in Marc Pachter and Frances Wein, eds., *Abroad in America* (Reading, Mass.: Addison-Wesley, 1976), p. 263. It was given by Dr. Thomas F. Conroy, Quinn's nephew-in-law, to the National Portrait Gallery, Smithsonian Institution, Washington, D.C.

51. Lollie 14 Feb. 1921.

52. WBY 28 Sept. 1908 (also in *JBYL*, p. 113).

53. Lily and Lollie 19 July; Lily 21 July, 1 Aug. and 3 Aug. 1908.

54. Lily 14 Aug. 1908.

55. Q to Lily 20 Dec. 1908; Lollie 16 Sept. 1908.

56. Q to Lily 20 Dec. 1908.

57. Lily to Q 4 Jan. 1909, NYPL.

58. Lily 10 June 1908.

59. Lily and Lollie 12 June 1908.

60. Lollie., [ca. 4 Feb. 1908], "I am a long time . . . " The picture of Mrs. Ford one gets from JBY's letters adds some modifying lines to the incomplete sketch, suggesting a lapidary inscription, given by Francis Bangs in, "Julia Ellsworth Ford," *Yale University Library Gazette*, xxvi(1951), 153–192.

61. Lily 7 Dec. 1908.

62. Lily, Lollie, and Ruth Pollexfen 13 July 1908.

63. WBY 1 July 1908 (also in *JBYL*, p. 107). Gaynor, elected mayor of New York in 1909, is perhaps best remembered as the victim of an assassin on a ferry in New York harbor. An alert photographer snapped the staggering Gaynor as he clutched his abdomen and began sinking to the deck. The photograph has become a classic. Gaynor survived, dying a natural death in 1913.

64. Lily [ca. 12 June 1908], "You may measure . . . "

65. Lily and Lollie 19 July 1908.

66. Lily 12 Aug. 1908. He and King remained friends until JBY's death. King died in the same year as WBY. See the brief notice of him in the *New York Times*, 1 Nov. 1939.

67. Lollie 24 Feb. 1908.

68. Van Wyck Brooks, *Scenes and Portraits* (New York: E. P. Dutton, 1954), pp. 151, 169.

69. Lily 2 Dec. 1908.

70. Q 1 Nov. 1908, Coll.: Foster-Murphy (*Abroad in America*, p. 267).

71. Lollie 18 Nov. 1908. JBY refused to argue with Quinn about Miss Duncan's beauty or her talent except to say that her "naked arms" were "lovely," and that he found her a bewitching and captivating woman of quick wit. One day he told her he had seen her fellow dancer Genée perform. "Ah! my enemy!" she said. "Then," said JBY, lifting his glass, "I will drink to her downfall."

"No!" she said, "Don't wish the downfall of any lady. They tumble down so easily of themselves" (Q 9 Nov. 1908, Coll.: Foster-Murphy).

72. John Butler Yeats, "Outdoors in New York," *Harper's Weekly*, 19 Nov. 1912.

73. Lollie 9 June, Isaac 2 July, Lily and Lollie 24 July, Lollie 25 July, Lily 28 July 1908.

74. WBY 9 May (also in *JBYL*, p. 104), 1 July (also in JBYL P. 108), and 11 Aug. 1908. In Lily 30 Oct. 1908 he put the matter in another way: "If Willie would only pitch

his constraining theories to the devil and write *to really amuse himself*—that is, according to inspiration. . . . I am always saying what no one will listen to—that art should touch at one and the same moment *at all points*, the conscience, the sympathies, the desires, and also no doubt the intellect."

75. E.g., WBY to JBY 30 Oct. 1908.

76. WBY 11 Aug. 1908.

77. WBY 25 Oct. 1908; WBY to JBY 30 Oct. 1908, postscript 4 Nov.

78. WBY 11 Nov. 1908 (also in *JBYL*, p. 115). The two stories bore the titles "The Ghost Wife" and "Elizabeth in Heaven."

79. Lollie 24 Nov. 1908. He added: "It is the fixed idea of Willie and Lady Gregory that Willie is the artist of the family and that I am to do the critical part. The imagination is for him—the humbler part of mere prose is for me—or rather that I should accept the inevitable and show myself what I really am, a nice, amiable, garrulous old gentleman abounding with shrewd insight into character and life and possessing a clear and prepossessing method of speech."

80. Lily 23 Oct. 1908.

81. Lily to JBY 9 Sept. 1908.

82. AE to Q 1 Oct. 1908 (Alan Denson, *Letters from AE* [London: Abelard Schuman, 1961], p. 65).

83. Lily and Lollie 12 July 1908. Perhaps this gossip is what Synge had in mind when he wrote, "What a bit of news about Old Yeats!" (JMS to Molly Allgood 25 Oct. 1908; *Letters to Molly*, p. 295).

84. WBY 28 Sept. 1908 (also in *JBYL*, p. 112); Q 9 Nov. 1908, Coll: Foster-Murphy.

85. Van Wyck Brooks, *Scenes and Portraits*, pp. 172–173.

86. Isaac 29 July 1921.

87. Lily 19 Feb. 1909. May Morris would fall in love with Quinn the following year. His ardor cooled quickly, though hers didn't. Reid (pp. 80–81) observes that Quinn did not "come out" of his affair with May "well." She nursed his rejection for years and wrote plaintive appeals which he didn't heed.

88. Lily to JBY 28 March and 8 April 1909 (typed copies), Coll.: Foster-Murphy.

89. WBY to LAG [29 Sept. 1910] (Wade, *Letters*, p. 553); Lily to JBY 28 March 1909; Holloway, 24 and 26 March 1909, p. 125. Willie tried to get permission from the Synges to have a death mask made, but they declined, saying they already had photographs, "never thinking at all of the people outside the family" (Lily to JBY 28 March).

90. WBY to JBY 30 Oct. 1908.

91. Lily to JBY 28 March 1909 (typed copy), Coll.: Foster-Murphy.

92. New York *Evening Sun*, 2 April 1909. The portions reprinted here are taken from Thomas Curtin's typescript copy, with handwritten corrections by JBY, of JBY's original draft. The article includes an interesting description of Synge: "He was a man of singularly fine appearance. Ever since I knew him there was some physical delicacy which surprised you in a man so handsome and so well built and so capable of great fatigue. I shall never forget the beauty of his hazel eyes nor the frankness of his steady gaze and its entire friendliness. Of all men he was the easiest to live with or to talk to. Most times he was listening, but when he talked in his hasty and rapid utterance everyone listened and gave way."

93. Lily 2 April 1909. Two weeks later, reflecting on another such tragedy, he wrote her: "[Michael] Davitt died just as a great educational controversy was beginning. Since he died it seems to have dropped. No doubt the Priests found in his death the work of a good God bent on keeping them in power" (Lily 15 April 1909).

94. Lily 2 April 1909.

95. WBY to Q [Oct.] 1908 (Wade, *Letters*, p. 512).

96. *Sinn Fein*, 8 May 1909.

97. Lily to JBY 17 May 1909.
98. Lollie 26 June 1909; WBY 21 May 1909.
99. Lily 10 June 1909.
100. WBY 21 May 1909.
101. WBY 14 April 1909, no. 1, "I send you . . ."; it appears in *JBYL* (pp. 118–120) as the second letter of that date.
102. Lily 25 Aug., 10 Sept., and 26 Jan. 1909.
103. Reid, p. 74. Lily 8 Feb. 1921 verifies that Miss Coates's account of her relationship with Willie was the cause of Quinn's anger.
104. Ezra Pound to WMM: conversation, Venice, 15 June 1966.
105. Q 15 July 1909, NYPL. Nothing in Miss Coates's known history contradicts the conclusion drawn from the fragmentary evidence. She was a cold and ruthless person who collected celebrities much as Mrs. Ford did, but in a far from innocent way. Once latched on to Quinn she proved difficult to shake off. He ultimately paid her a vast annual tribute disguised as "interest" on "investments" he had made for her, and it is a matter of public record that he left her $40,000 in his will. Not satisfied with the bequest, Miss Coates threatened to have herself legally declared Quinn's widow by virtue of an alleged but never documented marriage between 1901 and 1906. She eventually dropped the suit. See Reid, pp. 640–645.
 When Quinn years later tried to shake her in favor of Jeanne Robert Foster she refused to stay away, and Quinn had to resort to ruses and dodges to avoid her. During the same period Mrs. Foster was asked by another victim, a middle-aged married man with children, also a member of the literary set in New York, to stand between him and a scheming woman who was trying to blackmail him because he had committed an "indiscretion" with her. To Mrs. Foster's surprise the schemer proved to be Dorothy Coates. In later years, according to Mrs. Foster, Miss Coates moved to Mayfair in London, where she occupied a most expensive apartment. She supplemented her income from Quinn's legacy by what she earned as an amorous consultant, her clients including one highly-placed member of the royal family (JRF to WMM: conversation). Despite the somewhat sensational character of the revelations, Mrs. Foster, though hardly an unbiased observer of Miss Coates, was a reliable narrator of events. Nothing said here about Miss Coates is inconsistent with the comments about her by JBY.
106. Reid, p. 75.
107. Ruth Pollexfen to JBY 28 Sept. 1909.
108. Lily 22 Oct. 1909.
109. Lily 27 Jan. 1909.
110. Q 18 Jan. 1909, NYPL.
111. Jack 23 Nov. 1909.
112. Lily 5 June 1909.
113. WBY 26 Sept. 1913, no. 1, "I don't know how . . ." See also WBY 7 Jan. 1909.
114. Lily and Lollie 13 April 1921. The remarks were made after JBY had lived in New York more than thirteen years but represent a distillation of the observations he had made from the beginning.
115. ED to JT 17 Feb. 1909, TCD (also in Dowden, *Letters*, p. 360).
116. Lily 22 Oct. 1909, no. 1, "That news of . . . "
117. Oliver Elton 11 April 1911, Coll.: Leonard Elton; WBY 10 Dec. [1910], "I do think . . . "
118. WBY 11 Jan. 1910.
119. Isaac 21 Sept. 1918; John Quinn, "John Butler Yeats" (unpublished typescript, 1922), p. 20.
120. Frank Yeats 23 Dec. 1920, Coll.: Harry Yeats; Lollie 6 Feb. 1909.
121. Lollie 6 Feb. 1909.

122. Lily 9 Feb. 1909.

123. Lily 6 Nov. 1909.

124. John B[utler] Yeats, "The Difference between Us: An Irish Spot-Light on Some English and American Contrasts," *Harper's Weekly*, 11 Dec. 1909, pp. 24–25. It is interesting to note that JBY's good fee from the Plainfield talk came about because Van Wyck Brooks had arranged it. When he was on his own he did poorly. Mrs. Thomas W. Lamont, wife of a millionaire, asked him to give a lecture before a class that was studying Yeats's poetry. He agreed and asked for a fee of twenty-five dollars. Mrs. Lamont objected, saying he would be given instead a free dinner and overnight lodging. "All right, pay me what you like—15 dollars for instance," he replied (Lollie 9 March 1909). He gave the talk, but it is not known whether he received the fifteen dollars.

125. Isaac 1 July 1909.

126. Years after the event JBY learned that when Isadora Duncan stayed in a house in Rye adjacent to the Fords' with a crowd of pupils, everyone wrongly believed Mrs. Ford was donating the quarters; Miss Duncan left because the rent was too high (Lily 17 Sept. 1921).

127. Ruth Hart 26 Aug. 1909, Coll.: RHJ; Lollie 17 July 1921; Lily 7 Oct. 1914. The eviction so rankled JBY that he repeated its details in two later letters to Lily (23 Feb. 1916 and 22 Oct. 1919).

128. Lily 23 Feb. 1916; VWB 2 Sept. 1909.

129. He wrote Van Wyck Brooks that he would be "turned out" on 15 Sept. (VWB 2 Sept. 1909) but later told Lily he had been reprieved "till about Oct. 9th" (Lily 10 Sept. 1909). That letter is the last from West Forty-fourth Street; the first from 317 West Twenty-ninth Street is Lollie 18 Oct. 1909.

130. Lollie 18 Oct. 1909.

131. Ruth Hart 26 Aug. 1909, Coll.: RHJ

132. Ruth Hart 3 July 1912, Coll.: RHJ (also in *JBYL*, p. 142); Lily 4 July 1918, 21 Oct. 1920, 6 Aug. 1920, 25 Jan. 1918, and Lily (?), fragment, 13 March 1921 (Hone assigns this letter to Lily; the original lacks a salutation). A portion appears in *JBYL*, pp. 274–275, but not what is given here.

133. During all the years JBY lived at Petitpas, Quinn limited his appearances there to picking up the old man to take him out to dinner, to talk with the Breton sisters about him, or to visit him when he was ill, and he was annoyed when people identified him as one of the "regulars" there. He told WBY emphatically (4 April 1922), "The fact is I never had a meal there in my life."

134. JRF to WMM: conversation.

135. Van Wyck Brooks, "At Petitpas: J. B. Yeats," in his *John Sloan* (New York: E. P. Dutton, 1955), pp. 107–108.

136. Mem. III.

137. See Ira Glackens, *William Glackens and the Ashcan Group* (New York: Grosset and Dunlap, 1957).

138. Sloan, *Diary* 22 July 1909, p. 324.

139. Lily 30 July 1909.

140. Sloan, *Diary* 19 Dec. 1909, p. 361.

141. Van Wyck Brooks, *John Sloan*, pp. 35–36.

142. Sloan, *Diary* 4 Oct. 1909, pp. 338–339; Helen Farr Sloan, Introduction, *ibid.*, p. xix.

143. Lily 22 Oct. 1909, no. 1, "The news of . . ."; no. 2, "I got a letter . . ."; Jack and Cottie 23 Nov. 1909.

144. Lily 8 Dec. 1909.

145. Lily 15 Dec. 1909.

146. Another friend of Brooks's introduced to JBY was Maunsell Crosby of Rhinebeck, a dedicated birdwatcher and friend of Franklin D. Roosevelt. JBY sketched Crosby and his young wife and spent some days with them in Rhinebeck. Crosby produced *The Birds of Dutchess County*, a new edition of which is being prepared by Davis Finch, to whom I am indebted for information about Crosby's ornithological interests and achievements. In later years JBY saw much of Mrs. Crosby in New York, but the commissions he hoped for never materialized. I thank Mrs. Helen Crosby Glendening for recollections of her parents.

147. Van Wyck Brooks, *Days of the Phoenix* (New York: Dutton, 1957), pp. 100–101.

148. Sloan, *Diary* 6 May 1910, p. 418.

149. WBY 22 Oct. 1909.

150. Ruth Hart 26 Aug. 1909, Coll.: RHJ.

151. Lily to JBY 2 Nov. 1909.

152. Lily 29 Jan. 1909.

153. Lily to JBY 8 April 1909 (typed copy, Coll.: Foster-Murphy) and 26 May 1909. Ruth Pollexfen, on her way to Frankfurt, stopped by to see the Chestertons and reported that Gilbert was "enormous, hardly able to move about," though "very amusing."

154. Lily to JBY 2 Dec. 1909. Unfortunately the letter exists only as a fragment, ending with the words, "He [John Dowden] said he has all of Willy's books and——."

155. Lollie 17 July 1909.

156. WBY 5 March 1909.

157. Reid, pp. 78, 86; Q to Florence Farr 2 Nov. 1910, NYPL.

158. Sloan, *Diary* 5 Nov. 1910, p. 473; Isaac 25 Aug. 1910.

159. Conrad Aiken, who was present when the remark was made, recounted the story to WMM, and commented on JBY's retort, "He meant it too!"

160. Van Wyck Brooks, "A Reviewer's Notebook," *Freeman*, 1 March 1922, pp. 598–599.

161. Lily 13 June 1911 and 16 March 1911, no. 2 "Your letter just arrived . . ." Bell's father hadn't sold a picture in years, JBY told her, though his work, quite conventional, hung regularly in the Royal Academy. His mother wrote successful books on art.

162. WBY 8 Dec. 1917. Other accounts of Seeger are in Lily 6 Oct. 1915 and WBY 12 July 1917.

163. Details of the association of JBY and Aiken come from Conrad Aiken in conversation with WMM. I thank Joseph Killorin for having been instrumental in arranging the meeting.

164. JBY was opposed to war in general but never codified his beliefs. When World War I broke out in 1914 his neutrality gave way quickly to a pro-British position. See Chapter Fifteen, pp. 423–424.

165. The disguise was not a deep one. JBY appears as "old man Butler, the portrait painter." In the story (in *Bring, Bring, and Other Stories* [New York: Boni and Liveright, 1925], pp. 158–170), some of the events described here are recounted. Conrad Aiken to WMM 8 Aug. 1970: "Cooke is a combo of myself and Walter Cooke, classmate at Harvard, researcher on altar painting in Spain; Flodden is Sneddon; Bullington is Brooks; but I never knew who C. Dagget was—maybe you're right!" In the story Celia Dagget was a miniature painter; I had asked whether Eulabee Dix might be the real-life counterpart. The term "the leat great Yeat" is from Aiken to WMM 18 March 1971 and elsewhere.

166. John Hall Wheelock to WMM: conversation.

167. Sloan, *Diary* 21 Sept. 1910, p. 458.

168. Lollie 9 July 1910.

169. Sloan, *Diary* 16 April 1910, p. 410; see also 8 Jan., p. 373; 10 Feb., pp. 385–386;

21 March, p. 402. A JBY sketch of Dolly appears on p. 430 and one of Sloan on p. 416. Sloan's painting is reproduced in color as the frontispiece; see entries for 25 May, p. 246, and 1 June, p. 249.

170. *Ibid.*, 15 Aug. 1910, p. 449. See also Brooks, *Scenes and Portraits*, p. 189

171. "John Sloan's Exhibition," *Seven Arts*, June 1917, pp. 257–259. The original hangs in the Corcoran Gallery in Washington, D.C. It has been reproduced often. See, e.g., *JBYL*, facing p. 39; Sloan, *Diary*, p. 449; *John Sloan, 1871–1951* (Washington: National Gallery of Art, 1971), p. 115; and *Abroad in America*, p. 264. The first and third of these misidentify Eulabee Dix as Ann Squire, who had not at the time appeared on the scene at Petitpas. I take the identifications from Van Wyck Brooks, who marked them in pencil for me on a reproduction that appeared in a newspaper. The third fails to mention either Celestine Petitpas or Mrs. Johnston (whose name is misspelled in the fourth). Miss Eulabee Dix married Alfred Le Roy Becker later in the year in Buffalo, and JBY attended the wedding in one of his few forays outside New York. He was annoyed at the prices people paid her. Quinn gave her five hundred dollars for a miniature of Mary Anderson, yet Miss Dix had commissioned JBY to do a sketch of herself and paid him only five dollars for it. He was always uneasy in her presence, even though he liked her and she liked him. "I once told her I would not envy the man that she married, for she would be sure to devour him. She has a clinging way like ivy which we know always kills the tree to which it attaches itself" (Lily 23 Dec. 1910).

172. Lily 23 May 1910.

173. Sloan, *Diary* 31 Dec. 1910, p. 490.

174. Brooks, *John Sloan*, p. 100 n.

175. Sloan, *Diary* 5 April 1910, p. 407; 13 March 1910, p. 397.

176. WBY 7 April 1910 (also in *JBYL*, pp. 128–129) and 8 April 1910. Later in the year it hung again in another exhibition of the "Independents"; see WBY 29 Nov. 1910 (also in *JBYL*, p. 130). Sloan's *Diary* for 1910 beginning 2 Jan. and continuing through 15 May (pp. 371–422) gives a full account of his work with the spring exhibition, in which all of "the Eight" did not participate.

177. Sloan, *Diary* 13 June 1910, p. 433. Quinn bought only etchings; the sale of the painting never materialized.

178. Pyle, p. 84.

179. Sloan, *Diary* 26 May 1910, p. 426; 28 July, p. 444. The hearing grew worse; in 1913, Sloan wrote of it to Quinn. Reid (p. 140) reproduces a page of Sloan's letter to Q 20 April 1913 showing WBY in thick glasses and JBY with large hearing tubes protruding from his ears.

180. Sloan, *Diary* 6 Oct. 1910, p. 463; 13 Oct., p. 464.

181. Lily 6 and 23 Nov. 1910.

182. Sloan, *Diary* 11 Oct. 1910, p. 464.

183. Brooks, *Scenes and Portraits*, p. 187.

184. Sloan, a fervid pacifist during World War I, wanted America to have nothing to do with it; Kent supported the Prussians over the English. After Sloan "saw what happened under Mussolini, Hitler, and Stalin," he realized "that the desire for power over other people is a far more terrible evil" than greed (*Diary* 1 Feb. 1910, p. 382 n.). Kent became an admirer of Stalin and was honored for his views by the Soviet government. He was "deeply outraged" at America's involvement in Southeast Asia but was silent when Russian troops invaded Hungary and, later, Czechoslovakia. Clearly, not all the socialists of the 1910's marched to the same drummer.

185. Lily 25 June 1910. "You must not give way to that comfortable vulgarity, *class* feeling. It was the enemy *from which all the Pollexfens suffered in Sligo. . . . Be a good American* and have nothing to do with class." See Chapter Four, pp. 93–94. Some years later, returning to the subject, he called class feeling "a curse, a sort of imprisonment

corrupting the people who benefit by it, and enraging and brutalising the others" (Isaac 3 April 1916).

186. WBY to LAG [10 Dec. 1909] (Wade, *Letters*, p. 543). Pound had first written to WBY from Venice the year before (Oliver Edwards, "Annals of W. B. Yeats," unpublished).

187. Q [ca. 10 Aug. 1910], "Tomorrow (Thursday) would be . . . "; NYPL.

188. Oliver Elton 11 Aug. 1910, Coll.: Leonard Elton; WBY 11 Feb. 1911 (also in *JBYL*, p. 133).

189. The account of the evening is based on the following sources: Sloan, *Diary* 13 Aug. 1910, p. 448; Lily 13 Aug. 1910; Ezra Pound to Q 26 Feb. 1916 (Reid, p. 242); and Ezra Pound to WMM: conversation, 15 June 1966, Venice. Pound remembered JBY's lilting Irish accent, "not that of the stage Irishman, if that's what you think I mean." He refers to the elephant ride at Coney Island in Canto LXXX.

190. ED 4 Feb; Lily 26 Jan. 1910.

191. ED 24 Feb; ED to JBY 26 April; ED 19 May 1910.

192. Lily to JBY 18 Jan.; Lily 26 Jan. 1910.

193. Lily to Louis Purser 22 March 1910. The original of this letter was owned by the late Miss Olive Purser, who generously provided me with a copy of it in her own handwriting, from which the text here is reproduced.

194. Lily to JBY 18 Jan. 1910.

195. Flannery, p. 28.

196. WBY [spring, 1910], "This young Blake . . . "

197. Robinson, p. 86.

198. Flannery, p. 29.

199. *Ibid.*, p. 32. Miss Horniman, whose interest in the theatre was genuine, continued her work with the Manchester Repertory Theatre for many years.

200. Hone, *WBY*, p. 249.

201. Lily to JBY 22 Aug; Lollie 30 Sept; WBY to Lily 1 Sept. 1910.

202. Lily to JBY 20 Sept. 1910.

203. Lily to JBY 26 Sept.; WBY to Lily 26 Sept. 1910.

204. See my *The Yeats Family and the Pollexfens of Sligo* (Dublin: Dolmen, 1971) for a fuller discussion of George Pollexfen.

205. Lily to JBY 29 Sept. 1910.

206. WBY to LAG 29 Sept. 1910 (Wade, *Letters*, p. 553); Lily 1 Feb. 1922. Speaking of the success of the Pollexfen company, JBY gave Arthur Jackson the credit for it because of "his energy and enterprise." Of George he wrote that he was "rather a *saver* of money than a maker of it" (Lollie 30 Sept. 1910).

207. Sloan, *Diary* 9, 13, and 15 Oct. 1910, pp. 463–464.

208. WBY 20 Sept. 1912. *JBYL* reprints part of the letter (pp. 145–146) but not what is given here.

209. Fredrick was to receive only the income from his half-share. The other half-share was to be managed by a trustee for the education of Fredrick's children but was to benefit the sons only if the trustees approved. On the sons' reaching twenty-one, their portion of the trust was to be divided among the three daughters, Ruth, Hilda, and Stella; and on their father's death they were to divide his portion also. The terms of the will are set forth in LYS and in letters of the period, particulary Lily to JBY 26 Oct. 1910.

210. WBY 6 Sept. 1916; Lily 20 Oct. 1910; Mem. I.

211. WBY to Lily [ca. Oct. 1910], "I think George . . . "

212. WBY to JBY 24 Nov. 1910 (Wade, *Letters*, p. 555).

213. Lily to JBY 9 Oct. 1910.

214. WBY to J. P. Mahaffy, n.d., 1910. I thank Dr. John Kelly for calling this amusing letter with its interesting misspelling to my attention.

215. Lily 20 Oct. 1910.

216. WBY 29 Nov. 1910. *JBYL* (p. 130) contains part of the letter but not what is quoted here.

217. ED to Prof. Rudmose-Brown 2 Jan. [1911], TCD (Dowden MSS 1173ᵃ).

218. Isaac 1 Dec. 1910.

219. Lily to JBY 5 Dec. 1910.

220. Oliver Elton to JBY 26 Dec. 1910.

221. WBY to JBY 24 Nov. 1910 (Wade, *Letters*, pp. 554–555).

222. WBY to JBY 23 Feb. 1910 (*ibid.*, pp. 548–549, where "Life" is not capitalized). For a discussion of the change in the relationship between JBY and WBY around this time see Richard Ellmann, *Yeats: The Man and the Masks* (London: Faber and Faber, 1961), pp. 210–211.

223. WBY 26 June 1910.

224. WBY 21 Sept. 1910.

225. SM 19 June 1920, and elsewhere.

226. Q 7 Aug. 1910, Coll.: Foster-Murphy.

227. Lollie 3 Dec. 1910.

Chapter Fourteen: *1911–1913*

1. Lily to JBY 30 Aug. 1910.

2. WBY 15 Dec. 1910, no. 1, "You must think . . ." He issued a warning: "Don't tell Lady Gregory. Her Spartan methods would not at all suit this case."

3. WBY 13 Dec. 1910. The letter is marked, in JBY's hand, "Private."

4. Lily to JBY 22 Jan. 1911. "She lets outside things possess her, the stones on her path, always either too hot or too cold, people irritate her, she flies at them and then feels so much better, but they don't" (Lily to JBY 3 Jan. 1911).

5. WBY 13 and 14 Dec. 1910.

6. Isaac 28 April 1911.

7. It is clear that what Lollie suffered was never more than what is popularly called a "nervous breakdown," though a severe one: she never showed signs of losing contact with her environment.

8. Lily to JBY 14 Nov. 1910.

9. Lily 6 July 1911.

10. Isaac 5 Aug. 1911. JBY took his description from Lily's long letter of 23 July 1911.

11. Ruth Pollexfen to JBY 20 July 1911.

12. Isaac 5 Aug. 1911.

13. Lily to JBY 21 Aug. 1911.

14. Lily 12 Sept. 1911.

15. Lily to JBY 29 Aug. 1911.

16. Q to Lily 5 Feb. 1911.

17. WBY to JBY 17 July 1911 (also in Wade, *Letters*, p. 559).

18. Lily to JBY 29 Aug. 1911.

19. ED 29 Sept. 1911.

20. ED to JBY 2 Oct. 1911.

21. WBY to LAG 28 Oct. 1911 (from Wade, *Letters*, p. 564).

22. Lily to JBY 12 Nov. 1911: "[Willie] says a much more amusing book could be written on Moore, who is much funnier to look at than to look out of."

23. WBY to Lily 15 Sept. 1910.

24. Lily to JBY 3 Jan. 1911.

25. Oliver Elton 9 April 1911, Coll.: Leonard Elton. Part of this letter appears in *JBYL*, p. 136, but not what is given here.

26. SM to JBY 25 Jan. 1911; Lily 31 March and 29 Sept. 1911.

27. Q to Lily 11 March 1911.

28. Q to Lily 19 March 1911. See also Lily to Q 6 March 1911, NYPL.

29. Q to Lily 5 Feb. 1911, NYPL.

30. WBY 4 Feb. 1911 (*JBYL*, p. 132). I have not seen the original of this letter.

31. Reid, p. 94.

32. Sloan, *Diary* 22 Feb; 3, 4, and 9 March; 13, 22, and 25 April; 4, 5, 6, 9, 27, 28, and 31 May; pp. 511, 513–514, 526, 529–530, 532–534, 536, 539–540.

33. Q to Lily 5 Feb. 1911.

34. Bill Collector 7 Nov. 1911.

35. Lily 26 Jan. and 16 March 1911.

36. In early April he lectured in Philadelphia "to an immense crowd of grim-faced men and women," all Presbyterians, and attacked the Protestant notion of "getting on" while saying "a lot in praise of the Catholic religion." See Oliver Elton 9 April 1911, Coll.: Leonard Elton (a portion of which appears in *JBYL*, p. 136).

37. All four appeared in *Harper's Weekly*, LV: "Brutus' Wife," 14 Jan., pp. 14–15; "Back to the Home," 29 April, pp. 12–13; "Synge and the Irish," 25 Nov., p. 17; "The Modern Woman," 16 Dec., pp. 24–25.

38. Lily 18 April and 16 Dec. 1911; EDB 16 Dec. 1911. In Buffalo he viewed the exhibition of French art at the Buffalo Art Gallery and signed his name in the guest book on 12 Dec., under that of Lady Gregory, who had attended a week earlier. The book is now in the Albright-Knox Gallery, Buffalo. I thank Annette Masling for unearthing it for me.

39. Isaac 5 Aug. 1911. Jameson was in America to put pressure on the government to reduce the tax on Irish whisky. "I hope he does not succeed," Lily remarked saucily. "He can't want more money, and the world certainly wants less whisky" (Lily to JBY 16 May 1911).

40. JRF to WMM: conversation; VWB 3 Sept. and 5 April 1911.

41. Lily 3 March 1911; WBY 4 Feb. 1911 (also in *JBYL*, p. 133).

42. Lily 16 March 1911, no. 2, "Your letter. . . ."

43. VWB 14 June 1911.

44. Lily 26 Jan. 1911. He mentions Sloan's unpleasantness at Petitpas, and his undesirability as a patron there, on two other occasions during the year. One night he got into "a fierce argument" with two men, "veritable dogfights," and JBY was afraid the Breton sisters would find ways of offending him so that he wouldn't return (Lily 16 March 1911). In April he called Sloan's behavior "unbearable" (Lollie 20 April 1911); and later he wrote Lily that "Sloan had become impossible on the subject of the well-to-do," and that "I had to *discourage* his dining here. He made himself disliked" (Lily 21 Dec. 1911).

45. Oliver Elton 7 Sept. 1911; Coll.: Leonard Elton (also in *JBYL*, p. 139).

46. Q 14 March 1911, Coll.: Foster-Murphy.

47. Lily 21 Dec. 1911.

48. Sloan, *Diary* 8 Jan. 1911, p. 495.

49. Clare Marsh 24 Aug. 1911, TCD.

50. Robinson, p. 95.

51. Lily 15 Sept. 1911.

52. WBY to JBY 24 Sept. 1911.

53. Robinson, p. 96.

54. WBY to JBY 4 Oct. 1911.
55. Lollie 10 Oct. 1911; EDB 16 Dec. 1916.
56. JBY to the editor of the New York *Evening Sun* 5 Oct. 1911; published 9 Oct.
57. LAG 27 Nov. 1911, NYPL.
58. Lily 27 Nov. 1911. See also Q 9 Feb. 1912.
59. Reid, p. 116.
60. LAG 28 Nov. 1911, no. 1, "Though the least. . . ."; NYPL.
61. Lollie 30 Nov. 1911; Reid, p. 117.
62. Isaac 19 Dec.; Lily 16 Dec. 1911.
63. Reid, p. 118.
64. Robinson, p. 97.
65. Chapman was a picture dealer. JBY described him as having "the manner and ways of the Englishman of the type Tristie Ellis, only without the intellect." Supercilious and quick to imagine injury, he was not one of the more popular diners at West Twenty-ninth Street. "The Petitpas hate him," Papa told Lollie, "and are scarcely civil to him, and I think the explanation is that he addresses them by their Christian names without the 'Mademoiselle'" (Lollie 24 April 1911).
66. Sloan, *Diary* 11 Oct. 1911, p. 569.
67. Lily 12 Oct. 1911; Oliver Elton 16 July 1917, Coll.: Leonard Elton (also in *JBYL*, pp. 240–241). Mrs. Beattie charged nothing for the visit.
68. *Outlook*, 16 Dec. 1911, p. 915. See also EDB 27 Dec. 1911.
69. EDB 20 Dec. 1911, Princeton. The eight were Eithne Magee, Sara Allgood, J. M. Kerrigan, Sydney J. Morgan, Arthur Sinclair, Fred O'Donovan, J. A. O'Rourke, and Udolphus Wright.
70. Lily 26 Jan. 1911: Q 15 Feb. 1912.
71. Q to JBY 16 Feb. 1912.
72. LAG 17 Feb. 1912, NYPL.
73. Clare Marsh 8 March 1912, TCD.
74. Sloan, *Diary* 19 April 1912, p. 618. See Chapter Thirteen, n. 179; Reid, p. 140.
75. Lollie 9 July 1912.
76. Sloan, *Diary* 11 March 1912, p. 609.
77. WBY 20 July; Jack 30 April; Q 9 Feb. 1912, Coll.: Foster-Murphy.
78. He published about a dozen articles in America through 1912, and (not counting letters to editors and some selections from his first Cuala book of letters) less than half a dozen thereafter. He lectured a few times, at the Cosmopolitan Club, at the Pen and Brush, and at a home in Englewood, New Jersey.
79. JS 11 Jan. 1912.
80. Lily 26 Jan. 1912.
81. Clare Marsh 15 Oct. and 18 Dec. 1913, TCD. The room remained vacant, he told her, "for more than a week after you left." "Of course respectability is your uncle's religion," he added later (9 March 1914). JBY's letters to Clare Marsh in the Library of Trinity College, Dublin, give a complete account of her stay in New York and the aftermath.
82. Eric Bell to JBY 13 April and 9 Sept. 1912.
83. Isaac 2 Dec. 1912.
84. In the surviving letters of JBY during 1912 and of those of his children there is no mention of the coming Armory Show.
85. EDB 17 May 1912, Princeton.
86. Lollie 24 Sept. 1912.
87. Lollie 16 April 1912.
88. Q 15 Feb. 1912, NYPL.
89. Lily 11 May 1912.

90. In 1900, Mrs. Foster was in New York acting and modeling. She was featured, under the name "Jean Elspeth," in an issue of *Vanity Fair* in 1900, where in a two-page spread of photographs she was described as "unquestionably the loveliest woman ever." She was also a woman of high intelligence and unusual literary perception. She was interested in the occult and long before she met John Butler Yeats had become a member of the Theosophical Society. With the agreement of her husband she moved to Boston, where she took courses in the Extension Division of cooperating colleges in the area, including Harvard. She associated with bright young graduate students and instructors, like John Weare and Frank Wilson Cheney Hersey, and the first of these advised her to visit John Butler Yeats when she got to New York. By the time she settled in New York her husband, in his sixties, was an invalid depending on her for support.

91. Lily 24 Sept. 1912.

92. Lily 26 Jan. 1912.

93. Q 5 Oct. 1912, NYPL.

94. Q 28 May 1912, Coll.: Foster-Murphy. To Dowden JBY wrote that Quinn was the archetypal American. "To understand him is to understand America." He implied that the kind of power and energy Quinn showed in America might have been put to good use by Irishmen in Ireland. See ED 27 Sept. 1912.

95. Reid, p. 135.

96. *Ibid.*, p. 138.

97. WBY 8 June 1912.

98. Van Wyck Brooks, in *Freeman*, 1 March 1922.

99. WBY to JBY 21 Nov. 1912 (also in Wade, *Letters*, pp. 571–572).

100. Julia Ford 23 Dec. 1912, Coll.: James A. Healy.

101. Lollie 16 April 1912. Whether the canvas on which he was working in 1912 was the same as that on the easel at Sloan's Twenty-third Street studio is not easy to determine. He told Jack he had been at the portrait for months. "I worked at it a long time last year at Sloan's. Not only was the light bad, but there was Sloan adversely criticizing every detail, though with the best intentions. . . . Since that I have done two other portraits, and the last of these stands before me, and it is good. Of course these two I have done in my room, where there is not much light, and where the looking-glass is not in a good place" (Jack 30 April 1912). Less than two months later (6 June) he wrote to Lily: "I have just finished for Quinn a portrait of myself." Yet in mid-August he was telling Lollie that the self-portrait would be "more than a portrait"; it would be "a work of art, as every portrait ought to be" (19 Aug.). As the self-portrait remained unfinished at his death in 1922 and as no intermediate canvases are known, it seems likely that either the two other portraits mentioned in the letter to Jack were discarded or the canvases were scraped off so that the artist could begin afresh. The portrait "finished for Quinn" in June could refer to a small oil or to a pencil sketch somewhat more elaborate than a simple study.

102. LAG 14 Oct. 1914, NYPL.

103. Lily 11 May 1912.

104. Lollie 16 April 1912.

105. EDB 28 March 1912, Princeton.

106. SM 10 May 1912.

107. WBY to JBY 5 March 1912 (Wade, *Letters*, p. 568).

108. Holloway, 2 Jan. 1912, p. 151; 29 March 1912, p. 152.

109. WBY 20 Dec. 1912.

110. LAG 11 Oct. 1912, NYPL.

111. MFB 1 April 1912, Princeton.

112. WBY to JBY 5 March 1912 (also in Wade, *Letters*, p. 567).

113. Lily 11 Dec. 1912.
114. William Butler Yeats, *Synge and the Ireland of His Time, with a note concerning a walk through Connemara with him by Jack Butler Yeats* (Churchtown: Cuala, 1911); EDB 23 Sept. 1912.
115. Lollie to JBY 5 Oct. 1912.
116. Mary Colum, *Life and the Dream* (Chester Springs, Pa.: Dufour, 1966), p. 161.
117. EDB 6 Jan. 1913, Princeton.
118. Lily 27 Oct. 1912. See also Lollie 3 Dec. 1910.
119. Q to F. H. O'Donnell 23 Feb. 1912 (Reid, p. 120). See on the same page Q to AE 15 May 1912.
120. Reid, p. 120.
121. *Ibid.*, pp. 123, 212, 233.
122. WBY 20 Dec. 1912.
123. ED 13 Nov. 1912.
124. Q to Lily 8 Feb. 1913.
125. WBY 25 Feb. 1913 (also in *JBYL*, pp. 155–156).
126. The original catalogue (*New York, 1913, International Exhibition of Modern Art, Association of American Painters and Sculptors, Inc., February Seventeenth to March Fifteenth*) lists 1041 items, numbers 1–1040, plus 919a, a Bellows. There was also a supplement numbering 1047–1112. The fiftieth-anniversary catalogue, *1913 Armory Show, 50th Anniversary Exhibition* (New York and Utica: Henry Street Settlement and Munson-Williams-Proctor Institute, 1963), declares (p. 182) that the original catalogue numbered 1046 works, but the Foster-Murphy copy of the 1913 catalogue, which I have used as a reference here, ends with 1040. Even allowing for additional entries or those that encompassed more than one work, the total number did not exceed about 1,200, far below Quinn's exuberant estimate to Lily (8 Feb. 1913) that there would be 3,000 items. The 1963 catalogue omits Gwen John from its alphabetical listing (p. 210).
127. Sloan, *Diary* 16 Jan. 1913, p. 633.
128. Note by Helen Farr Sloan, *ibid.*, p. 629.
129. See Milton Brown, "The Armory Show in Retrospect," *1913 Armory Show, 50th Anniversary Exhibition*, p. 35. Brown adds: "The impact of the Armory Show shattered the even complacency of American art. The Academy, dominated by dead ideas and shopworn forms, had consistently stifled the breath of change. The Armory Show catapulted art out into the public view, and what the public saw was a new art which shocked rather than lulled. The 'fakers,' the 'madmen,' the 'degenerates,' were abused, reviled, and jeered. The press and public laughed, the critics, with their standards crumbling about their ears, fulminated, but it was all to no avail. The greater the vituperation and hilarity, the greater the publicity and the greater the attendance. The Armory Show had done its job. The *Globe* guessed that 'American art will never be the same again,' and it wasn't."
130. Lily 24 Feb. 1913. JBY offered a comment on the lady from Coole: "I talked a while to Lady Gregory. *Sometimes* she is very difficult to talk [with], mainly because being from South Ireland she never believes anything you tell her, answering every remark with an enigmatic smile and an averted look in her eyes. At other times she is pleasant and sympathetic."
131. *Outlook*, 22 March 1913; reprinted in *1913 Armory Show, 50th Anniversary Exhibition*, pp. 160–162.
132. WBY 16 March 1913 (also in *JBYL*, p. 158).
133. Six works of Jack's were exhibited: *The Political Meeting*, a 1909 watercolor lent by John Quinn, and five others: *A Stevedore*, *The Barrel Man*, *Strand Races*, *The Last Corinthian*, and *The Circus Dwarf*. All six works are listed in the 1913 catalogue, Quinn's

watercolor as no. 587, the others as nos. 352–356. *Strand Races*, no. 354, was purchased from the floor by George F. Porter and later came into the possession of the Art Institute of Chicago (1963 Catalogue, p. 208). See also Pyle, p. 116.

134. Lily 24 Feb. 1913.

135. Q, "Statement by L.G. to J.Q." (n.d., ca. 16–20 March 1913); see n. 137 below.

136. It has been asserted that Quinn became Lady Gregory's lover. Mrs. Foster told WMM she had read some letters from her to him that confirm the suspicion. After Quinn's death she returned all the letters to Lady Gregory and received a note of thanks for not having made another use of them. Letters recently retrieved add substance to the rumors.

137. Q, "Statement by L.G. to J.Q." This remarkable document, of four typewritten pages, exists in a carbon copy in the Foster-Murphy Collection. I have not tried to locate the original. At the top of the first page is written, in JRF's hand, "Lady Gregory" (in ink), and "John Quinn material" (in pencil). The account is in the third person throughout, except once when Quinn slips and refers to himself as "me." It occasionally makes use of short sentences ("Give story of Cockran's dinner") or nonsentences ("Episode about Gosse and Yeats pension"). The date of the memorandum is inferred from a reference to the celebration on the last evening of the Armory Show. Almost the only sentence in the memorandum that does not appear to be critical of WBY either directly or indirectly is the last: "Lady Gregory also told of Gosse presiding at a Yeats lecture and of Trench and Shaw being there and it being a very distinguished lecture and Yeats netting seventy pounds."

138. *Ibid.* See Chapter Twelve, p. 318.

139. *Ibid.* See Chapter Nine, p. 196 and n. 11.

140. Q to LAG 25 April 1913.

141. Thomas Bodkin, *Hugh Lane and His Pictures* (Dublin: The Arts Council, 1956), pp. 29–30, gives a complete listing of Lane's paintings and provides throughout a good history of the controversy over the pictures.

142. Q, "Statement by L.G. to J.Q."

143. LAG, letter to the editor, *Irish Independent*, 7 Sept. 1913; newsclipping, Coll.: Foster-Murphy.

144. It is reproduced in Robinson, opposite p. 81, where it is inaccurately described as a "souvenir programme." All originals of the sketches are signed.

145. Lily 28 July 1913.

146. Bodkin, *Hugh Lane*, pp. 34–36.

147. EDWD to JBY 23 May 1913.

148. WBY 6 April 1913 (also in *JBYL*, p. 160).

149. To EDWD 12 June 1913, JBY wrote: "Unfortunately I have no copy of the original letter."

150. *Nation*, 24 April 1913, pp. 413–414.

151. EDWD to JBY 23 May and 21 June 1913.

152. WBY to Lily 1 July 1913.

153. WBY to Lollie 25 Oct. 1913.

154. *A Woman's Reliquary* (Dublin: Cuala, 1913), sig. a⁴. Mrs. Dowden wouldn't allow her husband's authorship to remain concealed; beneath Dowden's note she caused Lollie to print a "Publisher's Note": "If readers desire to attribute authorship of this book to the editor, no wrong is done to anyone."

155. WBY 11 Dec. 1913; partially reprinted in *JBYL*, pp. 168–169, where an interesting passage is omitted: "He once sent me £300 and some years afterwards I had some difficulty in inducing him to let me repay him."

156. See also Miller, pp. 67, 108. Miller records the disclaimer but was unaware of the circumstances surrounding the book's publication.

157. WBY to Lily 1 Dec. 1913.
158. WBY to JBY 5 Aug. 1913 (Wade, *Letters*, p. 583); WBY to Lily 1 Dec. 1913.
159. Lily 15 Dec. 1913.
160. Lily to Q 12 Aug. 1913, NYPL.
161. Lily 23 April 1913. On Lady Gregory's pragmatic approach JBY commented to Lollie (22 April), "She has a shrewd eye for the material side of life."
162. W. B. Stanford and R. B. McDowell, *Mahaffy: A Biography of an Anglo-Irishman* (London: Routledge and Kegan Paul, 1971), pp. 113–114.
163. See also Philip Edwards, "Yeats and the Trinity Chair," *Hermathena*, autumn 1965, pp. 5–12, which makes use of other sources.
164. Death Certificate, north subdistrict of St. Giles, St. Andrews Hospital, Northampton, which lists William's death on 25 Feb. 1913, after twenty-one days of bronchitis. I am indebted to Dr. Oliver Edwards for having traced this information for me.
165. Lily to JBY 9 July 1913, 23 Jan. 1917.
166. Lily 10 April; Lollie 1 May; Lily 19 Dec. 1913.
167. Lily to JBY 15 Aug. 1913.
168. Lily 2 Dec. 1913.
169. Holloway, 22 March 1913, p. 157.
170. Lily 23 April; Lollie 22 April 1913.
171. WBY 22 Oct. 1913.
172. WBY n.d. (ca. Nov.) 1913 (for dating see Wade, *Letters*, pp. 584–585).
173. WBY 22, 24, and 25 Dec. 1913 (the last of these also in *JBYL*, p. 170).
174. JBY's letters to Jack from America reveal a cautious affection, a kind of toe in the water. Had Jack responded with enthusiasm he might have received as many letters as the other children. But he wrote seldom, though always politely and respectfully. There is an occasional hint that Cottie still felt herself not part of the family. "She is in the position," Papa wrote Jack (4 Dec. 1913), "of being one of the family and at the same time a critic and observer from outside. I like her not to be afraid of 'husband's relations.' I will understand even though she tells me what she thinks of me, for I know her quite well and am not afraid, and I *never never criticize* her." There is a hint, too, that Cottie had found him a difficult houseguest, as Lady Gregory had: "When I go home I will come and stay with you and Cottie for a couple of weeks and be on my best behavior, quite modest, never laying down the law, and not talking more than enough, so that when I vanish into the shadows you and Cottie may remember me with favour" (16 Dec. 1913).
175. George A. Birmingham, *Irishmen All* (New York: Frederick A. Stokes, 1913). Jack did not read the book nor Hannay see the drawings till each had completed his work.
176. Lily 2 Dec. 1913.
177. Lily 10 Oct. 1913.
178. Lily 12, 15, and 16 Nov. 1913.
179. Lily 12 Nov. 1913.
180. Lollie 11 Sept. 1913.
181. Lily 19 Dec. 1913.
182. See WBY to LAG 5 March 1913 (Wade, *Letters*, p. 578): "Do what you think right about my father. I have that £160 legacy instalment and I leave you quite free within this limit—I would prefer not to pay more than £50 but I trust you entirely in this matter."
183. Lollie 23 June 1913; WBY 26 Sept. 1913, no. 1, "I don't know how. . . ."; Lily [ca. Oct. 1913], "At last. . . ."
184. From a literal copy of Henri's letter of 1913 to John Sloan, in Dolly Sloan to Lily and Lollie 8 Feb. 1922.

185. Jack 16 Dec. 1913.

186. Clare Marsh 18 Dec. 1913, TCD.

187. SM to JBY 26 July 1913: "You have meant a great deal to me from the first. . . . I do not think the little book will disgrace you." The book was *The Living Chalice* (Dublin: Maunsel and Co., 1913), new (i.e., 2d) ed.

188. Lily 2 Dec. 1913.

Chapter Fifteen: *1914–1916*

1. SM to Q 5 Jan. 1914, Coll.: Foster-Murphy.

2. WBY 18 Feb. 1914.

3. WBY 6 Jan. 1914 (also in *JBYL*, p. 171).

4. WBY 10 May 1914 (also in *JBYL*, p. 180).

5. VWB to WMM: conversation. Conrad Aiken to WMM: conversation.

6. Mary Colum, *Life and the Dream* (Chester, Pa.: Dufour, 1966), p. 185.

7. Clare Marsh 9 March 1914, TCD.

8. JBY got the bad news from *Harper's* early in the year (WBY 10 Feb. 1914). The loss of the promised fees amounted to about three hundred dollars. "I said to *Harper's* editor," Father told Willie, " 'Surely you are bound in law.' He agreed but said, 'No one minds law in N. York' " (WBY 5 Dec. 1914).

9. There is little mention of economically rewarding painting at all in the correspondence of 1914. He had done a sketch of the son of Charles Carstairs, owner of Knoedler's Gallery (Clare Marsh 4 Feb. 1914, TCD), and later in the year did one of Padraic Colum. He sketched at the Petitpas table constantly, as he would do until he died; but no large payments were forthcoming in 1914 except for Quinn's commission for the sketch of his sister and niece.

10. Lily to Q 16 June 1914, NYPL.

11. Van Wyck Brooks, *Scenes and Portraits* (New York: Dutton, 1954), p. 175.

12. WBY 6 Jan. 1914 (also in *JBYL*, p. 170).

13. WBY to JBY [Jan. 1914] (Wade, *Letters*, pp. 586–587).

14. Isaac 22 May 1915.

15. WBY to LAG 13 Feb. 1914 (from Hone, *WBY*, p. 279).

16. Q to WBY 9 Feb. 1914.

17. WBY 10 Feb. 1914.

18. Clare Marsh 6 April 1914, TCD. "He [WBY] made over £500 and the day before he left he said to me triumphantly, 'Now I don't owe a penny in the world,' for it was all owed."

19. Lily 19 Feb.; WBY 18 Feb. 1914.

20. WBY 23 Feb. 1914 (quoted from Hone, *WBY*, p. 279). On the same page Hone quotes from WBY to LAG 13 Feb. in which, perhaps wanting to spare his father's pride, he mentions his contribution but calls it voluntary. "I have just written him that I will give him £50. He did not ask for it and seemed unwilling to talk over his affairs." I have not seen the original letter; the "£50" may be a misprint. As JBY twice mentions forty pounds there is little doubt that was the sum involved. As the letter to Lady Gregory might have crossed with JBY's of the tenth it is possible that WBY's words, "He did not ask for it," were literally correct when he wrote them.

21. Reid, p. 176.

22. WBY 16 March 1914, no. 2, "I am more glad . . . " (also in *JBYL*, pp. 172–173).

23. Q to WBY 28 April 1914 (Reid, p. 178). For a complete account of Quinn's collecting, see Reid (throughout) and Aline B. Saarinen, *The Proud Possessors* (New York: Random House, 1958), pp. 206–237.

24. WBY to Q 9 July 1914 (Reid, p. 179).
25. Lily to Q 4 May 1915 (*ibid.*); Q to WBY 7 Aug. 1919.
26. Jack 17 Sept. 1914.
27. Lily 20 April; WBY 6 May 1914.
28. Lily 27 March 1914 (also in *JBYL*, pp. 175–176).
29. The photograph appears in Wade, *Letters*, facing p. 412, but is misdated "1904." Quinn's copy (Coll.: Foster-Murphy) has inscribed on the mat in his hand, "John Quinn (with William Butler Yeats) to Jeanne Robert Foster. Taken in 1914 and presented to her May 30, 1921. J.Q." See p. 421.
30. See Wade, *Bibliography*, no. 109, p. 115. According to W. M. Roth, Wade writes, each guest received a copy with his own name pasted on the cover. Wade noted that a copy with no label was in Yeats's library. Another is in the Foster-Murphy Collection. Wade says that only twenty-five copies were printed, on expensive uncut paper, "printed on alternate openings"—i.e., on double leaves unopened at top edge—and that the type was set by Bertha Goudy at the Village Press, Forest Hills, New York. Reid (p. 177), however, maintains that fifty copies were printed, that thirty-eight guests attended the dinner, and that Quinn distributed the remaining twelve copies to friends in Ireland.
31. Lollie 5 April 1914; Lily 27 March 1914 (from *JBYL*, p. 176).
32. George Moore, *Vale* (New York: Boni and Liveright, 1923), pp. 145–146.
33. Hone, *WBY*, p. 275.
34. Moore, *Vale*, pp. 135, 136, 136–137. Cf. Annie Horniman to WBY 10 Dec. 1906, NLI, MS 13068: "You have been too much petted of late years until you have taken to use that crushed pained and disturbed look of misery as a means of terrorising Lady Gregory and me whenever we object to anything."
35. Reid, p. 177.
36. WBY 20 Feb. 1914.
37. WBY 6 March 1914.
38. WBY to JBY 16 March 1914.
39. Lily 24 March 1914. Part of the letter appears in *JBYL*, pp. 174–175, where the sentence about Pound's "money" and "manners" is omitted.
40. "Pardon, old fathers," *Poems* (London: Macmillan, 1965), p. 113. T. S. Eliot, in the First Annual Yeats Lecture to the Friends of the Irish Academy at the Abbey Theatre in 1940, quotes the nineteenth and twentieth lines of the poem ("Pardon that for a barren passion's sake," etc.) as "great lines" and calls the whole poem "violent and terrible." In the poem Yeats "fully evinced," says Eliot, the speech of the "particular man." "And the naming of his age in the poem is significant. More than half a lifetime to arrive at this freedom of speech. It is a triumph" ("The Poetry of W. B. Yeats," *Purpose* [London], vol. 12, nos. 3–4 [July-Dec. 1940], pp. 115–127).
41. Hone, *WBY*, p. 259.
42. Jeanne Robert Foster, "Notes by J.R.F.: J. B. Yeats, Feb. 14, 1914" (unpublished typescript, Coll.: Foster-Murphy). JBY said further that it was futile to seek "everlasting happiness" in love. "Love is not happiness; it is torture. Love kills by satiation; it destroys itself like the Phoenix. Affection must replace love in marriage, or else one hates."
43. WBY to Lily 28 July 1914.
44. Wade, *Bibliography*, no. 110, p. 116. The slip Wade saw is in the copy at the Lockwood Memorial Library at the University of Buffalo. It is the only one Wade ever saw; apparently very few were issued. I thank K. C. Gay of the Lockwood Library for letting me see this and other material in his collection.
45. Lollie 4 May 1914.
46. WBY to Lily 11 Nov. 1914.

47. Lily to JBY 2 Aug. 1914.

48. WBY to Lollie 27 Oct. 1914. The author of *Memory Harbour* (1909) was Alexander Bell Filson Young.

49. Lily 13 Aug. 1914.

50. WBY to Lily 29 Dec. 1914.

51. Jack 1 Sept. 1914.

52. Jack 17 Sept. 1914.

53. Lollie 23 Nov. 1914.

54. George Russell to Q 10 Dec. 1914 (Reid, pp. 187–188).

55. Lily 17 Aug. 1914 (*JBYL*, pp. 186–187 contains part of this letter). Sir Roger, knowing that the Yeatses were involved in printing, volunteered the information that he knew Evelyn Gleeson and liked her very much. Papa replied that she was "an unreliable Humbug," and asked Lily whether he had been "judicious" in speaking his mind (20 Aug.).

56. SM 21 Sept. 1915.

57. Isaac 24 Oct. 1915. He added of Casement: "He is a very fine gentleman . . . a prince of courtesy." Casement sent JBY a pamphlet in support of the German cause, and Papa told Lily he would read it if only to be fair. "But if it converts me I shall not be nearly as happy" (10 Sept.).

58. Reid, p. 189. The account of Casement's visit is on pp. 187–189. For an excellent account of Casement's life, see B. L. Reid, *The Lives of Roger Casement* (New Haven and London: Yale University Press, 1976).

59. Lily 2 Dec. 1914. JBY also wrote Willie (5 and 14 Dec. 1914) that Meyer had talked of "buying a paper," perhaps having his eyes on a Hearst publication. "I hear that Hearst, who controls 300 papers, has become pro-German, and most people suppose a pecuniary arrangement to have been effected with the Kaiser—perhaps Kuno Meyer the agent in this dirty work."

60. RHJ to WMM: conversation.

61. Lily 6 and 7 Nov.; 9, 10, and 16 Dec.; WBY 14 Dec. 1914. His comments in the letter to WBY on the East River, visible from the Colums' flat, make painful reading today: "Out of their windows you look down upon the water and can watch the seagulls making their evolutions, and the tide ebbs and flows over the *clean* stones—no sewage in this river although in the midst of New York."

62. Lily to JBY 5 Dec. 1914. It was almost certainly the situation at Gurteen Dhas that Papa was thinking of when he wrote Jack (17 Sept. 1914): "*Remember I am an exile*, and by no means a willing exile."

63. Lily 7 Jan. 1914 (misdated 1913). Many January letters in all years are dated a year early.

64. Lily to Q 13 May 1914, NYPL (also in Reid, p. 178).

65. Lily to JBY 22 June 1914. Later in the year, when Hinkson got a new job he had been coveting, JBY wrote a revealing commentary to Lily: "I am glad of Hinkson's success. How they have toiled for it! But if his wife does not go with him and put an eye on him, he will return to drink. I bet he gets himself much disliked. He has good qualities, but his superficies is disagreeable. . . . I think that of all men I ever met he has the most unfortunate manners." He told her how Hinkson had once announced he was coming to JBY's studio to have him complete an unfinished portrait, but on being asked to pay ten pounds for the work had dropped the subject (16 Oct. 1914).

66. WBY 19 and 20 Nov. 1914.

67. WBY 12 May 1914.

68. WBY 14 Aug. 1914. In a postscript he added: "The man who would be himself lives the intense life and is neither a Walt Whitman nor an Ezra Pound."

69. Clare Marsh 4 Feb. 1914. Charles Carstairs, the owner of Knoedler's, had been given JBY's name by Hugh Lane.

70. JBY, Introduction, Catalogue of Whistler Exhibition, March-April 1914.

71. WBY 7 Sept. 1914 (also in *JBYL*, pp. 191–192).

72. Later he put the idea in yet another way: "*The poet is the antithesis of the man of action*" (18 Aug. 1914).

73. WBY 23 Feb.; 6 March; 6 May; 10 May (also in *JBYL*, p. 179); 30 Aug. (also in *JBYL*, pp. 188–190); and 22 Dec. 1914 (also in *JBYL*, p. 199).

74. WBY 7 Sept. 1914 (*JBYL*, p. 191).

75. Lily 19 March 1914.

76. Lily 19 Feb. 1914.

77. Lollie [ca. 20 March 1914], "I have just. . . ."

78. WBY 30 Jan.; Lily 19 Jan. 1916.

79. Lily 16 Oct. 1914.

80. Jack 19 Nov. 1914.

81. Lily 16 Oct. 1914. The lithograph appears on p. 430. A portrait of JBY by Henri is in the Hirshhorn Museum and Sculpture Garden in Washington.

82. Lily 2 Dec. 1914.

83. Clare Marsh 1 May 1914, TCD.

84. WBY 31 May 1914.

85. Lily 27 May 1914, fragment.

86. Lily 27 Jan. 1914; 25 June 1914.

87. Q to WBY 15 Sept. 1918 (Reid, pp. 310–311); Q to Lily 19 June 1917.

88. WBY to LAG 25 April [1900] (Wade, *Letters*, p. 340).

89. Reid, p. 194; *Confessions of Aleister Crowley: An Autohagiography*, ed. John Symonds and Kenneth Grant (New York: Hill and Wang, 1969), p. 765.

90. See Chapter Fourteen, n. 90.

91. Lollie 22 Jan. 1915; 4 May 1916.

92. Lily 26 Jan. 1915; Oliver Elton [8] Feb. 1915, Coll.: Leonard Elton.

93. VWB 25 Jan. 1915.

94. See Lollie 22 Jan., Lily 18 Feb., Clare Marsh 15 June, Lily 18 Sept. 1915.

95. Oliver Elton [8] Feb. 1915, Coll.: Leonard Elton.

96. WBY to Lily 18 Feb. [1915]. The year is written by Allan Wade on the unpublished letter.

97. Lily 27 April 1915, no. 2, "I am at . . . "

98. WBY 25 April 1915.

99. Q to WBY 24 April 1915.

100. Lily 27 April 1915, no. 2, "I am at . . . "

101. Q to WBY 24 April 1915.

102. Isaac 24 Oct. 1915.

103. WBY 3 Nov. 1915.

104. Lily 19 Feb. 1915.

105. C 17 Nov. 1915, Princeton.

106. C 12 Aug. 1915, Princeton. See also Lily 25 Jan., Jack 14 Aug., SM 27 Oct., Lily 16 Nov. 1915.

107. WBY to Lily [probably 25 Dec. 1915], "I had hoped . . . "

108. A letter from WBY to Lily and Lollie some years later (29 Oct. [1925?]) gives the chilling figures: "I have now paid off your overdraft, including Lilly's bill of £245, and the total sum paid off is £2010.11.1 I have also guaranteed a future overdraft for each of your two departments of £100 each. I cannot exceed that £100 in each case. . . . If I spread your overdraft plus the Cadbury and Miss Boston's money over the last 20 years

it shows an annual deficit of about £135. This seems roughly therefore the amount you have to make up annually by economies or increased sales."

109. Quinn read the manuscript of *Reveries* and promptly sent a seven-page list of suggested corrections or improvements. "You will probably think I am damned impertinent or cheeky to write all these things," Quinn protested in a kind of apology in advance for having dared impose his suggestions on the great man (Q to WBY 16 July 1915). Willie didn't tell what he thought; he simply disregarded Quinn's letter completely.

110. WBY to Lily 11 Jan.; Lily to WBY 12 Jan. 1915.

111. Q to WBY 16 July 1915.

112. WBY to JBY 18 Jan. 1915 (also in Wade, *Letters*, p. 591). The Cuala edition lists "MCMXV" but publication was in 1916 (Wade, *Bibliography*, p. 119).

113. Jack 16 June 1915.

114. WBY 2 April 1915.

115. WBY to JBY [ca. Nov.-Dec. 1915] (Wade, *Letters*, pp. 602–603). The list of subscribers, most of whom made their contributions through Lady Cunard, included Augustine Birrell (£5), the Aga Khan (£30), the Earl of Iveagh (£5), and Thomas Beecham (£23). A typewritten copy of the list, which may not have been a final one, is in the collection of Michael B. Yeats. It shows a total of £204.6.0 lodged in the bank.

116. WBY to JBY [ca. 1 Feb. 1915], "This will probably . . . "

117. WBY 7 Sept. 1915, no. 2, "You once wrote . . . " He repeated the remark in SM 20 Sept. 1915 (Hone reprints part of this letter in *JBYL*, pp. 210–211, but not these words).

118. WBY to JBY [ca. Nov.-Dec. 1915] (Wade *Letters*, p. 603). I have not seen the letter on Wordsworth.

119. WBY to Lily 15 June 1915. Uncle William's son, Leo Armstrong Butler Yeats, fought at the Dardanelles and later moved to Australia. He was married to Florence Miller of Brazil. A son, Peter Butler Yeats, and two grandchildren still live in Australia. I thank Mrs. Pamela Butler Yeats for help in identifying the Australian Yeatses.

120. WBY to Q 24 June 1915 (Wade, *Letters*, p. 595).

121. WBY to Lily 21 Aug. [1915] (year taken from postmark). The letter is written from Coole Park.

122. Lily to JBY 2 July 1915.

123. Lily to Q 19 Feb. 1915, NYPL.

124. Lollie 20 Oct. 1915.

125. Lily to JBY 23 Aug. 1915. Her illness did not prevent her from giving help to the thirty-three-year-old Joseph Hone, who was producing the first full-length book on the life and achievement of William Butler Yeats, a copy of which she sent to her father in December. "I think it is a very good book," she told him, "a valuable book. It gives the Abbey story and the Gallery story. He gave it to us here to read in proof to put facts right for him, which we did" (12 Dec.). Lily's letter confirms the impression of readers of Hone's book (both the original version and the expanded *W. B. Yeats: 1865–1939*) that much of the information, while not documented in scholarly fashion, came from Lily's conversations with the author. As Lily's memory for dates was no more precise than her father's or brother's, one cannot always be sure that factual information is absolutely correct; but described events and impressions can be assumed to be true.

126. Q to WBY 24 April 1915.

127. Charles Richard Cammell, *Aleister Crowley: The Man, the Mage, the Poet* (London: The Richards Press, [1951]), pp. ix, 153.

128. Crowley, *Confessions*, pp. 798–799.

129. It was printed in *Wild Apples* (Boston: Sherman, French, 1916), a volume Mrs. Foster dedicated to John Butler Yeats. She also dedicated "To the Memory of My

Friend John Butler Yeats, R.H.A." *Rock-Flower* (New York: Boni and Liveright, 1923), which has as frontispiece a pencil sketch of her by him.

130. JRF 18 May 1915. JBY advised Mrs. Foster regularly over the years. She wrote a poem called "Advice from John Butler Yeats" which describes his method:

> Now, I understand
> What you meant
> When you said to me:
> "Be more reticent;
> Spread the lavish phrase
> Rarely in your rhyme,
> Keep the *thought intense*
> So that passing time
> As a moth to flame,
> Pauses on your word:
> So is beauty won,
> So is passion stirred."

MS copy in Foster-Murphy Collection; reprinted in Paul Andrews, "Jeanne Robert Foster," *Idol* (Schenectady, N.Y.), XLVII, no. 1 (winter 1971), p. 5.

131. JRF 4 July 1915, Coll.: Foster-Murphy.

132. Crowley, *Confessions*, pp. 772, 801. In "The Answer," *Wild Apples*, p. 34, JRF alludes to this child.

133. Q 14 March 1916, Coll.: Foster-Murphy. Of Crowley and JRF, JBY added: "He boasts that he is not afraid because John Quinn will alway find bail for him and protect him. She thinks he is a cocaine fiend. At the very start I had warned her, so that she has never let him get so much as a letter from her. He has some girl with him, and he sent this girl to her with a message to say that she must help him or he would destroy her. The girl wept all the time while giving the message. Mrs. Foster told her politely to go to the devil. *The Government here* and the *English government* are both busy watching him with detectives. The English authorities say he is a spy and that he has been to Canada."

134. Lollie 12 March 1915.

135. WBY 1 May 1915.

136. Lily 24 Oct. 1915.

137. Lollie 12 March 1915.

138. EDB 20 Oct. 1915, Princeton.

139. Lollie 12 March 1915.

140. LAG 27 Jan. 1920, NYPL.

141. Isaac 22 May 1915.

142. Lollie 20 Oct. 1915.

143. Reid, p. 214.

144. See *ibid.*, pp. 7, 12. As a result of the early deaths of so many in his family Quinn "had begun to have a morbid horror of death and an active hatred of disease. . . . He hated and feared the thought of death and tried to avoid the sight of death and its accoutrements."

145. Thomas Bodkin, *Hugh Lane and his Pictures* (Dublin: The Arts Council, 1956), p. 43 and *passim*. In the late 1960's an agreement was finally reached under which no more than half the paintings would be put on loan for exhibition in Dublin, rotating with the other half. The English still retain title to the paintings.

146. LAG [ca. 1919], "Altho' Hugh Lane . . . " This copy appears to be a draft; it is filled with deletions and careted insertions and is unsigned. The book is *Hugh Lane's Life and Achievements, with Some Account of the Dublin Galleries* (New York: Dutton; London: Murray, 1921).

147. WBY 10 May 1915.

148. Oliver Elton 28 April 1915, Coll.: Leonard Elton; WBY 6 Sept. 1915, no. 2, "I hope I am not . . . "; Lily 14 Nov. 1915.

149. Lily 25 June 1915.

150. Lily 9 April 1915.

151. Lily 26 Sept. 1915.

152. Isaac 22 May 1915.

153. Isaac 1 July 1915, no. 2, "When I write . . . "

154. Leonard Elton to WMM. The picture was repaired and is now in the National Gallery of Ireland.

155. It is to be hoped that Miss Connolly (now Senator Nora Connolly O'Brien) will some day reveal the nature of her secret mission. In 1968 at tea with WMM she smilingly declined to go into details. I am indebted to her for her observations on JBY. Mrs. O'Brien contrasted JBY with his son Willie, who "offended" her terribly by remarking to her that the failure of Constance Markievicz to die or be executed in the Easter Rising spoiled the symmetry of the martyrdom and rendered her unfit as the subject of a poem. "If she had died she could have made a good theme in a poem," Senator O'Brien quotes him as saying.

156. Oliver Elton 20 Dec. 1915, Coll.: Leonard Elton.

157. Q to WBY 16 July 1915.

158. Jack 16 Dec. 1915.

159. Reid, pp. 210–211.

160. Lily 26 Sept. 1915.

161. Lily 3 Sept. 1915.

162. WBY 14 Aug. 1915. In Lily 20 Aug. 1915 he wrote: "I began them accidentally in what was meant for a letter to Willie on the modern way of living."

163. Lily 20 Aug. 1915.

164. See WBY 13 Jan. and 25 April; Lily 27 April, Jack 28 May, Lily 19 Oct. and 16 Nov. 1915.

165. Jack 16 June 1915. A black-and-white reproduction of Jack's portrait of himself appears in Pyle, facing p. 37, where it is dated ca. 1920.

166. WBY 10 Jan. 1915.

167. WBY 7 Sept. 1915, no. 1, "Here is yet . . . " It is instructive to compare with JBY's attitude that of Max Beerbohm toward WBY's mysticism: "At a time when Yeats was fairly generally revered, Max admitted that he was bothered by the poet's preoccupation with the occult. In a sketch on Yeats, written in 1914, he says that he felt always 'rather uncomfortable' [with Yeats], 'as though I had submitted myself to a mesmerist who somehow didn't mesmerize me.' Often, he says, Yeats engendered 'a mood in a vacuum' " (S. N. Behrman, *Portrait of Max* [New York: Random House, 1960], p. 146). On p. 147 is a reproduction of Beerbohm's sketch, *Mr. W. B. Yeats presenting Mr. George Moore to the Queen of the Fairies.*

168. WBY 6 Sept. 1915, no. 2, "I hope I am not . . . "

169. C 21 Sept. 1915, Princeton.

170. WBY 10 Dec. 1915.

171. Q to James G. Huneker 3 April 1915 (Reid, p. 202).

172. Lollie 4 March 1915.

173. Lollie 25 March; Lily 19 Oct.; C 29 Nov. 1915, Princeton.

174. See Harris's *My Life and Loves* (New York: Grove Press, 1963) for abundant evidence from his own pen of his peculiar character.

175. Oliver Elton 17 Dec. 1915, Coll.: Leonard Elton. Part of the letter appears in *JBYL*, pp. 212–213 but not the portion quoted here.

176. Mrs. Foster gave the sketch to WMM in 1963. It is now part of the Foster-Murphy Collection. See p. 447.

177. EDB 25 April 1916, Princeton.

178. Jack 19 Aug. 1916 (also in *JBYL*, pp. 228–229).

179. WBY 10 Jan. 1915; JS 11 Jan. 1916.

180. WBY to JBY [ca. 1 Feb. 1916] (according to Wade, *Letters*, pp. 605–606). I suspect the date should be a month or two earlier. I have made use of the original. It was dictated by WBY and typed by Ezra Pound; it is badly misspelled and mispunctuated.

181. WBY to JBY [ca. Nov.–Dec. 1915]. I have quoted from the original typescript. Wade (*ibid.*, p. 603) gives "ungracious realities" instead of the "ungracious unrealities" of the original.

182. WBY, *Autobiographies*, p. 85.

183. I have discussed the relationship of the Dowden brothers with the Yeatses, father and son, in an unpublished paper, "The Yeatses and the Dowdens," presented at the Yeats International Summer School at Sligo, Aug. 1973, and at a meeting of the International Association of University Professors of English at Cork a week later. In it I remark that from the point of view of the student of the Irish Renaissance, WBY's picture of Dowden is unfortunate because it obscures and in some measure distorts a family relationship that was extremely important to both groups involved and to the Irish Renaissance itself. Edward Dowden will never be a hero to Irish nationalists, and one may disagree with his political preferences, which were entirely Unionist. But he deserves, I believe, a better memorial than the grudging semicompliments and subtly derogatory remarks made about him by Yeats in his autobiographical writings. Edward Dowden awaits his biographer, and he deserves one as sympathetic and kindly as Dowden was himself.

184. C 8 April 1916, Princeton. See also Mrs. George Hart 28 July 1916, Coll.: RHJ.

185. Lily 13 March 1921 (also in *JBYL*, p. 274).

186. WBY to JBY 5 March 1916 (also in *ibid.*, pp. 222–223, and Wade, *Letters*, pp. 606–608).

187. WBY 19 March 1916. Pound told WMM (June 1966) that WBY had made an initial culling, which Pound further reduced.

188. Ezra Pound to Q 26 Feb. 1916 (from Reid, p. 242). I have put a comma for Pound's period.

189. Lily 26 Sept. 1916.

190. WBY to Lollie [ca. March or April 1916], "My only free evening . . . " The book was published in 350 copies on September 16, and distribution and sales were just under way when Lollie wrote Pound expressing her dissatisfaction with the brevity of the selections he had sent her for her father's book. Rather than print whole letters or large excerpts from them, Pound chose brief aphorisms seldom more than a hundred words long. In the same letter she casually mentioned that one of her distributors had returned four unsold copies of Pound's book. Pound's reply was sharp and arrogant, and Lily protested to Willie about his manner. He took Pound's side: "Ezra's letter is characteristic. He is violent by conviction; but Lollie seems also to have been characteristic. Why choose the moment when she wanted to get something out of him to tell him that four copies of his book had been returned? I wonder if she also told him that his book was not selling well?! That also would be just like her" (4 Oct. 1916).

The dispute raged for years. Pound's book sold slowly, and as late as 1921 (WBY to Lily 25 Jan. 1921) Willie spoke of Lollie's "perpetual complaints" about its failure to sell. He had taken "weeks" of his time to write the introduction for it, he told her. "But for Lolly's need I would never have written that essay."

Although Cuala was barely seaworthy in the rough economic waters, yet JBY noted

that the value of the books constantly rose (C 13 Sept. 1916), and that a visiting Scot, W. G. Blaikie Murdoch, trumpeted the sisters' wares whenever he could (EDB 25 Jan. 1916). He wrote an appreciative account of the Press—"all disinterestedness on his part because he never met them"(C 13 Sept. 1916)—which was later published in *Bookman's Journal and Book Collector*, vi, no. 10 (July 1922), pp. 107–111.

191. Lily to JBY 1 May 1916, Princeton. I thank Prof. Glenn O'Malley for calling this letter to my attention and providing me with a copy of it. JBY had passed it on to Mrs. Caughey, along with Lily's letters of 1 May 1916; 12 and 16 May, 6 and 29 July 1917; and 2 and 6 April 1919. All these are at Princeton.

192. In the artistic competition in 1966 to commemorate the fiftieth anniversary of the Rising, by far the largest portion of the entries depicted Connolly in his chair. Perhaps the vividness of the symbolism, that of a helpless wounded creature utterly at the mercy of ruthless marksmen with guns, said something to a people who had endured almost eight hundred years of being metaphorically strapped in a similar chair. Kilmainham Jail in May 1916 was Ireland on a little stage, the firing squad a group of actors playing absentee landlords, Castle administrators, and patrolling soldiers, the prisoners the natives of a country who had been forcibly deprived of their rights to it.

193. Lily to JBY 7 May 1916.

194. *Ibid.*

195. Lily to JBY 26 April; WBY 29 April 1916.

196. Lily to JBY 29 May 1916.

197. B. L. Reid, *The Lives of Roger Casement*, pp. 324–362, 455–490.

198. LYS, "The Rebellion of 1916."

199. WBY 3 May 1916.

200. Holloway, 27 April 1916, p. 183.

201. Lily 4 May; WBY 18 May 1916. There was no mistaking his view of Pearse and MacDonagh and their company or of the English, for he repeated his judgment many times: "Those poor fools (for they were fools) are now heroes and martyrs for all time, and their 'folly' has done more for Ireland and for the dignity of Irishmen than anybody's 'wisdom' " (Lily 11 May 1916). And a day later: "Those poor heroes, for they are heroes and now martyrs, even though their attempts were folly. And yet these featherhead enthusiasts have perhaps done more for Ireland than years upon years of politics would do." Ten days later he told her the executions could be compared to the sinking of the *Lusitania*. "In both horrors the stupidity is as conspicuous as the cruelty."

202. John Quinn, "In the Matter of Sir Roger Casement and the Irish Situation in America" (24-page typescript carbon, 2 June 1916, Coll.: Foster-Murphy).

203. Oliver Elton 1 Nov. 1916, Coll.: Leonard Elton.

204. Lily to JBY 12 Dec. 1916. The unsold picture brought John Butler Yeats an unexpected bonus. Joseph Hone put in a claim for £4.4 for the picture and was awarded, after expenses, £3.17, which Lily sent to Papa. Hone also claimed damages for the loss of the plates of Synge's complete works. His total claim was for £74.4.0, of which the assessors awarded him £69.4.0. But Synge's plates were safe in Scotland. Hone lost instead manuscripts of Padraic Pearse but dared not claim for them and devised the ruse of Synge's plates in compensation. I am indebted to Frances-Jane French for this information. See Claims 2896 and 489, 7 July 1916, State Paper Office, Claim File Accounts: Property Losses of Ireland Committee of Papers. Hone claimed that all property at 96 Middle Abbey Street had been destroyed.

205. Lily to Lollie 9 May; Lily to JBY 12 May 1916. Six months after the Rising, Lily could still hear "the frightful noises," the worst "the rending and tearing of buildings."

206. WBY to LAG [11 May 1916] (Wade, *Letters*, p. 613).

207. WBY to Q 23 May 1916 (*ibid.*, p. 614).

208. WBY to Lily 24 Aug. 1916. The poem is a virtual rewording of a letter Lily sent to WBY. For an extended discussion of the poem and its origins, see my " 'In Memory of Alfred Pollexfen': W. B. Yeats and the Theme of Family," *Irish University Review*, I, no. 1 (Autumn 1970), pp. 30–47. The original of WBY's letter and the first draft of the poem, accompanying a forwarding note from Lily Yeats to Richard I. Best of the National Library of Ireland, is in the Library, MS 3255.

209. WBY 6 Sept. 1916.

210. Lily 15 Sept. 1916. Part of the letter appears in *JBYL*, p. 229, including part of this passage, but the punch line is omitted.

211. Lily 1 Feb. 1916. See also Lily to JBY 7 May and 14 Aug. 1916.

212. Jack 1 March 1916.

213. See Pyle, pp. 118–120. Miss Pyle points out that the Rising and the political distinctions it gave birth to further separated the Yeats brothers, "who had kept their creative lives distinctly apart" (p. 119). Jack was dedicated to Republicanism, to a free and independent Ireland, and in later years wanted nothing to do with the Free Staters, who were willing to settle for a self-governing colony under the British sovereign. In the troubles after 1922, it was WBY who joined the conservative followers of the Free State partition, Jack who remained intransigently Republican.

214. Lily 17 May 1916; *JBYL*, p. 225, gives the first part of this quotation ("If only . . .") but omits the second ("That is . . . ").

215. Clare Marsh 29 Sept. 1916, TCD; JRF 30 July 1915, Coll.: Foster-Murphy.

216. Lollie 28 Jan. 1916.

217. MFB 1 June and 13 Sept. 1916; C 13 Sept. 1916.

218. MFB 24 Aug. 1916.

219. WBY 6 and 15 Jan. 1916.

220. C 3 June 1916, Princeton; WBY 10 March 1916. See also Lily 17 May 1916.

221. Lily 14 Nov. 1916.

222. WBY 4 Nov. 1916. When JBY learned of Todhunter's death he wrote bitterly to Lily (14 Nov.) of "that she-dragon of contention, his wife," who forced upon them an estrangement neither wanted. She "soured the cream." Later (21 Jan. 1917) he wrote to Isaac: "Poor Todhunter has gone where his wife can torment him no longer. He was a good man, incapable of falsehood as he was [of] unkindness. I wonder what killed him. He was my age, he was extraordinarily clever, and yet he missed the goal everywhere, and now he is gone to Eternal Night. At any rate he and T[homas] D[rew] can't go to the same place."

223. EDB 12 Oct. and 19 Dec. 1916.

224. Lily 27 Dec. 1916.

225. Lily 7 Jan. 1916.

226. JS 8 Jan. 1916.

227. WBY 12 Jan. 1916.

228. Lily 3 Sept., 12 May, and 12 Aug. 1916.

229. Q 13 July; 8 April; 13 April 1916, Coll.: Foster-Murphy.

230. WBY 23 Feb.; 6 Jan.; 12 Jan.; 27 Feb. (also in *JBYL*, p. 221); 19 March; 4 April; 1 Oct.; 17 Jan.; and 10 Aug. 1916.

231. WBY 17 March 1916; Oliver Elton 10 Dec. 1916, Coll.: Leonard Elton.

232. WBY 27 Feb. 1916 (also in *JBYL*, p. 220).

233. WBY 4 Nov. 1916. Cf. Lily 3 Sept. 1916: "Life is sometimes terrible and is always sad, but we have to live; and to live one must make out some kind of happiness, for which purpose we have invented fables such as the immortality of the soul and the goodness of God. I myself believe in both *because I can't* help myself, while my reason keeps an inscrutable gravity."

234. Isaac 20 Dec. 1916; SM 6 Oct. 1916.

Chapter Sixteen: 1917–1919

1. Mrs. George Hart 8 Jan. 1917, Coll.: RHJ.

2. Q 5 May 1917. See also Lily 22 Nov. 1917: "Every evening I drink my two bottles (half bottles) of California claret. Occasionally I take a glass of Vermouth. I never go farther, and I never drink whiskey, and have *always refused it* from the first." (He was not including special occasions like the news of Willie's decision to support him: see Chapter Fifteen, p. 433). On 18 Jan. 1918, after drinking his claret, he wrote Lollie, "[I] defy the foul fiend and after go to bed and fall asleep before it returns. In the mornings I feel all right always. It is towards afternoon and evening that I feel bad till I get the claret."

3. WBY 17 July and 12 Sept. 1917.

4. Although Pound is listed on the title page and describes his part in the "Editor's Note" as "making a selection," Willie had "picked paragraphs" out of his father's letters and given them to Pound to publish "to boost the Cuala Press" (see Chapter Fifteen, p. 448 and n. 187).

5. Lollie to JBY 3 May 1917.

6. Lollie to JBY 26 May 1917.

7. C 10 Oct. 1917, Princeton.

8. Ezra Pound, Editor's Note, *Passages from the Letters of John Butler Yeats* (Dublin: Cuala, 1917), sig. [a3].

9. EDB 12 Aug. 1917, Princeton.

10. Lollie 4 Aug. 1917. There were a few not so favorable reviews, like that in the *Manchester Guardian* signed by "H.M.," whom I have not been able to identify. JBY wondered whether it might be Laurence *Housman*. The reviewer quarreled chiefly with the selection, more a slap at Pound than at the author. Pound and WBY made an odd pair with their different troops of antagonists. Pound reported to JBY that when he told WBY that A. R. Orage, editor of the *New Age*, had expressed admiration for the letters Willie had only glowered and said nothing. "The mutual detestation between him and Orage is a hardy perennial" (Pound to JBY 21 June 1917).

11. T. S. Eliot, "The Letters of J. B. Yeats," *Egoist*, June 1917, pp. 89–90. What influence JBY may have had on T. S. Eliot I leave to the wiser and more informed deliberations of others. But it may be said at the very least that Eliot's notions of what he called the "objective correlative" resemble closely JBY's repeated axiom that although a poem needs a subject, which may even involve a deeply held belief of the poet, the poetry resides not in the subject but in the poet's treatment of it. In the Cuala letters, passages dealing with the theory appear on pp. 22–24, 33–34, 42–45, 48–49, and particularly on pp. 19–20 in the letter to WBY on Blake: "I know that Blake's poetry is not intelligible without a knowledge of Blake's mystical doctrines. Yet mysticism was never the *substance* of his poetry, only its machinery. . . . His mysticism was a make-believe, a sort of working hypothesis as good as another. He could write about it in prose and contentiously assert his belief. When he wrote his poems it dropped into the background, and it did not matter whether you believed it or not, so apart from all creeds was his poetry. I like a poem to have fine machinery, but if this machinery is made to appear anything more than that, the spell of the poetry is broken."

12. Lollie 27 May 1917.

13. MFB n.d., June 1917, "There is a book . . . "; Princeton.

14. Even when he recalled the Law Society speech to Willie later in the year, reminding him that he gave the whole thing without once consulting his notes (13 Dec. 1917), he neglected to mention that it had been published. Like the second book, the first had been published as a result of someone else's work, with the author merely providing the copy and waiting for the completed book to materialize. The interval of

fifty years between the publication of his first book and his second, if not a world's record—as it may well be—must certainly rank high in the competition.

15. Lollie 27 May 1917. The two poets included a sentence about Isaac Butt that "would have wounded Miss Rosa." The sisters, "without consulting Willy or Ezra," removed it (Lily to JBY 18 Jan. 1917).

16. Q 30 May 1917, Coll.: Foster-Murphy. Now that the "widows, etc." are "dead and forgotten," the identifications can be safely made. Some of the original letters are lost and the identifications with them. Of the others, on p. 7, "A" is Todhunter; on p. 8, "B" is Edward Dowden; on p. 12, "H" is Sydney Hall; on p. 13, "T" is Edwin Ellis; on p. 15, "M" is Elizabeth Pollexfen (Orr); on p. 23, "G.P." is George Pollexfen; on p. 29 the poet from Buffalo is James Johnston; on p. 33, "C" is Canon Hannay and the play *General O'Regan*; on p. 47, the "she" in line 9 is Lady Gregory; on p. 57, "E" is Dr. George Salmon and "J.D." John Dowden; on p. 58 "X" is John Quinn.

17. Papa entered only a mild objection to the omission of the word "Greek" before "temple" on page 58. He failed to notice the misspelling of "knowledge" on page 9 and the misprint on p. 58 of "loungers" for "lawyers."

18. Lollie 27 May; WBY 1 June 1917.

19. Editor's Note, sig. [a3]v. The note is dated 20 May 1916. "Latin" is spelled by Pound with a lower-case "l." As soon as Lollie learned of the errors she had errata slips printed for the unsold copies but sent Papa her own handwritten slips for his copies. One of these, with Jeanne R. Foster's autograph on the flyleaf, is part of the Foster-Murphy Collection.

20. Lollie to JBY 20 June 1917.

21. Ezra Pound to Lollie 21 June 1917. Pound was apparently serious about the cost, writing JBY the same day, "I think there will have to be another edition for those who cannot pay 11/– (a terrible price)."

22. Ezra Pound to JBY 21 June 1917.

23. Ezra Pound to Lollie before 23 May 1917; enclosed in LAG to JBY 23 May 1917.

24. MFB [ca. June 1917], "I had just learned . . ." Princeton; LAG 11 June 1917, NYPL.

25. Q to Lily 19 June 1917. He wrote later to MFB (13 Jan. 1919, NYPL): "Ezra Pound's selection from Mr. Yeats' letters was a very skilful illustration of the truth of imagism and of imagist writing, for each one of the selections contained its proper image and the selection was a bit of real creative work."

26. Pound to Q 30 June 1917, NYPL (Reid, p. 292). To JBY himself Pound put it differently (21 June): "I had hoped to make excerpts from your later letters and use them in the *Little Review*—along with all the mad vorticists, etc.—W.B.Y. has let me see them, and I have been very much interested, but I cannot see them in a magazine. I am going through them again but I do not think it will alter the impression. A book where the personality of the author is the center, is very different from even a series of short articles or selections. Having succeeded in the book, I should hate to ruin or diminish the effect."

27. Lily to JBY 4 July 1917; Oliver Elton 27 June 1917, Coll.: Leonard Elton.

28. MFB 28 Feb. 1917, Princeton.

29. C 22 Dec. 1917, Princeton.

30. See *Seven Arts*, June 1917, pp. 252–260; April 1917, pp. 667–680.

31. Unpublished. It exists in both manuscript and typescript.

32. Lily 13 Jan. 1917.

33. Lily 22 Jan.; Lollie 6 March; C 24 March 1917, Princeton.

34. The money was somehow improperly sent, had to be returned to Ireland, may have been sunk on the *Laconia*, and had to be replaced (Lily 13 April 1917). Since the daughters mentioned receiving a portion of Uncle William's estate, and that a small

one—and since William was incompetent to make a will—the large sum could not have come from him. The Thomastown account had presumably been settled completely in 1907, but perhaps an additional £137 had somehow accumulated in it. Perhaps it was his share of another family legacy. Its size is surprising. See Lily to JBY 29 July 1917 (Princeton): "I am glad you have that money at last, and that *all paid* leaves something worthwhile over. You will know financial ease for a little while, no peace like it." I thank Glenn O'Malley for calling this letter to my attention.

35. Lollie 24 Aug. 1917.

36. Reid, p. 207.

37. Lily 20 May and 25 Sept. 1917.

38. Lily 20 May; Dolly Sloan 16 May 1917. He told Lily (25 Sept. 1917) that he got on well with Mrs. Perkins and that they had "a mutual liking."

39. JRF to WMM: conversation.

40. Lily 17 March 1917. Both these sketches are in the Foster-Murphy Collection.

41. Jeanne Robert Foster, *Neighbors of Yesterday* (Boston: Sherman, French, 1916); *Rock-Flower* (New York: Boni and Liveright, 1923).

42. C 17 Jan. 1917, Princeton; Lily 23 Jan. 1917.

43. Q 18 and 19 Jan. 1917. He advised Elton to read *A Portrait*: "If you want to understand Irish Catholic student life, read it—and I think it will throw a light back on medieval times, when people were supersaturated with the Catholic religion and yet by force of the original Adam free-thinking" (20 Jan. 1917). He wrote to Mrs. Caughey (10 Dec. 1917): "it is a painful book because it describes a painful birth. The Catholic student in Ireland lives in squalor and is crushed under religious terror and under poverty. He has no chance of being a gentleman—such ideals are not for him. I need not say that the Protestants and the students of Trinity College Dublin don't in the least resemble the poor lads that people Joyce's book."

44. Q 13 Dec. 1917 (partly quoted in Reid, p. 311).

45. Q 6 Nov. 1917, no. 1, "Very much obliged . . . "; no. 2, "I would like . . . "

46. Q 3 Dec. 1917.

47. Q 19 Nov. 1917. Of Pound he also wrote in the same letter: "I fancy he is doing some very good work. He is a hair-shirt to be worn next the skin. Long ago I used to speak of certain friends of mine as hair-shirt friends. I am sorry to say they are dead; and I sincerely mourn them, and can do so the more contentedly as none of them came to much. I did not wear their hair-shirt and they died of it. However, Ezra Pound is never this kind of friend in *his* book; he may be so personally."

48. Lollie 6 March 1917.

49. LAG 20 June and 20 Oct. 1917, NYPL.

50. WBY 19 Dec. 1917.

51. Lollie 7 April 1917.

52. EDB 5 April 1917, Princeton.

53. Lollie to JBY 26 May 1917.

54. WBY 11 Jan. 1917.

55. WBY 26 Aug. 1917. He also gave Willie his opinion of one practitioner of free verse which he carefully refrained from uttering among the literati at the Petitpas high table: "I think Amy Lowell a bouncing Amazon intensely clever and imitative. This is confidential, for I would never be forgiven."

56. WBY 29 Sept. 1917.

57. WBY to JBY 14 June 1917 (also in Wade, *Letters*, pp. 626–627).

58. Lollie 1 Jan. 1917.

59. When he finished the first volume he began a second, which he entitled "Memoirs, 1918" (see p. 544).

60. Lily 20 Feb. 1917.

61. WBY 22 Sept. 1918.

62. WBY 20 March 1917.

63. As no manuscript of the printed version of *EM* has turned up, it may be that the book was largely shaped by WBY's editorial hand. I thank George Bornstein for letting me see his unpublished paper, "The Antinomial Structure of John Butler Yeats's *Early Memories: Some Chapters of Autobiography*," in which he recognizes the "tight organization" of the published volume.

64. Q to Lily 19 June 1917. Pound shared some of JBY's preconceptions about Kuhn's work. "Whether the portrait will reconcile your father to *modernestness* in art, I do not know. I don't think Dublin will admire the result, but that does not very much matter" (Pound to Lollie 21 June 1917). The portrait is in the National Gallery of Ireland.

65. Jack 17 Aug. 1917.

66. Robinson (p. 116) gives the author of the play as "A. and O." Gogarty's name doesn't even appear in the index.

67. Lily to JBY 12 Dec. 1917.

68. Lily to JBY 12 Jan. 1917.

69. Lollie to JBY 20 June 1917.

70. Lily to JBY 8 Nov. 1917. Papa's reply to Lily's letter about Henry James has not been preserved, but presumably it resembled the one he wrote to Mrs. Bellinger on 17 Jan. 1918 (Princeton): "Not for a long time have I read anything so interesting, but his sentences sometimes are labyrinths, and sometimes one has to parse them. If Latin is given up at schools and colleges, and teachers look about for some means of teaching grammar, Henry James will serve their purpose. In this book is a long sentence ending in the preposition 'to.' Let the candidate for college honours be required to state what the preposition governs. Some believe that this war is a blessing disguised. It is enough for me that it stopped Henry James in writing a continuation of *The Middle Years*."

71. Lily to Q 10 Dec. 1917 (partly quoted in Reid, p. 310). Reid's comment is worth repeating: "It was a just if partial judgment. John Butler Yeats was one of those men whose practical success always followed behind them, just out of present reach, and whose visible success, splendid but uncountable, lay in the act of humane association."

72. Lily 8 May 1917.

73. Lily 25 Sept. 1917.

74. SM 6 March; Lollie 6 March 1917.

75. VWB [ca. 17 March 1917], "I must write . . ." Pennsylvania; Lily 24 March 1917.

76. JS 14 June 1917, Princeton.

77. JS 14 Aug. 1917, Princeton.

78. Lily 28 Dec. 1917.

79. WBY to LAG 12, 15, and 21 Aug. 1917 (Wade, *Letters*, pp. 628–630).

80. Lily 18 July 1917.

81. Lily to JBY 2 Nov. 1917. WBY wrote JBY a letter dated only "Monday" (probably 8 or 15 Oct.) announcing his plans, and describing his "betrothed" as "comely and joyous & aged but 24." She "has enough money to put us above anxiety & not too much money," Coll.: Foster-Murphy.

82. WBY to Lily 30 Oct. 1917.

83. Lollie 5 Nov. 1917.

84. WBY 6 Nov. 1917.

85. WBY 15 Nov. 1917.

86. Lily 22 Nov. 1917. JBY refers here to Lady Gregory's grandchildren.

87. Lollie 29 Nov. 1917.

88. Q 6 Dec. 1916, NYPL.

89. Lily 24 April 1918.

90. John Quinn, "John Butler Yeats" (unpublished typescript, 1922), p. 5.
91. Lollie 18 Jan. 1918.
92. Q to WBY 15 Sept. 1918.
93. Q to WBY 3 Feb. 1918.
94. Jack 2 Jan. 1918 (misdated 1917).
95. Reid, p. 12.
96. Q to WBY 3 Feb. 1918; Reid, pp. 7, 44, 333, 335, 641.
97. JRF to WMM: conversation; Reid, p. 336.
98. Q to WBY 15 Sept. 1918 (also in Reid, p. 337).
99. Q to JBY 3 Dec. 1918.
100. Q 17 Feb. 1918, Coll.: Foster-Murphy.
101. Q to JBY 3 Dec. 1918.
102. WBY to Lily 10 Jan. 1918. The letter is written from 45 Broad Street, Oxford, and except for the signature is in the hand of George (Mrs. W. B.) Yeats.
103. Q to WBY 3 Feb. 1918.
104. Lily 16 April 1918; Clare Marsh 15 May 1918, TCD; C 25 June 1918.
105. Lollie 10 Feb. 1918.
106. Lollie 21 July 1918.
107. John Butler Yeats, R.H.A., *Essays Irish and American*, with an appreciation by AE (Dublin: Talbot; London: T. Fisher Unwin, 1918). The six essays were "Recollections of Samuel Butler," "Back to the Home," "Why the Englishman Is Happy," "Synge and the Irish," "The Modern Woman," and "Watts and the Method of Art." The Butler piece first appeared in *Seven Arts*, Aug. 1917, pp. 493–501. That on Watts was from a report on JBY's lecture to the R.H.A. in Dublin (incorrectly dated on p. 75 as spring of 1907), the others from *Harper's Weekly* (29 April 1911, pp. 12–13; 13 Aug. 1910, pp. 10–11; 25 Nov. 1911, p. 17; 16 Dec. 1911, pp. 24–25). The six omitted from Mrs. Bellinger's selection were "Outdoors in New York" (*Harper's Weekly*, 19 Nov. 1910, pp. 11–12); "The Differences between Us" (*ibid.*, 11 Dec. 1909, pp. 24–25); "Brutus' Wife" (*ibid.*, 14 Jan. 1911, pp. 14–15); "Can Americans Talk?" (*ibid.*, 6 March 1909, pp. 11–12); "John Sloan's Exhibition" (*Seven Arts*, June 1917, pp. 252–260); and "A Painter on Painting" (*ibid.*, April 1917, pp. 667–680).
108. Lollie 12 Jan. 1918. See Lily 26 Sept., 1916, and p. 448 above.
109. Lily to JBY 13 June; Lollie 24 Sept.; Lily 28 Sept. 1918.
110. Q to Lily 16 Sept. 1918.
111. *Manchester Guardian*, 11 July 1918, p. 3; Lollie 5 Aug. 1918; Ernest Boyd to Lollie [ca. July 1918], "I hope you will arrange . . . " The *Guardian* continued: "[The essays] are light-hearted, discursive, frequently inconsistent, and never dull, and into them flashes now and then a gleam of psychological analysis quite startling in its revealing qualities."
112. *Essays Irish and American*, pp. 7–8.
113. Oliver Elton to JBY 29 Aug. 1918.
114. Elkin Mathews to JBY 29 Aug. 1918.
115. Ernest Boyd to Lollie [ca. July 1918], "I hope you will arrange . . . "
116. Q to JBY 3 Sept. 1918.
117. Q to WBY 7 Aug. 1919. Many of these separate typescripts survive, some virtually duplicating the handwritten material in the notebooks, some quite different.
118. Lily 24 April; Isaac 18 June 1918.
119. C 22 May 1918, Princeton; Lily 24 June 1918.
120. SM 17 June; Isaac 13 Sept. 1918.
121. Lily 20 Jan.; WBY 25 Jan. 1918.
122. Lily 29 May 1918 (part in *JBYL*, p. 247).
123. WBY 10 June 1918 (part in *JBYL*, pp. 247–248, but not what is quoted here).

124. WBY to JBY 14 June 1918 (also in *JBYL*, p. 248, and in Wade, *Letters*, p. 649).
125. Lollie 9 July; LAG 29 July 1918, NYPL.
126. LAG 19 April 1918, NYPL. Lily writes to JBY (17 May 1921) that Lady Gregory spoke at the Mansion House and "was pleased and proud, and that very day Robert was killed."
127. Lollie to JBY 13 March; Lily to JBY 24 May 1918.
128. Q 23 Oct. 1918, Coll.: Foster-Murphy.
129. Q to WBY 20 Dec. 1918.
130. See the account in Elizabeth Coxhead, *Daughters of Erin* (London: Secker and Warburg, 1965), pp. 64–65.
131. Lily to Q 28 Nov. 1918. The letter contains some acid comments about Mme MacBride and her children.
132. Pound to Q 15 Nov. 1915 (Reid, p. 352).
133. LAG 1 April 1918, NYPL. See also SP 7 July 1897, NLI (*LBP*, p. 37).
134. Isaac 28 Jan. 1918.
135. WBY 27 April 1918.
136. Q 17 Feb. 1918, Coll.: Foster-Murphy. This was one of the letters sent to Quinn at the hospital against his express command.
137. Lily 25 Jan.; Isaac 9 March 1918.
138. Q 27 May 1918, NYPL; Dolly Sloan 8 July 1918.
139. I am indebted to Edwin Avery Park for his recollections of his visits to the Petitpas dining room with Paine, his father-in-law, and to Mr. and Mrs. David Park of Williamstown, Mass. Paine was married to (and later divorced from) Frances Bacon Martin, private secretary to Mrs. Joseph Pulitzer.
140. Clare Marsh 27 Jan. 1919, TCD.
141. Lollie 7 April 1918.
142. Lily to JBY 26 April 1918.
143. Q to Lily 20 Nov. 1918.
144. Lily to JBY 11 Nov. 1918: one of those who died was York Powell's daughter Mariella ("Cuckoo") who, unknown to JBY, had been living in New York with her husband Francis Hartman Markoe. (As "Cuckoo" was Powell's only survivor, it is likely that she would have had custody of her father's correspondence—now lost, including JBY's letters to him. Her husband remarried. His stepdaughter, Mrs. Don Orlando Cord, tells me she has no knowledge of the Powell material, and I suspect there is little chance of its turning up. I am indebted to my classmate Francis Markoe Rivinus for putting me in touch with members of his family.)
145. Q to Lily 20 Nov. 1918.
146. Isaac 18 Dec. 1918; Q 12 Dec. 1918, NYPL; Q 11 Dec. 1918, Coll.: Foster-Murphy; Lily 19 Feb. 1919; JRF to Q 20 Nov. 1918.
147. C. Finch-Smith to Q 21 and 19 Nov. 1918.
148. Q to Lily 20 Nov. 1918.
149. Q to JBY 21 and 22 Nov. 1918.
150. Q to Lily 25 Nov. 1918.
151. Q 11 Dec. 1918, Coll.: Foster-Murphy.
152. Q to JBY 10 Dec. 1918.
153. Q to JBY 13 Dec. 1918.
154. Lily to JBY 28 Sept. 1918.
155. Frank Yeats 8 Sept. 1920, Coll.: Harry Yeats.
156. Lily to JBY 22 Sept. 1918. See also my "Psychic Daughter, Mystic Son, Sceptic Father," *Yeats and the Occult*, ed. George Mills Harper (Toronto: Macmillan of Canada, 1975), pp. 11–26.
157. SM 27 Aug. 1918.

158. Isaac 21 Sept. and 7 Nov. 1918.

159. Lily 18 Dec. 1918.

160. JS 25 and 26 Dec. 1918, Princeton; VWB 26 Dec. 1918, Pennsylvania; Padraic Colum 3 Dec. 1918, NYPL; C 31 Dec. 1918, Princeton.

161. Q 6 Jan. 1919, NYPL.

162. Q to JBY 6 Jan. 1919.

163. Lily 16 Jan.; LAG 12 June, NYPL; Lollie 7 July 1919.

164. LAG 12 June, NYPL; Lily 13 April; Jack 5 Feb.; Lollie 3 April; Robert Henri 19 June 1919, Yale.

165. Lily 9 and 24 April 1919.

166. Q to WBY 4 April 1919.

167. Q 15 Jan. 1919 (*JBYL*, pp. 258–259). I have not seen the original.

168. John Quinn, "A Scenario of an Unfinished Novel by Henry James, Entitled 'The Deferred Return,' or 'The Return Deferred' " (unpublished, original typescript in the Foster-Murphy Collection). I thank Dr. Thomas F. Conroy for permission to quote from this document.

169. WBY 12 Feb. 1919.

170. Q 4 April 1919 (quoted from *JBYL*, p. 262).

171. Q 19 Oct. 1918 (quoted from *JBYL*, p. 252).

172. Q [ca. April 1919] "All thro' the worst part of my illness . . . " Because of the first sentence and the letter's connection with JBY's letter of April 4, I estimate a date between April 5 and April 12, though it may not have been sent until some time later. Perhaps the absence of a date, uncharacteristic in a JBY letter, suggests that he intended holding on to it until he thought the time right for it, or until he had the courage to send it. There is also, of course, the distant possibility that he never sent it, especially as it survives among Michael Yeats's family papers. The letter itself could not be the "suppressed chapter," which, JBY tells us, was written before his illness.

173. Lollie 12 June 1919.

174. Lily 17 May 1919.

175. Q to JBY 19 May 1919 (quoted from Reid, p. 390).

176. Q 19 Jan. 1919, NYPL.

177. WBY to Q 21 Jan. 1919 (quoted from Reid, p. 388).

178. WBY to JBY n.d., ca. 1 Sept. 1919, "When do you . . . "

179. Holloway, 22 Jan. 1919, p. 202.

180. AE to Q 10 July 1919 (Reid, pp. 386–387).

181. Pound to Q 13 Dec. 1919 (*ibid.*, p. 389).

182. W. B. Yeats, *A Vision* (New York: Macmillan, 1938). In the Introduction, section V (p. 12), WBY directly implicated his father in the genesis of the work: "Apart from two or three of the principal Platonic Dialogues I knew no philosophy. Arguments with my father, whose convictions had been formed by John Stuart Mill's attack upon Sir William Hamilton, had destroyed my confidence and driven me from speculation to the direct experience of the mystics."

183. Holloway, 9 Dec. 1919, p. 206. See JBY to SP 7 July 1897, NLI (*LBP*, p. 37), in which he calls *The Shadowy Waters* "absolutely unintelligible."

184. Lily to JBY 25 Feb. 1919. Anne was born the following day.

185. Q 1 Feb. 1919, Coll.: Foster-Murphy.

186. Lily 15 March 1919.

187. Lollie to Prof. Alfred De Lury 5 March 1919, Toronto.

188. Lily to JBY 20 April 1919. The poem, "A Prayer for My Daughter," first appeared in the *Irish Statesman*, 8 Nov. 1919, and in *Poetry* (Chicago), Nov. 1919 (Wade, *Bibliography*, p. 131).

189. Leonard Elton to WMM: conversation.

190. WBY to Q 11 July 1919 (Wade, *Letters*, p. 659).

191. See *Thor Ballylee—Home of William Butler Yeats* (Dublin: Dolmen, 1965), edited by Liam Miller from a paper given by Mary Hanley to the Kiltartan Society in 1961, with a foreword by T. R. Henn.

192. See George M. Harper, *"Go Back to Where You Belong": Yeats's Return from Exile* (Dublin: Dolmen, 1973).

193. WBY to JBY [ca. 16 July 1919], "The enclosed letter . . . "

194. Lily 9 April 1919.

195. Lollie 8 April 1919.

196. *Ibid.*

197. Lily to JBY 18 Dec. 1919. There are at least two surviving copies of the talk, both in Miss Mitchell's handwriting. One, on separate sheets of paper, perhaps the copy from which she read, is in the County Sligo Museum: I am grateful to Nora Niland for providing me with a reproduction of this copy. The other is in a small notebook in the collection of Michael Yeats. It does not differ in any significant detail from the Sligo copy.

198. Q to WBY 4 April 1919, postscript, handwritten.

199. Q 21 Aug. 1919, NYPL.

200. Q to JBY 19 Sept. 1919.

201. Q to JBY 26 Sept. 1919.

202. Q to WBY 4 April 1919.

203. Q to Lily 18 Aug. 1919.

204. Q to WBY 4 April 1922.

205. Q to WBY 4 April 1919.

206. Q to JBY 3 April and 6 Aug.; Q to Joseph Conrad 28 April (Reid, p. 385); Q to WBY 7 Aug.; Q to Lily 18 Aug. 1919.

207. Q to JBY 25 June 1919.

208. Lily 9 July 1919.

209. Q to JBY 19 Sept. 1919. The judge was Samuel Seabury.

210. Q 18 Aug. 1919, NYPL.

211. Jack 22 Nov. 1919.

212. Lily 1 Oct. 1919.

213. The sketch passed from Quinn to Mrs. Foster, who bequeathed it to WMM. It is now part of the Foster-Murphy Collection. Perhaps this is one of the two Quinn ordered for twenty-five dollars each, total payment to be made on delivery of them *and* the self-portrait (Lollie 12 June 1919). This sketch hung in the Bicentennial Exhibition at the National Portrait Gallery of the Smithsonian Institution in 1976. It is reproduced in Marc Pachter and Frances Wein, eds., *Abroad in America* (Reading, Mass.: Addison-Wesley, 1976), p. 260.

214. Jack 4 Jan. 1919.

215. Q 15 and 26 Jan. 1919 (quoted from *JBYL*, pp. 258, 260).

216. Lily 16 Jan.; MFB 22 Sept. 1919, Princeton.

217. JRF 11 Feb. 1919, Coll.: Foster-Murphy.

218. WBY 12 Feb. 1919.

219. WBY 8 May 1919.

220. JS to Q 20 Dec. 1919 (Reid, p. 389). Quinn paid the dentist's bill of two hundred dollars.

221. Q to WBY 20 May 1919.

222. Jack 5 Feb.; MFB 31 July 1919, Princeton.

223. Lily 9 and 12 April 1919.

224. Lily 19 March 1919.

225. Q to Lily 10 Jan. 1920.

226. Lollie 5 Nov.; Ann Squire 27 Nov. 1919, Princeton.
227. Dr. C. C. Rice to Q 6 Nov. 1919.
228. Lily 22 Oct.; JRF 29 Dec. 1919, Coll.: Foster-Murphy.
229. Jeanne Robert Foster, "John Butler Yeats: Alas, for the Wonderful Yew Forest," *New York Times*, 6 Feb. 1922; reprinted in James White, *John Butler Yeats and the Irish Renaissance* (Dublin: Dolmen, 1972), pp. 31–32.

Chapter Seventeen: 1920–1922

1. C 5 Jan. 1920 (misdated 1919), Princeton.
2. Lily 11 Jan.; Jack 18 Jan. 1920.
3. Lily 26 Jan. 1920.
4. Q to Lily 25 Jan. 1920.
5. Lily 26 Jan. 1920.
6. Isaac 2 Feb. 1920.
7. Program, Annual Dinner, Poetry Society of America, Hotel Astor, Thursday, 29 Jan. 1920; Mrs. William Butler Yeats's copy in the collection of MBY. Beside "Table 21" George wrote: "Mrs. Foster and JBY came together, John *Quinn* absent!" One wonders at the exclamation point. Perhaps George Yeats had already heard of the growing ascendancy of Mrs. Foster over Dorothy Coates and wondered whether Quinn's absence was a delicate way of avoiding public pronouncement of his new association. The real reason, however, was simpler and more innocent. Mrs. Foster, as a member of the Society, had bought the tickets and invited Quinn and JBY. Quinn had to beg off at the last moment because he was involved in a legal case, one of the biggest of his life, and told her it was "going wrong" (Lily 30 Jan. 1920). It was the celebrated Botany Mills case, involving the Alien Property Law and the devious attempts by German owners to disguise their title to the company. Quinn won the case after a protracted struggle (Reid, pp. 458–460). Padraic Colum, whose name did not appear on the program, sat at Table 27.
8. Lily 10 June 1920.
9. Lollie 13 Feb. 1920.
10. Lily 15 Feb. 1920.
11. Lily and Lollie 13 April 1921.
12. Isaac 8 Feb. 1920.
13. Lily 15 Feb. 1920.
14. MFB 5 Feb. 1920, Princeton.
15. Lily 27 Feb. 1920, no. 1; "I enclose . . . "; Jack 28 Feb. 1920.
16. In Seattle, WBY was approached by a "Johnnie Yeats," grandson of the John Yeats born in 1808 (next younger brother to the Reverend William Butler Yeats), who had been county surveyor of County Kildare. "Johnnie" was the son of another John Yeats, who had died in 1908 in Winnipeg. He showed a coat of arms to prove his connection with the family. "Willie said he was a very nice fellow," Papa wrote Lily. "I would like to meet him, or for that matter any Yeats anywhere. I love the whole breed" (Lily 1 May 1920).
17. Q to WBY 29 April 1920. When they accepted his offer and arrived a few days later, Mrs. Foster was present in the apartment. Perhaps because Miss Coates had been reigning "hostess" when WBY had visited him last, or perhaps for more obscure reasons, Quinn shoved her into a closet, to be presented later when they emerged from their room (Reid, p. 415). The closet adjoined their room, and Mrs. Foster heard a mild debate—not an argument, as she put it, but a lively discussion—about whether they should have another child. Willie seemed reluctant, but George was insistent that they should. Apparently George won the argument, for seventeen months later their son

Michael was born (JRF to WMM: conversation; Mrs. Foster also told the story to Michael Yeats himself and his daughter Caitríona).

18. Lollie 18 May 1920.

19. Q to WBY 13 Sept. 1920. That Willie had made new, positive assurances to his father is made clear by a remark JBY made to his cousin Frank: "Willie has become so well off that he guarantees all my expenses, though I still try to pay them all myself" (15 Feb. 1920).

20. Lily 29 May 1920. There is no information on the success of the scheme. WBY earned $944 from his Texas talks alone (Q to WBY 1 May 1920).

21. Lily to JBY 12 June 1920.

22. Isaac 26 Oct. 1920. Later, when the Yeatses lived at Ballylee, Lady Gregory quietly chided George for inviting the curate to dinner. "You have the rector for lunch, the curate to tea, and the bishop to dinner," advised the proper Lady of Coole. George continued to invite the curate because he was more interesting and intelligent than the rector or the bishop (ABY to WMM: conversation).

23. Lollie 7 July 1920.

24. George Yeats 18 March 1920.

25. Of the total sum, $100 came from Quinn for the purchase of five drawings; another $40 came for 8,000 additional words of memoir; and Lollie sent in advance the complete royalty of the new Cuala edition of his letters amounting to £26.12 (Lollie 17 April 1920). There were also small sums from the *Irish Statesman* and a two-pound honorarium from Lady Gregory for his help with her memoir of Hugh Lane.

26. Lily 27 July; JS 4 Sept. 1920, Princeton. Whether such a financial feat was possible was open to question. "Some are scornful and others believe," JBY commented to Sloan.

27. Lily 27 July 1920.

28. Isaac 2 Feb. 1920.

29. Lily 27 July 1920.

30. George Yeats 16 Aug. 1920.

31. JS 4 Sept. 1920, Princeton.

32. Lily 28 Aug. 1920.

33. Q to WBY 13 and 21 Sept. 1920.

34. WBY to Q 30 Oct. 1920 (Wade, *Letters*, pp. 663–664).

35. Q to WBY 6 Oct. 1920. That JBY still retained his sense of humor is evidenced by a letter he wrote Quinn containing a sketch of the landlady stepping from the bath, almost nude, with hand extended to grab the money.

36. WBY to JBY 27 Oct. 1920.

37. WBY to JBY 9 Nov. 1920.

38. Joseph Hone, "Memoir," *JBYL*, p. 44.

39. Frank Yeats 8 Sept. 1920, Coll.: Harry Yeats. "His mind is as bright as ever," Quinn admitted to Lily, "and his spirit the most indomitable of any man I ever knew, and his sense of humor has not dulled a bit" (Q to Lily 10 Jan. 1920). JBY told her (8 Oct.) that he was "in the best of spirits and the best of good health."

40. Lily 15 Feb.; Lollie 5 April; Lily 6 April; Isaac 4 May 1920.

41. Lily to JBY 13 July and 30 Sept. 1920.

42. Lily 24 March; Lily to JBY 9 Dec. 1920.

43. Lollie to JBY 28 Oct. 1920.

44. Lily to JBY 23 Nov. 1920.

45. Lily 1 May 1920.

46. Lollie to JBY 9 March 1920; SM 19 June 1920. Lollie at first thought the *Homestead* review had been written by AE.

47. Lollie 17 April and 18 May 1920.

48. Lollie to JBY 4 June 1920.

49. Lollie 5 July 1920 (quoted from *JBYL*, p. 270).

50. The Foster copy was given by JRF on 19 Jan. 1958 to WMM and is now part of the Foster-Murphy Collection. The Sloan copy, owned by Helen Farr Sloan (John Sloan's second wife), is on permanent loan at the University of Delaware.

51. Lily to JBY 30 June 1920.

52. Lollie to JBY 24 May 1920.

53. Lily to JBY 23 Nov. 1920.

54. Lily to JBY 15 Aug. 1920.

55. Lily to JBY 18 Aug. 1920. The two poets had little chance to talk to each other, only a few minutes together on the sofa while all were having tea. The whole Bridges family was there, including a married son and a daughter who was "delicate and rather lifeless." She was in love with a Persian, according to Lily, "and her father will have none of it." It was, Lily declared, "all very agreeable and friendly and unstimulating."

56. See p. 544 for a description of Lily's notebooks.

57. Lily 19 Aug. 1920.

58. John Butler Yeats, "Petitpas Memories," in the *Literary Review* of the *New York Evening Post*, 2 April 1921, section 3, p. 1. Next to JBY's article is Stephen Vincent Benet's poem "Nomenclature."

59. Q 15 Jan. 1920, NYPL. By mid-September of 1920 he had added about 8,000 words to the product of earlier years. Quinn sent the last section of twenty-nine typewritten pages to Willie and added that his father had a little more typewritten and some in manuscript.

60. Q to WBY 13 Sept. 1920.

61. Lily 6 Aug. 1920.

62. JS 8 Aug. 1920, Princeton.

63. JS [ca. 4 Sept. 1920], "Why does a painter . . . "; Princeton.

64. Lollie 29 Aug.; Q to WBY 13 Sept. 1920 (JBY's comment was included in this letter).

65. Lily 6 April 1920. He found Kuhn pleasant enough, with an amiable smile always on his smooth German face, but "he bores me to death, for he is constantly talking and is quite without intellect, though Quinn thinks him the greatest of American artists" (Lollie 5 April 1920).

66. Q 25 Dec. 1920, NYPL. Reid quotes extensively from this letter and comments on the last sentence quoted here: "It was the most penetrating of J. B. Yeats's many insights into art and life, and he did well to italicize it: it was worth eighty-two years of work and thought. The sketch which was not a beginning but an end, the *sprezzatura* of careless absoluteness which is the finality of form—it was the vision of great art which his own art approached only at its rare best, but which was expressed by his whole beautiful personal presence, at once dense and fluent, tough and warm, coevally finite and infinite. What he was trying to describe, as he clearly saw, was the collision of two kinds of taste, traditional and experimental, classical and romantic, his own and Quinn's" (pp. 429–430).

67. JS 9 June 1920, Princeton.

68. Lily 8 Dec. and 29 April 1920; Jack 16 March 1920.

69. The epigram appears in several letters, among them SM 19 June 1920.

70. WBY 9 Jan. 1920, or so the date appears on the letter, part of which (but not what is quoted here) is printed in *JBYL*, p. 267. As Willie was already at sea on 9 Jan. 1920, it is likely that the letter was written in 1921, joining many other January letters in which the date is a year off.

71. WBY 30 May 1920.

72. George Yeats 1 Nov. 1920.
73. Lily 24 Aug. 1920.
74. The story of Quinn's fight is summarized in Reid, pp. 440–457.
75. LAG 14 Aug. 1920, NYPL.
76. Q 14 Oct. 1920, NYPL. Also published as "A Letter: J. B. Yeats on James Joyce," edited by Donald T. Torchiana and Glenn O'Malley, *Tri-Quarterly*, fall 1964, pp. 70–76.
77. Reid, pp. 454–455.
78. Lily 11 Jan. and 24 March 1920.
79. Q to JBY 23 March 1920. The letter he replied to was Q 14 March 1920, Coll.: Foster-Murphy.
80. Lily 14 Nov. 1920.
81. SM 19 June 1920.
82. Prof. Alfred De Lury 21 Jan. 1921, Toronto.
83. Padraic Colum accepted the poem for *Measure* but upset JBY by changing the author's word "wisdom" to "freedom." When Van Wyck Brooks published "A Dialogue in Heaven," he changed JBY's "pleasure" to "joy," a word JBY characterized as the "silliest" in the English language. Fortunately, he caught the change in proof and it was corrected in the final version.
84. Alan Denson, *Letters from AE* (London: Abelard-Schuman, 1961), p. 260, where Denson also includes a passage from JBY's letter to her of 21 Oct. 1912. Susan Mitchell's book was *George Moore* (Dublin: Maunsel, 1916).
85. George Moore had not endeared himself to his countrymen by his poorly disguised feelings about them. When the American Philip Darrell Sherman, preparing a lecture on Ireland, asked Moore what he thought was the difference between the Ireland interpreted by "Yeats and the Abbey Theatre" and "the Ireland interpreted by George Birmingham (James O. Hannay)," Moore replied, "Neither one nor the other, in my opinion, bears any relation to the real Ireland, a smug little country, grey and foolish." He recommended his own *The Untilled Field* as an accurate picture of the country (George Moore to P. D. Sherman 14 April 1920, Brown).
86. MFB 31 Aug. 1921, Princeton.
87. *Dial*, Sept. 1921, pp. 351–354.
88. MFB 31 Aug. 1921, Princeton; SM 28 Aug. 1921.
89. SM to JBY 12 Sept. 1921. Two weeks later he replied (24 Sept.): "Moore is one of those unhappy people who have no friends. On the Judgment Day the recording angel will call out, 'Who speaks for this man?' And no man will answer."
90. Lollie to JBY 24 May, 16 Feb., and 10 May 1921.
91. Lily to JBY 23 Jan. 1921.
92. Lollie to JBY 8 March 1921.
93. Lollie 25 Jan. 1921. The invitation was extended in January; the visit took place on 5 April.
94. Lily 6 April 1921. A further account appears in Q 4 May 1921, NYPL.
95. C 15 April 1921, Princeton.
96. Q 4 May 1921 (typed copy), Coll.: Foster-Murphy.
97. WBY 23 Feb. 1921.
98. *New Republic*, 9 March 1921; Wade, *Bibliography*, no. 132, p. 134.
99. Q 13 March 1921, Coll.: Foster-Murphy.
100. Q 4 May 1921 (typed copy), Coll.: Foster-Murphy. He expresses the same idea in WBY 14 March 1921.
101. Lily 7 May 1921.
102. VWB 3 Oct. 1921, Pennsylvania.
103. John Quinn, "John Butler Yeats" (unpublished typescript, 1922), p. 45. Quinn

called Mrs. Becker "a self-seeking, neurotic wasp of a woman," and wouldn't allow her name to be uttered in his presence. "Everyone likes her husband," JBY told Jack. "Her only bad trait is that she likes to get something for nothing" (Jack 3 April 1921).

104. LIly 20 April 1921.

105. WBY to Lily 21 June [1921].

106. Lollie to JBY 29 May 1921. It was a "dreadful" thing to see, Lollie wrote. Lily told Papa (30 May) that the job itself was simple, at least as they heard the story. There was but one policeman on guard. The Sinn Feiners "just walked in, sprinkled petrol and set it on fire—no one to stop them."

107. WBY 28 May 1921 (also in *JBYL*, pp. 276–277).

108. Q 19 Feb. 1921, NYPL.

109. WBY 10 March 1921.

110. WBY to George Russell 29 March [1921] (Wade, *Letters*, p. 667).

111. WBY to Lily 25 Jan. 1921.

112. Lollie 25 July 1921.

113. WBY to Lollie 23 Dec. 1921.

114. Lollie 2 Jan. 1921. He made many complaints about his health in the space of a few months; e.g., Lily 22 Jan., Jack 1 Feb., Lollie 14 Feb., Isaac 17 Feb., and George Yeats 19 March 1921.

115. At the end of the summer he bought a fresh bottle of cheap ink of a pale blue color that faded with time, and many of the letters written after 21 Sept. are virtually illegible. He often omitted words completely, or repeated them, or made use of the wrong word. For example, in one letter (Lily 6 April 1921) he wrote: "I am get lots of congratulations," and later, "I am been a good deal out of sorts lately."

116. Ezra Pound to WMM: conversation, Venice, 15 June 1966.

117. Quinn, "John Butler Yeats," pp. 11–12.

118. George Yeats 28 Oct. 1921.

119. *Dial*, LXXI (July 1921), p. 80; *Four Years* (Churchtown: Cuala, 1921), p. 46; *Autobiographies*, p. 154.

120. WBY 24 June 1921.

121. WBY 25 June 1921. Part of the letter, but not what is included here, appears in *JBYL*, p. 280.

122. Lollie 29 June 1921.

123. WBY 30 June 1921, no. 3, "When is your . . ." (also in *JBYL*, pp. 280–282).

124. WBY to Lollie 8 July 1921. The Cuala edition reads "troubled" (p. 46), as does the final *Autobiographies* (p. 154). Willie preferred to let Lollie take up the dispute with her father if she wished: "You can tell JBY that the published parts are not all, that I have written much more which cannot be published during my lifetime, and that this does not give an unfriendly account of any of you. . . . I cannot write of living people for publication except in the most cursory way. I cannot write of anyone, much less of my family, if I have to think of any point of view but my own and making that just in my own eyes" (WBY to Lollie 13 July [1921]).

125. Lily to JBY 23 Aug. 1921. Her implied hope was realized. Michael Yeats married Gráinne ní Éigeartaigh (daughter of P. S. O'Hegarty, the Irish nationalist and head of the Postal Service in the Free State, and noted bibliographer). Their children are Caitríona Dill (b. 1951), Siobhán Maire (b. 1953), Síle Áine (b. 1955), and Pádraig Butler (b. 1959).

126. WBY 23 Aug. 1921.

127. WBY to Lollie 23 Sept. 1921.

128. From *The Aftermath*; quoted in Earl of Longford and Thomas P. O'Neill, *Eamon de Valera* (Dublin: Gill and Macmillan, 1970), p. 129.

129. C 15 Aug. 1921, Princeton.

130. Q to WBY 5 June 1921.
131. WBY 13 June 1921.
132. Q to WBY 5 June 1921.
133. C 26 June 1921, Princeton; Q to JBY 30 Nov. 1921.
134. Q to WBY 24 June 1921. Q was repeating JRF's account of JBY's observations.
135. Lily 26 Aug. 1921; MFB 31 Aug. 1921, Princeton.
136. Lily 3 Sept. 1921; Q to WBY 6 Sept. 1921.
137. Lily 3 Sept. 1921; Q to WBY 19 Sept. 1921.
138. Lily 3 Sept. 1921.
139. WBY to JBY 25 Sept. [1921], "I have received . . . "; Wade dates the letter as 1920, but it seems to me the later date is more reasonable. Wade's date is marked in his hand on the original.
140. WBY to JBY 30 Sept. 1921.
141. WBY to Q 30 Sept. 1921 (quoted from Reid, pp. 493–494).
142. Lollie called him "a heart-breaking father," and reminded him of the renovated mattress, costing three pounds, which they were saving for him. She even promised that she herself would be better company than she had been fourteen years before, as she was "not so irritable" (19 Sept. 1921). But he kept insisting he needed just a few more months for the portrait and some fresh commissions, and he even sent Susan Mitchell so many letters that George Russell was convinced he was preparing the way for his arrival. She sent Russell JBY's letter to her of 1 Oct., and on the back of the envelope he wrote before returning it, "Old JBY is working off arrears of correspondence before he comes back. He knows, once he is here, he won't be able to write and can only talk. Three letters in two days is very heavy traffic for transatlantic liners."
143. MFB 10 Oct. 1921, Princeton.
144. WBY to JBY 29 Oct. 1921.
145. Q to JBY 22 Nov. 1921.
146. Q to WBY 26 Nov. 1921.
147. *Ibid.*
148. Q to WBY 28 Nov. 1921 (postscript to letter of 26 Nov.).
149. Q to JBY 30 Nov. 1921. A rumor grew in New York and spread among JBY's friends, even John Sloan, that the old man had kept redeeming the deposits left at Cunard for the sailings Quinn had scheduled for him. But the evidence is clear that no such thing happened. Only one deposit was ever made, and that went directly back to Quinn. Quinn may have found legitimate ways of giving money indirectly to the old man—by ordering sketches he didn't really want, for example—but neither he nor John Butler Yeats was so devious as to engage in the redemption of ticket deposits.
150. Q to WBY 2 Dec. 1921; MFB 3 Dec. 1921, Princeton.
151. WBY 11 Oct. 1920.
152. Edward Caughey 28 Dec. 1921, Princeton.
153. Lollie 30 Dec. 1921.
154. Frank Yeats 23 Dec. 1920; Coll.: Harry Yeats.
155. Lily 4 Jan. 1922.
156. JRF 12 Jan. 1922, Coll.: Foster-Murphy.
157. Quinn, "John Butler Yeats," p. 3. Quinn repeated what Mrs. Foster told him. JRF told the same story to WMM.
158. SM 10 Jan. 1922.
159. See the full account in Longford and O'Neill, *Eamon De Valera*, pp. 157 ff.
160. Lily to JBY 10 Jan. 1922.
161. Lily to JBY 18 Jan. 1922.
162. Lollie 23 Jan. 1922.
163. Lily 4 Jan. 1922. JBY should have been comforted by Lily's remark to him in

her letter of 17 Dec. 1921 (it may also relieve the insecurities of a generation of Yeats scholars): "George Yeats writes to no one. She is the worst correspondent I know." In her later years, especially after her husband's death in 1939, and increasingly toward the last decade of her life (1958–1968), George Yeats was so overwhelmed by correspondence, usually involving requests for materials, reminiscences, and the like, that she stopped answering letters altogether. At the very last she refused even to open her mail, and tax notices, royalty checks, and requests from Ph.D. candidates and would-be biographers were alike ignored.

164. VWB 6 Jan. 1922, Pennsylvania.

165. Quinn, "John Butler Yeats," p. 7.

166. EDB 20 Jan. 1922, Princeton; Q 26 Jan. 1922, NYPL.

167. Q 26 Jan. 1922, NYPL; Quinn, "John Butler Yeats," pp. 21–26.

168. Lollie 24 Jan. 1922 (misdated 23).

169. Q 24 Jan. 1922, NYPL; Quinn, "John Butler Yeats," p. 22. Jeanne Foster had sent him a copy of Miss Lowell's poems the week before, and he had written of them: "she is to be read with enthusiasm for she is inspired by enthusiasm. . . . The true poets are read, it seems to me, with a different feeling" (JRF 18 Jan. 1922, Coll.: Foster-Murphy).

170. Lollie 24 Jan. 1922 (misdated 23).

171. Quinn, "John Butler Yeats," pp. 16–20.

172. MFB 28 Jan. 1922, Princeton.

173. Mary Colum to Lily 6 Feb. 1922. Mrs. Colum's account is somewhat confused, as she got it at second hand. The accounts of Mrs. Foster (particularly her letter to WBY of 5 Feb. 1922) and Quinn (in "John Butler Yeats") are more reliable.

174. JRF to WBY 5 Feb. 1922.

175. Lily 1 Feb. 1922.

176. Mary Colum to Lily 6 Feb. 1922.

177. JRF to WBY 5 Feb. 1922.

178. Quinn, "John Butler Yeats," p. 30.

179. *Ibid.*, p. 40.

180. *Ibid.*, pp. 54–55.

181. WBY [ca. 1 June 1906], "Miss Tobin is a princess . . . " (quoted from *JBYL*, p. 91).

182. WBY 30 May 1920.

183. WBY 21 Dec. 1914.

184. Mary Colum to Lily 6 Feb. 1922.

185. Q to WBY 4 April 1922.

Epilogue

1. JRF to WBY 5 Feb. 1922; Lily to WBY 23 Feb. 1922. See also Reid's account of the funeral and burial, pp. 524–526.

2. See Caroline Fish, "Rediscovered in Chestertown," *Adirondack Life*, I, no. 4 (fall 1970), pp. 30–31, 42–43.

Mrs. Foster was buried between the graves of her husband and John Butler Yeats on September 26, 1970. She retained her belief in theosophy to the end, and in the meaningfulness of apparently accidental circumstances. The last person she met before she died on September 22, at the age of 91, was Dr. Oliver Edwards, friend of WBY and Lily; the last person to view her collection of JBY's portraits and other Irish memorabilia before they were removed from her home was A. Norman Jeffares,

biographer of WBY. At her funeral, pallbearers included Benjamin L. Reid, biographer of John Quinn, and William M. Murphy, biographer of John Butler Yeats. She would have thought none of these coincidences coincidental.

 3. Reid, pp. 630, 647 ff.

Index

Numbers in boldface refer to the illustrations.

Abbey, Players, 301–302, 308, 313, 345, 388–391, 400–402, 405, 412, 522; sketches by JBY, 390, **406**, 584, 597, 619

Abbey St. (Dublin), 269, 453

Abbey Theatre (*see also* Irish Literary Theatre, Irish National Theatre Society, Ormonde Dramatic Society, W.G. Fay's Irish National Dramatic Company), 190, 194–195, 209, 211, 218, 223, 229, 245, 255, 269–270, 276–278, 280, 288, 290, 292, 298, 301–302, 307, 314–318, 320–321, 331, 345–348, 362, 374–375, 382, 388, 398–401, **406**, 410, 440, 474, 483–484, 495–496, 593, 597–598, 603, 605–606, 628, 645

Abbey Theatre Directors (WBY, LAG, JMS), 296, 302, 313–314, 316, 318, 331, 374–375, 606, 608

Abroad in America (ed. Pachter and Wein), 607–608, 610, 641

Acton, 157, 586

Acton Rural Cemetery, 215

Adam, Villiers de L'Isle, 191

Adams, Dr., 536–537

Adams Gallery (Dublin), 602

Address Delivered before The Law Students' Debating Society of Dublin, An (JBY), 46–49, 463

"Advice from John Butler Yeats" (poem, J. R. Foster), 629

AE: *see* Russell, George

Agricultural & Technical Instruction, Department of, 266

Aiken, Conrad, **363**, 364, 367, 463, 614

"Aid to Personal Religion Afforded by Mental Science" (John Dowden), 553

Albright-Knox Gallery (Buffalo), 618

"Aleel" (in *The Countess Cathleen*), 209

Alexandra College (Dublin), 56, 60, 139

Algonquin Hotel (New York), 505, 508

Alien Property Law (U.S.A.), 642

All Ireland Review, 245

"All Souls' Night" (WBY), 524–525

Allgood, Molly: *see* O'Neill, Maire

Allgood, Sara, 292, 296–299, 301, 319, 345,

406, 619

Allingham, William, 287

"Alphabet, An" (WBY), 472, 481

America (Americans), 325, 344, 349–350, 352, 361, 372, 400–401, 411–412, 427–428, 453, 457–459, 461, 465, 466, 474, 507, 517, 524, 540, 620

America (journal), 576

Amherst College, 260, 419

An Claidheamh Soluis, 244

Analogy of Religion, The (Bishop Joseph Butler), 31

Ancient Order of Hibernians (A.O.H.), 312, 317, 350, 363

Anderson, Julia Quinn, 348, 417, 445, 624

Anderson, Mary, 363, 417, 445, 615, 624

Andrews, Paul, 629

Anglo-Irish, the, 21, 23, 32–33, 54, 91, 96, 113, 121, 125, 149, 169, 194, 196, 249, 252, 280, 301, 371, 548, 569

"Annals of W. B. Yeats" (Oliver Edwards), 596

Antient Concert Rooms (Dublin), 209

Aran Islands, 194, 255, 257, 269

Aran Islands, The (J. M. Synge), 607

Archibald, Douglas, 581, 584–585, 600

Ardilaun, Lord and Lady, 209

Argyll Road (London), 60–61, 105

Armory Exhibition, 359, 392, 401–404, 410, 427, 619, 621–622

Armstrong, Grace, 21

Armstrong, John, General, 21

Armstrong, Laura (*see also* "Vivien" *and* "Margaret Leland"), 46, 132–133, 568–569, 573

Armstrong, Richard, Sergeant, 132, 569

Armstrong, Robert (father of Grace Armstrong Corbet), 21

Armstrongs, the, 554

Armstrong, Sir Walter, 237, 277, 348

Artisan Drilling Co. (Dublin), 583

Artists and Architecture of Bedford Park (ed. Mark Glazebrook), **155**, 578

Artists' Evening (lithograph by George Bellows), 429, **431**, 627

Arts Club (Dublin), 490, 510
Ashbourne Act, 151
"Ashcan School," 359, 403
Ashfield Terrace, No. 10 (Terenure), 135, 140
Association of American Painters & Sculptors,
 402
Astor, Hotel, 505
Astor Library, 341, 367
"At Parting" (Katharine Tynan), 574
At the Hawk's Well (WBY), 481
Atalanta, 154
Atholl Academy, 27–29, 31, 79, 95, 215, 473,
 550, 556
"Audi Alteram Partem" (pseudonym for JBY),
 281
Auditor's Address (talk by JBY), 40, 45–49
Autobiographies (WBY), 646
"Autumn" (JBY), 522, 528, 536
Ave (George Moore), 383
Axel (Villiers de L'Isle Adam), 191
Ayre, Jack, 569

Bachelors Walk, 423, 455
"Bachelors Walk: In Memory" (Jack Yeats),
 455
"Back to the Home" (JBY), 638
Bailey, W. E., 232, 452
Baker, George Pierce, 405
Bakunin, Mikhail, work of, 371
Balfour, Arthur, 474, 562
Ballina (Co. Mayo), 79, 92, 578
Ballisodare (Co. Sligo), 91
Ballykilbeg House, 167
Ballylee, Thor (Gort) 454, 496, 643
"Balscadden Cottage" (Howth), 123
Banshees, 105, 137, 376
Barnard College; 350
"Barrel Man, The" (painting by Jack Yeats),
 621
Barry, Rev. Dr. William, 211
Bath Road (Bedford Park), 118
Beach, Sylvia, 538
Beaconsfield, 426
Beattie, Mrs. (fortune teller), 335, 390, 619
Beatty, Dr. Thomas, 45, 554
"Beautiful Lofty Things" (WBY), 317
Becker, Alfred Le Roy, 646
Becker, Eulabee Dix, 342, 369, 387, 392,
 398–400, 426, 441, 446, 457, 462, 463, 471,
 525, 535, 614–615
Bedford Gardens (London), 565
Bedford House, 117
Bedford Park (*see also* Blenheim Road *and*
 Woodstock Road), 117–118, 122, 151, 154,
 155, 157–158, 166, 168–169, 171–172, 174,
 180, 182, 184, 196, 204, 208, 217, 219, 224,
 231, 237, 276, 321, 346, 527–528, 560, 566,
 573, 575, 580

Beech Villa, 110
Beecham, Thomas, 628
"Beechwood, The" (painting by JBY), 232
Beekman Place (New York), 425
Beerbohm, Max, 507, 630
Belfast, 150, 196, 404–405, 407
Bell, Eric (and family), 364, 387, 390, 392,
 468, 514, 614
Bellinger, Dr. Frans, 387, 445, 507–508, 525
Bellinger, Martha Idell Fletcher (Mrs. Frans),
 387, 399, 445, 455–456, 463, 466–467, 481,
 487, 501, 507–508, 523, 525, 530, 533, 536,
 588, 635, 637
Bellingham, Mrs., 237
Belloc, Hilaire, 426
Bellows, George, 17, 402, 429, **431**, 627
Beltaine, 228
Bending of the Bough, The (George Moore),
 218–219
Benet, William Rose, 514
Benson, Allan, 17, 514
Benson, Mrs. (Bedford Park), 184
Berkeley, University of California at, 260
Bicentennial Exhibition, 1976, 641
"Bird Market, The" (JBY), 232
Birmingham (England), 318, 594
Birmingham, George: *see* Hannay, James O.
Birrell, Augustine, 628
Black and Tans, the, 511, 525
Blake, William, 65, 67, 105, 134, 169, 171,
 387, 444, 574, 577, 634; *Works of William
 Blake* (ed. Ellis and WBY), 171–172, 192, 312
Blavatsky, Helena Hahn (1831–1891), 139, 167
Blenheim Road, No. 3 (Bedford Park), 154,
 157, 160, 164, 167, 174, 176, 184, 186, 188,
 190, 196, 199, 204, 207, 212–213, 217–218,
 225, 230–231, 234, 237, 240–242, 266, 346,
 573, 581
Blight (Oliver St. John Gogarty), 474
Blogg, Frances: *see* Chesterton, Mrs. G. K.
Blogg, Frances (mother of), 224–225
Blundellsands, 217
Blunt, Wilfred Scawen, 264
Bodkin, Thomas, 272, 590, 594
Bodleian Library, 588
Boer War, 213, 217–219, 224, 367
Bohemian (-ism, -ists), 216, 428
"Bolingbroke" (later "Henry The Fourth"; in
 Richard II), 97, 99, 100
Bolsheviks (-ism), 525, 531
Bookman, The, 191, 386
Borglum, Gutzon, 508
Bornstein, George, 637
Borrow, George, 490
Boston (Massachusetts), 388, 390, 405, 620
Boston Pilot, The, 146, 573, 576
Botany Mills case, 642
Boughton, Alice, **329**, 332, 609

Bourne, Henry R. Fox, 188, 580
Bowmore Strand, 91, 132, 184
Boycott, C. C., Captain, 125
Boyd, Judge Walter, 237
Boyd, Ernest, 17, 482, 490, 510, 523, 534
Boyle, William, 288, 294, 315, 318–320, 399, 605, 608
Bradford, Curtis, 568, 578
Brady, Joe, 567
Branscombe (Devon), **119**, 120, 566
Brazil, 72, 213, 437, 628
Bridges, Robert, 147, 514, 644
Brien, Maria, 166, 186, 215, 217, 241, 382, 576
British Museum, 191, 213, 378
Broadsheet, A (Jack Yeats), 244
Broadsides (Jack Yeats) (Cuala Press and Dun Emer), 334
Brontës, the, 95
Brooks, Mr. (pencil sketch by JBY), 232
Brooks, Van Wyck, 17, 342, 344, **351**, 354, 360–361, 364, 367, 369, 371, 378–379, 387, 397, 429, 467–468, 476, 482, 491, 514, 525, 535, 550–551, 609, 613–615, 645
Bronx (New York), 536
Brophy, Dorothy, 387, 487
"Brotherhood, the," 61, 67, 69, 71, 83
Broun, Heywood, 17, 487
Brown, Elma Gorman, 579
Brown, Ford Madox, 56, 233
Brown, Malcolm, 551, 567, 571, 605
Brown, Milton, 402–403, 621
Brown, Oliver Madox, 56, 80, 561; work by, 85, 561
Browning, Robert, 68, 76–77, 116, 397, 559, 589
"Brutus' Wife" (JBY), 638
Bryan, William Jennings, 442
Bryant, Harriet, 468
Bryn Mawr College, 260
Buffalo (New York), 387, 398, 615, 618
Buffalo Bill, performance at Earl's Court, 152
Buffalo, State University of New York at, 625
Building Fund, The (William Boyle), 288
Bullen, A. H., 177, 192, 230, 323
Bullen, Tottie, 188
Bundoran (Co. Sligo), 35
Burke, Honour, 20
Burke, Mrs. (portrait by JBY), 323, 607
Burke, Thomas, 126
Burlingham, C. C., 494
Burne-Jones, Sir Edward, 69
Burnham Beeches, 110, 565
Burroughs, John, 330
Butler: *see* Ormonde Butlers
Butler, Archer, 20, 31
Butler, Edmond, 20
Butler, Joseph, Bishop, 31

Butler, Mary Voisin, 549
"Butler, Old Man" (JBY in "The Orange Moth"), 614
Butler, Samuel, 53–54, 57, 61, 126, 152, 467
Butler, Thomas William Gale, 53, 555
Butt, Isaac, and Mrs., 20, 31, 46, 50–51, 107, 109, 125–126, 141, 321, 371, 551, 635; portrait of Butt by JBY, 232; chalk portrait of Butt by JBY, 236
Butt (Isaac) Bridge (Dublin), 526
Butt, Rosa, 225, **226**, 231, 238, 588, 635
By Still Waters (George Russell), 306
Bynner, Witter, 17, 487, 507
Byrne, Henry Morgan, 132, 569
Byrne, Judge James, and Mrs., 328
Byrne, Patrick, 564

Calry Parish (Sligo), 51, 59, 79
Calumets, the, 154, 159, 167, 184, 188, 213, 224, 444
Calvert, Edith (Mrs. Elkin Mathews), 186
Campbell, Mrs. Patrick, 316
"Can Americans Talk?" (JBY), 638
Canada, 249, 387, 508, 549
"Cantleman's Spring Mate" (Wyndham Lewis), 470
Carleton, William, 317, 346
Carman, Bliss, 514
Carnegie, Andrew, 405
Carnegie Lyceum (Hall), 252, 511
Carr, Jonathan, 117
Carroll Gallery (New York), 468
Carson, Edward, Sir, 423
Carstairs, Charles, 624, 627
Casadh an 'tSughain (Douglas Hyde), 228
Casalinga Club, 359, 360
Casement, Sir Roger, 424–425, 443, 452–453, 626
Cassell's (London), 154, 159, 574
Cassidy, Beatrice, **259**
Catholic Church, Roman, 20, 30, 72, 113, 137, 249, 290, 312, 426, 570, 618
Catholics, Irish (Ireland), 115, 192, 194, 211, 228, 244, 249–250, 254, 257, 350, 400, 470, 570, 589, 599, 636
Catholics, Irish (U.S.A.), 252, 350, 400
Cathleen, The Countess (WBY): see *Countess Cathleen*
Cathleen ni Houlihan (WBY), 229, 245, 257, 280, 288, 317, 595
Caughey, Edward, and Mrs., 435, 444–446, 462, 468–469, 481, 491, 524, 534, 632
Caughey, Mary Lapsley, 534
"Cavalier's Wife, The" (drawing by JBY), 574
Cavan, County, 21, 150
Cavendish, Lord Frederick, 126
Celbridge (Co. Kildare), 126, 495

Celtic (mist, revival), 162–164, 169, 194, 195, 203, 209, 228, 230, 312, 316
Celtic Christmas, A, 573
Celtic Twilight, The (WBY), 171, 192, 563
Central Park West (New York), 338, 458, 527
Century (magazine), 429
Certain Noble Plays of Japan (Ezra Pound: Cuala), 448, 631
Chambers Street (New York), 370
Chapman, Frederick, and Mrs., 390, 619
"Charlemont" (Sligo), 151
Charlotte Street (London), 167
Chatterji, Mohini (sketch by JBY), 232
Chattopadhay, Sarojini, 201
Chaucer, Geoffrey, 95, 134, 378, 458; works of, 102
Chelsea Hotel (New York), 354
Chertsey, Surrey, 177
Cheshire Cheese, 171
Chess, 131, 134
Chesterton, Gilbert Keith, 204, 207, 224, 362, 426, 462, 490, 494, 524, 566, 580, 584, 614
Chesterton, Frances Blogg (Mrs. G. K.), 362, 426, 437, 490, 524, 614
Chestertown (New York), Rural Cemetery, 541, **542**
Children of the New Forest, The, 24
Chiswick Art School (Bedford Park), 164, 573
Christ Church Cathedral (Dublin), 41
Christianity, 71, 137, 528, 572
"Christy Mahon" (in *The Playboy*), 314
Chronicle, The Daily, 177, 191
Chudd, Mrs. Robert: *see* Frank, Laura
Church of the Holy Apostle (New York), 541
Church of Ireland, 21, 30, 71, 102, 249
Churchtown, 241
"Circus Dwarf, The" (painting by Jack Yeats), 621
Citizens Army, 450
Civil War (Irish), 535
Clan-na-Gael, 400, 474
Clancy, Miss, 413
"Clarin" (WBY), 132, 569
Clark, Anne, 107
Class feeling, 79, 93–94, 352, 371, 401, 482, 615–616
Clausen's Gallery (New York), 267
Clendenin, Jane Armstrong (Sis), 30, 472–473
Clerke, Mary (1st Mrs. Edward Dowden): *see* Dowden, Mary Clerke
Clifford Gallery (London), 196
Clongowes School, 308
Clonmel House (Dublin), 407
Coates, Dorothy, 307, 336, 338–339, 341, 344, 348, 361, 395, 416, 425, 471, 527, 530, 612, 642; painting by JBY, 338–339
Cockran, Bourke, 622
Cochrane, Alexander, 405

Coercion Bills, 125
Coffey, George, 231–233; paintings by JBY, 232
Cohalan, Daniel, 474, 476
Colby, Bainbridge, 235
Colby College, 600, 607
Coleridge, S. T., 343
Collected Works of William Butler Yeats, 344
College Park, Trinity College, Dublin, 121
Collins, Michael, 535
Colony Club (New York), 328
Colum, Eileen, 242, **258**
Colum, Mary Maguire (Molly; Mrs. Padraic), 317, 399, 414, 425, 443, 450, 474, 476, 536, 539, 607–608, 626, 648
Colum, Padraic, 17, 215–216, 249, 277, 285, 299–300, 308, **309**, 313, 316, 318, 362, 425–426, 443, 450, 452, 474, 491, 507, 514, 534–536, 607, 626, 642, 645; sketch by JBY, 425, 600, 624
Colum, Patrick (father of Padraic), 315
Commonweal, 156
Comte, Auguste, 31, 44, 55, 110, 208, 308
Comtism, 27, 93
Conkling, Grace H., 507
Connolly, James, 443, 450, 632
Connolly, Nora (Nora Connolly O'Brien), 443, 450, 630
Conroy, Dr. Thomas F., 610, 640
Constable, John, 281
Contemporary Club, 140, 143, 147–149, 230–232, 444, 571
Contemporary Review, The, 55
Cooke, Walter, 614
Coole Park, 192–194, 201, 209, 219–221, 229, 238, 247–248, 277, 318, 348, 399–400, 419, 484, 588, 604, 643
Corbet, Arthur, 30
Corbet family, 568
Corbet, Grace Armstrong (JBY's grandmother), 30, 472–473
Corbet, Jane Grace (wife of Rev. William Butler Yeats): *see* Yeats, Jane Grace Corbet
Corbet, Robert, 21, 24, 29, 31–32, 34, 39, 51, 63, **64**, 78, 550–551, 553, 560
Corbets, the, 455
Corcoran Gallery, 615
Cork, 56, 511
Cork College, 232
Cornwall, 27, 37
Corot, 83, 281
Cosby, Major E. A. S., 563
Cosby family (Stradbally), 96, 102, 563
Cosmopolitan Club (New York), 619
Cottie: *see* Yeats, Mrs. Jack B.
Countess Cathleen, The (WBY), 168, 172, 191, 193, 209, 211, 228, 249, 254, 399, 401–402, 585, 598, 599

Court of Chancery (Ireland), 551
Courtenay, Charles, and Mrs., 470, 487
Cousins, James, 246, 300
Coxhead, Elizabeth, 201, 582, 589, 596
"Crake, The" (Edward Dowden), 130
Crane, Walter, 156
Crimes Bill, 126
Crosby, Maunsell, and Mrs., 614
Crowder, J. F., and Mrs., 594
Crowley, Aleister, 221–222, 395, 431, 438–
 440, 445, 468, 629; works of, 440
Cuala (Industries, Press, etc.; *see also* Dun
 Emer), 242, 334, 344, 362, 373, 382, 388,
 399, 407, 409, 411, 422–423, 426, 435–436,
 448, **449**, 458, 461, 466, 471, 481, 496–497,
 511–512, 526–530, 541, 560, 588, 591, 600,
 609, 631, 634, 646
Cubists, 402–404, 427, 515
Cuchulain, 241, 269
Curran, Constantine P., 495, 550, 555
Curran, Mrs. Constantine, 325
Curtin, Thomas, 330, 480, 497, 611
Customs House (Dublin), 525, 646
Cutting of an Agate, The (WBY), 415

Daily Express (Dublin), 233, 256
Daily News (London), 462
Dalkey (Co. Dublin), 560, 563, 574, 588
Dallas, Letitia Marion: *see* Darragh, Florence
Daly, Arnold, 412
"Dame School," Sligo, 95
"Dark Man, The" (painting by Jack Yeats), 601
Darling, John Singleton, Jr., 574
Darragh, Florence (Letitia Marion Dallas),
 301–302, 603
Dartmouth (Devon), 177
Darwin (-ism), 27, 44, 129, 164, 459
Davenport sisters, 24, 522
David, M., 570
Davidson, John, 171, 191, 581
Davies, Arthur B., 359, 402
Davis, Thomas, 125
Davitt, Michael, 140, 611
Dawson Gallery (Dublin), 602
"Day Dreams" (painting by JBY), 232
"Deane, Ulick": *see* "Ulick Deane"
"Dectora" (in *The Shadowy Waters*), 195, 303
"Deferred Return, The" (John Quinn),
 492–493
Defoe, Daniel, 182, 185, 474, 579; works of, 23
Degree of the Portal, 231
Degree of Theoricus, 231
Degree of Zelatores, 231
Deirdre (George Russell), 229, 245
Deirdre (WBY), 301, 347, 374
Deirdre of the Sorrows (J. M. Synge), 374
Delaware Art Museum, 615
Delehanty, Thomas, 330, 361

Delmonico's (New York), **340**, 341
"Demon": "Demon Est Deus Inversus" (secret
 name of WBY), 271
Denby (England), 154
Denson, Alan, 522
Dent, J. M., 182, 185–186, 579
Dervorgilla (Lady Gregory), 607
DeValera, Eamon, 525, 530, 535
De Vere, Aubrey, 563, 568
Devon, 27, 37, 120, 218, 222
Devoy, John, 317, 389
Dewar-Durie, Ida Varley, 164, 566, 576
Dhoya (WBY), 154
Dial, The, 516, 523, 526, 528
"Dialogue in Heaven, A" (JBY), 645
Diarmuid and Grania (WBY and George
 Moore), 223, 227–229
Diary of a Drug Fiend (Aleister Crowley), 438
"Diary of Sir Long Lean Clatterly Bones, The"
 (Jack Yeats), 574
"Dick Morton," 550
Dickens, Charles, 95, 134; works of, 120
Dickens Society of Liverpool, 150
"Differences between Us, The" (JBY), 638
Digby, Dora Louisa: *see* Todhunter, Dora
 Louisa Digby
Digges, Dudley, 256, 318, 331, 375–376, 413,
 597, 598
Dineen, Rev. P. S., 249
Discoveries (WBY; Dun Emer edition), 334
Divine Vision, The (George Russell), 260
Dix, Eulabee: *see* Becker, Eulabee Dix
Doherty, Mr. (sketch by JBY), 232
Doherty, Mrs. (the widow), 109
Dolmen Press, 591
Dome, The, 222
Donnybrook (Dublin), 20, 495, 583
Donoghue, Denis, 608
Doolittle, Hilda (H.D.), 515
Doran, John, 63, 72, 107, 133, 557
Doran, Richard, 72
"Dormouse, The" (painting by Frank Potter),
 566
Dorset St. (Dublin), 20, 33, 38, 85, 109
Doty, Dr. Joseph, 562
Dowden, Edward, 38, 40, **42**, 44–45, 50–51,
 54–58, 60–62, 65–71, 75, 77–79, 84–86, 95,
 97, 99, 102, 105, 107–110, 118, 120–122,
 126–127, 129–131, 134–136, 140, 143–144,
 147, 149, 151, 154–155, 168–169, 191, 219,
 229–230, 234, 268, 277, 281, 285, **325**, 330,
 349, 372–373, 376–378, 383, 385, 401,
 407–410, 422–423, 436, 444, 446, 463, 465,
 497, 550, 556, 558–559, 561, 563–564,
 568–569, 572, 577, 590, 592, 597, 607, 620,
 622, 631, 635
Dowden, Elizabeth Dickinson West (2d Mrs.
 Edward), 60, 77, 85, 99, 102, **168**, 169, 298,

Dowden, Elizabeth Dickinson West (2d Mrs. Edward) (*cont.*)
407, 556, 563, 602, 622
Dowden, Hester (Essie; Mrs. Travers Smith), 120, 231, 566; portrait by JBY, 130, 232, 590
Dowden, John, 38, 40, 44–45, 51, 58–59, **59**, 65, 75, 79–80, 85, 100, 102, 151, 169, 200, **202**, 362, 372–373, 497, 550, 553, 573, 583, 614, 631, 635
Dowden, Mrs. John, 51, 59, 169, 362
Dowden, Mary Clerke (1st Mrs. Edward), 51, 60, 78, 120, 169
Downpatrick, 167
Dowse, Richard, 52
Dowson, Ernest, 171
Doyle (George Pollexfen's bookkeeper), 175, 537
Doyle, Richard (Dicky), 53
"Draft Scrapbook" (Lily Yeats), 644
"Dramatic Rivalry" (Susan Mitchell), 346
Dreams of Dania, The (Frederick Langbridge), 199
"Dressing Dolls" (painting by JBY), 232
Drew, Sir Thomas, 222, 225, 231, 237–238, 250, 280–281, 325, 405–407
Drumcliff, 19–20, 89, 549
Dublin, 31, 45, 52, 56, 67, 79, 84–85, 102, 107, 120–121, 140, 151, 171, 194, 204, 222–223, 230–231, 241–242, 244, 249, 257, 264, 270, 277, 280, 295, 311, 313, 316–318, 320, 323–324, 326–327, 331, 335, 346, 348–349, 363, 370, 373, 384, 386–387, 398–399, 405, 407, 410, 413, 419, 423, 428, 437, 441, 446, 449–450, 456, 474, 491–492, 511–512, 517, 521–523, 525–527, 583, 598, 604, 637
Dublin Castle, 19, 316
Dublin Corporation, 280–281, 405, 407, 442
Dublin Gallery, 277
Dublin High School, 127, 131, 139
Dublin University Review, 144, 146, 149
Dublin Verses: By Members of Trinity College (ed. Henry Hinkson), 191
Dublin Volunteers, 423–424, 453
Dubliners (James Joyce), 280, 430, 470
Duchamp, Marcel, 402–403
Dudley Gallery (London), 69, 74
Dudley, Lord, 250, 272
Duffy, Gavan, 191, 219, 551
Duffy, Vincent, 225
Dulac, Edmund, 264
Dun Emer (Industries, Press; *see also* Cuala), 240–242, 248, 258, **258**, **259**, 260, 263–266, 278, 287, 292, 303–308, 311, 322, **322**, 334, 373, 591–592, 601, 609
Duncan, Isadora, 342, 361, 387, 610, 613
Dundrum, 241, 308, 323, 334, 425, 433, 450, 487, 505, 511

Dunne, Finley Peter, 341–342, 405
"Dynamitards," 142

Eakins, Thomas, 359
Eardley Crescent, No. 58 (London), 152, 154, 218
Earl's Court (London), 152
Earle, Mr. and Mrs., 110, 113, 116, 565
Early Memories (JBY), 473, 541, 637
Eason (bookseller, Dublin), 230
"Easter 1916" (WBY), 454, 516
Easter Rising (Dublin), 400, 443, 449, 453, 455, 468, 511, 630, 632–633
"Echo" (painting by JBY), 238, 590
Edinburgh, 362, 372
Edith Villas, No. 14 (London), 102, 110, 113, 117, 563, 565
Edward VII, King, 263, 375
Edwards, Oliver, Dr., 554–557, 561, 564, 576, 578, 586–587, 596, 623, 648
Egan (picture framer, Dublin), 321, 468
Eglinton, Lord, 33
Eglinton, John: *see* Magee, William Kirkpatrick
Egoist, The, 462–463
"Eight, The" (Henri, Sloan, et al.), 359, 402
Eilis Agus an Bhean Deirce (Elizabeth and the Beggar Woman) (Peadar MacFhionnlaigh), 246
Elgee, Jane Francesca: *see* Wilde, Lady Francesca
Eliot, George, 44, 149
Eliot, T. S., 462–463, 521, 625, 634; work of, 524
Elizabeth and the Beggar Woman (Peter McGinley): see *Eilis Agus*, etc.
"Elizabeth in Heaven" (JBY), 611
Ellis, Alexander J., 62, 92, 105
Ellis, Edwin John, 57, **58**, 60–63, 65–67, 69–72, 77, 83, 96, 103, 113, 116, 134, 169, 192, 216–217, 225, 312, 403, 408, 463, 497, 514, 528, 557–560, 565, 577, 584, 587, 589, 635
Ellis, Mrs. Edwin (2d), 169, 217, 587, 594
Ellis, Tristram, 63, 74, 116, 497, 528, 619
Ellmann, Richard, 247, 550, 551, 617
Eloquent Dempsey, The (William Boyle), 288, 296, 609
"Elsinore" (Rosses Point), 91
Elton, Charles Sutherland, 213; sketch by JBY, 232
Elton, Leonard, 213, 495–496, 556, 586; sketch by JBY, 232
Elton, Letitia (Mrs. Oliver), 168, 326, 576; sketch by JBY, 232
Elton, Oliver, 154, 168, 188, 213, 216, 231, 303, 311, 321, 324, 326, 349, 372, 378, 384, 425, 433, 443, 445, 453, 459, 466, 482, 580, 586, 589, 599, 636

Elvery, Beatrice: *see* Glenavy, Beatrice, Lady
Elwin, Eleanor (née Yeats), 21
Elwood, Archdeacon, and descendants, 549
Ely Place (Dublin), 230, 347, 388
Emer, 241
Emery, Edward, 190
Emery, Florence Farr: *see* Farr, Florence
Emmanuel Church (Gunnersbury), 177
Emmett, Robert, 125, 473
England, 252, 320, 364, 375, 423–424, 442, 450, 461, 517, 524–526, 530, 615
English (-men, etc.), 54, 79, 125, 149, 213, 219, 256, 352, 391, 401, 423, 450, 452, 458, 473, 482, 511, 526, 535, 548, 569
Enniscrone (Co. Sligo), **50**, 51
Erasmus Smith High School: *see* Dublin High School
Ervine, St. John, 550–551
Eschmann, Henri, 509
Esoteric Buddhism (A. P. Sinnett), 137
Essays: Irish and American (JBY), 467, 481, 588
Essays on Robert Browning's Poetry (J. T. Nettleship), 57
"Eurydice" (painting by JBY), 121
Evelyn Inness (George Moore), 201, 208
Exhibition of "Independents" (New York, 1910), 615
"Exhibition of Paintings for a Gallery of Modern and Contemporary Art" (Dublin, 1904), 276, 287
Exhibition of works of JBY (1972), 541

Failing Family, The (William Boyle), 399
Farley, Archbishop, 252
Farnham Royal, 110, 112, 560
Farr, Florence, 166–169, 182, 188–190, 195, 201, 209, 211, 272, 287, 290, 302, 330, 335, 338, 363, 404, 478, 608
Farrers, the (Bedford Park), 158–159, 191, 581
Farrer, Nannie: *see* Smith, Nannie Farrer
"Father and Son: John Butler Yeats and William Butler Yeats" (Douglas Archibald), 585
Fatherland, The (ed. George S. Viereck), 442
Fay, Frank, 229, 245, 246, 254, 269–270, 278, 290, **291**, 292–293, 296, 298–299, 301, 318, 330–331, 375, 474, 584, 602
Fay, William G., 229, 245–246, 249, 254–256, 269–270, 272, 278, 290, 293, 296, 298–299, 301–302, 308, 319–320, 330–331, 375, 410, 412, 584, 594, 602, 606, 608
Fay, Mrs. W. G., 330
Fenian (-s, -ism), 54, 87, 107, 125–126, 140, 142, 192, 250, 571
Ferguson, Sir Samuel, 136, 149
Finch, Davis, 614
Finch-Smith, Miss C., 487–489

Fingall, Lady, 452
Fisher Unwin, 212, 481, 586
Fitzgerald, Charles, 120, 231, 281, 286, 342, 567
Fitzgerald, family of, George, Charles, 130, 342
Fitzgerald, Lord Edward, 50, 250
Fitzgerald, George (portrait by JBY), 232
Fitzgerald, Maurice, 231
Fitzgerald, Mayor John (Boston), 405
Fitzgerald will case, **48**, **49**
Fitzgibbon, Lord Justice Gerald, 150, 590
Fitzroy Road (London), 53, 56, 60, 63, 65–67, 71–72, 74, 76–77, 79, 83, 85, 94, 105, 113, 550, 555, 560, 565
Fitzroy Square (London), 167
Flaming Sword, The: see *An Claidheamh Soluis*
"Flanagan, Mrs.," 86, 107
Flannery, James, 292, 301, 374, 593, 601
Fletcher, Ian, 576, 580, 582–583
Foley, John Henry, 53
Ford, Ellsworth, 340, 353–354
Ford, Hobart, 340
Ford, Julia (Mrs. Simeon), 287, 306–307, 325, 328, 330, 339, 341, 343, 353–354, 354, 360, 398, 426, 428, 507, 537, 610, 612–613
Ford, Lauren, 340
Ford, Simeon, 287, 328, 340, 343, 353–354
Ford family, 340
Ford-Smith, James, 568
"Forgael" (in *The Shadowy Waters*), 195, 303
Forrester, Joseph, 521
Forrester, Walter, **26**, 27, 29
Fortnightly Review, The, 55, 57, 169
Foster, Annie, 478
Foster, Jeanne Robert (née Jean Julie Oliviere), **265**, 324, 387, 395, 415, 421–422, 426, 431, 434–435, 438–440, **439**, 445, 455, 468–469, **469**, 487, 489, 501, 503–504, 507, 512–513, 525, 527, 534, 536–538, 541, 575, 596, 598–599, 612, 620, 622, 625, 628–629, 635, 641–642, 648–649; called "Hilarion," 438; known as Jean Elspeth, 620; sketches by JBY, 468, 537
Foster, Matlack, 440
Foster-Murphy Collection, 601, 622
Fountain's Court, Temple (London), 581
Four Courts, The (Dublin), **48**, **49**, 49–50, 52, 107, 396, 473
"Four Years" (in *Dial*) (WBY), 171, 528
Four Years (Cuala ed.; WBY), 161, 526–527, 535
Franco-Prussian War, 70, 367
Frank, Laura, 584
Fraser's Magazine, 55
Frayne, John, 571–572
"Fred Roland," 550
Free State, Irish, 541, 633

Free verse, 472
Freeman, The (New York), 525, 535
Freeman's Journal, The, 161, 191, 219, 252, 316–317, 589
French, Frances-Jane, 584, 632
Friar's Park (Branscombe, Devon), 566
"Friday" (in *Robinson Crusoe*), 579
Friendly Sons of St. Patrick, 350
Frohman, Charles, 318, 331
Frohman, Daniel, 331, 608
Froude, James Anthony, 44
Fuge (Devon), 196
Fulham (London), 106
Fun (magazine), 51, 53, 55
Further Letters of John Butler Yeats (ed. Lennox Robinson), 512, **513**
Futurism, 515

Gael, The, 146
Gaelic (-ism), 92, 149, 199–200, 211, 254–255, 280, 287–288, 385, 400, 518
Gaelic-American, 317
Gaelic League, 54, 228, 318, 413
Gaiety Theatre (Dublin), 218, 227, 374, 599
Galsworthy, John, works of, 79, 410
Galway, County (Ireland), 43, 192, 553
Gambles, the, 158
Garavogue River, 150
Garbhaigh, Maire ni: *see* Garvey, Mary
Gardiner St., No. 90 (Dublin), 122–123
Garvey, Mary, 292, 300
Gay, K. C., 592, 625
Gaynor, William Jay, 341, 610
Genée, Adeline (Mrs. Frank S. N. Isitt), 610
General O'Regan (George Birmingham), 412, 414, 635
General Post Office (Dublin), 449, 450
Genthe, Arnold, 418
Geoghegan, Jacob, 321
George Moore (Susan Mitchell), 522
"Georgeville" (Sandymount), 43, 45, 53
Germans, 441, 443, 452, 457, 476, 498, 615, 642
Germany, 267, 424–425, 442, 452, 474, 614, 626, 642
"Gertie MacDowell" (in *Ulysses*), 517
Gethin, Richard, 552
"Ghost's Wife, The" (JBY), 611
Gibbon, Edward, work of, 524
Gibran, Kahlil, **500**, 501
Gifford, Frederick, 248, 321
Gill, Jane, **258**
Gills, the, of Dalkey, 238
Gills, the, of Roebuck, 238
"Girl Reading" (painting by JBY), 232
"Girl with the Basket, The" (painting by JBY), 152
Glackens, Ira, 359, 609

Glackens, William, 17, 402, 467
Gladstone, William E., 70, 102, 530
Glazebrook, Mark, 580
Gleeson, Evelyn, 240–242, 258–260, 263, 266, 303, 308, **322**, 323–324, 328, 334, 362, 373, 592, 626; "The Mother Abbess," 303, 334; "The Spider," 303
Glenavy, Beatrice, Lady, 295, 601
Glendalough, 255, 484
Glendening, Mrs. Crosby, 614
Globe (New York), 621
Gloucester St., No. 10 (London), 53
"God Creating Evil" (design by J. T. Nettleship), 60–62, 65–66
Godkin, Lawrence, Jr., 494
Godkin, Lawrence, Sr., 494
Godolphin School (Hammersmith), 113, **114**, 115–116, 120, 122, 131
Goethe, Johann Wolfgang, 121, 396
Goff, Dr., 268
Gogarty, Oliver St. John, 247, 345, 383, 437, 474, 593, 637
Gonne, Iseult, 476, 484
Gonne, Maud, 160–161, 171, 191–192, 194–196, 201, 203, 208–209, 212, 245–246, 261, 263, 269, 272, 344, 362, 404–405, 422, 450, 454, 461, 473, 476, 484–485, 575, 582, 584, 639
"Good Things of Day Begin to Droop and Drowse" (sketch by JBY), 68
Gordon, Lily, 231; painting by JBY, 232
Gore-Booth, Constance: *see* Markievicz, Countess Constance
Gorman, Robert, 117, 183, 579
Gosse, Edmund, 121, 376, 404, 622
Gould, Warwick, 580, 583
Gower, John, 378
Grafton St., No. 116 (Dublin), 140
Grahame, W. T., 68, 74, 78
Grahame, Whidden, 330
Grand Union Hotel (New York), 287, 328, 332, 334–335, 340, 342, 354–355
Graves, Arthur Perceval, 232, 572
Great Cumberland St. (Dublin), 20, 548
Green, Alice Stopford (Mrs. J. R.), 490–491
Green Helmet, The (WBY), 380, 382, 388
Green, J. R., 490, 549
Greene, Belle da Costa, 507
Greene, David, 320
Greenhut and Company, 432–433
Gregg, Frederick James, 127, 140, 342, 361
Gregory, Lady Augusta (Isabella Augusta Persse Gregory), 193–196, 201, 203–204, 208–209, 211–213, 215, 217, 221, 225, 229, 238–239, 246–250, 252, 263–264, 267, 269–272, 277–278, 280–281, **284**, 288, 290, 292, 295, 298–301, 303, 313–314, 319, 324, 344–345, 371, 374–377, 380, 383, 388–389,

Gregory, Lady Augusta (Isabella Augusta Persse Gregory) (*cont.*)
391, 399–401, 403–405, 407, 409, 411–413, 418–419, 426, 433, 440–442, 454, 465–468, 473–474, 477, 480–481, 483–485, 492, 509, 517, 529, 553, 581, 583–586, 588, 593–594, 596, 598, 602–603, 606–607, 617–618, 621–625, 635, 639, 643; "Aunt Augusta," 307, 348; "Her Ladyship," 318; "Strega," 193; sketch of, by JBY, 285
Gregory, Robert, 209, 264, 272, 400, 484, 588, 639
Grierson, H. J. C., 326
Griffith, Arthur, 256, 346, 375, 535
Grosvenor, Lady, 250
Guildhall Exhibition (London, 1904), 271
Guiney, Imogen, 182, 188
Guiterman, Arthur, 507
Gunnersbury (London), 177
"Gurteen Dhas," 242, 285, 296, 298, 308, 313, 321, 323, 334, 341, 348, 373, 381, 383, 425, 435, 437, **467**, 490, 523, 525, 597, 600, 626
Gwynn, Stephen L., 144, 264

Hackett, Francis, 311, 324, 330, 387
Hackwood (Co. Cavan), 21
Haeckel, Ernst, 129
Hail and Farewell (George Moore), 418, 523
Hall, Joseph, 553
Hall, Sydney, 61, 65, 69, 121, 635
Hamilton, Paul (*see also* Pollexfen, George), 92
Hamilton, Sir William Rowan, 169, 640
Hammersmith (London), 113, 133, 159
Hammersmith High Street, 166
Handel, George Frederick, 41
Hannay, Canon James O. (George Birmingham), 412, 414, 623, 635, 645
Harcourt St. (Dublin), 127, 323, 407
Harold's Cross Road, No. 418, 570
Harper, George Mills, 562
Harpers (London), 154, 159
Harper's Weekly (New York), 352, 386, 414–415, 624
Harrington, Lord Mayor Tim (Dublin), 311, 584, 604
Harris, Frank (and sketch by JBY), 445, **447**, 630
Harris, W. G., 116
Harrison, Sarah, 324
"Harry Bentley," 28, 41, 43–44, 51, 54, 66, 74–75, 100, 550, 552, 558
"Harry Revell," 34
Hart, Sir Andrew, 150
Hart, George and family, 233–234, 237, 240, 324, 461, 584, 601
Hart, Hilda, 237
Hart, Ruth: *see* Jameson, Ruth Hart
Harvard, 235, 260, 342, 364, 387, 405, 620

Harvard Club (New York), 353–354
Harvey, T. Arnold (later Bishop Harvey), 209, **210**, 584–585
"Haunted Room" (painting by JBY), 232
"Hawk's Well, At the" (WBY), 481
Hazelwood Racecourse (Sligo), 92
Healy, Johnny, 92, 105
Hearst, William Randolph, 626
Heather Field, The (Edward Martyn), 209
Heatherley's Art School (London), 53–57, 60–61, 78, 97, 102, 113
Hebditch's Legacy (Oliver Madox Brown), 561
Hebdomadal Board, Trinity College, Dublin, 121, 130, 378, 410, 514
Héloïse and Abélard (George Moore), 523
Henchy, Dr. Patrick, 593
Henderson, Acheson T., 130, 150
Henderson, W. A., 302
Henley, William Ernest, 161–162, 532
Henri, Marjorie Organ (Mrs. Robert), 359, **430**, 492
Henri, Robert, 17, **355**, **357**, 359–360, 367, 370, 385, 397–398, 402–404, 413, 429, **430**, **431**, 456, 492, 514, 525, 627
Henrietta St. (Dublin), 38
Henry, Dr. Augustine, 241, 592
Herbert (family) of Muckross Abbey, 84, 95–96, 562, 563
Herbert, Mrs. (Muckross) (portrait by JBY), 96
Herford, Oliver, 17, 487
Hermetic Society (Dublin), 139, 575
Hersey, Frank W. C., 620
High School, Dublin: *see* Dublin High School
Hinkson, Henry, 191, 213, 238, 426, 512, 626
Hinkson, Mrs. Henry: *see* Tynan, Katharine
Hinston, Mr., 34–35
Hippodrome Theatre (New York), 348
Hitchcock, Dr. F. R. Montgomery, 568
H.M. (reviewer, *Manchester Guardian*), 634
Hoare, Mrs., 84–85
Hodgins, Roseanna, 158, 166, 177, 184, 215, 382, 477
Hogan, Robert, 585
Hogarth, William, 387
Hogg, Dr. William B. Gordon-, 188, 215, 590
Holland, Norah, 249, 594
Holland Park (London), 105, 514
Holland Park Road (London), 116, 565
Holloway, Joseph, 211, 245, 254–255, 257, 268–270, 277–278, 280, 288, 290, 292, 294, 296, 298, 302–303, 313–314, 316, 321, 345, 399, 411, 453, 495, 595, 599, 602
Holmes, Hugh, 53, 240, 455
Holts, the, 549
Holy Apostle, Church of the (New York), 541
Home Rule, 107, 140–141, 213, 388, 423–424, 443, 448–449, 474
Home Rule Confederation, 125

Hone, Joseph, 270, 296, 541, 551, 628, 632
Hone, Nathaniel, 225, 231, 237, 348, 584, 590
Hone-Yeats Exhibition (Dublin, 1901), 225,
 231–234, 250, 311, 588–589
Hood, Tom, 51–54
Hopkins, Everard, 574
Hopkins, Gerard Manley, 146–147, 574
Hopper, Nora, 182, 188
Horniman, Annie Elizabeth Frederika, 167,
 190, 245–246, 254–255, 258, 269–272, **273**,
 276, 278, 285, 288, **289**, 290, 292–293, 296,
 300–303, 318–320, 374–375, 404, 410, 584,
 597–599, 616
Hour-Glass, The (WBY), 254
House, Col. Edward (sister of), 514
Housman, Laurence, 507, 634
Howth (Dublin), 123, 127, 131–132, 136, 216,
 295, 423, 564
Huddersfield (England), 154
Hudson's Bay Company, 254, 258, 290
Hugh Lane's Life and Achievements (Lady Greg-
 ory), 442
Hume St. (Dublin), 203
Humphry, John, 20, 548
Huneker, James G., 445
Hunt, Holman, 233
Hunter, Dorothy, 201
Huxley, Thomas Henry, 44, 110, 129, 164
Hyacinth Halvey (Lady Gregory), 388
Hyde, Douglas, 140, 203, 209, 228, 232, 238,
 245–246, 248, 277–278, 281, 325, 362, **393**,
 400, 521, 572, 584, 586, 592, 598, 599
Hyde, Mrs. Francis De Lacey, 352, 361
Hyde-Lees, Bertha: *see* Yeats, George (Mrs.
 William Butler Yeats)
Hyde, Lucy (Mrs. Douglas), 278
Hyndman, Henry, 156

Ibsen, Henrik, 315
Ideas of Good and Evil (WBY), 343
Iffley Road (Hammersmith), 113
Imperial Hotel (Sligo), 42, 376
"In a Balcony" (Robert Browning), 589
"In a Gondola" (painting by JBY), 116, 232
"In Memory of Alfred Pollexfen" (WBY), 454,
 633
In the Seven Woods (WBY), 242, 260, 592
In the Shadow of the Glen (J. M. Synge), 255, 268,
 280, 285, 287, 315, 518, 598
Independent, The (Dublin), 391, 595
Independent Exhibition (New York, 1908),
 359
Independent Exhibition (New York, 1910),
 359, 370
"Independents, the," 615
Ingram, John Kells, Dr., 32, 551
"Innisfree" (illustration by JBY), 186, 580
International Academy Exhibition (Rome,

1914), 429
International Exhibition of Modern Art (New
 York, 1913): *see* Armory Exhibition
Internationalist, The, 204
"Invincibles, the," 126–127, 557, 567
Ireland, 125, 240, 255–257, 320, 346, 352,
 371, 423, 443, 450, 454, 461, 470, 491, 511,
 526, 530, 535, 540–541, 632, 645
"Ireland after Parnell" (WBY), 575
"Ireland out of the Dock" (JBY), 256–257
"Ireland to be Saved by Intellect" (JBY), 391–
 392
Ireland's Eye, 132, 423, 473
Irish (-men; *see also* Gaelic, Celtic), 228–230,
 255–257, 271, 280, 288, 292, 316, 320, 346,
 352, 391, 399–400, 423, 442, 452, 458, 570,
 578, 620
Irish Academy, Friends of the, 625
Irish-Americans, 252, 290, 312, 325, 350, 353,
 388, 398–400, 424, 474–476
Irish Citizens' Army, 449
Irish clubs, 269, 299
Irish Coercion Bills, 125
Irish Free State, 541
Irish Fireside, The, 149
Irish Homestead, 252, 512, 643
Irish Independent, 256, 287
Irish Industrial Exhibition (London), 159
Irish Industrial Exhibition (New York, 1905),
 287, 306
Irish Industrial Exhibition (New York, 1908),
 324, 328
Irish Land Commission, 151, 159, 217, 222,
 225, 321, 574
Irish language, 194, 257, 523
Irish League (Paris), 194
Irish Literary Revival, 171
Irish Literary Society (London), 167, 190, 231,
 237, 572
Irish Literary Society (New York), 252, 271
Irish Literary Theatre (*see also* Abbey
 Theatre), 209, 218, 223, 229, 245, 255–256
Irish National Theatre (*see also* Abbey
 Theatre), 227–229, 254–255, 320
Irish National Theatre Society (*see also* Abbey
 Theatre), 256, 268–270, 280, 288, 290, 292,
 296, 299, 331, 374, 582, 585, 597–598,
 602–603
Irish nationalism (nationalists, etc.), 33, 54,
 125, 164, 211, 300, 374–375, 400, 424, 455,
 511, 631
Irish Party (House of Commons), 107
Irish peasant, 290, 315, 317, 473, 599
Irish Renaissance, 204, 245, 308, 631
Irish Republic, 449, 453, 525
Irish Republican Brotherhood, 126, 449
Irish Republicanism, 633
Irish Society (Boston), 388

Irish Statesman, The, 643
Irish Theatrical Company, 330
Irish Times, 211, 233, 315–316, 382, 462
Irish Volunteer Movement, 300, 449, 453
Irishmen All (George Birmingham), 412
Is the Order of R.R. and A.C. to Remain a Magical Order? (WBY), 231
Isbister, Dora, 183
Isis and Urania Temple (Golden Dawn), 431
Isitt, Adeline Genée: *see* Genée, Adeline
"Island of Statues" (WBY), 132, 144, 571
"Island View," Howth (Dublin), 123
Isle of Man, 27, 176, 578
Italy, 72, 324, 381

J. B. Yeats: Letters to His Son W. B. Yeats & Others, 1869–1922 (ed. Joseph Hone), 541
Jackson, Alice: *see* Pollexfen, Alice
Jackson, Arthur, 150, 175, 204, 616
Jais, Mme Adèle, and husband, 515, 531, 535, 537
James Flaunty, or the Terror of the Western Seas (Jack Yeats), 218
James, Henry, 255, 492; works of, 474, 637
Jameson, Andrew, 240, 323–324, 326, 387, 462, 591, 618
Jameson, Mrs. Andrew (1st), 326, 387
Jameson, Ruth Hart (2d Mrs. Andrew), 324, 362, 551, 591, 607
Jameson whisky, 242
Jeanne R. Foster-William M. Murphy Collection of Irish and Anglo-Irish Miscellanea: *see* Foster-Murphy Collection
Jeffares, A. Norman, 574, 648
Jenner, Rev. W. Jack, 586
Jenny (Rockwell Kent's friend), 371
John, Augustus, 402, 443, 608
John, Gwen, 402, 621
John Butler Yeats (Douglas Archibald), 585
"John Butler Yeats" (Denis Donoghue), 608
"John Butler Yeats" (Susan Mitchell), 496, 641
"John Butler Yeats" (John Quinn), 648
"John Butler Yeats: An Appreciation" (F. York Powell), 590
John Eglinton: *see* Magee, William Kirkpatrick
John Sherman (WBY), 132, 154, 573, 577
"John Sloan's Exhibition" (JBY), 638
"John Whiteside," 550, 552
Johnson, Henrietta (Mrs. Fredrick Pollexfen), 150
Johnson, Josephine, 601, 607–608
Johnson, Lionel, 171, 182, 287, 572
Johnson, Samuel, Dr., 285, 373
Johnston, Charles, and Mrs., 127, 131, 137, 139, 167, 195, 252, 342, 347, 369, 573, 615
Johnston, James Nicoll, 635
Jones, C. Standfield, 440
Joseph Holloway's Abbey Theatre (ed. Robert

Hogan and Michael J. O'Neill), 585
Journal (New York), 359
Jowitt, Martha, 112–113, 120
Joyce, James, 247, 276, 280, 292, 317, 430, 470–471, 517, 517–518, 521–522, 538, 584–585, 593, 602, 636; works of, 470, 498, 517, 521, 538, 602

Kaiser Wilhelm, 424, 626
Keating Branch (Gaelic League), 228
Keats, John, 95, 134, 335, 343, 346, 472, 534
Kelekian's Galleries (New York), 536
Kelly, Dr. John, 617
Kelley, P. J., 598
Kelmscott House (London), 166
Kennedy, Mr. (Boston), 388
Kenny, Pat, 316
Kensington (London), 60, 102, 514
Kensington Pond (London), 105
Kensington Station (London), 563
Kent, Rockwell, and Mrs., 359, **369**, 371, 457, 615
Keogh, Martin, Judge, 313, 333, 350
Keogh, Mrs. Martin, 313
Kerrigan, J. M., 390–391, **406**, 619
Kerry, County, 597
Kildare, County, 642
Kildare St. (Dublin), 139
Killeeneen Feis, 238
Kilmainham jail, 125, 450, 632
Kilroy, James, 604
Kincora (Lady Gregory), 277
King of England, JBY on, 330
King, Frederick A., 335, 342, 367, 369, 372, 387, 390, 397, 610
"King Goll: An Irish Legend" (WBY), 573
"King Goll" (drawing by JBY), 573; painting by JBY, 232, 235
King, Richard Ashe, 213, 222, 225
King, Mrs. Richard Ashe, 213
King's Threshold, The (WBY), 257–258, 268, 288
King's Inns, 34, 38, 40–43, 45, 237; Treasurer, 186
Kingstown, 32, 441
Kirby, Rollin, 361, 370
Kirkland, Charles Knox, 574
Kitley Manor, 37
Knoedler's Gallery, 427, 535, 624
Kuhn, Walt, 402, 473–474, 515, 637, 644

Laird, Helen, 344
"Lake Isle of Innisfree, The" (WBY), 169, 577, 580
Lamb, Charles, 335, 343
Lambe, Janet, 566
"Lament of Deirdre" (Sir Samuel Ferguson), 149

Lamont, Mrs. Thomas W., 613
Land, The (Padraic Colum), 299
Land of Heart's Desire, The (WBY), 190, 229, 589
Land reform, 244
Landed Estates Court, 248
Landlords, absentee, 115
Lane, Hugh, 204, 250, 252, 263, 271–272, 276–277, 280–281, 285, 295, 299, 323–324, 405, 407, 441–442, 594, 598, 627, 643; gallery of, 250, 628; mother of, 598
Lane, John, 186
Lane pictures, the, 277, 280–281, 405, **406**, 442, 622, 629
Lane, Ruth (Mrs. Shine), 272
Lane-Poole, Charles, 373, 381
Lane-Poole, Ruth: *see* Pollexfen, Ruth
Langbridge, Frederick, 199
Larminie, William, 201
"Last Corinthian, The" (painting by Jack Yeats), 621
Last Feast of the Fianna, The (Alice Milligan), 218
Laszlo, Fülöp Elek, 535, 538
Latin, 116, 637
Laurella and Other Poems (John Todhunter), 109
Law school: *see* King's Inns
Law Students' Debating Society, King's Inns, 40, 43, 634–635
Lawrence and Bullen, 177, 192
Lawrence, Harry, 177, 227
Lawrence, W. J., 399, 605
Lawrencetown, County Down, 19
Lawson, Ernest, 359
Laying of the Foundations, The (Fred Ryan), 246
Leader, The, 228, 252, 288
"Leaders of the Crowd, The" (WBY), 526
Lecturer in Literature (University College Dublin), 349
Lee, Kate, 213, 222
Leeds University, 592
Leisure Hour, The, 186, 199, 573–574
Lenny, Mrs. (portrait by JBY), 234
"Leopold Bloom" (in *Ulysses*), 276
Letters to Molly (ed. Ann Saddlemyer), 603
Lewis, Wyndham, 470–471
Liebler and Company (New York), 412, 414
Life, 487
Life in the West of Ireland (Jack Yeats), 412
Liffey River (Dublin), 136, 405, 423, 453, 525
Likely, David S., Dr., 537
"Lily Yeats's Scrapbook" (Lily Yeats), 644
Lincolnshire, 578
Lindley, John, 117
Lindstrand, Mrs. Agda E., 537–538
Lissadell (Sligo), 164
Literary Digest, 342

Literary Ideals in Ireland (WBY, AE, and William Larminie), 201
Literary Review, The, 514
Little People, the, 137, 496
Little Review, The, 466, 469–471, 498, 517, 521, 635
Liverpool (England), 66, 79, 102, 117, 150, 164, 183, 217, 321, 326, 378, 388, 441, 531
Living Chalice, The (Susan Mitchell), 624
Lloyd George, David, 535
Lloyd's Boarding House (New York), 364
Logue, Michael, Cardinal, of Armagh, 209
London, 53, 56, 60, 65–67, 70, 77–79, 83, 85, 102–103, 105, 112–113, 121, 124, 151, 167, 184, 192–193, 204, 211–212, 218, 237–238, 254–255, 271, 362, 407, 494, 512, 535, 565, 575
London, Jack, 395, 514
Long, Miss, 208
Loomis, Charles Battell, 323–324
Loughrea, Cathedral, 596–597
Louis, Fort (Sligo), 92
Lowell, Amy, 515, 536, 636, 648
Lowes, John Livingston, 507
"Lucian Gregory" (in *The Man Who Was Thursday*), 588
"Luck of the O'Beirnes" (JBY), 595
Luks, George, 359, 402
Lusitania, S.S., 361, 441–443, 445, 457, 632
"Lute Girls, The" (painting by JBY), 105, 108–109
Lutyens, Sir Edward, 405
Lyon, Mrs. Maurice, 445
Lyster, Alice, 188
Lyster, Thomas, 188, 237, 411

Macaulay, Thomas Babington, works of, 95
Macbeth Gallery (1908), 370
MacBride, John, 261, 450, 454
MacBride, Maud Gonne: *see* Gonne, Maud
MacBride, Séan, 484
McCabe, Ellen, **258**
McClure's (London), 429
McCormack, Katherine, 266
McCullagh, Dr., 169
MacDonagh, Q. C., 52
MacDonagh, Thomas, 450, 632
Macdonell, Sir Anthony, 232, 272, 277; portrait by JBY, 285
McDonnell, Francis Quinton: *see* Sinclair, Arthur
Macdonnell, Dr. (Contemporary Club), 232
MacDowell Club, 536
MacFhionnlaigh, Peadar (Peter McGinley), 246
MacGreevy, Thomas, Dr., 594, 604
MacKaye, Percy, 17, 387, 507

MacKenna, Stephen, 268, 288, 315
MacKinnon, Miss, 185, 232
MacManus, Seamus, 268, 389
McNeill, John, 568
McNiffe, Mr. (sketch by JBY), 232
MacSwiney, Terence, and Mrs., 511
Madden, Dodgson Hamilton, 150, 276, 462
Maeve (Edward Martyn), 218
Magee, Eithne, **406**, 619
Magee, William Kirkpatrick (John Eglinton),
 127, 201, **283**, 287; sketch by JBY, 285, 287,
 530
Magic: *see* Occult
Maguire, Mary (Mrs. Padraic Colum): *see*
 Colum, Mary Maguire
Mahaffy, John Pentland, 130, 140, 149, 209,
 230, 272, 281, 286, 377–378, 383, 397, 410,
 512, 584, 600; portrait by William Orpen,
 285; portrait by JBY, 285
Mahony, Nora Tynan, 574
Maine, 429, 476
Malahide, 523
Mallarmé, Stéphane, 191
Man Who Was Thursday, The (G. K. Chesterton),
 580, 588
Manchester, 54, 177, 196, 245, 320
Manchester *Courier*, 576
Manchester Guardian, 287, 462, 481, 512, 573,
 634
Manchester Repertory Theatre, 616
Mancini, Antonio, 323, 607
"Manifesto" (Royal Hibernian Academy), 281
Manning, Miss M. R., 203, 231, 388
Mansion House (Dublin), 639
Marconi, Guglielmo, 491
Marcus, Phillip L., 587, 590
"Margaret Leland" (in *John Sherman*), 132, 573
Mark Twain, 361, 491
Markham, Edwin, and Mrs., 507
Markievicz, Countess Constance, 281, 450,
 451, 452, 474, 630
Markoe, Francis Hartman, 639
Markoe, Mrs. F. H.: *see* Powell, Mariella
Marlborough Road (Dublin), 484
Marlborough Street (Dublin), 269
Marryat, Captain Frederick, works of, 565
Marsh, Clare, 203, 223, 231, 333, 388, 391–
 392, 410, 426, 455, 481, 512, 619
Marsh, Seymour, 392
Martyn, Edward, 192, 194–196, 201, 209–
 211, 218–219, 299–300; portrait and sketch
 by JBY, 232, 238, 453
"Mary Carton" (in *John Sherman*), 573
Masefield, John, 409
Masling, Annette, 618
Mason, K. G., 560, 563, 572, 578, 587
Mason, Lily, and mother, 166
Massingham, H. W., 494

Matchett, Sam, 549
Mathers, Alice, 191
Mathers, MacGregor, 167, 191–192, 221–222,
 431
Mathews, Ada, 528
Mathews, Elkin, 154, 167, 182, 186, **187**, 191,
 218, 241, 244, 265, 482, 580–581, 607
Mathews, Minnie, 241–242
Matisse, Henri, 402–403
Maugham, W. Somerset, works of, 468
Maunsell Publishing Co. (Dublin), 386, 453,
 468, 607
Maxwell, General Sir John, 450, 452
Mayo, County, 288, 314
Measure, 522, 528, 645
Mechanics Institute (Abbey St., Dublin), 269,
 597
"Meditations in Time of Civil War" (WBY),
 221, 517
Memoirs, WBY's (unpublished), 568
Memorial Dinner (for JBY, 1922), 17–18, 541
"Memory Harbour" (painting by Jack Yeats),
 423
Memory Harbour (Alexander Bell Filson
 Young), 423, 626
Meredith, George, 276, 396
Meredith, Will, 276
Merrick, Esther, 95
Merrington, Marguerite, 324
"Merville" (Sligo), 53, 79, 85–86, 89–94, 113,
 117, 151, 429, 496, 565
Mervyn, Violet, 598
Metropolitan School of Art, 139, 570
Meyer, Kuno, 249, 321, 378, 424, 425, 441,
 443, 626; portrait by Augustus John, 443
"Michael Hearne," 557
"Michael Robartes and the Dancer" (WBY),
 516
Michael (Robert Corbet's servant), 51, 63
Middle Temple (London), 42
Middleton and Pollexfen Co., 37, 91, 150, 573
Middleton, Elizabeth Pollexfen (mother of
 Elizabeth Middleton [Mrs. William] Pollex-
 fen), 37
Middleton, Henry, 573
Middleton, Lucy, 91, 173, 193, 562
Middleton, Mary, 91
Middleton, William (great-uncle of WBY),
 27–28, 37, 91, 150, 174, 175
Middleton, William (great-grandfather of
 WBY), 91
Middleton family, 91, 150, 174, 455
Middletons, the, 174
Mill, John Stuart, 44, 55, 65, 69, 110, 115, 208,
 308, 558, 640
Millais, John Everett, 137
Miller v. California, 605
Miller, Florence, 628

Miller, Liam, 591, 622
Millevoye, Lucien, 161
Milligan, Alice, 218
Mitchell, Susan, 196, 204–205, **205**, 206, **206**,
 207, 213, 230–231, 249, 276, 307, 313, 347,
 380, 384, 398, 413–414, 424, 437, 452, 460,
 468, 474, 482–483, 490–491, 496, 511,
 522–523, 534, 584, 588, 624, 641, 647
"Modern Landscape Painters: A Propos of Mr.
 Hone" (George Moore), 590
"Modern Woman, The" (JBY), 638
Moira (Co. Down), 20
Molesworth Hall (Dublin), 300
Monahan, Michael, 395
Montreal, 261, 491, 508
Montrose (art suppliers), 468
Mooney, Sarah, **258**
Moore, George, 192, 195, 201, 204, 208, 215,
 218–219, 223, 227–231, 237–238, 246, 264,
 274, 277–278, 285–286, 311, 347, 362, 375,
 383, 400, 413, 418–419, 423, 437, 448, 469,
 482, 522–523, 584, 587, 589–600, 617, 645;
 sketch and painting by JBY, 285, 469
Moore, George (Susan Mitchell): see *George
 Moore*
Moore, Sturge, 435
Moore, Virginia, 566
Moran, D. P., 288
More, Thomas, 418
Morehampton Road (Dublin), 496–497, 583
Morgan, J. P., 441.
Morgan, Sydney J., **406**, 619
Morley, John, 57, 480
Morris, Jenny, 156
Morris, May, 156, 160, 164, 166, 180–182,
 190, 332, 345, 362, 494, 581, 611; "the Gor-
 gon," 180
Morris, Rupert H., 565
Morris, William, 117, **147**, 147–149, 155–157,
 161–162, 164, 166, 173, 186, 529, 532, 558,
 574; sketch by JBY, 232; portrait by JBY,
 580
Mosada (WBY), 146, 572
Mosquito, the, 342–343
Mount Holyoke College, 260
Mount Jerome Cemetery (Dublin), 345
"Mr. Dooley" (Finley Peter Dunne), 341–342
"Mr. W. B. Yeats presenting George Moore to
 the Queen of the Fairies" (Max Beerbohm),
 630
Muckross Abbey, 84, 93, 95–96, 102, 562
Murdoch, W. G. Blaikie, 632
Mullins, I. W., 150–151
Mullins, John (portrait by JBY), 232
Mullinses, the, 238
Municipal Gallery of Modern Art (Dublin),
 281, 285, 323, 405, 413, 540
Murphy, Myles, 598

Murphy, William Martin, 256, 595
Murray, Gilbert, 264
Mysticism (WBY's): *see* Occult, the

Napoleon, **520**, 521
Nash, Joseph (and family), 154, 167, 182
Nassau Hotel (Dublin), 247, 323, 345, 608
Nation, The (New York), 407, 494
Nation (London), 494
Nation, The (ed. Gavan Duffy), 551
National Academy of Design (New York), 359,
 402
National Arts Club, 385
National Gallery of Ireland, 203, 272, 277,
 346, 362, 413, 442, 540–541, 554, 564, 566,
 584, 594, 600, 637
National Gallery (London), 105
National Library of Ireland, 108, 209, 633
National Portrait Gallery (London), 641
National Portrait Gallery (Washington, D.C.),
 607, 610, 641
Nationalism: *see* Irish nationalism
Navajo rug, 403
Neighbors of Yesterday (Jeanne Robert Foster),
 469
Nelson's Pillar, 450, 453
Neo-Impressionists, 402
Nesbit, Evelyn, 336
Nethersole, Olga, 316
Netherstink, Olga: *see* Nethersole, Olga
Nettleship family, 61
Nettleship, John Trivett, 57, 60–62, **62**,
 65–66, 69–70, 83, 103, 115, 134, 330, 497,
 528, 558
Nettleship, Lewis, 69
Nevinson, H. W., 508
New Age, The, 462, 634
New England mind, the, 468
New Statesman, 462, 481, 512
New York City, 234, 252, 260–261, 306–307,
 313, 326–328, 334–335, 341, 344, 370, 379,
 388–389, 391, 401, 428, 492, 537
New York Repertory Theatre, 390
New York Times, 469
Newman, John Henry, Cardinal, 59
Newman St., No. 74 (London), 67
Nicoll, William Robertson, 212
ní Éigherteagh, Gráinne (Mrs. Michael B.
 Yeats): *see* Yeats, Gráinne
nic Shiubhlaigh, Maire: *see* Walker, Mary
Nietzsche (-anism), 264, 299, 303, 343, 399,
 596
"Nihilist, The" (painting by JBY), 186, 232
Niland, Nora, 584, 641
Nine Poems (WBY), 418, 625
Nineteenth Century, The, 196
Noguchi, Yone, 507
Norman Ireland, 496

North, Anne, 321
North End (London), 102
Northampton (England) Mental Hospital, 117, 174
Northern Ireland (*see also* Ulster), 21, 360
Northumberland Road (Dublin), 247
Noyes, Alfred, 411
Nuts of Knowledge, The (George Russell), 260

O'Brien, Barry, 231, 237–238; portrait by JBY, 232
O'Brien, Conor Cruise, 596
O'Brien, Nora Connolly, Senator: *see* Connolly, Nora
O'Briens (on Stephen's Green, Dublin), 320
Observer, The, 481
O'Casey, Sean, 483, 588; works of, 316, 483
Occult, the, 91, 127, 137, 139, 167, 171–173, 175–176, 191–192, 195, 201, 203, 212, 245, 312, 360, 399, 422, 431, 444, 472–473, 485, 491, 495, 522, 525
O'Connell Bridge, 232, 423, 450
O'Connell, Daniel, 473, 567
O'Connell Street (Dublin), 449
O'Connor, Father, 426
O'Connor, T. P., 395
"Odds and Ends" (Lily Yeats), 644
O'Donnell, F. Hugh, 209, 228, 585, 599
O'Donnell, Frank Hugh (the playwright), 585
O'Donnell, William H., 581
O'Donoghue, Denis J., 278, 319, 362
O'Donovan, Fred, 391, **406**, 619
"Oenone" (painting by JBY), 121
O'Grady, Standish (and Mrs.), 238–239, 268, **275**, 277, 286, 430, 490, 591; painting by JBY, 277
O'Hegarty, P. S., 646
Olcott, Henry Steel, 139
"Old Memory" (WBY), 261–263
Oldham, Charles Hubert, 140–141, 144, 232, 571; sketch by JBY, 232
O'Leary, Ellen, 571
O'Leary, John, 126, 140–141, **141**, 142, 144, 146, 154, 168, 171–173, 182, 186, 188, 192, 195, 199, 209, 213, 222, 224, 231, 277, 321, 324, 370, 423, 436, 446, 476, 570–571, 573, 575, 598, 615; pencil sketch by JBY, 232; portraits by JBY, 232–233, 235, 249, 271, 571, 578, 580
O'Malley, Glenn, 632, 636
On Baile's Strand (WBY), 278, 280
"On the Road to Croke Park" (Jack Yeats), 601
O'Neill, Maire (Molly Allgood), 299, 301–302, 307, 318–319, 345, 374, 412, 414, 416, 452, 603, 606; portrait by JBY, 412, 414
O'Neill, Michael J., 585
Orage, A. R., 634

"Orange Moth, The" (Conrad Aiken), 367, 614
Orchard, The (Bedford Park), 118
"Orchardcroft" (Bedford Park), 118, 169, 580
Order of the Golden Dawn, 192, 221, 271, 308, 431
O'Reilly, John Boyle, 573
Ormonde Butlers, the, 43, 91, 321, 418
Ormonde, Duke of, 418
Ormonde Dramatic Society, 229
Ormond, Richard, 641
O'Rourke, J. A., **406**, 619
Orpen, Sir William, 272, 285, 600
Orr, Alexander Barrington, 86, 93, 94
Orr, Elizabeth Pollexfen: *see* Pollexfen, Elizabeth Anne
Orr, Susan, 164, 172
Osborne, Walter, 222, 227, 231, 252, 584
O'Shea, Countess Cathleen, 168
O'Sullivan, Seamus: *see* Starkey, James
"Outdoors in New York" (JBY), 638
Outlook, The, 390
Oxford (England), 65, 152, 638
Oxford University, 61, 121, 162, 224, 276, 350, 364, 387, 395, 528

Pacifism, 360, 476
Paget, Henry Marriott, 154, 162, 166, 167, 182–183, 185, 188, 199, 575
Paget, Mrs. H. M., **189**, 190
Paine, Henry Gallup, 487
"Painter on Painting, A" (JBY), 638
Pall Mall Gazette, 232
Palmer, Arthur, 180
Pan Celtic Society, 227
Paris, 78, 191, 194, 212, 217, 222, 255, 338, 348, 538, 578, 608
Park, Mr. and Mrs. David, 639
Park, Edwin Avery, 639
Parliament, English, 107, 125, 151, 511
Parnell, Charles Stewart, 125–126, 167, 219, 371
Parnellism (-ite), 142
Passages from the Letters of John Butler Yeats (ed. Ezra Pound), 461–462, 481, 512
Patmore, Coventry, 146–147
Patten, Arthur (pencil sketch by JBY), 232
Peabody, Josephine Preston, 387
Pearsall, Dr., 590
Pearse, Padraic, 300, 399–400, 450, 453, 632
Peary, Robert, Admiral, and Mrs., 333
Peau de Chagrin, La (Balzac), 62
"Pegeen Mike" (in *The Playboy*), 314
Pen and Brush Club, 619
Pennsylvania Academy, 355
Per Amica Silentia Lunae (WBY), 485
Perkins, Mrs. Charles, 468, 481–482, 636

Perkins, Maxwell, 361, 367, 429, 468
Perkins, Mrs. Maxwell: *see* Saunders, Louise
Perry the painter, 514
Persse, Mrs. Algernon, 249
Petitpas (boarding house), 354, 360, 363–364,
 367, 371–372, 385–387, 390, 392, 395, 397,
 413–418, 422, 428–429, 445, 457, 468, 477,
 481, 485–487, 491, 493, 505, 509–510,
 514–515, 525, 533, 613, 615, 618, 624, 636,
 639
Petitpas, Celestine, 354, 369, 509, 615
Petitpas, Josephine, 354, 429, 509
Petitpas, Marie, 354, 509
Petitpas sisters, 342, **353**, 354–355, 363, 387,
 392, 398, 433, 468, 487, 491, 498, 509–510,
 514–515, 618–619, 643
Philadelphia, 359, 388, 390, 398–400, 618
Phoenix Park murders, 126
Pied Piper, The (Josephine Preston Peabody),
 387
"Pippa" (painting, drawing, and watercolor by
 JBY), 68–69, 71, 74, 78, 116, 232, 558
Pitman, Isaac, 62
Plainfield (New Jersey), 352, 361, 429, 613
Plarr, Mrs. Victor, 272
Playboy of the Western World, The (J. M. Synge)
 (performance, riots, etc.), 313–314, 316–
 318, 388–390, 604–605, 607–608
'Playboy' Riots, The (ed. James Kilroy), 604
Player Queen, The (WBY), 343, 481, 495
Players Club, 330
"Playing Cards" (painting by JBY), 232
"Playing Truant" (painting by JBY), 232
Pleiades, The, 157, 574
Plunkett, Horace, 203–204, 272, 281–285,
 584; sketch, painting by JBY, 232, 453
Poel, William, 318
Poems (Edward Dowden), 109
Poems and Translations (J. M. Synge; Cuala),
 346
Poetry and Ireland (WBY and Lionel Johnson),
 334, 344
Poetry Society of America, 415, 505, 536, 642
"Political Meeting, The" (painting by Jack
 Yeats), 621
Pollexfen, Agnes Middleton (Mrs. Robert
 Gorman), 37, 80, 82, 84, 102, 117, 174, 183,
 362, 537, 579
Pollexfen, Alfred Edward, 37, 80, 89, **90**, 95,
 110, 150, 454–455, 565, 573, 633
Pollexfen, Alice Jane (Mrs. Arthur Jackson),
 37, 80, 150, 377, 579
Pollexfen, Charles, 27–28, 37, 79, **90**, 102,
 150, 550, 554, 560, 573
Pollexfen, Elizabeth Anne (Mrs. Barrington
 Orr), 37, 80, 86, 93–95, 109, 117, 154, 174,
 217, 436, 537, 556, 635
Pollexfen, Elizabeth Middleton (Mrs.

William): *see* Pollexfen, Mrs. William
Pollexfen, Fredrick Henry, 37, 80, **82**, **90**, 92,
 150, 174–175, 208, 215, 218, 240, 304, 377,
 381–382, 410, 536, 560, 616
Pollexfen, Fredrick, children of, 218, 377
Pollexfen, Mrs. Fredrick H. (Henrietta
 Johnson), 175, 218, 381, 382
Pollexfen, George, 27–29, 35, 37, 69, 79, **90**,
 92–93, 95, 102, **138**, 171, 174, **175**, 176,
 184, 188, 192, 204, 212, 231, 249, 263, 266,
 268, 271, 324, 361–362, 376–377, 381, 383,
 386, 410, 444, 454, 473, 537–538, 550, 573,
 578, 602, 616, 635
Pollexfen, Hilda, 382, 425, 536, 616
Pollexfen, Isabella (Mrs. John Varley), 37, 53,
 56, **75**, 80, 85, 137, 152, 566, 596
Pollexfen, John Anthony, 37, 60–61, 80, **90**,
 183, 204, 217, 410, 587
Pollexfen, Lolla (*see also* Pollexfen, Elizabeth
 Anne), 556
Pollexfen, Ruth, 215, 217–218, 240, 242, 268,
 330, 373, 381–383, 425, 587, 614, 616
Pollexfen, Stella, 616
Pollexfen, Susan Mary (Mrs. John Butler
 Yeats): *see* Yeats, Susan Pollexfen
Pollexfen, W. and G. T., Co., 150, 175
Pollexfen, William (1811–1892), 27, 37, **38**, 50,
 53, 66, 74, 80, 84, 86–87, 93–94, 117, 131,
 148, 150–151, 156, **173**, 174, 192, 204, 217,
 410, 455, 553, 559–560, 587
Pollexfen, Mrs. William (Elizabeth Middleton),
 37, 45, 83, 87, **88**, 89, 93, 117, 136, 150–
 151, 174, 564, 587
Pollexfen, William Middleton (1847–1913),
 37, 80, 82, 84, **90**, 117, 174, 410, 566, 623,
 635
Pollexfens, the (influence as family, etc.), 27,
 35, 37, 43, 53, 58, 74, 79–80, 89, 91–95,
 102, 113, 121, 133–134, 175, 183, 215–216,
 244, 247, 249, 265–268, 307, 350, 376, 381,
 410–411, 436, 444, 448, 454–455, 473, 496,
 529, 532, 536–537, 552–553, 559–560,
 578–579
"Polly's" (New York restaurant), 429
Pomfret Castle, 97
Pond, J. B., 405
Pond's Lyceum Bureau, 405
Ponsonby's Book Shop, 140
Porter, George F., 622
Portrait of the Artist as a Young Man, A (James
 Joyce), 470, 636
Positivism, 31
Post, Evening (New York), 407, 494
Pot of Broth, A (WBY), 246, 277, 331
Potter, Frank, 120, 134, 152, 566, 572, 574
Pound, Dorothy Shakespear, 476
Pound, Ezra, 348, 371–372, 395, 419, 422,
 427, 448, 458, 461–463, 465–466, **466**, 471,

Pound, Ezra (*cont.*)
476, 484–485, 495–496, 512, 515, 521, 616, 626, 631, 634–637
Powell, "Cuckoo": *see* Powell, Mariella
Powell, Frederick York, 154, 162–164, 167, 182, 185–186, 188, 191, 199–200, 213, 219, **220**, 224, 231, 248, 260, 276, 311, 324, 444, 496, 529, 532, 556, 573, 575, 580, 583, 590, 599, 639; portrait by JBY, 232
Powell, Mariella (Cuckoo), 166, 231, 639; portrait by JBY, 232
Powys, John Cowper, 326
Poynter, Sir Edward John, 78, 83, 85, 560
"Prayer for My Daughter, A" (WBY), 517
Prendergast, Maurice, 359, 402
Presbyterian (-ism), 21, 69, 249, 360, 618
Prescott, George, 590
"Priest and the Fairy, The" (WBY), 139–140, 570
"Prince S." (WBY), 271
Princeton University, 480, 485
Priory Gardens (Bedford Park), 162
"Prisoners of the Gods" (Lady Gregory and WBY), 196, 404, 582
Prohibition, 487, 514, 525
Prometheus the Firegiver (Robert Bridges), 147
Protestant (-ism), 30, 72, 125, 137, 249, 301, 350, 570, 618
Providence Sunday Journal, 146
Publications of the Modern Language Association of America (PMLA), 590
Pulitzer, Mrs. Joseph, 639
"Purchase Street," 443, 458
Purser, John, 122
Purser, Louis, 180, 237, 242, **243**, 322, 373–374, 378, 465, 512–514, 583, 592
Purser, Olive, 322, 349, 378, 592; portrait by Sarah Purser, 592
Purser, Sarah, 122, 127, 130, 137, 139–140, 180, 188, 195, 199, 218, 223, 225, 231, 233, **236**, 240, 250, 311, 325, 348, 378, 385, 400, 473, 485, 567, 570, 588, 590, 592
Purser, W. E., 231
Pursers, the, 207, 321, 324
Pyle, Hilary, 554, 633

Queen's University Museum (Belfast), 568
Queen's Gate Hall (London), 254
"Quin, The Widow" (in *The Playboy*), 314
Quinn, Annie (sister of John Quinn), 478
Quinn, Edmund, 541
Quinn, James (brother of John Quinn), 478
Quinn, James William (father of John Quinn), 478
Quinn, Jeremiah (uncle of John Quinn), 325
Quinn, Jessie (sister of John Quinn), 478
Quinn, John, 17–18, 234–235, 238, 242, 244, 285, 287, 312–313, 325, 331, 335, 338,
341–342, 344, 401, 419, 426, 430, 432, 443, 446, 457–458, 477, 498, 505, 586, 594, 610, 615, 624–625, 635, 643, 646–647, 649
—Abbey Theatre, 254, 277–278, 330–331, 390–391, 401, 598, 608
—Armory Show, 392, 401, 404
—birth, 234
—Catholics, 400
—Casement, Roger, 424, 443, 453
—censorship, 469–470, 498, 517, 521
—Coates, Dorothy, 307, 336, 338, 339, 348, 361, 471, 612
—Colum, Padraic, and Molly, 425, 474
—Crowley, Aleister, 431, 438, 629
—Cuala Industries, 463
—death, feelings about, 442, 478, 629
—Dun Emer, 260, 287, 303, 307, 328, 334, 592
—education, 234–235
—England, visits to, 238
—Europe, visits to, 238, 527, 531
—Fay, Frank, and William, 330–332
—Foster, Jeanne Robert, 395, 503, 512, 527, 536–537, 642
—Gonne, Maud, 484–485
—Gregory, Lady Augusta, 238, 248, 400, 404, 441, 480, 582, 622
—Hone-Yeats Exhibition, 234–235
—illness, 458, 471, 478, 480, 489–490, 497, 521
—illustrations of (drawings, photographs), **337**, **340**, **368**, **394**, **421**, **479**, **502**, **519**
—Ireland, visits to, 238, 242, 348; Coole, 238, 588; Dublin, 238, 277–278
—Irish, on the, 277, 389, 400, 443
—Irish-Americans, on the, 252–254, 312–313, 317, 390, 474
—Lane, Hugh, 250, 405, 441–442
—Morris, May, 581
—Nietzscheanism, 264, 303
—Petitpas, 355, 418, 478, 487, 491, 531, 613
—Pound, Ezra, 371–372, 448, 466, 471, 484–485, 635
—Reid, B. L. (including his comments on Quinn), 290, 336, 649
—Russell, George (AE), 260, 277, 593–594, 602
—self, on, 522
—Sloan, John, and Dolly, 370, 387, 396, 404, 497–498, 533, 615
—Smith, Ada, 430
—Synge, J. M., 324, 332, 345–346, 490
—Wilson, Woodrow, 442, 458, 474, 498
—World War I, 423–424, 441–442, 457–458, 474
—writings: Casement, Roger, brief defending, 453; "Deferred Return, The," 492–493; diary, 277; "John Butler Yeats," 648
—Yeats, Jack, 235, 238, 242, 250, 267, 601

Quinn, John (*cont.*)
—Yeats, John Butler, 235–236, 238, 285, 303,
 311, 324–326, 328, 330–331, 333, 335–339,
 341–342, 345–346, 348–349, 355, 361–363,
 370, 372, 379, 384, 387, 391, 396, 414, 416,
 430, 432, 433, 436, 445, 458, 461, 469–471,
 473–474, 478, 481–482, 487, 490, 493–494,
 497–498, 501–503, 505, 510, 526–527,
 532–533, 535–536, 561, 635, 642–643;
 commissions to, 238, 248, 276–277, 285–
 286, 324, 328, 336, 338, 384, 390–391, 417,
 494, 498, 607, 641, 647; correspondence
 with, 277, 312, 326, 458, 463, 469–471, 480,
 494, 515, 602; illness (JBY's, 1918), 487–
 490, 503; illness (JBY's, 1921), 527, 531,
 533; illness (JBY's, 1922), 537–538;
 memoirs, JBY's, 482, 497, 514–515, 644;
 money, 355, 361, 370, 384, 386, 395, 417,
 432–433, 454, 480–481, 491, 495, 509, 510,
 641; on his play, 483; purchase of his works,
 235–236, 238, 412, 414; Quinn, JBY's
 comments on, 396, 441, 458, 471, 496, 515,
 521–522, 620; return to Dublin, 384, 490–
 492, 508–510, 525, 530–533, 647; self-
 portrait (unfinished), 384, 386, 498–501,
 515, 524, 531, 535, 620
—Yeats, Lily, 238, 286–287, 307, 324–326,
 328, 330–331, 333, 335, 348, 384, 474,
 488–489, 505
—Yeats, Lollie, 238, 287, 303, 307, 348
—Yeats, William Butler, 260–261, 264, 303,
 331–332, 416–418, 433, 436, 454, 478, 480,
 485, 495, 498, 531, 533, 541, 625, 628; pur-
 chase of manuscripts, 417, 433, 435, 480–
 481; quarrel with, 348, 379, 390, 404, 415–
 417; and wife, 477, 505, 508–509, 523, 642
Quinn, Maire (Mrs. Dudley Digges), 256, 331,
 375–376, 413, 597, 598
Quinn, Mary Quinlan (mother of John
 Quinn), 478

Racing Lug, The (James Cousins), 246
Raftery the poet, 238
Recollections (John Morley), 480
"Recollections of Samuel Butler" (JBY), 638
"Red Girl, The" (painting by JBY), 108
Red Hanrahan: see Stories of Red Hanrahan
 (WBY)
Redmond, John, 272, 281, 424; portrait by
 JBY, 272, 277
Regent's Park (London), 53
Reid, Benjamin L., 290, 336, 348, 385, 389,
 396, 478, 625, 649
Réjane, Mme., 316
Religious Songs of Connaught, The (Douglas
 Hyde), 586
Renoir, Pierre Auguste, 136, 402
Responsibilities (WBY), 422, 501

Reveries over Childhood and Youth (WBY), 174,
 422–423, 435–436, 446, 448, 562
Review of Reviews, The, 395
Rhymers Club, 171, 191
Rhys, Ernest, 171, 213
"Ria Mooney" (in The Plough and the Stars), 316
Rice, Dr. C. C., 487, 503
Ricketts, Charles, 264, 272
Riders to the Sea (J. M. Synge), 255, 268–269,
 288, 331, 445
Rio de Janeiro, 107, 215
Rising of the Moon, The (Lady Gregory), 269,
 331
Rittenhouse, Jessie B., 507
Ritz-Carlton Hotel (New York), 405
Rivinus, Francis Markoe, 639
Roberts, George, 292, 296, 299–300, 386
Roberts, Mary Fanton (and sketch by JBY),
 359, 390
Robertson, Forbes, 83, 115
Robinson, Mr., 311
Robinson, Edwin Arlington, 387, 507, 512
Robinson, Lennox, 270, 375, 496, 512, 582
Rock-Flower (Jeanne R. Foster), 469, 629
Rolleston, Thomas W. H., 140, 154, **185**, 186,
 190–191, 219, 238, 278, 285, 572, 581;
 sketch by JBY, 285
Romney Exhibition, 218
Roosevelt, Theodore, 260, 339, 389–390, 403,
 441–442, 614
"Rosamond Gregory" (in The Man Who Was
 Thursday), 588
Rose: see Hodgins, Roseanna
Rosenthal (librarian), 341
"Roses for Me, the Thorns for You, The"
 (JBY), 232
Rosses Point (Sligo), 35, 91, 93, 95, 102, 230,
 423
Rossetti, Dante Gabriel, 60, 66, 74, 76, 155,
 529
Rossetti, William Michael, 76
Rothenstein, William, 584
Royal Academy (London), 53, 78, 83, 105,
 115–116, 120, 199, 614
Royal Exchange Assurance Co., 551, 552
Royal Hibernian Academy (Dublin), 137, 222,
 225, 250, 276–277, 281, 325, 453, 599
Royal Society of Antiquaries, 225
"Rufus" (painting by JBY), 232
Rufus, Marcus Caelius, 180
"Runnymede" (Dublin), 241
Rural Cemetery, Chestertown (New York),
 541
Ruskin, John, 559
Russell, George W. (AE), 195, 201, 203, 227,
 229, 232, 238, 245–249, 260, 264, 266, 270,
 277, 278, 281, 299, 304, **305**, 306–307, 313,
 316, 324, 344, 347–348, 361–362, 375, 397,

Russell, George W. (AE) (*cont.*)
 399–400, 418, 424, 462, 471, 481–484, 490,
 495, 515, 521, 526, 553, 584, 587–588, 597,
 599, 602–603, 643, 647; painting and sketch
 by JBY, 594
Russell, T. W. E., 140, 232, 316
Ryan, Esther, **259**
Ryan, Fred, 245–246
Ryan, Thomas Fortune, 387
Ryan, W. P., 167
Rye (New York), 306, 343, 613

Sackville St. (Dublin), 449–450, 453
Saddlemyer, Ann, 585, 603
"Saffron Park" (in *The Man Who Was Thursday*),
 566, 580, 588
"Sailing to Byzantium" (WBY), 562, 566
St. Alban's, Viscount of, 209
St. Enda's School (Rathfarnham), 400
St. George's Church (Dublin), 411
St. John's Church (Sligo), 42, 45, 51, 95, 174,
 216
St. Louis World's Fair, 271, 597
St. Mary's, Donnybrook, 20, 495
St. Michael and All Angels (Bedford Park),
 216, 586
St. Stephen's Church (Dublin), 79
St. Stephen's Green, 123, 203, 325, 484
St. Stephen's Green, No. 6, 225
St. Stephen's Green, No. 7 (JBY's studio), 136,
 140, 225–226, 252, 276–277, 285, **310**, 320,
 323, 326, 370, 398, 413
St. Stephen's Green, No. 60, 569
Salmon, George, Dr., 169, 635
Samhain, 229, 589
Sandymount, 21, 33, 43, 52
Sandymount Castle, 21, 29, 38, 55, 63, 550,
 556
Sandys, Frederick, 57
Santayana, George, 524
Sargent, John Singer, 252, 323, 430
Sassoon, Siegfried, 507
Saunders, Louise (Mrs. Maxwell Perkins), 361,
 429
Saunders family (Plainfield, New Jersey), 361
Scanlan the Coachman, and wife (Sligo),
 92–93
Schauffler, Robert Haven, 507
School of Art, South Kensington, 573
Scotch National Gallery, 225
Scotland, and the Scotch, 375, 391, 473
Scots Observer, The, 576
Scott, Sir Robert, 596
Scott, Lady Rosalind, 596
Scott, Sir Walter, works of, 95, 120
"Scrubwomen in the Old Astor Library"
 (painting by John Sloan), 369
Seabury, Samuel, 641

Seaforth, 24, 27, 522
Sealy, Bryers, and Walker, 146
Searle and Co. (tailor, Dublin), 321, 386
"Second Coming, The" (WBY), 516–517
Seeger, Alan, 364, 367, 369, 514, 614
Self-portrait (by JBY, unfinished): *see* Yeats,
 John Butler, self-portrait
Seven Arts, The, 466, 467
Sewickley (Pennsylvania), 435
Shadowy Waters, The (WBY), 195, 209, 212, 215,
 268, 296, 303, 485, 495, 640
Shakespear, Dorothy, 419–422
Shakespear, Olivia, 183–184, 191, 419, 579
Shakespeare, Dowden's lectures on, 97
Shakespeare, William, 95, 195, 229–230, 257,
 303, 428, 458, 482, 590; works of, 86, 97,
 100, 102, 134, 230, 312, 419, 590
Shakspere: His Mind and Art (Edward Dowden),
 99
Shannon, Charles, 271–272, 598, 607
Shannon, William V., 570
Sharp, William, 195
Sharpe, Alexander (*see also* Ellis, Alexander J.),
 62
Shaw, Albert, 395
Shaw, George Bernard, 156, 244, 588, 622;
 works of, 190, 405
Shaw, Norman, 117
Shaw, Samuel, 287, 353
Shawe-Taylor, John, 272, 278
"Shawn Keogh" (in *The Playboy*), 390
Sheehy-Skeffington, Francis, 375
Sheepshead Bay, 335, 372, 430
Shelbourne Hotel (Dublin), 277–278
Shelley, Percy B., 95, 134, 136, 151, 312, 346,
 534, 569
"Sherman and Saunders" (in *John Sherman*),
 573
"Sherman, Uncle Michael" (in *John Sherman*),
 573
Sherman, Philip Darrell, 645
Sherman, Viva, 574
Shinn, Everett, 359
Shiubhlaigh, Maire nic: *see* Walker, Mary
Shorter, Clement, and Mrs., 182, 188, 204,
 212–213, 230, 494, 585
Shorter, Dora: *see* Sigerson, Dora
Sicilian Idyll, A (John Todhunter), 168, 190
Sigerson, Dora, 182, 188, 212–213, **214**, 222,
 508
Sigerson, Dr. George, 140, 222, 238, 240, 497
Sinclair, Arthur (Francis Quinton McDonnell),
 292, 391, **406**, 619
Singleton, Edward, 553
Sinn Fein (newspaper), 346, 646
Sinn Fein Society (New York), 330
Sinn Fein (Ireland), 452, 455, 511, 525, 535
Sinnett, A. P., 137

Sixteen Poems (William Allingham), 287
"Sketches of Life in the West of Ireland" (Jack Yeats), 227
Slade's School (London), 78, 83, 97, 364
Sleep of the King, The (James Cousins), 246
Sligo, 20, 29, 35, 42, 45, 51–53, 57, 65–66, 71, 77, 79, 83, 84, 86–87, 89, 92, 95, 105, 110, 113, 117, 120–122, 150–151, 164, 169, 171, 174, 184, 193, 195, 204, 216, 227, 287, 324, 373, 376–377, 422, 444, 454, 550, 552–553, 559, 562, 565, 571
Sligo Harbour, 80, 93, 151
Sligo, County, Museum of, 641
Sligo Steam Navigation Co., 37, 79, 150, 433, 495, 573
Sloan, Dolly (Anna Wall, 1st Mrs. John Sloan), **358**, 360, **366**, 367, 369, 370–372, 385–387, 390, 396, 414–415, 429, 435, 445, 455–457, **464**, 476, 487, 497–498, 512, 516, 525, 533, 536–537, 615
Sloan, Helen Farr (2d Mrs. John Sloan), 562
Sloan, John, 17, 342, **355**, **356**, 359–361, 364, **365**, **366**, 367, 369–372, 377, 384–388, 390–391, 395–398, 402, 404, 413, 426, 429, 456–457, 476, 487, 491, 498, 509–512, 514–516, 525, 535–536, 563, 609, 615, 618, 620, 644, 647
Sloan's Diary, John, 359, 367, 372, 390
Slough, 110, 112, 560
Smith, Ada, 307, 328
Smith, Annie, Mrs., 328, 348
Smith College, 260
Smith, Leo, 602
Smith, Nannie, 213, 222, 225, 598; portrait by JBY, 271
Smith, Pamela Colman (Pixie), 244, 313, 593
Smith, Robert Catterson, 97, 102–103, 115, 594
Smith, Stephen Catterson (the elder), 594
Smith, Stephen Catterson (the younger), 250, 252, 325, 405, 594
Smith, Stephen Catterson, Mrs. (the younger), 250–252, 594
Smith Elder and Co., 85, 561
Smith, Travers, 231
Smyth, grocer (Stephen's Green), 136, 321, 398
"Snaile's Castle," 177, **200**, 579
Sneddon, Robert W., 364, 369, 390, 397, 614
Socialism (-ists), 360–361, 396, 429, 435, 615
Society of Political Education (New York), 508
Sold (James Cousins), 246
Some Essays and Passages (John Eglinton), 287
"Song of the Faeries, The" (WBY), 144
Sothern, Edward Hugh, 341
Sparling, Herbert Halliday, 156–157, 190, 576
Sparling, Mrs. Herbert Halliday: *see* Morris, May

Speaker, The, 229
Speckled Bird, The (WBY), 192, 195, 212, 570
Spencer, Herbert, 82, 110
Speyer, Lady (Leonora), 507
Sphere, The, 212, 462
Spreading the News (Lady Gregory), 278, 280
Sprinchhorn, Carl, 359
Squire, Ann, 390, 395, 429, 456, 487, 525, 530, 615
Stanford University, 260
Starkey, James, 292, 602
Starkie, Walter, 249
"Statement by L.G. to J.Q." (John Quinn), 582, 622
Stead, W. T. (sketch by JBY), 232
Stephens, James, 362, 452
"Stephenson fairy article" (WBY), 576
Stepniac, Sergius, 167, 173, 188
Stepniac, Mrs. Sergius, 188, 578
"Stevedore, A" (painting by Jack Yeats), 621
Stevens, Mr., 186
Stewart, Vyvyan, 238
Stockley, W. F., 140
Stokes, Adrian, 565
Stories of Red Hanrahan (WBY), 266, 278, **279**, 287, 599
"Story Without a Plot, A" (Lollie Yeats), 574
Stradbally Hall, 93, 96, 102, 230, 563
"Strand Races" (painting by Jack Yeats), 622
Stratford-on-Avon, 229, 230
"Street Children Dancing" (painting by JBY), 232
Strete (Devon), 177, 196, **200**
Strong, L. A. G., 264
Studio (JBY's, with Ellis), 67
Studio, The, 392
Studio Evening (Marjorie Organ Henri), **430**
Sullivan, Professor (sketch by JBY), 232
Sullivan, Alexander, Mrs., 136
Sumner, John, 517
Sun, Evening (New York), 330, 345, 361, 388
Sun, Weekly (London), 192
"Suppressed Chapter of My Memoir, A" (JBY), 494
Swinburne, A. C., 155, 312, 604
"Sword of Light, The": see *An Claidheamh Soluis*
Symbolist movement, 191
Symons, Arthur, 171, 184, 190–193, 201, 222, 272, 345, 599
Symons, Mrs. Arthur, 272
Symonds, John Addington, 564
Synge and the Ireland of His Time (WBY), 382, 399
"Synge and the Irish" (JBY), 638
Synge, John Millington, 194–195, 228, 238, 255–257, 268–269, 272, 278, 280, **282**, 285–288, 290, 292–294, 298–303, 307,

Synge, John Millington (*cont.*)
 313–321, 324, 332, 345, 350, 374, 376, 389,
 409, 413, 445, 490, 517, 521, 553, 582, 584,
 588, 593, 599, 600–603, 605–606, 611, 632;
 drawings by JBY, 600; portrait by JBY, 272,
 285, 600
Synge, J. M., family of, 345

Tagore, Rabindranath, 408, 411
Talbot Press, 481
Tale of a Town, The (Edward Martyn), 219
Tarot cards, 254, 258
Tate Gallery, 566
Taylor, Jane, 19
Taylor, John F., 140, 143, **143**, 232, 436
Taylor, W. A., 594
Taylor, William, 19
TCD: *see* Trinity College, Dublin
Temple, The (London), 184, 191, 581
Temple Library, the, 182
Tennyson, Alfred Lord, 120–121, 133, 155,
 427; works of, 133, 427
Terenure (Dublin), 136–137, 140, 149
Terry, Ellen, 168
Thaw, Harry K., 335–336
Theatre of Ireland, 298–300, 303, 346–347,
 362, 374
Theatre Royal (Dublin), 599
Theological Society, TCD, 553
Theosophical Society (Dublin), 495
Theosophical Society, U.S.A., 620
Theosophy, 139, 167, 431, 648
Thomas, Charles, 594
Thomastown (estate of JBY), 20, 33–34, 38,
 42, 55–56, 63, 72, 75, 102, 107, 109, 131,
 133, 150, 152, 159, 161, 217, 248, 321, 473,
 552, 557, 574, 606, 636
"Thornhill" (Sligo), 175
"Time and the Witch Vivien" (by WBY), 132
Times, The (London), 462
"To a Prostitute" (Walt Whitman), 121
"To the People of Ireland" (Proclamation at
 1916 Rising), 453
"To Be Carved in a Stone at Ballylee" (WBY),
 517
Tobin, Agnes, 193, 311, 404, 582
Todhunter, Arthur Henry, 77, 102, 559–560
Todhunter, Dora Louisa Digby (2d Mrs.
 John), 118–119, 158, **163**, 169, 182, 272,
 372, 633
Todhunter, Edith, **163**, 164
Todhunter, John, 38, 40, 44–45, 50–51, 55,
 57, 60–62, 65–72, 78, 97, 102–103, 105,
 107–109, 113, 116, 118–119, 121–122, 127,
 130–131, 134, 144, 151, 154–155, 158, 161,
 164, **165**, 167–169, 182, 190, 231, 272, 372,
 408, 444, 457, 497, 550, 558, 564, 566, 580,
 585, 594, 633, 635

Todhunter, 1st Mrs. John, 68, 77
Tolstoy, Leo, work of, 158
Towne, Charles Hanson, 507
Townland of Tamney, The (Seamus MacManus),
 268
Tract Society, The (London), 154, 170, 186
Traill, Anthony, 410
Trench, W. Wilberforce, 410, 622
Trinity College, Dublin (TCD), 20, 29,
 32–34, 40, 51, 56, 115, 120–121, 130, 139,
 149, 180, 194, 209, 322, 373, 376, 378, 383,
 407, 409–410, 454, 472–473, 512–514, 550,
 553, 563, 574, 583, 592, 619, 636; Council,
 109
Troubles, the (1920), 511, 525
"Trust Account, W. B. Yeats in Account with
 John Quinn," 417, 433, 509
Tullylish Parish, County Down, 19, 21, 24,
 473, 549–550, 554
Turner, J. M. W., 397
Turnham Green, 117
Twenty-Five (Lady Gregory), 246, 254
Twenty-One Poems (Lionel Johnson), 287
Twenty-One Poems (Katharine Tynan), 322
Twisting of the Rope, The (Douglas Hyde), 228
Two Kings, The (WBY), 427
Tynan, Andrew, 144; portrait by JBY, 232
Tynan, Katharine (Mrs. Henry Hinkson), 129,
 136, 144, 146, 150–151, 167–168, 182, 188,
 191, 213, 231–232, 238, 341–342, 414, 426,
 571, 573–574; portrait by JBY, 232, 238,
 306, 322, 512
Tyrrell, Robert Yelverton, 180, 377

"Ulick Deane" (WBY in George Moore's *Evelyn
 Inness*), 201
Ulster, 19, 21, 249, 423, 473, 530, 548
Ulysses (James Joyce), 470, 498, 517, 521, 538,
 602
Unicorn from the Stars, The (WBY), 589
Union Place (Sligo), 35, 53
Unionism (-ists), 107, 140, 250, 452, 569, 573
United Irishman, The, 229, 247, 256–257
University Club, Dublin, 532
University College Dublin, 349, 362, 585
Untilled Field, The (George Moore), 645

Vagabond Club (New York), 341, 350–352
Vale (George Moore), 418
Vanity Fair (New York), 620
Varley, Ida (later Mrs. Dewar-Durie): *see*
 Dewar-Durie, Ida Varley
Varley, John, 157
Varley, Mrs. John: *see* Pollexfen, Isabella
Vassar College, 260, 507, 627
Veasey, Cyril, 566
Vergil, quoted, 465
Verlaine, Paul, 191

Vice-regal Lodge (Dublin), 126
Victorian (-ism), 32, 465
Viereck, George Sylvester, 442–443
"Village Blacksmith, The" (painting by JBY), 232
"Village Ghosts" (in WBY's *Celtic Twilight*), 567
Vision, A (WBY), 495, 640
Visions: *see* Yeats, Lily, visions
Visions and Beliefs (Lady Gregory), 481
"Vivien" (Laura Armstrong), 132
Vizzard, Harold, 387, 487
"Voices" (WBY), 144
Voisin, Abraham, 548
Voisin, Claude, 549

W. and G. T. Pollexfen & Co., 616
W. B. Yeats and the Idea of a Theatre (James Flannery), 601
W. B. Yeats: 1865–1939 (Joseph Hone), 628
W. G. Fay's Irish National Dramatic Company, 229, 245
Wade, Allan, 568, 582, 631
Walker, Dolly, 344
Walker, Emery, 156, 166, 240, 344, 600
Walker, Frank, 292, 296, 299–300
Walker, James, Rev., 140
Walker, Mary (Maire nic Shiubhlaigh), 242, **258**, 292, 296–298, **297**, 298–303, 346, 362, 391, 584, 598, 600, 602–603; portrait by JBY, 298
Walker's Gallery, 222
Wall, Anna: *see* Sloan, Dolly
Walpole, Horace, 30
Walsh, Archbishop William J., 593
Walsh, Townsend, 333
Wanderings of Oisin (WBY), 155, 161, 164, 168, 230
Wardle, Mildred (Martha), 185, 580
Watson, John, 531–533
Watson, Mrs., 158
Watson, William, 596
"Watts and the Method of Art" (JBY), 638
Watts, George, 116, 233, 295, 299, 430, 471, 601; lecture, JBY, 295
Weare, John, 387, 620
"Wearing of the Green, The," 558
Webb, Miss, 590
Weekly Review, 576
Well of the Saints, The (J. M. Synge), 280, 288, 290
Wells Central Hall (London), 244
West, Elizabeth Dickinson: *see* Dowden, Elizabeth Dickinson West
Westminster School, 573
"What Should Be the Subjects of National Drama" (W. K. Magee), 201
Wheelock, John Hall, 367, 463
Where There Is Nothing (WBY), 271, 589, 593, 598

Whistler, J. M., 323; JBY's essay on, 427
White, Arnold (sketch by JBY), 232
White Cockade, The (Lady Gregory), 292
White, James, Dr., 541, 554
White, Stanford, 335–336
White, Terence de Vere, 555, 596, 600
"Whitehill" (Dublin), 144
Whiteside, James (Lord Chief Justice of Ireland), **49**, 50, 554
Whitman, Walt, 121, 330, 427, 626
Whitney, Gertrude Vanderbilt, 469
"Why the Englishman Is Happy" (JBY), 638
Wickens, Anne (Mrs. Arthur), 594
Widdemer, Margaret, 507
"Wife to a Husband" (J. R. Foster), 438
Wild Apples (J. R. Foster), 628
Wild Swans at Coole, The (WBY), 501
"Wild Swans, The" (WBY), 481
Wilde, Oscar, 133, 161, 530
Wilde, Lady Francesca (wife of Sir William), 31, 551
Wilde, Sir William, 31, 46
Wilkins, William, 129, 133
Wilkinson, Marguerite, 569
Williamson, Thomas, 188
Wilson, George, 61, 65, 69–70, 83, 85, 115, 134
Wilson, Grove, and Mrs., 17, 428–429, 456
Wilson, Woodrow, 442, 458, 474, 485
"Winter" (painting by JBY), 232
"Wizard's Daughter, The" (JBY), 468
Woburn Buildings, No. 18 (London), 191, 201, 211, 266, 484, 581
Woman's Reliquary, A (Edward Dowden), 408–409, 422, 622
Women's Printing Society (London), 240
Woodlawn Cemetery, 541
Woodroffe, Jane, 565
Woodroffe, William Litton, 115, 131, 565
Woodstock Road (Bedford Park), 117–118, 122, 566
Wordsworth, William, 71, 436, 550, 628
World (New York), 359, 443
World War I, 423, 441, 457, 474, 614–615
World War II, 476, 498
"Worn Out with Dreams" (Ann Saddlemyer), 585
Wright, Charles K., 564
Wright, Udolphus (Dossy), **406**, 603, 619
Wyndham, George, 250
Wynne family (Sligo), 92

Yale University, 260
"Yeats" (lecture, T. S. Eliot), 625
"Yeats at Petitpas" (painting by John Sloan), 369, 615
Yeats, Anne Butler, 484, 495–496, 505, 566,

Yeats, Anne Butler (*cont.*)
590, 640
Yeats, Benjamin, 20
Yeats, Caitríona Dill, **265**, 596, 643, 646
Yeats, Cottie: *see* Yeats, Mrs. Jack B.
Yeats, Eleanor (Mrs. Elwin), 21, 549
Yeats, Elizabeth (daughter of Matthew Yeats), 594
Yeats, Elizabeth Corbet (Lollie): *see* Yeats, Lollie
Yeats, Ellen (aunt of JBY), 266, 559
Yeats, Ellen (sister of JBY), 34, 37, 537
Yeats, Fanny (sister of JBY), 34, 497
Yeats, Frank (John Francis Butler), 102, 491
Yeats, George (uncle of JBY), 31–32
Yeats, George (Georgie Hyde-Lees Yeats; Mrs. WBY), 422, 476–478, 484–485, 495–497, 505, **506**, 507–510, 517, 523, 560, 574, 638, 642–643, 648
Yeats, Grace Jane (sister of JBY), 34, 105, 436, 497, 583
Yeats, Grace (Mrs. Matthew), 495
Yeats, Gráinne ní Éighertaigh (Mrs. Michael B.), 592, 646
Yeats, Isaac Butt, 34, 199, 234, 238, **239**, 240, 276, 426, 454, 491, 497, 583
Yeats, Jack (John Butler Yeats, Jr.; son of JBY), 150, 359, 370, 466, 646
—birth, 77
—character, 94, 106, 113, 118, 164, 172, 193, 203, 411–412, 523, 587, 596
—confusion with John Butler Yeats, 235, 590
—Coole, 585, 588
—Cottie: *see* White, Mary Cottenham, *within this entry*
—Coxhead, Elizabeth, her comments on, 596
—Cuala, 334
—as designer, 596–597, 601
—Devon, 120
—Dun Emer, 241
—Earl's Court, 152
—Easter Rising, 450, 454–455
—education, 151, 593; Chiswick Art School, 154, 164, 573; by Pollexfen grandparents, 120; School of Art, South Kensington, 573; in Sligo, 150; Westminster School, 573; by Yeats, John Butler, 120
—Exhibitions, 196, 227, 242–244, 402, 523, 621
—Gregory, Lady Augusta, 196, 203, 209, 219, 267, 585, 588
—Gregory, Robert, 221
—"Gurteen Dhas," 348, 523
—Hannay, Canon James O. (George Birmingham), 623
—Harvey, T. Arnold, 209, 221, 585
—health, 455
—Hone-Yeats Exhibition, 235
—illustrations (photographs of, sketches of and by), **98**, **108**, **112**, **119**, **123**, **148**, **198**, **200**, **261**
—Irish language, 523
—Jowitt, Martha, 113
—Lane, Hugh, 250
—Manchester, 177
—marriage, 177, 383
—"Memory Harbour," 93, 423
—money, handling of, 164, 222, 287, 576, 601
—Moore, George, 362
—New York, visit to, 267
—Orr, Susan, 164, 172
—as painter, 164, 196–199, 223, 244, 248, 360, 403, 412, 444, 523, 597, 601, 630
—paintings, sketches, 93, 150, 164, 412, 423, 444, 454–455, 601
—politics, 127, 450, 455, 633
—Pollexfen, Elizabeth (Mrs. Barrington Orr), 86, 94, 109
—Pollexfen, George, 377
—Pollexfen, William and Elizabeth (grandparents), 120, 150–151
—Pollexfens, the, 83, 455
—portrait by JBY, 232
—Powell, Frederick York, 164
—Quinn, John, 235–236, 238, 244, 250, 267, 348, 601
—residences: Bedford Park, Blenheim Road, 154, and Woodstock Road, 118, 566; Chertsey, Surrey, 177; Eardley Crescent, 152; Edith Villas, 105, 112; Fitzroy Road, 560; Marlborough Road, 484; Sligo, 120–122; Strete, Devon ("Snaile's Castle"), 177, 196, **200**, 579
—Sligo, 79, 83, 150–151, 164, 193, 203, 566
—Smith, Pamela Colman (Pixie), 244
—Synge, J. M., 287, 320
—Todhunter, Edith, 164
—White, Mary Cottenham (Cottie; Mrs. Jack B. Yeats), 177, 193, 196–199, 203, 218, 267, 383, 585
—writings: *Broadsheet*, 244; *Broadsides* (Dun Emer and Cuala), 334; fiction, 196, 574; plays, 218; prose, nonfiction, 412
—Yeats, Jane Grace (sister), 106, 109
—Yeats, John Butler, 161, 183, 218, 222–223, 250, 267, 403, 412, 430, 443–444, 446, 497, 588, 590, 623, 626; memoirs, 409; portraits by, 173, 232, 578, 583; return to Dublin, 492; self-portrait (unfinished), 498, 620
—Yeats, Lily, 160, 185, 218, 241, 267, 362, 409, 523, 597
—Yeats, Lollie, 167, 177, 587; diary, 159–160, 164
—Yeats, Susan Pollexfen, 216, 587
—Yeats, William Butler, 161–162, 164, 177, 193, 219, 221, 267, 348, 436, 484; *Reveries*

Yeats, Jack (John Butler Yeats, Jr; son of
JBY) (*cont.*)
 over Childhood and Youth, 423
Yeats, Mrs. Jack B. (Cottie), 177, **178**, 193,
 196–199, 203, 218, **253**, 267, 383, 585
Yeats, Jane Grace Corbet (wife of the Rev-
 erend William Butler Yeats), 20–21,
 23–24, **25**, 34, 39, 63, 89, 107, 109, 436,
 484, 495, 497, 523, 548–549, 551, 553, 597,
 623
Yeats, Jane Grace (daughter of JBY), 105, 109,
 117, 564
Yeats, Jane Grace (sister of JBY), 436, 497, 583
Yeats, Jervis, 20
Yeats, John (Rev., of Drumcliff; Parson
 John), 19–20, 321, 548–549
Yeats, John (*see also* Yeats, Michael B.), 523
Yeats, John (son of John Yeats, grandson of
 Parson John Yeats), 642
Yeats, John (uncle of JBY), 30
Yeats, John Butler, Jr.: *see* Yeats, Jack B.
Yeats, John Butler, Sr. (JBY)
—Abbey Theatre, 296–302, 308, 330–332,
 346, 388–390, 399–402, 405, 604–605
—birth, 19–21
—character, 83, 116, 129, 130–131, 143–144,
 151, 161–162, 207–208, 224, 248–249, 276,
 311, 317, 324, 361, 364, 371, 391–395,
 412–413, 415, 468, 474, 482, 492–494, 497,
 503–504, 532–533, 538–540, 573, 596, 602,
 611, 614, 624, 628–630, 637, 648
—on class feeling, 93–94, 352
—confusion with Jack Yeats, 235, 590
—death, 17–18, 527–538, 541, 648
—education: as artist, 78, 107; Atholl
 Academy, 27–29; Heatherley's, 53, 78;
 home, 23; King's Inns, Dublin, 34, 40;
 Poynter, Sir John, 78; Seaforth School, 24;
 Slade's, 78, 83, 102–103; Trinity College,
 Dublin, 29, 32–35
—estate: *see* Thomastown, and Dorset St.
 (Dublin)
—exhibitions: Guildhall (London), 271, 598;
 Hone-Yeats (1902), 225–234, 588, 590–591;
 National Gallery (Ireland), 541; Whitney,
 Mrs. Gertrude, 469
—and Gregory, Lady, 193–194, 196, 203,
 208–209, 212–213, 247–249, 254, 270, 272,
 295–299, 303, 344, 379, 390, 400–401, 409,
 411, 413, 465–466, 477, 484, 517, 586, 603,
 606–607, 621, 623, 643
—health (*see also* death, *within this entry*), 59, 72,
 161–162, 183–185, 276, 311, 321–322, 335,
 363, 370–371, 384, 391–395, 414, 416, 428,
 432–433, 445–446, 455, 460–461, 478,
 487–491, 501–503, 511, 525, 527–538, 553,
 556, 598–599, 615, 634, 643, 646, 648
—and Horniman, Annie E. F., 270–271, 285,

375, 598
—illustrations (photographs, sketches of),
 frontispiece, **41**, **103**, **106**, **253**, **293**, **310**,
 329, **340**, **355**, **430**, **431**, **432**, **475**, **486**, **499**,
 502, **513**, **539**; letters, **26**, **234–235**, **368**,
 393, **394**, **434**, **479**, **500**, **502**, **520**; tomb-
 stone, **542**
—literature read to his children: William
 Blake, 134; the Brontës, 95; Geoffrey
 Chaucer, 95, 102, 134; Charles Dickens, 95,
 120, 134; John Keats, 95, 134; Thomas
 Babington Macaulay, 95; Captain Frederick
 Marryat, 565; Sir Walter Scott, 95, 120;
 William Shakespeare, 95, 102, 134; Percy B.
 Shelley, 95, 134
—literature read: Mikhail Bakunin, 371;
 Daniel Defoe, 23; T. S. Eliot, 524; Edward
 Gibbon, 524; James Joyce, 470; George San-
 tayana, 524; William Shakespeare, 97, 312,
 419
—memoirs, 386, 398, 435, 444, 456, 472–474,
 482–483, 494, 497, 514–515, 549, 636,
 643–644
—money (troubles with), 38–39, 55–56, 66,
 74–76, 84, 84–85, 102, 105, 107, 109, 119,
 122, 131, 133, 135, 139, 151–153, 158–159,
 164, 190, 199, 204, 213, 216–217, 222, 225,
 237, 240–241, 247–248, 261, 263, 311, 321,
 323, 330, 333, 335–336, 341, 352, 370, 386,
 392, 398–399, 413–417, 427, 432–433, 435,
 455, 468, 481, 491–492, 498, 501, 509, 535,
 572–574, 606–607, 610, 613, 615, 622, 624,
 636, 643, 647
—as painter, 57, 60, 68, 74, 76, 78, 83–86, 97,
 103, 105, 107–109, 112, 116, 119, 121–122,
 136–137, 162, 169, 186, 203, 413, 429–430,
 469, 598
—paintings (sketches, portraits, landscapes; *see
 also* self-portrait, *within this entry*), 38, 51–52,
 54–55, 67–69, 71, 74, 78, 83–86, 95–96,
 102, 104–105, 107–110, 112–113, 115,
 119–122, 127, 130, 132, 136–137, 142–144,
 146–147, 150, 152, 159, 162, 169, 171,
 173–174, 182, 186, 196, 199, 203–204, 213,
 222–223, 225–240, 248–250, 263, 271–272,
 274, 285–286, 298, 311–313, 320, 323–324,
 326, 330, 335–336, 338–339, 341–342, 354,
 359, 360–362, 367, 370, 386, 390–391, 396,
 405, 413–418, 429–430, 438, 445, 468–469,
 481, 485, 498, 512, 515, 532–534, 536, 538,
 550, 555, 558, 560, 563, 567, 574, 577–578,
 580, 583–584, 594, 597–598, 600, 602,
 606–608, 615, 624, 632, 641, 643
—residences, in England: Bedford Park:
 Blenheim Road, 154, 494, and Woodstock
 Road, 117; Burnham Beeches, 110, 113;
 Eardley Crescent, 152; Edith Villas, 102,
 112; Fitzroy Road, 53, 85; Gloucester Road,

Yeats, John Butler, Sr. (JBY) (*cont.*)
53; London (unspecific), 151–152; in Ireland: Dublin (unspecific), 237; Gardiner Street, Dublin, 122–123; "Georgeville," Sandymount, Dublin, 43; "Gurteen Dhas," Dundrum, 242; Howth, 123, 135; Sandymount Castle, Sandymount, 29–32; Terenure, 135; in New York: Grand Union Hotel, 328–353; 12 West 44th Street, 353–354; Petitpas (317 West 29th Street), 354–538
—self-portrait (unfinished), **frontispiece**, 384–386, 398, 414, 416, 430, 444, 456, 457, 473–474, 483, 498–501, 515, 524, 531, 533, 535, 538–539, 620, 647
—as speaker, conversationalist, 40, 45–49, 102–103, 115, 143–144, 207, 330, 341, 350, 352, 355, 360–361, 364, 386, 395, 435, 445, 455–456, 474, 476, 480, 485, 494, 536, 538, 554, 601–602, 604–605, 613, 618–619, 634
—studios, 67, 107–108, 116, 127, 135, 370
—and Synge, J. M., 285–287, 293, 313, 316–317, 320, 324, 332, 345–346, 389, 445, 518, 593, 600–601, 605, 611
—on WBY's character and personality, 94, 129, 143–144, 162, 191, 208, 246–247, 272, 286–287, 300–301, 304–306, 343–344, 346–349, 378–379, 382, 391–392, 399, 413, 483, 507–508, 517, 521, 527–529, 532, 562, 573, 630
—on WBY and Maud Gonne, 208, 422
—on WBY and the occult, 137–139, 167, 172, 195, 212, 308, 312, 444, 459, 472, 485, 501, 525, 570, 630, 640
—writings (*see also* memoirs, *within this entry*), 341, 436, 445, 458, 466–468, 471, 482, 535, 588, 645; *Auditor's Address, King's Inns*, 45–49, 463, 554, 634; *Early Memories*, 541, 637; *Essays Irish and American*, 467, 481–482, 588, 638; fiction, published, 252, 643, 645; fiction, unpublished, 28, 34, 54–55, 66, 159, 343–344, 468, 550, 552, 555, 611; *Further Letters of JBY*, 496, 512, 588, 643; *JBY: Letters to His Son*, 541; letters, 252, 426–427, 444, 470–471, 491, 533, 537, 588, 640; letters to newspapers, 252, 281, 389; nonfiction, published, 256–258, 281, 330, 345–346, 352, 386, 389, 391–392, 407, 413, 415, 427, 442, 514, 518, 522, 525, 535, 566, 599; nonfiction, unpublished, 341, 413, 442; open letter, 252; *Passages from the Letters of JBY*, 426–427, 436, 448, 462–466, 471, 588, 619, 634–635; play (unpublished), 286, 324, 456–457, 483–484; poetry, 522, 536, 645
—Yeats, Jack: *see under* Yeats, Jack
—Yeats, Lily: *see under* Yeats, Lily
—Yeats, Lollie: *see under* Yeats, Lollie
—Yeats, Susan Pollexfen, 35, 37, 39, 41–43,

45, 50–51, 53, 55–56, 59, 63, 66–67, 70–72, 77, 83–86, 94, 102, 112–113, 118, 121–123, 134, 136, 149–150, 152, 167, 186, 199, 215–217, 267, 376, 384, 411, 423, 473, 477–478, 494, 527–528, 537, 553, 586–587
—Yeats, William Butler: *see* WBY *within this entry, and* Yeats, William Butler
Yeats, John Michael (*see also* Yeats, Michael B.), 523
Yeats, Johnnie (son of John Yeats, grandson of John Yeats, and greatgrandson of Parson John Yeats), 642
Yeats, Laura (Lollie; daughter of Matthew Yeats), 556
Yeats, Leo Armstrong Butler, 628
Yeats, Lily (Susan Mary; daughter of JBY), 17, 66, 105, 186, 298, 308, 324, 330, 334, 348, 383, 418, 426, 437, 480, 496, 510, 525, 557
—Abbey Theatre, 300, 308, 330–331, 345, 347, 374, 474, 484
—Allgood, Molly: *see* O'Neill, Maire, *within this entry*
—Armstrong, Laura, 568
—Belloc, Hilaire, 426
—birth, 51
—Boer War, 213
—Boughton, Alice, 332–333, 609
—character, 307–311, 332–334, 373, 382, 411, 425
—Chesterton, G. K., 224, 426, 437, 490, 588
—Colum, Padraic, and Molly, 425, 600
—Cuala Industries (*see also* Dun Emer, *within this entry*), 334, 373, 382, 411, 422, 435, 496, 511, 526, 596–597
—De Valera, Eamon, 535
—Devon, 120
—diary, 182–186, 188
—Dowden, Edward, 376
—Dowden, John, 362
—Dublin, 89
—Dun Emer, 240–242, 248, 260, 266–267, 287, 324, 328–330, 334, 592, 596–597
—Easter Rising, 450–454, 474, 632
—education: at Kelmscott House, 156; at Metropolitan School of Art, 139; at Notting Hill School, 120; by Yeats, John Butler, 120
—Ellis, Edwin (and family), 63, 514, 560
—embroidery, 596–597
—Fay, Frank, and William, 330–331, 474, 608
—Ferguson, Sir Samuel, 135
—Ford, Julia, 287, 326
—Gleeson, Evelyn, 240, 242, 260, 263, 266, 303, 308, 328, 334, 362, 373, 592
—Gonne, Maud, 160, 208, 450, 485, 575
—Green, Alice Stopford, 490–491
—Gregg, Frederick J., 140, 342
—Gregory, Lady Augusta, 196, 267
—health, 84, 152, 180, 185–186, 199, 426,

Yeats, Lily (Susan Mary; daughter of JBY)
 (*cont.*)
 437, 445, 523
—on herself, 382
—Hinkson, Henry, 426
—Hone, Joseph, 628
—Hone-Yeats Exhibition (1901), 231–232,
 591
—Hyères, 182, 184–185, 580
—illustrations (photographs, sketches), **73**, **76**,
 101, **119**, **181**, **258**, **322**, **332**, **467**
—Irish nationalism (troubles in Dublin),
 511–512, 525, 535
—Johnston, Charles, 342
—Jowitt, Martha, 112–113
—Joyce, James, 593
—Lane, Hugh, 407
—letters of (as letter-writer), 95, 182, 333–334,
 341–342, 345, 362, 426, 474, 512, 579, 609,
 617
—Mancini, Antonio, 323
—Markievicz, Constance Gore-Booth, 450–
 452, 474
—Mathews, Elkin, 186
—"Merville," 92
—Mitchell, Susan, 204, 213, 347, 474, 497, 511
—Moore, George, 286, 362, 437, 617
—Morris, May, 160, 164–166, 180–182, 494,
 529
—Morris, William, 166
—New York, visit to, 324–333
—occult: *see* visions, *within this entry*
—O'Neill, Maire (Molly Allgood), 307, 345,
 412
—Orr, Susan, 172
—Phoenix Park murders, 126
—Pollexfen, Elizabeth (Mrs. Barrington Orr),
 86, 93–94, 109
—Pollexfen, Fredrick, 382
—Pollexfen, George, 175, 184, 268, 376, 437
—Pollexfen, Isabella (Varley), 152
—Pollexfen, Ruth (Lane-Poole), 215, 217–
 218, 268, 373, 382
—Pollexfen, William Middleton, 410
—Pollexfen, William, and Elizabeth (grand-
 parents), 130, 174
—Pollexfens (family), 83, 89, 93, 436, 552
—Pound, Ezra, 631
—Purser, Louis, 242, 373–374, 592
—Purser, Sarah, 231
—Quinn, John, 238, 266, 278, 307, 324, 326,
 328, 333, 335, 339, 348, 384, 409, 417, 471,
 593
—residences: Bedford Park, Blenheim Road,
 154, 182, 184–185, and Woodstock Road,
 118; Eardley Crescent, 152; Edith Villas,
 112; Fitzroy Road, 560; "Gurteen Dhas,"

242, 285, 308, 348, 411, 425, 490, 600;
 Howth, 123; Terenure, 137, 140
—Russell, George (AE), 471
—Sligo (Rosses Point, etc.), 83, 86, 91–93, 105,
 166, 184, 287, 376, 566
—Synge, J. M., 238, 285, 307, 345
—Thomastown estate, 133, 159, 217, 574
—visions, 173, 217, 308, 410, 491
—Walker, Emery, 166
—Walker, Mary (Maire nic Shiubhlaigh), 300
—writings (*see also* diary, *and* letters of, *within
 this entry*), 597; draft scrapbook, 514; "My
 wishes," 267–268; "Odds and Ends," 514;
 scrapbook, 514
—Yeats, Anne Butler, 495, 505
—Yeats, Georgie Hyde-Lees (Mrs. W. B.), 477,
 484, 514, 648
—Yeats, Isaac, 583
—Yeats, Jack (and Cottie), 109, 177, 185, 267,
 362, 383, 409, 423, 523, 597
—Yeats, Jane Grace (sister), 109
—Yeats, Jane Grace Corbet (grandmother), 89
—Yeats, John Butler, 180, 208, 267, 311,
 324–326, 328, 330, 335, 344, 371, 418, 445,
 477, 490; drawings, portraits, etc., of Lily by
 JBY, 225, 232, 271, 277, 413, 574, 598;
 financial problems, 336, 384, 468, 481, 501,
 632, 635–636; as friend and companion,
 208, 308, 311, 326–333, 474; *Further Letters
 of John Butler Yeats*, 496; illness of, 488–489;
 memoirs, 409; as model for paintings by,
 159, 182, 579; painter, on JBY as, 182,
 285–286, 339, 413, 594; *Passages from the
 Letters of John Butler Yeats*, 409, 463, 635;
 play, 483; return from New York, 344, 384,
 474, 531–532; at York Street studio of, 133
—Yeats, Lollie, 156, 213, 242, 260, 266, 303–
 304, 308, 328, 435, 450, 484, 496, 576, 631;
 diary, 157–164; emotional problems, 242,
 267, 267–268, 307, 373–374, 381, 425, 514,
 592
—Yeats, Michael Butler, 530
—Yeats, Susan Pollexfen, 109, 154, 215,
 216–217
—Yeats, William Butler, 105–107, 137, 156,
 172, 184, 208, 260, 263, 267, 304, 345, 347,
 376, 409, 417, 422, 435, 437, 474, 483, 490,
 495, 517, 565, 575, 581, 628, 631, 644; as
 companion to, 105–107, 184, 345, 514; and
 his marriage, 477, 484; *Reveries over Child-
 hood and Youth*, 423, 435–436
Yeats, Lollie (Elizabeth Corbet; daughter of
 JBY), 66, 213, 237, 379, 437, 490
—Abbey Theatre, 300, 308, 399, 484
—birth, 56
—character, 84, 106–107, 113, 158, 166–167,
 177, 213, 242, 260, 264–265, 307, 311, 411,

Yeats, Lollie (Elizabeth Corbet; daughter of JBY) (*cont.*)
509, 514, 586–587, 604, 647
—Chesterton, G. K., 224
—Coates, Dorothy, 307
—Cuala (Press, Industries), 334, 407–408, 422, 448, 472, 496–497, 526–527, 596, 622, 635
—Devon, 120
—diary (1888–1889), 157–164, 574, 576
—Dowden, Edward, 407–409, 422, 622
—Dowden, Elizabeth Dickinson West (Mrs. Edward), 407
—Dun Emer, 240–242, 248, 260, 264–266, 278, 303–308, 322–323, 328, 334, 592, 596
—Easter Rising, 450
—education, 576; Froebel system, 166; Metropolitan Art School, 139; Morris, William (Kelmscott), 156; Women's Printing Society, 240
—emotional problems, 84, 267, 307, 322, 373–374, 379, 381, 411, 425, 617
—Gleeson, Evelyn, 240, 242, 258–260, 266, 303, 334, 592
—Gonne, Maud, 160
—Gregg, F. J., 140
—Gregory, Lady Augusta, 196, 399
—as household manager, 120, 166, 177, 204, 213
—illustrations (sketches of and by, photographs), **99**, **101**, **119**, **197**, **259**, **322**, **467**
—Irish Literary Society (London), 237
—Irish nationalism (troubles), 525
—Jowitt, Martha, 112
—London, 287
—"Merville," 92–93
—Mitchell, Susan, 497
—and money, 157, 159–160, 177, 204, 529
—New York, visit to, 306–307
—Phoenix Park murders, 126
—Pollexfen, Elizabeth (Mrs. Barrington Orr), 86, 94, 109
—Pollexfen, George, 377
—Pollexfen, William Middleton, 410
—Pollexfens, the, 381, 411
—Pound, Ezra, 448, 465, 631
—as printer, 240, 242, 592
—Purser, Louis, 180, 242, 322, 373–374, 512–514, 592
—Quinn, John, 238, 278, 307, 324, 348, 496
—residences: Bedford Park, Blenheim Road, 154, 157–164, 182, and Woodstock Road, 118; Eardley Crescent, 152; Edith Villas, 105, 112; Fitzroy Road, 560; "Gurteen Dhas," 242, 308; Howth, 123
—Sligo, 79, 82, 92–93, 193
—as teacher, 166, 177

—Thomastown estate, 159
—Walker, Mary (Maire nic Shiubhlaigh), 298, 300
—*Woman's Reliquary, A*, 407–409
—writings (*see also* diary, *within this entry*): fiction, 157, 574; painting books, 166, 177
—Yeats, Georgie Hyde-Lees (Mrs. W. B.), 477, 484, 509
—Yeats, Jack, 193, 566, 576
—Yeats, Jane Grace (sister), 109
—Yeats, John Butler, 311, 322, 324, 326, 328, 413, 426, 471, 474, 481, 484, 494, 496, 512, 529, 586, 647; *Essays Irish and American*, 481; *Further Letters of John Butler Yeats*, 496, 512, 643; memoirs, 472–473, 497; *Passages from the Letters of John Butler Yeats*, 463, 471, 635; return to Dublin, 487, 492, 647; self-portrait (unfinished), 515, 620
—Yeats, Lily, 184, 213, 238, 267, 308, 326, 328, 426, 463, 484, 496, 529
—Yeats, Michael Butler, 523–524, 530
—Yeats, Susan Pollexfen, 166, 186, 215, 217, 411, 566
—Yeats, William Butler, 106–107, 137, 193, 260, 264–265, 304–307, 322, 407–408, 422, 435, 448, 484, 526–527, 529, 565, 576, 581, 592, 596
—York Street studio, 133
Yeats, "Lollie": *see* Yeats, Laura
Yeats, Mary (Mrs. Robert Wise; sister of JBY), 34
Yeats, Mary (Aunt Mickey; aunt of JBY), 21, 79, 91–92
Yeats, Mary Butler (Mrs. Benjamin), 20, 548–549
Yeats, Matthew (uncle of JBY), 30, 63, 75, 79, 85, 92, 102, 108–109, 115–116, 119, 122, 126, 131, 136, 150, 336, 491, 495, 556, 561, 572, 594
Yeats, Michael Butler, 523, 530, 563, 574, 584–585, 587–588, 594, 607, 628, 640–643, 646
Yeats, Pádraig Butler, 646
Yeats, Pamela Butler, 628
Yeats, Peter Butler, 628
Yeats, Robert Corbet (brother of JBY), 27, 34, 72
Yeats, Robert Corbet (son of JBY), 72–73, 84
Yeats, Síle Áine, 646
Yeats, Siobhán Maire, 646
Yeats, Susan Pollexfen (Mrs. JBY), 35, **36**, 37, 39, 41, 43, 45, 50–51, 53, **54**, 55–56, 59–60, 63, 66–67, 70–71, 72, **73**, 77, 83–86, 94, 102, 109, **111**, **112**, 112–113, 118, 120–124, 126, **128**, 134, 136, 149–152, 154, 158, 167, 171, 174–175, 186, 192, 199, 204, 215–217, 267, 376, 384, 410–411, 423, 473, 477, 494,

Yeats, Susan Pollexfen (Mrs. JBY) (*cont.*)
527–528, 537, 550, 553, 555, 566–567,
573–574, 583, 586–587
Yeats, Thomas (uncle of JBY), 63, 72, 77, 454,
560
Yeats, Rev. William Butler (father of JBY),
19–22, **22**, 23–24, 29, 31–33, 38, 49–50,
125, 250, 353, 473, 490, 495, 548–552, 554,
565, 589, 642
Yeats, William Butler, Jr. (brother of JBY), 27,
34, 72, 84, 94, 107, 213–215, 437, 564, 628
Yeats, William Butler (son of JBY), 68, 132–
133, 144, 151, 196, 230, 244–245, 252, 254,
256, 263, 287, 294, 308, 323–324, 332,
334–336, 338, 341, 463, 472–473, 494,
496–497, 526, 540–541, 557, 565, 572–573,
583–584, 588, 609, 612, 615, 625, 627–628,
644, 649
—Abbey Theatre (Ormonde Dramatic Society,
Irish Literary Theatre, Irish National
Theatre Society), 195, 201, 209, 219, 227–
229, 245–246, 248, 254–255, 268–270,
277–278, 280, 288, 290, 293, 296, 299–303,
313–320, 330–331, 345–348, 374–376, 382,
388–389, 398–399, 405, 474, 484, 495,
602–603, 606, 608, 616, 645
—Armstrong, Laura, 132, 568, 573
—birth and infancy, 45, 50–51, 554
—character, 53, 82, 89, 94, 110, 113, 115, 129,
133, 143–144, 164, 172, 182–183, 190–191,
207, 219, 227, 246, 254, 260, 264–266,
277–278, 286–288, 296, 298–300, 303, 306,
308, 317–318, 343–345, 347–348, 361–362,
378, 380, 384, 390, 399, 411, 415, 418–419,
436, 448, 454–455, 477, 483–484, 495, 507,
527, 529–531, 575–576, 581, 595–596, 599,
605–606, 628, 630, 634
—chess, 131, 134
—childhood (*see also* Sligo), 66, 87, 92
—Contemporary Club, 140, 143–144, 147–
149
—Cuala Press (*see also* Dun Emer *within this en-
try*), 334, 382, 407–409, 422, 426, 435, 448,
461–462, 465, 526–527, 529–530, 592, 596,
627–628, 631, 634–635, 646
—Dowden, Edward, 129–130, 134–135, 144,
149, 168, 229–230, 383, 407–409, 422, 436,
446, 577, 597, 631
—Dublin, 127, 244–245
—Dun Emer (Industries, Press; *see also* Cuala
Press *within this entry*), 240–242, 260, 265–
266, 287, 303–307, 322, 334, 592, 596, 599
—Easter Rising, 450, 453, 454
—education: at Dublin High School, 127–129,
131, 133, 139, 568, 569; at Godolphin
School, 113, **114**, 115–116, 120, 122, 565–
566; at Kelmscott House, 576; at Metropoli-
tan School of Art, 139; at Sligo, 82, 94–95,

562, 564; by Yeats, John Butler, 95, 110,
117, 120, 127, 134
—Ellis, Edwin J., 63, 67, 169, 171, 192, 312,
557, 577
—Farr, Florence, 167, 169, 190
—Fay, Frank J., and William G., 229, 245–
246, 269–270, 278, 331–332, 606, 608
—Ferguson, Sir Samuel, 149
—*Four Years*, 161, 171, 526–530, 642
—Golden Dawn, Order of the, 167, 221–222
—Gonne, Maud, 160, 171, 191, 194–196, 203,
212, 245, 261–263, 269, 404–405, 454,
484–485, 575
—Gregory, Lady Augusta, 192–194, 196, 201,
203, 209, 221, 228–229, 238, 246, 252, 263,
269, 270, 278, 280, 290, 296, 299–301,
318–319, 348, 374–375, 399, 404–405, 409,
411, 433, 441, 454, 476, 581, 596, 624
—health, 72, 127, 201, 510, 578–579, 615
—Horniman, Annie, 167, 245, 254–255, 258,
269–271, 278, 301–303, 318–320, 374–375,
404, 599, 625
—illustrations (photographs, sketches, school
records), **46**, **47**, **81**, **82**, **100**, **104**, **111**, **114**,
119, **145**, **153**, **156**, **176**, **179**, **251**, **261**, **262**,
420, **421**
—*Ireland's Eye*, 131–132
—Irish National Theatre Company: *see* Abbey
Theatre, *within this entry*
—Irish nationalism (Celtic), 124, 149,
194, 203, 219, 269, 296
—Joyce, James, 247
—Lane, Hugh, 250, 280–285, 594
—marriage (*see also* wife and children, *within
this entry*), 384, 422
—money, 154–155, 176, 184, 190, 192, 204,
240, 261, 495, 573, 576, 624, 643
—Moore, George, 195, 201, 215, 219, 222,
227, 229–230, 246–247, 278, 362, 383,
418–419, 437, 589, 599, 617, 645
—Morris, William, and circle, 155–157
—Nietzscheanism, 264, 303, 343, 399
—occult (mysticism, magic), 89–91, 137–139,
167, 172, 175, 184, 201, 221–222, 231, 248,
271, 390, 399, 437, 444–445, 459, 472,
485–486, 495, 501, 562, 570, 630, 640
—O'Leary, John, 140–144, 154–155, 168,
171–172, 194–195
—paintings of (portraits, sketches, etc.), by
John Butler Yeats, 146, 232, 235, 324, 328,
453, 573, 580, 607–608; by others, 323,
607–608
—in Paris, 191
—pension (from British government), 376–
377, 388, 622
—*Playboy of the Western World, The*, 313–318,
339
—Pollexfen, Agnes, 80, 102

Yeats, William Butler (son of JBY) (*cont.*)
—Pollexfen, Alfred, 454
—Pollexfen, Elizabeth (Orr), 86
—Pollexfen, George, 171, 175–176, 376–378, 437
—Pollexfen, Ruth, 382
—Pollexfen, William (grandfather), 86–87, 93, 156, 174
—Pollexfens, the (general references, his similarity to, their influence), 53, 82, 84, 89, 92–94, 436, 454–455, 529–530, 537, 539, 579
—Pound, Ezra, 419–422, 465, 631, 634–635
—Powell, Frederick York, 154, 529
—professorship, candidacy for: at Trinity College, Dublin, 376–378, 383, 409–410; at University College, Dublin, 349
—Quinn, John, 236, 238, 254, 264, 277–278, 290, 303, 348, 379, 390, 404–405, 415–418, 433, 436–438, 441, 443, 454, 477–478, 480, 482, 495, 505, 508, 510, 521–522, 530, 532, 592, 628
—residences: Bedford Park, Blenheim Road, 154, 157–164, 171, 182, 184, 190, 215, 528, 580, and Woodstock Road, 117–118; Eardley Crescent, 152; Edith Villas, 112; Farnham Royal, 110; Howth, 123–124; "Merville," 92–93; Temple (Fountain's Court), 184, 581; Terenure (Ashfield Terrace), 137; Thor Ballylee, 454, 496, 643; Woburn Buildings, 191, 201, 211–212, 436, 581
—*Reveries over Childhood and Youth*, 174, 383, 422–423, 433, 435–436, 446–448, 560, 628
—Russell, George (AE), 195, 204, 245, 260, 270, 299, 399, 495, 526, 603
—Shakespear, Olivia, 183–184, 191
—Sligo, 79, 82, 92–94, 105, 169, 171, 174–176, 193, 376, 566
—as speaker, conversationalist, 207, 378, 390, 411, 415, 490, 495, 507–508, 595
—Symons, Arthur, 191–193, 345
—Synge, J. M., 194, 255, 268–269, 280, 286, 301, 313–320, 332, 345, 399, 582, 605–606, 611
—Todhunter, John, 144, 154–155, 168
—Trinity College, Dublin: *see* professorship, candidacy for, *within this entry*
—Tynan, Katharine (Mrs. Henry Hinkson), 144, 146, 157, 168, 191, 306, 571, 574
—United States of America, tours: in 1902, 260–264; in 1911, 388–390; in 1914, 405, 415–419; in 1920, 496, 505–508, 643
—wife and children, 422, 436–437, 476–477, 484–485, 495–496, 507, 642, 643; Anne Butler, 495–496; Michael Butler, 523–524, 530, 642
—Wilde, Oscar, 133

—writings: autobiography, 161, 171, 174, 383, 422–423, 433, 435–436, 446–448, 527–530, 560, 564–565, 568, 575, 582, 646; drama, 132–133, 168–169, 190–191, 193, 195, 209, 211, 215, 222, 227, 229, 245–246, 252, 254, 257, 268–269, 271, 277–278, 280, 303, 343–344, 374, 399, 401–402, 450, 481, 495, 569, 582, 585, 589, 595, 597–598; fiction, 132, 154, 192, 195, 212, 344, 550, 557, 570, 573, 577; letters, 110–112, 230, 361–362, 565, 609; poetry, 132–133, 137, 140, 144, 146, 155, 161, 168–170, 182, 230, 242, 261–263, 344, 382, 388, 405, 418, 422, 427–428, 454, 481, 495, 501, 516, 526, 562, 566, 573, 577, 580, 625; prose, 146, 149, 161, 171, 174, 191, 196, 201, 228–230, 266, 287, 312, 334, 343–344, 382, 399, 404, 415, 481, 485, 495, 563, 567, 570–571, 577, 582, 590, 599
—Yeats, Jack, 93, 162, 177, 203, 218, 219–221, 436, 597, 633
—Yeats, John Butler, 323, 344, 378–379, 390, 409, 414–415, 419, 426–428, 436, 438, 444, 457–459, 461, 495, 501, 516–517, 529, 569, 601–602, 617; comments on by WBY, 130–131, 306, 532; domination by, 94–95, 100, 110, 122, 141, 149, 154; education by, 95, 127, 562; financial support of, 261, 263, 266, 321, 323, 330, 413, 415–417, 432–433, 435, 455, 480, 495, 510, 623–624, 643; influence of, 171–172, 207, 229–230, 343, 378–379, 396–397, 411–412, 415, 426, 436, 446–448, 472, 526; liberation from, 161, 172, 192, 201, 212, 221; on memoirs of JBY, 398, 444, 473, 482, 637; *Passages from the Letters of* (ed. Ezra Pound), 409, 427, 448, 461–462, 634, 635; play, comments on, 456–457, 483–484; return to Dublin, comments on, 508, 510, 530, 532–533
—Yeats, Lily, 105–106, 182, 184, 260, 263, 266, 376, 382, 409, 436–437, 514, 529
—Yeats, Lollie, 106, 167, 177, 184, 260, 263, 265–266, 303–307, 408–409, 422–423, 448, 454, 465, 526, 529–530, 592, 596, 627–628, 631, 646
—Yeats, Susan Pollexfen, 86, 124, 167, 199, 215, 217, 567
Yeats, William Butler, Mrs.: *see* Yeats, George (Georgie Hyde-Lees Yeats)
Yeats, William H. (of Ballincar House, Sligo), 563
Yeats, William Michael Butler (*see also* Yeats, Michael Butler), 530
Yeats family (descendants of Benjamin Yeats and Parson John Yeats, generally), 32, 91–92, 265–266, 436, 444, 473, 548–549
Yeats family (JBY brothers and sisters, Susan Pollexfen Yeats and children, generally), 27,

Yeats family (JBY brothers and sisters, Susan
 Pollexen Yeats and children, generally)
 (*cont.*)
 77, 79, 82, 86, 91–93, 113, 139, 171, 174,
 183, 207, 237–238, 240, 245, 248, 254, 260,
 313, 321, 373, 376, 410, 423, 450, 454–455,
 473, 491, 578
Yeats International Summer School, 562, 573
Yeats Museum, County Sligo, 584
Yeats Society (Sligo), 541
Yeats: The Man and the Masks (Richard
 Ellmann), 550, 617

"Yeatses and the Dowdens, The" (William M.
 Murphy), 631
Yellow Book, The, 186
York Street, No. 44 (Dublin), 123, 126–127,
 129, 567
Yorkshire, 112, 397
Young, Alexander Bell Filson, 626
Young, Harry, 313

Zimmern, Alfred, 395, 525
Zuloaga, Ignacio, 467

PRODIGAL FATHER

Designed by R. E. Rosenbaum.
Composed by Graphic Composition Company, Inc.,
in 10 point VIP Baskerville, 2 points leaded,
with display lines in Baskerville.
Printed offset by Vail-Ballou Press, Inc.
on Warren's Patina Coated Matte, 60 pound basis.
Bound by Vail-Ballou Press, Inc.
in Joanna book cloth
and stamped in All Purpose foil.

Library of Congress Cataloging in Publication Data
(For library cataloging purposes only)

Murphy, William Michael, 1916–
 Prodigal father.

 Bibliography: p.
 Includes index.
 1. Yeats, John Butler, 1839–1922. 2. Portrait
painters—Ireland—Biography. I. Title.
ND1329.Y43M86 759.9415 [B] 77–3122
 ISBN 0–8014–1047–9